This book is due for return on or before the last date shown below.

Master Drawings

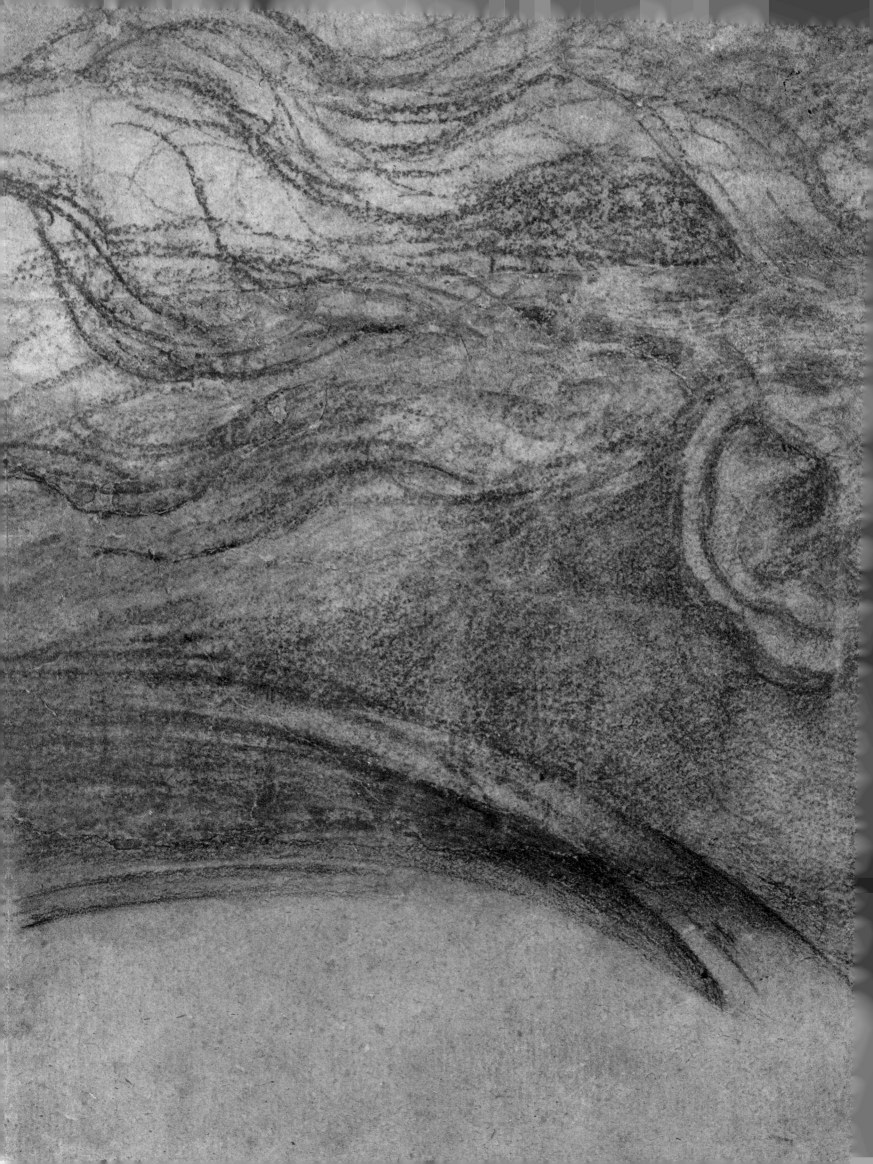

Terisio Pignatti

Master Drawings

From Cave Art to Picasso

Captions by Maria Agnese Chiari

Evans Brothers, London

Jacket and frontispiece:
Raphael: *Head of an Angel* (detail)
Musée National du Louvre, Paris

Translated from the Italian
by Sylvia Mulcahy
© 1981 Arnoldo Mondadori Editore,
S.p.A., Milan
English translation © 1982
Arnoldo Mondadori Editore S.p.A., Milan

© 1981 ADAGP, Paris: pp. 39 (above), 351,
357, 361, 368–9, 372, 374, 377. Beeldrecht,
Amsterdam: p. 370. Bild-Kunst, Frankfurt:
pp. 378, 380. Cosmopress, Geneva: pp. 358 (right),
368, 375, 377. SIAE, Rome: pp. 360, 365.
SPADEM, Paris: pp. 321, 322–3, 325, 326,
327, 328, 335, 350, 352, 353, 354–5, 356, 359,
371, 373. V.A.G.A., New York: pp. 39 (below),
381

The extract from Cennini's *Il Libro dell'Arte*
on page 15 is taken from Daniel V.
Thompson Jr.'s translation (New Haven,
NJ, 1961).

Published in 1982 by Evans Brothers Ltd.,
Montague House, Russell Square,
London W.C.1

Filmset by MS Filmsetting Ltd.,
Frome, Somerset

ISBN 0237 45674 5

Printed and bound in Italy by
Officine Grafiche di Arnoldo Mondadori
Editore, Verona

Contents

The Great Draughtsmen
from Antiquity to the Present Day

**Primitive Drawing
in Greece, Rome
and Byzantium**

For how long has man felt the urge to draw? For centuries? Millennia? Since the Stone Age? And how has he drawn? What has motivated him? Anthropologists have been seeking to answer such questions as these by studying the art of primitive peoples of the present day. Their reasoning goes something like this: if a tribe of hunters, living in isolation in the African or South American or Australian jungle, completely devoid of any trace of civilization, is found to be practising some form of decorative art (as distinct from its traditional crafts), then it follows that graphic art has existed for as long as humanity itself. Further, these primitive people will be using almost exactly the same techniques as their prehistoric forebears, who lived thousands of years before Christ.

The art of drawing has always been an integral part of human life. It seems justifiable, therefore, to regard such examples as can be found in the lifestyle of contemporary primitive people as analogous to the artistic traditions of those who have vanished into the mists of time. Nevertheless, this tantalizing hypothesis contains a shadowy area of doubt for it is a fact that, when certain semi-primitive peoples such as pygmies or Bushmen have been asked to demonstrate their skill at drawing, the results have been inferior to the work of their much more savage prehistoric ancestors. Not only do their techniques appear to be inferior: their imagination also seems to be lacking, and they give the impression sometimes that their desire to create figurative work has been extinguished. However, even if the primitive peoples of today are unable to re-create for us the precise way in which their distant forebears depicted scenes from life as they saw it, the principle is still valid, in so far as we can at least recognize certain expressive tendencies and the techniques involved in realizing them.

Between 20,000 and 15,000 BC, primitive man found an outlet for his artistic expression by making rock pictures in which he depicted subjects with which he was familiar. These included domestic and wild animals, hunters with bows and arrows, warriors with lances, and even ritual dances and magic symbols. Through such work he felt he was appeasing the forces of Nature which, for him, were personified in the gods of hunting and of fishing. It was customary, too, according to a tradition which is still observed in many parts of the world today, to carve or draw on a tangible surface a simple outline of the animal that was to be hunted or of the enemy to be overcome. This representation of the 'victim' assumed a magical significance, almost as though man were trying by this means to ensure the capture of his prey. Alongside social, animistic and religious motivations, of course, ran the artistic streak too, demonstrated with great clarity in such examples as the

rock carvings already mentioned. Communication through a graphic medium had been achieved. In close harmony with the anthropological motivation, man's irrepressible poetic sense now began to emerge.

Just how many of the figurations that have survived the centuries are actually drawings, that is wholly artistic representations motivated by artistic impulses as distinct from mere painted likenesses, it is difficult to establish. Probably the only way to arrive at a definitive answer is by closely examining the techniques. The prehistoric artist worked with a pointed black stone or a piece of charred wood (a form of charcoal) on a white background; he would then either colour or shade in the areas within the outlines he had drawn, usually using red ochre or a brown vegetable dye, either of which was often blown on to the picture through a reed. The pigments were then fixed with some kind of oily substance or with white of egg. We can therefore most certainly describe these early efforts as drawing in the artistic sense. The dark lines stood out boldly against the light-coloured rock – which had sometimes been artificially whitened – with burning vitality; there was a constant tension, an expressive existential rhythm. In the initial phase, at least, there can be no doubt that much of the figurative work was drawn as an artistic expression, if we are to regard 'drawing' as described in some dictionaries as the outlining on a surface of shapes which can then be enhanced by the application of close parallel lines (hatching), light and shade, colours, and so forth.

I believe it is fair to say that the most outstanding evidence of primitive artistic drawing of this kind can be seen in the caves of Altamira, near Santander, Spain. These pictures, which were discovered by chance in 1869, are in a cavern only a little over 6 ft. 5 in. (2 m.) high, yet they are of gigantic proportions. A herd of life-sized European bison extends all round the walls, the huge, clumsy bodies and long pointed horns giving the impression of a pounding force of legs and hooves. Some of the beasts are depicted as they charge their predators, while others are shown resting. The expressive power of these graphic studies, given particular emphasis by the use of charcoal, is such as to suggest a vibrant tension that seems to bring the animals to life, to quite frightening effect (p. 41).

The cave-paintings at Lascaux, near Montignac, France, may also be from 13,000 to 15,000 years old. The graphic quality is particularly prominent in many of these, especially in the long frieze in which deer are depicted fording a river. The linear effect is essentially based on the sharp definition of the great antlers, which are seen from a typically contorted perspective, the heads being turned to face forwards, while the bodies are seen in sideways profile (p. 42). This profoundly naturalistic art of a people who lived by the chase, and who were themselves a part of Nature, displays a technical knowledge and a sensitivity to graphic art that was already very advanced.

Other prehistoric examples that have survived the years are to be found, in the form of rock pictures, at Les Combarelles, Niaux, Trois-Frères and Font-de-Gaume in France, at Wadi Giorat in the Sahara, as well as in other caves in North Africa. One feature that they all have in common is that the drawings – executed in charcoal or manganese black – were clearly conceived with a view to subsequent coloration.

In the absence of evidence of any kind of paper-like material, a number of pebbles have been preserved from prehistoric times on which numerous figures of animals have been scratched. The fact that such drawings are frequently superimposed on each other, creating an apparently confused jumble of lines, seems to support the idea that these

Prehistoric engravings on a pebble, from La Colombière
Cambridge, Mass., Peabody Museum of Archaeology and Ethnology

may well have been used as trial-and-error tablets on which the drawings to be executed were casually positioned, just as for many centuries artists have used sketchbooks to try out particular effects.

It is clear therefore that drawing has always been one of Man's activities throughout the ages. Fundamental to this universal skill has been the discovery of the importance of line, which is, after all, an exceptionally pliable figurative element. Thus the miracle of linear art first found expression in the mysterious gloom of those prehistoric caverns.

As we move forward into the early centuries of recorded history, the surviving evidence of graphic art seems to diminish rather than proliferate. Very little can be identified, for instance, from the Sumerian civilization, that could be described as graphic art. Rather than depicting figurative shapes, these people – who flourished three thousand years before the birth of Christ – were more interested in experimenting with designs related to their hieroglyphic and cuneiform characters. The concept of drawing as an art-form becomes clearer, however, from the civilization of Ancient Egypt in the third millenium, and the imperial age of Rome. In fact, the technique of wall-decoration known as the fresco certainly involved the making of preliminary sketches *in situ*; these outlines were generally executed with brush-point in red and were only partially concealed by the final painting. In many of the more beautiful frescoes, such as the extremely realistic ones executed during the period of the New Kingdom (1567–1329 BC) in the Tomb of Nebamon, the colours have been applied in delicate shades of deep blue, ochre, sky blue and pale green. These are individually bounded by precisely defined outlines which, in their crisp yet fluid distinctiveness, produce a fresh and vital effect (p. 43). During this period, the artist would make preparatory work-drawings by sketching on flat pieces of terracotta, *ostrakas*, some of which can be seen in the Egyptian Museum, Cairo.

From the Phoenician, Hittite and Mycenaean civilizations of the Mediterranean, nothing of a pictorial or graphic nature remains to us at all. In Crete, on the other hand, many pictures have been preserved which can be dated to between 2500 and 1500 BC, but it is not easy to distinguish any element of individual artistic expression in their iconic rigidity.

The Greeks were particularly active in Attica during the last thousand years prior to the birth of Christ. Although their main means of artistic expression was through architecture and sculpture, a great deal of this work contained important graphic elements, at least in the creative process. The painted vases of the period are an excellent example of this. Their decoration consisted at first of black figures whose anatomical features were emphasized by incised lines; a little later on these figures came to be executed in red, especially in Athens.

Even more attractive are the pots on which figures were painted on a white background, the best examples being those dating from the fifth century BC. These are the famous *lekythoi*, so called because of their distinctively elongated cylindrical shape; the design was first drawn in dark, opaque colours with brush-point, giving a similar effect to that of a quill pen used on parchment (p. 44). A wonderful fluidity of line distinguishes this technique, which more than any other approaches the modern conception of artistic draughtsmanship.

It is only through literary sources, in which the history of art has been meticulously documented, that it is possible to gain some inkling of the remarkable technique and surprising realism of artists in the fifth to third centuries BC. Such artists as Polygnotus, Apollodorus,

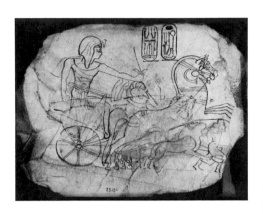

'Ostrakon' with Pharaoh in his war-chariot
Cairo, Egyptian Museum

Parrasius, Zeusus and Apelles achieved fame in their time, but it is only thanks to historians that we know of their work. These masters of their art all exercised their drawing ability in the planning stages of their work, in addition to using it as an entirely separate art-form. The Roman historian Pliny the Younger mentions the use of wooden panels which were prepared with a white background made from powdered bones; he also refers to parchment on which the artist would draw with soft metal points made of silver or lead. As a result of training in this medium, the pupils of Parrasius learnt the techniques of graphics and painting.

The Romans, due to the importance they gave to architecture and sculpture – perhaps because these afforded more scope to the glorification of political greatness – left little room for drawing as an art form in its own right. Indeed, Roman painting during the early Empire, the best examples of which are in Pompeii and Herculanium, was typified more by its pictorial quality and colour than by linear and graphic characteristics.

On the other hand, a definite awareness of the expressive possibilities of graphic media can be detected in Byzantine art. The return to draughtsmanship as an art-form was probably due to the tendency in Byzantine painting to dispense with the illusion of reality, and to concentrate on stylization and the transformation of natural things into unreal symbols.

There was also that strange, isolated culture that developed in the peninsula we now call Italy between the sixth and fourth centuries BC. This was the Etruscan civilization. Because of their religious beliefs, the Etruscans used their artistic skills almost entirely in the decoration of their tombs. The graphic qualities that predominate give great linear energy and emphasis to the idea of movement. Fine examples of this can be seen in such well-known tombs as the *Tomba degli Auguri* (Tomb of the Augurs) (p. 45) and the *Tomba della Leonessa* (Tomb of the Lioness).

Asia and the Far East

At least two thousand years before the birth of Christ, a remarkable tradition of painting developed in India, alongside other art forms, of which the best examples are to be found in the rock sanctuaries of Ajantā. These are frescoes inspired by themes illustrating everyday life and court ceremonies in that part of India.

Whilst it is difficult to identify traces of drawing as such in what survives of Hindu art, we can detect them in some of the later illustrations of sacred and profane texts on decorative tiles or painted panels. The illustrations in the codices, which were executed on palm leaves in Southern India, also come under the category of drawings. In these, the outlines were first incised with a stylus and then darkened with coal-dust. The Bengali technique, however, was to prime the ground surface with plaster. It was not until after the introduction of paper from Persia in the fourteenth century AD that there was any real artistic draughtsmanship in Indian art. This showed itself particularly in the form of black-ink sketches on a light background, and these were known as 'Persian style' (*iráni qalam*) drawings. After 1600, however, this form degenerated into ordinary illustrative work to appeal to the popular taste and no longer purported to be creative art. Hindu artists also made use of doeskin to make drawings for tracing (*carba*) and these sometimes displayed genuine graphic characteristics.

With the advent of Muhammad (AD 622) and the foundation of

Islam, a new, important trend began to develop in the Middle East which had a strong influence on the surrounding civilizations, particularly India. Islamic art grew out of the convergence of various cultures, incorporating such basic elements as the linear arabesque from the Arabs, geometric ornamentation from the Turks, and pictoral imagination from the Persians. The Islamic religion itself tended to concentrate artistic attention on ornamental and abstract features which favoured the development of an essentially graphic form of expression. Reproduction of the human figure was, of course, totally prohibited in religious iconography, but did appear in illustrated manuscripts, achieving very high levels of excellence in miniatures and in the rare frescoes that adorned some of the patrician houses. From the beginning of the thirteenth century, the miniaturists were organized in workshops under the protection of the courts, engaged in illustrating the epic poems and stories of the period.

With the establishment of the Tamerlane (Timur the Lame) dynasty, Persia became the centre of Islamic art. Painting continued to develop in the following period under the Safavids, colour and graphic qualities becoming increasingly refined. The frescoes by Reze-i-Abbasi in the Ali Qapu palace at Isfahan are fine examples of this work. After 1500, the influence of the Persian miniature spread even to India, where it contributed to the growth of the calligraphic school in Kabul. The resulting style was called 'Mogul' in India and was distinctive for its narrative tendency, which was expressed in essentially graphic terms, as well as the rich chromatic qualities of its ornaments.

In about 2000 BC, the artistic culture of the Chinese was beginning to take shape. In order fully to appreciate the qualities of figurative Chinese art, it is essential to consider its technicalities. Above all, we must remember that there is very little difference between painting and drawing in Chinese art, as a brush is always used for both. Such difference as there is lies in the way in which the brush is used. For instance, the ink may be applied in rather even strokes, that is 'linear profiling' (producing an effect very similar to our concept of drawing) or it may be used to give tonal variety, the 'calligraphic touch', to achieve effects that could be more specifically described as painterly.

In the oldest drawings, which were produced during the first century AD – and particularly in the T'ang dynasty (AD 618–907) – the linear effect prevailed, achieved by means of the controlled and sparing movement of the brush. In the pictures painted on silk, where the calligraphic brush strokes are lighter, the colours invest the drawing with delicate shadings, creating an atmosphere of timelessness. An artist whose work typifies this style is Chou Fang; he lived in the eighth century AD and worked in one of the courts (p. 49).

For thousands of years the Great Wall was not only an impassable military bulwark in the defence of China but also, and above all, the perfect frontier, with its powerful symbolic significance. China's place in the field of figurative art was therefore totally unassailable. Nevertheless, it is possible to sense that, in some very ancient Chinese figurative art, there is an echo of links with primitive cultures unrecorded in history, transmitted mysteriously through the brushes of those early artists. Some of the ceramic plates, for instance, which are decorated with raised brush strokes and which date from soon after the birth of Christ, may well recall the representative expressiveness of the prehistoric rock drawings. It seems not impossible that contact may have been made between migratory peoples

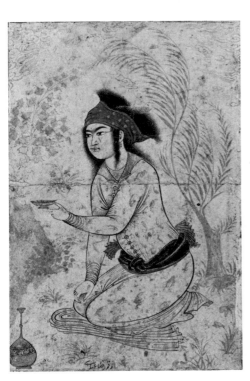

Reze-i-Abbasi: *Young Man Kneeling with a Cup of Wine.*
Washington, DC, Freer Gallery of Art

11

in those Dark Ages before history; these nomadic tribes may well subsequently have become scattered throughout various regions, far away from each other, but still retained something in common in their deeply rooted means of figurative expression.

With the spread of Buddhism from the sixth century onwards, the figurative arts acquired a common theme in innumerable representations of the Deity. Then, as the Taoist and Confucian religions became established, Chinese artists adopted a more liberal approach to the life of Man and to Nature. For example, drawings depicting landscapes proliferated, particularly in the T'ang and Sung dynasties (AD 618–1260), their charm and freedom of style becoming the basis for the same themes right up to modern times. It should be remembered, of course, that the countryside has a profoundly religious significance for the Chinese artist, since it reflects 'the universal soul' of the world. To achieve the required effect, linear strokes are used in conjunction with soft washes of watercolour applied with a brush with delicate unevenness (pp. 50–1).

During the Yüan dynasty (AD 1271–1368) naturalistic themes were developed, as well as those relating solely to scenery, including animals and the human form (p. 52). Not even the Mongol invasion, led by Genghis Khan at the beginning of the thirteenth century, could stop the work of the Chinese painters. Among these, one in particular stands out: this was Wu Chên, who discovered the graphic and painterly qualities of the bamboo plant. He found that, in depicting its leaves with a brush, the ink created magical effects of transparency and mobility (p. 53).

The next dynasty, the Ming (AD 1368–1644), saw the painting and draughtsmanship of Chinese artists reach its peak; it was during this period that they perfected their techniques. In the rarified atmosphere of the Peking court, a wide variety of figurative work was produced, including a great deal of portraiture (p. 56). The greatest masterpieces in the graphic sphere were, however, still to be found in landscape work, and it was the painter Tu Chin who was particularly outstanding. The graphic style was becoming increasingly free, with a technique of brush-strokes that we would now call Impressionist in the artists' attempts to catch the effect of light on a subject, giving the appearance of disintegration.

Japanese pictorial culture, although historically drawing its origins from China, is quite remote in style from the Chinese tradition. Its centre of production was in the ancient capital of Kyoto, which was founded in AD 794.

The establishment of the Buddhist religion, with its demand for representations of the Deity, was the first influence on the imagination of Japanese artists. From the twelfth century AD, therefore, completely autonomous and original styles were emerging, especially in the illustration of religious and popular texts. Representational designs were frequently drawn against the dark background provided by silken scrolls; these would be emphasized with powdered gold and silver bonded with resins. Subsequently, the use of ink came to the fore; the usual brush technique was employed, similar to that used for calligraphic ideography and closely linked to the contemporary Chinese styles. Nevertheless, Japanese figurative design was quite distinctive because, in my opinion, it gave particular importance to dynamic line (p. 55). There was a forceful linearity – exemplified in the drawings of the fourteenth-century painter, Kao (p. 57) – which was to remain typical of Japanese art through the succeeding Momoyama and Edo periods (AD 1567–1867) right up to

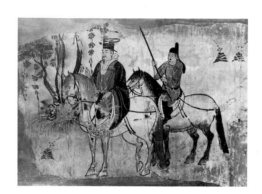

a T'ang Nobleman with Groom
Paris, Musée Guimet

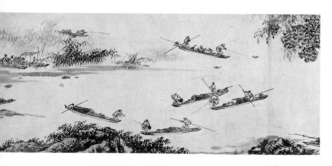

Tai Chin: *Fishermen on the River*
Washington, DC, Freer Gallery of Art

the present day. This style is clearly represented in the wood-block prints (xylographs) of landscape by Utamaro (eighteenth century) and by Hokusai and Hiroshige (nineteenth century) (pp. 58–9).

The Middle Ages in Europe

The Middle Ages can be seen as a period of decisive importance in the cultural development of Western Europe.

In a dramatic but mainly consequential succession, which centred on Central Southern Europe, there was the Lombardic period (sixth to eighth centuries), the Carolingian (ninth to tenth centuries) and the Ottonian (eleventh century), each period being named after the people who replaced each other within the boundaries of Roman culture in Europe, the Near East and in the Mediterranean area that once belonged to the Empire.

What role did artistic draughtsmanship play in the vast and complex spectrum of medieval figurative culture? Generally speaking, the main figurative tendency to emerge from the early Middle Ages – the period coinciding with the arrival of the 'barbarians' – was inspired by the desire to break away from the Classical image and was based on an attempt to reproduce reality in as natural a way as possible, with a strong emphasis on proportion and formal harmony. The 'active principle' to emerge from 'barbarian' art – especially from such items of industrial art that have survived in the form of small objects, decorative sculpture and architectural decoration, as well as from the miniature – seems to have been founded on characteristic motifs of entwined foliage and animal themes. This consisted of a tangle of dynamic linear drawing, potentially abstract but effective in its own right (*simplegma*). Although Lombardic in origin, this linear motif was undoubtedly inspired by a centuries-old art-form of protohistoric times; it retained its intrinsic strength even when passing through the various medieval cultures that followed one another, dominating the Western world. It is thus possible to identify one typical feature of that period as expressive strength of line.

Even in the Middle Ages, drawing as an independent art-form certainly existed, not only as a planning medium but also as an exercise in free graphic expression. The first signs of it can be seen in the marginal sketches in some of the very old codices, and later there was extensive activity in the pen-and-ink illustration of manuscripts, in miniatures, in *sinopie* for frescoes and in the sketchbooks of painters. If little of this kind of material – apart from the codices – has survived to our own day, the reason is partly to be found in the medieval aesthetic viewpoint which regarded a drawing as being purely of use as a working guide and thus not worthy of any particular attempt to preserve it. Another factor was the high price of parchment – the usual basis for a drawing – which must have placed a severe restraint on an enthusiastic draughtsman. This situation continued until at least the end of the fourteenth century, when paper, being much cheaper, became more widely used.

The oldest medieval drawings are therefore the marginal sketches, remarkable in that they may be attributed not only to the expert calligraphers who copied the manuscripts but also to anonymous artists who often managed to convey an impression that was at once ingenuous and keenly caricatural. There are some marginal drawings in a fifth-century Coptic Bible from Naples and others, in the Carolingian style, in a Bible in the Vallicelliana, Rome; there are also some in a drawing of the 'Last Judgement' in a manuscript from the

The Flight of St Paul
Naturno, N. Italy, Church of San Procolo

Capitulary of Verona. The symbol is usually executed free-hand, with the point of a quill pen, producing an effect charged with subtle energy.

An important contribution has also been made to the evolution of early medieval linear language by the Northern cultures which developed in isolation. This was disseminated throughout Europe by Benedictine monasteries such as that of Bobbio in Montecassino, Italy. A particularly good example is that of the school of miniature painting in Ireland. In looking closely at various eighth to ninth-century Hiberno-Saxon masterpieces, such as the Book of Kells, Dublin (p. 62), one is immediately aware not only of their exquisite decorative quality but also of the intrinsic dynamism of their geometric forms. Much of the essential restlessness and excitability of the Irish temperament is transmitted through the graphic style of the early Middle Ages, of which some evidence can be seen in certain frescoes and in illustrations in codices.

Even though no example of a really graphic work has been singled out, there is no doubt that the production of frescoes in the early Middle Ages can to a large extent be linked with similar influences in the North. On this basis, therefore, it is not difficult to imagine what would have been the graphic forms of the time. Possibly some of the best examples can be seen in the pictures of Castelseprio, near Varese (seventh to eighth centuries), with their colours accentuated by shafts of light, or in those of the eighth century in the church of Santa Maria Antiqua, Rome, in which the strongly dynamic effect is due mainly to the skilful use of lines.

The illustrations in many of the codices that came from the scriptors' offices (*scriptoria*) in the Benedictine monasteries were unquestionably drawings in the true sense of the word. Between the eighth and tenth centuries, the monks, who were dispersed throughout Europe from Switzerland and southern Germany to the south of Italy, evolved a kind of artistic language of their own. It amalgamated the dynamic and linear expression of the Northern idiom with Byzantine decorative abstraction. Thus the traditional 'barbaric' style became blended with those of Roman extraction from late Antiquity. The new 'vulgar' language that emerged from it managed to achieve an extraordinary narrative force.

The pen-and-ink sketches illustrating the famous Utrecht Psalter (*c.* 820–32), a masterpiece of Carolingian outline drawing, had a similar effect. The narrative style of the unknown draughtsman, who may have learnt his skills in the school of Reims, is based on unerring strokes which, by tapering at the ends, sought to give the effect of movement (p. 63).

The graphic styles of the succeeding periods can also be identified through illustrated codices. Examples range from the somewhat classically based styles which stemmed from the Carolingian restoration to the more incisive and realistic ones of the Ottonian school (p. 64). Examples such as these take us well into the Middle Ages, to the twelfth to thirteenth centuries in fact, when schools of painting and artistic groups were developing a system of making 'pattern-books'. These relatively durable sketchbooks became invaluable, not only for their immediate purpose of providing a source of reference for copying drawings and guide-lines for new works, but also for enabling succeeding generations to gain an insight into the mental processes that were involved in the production of drawn images.

The most famous sketchbook of the period is that of the early thirteenth-century French architect and stonemason Villard de Honne-

court, in which the drawings already contain a strong element of Gothic linear style, showing a distinct Northern influence. Even the artist's technique and artistic theories are carefully classified, rather like an instruction manual in which drawing often assumes a completely independent dimension.

The largest collection of advice was produced in the fourteenth century and simply called *Il Libro dell'Arte*. The author, Cennino Cennini, was an insignificant painter but a shrewd and precise writer of treatises. He devoted a great deal of this work to drawing, which for the first time was presented both from the technical point of view (the preparatory work) and the conceptual (the independent quality produced by structural comprehension).

Cennini was very proud of having been apprenticed in the studio of Agnolo Gaddi (a painter in the Giottesque tradition) which was one of the more typical corporative bodies of Florentine pictorial art at a time when the artists' guild was struggling to acquire the right to be accepted on a level with major guilds such as those of the doctors, chemists and merchants. Cennini's precise theorizing about drawing enables us to understand the autonomy of this medium, just when documentation on the subject was beginning. Particularly relevant is the section dealing with *sinopie*, in relation to the large number of fourteenth-century examples to be found in the Camposanto, Pisa. Even more rewarding is his reference to one of the most important drawings to have been handed down to us which can be seen in the Louvre, Paris; this picture was not only drawn but also shaded and painted in watercolours by Taddeo Gaddi, the father of Agnolo, Cennini's teacher (p. 65).

'Do you realize what will happen to you, if you practice drawing with a pen? It will make you expert, skilful and capable of drawing out of your own head.' This was how Cennini expressed himself in Chapter 13 of his book and, in so doing, made a statement that had never been made before. He affirmed categorically the independent conceptual value of drawing. Faced with the traditional overriding themes of medieval culture – either theological, as seen in religious painting, or aesthetic, as in the way Nature is portrayed – the book does not arrive at the awareness of the complete, inalienable freedom and moral independence of the artist; but there is no doubt that, after Cennini, drawing can be viewed both technically and theoretically with a modern eye, that is to say it can be related to the artistic whole right up to the present day.

It is difficult to say just how long Europe took to graduate through the various art-styles of the Italian Renaissance and reach the modern age, because the pace of this evolution in art varied from one cultural zone to another. In Northern Italy there was an artistic culture with a strong 'Gothic' flavour, which lasted throughout the fourteenth century until at least 1450, while in the rest of Europe it survived even longer. On the other hand, new styles had already been established in Florence in the first decades of the fifteenth century by such artists as Brunelleschi, Donatello and Masaccio. Naturally, these new trends spread to the graphic field as well, but it is important to note that by the late Middle Ages painters were already, with much confidence and sophistication, making full use of drawing, imparting to it the fundamental characteristics of their personal style. The recent attribution of drawings to artists known primarily for their painting activities thus becomes completely credible. One has only to recall the subtle silverpoint modelling by Simone Martini (p. 66) for his Berlin *Angel*; or the incisive and majestic *Archer* in Oxford, which has been

Villard de Honnecourt: *Figure and Gothic Apse*
Paris, Bibliothèque Nationale

attributed to the same (unknown) master who painted, on silk, the altar frontal (*c.* 1375) known as the *Paremont de Narbonne* (p. 67); or the *Education of Mary* in Nuremberg, which it seems may indicate the art of the refined court of Prague. (p. 68).

One common graphic element seems to link these sheets which belong to cultures so distant and so different from each other. It is to be found in the fine lines that seem to suggest a blending of the forms with the delicate grace of the extreme Gothic style of architecture, so widespread throughout Europe, which had become reunited in the fabulous wealth of its courts.

International Gothic culture is very rich in graphic works ranging from sketchbooks depicting animals, botanical and pharmaceutical subjects, and early fifteenth-century costume (p. 69) to preliminary drawings for panels and frescoes. There are many drawings extant from this rich '*ouvraige de Lombardie*' (the extreme Gothic style, so called after its main region of origin) attributed to Giovannino de' Grassi (p. 71), Michelino da Besozzo and Gentile da Fabriano (p. 70). These undoubtedly display a certain technical harmony – silverpoint or pen and watercolour on parchment or prepared paper – which gives them an obvious unity of language.

The first draughtsman whose work could be collected into a lengthy catalogue was Pisanello. While he used the same graphic media as others, he stood out among the rest because of his exceptional independence of style. He made use of every type of drawing from the simply sketched note in pen or brush – drawings of costume and of the nude – to the finished 'study' or preliminary art-work for a panel or fresco (p. 72–3) in which every detail was accurately defined. Pisanello's style offers so much more, both in quality and expressiveness, than that of his contemporary artists; it is as though he had caught the spirit that was pervading the culture of the spoken word – for this was the time when court troubadours were singing their Provençal poetry, when delicately languorous melodies were being played on the lute and the measured rhymes of songs were to be heard. Through the pages of his note-books the fabulous world of the late medieval courts seems to come back to life.

In the meantime, in Florence, such artists as Lorenzo Monaco ('the Monk') and Lorenzo Ghiberti were already exploring fresh channels that were to lead into a new realm of art – that of the great artists of the Renaissance.

Paolo Uccello: *Perspective Study of a Chalice*
Florence, Galleria degli Uffizi

The Early Renaissance

The early Renaissance gravitated between three main constellations – Florence, Venice and Flanders – and the most outstanding draughts-men of the time are associated with these cultural centres. But it was, of course, Florence that instigated that complex phenomenon known simply as the Renaissance. More than a mere revival of Classical values, it offered a new perspective of life centred on humanistic ideals and an awareness of reality. It was a period that seemed to inherit all the philosophical and historical greatness of Antiquity. In short, the Renaissance involved the acquisition of a new awareness of the world in all its poetic and rational forms. One of its more important phenomena was, indeed, the complete reassessment of the laws of perspective on which Brunelleschi theorized and which was applied by such artists as Masaccio and Piero della Francesca.

The combination of these factors exerted a surprising effect on the attitude of the cultural world towards draughtsmanship. Its position

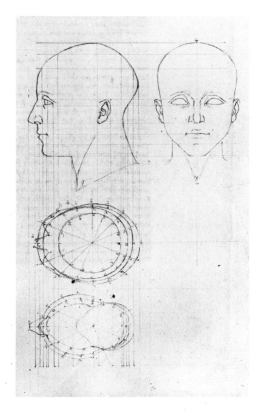

Piero della Francesca: *Geometric Heads*
Milan, Biblioteca Ambrosiana

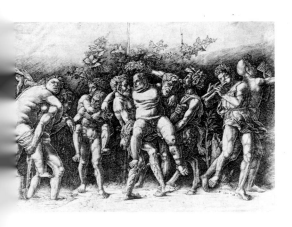

Mantegna: *Silenus* (engraving)
New York, The Metropolitan Museum of
Art, Harris Brisbane Dick Fund

as an art-form became pre-eminent until, almost as though by a natural process of logic, it became the epitome of figurative values. The early fifteenth-century Tuscan artists came to regard drawing as a means of reappraising the significance of reality, as though this were to be discovered through Nature in landscapes or through Man in portraiture.

Painters such as Paolo Uccello (p. 79) and Piero della Francesca held strong views on the significance of perspective and made use of the graphic medium to emphasize it. While the application of such theories can certainly be seen in Uccello's very distinctive drawings of objects – detailed headgear, for instance – with their many facets executed with such close attention to perspective, they are even more clearly illustrated in the work of Piero della Francesca. Here the graphic skill with which he obtained his effects of plasticity and light is paramount; he succeeded in achieving a complete reinterpretation of the values of colour in the representation of form.

The Florentine theorists of the early fifteenth century, Ghiberti for example, regarded drawing as the 'foundation of painting' because of its semantic, experimental qualities. As a result of this attitude, the graphic means of expression came to be used widely in all aspects of art – in the preliminary research and preparation as well as in the final solution of the problem of portraying the image. It became, in fact, one of the main features of Tuscan art.

In Florence, a good draughtsman was esteemed as much as a good painter. It is a very difficult task to select the most outstanding among them; many hundreds of sheets of drawings are still extant from the early Tuscan Renaissance and the standard was exceptionally high. Certain drawings which have been identified as the work of recognized masters would by themselves amply account for the extraordinary influence their work had on other artists of the time. It is easy, for instance, to understand the importance of Antonio Pollaiolo by considering the two or three drawings that are attributed to him, in which the linear strength clearly indicates movement and is at the same time charged with expression (p. 81). In the case of Verrocchio (p. 83), although only a few of his pages of drawings are available to us, the fluidity of his lines, which give such substance and plasticity to his figures, influenced a whole generation of artists from Sandro Botticelli (p. 82) to the sculptor Luca Signorelli (p. 87). Other draughtsmen, for example Benozzo Gozzoli (p. 80), Domenico Ghirlandaio (p. 84), Filippino Lippi (p. 84), Lorenzo di Credi (p. 85) and Pietro Perugino (p. 86), were more subtle in their figure modelling, using silverpoint embellished with touches of colour and taking skilful advantage of the pale yellow, pink, green and grey of their grounds. These artists undoubtedly turned to linear composition – which seems to have been the leitmotiv of Tuscan design – in their attempt to depict forms with full three-dimensional qualities.

In Venice, on the other hand, the tendency seems to have been much more towards achieving maximum effect through colour, almost as though consciously making the linear aspect of only secondary importance. Even at the time of transition between Gothic and the early Renaissance, Jacopo Bellini seems to have succeeded, in his complex architectural drawings, in harmonizing the effect of perspective with the pictorial qualities achieved through the use of light of dazzling limpidity. His drawings, collected into two volumes now in the British Museum and the Louvre (p. 88), thus formed a foundation for the development of all graphic activity in Venice.

Meanwhile another culture, based on the Tuscan pattern, was

developing in Padua. Francesco Squarcione, an entrepreneur and a prominent figure in the Paduan school, made great use of drawing in his work both as a teacher and as a painter in his own right: a drawing by Pollaiolo is, in fact, known to have been in his studio-workshop; and it is not difficult to see that the graphic style of engraving and design used by Andrea Mantegna – the greatest of the artists working in the revived classical style in Padua in the latter half of the fifteenth century – sprang from Florentine patterns, although these are somewhat modified by the special effects produced from his palette, which reflected the cold and changing light of the Venetian idiom, as illustrated in the Paduan frescoes (p. 89). Mantegna nevertheless assumed the position of master-painter in relation to his contemporaries, as can be seen from some of the graphic work produced by other artists who attended the school at Padua at that time; outstanding among these were the engraver, Marco Zoppo (p. 91), and those two great painters from Ferrara, Cosmé (or Cosimo) Tura and Ercole de' Roberti (p. 90).

There are difficulties in trying to distinguish the youthful drawings of Giovanni Bellini from those of his fellow artist, Mantegna, who worked with him under the influence of Donatello in the Paduan school. Some scholars today regard only the few drawings from Bellini's later period as being of unquestionable origin; but others – possibly with justification – claim to be able to identify his youthful draughtsmanship among drawings hitherto attributed to Mantegna, in which appear the freer, more painterly qualities that occasioned the distinctly similar character of their paintings (pp. 92–3).

Of particular importance to the last generation of fifteenth-century artists was the presence in Venice in 1494 of the 23-year-old Albrecht Dürer who was to return there in 1505 for a stay of two years. With a background of training in all the artistic techniques in his home town of Nuremberg, this young man brought with him ideas of an art realistic in its themes and clearcut in its line, which had a singular impact not only on such secondary artists as the engraver, Jacopo de' Barbari, but also on those of a very much higher calibre such as Lorenzo Lotto, Giorgione and Titian.

While the Italian Renaissance was flourishing in Florence and Venice, another great constellation of the figurative arts was coming to the fore – as already mentioned – in Northern Europe, centred on the elegant courts and wealthy bourgeois homes of Flanders and subsequently spreading into the neighbouring areas of France and Germany. Here, too, a rebirth took place, resulting from a cultural process which, at the beginning of the fifteenth century, had gradually superseded the International Gothic style. The only difference was that the Flemish painters, in contrast to the Italians, concentrated entirely on reality; it became the main object of all their representational work, whether inspired by sacred or secular themes.

Artists were working in Bruges, Ghent, Louvain and Brussels of the calibre of Jan van Eyck (p. 98), Rogier van der Weyden (p. 101), Gerard David and Hans Memlinc (or Memling). Their rare drawings, which were nearly always executed in silverpoint on specially prepared paper, are evidence of a graphic technique organically connected to a delving into reality – which is also apparent in their paintings – revealing actual microcosms to the more searching, meticulous minds. Outstanding examples of this style are the van Eyck portraits, built up with so much patience and attention to detail, almost as though seen through a magnifying glass.

Nor is there a lack of interiors, exemplified, perhaps, by the

eminent German-Swiss artist, Konrad Witz (p. 102), who worked mainly in Basle. Witz seems at times to have found a point of contact with the conception of spatial effect which predominated during the Italian Renaissance. In France, the work of Jean Fouquet – also reminiscent of van Eyck in the graphic spiderweb of its design – seems to have caught something of the plasticity of the Tuscan style, following a visit to Italy (p. 100).

By the end of the century, the Flemish Renaissance was already coming to an end with the strange, isolated work of Hieronymus Bosch. Several of his drawings are still in existence, all having some relevance to certain of his paintings with surrealistic or grotesque themes (p. 103). In their detailed penmanship they undoubtedly stem from the well-established Flemish tradition which, in the fifteenth century, had enjoyed an exceptional period of poetic coherence.

The High Renaissance in Florence and Rome

The sixteenth century saw the establishment of drawing as an art-form of great importance. From the main Italian centres of culture such as Florence, Rome, Parma and Venice, as well as from many in the Germanic world, a great inheritance of drawings has survived the centuries. These studies and sketches are of exceptional interest in that they show us how the graphic medium had become completely accepted both as an aid to research and as a creative instrument in its own right.

Leonardo da Vinci was one of the most prolific draughtsmen of his time and he used the graphic medium in the widest, most penetrating ways. In his famous codex manuscripts, for instance, which contain so much of his thinking on a variety of subjects, the pages are liberally interspersed with studies (p. 108). These include accurately drawn plans, patiently observed analyses of natural phenomena and fascinating projections of his own imagination. Leonardo's drawings, whether executed in pen, sanguine, pencil, metal-point or brush, frequently give the appearance of paintings because of the quality of shading and chiaroscuro in them (pp. 109–10). As a whole, this makes up a graphic corpus of extraordinary stylistic unity.

Michelangelo, on the other hand, was strongly conditioned by his sculptor's eye. His drawings give the impression that some super-human strength must have shaped the lines to give the onlooker a preview of the three-dimensional image already formed in the artist's mind. In the cartoons for his frescoes, too, Michelangelo drew the outlines – from which he could not deviate – with such assurance that they seem to be in full relief (p. 111). Equally confident in his use of pen in hatching as he was in sanguine and charcoal, Michelangelo has left a great many drawings; they include a number of architectural plans, original ideas and studies of details of a number of his own works.

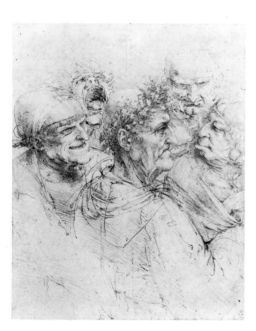

Leonardo da Vinci: *Grotesque Heads*
Windsor Castle, Royal Library

The drawings of Raphael, on the other hand, seem to reflect something of a refined and cultured – sometimes even elegantly hermetic – personality in the light, fluid use of the pen and pencil (pp. 113–15). His early life in the Umbrian region of Italy is amply documented in the many drawings he did when very young, their style being augmented by the fine lines he learnt to use during his stay of about four years in the workshop of Perugino. While he was in Florence he would have been influenced by the harmonious realism of Leonardo da Vinci. Raphael also spent some time in Rome, where he came into contact with Michelangelo and two Venetian painters, Sebastiano del Piombo and Lorenzo Lotto; it was during this period

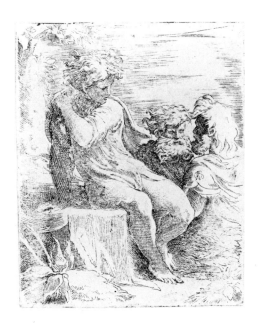

Parmigianino: *Boy and Two Old Men*
(engraving)
Rome, Accademia Nazionale dei Lincei, at
present on loan to the Istituto Nazionale per
la Grafica (inv. FC 76032)

that he finally discovered how best to achieve pictorial plasticity with pencil and charcoal.

The influence of the three great masters can be discerned in a number of prominent artists who were active in Florence and Rome at the beginning of the century. The portraits of Fra Bartolommeo della Porta, for instance, show the influence of both Leonardo da Vinci and Raphael, in that they are drawn with clear-cut lines, but are still rich in pictorial plasticity (p. 117). Andrea del Sarto, who created a vibrant effect in his outlines, shading the surfaces with the heavy, shadowy feeling of his own pictorial language, was clearly affected by his contact with both Leonardo and Michelangelo. This was particularly so in the detailed studies in sanguine for his paintings (p. 116). As the century progressed, the more highly evolved Mannerist style was developing, the first exponents of which were Pontormo and Domenico Beccafumi. They were already using the vigorous forms of this profoundly anticlassical trend within the smooth-flowing *ductus* of linear expression (pp. 118–19).

The Parma School was also to make an important contribution to Mannerist art. This was due not so much to its originator, Antonio Correggio (p. 121) – whose graphic work is still reminiscent of his early days under the influence of Mantegna, from whom he derived his feeling for a strong, clear-cut line and statuary values, while demonstrating the individual artist's right to independence in certain important pictorial styles – as to the numerous drawings of Parmigianino (p. 120). This prolific artist had been considerably influenced by the flowing, rapid style of Raphael during the latter's stay in Rome; as a result, he tended more and more towards a linear style, similar to the one he used for his etchings. And it was this dynamic style that was to prove the basis for the language of Mannerism, especially in Northern Europe. About this time, a number of outstanding draughtsmen were associated with the Parma School, including such artists as Niccolò dell'Abbate (pp. 122–3), who played a part in spreading this unquiet, emotional style far afield, even impinging on the elegant decoration of Fontainebleau.

Federico Barocci was also somewhat influenced by the Parma School. Later he came under the sway of Raphael, although his own sympathies lay primarily with the Venetian feeling for colour. He produced a great many drawings, most of which were executed in coloured chalks; they covered a seemingly endless range of themes although nearly all were studies for his paintings. Here the art of drawing is seen in its freest, most expressive form (p. 124).

The Sixteenth Century in Venice

In Venice, the century opened with Giorgione. While his new ideas made a significant impact on the world of painting, his contribution to graphic art is almost impossible to gauge, as the only page of his drawings to have survived seems to be his *Shepherd Boy*, which is in Rotterdam (p. 130). In this the figures appear to float on an almost unruffled sea of lines which recall not only the fine detail of the style of Giovanni Bellini – whose pupil Giorgione had been – but also something of the graphic technique so typical of the North.

Lorenzo Lotto gravitated towards a very independent graphic style which was nevertheless always inspired by story-lines and kept closely to reality (pp. 131–3). The wide range of experience he gained as he moved between Lombardy, Rome, and the Marches inevitably drove him away from the Venetian fascination with the effects of colour.

Other masters who had been working in Venice during the first decade of the century chose to detach themselves from the city's trends by moving into quite different cultural areas. Sebastiano del Piombo, for instance, was profoundly affected by his contact with Raphael and Michelangelo in Rome, and his many drawings, which nearly all belong to that period, clearly reflect this experience (p. 134).

Consequently, there is really only one early sixteenth-century Venetian draughtsman who can be discussed in depth: Tiziano Vecelli or, as he is more generally known to us, Titian. Far from being the reluctant draughtsman he was reputed to be, he left a collection of drawings that has proved more than sufficient to allow an insight into the character of his graphic work (pp. 135–7). From the first, Titian had been interested in xylography, as the rather primitive wood-engraving technique of the time is known, and in reproductive line-engraving. He clearly wanted to learn all he could in his quest for a vigorous graphic style along the lines of Dürer, in an attempt to reproduce the true effects of light. The slightly more mature Titian was then caught up on the wave of Mannerism in which the plastic element became important, giving the three-dimensional result so familiar in the work of Michelangelo. In his final phase, Titian returned to his preoccupation with light, adopting a similar technique to that used in his paintings. During this period he produced many drawings which are pure landscape, some of which are easily confused with the clear-cut, work of that fine copyist, Domenico Campagnola. (p. 138).

The graphic work of Jacopo Bassano has now been assessed, following recent research carried out on numerous pages of drawings which remained in his studio after his death and which were treated as patterns of the master's work by those using his workshop (pp. 141–4). His early period, which was characterized by his pencil and pen-and-ink techniques, seems to have been inspired by German engravings. The media whereby Bassano was to become best known, however, were two: one was charcoal heightened with opaque white-lead pigment and the other was coloured chalks on light blue or grey paper. These pages of Bassano's display the maximum effort on the part of the artist to give the illusion of painted pictures, and they do, indeed, achieve a striking luminosity through the handling of the charcoal and touches of white.

There are in existence over a hundred pages of drawings recognized as being by Jacopo Tintoretto; at least half of them are connected with the preparation of his paintings (pp. 145–7). They can be divided into two groups: firstly his youthful work, which consisted of copying from reproductions of classical subjects or from sculptures by Michelangelo in a strong, three-dimensional chiaroscuro style; and secondly his later work, characterized by a serpentine quality for which Tintoretto had clearly thought out in advance the movement of the figures who were to appear on his huge canvases.

A few of Tintoretto's drawings are complete compositions in themselves, but these are rare. The artist here seems to have been mainly concerned with studying the effects of light, which he achieved with emphatic, sweeping strokes in charcoal and white chalk.

Confusion long existed in attributing many of the drawings because the graphic style of Tintoretto's son, Domenico, so resembled that of his father. Only recently has it been found possible to distinguish the realistic style, with its narrative quality, of Domenico from that of Jacopo. Particularly distinctive in the son's work are his scenes from life in black chalk heightened with opaque white-lead pigment (p. 148).

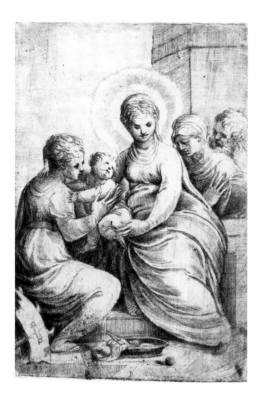

Schiavone: *The Holy Family* (engraving) London, British Museum

Paolo Veronese: *Studies*
Vienna, Graphische Sammlung Albertina

El Greco – whose real name was Domenikos Theotocopoulos – was a native of Crete, which at that time belonged to the Venetian Republic. It was therefore natural for this young Greek to go to Venice to study painting from the masters, probably acquiring his technique from the two main sources, the Tintoretto and the Titian schools. This much can be deduced from one of the few pages that have come down to us, a nude in charcoal, the *Study for 'Day' by Michelangelo*, now in Munich (p. 149).

One of the most prolific draughtsmen of all time, Jacopo Palma the Younger – known as Palma Giovane – also based his graphic style on the Tintoretto tradition (p. 150). In his sketchbooks, he first followed the styles of Titian and Bassano, as can be seen from some of his pages on which black crayon and white-lead pigment were used. He then changed to pen and ink, in which he developed bewildering celerity in his boldness of line which, after much twisting and turning, would be broken abruptly. But his powers of invention were inexhaustible. In many ways his work was similar to that of an outstanding representative of Roman Mannerism, Federico Zuccari; this draughtsman had a particularly bizarre and imaginative style with a distinctly pre-Baroque flavour (p. 155).

When Paolo Veronese died in 1588 he left an impressive number of drawings which remained in use as patterns in his workshop, as an inventory dated towards the end of the seventeenth century bears witness; many of these are still extant (pp. 151–3). Although the graphic work executed by Veronese developed along similar lines to that of Titian, Bassano and Tintoretto, his work indicates that he was mainly interested in the Mannerist styles of the trend developing in the Emilia region of Italy between Parma and Bologna.

Particularly interesting are Veronese's pen-and-ink sketches; in these, he often indulges in linear confusion which he then puts to rights with a few bold strokes. Many of his drawings were executed in black chalk, most of these being intended for use as studies from life and in the preparation of details for larger canvases. On the graphic level, it was in these drawings that Paolo's brilliant, silvery strokes were at their most effective. And, in a way, the sumptuous and essentially pictorial expressiveness that had typified this as the great century of Venetian art was thus brought to a close.

The Sixteenth Century in Northern Europe

While many sixteenth-century Italian draughtsmen were primarily painters, it can be said that most of their North European contemporaries were primarily engravers. The use of the graving tool (or graver) and later of nitric acid was almost universal, spreading particularly from the Germanic countries where the technique had been successfully used since the previous century.

One of the fifteenth-century German exponents was Martin Schongauer, who was both a painter and an engraver (p. 159). His drawings give the impression that he wielded his pen with the same flair and incisiveness as he wielded his graver. He thus succeeded in bringing about an almost total unification of the styles of the various graphic techniques.

Albrecht Dürer was an equally prolific worker in all the phases of his artistic life, each of which was related to some aspect of engraving (pp. 160–4). In aiming to achieve as realistic an effect as possible with a crisp line and absolute precision, he used pen, chalks and brown ink applied with a brush.

Dürer distracted attention from the linear aspect of his pictures

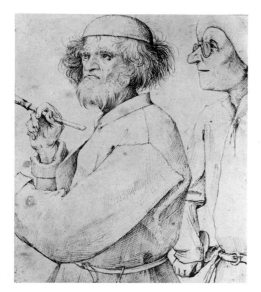

Pieter Bruegel: *The Painter and the Critic*
Vienna, Graphische Sammlung Albertina

Lucas van Leyden: *The Temptations of St Anthony* (engraving)
Vienna, Graphische Sammlung Albertina

by creating interesting backgrounds. He did this in one of two ways: he would either prepare his paper in dark blue, grey or pale green, or he would highlight the surfaces with streaks of white bodycolour. The result was one of amazing clarity, with brilliant surfaces and well-defined outlines.

A great many Northern artists working in the graphic field were inspired by similar themes, although they may have placed the emphases rather differently. Lucas Cranach the Elder, a rather bourgeois traditionalist, produced portraits in pencil and in brush (p. 165) which were faithful in all their details to their subjects. But more original were such figures as Mathis Grünewald (p. 167), Albrecht Altdorfer (p. 166), then Hans Baldung Grien (p. 168) and Manuel Deutsch (p. 169). They all had in common the use of white bodycolour on dark or coloured paper, which has the effect of raising the drawing off the background and gives the pages of their work the appearance of having an independent life of their own.

A very active centre of graphic art was also established in those parts of Switzerland bordering on the German States. In this category, may be included Urs Graf, an engraver and goldsmith of outstanding veristic force (pp. 170–1). Another citizen of Basle was Hans Holbein the Younger. His favourite medium, in graphic work, was chalk, not only in a wide range of colours but in black as well, and in this he immortalized important members of the German-Swiss, and more particularly the English, nobility and bourgeoisie.

The Dutch draughtsmen, too, were greatly influenced by German trends. One of the first exponents in Holland of woodcutting and engraving was Lucas van Leyden, who derived his inspiration from Dürer. The latter's influence can be seen clearly not only in van Leyden's prints, but also in his pen-and-ink and chalk drawings, so delicately emphasized by his clear-cut line (p. 172).

Pieter Bruegel (also Brueghel, Breughel), on the other hand, modelled himself on the graphic tradition of Bosch, both in his peasant scenes – which lay somewhere between the realistic and the imaginative – and in his portraits, which were sometimes grotesque or caricatural. He achieved the effect of a painted picture even in his landscapes, which owed their style mainly to the early Italian period; in those, the use of the pen and a light ink wash applied with a brush creates the illusion of pages from a travel notebook (p. 174–6).

The graphic style of Hendrick Goltzius was based on Italian Mannerism. He devoted the greater part of his life solely to drawing and engraving, developing a technique whereby, using a wide range of colours, he was able to achieve in his landscapes and portraits most unusual effects of representational realism (pp. 177–8). In this he had been preceded by the Frenchman François Clouet, whose style was more elegant in its hatching, which he built up carefully and painstakingly into a woven tissue of lines (p. 179).

The Seventeenth Century in Italy

Artistically, the seventeenth century gives the impression of having been a period of contradictions, since the aesthetic approach was so closely linked to revolution as well as to tradition. On one side there was the rise in importance of the Academies, in which Ludovico Carracci and his cousins, Agostino and Annibale, played such a large part. It was as though every piece of traditional art that was produced had to be measured against the 'ideal model': good design therefore implied a harmonious distillation of the Venetian and Roman cultures, something between Titian and Raphael. This meant that the graphic

skills were applied with meticulous precision in the preliminary study for the finished work, with strict adherence to objective truth rather than allowing subjective inspiration to intrude.

On the other side, the revolutionary ideas introduced by Caravaggio seem to be in complete contrast to the orderly procedure of the academic system. It is said that it was Caravaggio's own choice to live a solitary existence, without teachers and without pupils. And yet this did not prevent him from being largely responsible for the emergence of several distinctive trends in the world of painting, especially in the Netherlands.

As a consequence of the cultural atmosphere that resulted from these new ideas, the 1600s became the century in which design was all important – a fact that was due as much to the activity in academic circles as to the expressive and solitary meditative work of individual artists. The major contemporary critics expounded similar aesthetic principles in their writings, favouring a distinction between the conceptual value of the design (the idea) and its actual substance (the sketch), which was assessed both on the level of technical appreciation and on its attribution. Indeed, it was in the seventeenth century that the classification of works of art started to become a recognized activity. The seventeenth century saw the foundation of some of the great private collections.

Straddling the sixteenth and seventeenth centuries are the activities of the three members of the Carracci family, who founded a teaching Academy in Bologna (the Accademia degli Incamminati) and, perhaps even more importantly, exercised an innovative influence on artistic culture.

Ludovico, the eldest of the three, drew heavily on sources from the Veneto region, favouring the expressive linear dynamism of Tintoretto and Palma Giovane. Nevertheless, he did not neglect light and shade in his graphic work, and this clearly brought him close to the discoveries being made at the same time by Caravaggio (p. 183).

Agostino, one of Ludovico's nephews, began his career as an engraver and drawer of patterns from Venetian subjects required for instructive purposes in the Academy. From 1597 to 1598 he worked with his brother, Annibale, in the Farnese Gallery in Rome. His drawings are recognizable by their marked linear style, technically very similar to engraving (p. 184).

Annibale was undoubtedly the most gifted of the three, and emerges as an exceptional draughtsman whose work was not only outstanding but also prolific and varied. He used a number of different techniques, from pencil, pen and ink and sanguine to coloured chalks and watercolours. Especially remarkable was the clear-cut realism of his portraits and caricatures, as well as the impromptu spontaneity of his quick sketches from life, the atmosphere conjured up in his landscapes, and, above all, the inimitable quality of the drawings of the nude male figure executed in soft pencil and sanguine which he used in his preliminary work for his brilliant frescoes in the Farnese Gallery. These sheets of drawings were to exercise a strong influence over a whole generation of baroque 'decorators', from Rome to the Low Countries, for their hint of Classicism which at the same time was subtly vital, for their plasticity of line softened by sensuality, and for their shading, which although delicate produced a rich pictorial impression.

Followers of the two Carracci brothers, apart from Domenichino and Francesco Albani, included Guido Reni, who modelled his style closely on theirs, but whose drawings tended to be somewhat more

Agostino Carracci: *Satyr and Nymph* (engraving)
Bologna, Pinacoteca Nazionale

individualistic, his subtle use of hatching creating the feeling that they sought to detach themselves from reality in order to achieve some quality of abstract beauty (p. 189).

Further evidence of the important influence of the lessons of the Carracci family may be found in the work of a contemporary French painter, Simon Vouet. He absorbed much of the Carracci teaching during a stay in Rome and later introduced what he had learnt to France, where he came to be regarded as the founder of the decorative 'grand goût' at the court of Louis XIII (p. 194).

Another very talented, natural draughtsman from the Carracci period in Bologna and Rome is Guercino, whose real name was Francesco Barbieri (pp. 190–1). The main characteristic of his early works was their luminosity – or pronounced chiaroscuro – which he demonstrated in his use of pen-and-ink wash. Later, after working for two or three years in Rome, he acquired some of Raphael's fluidity as well as some of the sense of harmony of the Carracci brothers and Guido Reni. He can well be regarded as having bridged the conservative style of the early seventeenth-century Academy and the greater – by now Baroque – freedom of the following decades. In Tuscany, too, the Carraccesque-Guercinian training is apparent in the decisive drawings of Boscoli and Cigoli, up to Furini and Cecco Bravo. The latter is particularly remarkable for some lightning drawings of heads in red pencil, drawn quickly in short, broken lines but nevertheless with an eminently pictorial quality (p. 190).

From 1630 to 1640 the Carraccesque phase of figurative Roman culture can be regarded as having gradually petered out. Many of the protagonists had either vanished from the scene or returned to their countries of origin. Among the followers of Caravaggio – mostly foreigners – a similar phenomenon was taking place, accompanied by the spread, especially in the countries of Northern Europe, of the message of the great innovator, which would form the basis of figurative art in the Netherlands and other European countries. But it is a sad thought that not a single drawing attributable to Caravaggio himself has survived to this day.

In the meantime, a new generation was growing up which would produce the great architects who were later to become responsible for the new face of Rome – the Baroque Rome of Gian Lorenzo Bernini and Francesco Borromini. Apart from Bernini, whose graphic skill is particularly evident in several of his portrait studies (pp. 192–3), one of the most important draughtsmen of the time was Pietro da Cortona who, after 1630, made the transition to the grand manner of decorative Baroque. His drawings show clearly the transition between the decisive line of the school of Carracci, which was the basis of his development, and the Venetian pictorial qualities which are apparent in the way he enriched his lines with strokes of some type of soft material, or with brush-strokes of watercolour wash (p. 195). Thus Pietro da Cortona, strongly influenced by both the classical and pictorial styles, was clearly aware of the trend that was developing, especially among certain French artists living in Rome, for example Nicolas Poussin and Claude Lorraine (known as Claude). The former produced a vast amount of graphic material in the preparation of his paintings; it was as though he were trying to anticipate on his drawing paper, in sanguine or with his pen, the limpid chromatic effects of his finished work (pp. 196–7). It was the more classical aspect of Poussin's graphic work that inspired the luminous and elegant sheets of drawings by Carpioni, for there was little enough to be found in the field of graphics in the Veneto region in the 1600s. He was also such a good

engraver that he actually contributed to the development of eighteenth-century graphic art. Claude, however, tended even more patently towards a 'classical' interpretation of landscape, recalling the Venetian colour values of the schools of Titian and Bassano; in this way, he found new, almost pre-Romantic, eloquence by making Nature subjectively participate in human emotions (pp. 198–9).

The Roman school of the mid-seventeenth century drew inspiration from the graphic work of a number of leading artists from Naples, among them Mattia Preti (p. 203). In his drawings, which were mostly in soft pencil, the typical style which he had inherited from Caravaggio went hand in hand with a clarity of line characteristic of the Bologna tradition – somewhere between that of the Carracci brothers and Guercino, whom he had met during a stay in the Emilia region – and a certain neo-Venetian pictorial quality. His approach to his work links Preti to the style of the last great draughtsman of the Neapolitan school, Luca Giordano. This unusual artist filled his drawings with so many colour notations that they were really painting sketches, but he succeeded in expressing in them a certain airy lightness, with a cheerful handling of light that seems to herald imminent developments in the Rococo style (p. 204).

A culturally independent trend in design and drawing emerged in Genoa, elegantly decorative in character, through the work of Bernardo Strozzi and Giovanni Benedetto Castiglione (pp. 205–7). Influenced by the 'baroque' style of Rubens and van Dyck, both of whom had worked for some time in Genoa, Strozzi blended this with his early training in the late Mannerist style of Tuscany to achieve a particularly rich graphic style with a decisive quality.

The other Genoese innovator, Castiglione, an engraver whose work had the refined air of having been based on Parmigianino, created a new type of very elaborate painterly drawing. This involved the use of touches of white-lead pigment and washes of oil-paint, again anticipating the styles of the Rococo period.

The flowing line used by Rubens certainly inspired the drawings of the German artist Johann Liss and of the Genoese Strozzi while they were in Venice – an influence that was to make itself strongly felt later, especially in the early part of the eighteenth century. In the latter half of the seventeenth century, several painters with a common graphic style can be identified in the group known as the *Tenebristi* (although they did not call themselves this). The style was in a low key, shadowy, and was practised for example by Giambattista Langetti, Johann Carl Loth and Antonio Zanchi. There were also the *chiaristi* – the clear, well-defined school – one of whom was Andrea Celesti, and it was these artists who were heading towards the Rococo style which was to be realized by such painters as Sebastiano Ricci and Gian Antonio Pellegrini.

The Seventeenth Century in the Low Countries, France and Spain

A great many artists from Northern Europe felt it essential to experience as much as they could of the Italian world of art at first hand and this was especially true of the Dutch. A number of artists undertook the journey to Rome where their eyes were opened to the process of renewal that painting was undergoing during the transition from the late Renaissance to the Baroque period. One of the first such groups formed the immediate circle around Caravaggio and consisted of the great Dutch painters Gerard van Honthorst and Hendrick Terbrugghen, as well as the Flemish artist Ludovicus Finson (who painted under the more classical sounding name of Finsonius). More

important were the visits of Pieter Paul Rubens to Venice, Mantua and Rome between 1600 and 1608, and of Anthony van Dyck to Genoa, Rome and Venice between 1621 and 1627.

So far as his graphic work is concerned, Rubens emerges unchallenged. Having started by studying the late Mannerist style, he turned to making prints, and drawings in the style of Parmigianino. After a brief spell with the Fontainebleau school he went to Rome where he found what he had been seeking in the Classicism of the two Carracci brothers (pp. 211–13). The pictorial plasticity, based on the Roman style of Annibale Carracci, which seems to characterize the underlying discipline of his later drawings, displays an extraordinary degree of technical virtuosity and an inexhaustible capacity for invention.

On a more realistic plane are the pages of drawings by Rubens's near-contemporary and follower, Jacob Jordaens (pp. 214–15). In these, there is a striving after the mastery of line which is often associated with the influence of the school of Caravaggio in the Netherlands.

The drawings of van Dyck, on the other hand, are more intimately painterly. Looking at the sketchbooks he so eagerly filled during his travels – several are extant – it is not of Rubens that one is reminded but of the late sixteenth-century Venetian artists and their preoccupation with the effects of light. In his portraits, on the other hand, there is an incisively aggressive quality which clearly demonstrates the influence of Caravaggio (pp. 216–17).

The character of the major Dutch draughtsmen of the seventeenth century appears in general more introspective, realistic and sometimes strongly dramatic. Towering above them is one of the greatest figures of all time in the graphic field, Rembrandt van Rijn (pp. 218–223). In something like two thousand drawings, as well as in his remarkable etchings, Rembrandt seems to have tried his hand at every technique and to have made use of every type of thematic material, his distinctive personal touch shining through everything he did. There is no doubt that his early interest in the Caravaggesque style influenced his work. Although he never left Holland, Rembrandt was able to learn a great deal about the school of Caravaggio from a young German, Adam Elsheimer, who had spent some years in Rome. Thus the technique of incisively drawn lines, rich in luministic contrasts, was absorbed into Rembrandt's own expressive style, with the resulting atmospheric qualities and chromatic background effects that we know so well. At the same time, the pen-strokes build up the details with a freedom of line that gives them a kind of mobile vitality within the ambience of the picture. A great many landscape studies reveal an expressive, powerful drawing which reacts to even the slightest chromatic vibration in the graduated or impulsive use of the pen or of colour wash. In his later drawings, the master used a method similar to that which he adopted in his paintings; outlines became progressively more blurred in order to concentrate attention simply on the dialogue between light and shade. The result was startlingly dramatic.

An artist whose landscapes might be compared with those of Rembrandt is Hendrick Avercamp, one of whose sharply drawn pen, wash and pencil drawings appears below (pp. 226–7); he made a reputation for himself in his own day because of the unusually large number of drawings he kept in his workshop for the benefit of his pupils. And, in a more painterly idiom, there was Aelbert Cuyp (p. 225), with his broadly sweeping colour wash, so effective in creating natural effects.

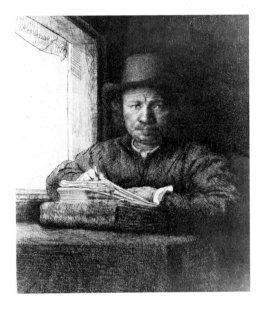

Rembrandt: *Self-Portrait with Book*
Vienna, Graphische Sammlung Albertina

On the fringes of the Dutch and Flemish schools, artistic activities in neighbouring France were often in ferment. Here an interminable feud raged in the academies and aristocratic Court circles between those who supported the severe classical discipline of the followers of Poussin and those who upheld the view of the Rubens school that in the use of colour lay the means of most closely imitating Nature. This became known as the 'quarrel of colour and design'. The man with the greatest influence in the French art world during the reign of Louis XIV was Charles Le Brun, Director of the French Academy, who, having studied under Poussin for a while, was naturally a Poussinist. However, I do not think that he completely dismissed the art of Rubens and he undoubtedly appreciated its importance in the field of drawing (p. 229).

The Spanish school, on the other hand, produced little in the way of graphic art, although a great deal as far as painting was concerned. The best seventeenth-century Spanish drawings are those by Jusepe de Ribera, who spent his working life in Naples, where he received his main inspiration from the Caravaggesque influence he found there (p. 231). His style, in which he placed great emphasis on chiaroscuro and plasticity, was probably passed on to Francisco de Zurbarán, an artist whose work was strikingly realistic and several of whose preliminary studies for paintings are extant (p. 228).

The Eighteenth Century in Italy

While artistic styles in Europe were gradually shifting from Baroque to Rococo, the centres of production for graphic work were also changing. Rome and the Low Countries were being replaced by Venice and Paris.

From the beginning of the eighteenth century, Venice was the focal point of some of the most glorious painting Europe had yet seen. One of the reasons for this was the presence in the Republic of so many brilliant artists who found the cultural and social environment particularly stimulating. This was the time when painters were eager to travel. It was therefore only natural that their style of drawing should reflect their broader international experience rather than pursue the same themes that had emerged in the Veneto region in the previous century.

It was Sebastiano Ricci who first made the transition from late Baroque to the Rococo style (pp. 236–7). His early drawings, made towards the latter part of the seventeenth century, are clearly rooted in the Carracci tradition and reflect a certain Neapolitan influence after the style of Luca Giordano. These characteristics can be traced in his work right up to the time when he began to broaden his 'plasticity' of style into what was to become known as *rocaille*, involving an increasingly resonant and decorative quality in the draughtsmanship. There was a great similarity between the graphic work of Ricci and that of Gian Antonio Pellegrini, both seeking to reach out beyond the traditional seventeenth-century boundaries to a conception of shapes in conjunction with space that certainly marked the transition from the Baroque to the Rococo idiom (p. 238). Later, under the influence of Baciccio, Ricci was to introduce decorative scrolls and counter-curves into his work, with a more receptive use of light. His greatest influence, however, came to him while in England. There he encountered works by Rembrandt and van Dyck, from whose styles he developed a new 'patchy' effect with which he was able to achieve even more interesting variations of luminosity combined with delicate outline strokes. After about six years in England he spent a further six years in the Low

Countries and Germany, during which time his drawings became even more influenced by the luminous style of Rembrandt – an influence that was also radically to affect the work of Giambattista Tiepolo in later years.

As Pellegrini matured, his drawings became more rarified in the dazzling Venetian atmosphere, and they were to play an important part in the development of Gian Antonio Guardi, elder brother of the better known *vedutista*, Francesco. With its incredibly light, decorative qualities, the graphic work in Gian Antonio's folios can be regarded as the pinnacle of the ethereal, dancing expression of the Rococo style (pp. 239–40).

Unfortunately, only a few examples of the graphic work by the internationally known painter Jacopo Amigoni remain to us. Having come under the Neapolitan influence in his early days, he retained a Giordanesque fluency of style which also had an impact on some of his contemporaries, for example Battista Crosato and Gaspare Diziani. Diziani, along with Giambattista Pittoni, is acknowledged to be one of the major draughtsmen of the mid-eighteenth century in Venice. His graphic work has a *rocaille* wittiness about it, with its tireless interplay of curling and folding lines, which are re-worked over and over again (p. 241).

The graphic style of Gian Battista Piazzetta, however, was far removed from the Rococo. He worked in a much wider field, from his somewhat academic nude drawings – reminiscent of the Bolognese school of Crespi and Creti (pp. 242–3) – to his elegant sketchbook drawings, produced for connoisseur collectors, ranging in subject from imaginary figures to the heads of saints and so on. His technique consisted basically of charcoal heightened with white chalk on ash-grey or azure-blue tinted paper which set off to their best advantage the effects of his brilliant plasticity (pp. 244–5).

The relationship between drawing and etching within the sphere of graphic art in Venice was very close. In fact, artists frequently worked for publishers as illustrators of the books being produced by the Venetian printers. Alternatively, they saw their drawings being reproduced quite extensively as etchings, which had a great attraction for a wider public than had previously had access to original works. In this context, it is interesting to recall Marco Ricci (p. 246) with his delightful series of landscapes, which were later to be etched; they represented scenes of Arcadian simplicity and were brought to life by the use of lightly shaded areas, very similar to the graphic style of another great landscape artist, Alessandro Magnasco, who came originally from Genoa (p. 247).

The example that had been set by Ricci was followed by other landscape artists, who were able to learn much from his extensive portfolio of graphic works. Such a one was Francesco Zuccarelli, who had a great reputation for his beautiful sketchbook folios, drawn in pencil and pen and then painted in watercolour (p. 248).

A particularly famous Venetian to follow in the footsteps of Ricci was Gian Battista Piranesi who, having gone to Rome at the age of twenty, became totally dedicated to producing etchings of classical subjects based on Roman architecture. In his drawings in pen or brush, with their strong changes of tone in the chiaroscuro effects or swirling patches of shadow, there is always a trace of his youthful upbringing in the atmosphere of the Venetian landscape artists (p. 251).

In the forefront of eighteenth-century Venetian drawing, the work of Gian Battista Tiepolo stands alone (pp. 249–50). More than a

Michele Marieschi: *Ca'Pesaro* (engraving)
Venice, Biblioteca Correr

thousand sheets of drawings are evidence of his work in several areas: there are his preliminary drawings for the frescoes, executed in soft materials on grey and azure-blue tinted paper; there are his 'finished' drawings for amateur collectors, and there are his sketches, by which he condensed his ideas in order to arrive at the composition of a painting. The vitality contained in Tiepolo's drawings is extraordinary, both in the way that they rely on the feathery line of his pen and on the three-dimensional effect of his chalk as it formed the shapes he wanted. Tiepolo's caricatures were unusual, too, with their unerringly humorous vivacity, executed with a light, almost disdainful touch. His influence on his contemporaries was considerable, largely due to the wide circulation of his etchings, many of which were made by his younger son, Lorenzo.

As far as the two greatest Venetian *vedutisti*, Canaletto (Antonio Canal) and Francesco Guardi, are concerned, extensive portfolios of graphic work – amounting to hundreds of drawings in each case – are in existence. Canaletto was undoubtedly one of the world's geniuses in the graphic field, both in etching and in drawing (pp. 253–4). It was the latter skill that is probably best known to us today, for he used it constantly in the preparation of his *vedute* paintings or as finished drawings to find their way into the collections of connoisseurs.

Compared with the clear-cut precision of Canaletto, a drawing by Guardi gives an airy, painterly impression. He displays his graphic style with swift, sweeping strokes. The subject, viewed within a softly defined space, becomes framed in the luminous Venetian atmosphere, exposed to all kinds of strange experiments very much in the manner of the overall uncertainty that prevailed during the Rococo period. Thus Guardi managed to avoid the somewhat documentary character of Canaletto's illuminism and opened the way to the more romantic approach '*d'après nature*' (pp. 255–8).

Towards the end of the eighteenth century came the paintings of Gian Domenico Tiepolo (p. 259). Besides his dutiful collaboration with his father on the latter's huge artistic undertakings, he developed a style and an attitude of his own. With a somewhat sardonic eye, he portrayed the customs and costumes of the period, frequently caricaturing his fellow Venetians. He applied himself particularly to drawing scenes from contemporary society which, although lacking the sharp, satirical force of Hogarth, were none the less effective in expressing his reactions to some of the social attitudes of the day.

Gian Battista Tiepolo: *'Scherzo' with Six People and a Snake*
Washington, DC, National Gallery of Art, Rosenwald Collection

The Eighteenth Century in France, England and Spain

At the beginning of the eighteenth century, the art of painting was following an unpredictable yet fascinating course in France. Within the ostentatious magnificence of the royal court and the opulence of the Parisian mansions, a quarrel had flared up that was very similar to that between the followers of Poussin and those of Rubens – the Classicists against the Colourists – except that this time it was between the Academicians and the bourgeois artists.

In the graphic arts, too, the French school was producing work with a completely original language. It was Watteau himself who developed new styles of drawing by scorning the inanimate patterns used in the past and drawing from life. His charming, painstakingly drawn studies, in which he employed only the simplest of media, such as charcoal, sanguine or coloured chalks, depicted figures and their surroundings with an inexhaustible vitality (pp. 264–7). The result was the emergence of his distinctive graphic style. This style, which is both

linear and fluent, is also rich in sensitive chromatic modulation, and it is these qualities that have made his drawings – hundreds of which he himself had bound into huge volumes for reference – one of the greatest landmarks in the history of the graphic arts.

François Boucher gained his first experience as an engraver of Watteau's paintings. As a portraitist, Boucher's use of coloured chalks was masterly, his purpose always being to create the impression of a painting in which the head had been first modelled in porcelain. Boucher also did a great many landscape drawings, which were often used as studies for tapestries. He designed a number of cartoons for these for manufacture by the famous establishments of Beauvais and Gobelins, gaining a high reputation for this kind of work (pp. 269–71).

Of all the eighteenth-century French draughtsmen, Jean Baptiste Siméon Chardin emerges as the central figure. He developed an even more fluent style than Watteau, with a straightforward presentation of reality. In his work with pastels, which were his main medium for portraiture in his later period, he sought to achieve a decidedly painterly effect, with controlled shading (pp. 272–3).

Rosalba Carriera: *Self-Portrait*
Dresden, Alte Meister Gemäldegalerie

In the meantime, the use of pastels for drawing had gained favour in Paris as a result of the impression made there by a remarkable young Venetian woman. This was Rosalba Carriera, one of only a very small number of women to achieve fame as an artist. Several artists were greatly influenced by her work, particularly Maurice Quentin de la Tour (p. 268), Jean Baptiste Perroneau and a Swiss artist, Jean Étienne Liotard (p. 274), whose preliminary drawings – a great many of which are to be found in the main museums and art galleries of Northern Europe – are fine examples of the poetic quality of pastels, giving as they do so much scope for the subtle blending of delicate colours.

During the second half of the century, the French school finally produced its most outstanding draughtsman – Jean-Honoré Fragonard. From his extensive output it is clear that he tried his hand at almost every technique and was particularly skilful with light, rapid brush-drawing over underdrawing in chalk or pencil (pp. 276–7). His variety of subject material was almost limitless, ranging from the portrait to genre, from the fleeting inspiration caught on the wing to the intricately detailed landscape drawing. In 1761 Fragonard travelled to Italy with another artist, Hubert Robert, whose drawings of landscapes almost equalled those of Fragonard in quality; he worked mainly in sanguine, building up his pictures with short parallel strokes (p. 278).

In eighteenth-century England, drawing held pride of place in the world of art, being especially favoured by portraitists, while engraving – line, stipple and crayon engraving, etching, mezzotint and aquatint – became the medium for more expressive work such as genre pictures. These were initially inspired by the French with their masterly 'conversation pieces', but later took a rather different route, most successfully followed by the satirical moralist William Hogarth, with his biting caricatures and talent for seeing the grotesque.

Among the great draughtsmen, Thomas Gainsborough stands out as having succeeded in creating a distinct style of his own, whereas the majority of contemporary artists had succumbed completely to the influence of van Dyck. From his studies of figures and landscapes he gives every appearance of having been interested solely in reproducing reality as accurately as he could (pp. 279–81).

A great many drawings are also extant by the landscape artist Richard Wilson, several of which are quick impressions, with notes, of

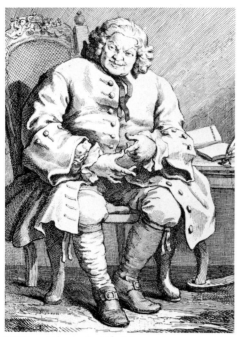

William Hogarth: *Lord Lovat* (engraving)
London, British Museum

people he saw during his travels in Italy and which he scribbled into his sketchbook, perhaps for later use (p. 282).

In the case of Thomas Rowlandson, however, here was an artist who expressed a great affection for his surroundings in his drawings, especially when they consisted of the crowded streets and interiors of London town houses (p. 283). He achieved a pleasant, narrative style with his pen, which he wielded incisively and frequently with more than a hint of caricature, and would sometimes enhance the drawings with watercolour.

In Spain, meanwhile, another great draughtsman was working along parallel but completely independent lines. Francisco José de Goya y Lucientes, known to us simply as Goya, concentrated in his graphic work almost entirely on engraving – simple prints, etchings and aquatints. In his drawings, which are smooth and flowing in style but biting and witty in content, Goya was expressing himself in the same terms as the Venetians towards the end of the eighteenth century, for he had learnt about them from Gian Domenico Tiepolo in Madrid. Later on, he was to give us his dramatic interpretation of the modern world – an outlook that was already becoming slightly involved with the Romantic spirit (pp. 284–5).

From Neoclassicism to Realism

Neoclassicism, which had begun to flourish in the mid-eighteenth century as a reaction against late Baroque and Rococo styles, spilled over into the first decades of the next century, with its concept of Ideal Art. This striving after perfection of form inevitably led to artistic creativity becoming smothered, obscured by aesthetic values and archaeological speculations. Even the greatest of the artistic figures of the Neoclassical period, which reached its zenith during the Napoleonic Empire, were often seriously hampered in their freedom of expression.

Drawing, however, took on a new importance during this era of stultified creativity and indeed seemed to become a repository for poetic imagination. Canova, for instance, was a prolific draughtsman as well as a fine sculptor. The pen drawings in his sketchbooks offer a detailed record of his strength, both in construction and plasticity, in their delicate and intricate penmanship which can well be described as a cobweb of lines. On occasion, Canova could also produce much softer shapes working in pencil or sanguine, when he would recall the more gracious style of the eighteenth century (p. 290). Similar examples among artists referred to in the previous chapter range from Rosalba Carriera to Jean Baptiste Greuze. Two further painters must also be included, Angelica Kauffmann and Élisabeth Vigée-Lebrun, both of whose work has a very delicate quality; in their portraiture they both worked in coloured chalks, using them with great sensitivity in the modelling and with a suggestion of pre-Romanticism (pp. 291, 293). In the same vein, the work of Pierre Paul Prud'hon seems to hover between a Raphaelesque classicism in his figures, which are represented with a formal plasticity, and a profoundly sensual expressiveness. Prud'hon drew mainly from the nude, in charcoal heightened with white on tinted paper. He thus created an effect of relief that seems to imbue his pictures with the deeper values of an existential presence (p. 292).

The more typical Neoclassical drawing tended to give great importance to line, almost as though to bear out the contention that pure outline is the most effective means of artistic expression. A draughtsman who followed this precept to the letter was the English

sculptor John Flaxman; the series of drawings which he produced to illustrate the famous editions of Homer and Dante, dated about 1800, are pure line. The linear severity of these drawings tended to inhibit the creation of atmosphere as well as of naturalistic content. It was the basic technique adopted by the early nineteenth-century Italian and French draughtsmen, following as it did in the general cultural trend. All the major contributions to the graphic arts took this form during the period in question. One of the leading figures in the movement was Jacques-Louis David (p. 294) with his sheets of pencil and pen drawings, so economical of line, where the pure contours are of prime importance.

But in the forefront was undoubtedly Jean Auguste Dominique Ingres, who carried the expressive quality of line to the farthest limit the decorative arabesque (pp. 296–7). His nudes are among the masterpieces of the Neoclassical era. There is an abstract beauty in these drawings which reflects his intransigent support of Classicism combined with his own sinuous use of line.

In England, too, a group of artists had got together during the last decades of the eighteenth century and early part of the nineteenth. After the somewhat severe use of hatching by Flaxman, the poet and artist William Blake, who devoted himself mainly to illustrating books, developed a more articulate style. In this, it is as though he sometimes gloried in dramatic tension as he sought to achieve painting effects – which he himself described as 'Michelangelesque' – through the use of watercolour (p. 299).

A Swiss artist in London, Henry Fuseli (Johann Heinrich Füssli), whose acquaintance Blake made, probably did much to encourage him along these lines. Fuseli was himself the creator of hand-coloured drawings which were frequently on the brink of surrealistic extravagance or ambiguous eroticism (p. 298).

The style of Joseph Mallord William Turner's drawings is also obviously linear, but it is easier to recognize a painterly feeling in them through the soft atmospheric effects achieved by means of a complex handling of watercolour (p. 301). John Constable, on the other hand, seems to have remained faithful to the eighteenth-century tradition. Even in his landscape drawings there is a masterly treatment of light which is sensitively realistic (p. 300). Although a great admirer of Turner, John Ruskin was to become more concerned with architectural and other related problems in the illustrations to his inspired volumes of art criticism (p. 303).

The English school, in bridging the two centuries, was already adopting an essentially visual approach to natural form – an attitude that was to prelude the development of the Romantic aesthetic and of the Realism of Jean Baptiste Camille Corot, Théodore Rousseau and Gustave Courbet. But before we proceed to trace the destinies of the various new styles of painting, there is one rather strange cultural 'island' that should be mentioned. It emerged during the second decade of the nineteenth century in Vienna and centred on a small group of artists who became known as the *Nazarener* (Nazarenes) but who called themselves the *Lukasbrüder* or Brotherhood of St Luke. Their aim was to revert to the tradition of Fra Angelico and Raphael, and their influence became felt mainly in Germany and Italy. Johann Friedrich Overbeck, Ludwig Schnorr von Carolsfelt and Peter von Cornelius, some of the leading exponents of the movement, unwittingly contributed to the final triumph of the philosophy of Ideal Art with the slender linearity of their work carried out in lead (graphite) pencil, their favourite medium. At the same time, the most

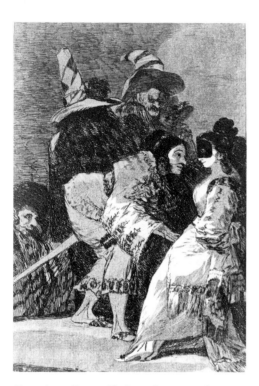

Francisco Goya: *Nadia is Recognized* (engraving)
Vienna, Graphische Sammlung Albertina

significant period of Neoclassicism was coming to an end.

There are many connecting factors linking the Nazarenes with the subsequent development of the Pre-Raphaelite Brotherhood in England. Its leading figures, for example Dante Gabriel Rossetti and Edward Burne-Jones, adopted a particularly delicate style of draughtsmanship (p. 302) in an attempt to revert to the purity of line and sincerity of expression which they believed had existed in art before the advent of Raphael.

The reaction against classicism came to the surface in France between the years 1810 and 1820 in the work of artists such as Théodore Géricault and Eugène Delacroix. The outstanding characteristics of the latter's drawings are their broken, impulsive line and vigour combined with the strong, painterly effect of the brush-strokes which bring the pages to life (p. 304). These drawings, charged with realistic and evocative qualities, were the antecedents of what was to be the aesthetic concept behind the Romantic movement.

One artist who certainly drew on the logical consequences of this technique to achieve immediate impact was Honoré Daumier (p. 305). Many examples can be seen in his vast output of drawings and lithographs, the technique of lithography having become fashionable and widely practised from the 1820s. By the end of the century, a great many illustrators had followed his example, one of the last being the American painter Winslow Homer (pp. 308–9).

From about 1830, landscape drawings were becoming increasingly popular; in them the artist-draughtsman was bringing a romantic approach to the main features, delicately linking creative imagination to a sense of reality. In this Camille Corot excelled, with his extraordinary effects of light which he obtained by graduating the density of the pencil and ink lines (p. 307). In his wake came Jean François Millet (p. 306) who used charcoal and pencil to achieve painterly shading, while he seems sometimes to regain a quintessential line which recalls some of the works of Rembrandt. On the other hand, the great Gustave Courbet never ceased to be a painter in his drawings, in which the contrasts between shadow and light are strongly emphasized; this was especially true in his use of chalk (p. 310). Finally we come to Eugène Boudin, whose style, although close to that of the Realists of the Barbizon school, stands out from the rest. His way of handling the effects of light in his drawings heralded the beginning of Impressionism (p. 311).

Impressionism and Post-Impressionism

The basic technique of Impressionism was founded on the use of varying tones of colour used one upon the other, as well as on the breaking down of the primary colours. This certainly went completely against all the traditional concepts of art that had established themselves in the Western world over the centuries, and the absence of a drawn line to give a firm contour was a totally strange idea.

This is not to say that great plasticity is not to be found in many of the Impressionists' drawings, especially in those of Édouard Manet who retained more links with tradition than the others. But the effect is achieved much more through the use of flickering touches and filled-in areas rather than through linear motifs (p. 324).

The drawings by Claude Monet, however, display a great deal more of the painterly quality of Impressionism. To arrive at this visual sensation of a breakdown of bright light reflected in various ways, he employed a very special technique. This involved the use of dark *crayons*, sharpened to a fine point, with which he delicately built up a

basis for the light-coloured background by 'brushing in' the tenuous lines (pp. 321–3).

Edgar Degas and Pierre Auguste Renoir, on the other hand, were more traditional in both technique and style (pp. 325–7). They were essentially in the Ingres tradition, Degas choosing the airy freedom of *sfumato* – the gradual transition of light tones to dark – in the unique atmosphere of ballet classes and among the dancers behind the scenes at the Opéra, while Renoir turned to a more vital, full-bodied style that seems to reach out towards the sensual, pictorial quality of Titian.

Interest in drawing as a means of chromatic experiment, as well as an expressive medium in its own right, revived with the emergence of those artists who by this time could be described as Post-Impressionists. They had passed through the early theorizing phases and were now openly filling their notebooks directly from life. Among the first of these was Paul Cézanne, who made innumerable experimental drawings, alternating between the most elementary media, such as pencil and charcoal, and the most elaborate, such as *crayons* and watercolour. The individual way in which Cézanne approached his themes led him to develop new techniques; how often, for instance, were his subjects depicted as faceted surfaces – virtually a foretaste of Cubism, which lends itself particularly well to linear treatment. Cézanne's vision shines through his pictures with great dynamic impact – the images caught, as it were, in a searching light (pp. 329–330).

There was also one great sculptor working on the fringe of Impressionism – Auguste Rodin. In his creation of a new style in sculpture – recalling the unfinished fragments of Michelangelo – he made many sketches which have an immediate and dynamic quality about them. These were mainly rather sensual pencil drawings which he enlivened with watercolour (p. 335).

The reaction to Impressionism is also evident in the work of Georges Seurat, who developed Pointillism or, as the Neo-Impressionists – of whom Seurat was one – preferred to call it, Divisionism. This new style, which seemed to deny any kind of artistic improvisation, favoured a colour-theory of optical mixtures resulting from the effect of light on colours and their complementary colours in shadow. Drawing was very important in Seurat's aesthetic development, as he used it in his search for the most essential qualities in the modulation of light (p. 334). He achieved his results by working in small dots, with soft Conté crayons, which he spaced more or less closely according to the effect he wanted to achieve.

Born nineteen years before Seurat – whom he survived by twenty-five years – was another artist, Odilon Redon, lithographer, painter and draughtsman *par excellence*. His skills recall the work of Seurat, if only from a technical standpoint. His subjects, though, were bizarre and sometimes surrealistic (p. 334), and he was undoubtedly one of the leading Symbolist artists.

Paul Gauguin made use of a particularly basic drawing technique of expressive outlines in strong marginal colours (pp. 336–7). A contemporary – and, for a time, a friend – of Gauguin was Vincent van Gogh, who in his early work in charcoal and watercolour adopted a realistic approach. This phase was followed by distinctive drawings which he executed with a blunted pen to create rather striking arabesque effects (pp. 338–9).

Henri Marie Raymond de Toulouse-Lautrec was also considerably influenced by van Gogh, whose acquaintance he made in Paris. His drawings became highly stylized, with a strong, decisive line

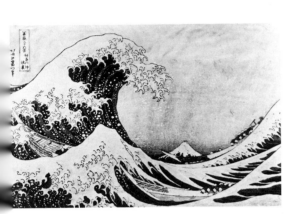

Katsushika Hokusai: *Mt Fuji Seen through the Waves off Kanagawa* (lithograph) London, Victoria and Albert Museum

which is particularly apparent in his coloured lithographs of the theatrical world (pp. 340–1).

During the so-called *belle époque* in Europe, between the end of the nineteenth century and beginning of the twentieth, the Art Nouveau movement evolved. This aimed particularly at achieving decorative effects which were stylized to a degree, thus providing the ideal atmosphere in which both drawing and design could flourish. The work of such figures as Gustave Moreau, Walter Crane, William Morris, Ferdinand Hodler (p. 342) Aubrey Beardsley, (p. 343), Georges Barbier (p. 344) and Gustav Klimt (p. 345) was nourished by the need for new types of design which emerged as a direct consequence of the Industrial Revolution.

From Cubism to the Present Day

'*Voilà Donatello parmi les fauves!*' ('Here we have Donatello among the wild beasts!') It was with this historic remark, at the 1905 Paris *Salon d'Automne*, that the art critic Vauxcelles drew attention to the contrast between the style of an academic sculpture exhibited by Albert Marquet and that of the artists' works all around it. The young 'wild beasts' who aroused so much outrage, proclaiming the freedom and absolute pre-eminence of colour as a means of artistic expression, certainly did not regard drawing as being of primary importance, but the greatest of the Fauves was probably responsible for restoring the values of draughtsmanship in his immediate, painterly touch. This was Henri Matisse, who a little later was to demonstrate these values in his drawings, in which interesting arabesques gravitate between floral and Ingresian rhythms (p. 350).

Not even Cubism, which followed immediately after the Fauvist movement, beginning in 1907 with Georges Braque and Pablo Picasso, seems to have concerned itself overmuch with graphic expression, at least in the early days. That the Cubists were able to draw and were actively doing so, there is no doubt. However, they regarded this skill as subordinate to the basic aims of their aesthetic vision, which sought to break down any given object into its simplest planes of form within a confined space. In pursuing this new concept during its early phase, Braque produced a drawing where the subject is reduced to almost calligraphic linearity (p. 351).

Picasso's early work, however, during the so-called Blue and Pink Periods, finds the artist still drawing his picture with realistic, if rather disdainful, chalk strokes (p. 353). At the height of his Cubist phase, his style closely resembles Braque's dissection of form. There are collages and sheets of drawings in pen and coloured pencils, the subjects being reduced to two-dimensional facets, thus totally dispensing with all linear or painterly qualities. In his Classical Period, after 1915, this tireless man produced numerous drawings in which he rather surprisingly revived the Ingresian line (p. 352), although his use of large patches of ink give a harsh, almost barbaric feeling which lends an essentially plastic quality to the work. Picasso's studies for his masterpiece, *Guernica* (1937), brought him back within the orbit of Cubism; his preliminary drawing clearly indicates the planes of colour by means of bold strokes and hatching, enabling their multi-dimensional quality to be recognized (pp. 354–5). During a career spanning three-quarters of a century, Picasso involved himself in every kind of figurative experiment of our age. His work is still able to communicate a universal, timeless appeal, almost as though possessed of an inner power to break down temporal barriers.

Giorgio De Chirico: *The Manikin Painter*
(1917)
Milan, private collection

In the meantime, the various movements related to figurative art continued to follow hard on each other in that extraordinary melting-pot of ideas and shapes that was Paris in the early decades of the twentieth century. Rather than pursue their courses of development, so often interwoven, it is more useful to mention individual artists whose graphic style produced highly original results. For instance, a French artist who was strongly influenced by Fauvism and Cubism, Fernand Léger, reached an extremely individual chromatic dynamism which evolved into a kind of curvilinear Cubism (p. 356). Another well-known figure was the Italian artist Amedeo Modigliani; his style was largely modelled on that of the Russian Kasimir Malevich – a Cubist with the expressive line of Matisse – and it was in this vein that he created his exquisite nudes, his work thus spanning the idioms of Art Nouveau and Cubism (p. 357).

Georges Rouault, one of the young 'revolutionaries' who took part in the 1905 Fauve exhibition, was to associate himself quite early with the Expressionists through a group that existed in Dresden between 1905 and 1913 known as Die Brücke ('The Bridge'). A strong painterly quality, expressed mainly in patches of ink or watercolour, took Rouault's drawings to the limit of true graphic expression by tending more towards an accentuation of colour (p. 359).

The draughtsmanship of Oskar Kokoschka, the Austrian artist, was also linked to German Expressionism, in spite of his acquaintance with contemporary artists who had been involved with the Fauvist movement in Paris (p. 358). His strong, decisive strokes spread like an obsessive grid over the white paper, where every element exudes a certain emotive quality and intense expressiveness.

It was also in Paris that the graphic style of the Russian Kasimir Malevich originated (p. 358), although already markedly Cubist, he evolved an even more refined form of his own which became known as Suprematism. Marc Chagall, also from Russia, came under the influence of the Cubists in Paris too; his work reflects Fauvism in its depth of colour and Symbolism in its abstraction and is a forerunner of Surrealism in its fantasy. Chagall's drawings are without equal in their charm and in their adherence to the transparent, vague line of a dreamlike world based on remembered folk-tales and traditions linked to some imaginative ancestral power (p. 361).

Coincidentally with the Fauves and the Cubists, Italian Futurists were reacting against the academic formalism and eclecticism that had infiltrated the Impressionist movement. Founded at the end of the first decade of the century, Futurism was based on the cult of a civilization dominated by machines, with particular emphasis on machines and figures in movement. This naturally soon led to conventional graphic symbols becoming adapted to expressing dynamic force in unusual ways. Umberto Boccioni (p. 362), Gino Severini and Giacomo Balla were among the best exponents of this new artistic language.

In Italy the Pittura Metafisica or Metaphysical Painting movement was also developing from about 1917, its foremost exponents being Giorgio De Chirico, Carlo Carrà and Giorgio Morandi. The most interesting aspect of the movement was its draughtsmanship. At this time, De Chirico actually worked in pencil – displaying brilliant technical virtuosity – but later came to use the widest possible variety of means of communication in a kind of general, rather bewildering, artistic eclecticism. Carrà, on the other hand, deliberately brought the graphic medium under control by detaching it completely from any form of painterly expression in his search for the essential qualities of plasticity within a Surrealistic theme (p. 360). But the most gifted

draughtsman of the three was Morandi, whether expressing himself through his etching or the pure strokes of his pen or pencil. His soft, continuous line somehow catches the tremulous effect of light, and skilfully emphasizes it, imbuing each work with a wholly realistic expressiveness. His customary avoidance of living subjects – despite his having painted a few landscapes and flower-pieces – and preference for still life led him to concentrate largely on groups of bottles, vases and small objects in everyday use. This obsession with the inanimate led naturally to his creating a world of the imagination where line takes on a dominant and definitive quality in his search for an inner truth within these objects (p. 363).

All the influences of the artistic movements which emerged during the first decade of the twentieth century can be detected in the work being produced today, ranging from Metaphysical Painting through to Neo-Plasticism, Futurism and the new Realism. It is only natural therefore that Expressionism and Abstract Expressionism – two ideologies, seemingly so contrasting, which arose in Germany with Ernst Ludwig Kirchner and Wassili Kandinsky before the First World War – should have had such a powerful effect upon later avant-garde movements in Europe and America. Unfortunately it is not possible to present here more than a brief indication of the complexities of such a situation, but the impression made by the draughtsmanship of Kandinsky cannot be stressed too much. It was he who in 1911 helped to form the Blaue Reiter (Blue Rider) group, whose members expressed themselves in undulating strokes that might be described as having a musical quality, set against hazy atmospheres, with sudden stresses that take one unawares and break through the misty veil of abstraction like a piercing cry (p. 369).

At the same time, the De Stijl movement (1917–28) was active, with Piet Mondrian, a Dutch painter, as one of its leading exponents. His graphic work laid great emphasis on geometrical design and his particular form of Abstraction is described as Neo-Plasticism (p. 370). The style of Paul Klee also evolved from Abstract Art. He created extremely elegant, mysterious designs in which cobweb-fine lines on allusive patches of colour seem to fill the empty spaces of poetic memory with Symbolistic or Surrealistic expressions (p. 368).

True Surrealism did not emerge until 1920, when Max Ernst became its leading graphic interpreter, with an indistinct, misty technique that creates almost hypnotic effects (p. 371). Sharing his ideas of Dadaism and Surrealism were Joan Miró (p. 372), Osvaldo Licini and Salvador Dali, and between them they produced a considerable amount of graphic work (p. 373).

Occupying a rather solitary position in this sphere was Hans Arp, a French sculptor who originated from Alsace. He adopted an entirely non-representational style in his graphic studies which nevertheless had a strong dynamic quality.

Because of the politically imposed sanction against what the totalitarian regime of the time defined as 'degenerate art', Italy was not affected by this artistic turmoil until considerably later. However, most of the present generation of artists have been through the figurative culture of Abstract Expressionism, if only by learning the theory of its characteristics, and this may well explain the typical sense of detachment of the present-day artist. He allows himself to be influenced by no particular school, tradition or even ideology – except his own. Furthermore, the range of recent tendencies – even within the graphic arts – has become far too varied and difficult to synthesize, although the field is full of outstanding people. It seems appropriate at this

Arturo Martini: *The Lovers* (monotype)
Treviso, Museo Civico

Hans Arp: *Black and White* (1960)
New York, private collection

point, to mention a few more examples of individuals who, in my opinion, are important for the direction they are taking rather than because they are unusual in themselves.

The thread of Post-Impressionist Realism – which, as has already been mentioned, flourished with Semeghini and de Pisis – is still apparent in styles which gravitate between Naturalistic and Symbolistic, which frequently venture into Abstraction, too. Some of the elegant drawings by Zoran Music exemplify this, in their recollection of beloved Dalmatian landscapes with their arid rocks and vari-coloured donkeys, the whole sheet often being overdrawn with purely decorative arabesques (p. 374).

At the same time, there are artists who still pursue the mainstream of Expressionism, finding there – for both moral and ideological reasons – the most satisfactory answer to the pressures of modern life. There was, for instance, Scipione, with his pitiless portraits drawn in staccato lines and the almost grotesque quality of their corporeity (p. 376).

Then there are the linear intricacies of British sculptor Henry Moore. His graphic style can be seen distinctly in his numerous preliminary drawings for sculptures, as well as in the moving pen drawings he made of life in the London Underground shelters during the air raids in the Second World War (p. 379).

Sometimes the fine-lined drawings of Alberto Giacometti, the Swiss sculptor, painter and poet, reach similarly expressive heights (p. 377), as, in another sphere, do the weird fantasies of the two British artists, Francis Bacon and Graham Sutherland (p. 375). Two exceptional German draughtsmen – who were also Expressionists – were the obsessive Max Beckmann (p. 378) and the tragic Georg Grosz whose quick, stark strokes produce an effect as though the scene were being watched through the smoky haze of explosions (p. 380). There were other remarkable draughtsmen who made use of a style involving a similarly obsessive concentration of lines.

It is thus apparent that contemporary drawing reflects, in a profound sense, the drama of a tormented humanity, with the artists' distressing vision of a world which is disintegrating. We cannot chase this knowledge away by seeking refuge in the contrived recycling of beautiful or pleasant artefacts perpetrated mainly by the graphic art of the mass media, which is by now such an integral part of our daily lifestyle (especially Popular (Pop) Art and Optical (Op) Art). The fixed expression of *Any Man (Him)* by Roy Lichtenstein, one of the leading exponents of Pop Art in America, is inescapably far removed from that creative miracle of expressiveness – thoughtful and gentle, intimate and communicative, cheering and consoling – we have for centuries called 'drawing'.

Ben Shahn: *Doctor Oppenheimer* (1954)
New York, The Museum of Modern Art

Primitive Drawing in Greece, Rome and Byzantium

Magdalenian painter (14,000–10,000 BC)
European Bison (Aurochs)
Polychrome cave painting
Spain, Altamira

In the line of this powerful figure of a European bison, drawn in black manganese, there is a feeling of vigour and tension. To increase the plastic quality, the artist also used yellow ochre and mistily blended shades of red. The cave paintings of Altamira are remarkable not only for their sharp realism but also for the confidently rapid strokes with which they have been delineated. This particular picture is in the first cave to have been discovered, which still remains the most important of all the prehistoric caves.
Bibliography: Almagro, 1947, pp. 52–60

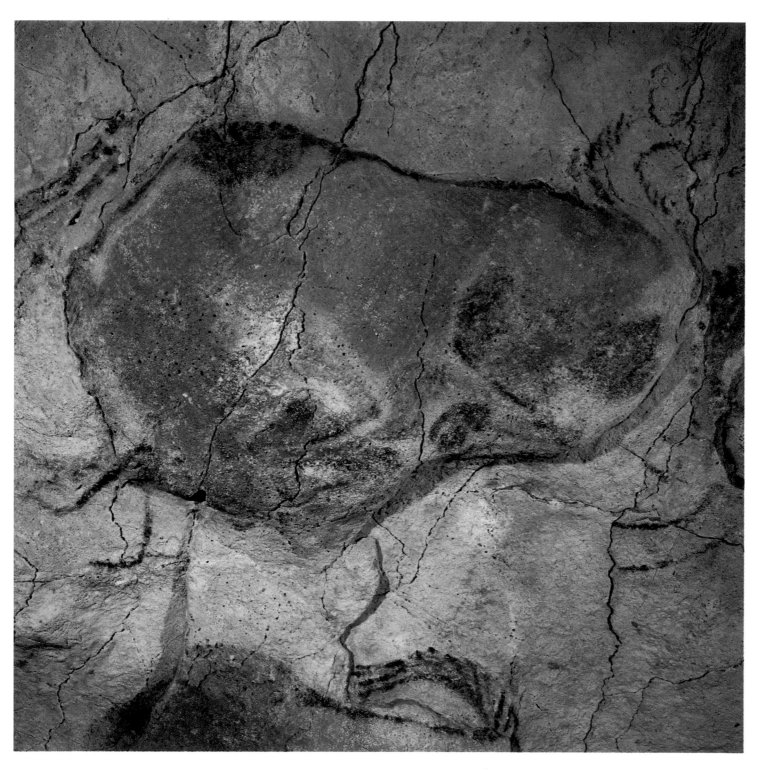

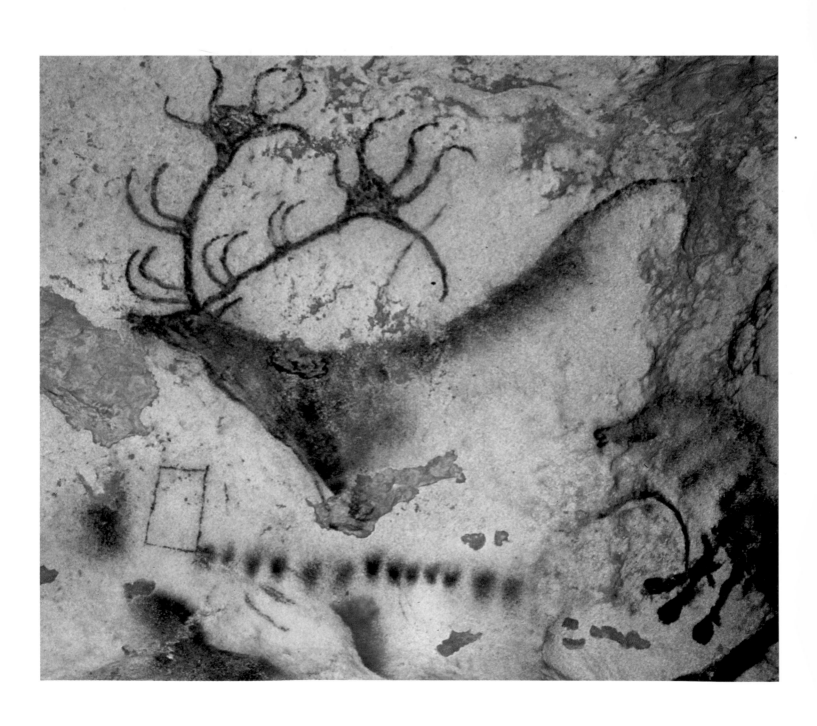

Magdalenian painter (*c.* 13,500 BC)
Deer
Cave painting
France, Lascaux

It was not uncommon for primitive man to attribute any likeness of an animal that he chose to draw on the walls of a cave with magical propitiatory powers. By depicting his prey, therefore, he hoped to influence to his own advantage the outcome of the fight for survival. This profile of a stag, which stands out clearly against the light-coloured rock wall, is the characteristic expression of a society whose economy was entirely dependent upon hunting.
Bibliography: Bataille, 1955, pp. 75, 82

Egyptian painter (fifteenth century BC)
A Hunting Scene in the Marshes
Tomb Painting
London, British Museum

The flowing, precise draughtsmanship, keen sense of line and perfect classicism of form are typical of the Nebamon tomb frescoes. In the scene reproduced here, the young man is seen concentrating on the chase in marshland inhabited by all kinds of birds, fish and animals. The typically abstract quality of Egyptian art is here combined with a warm feeling of life.
Bibliography: Farina, 1929, pl. 126

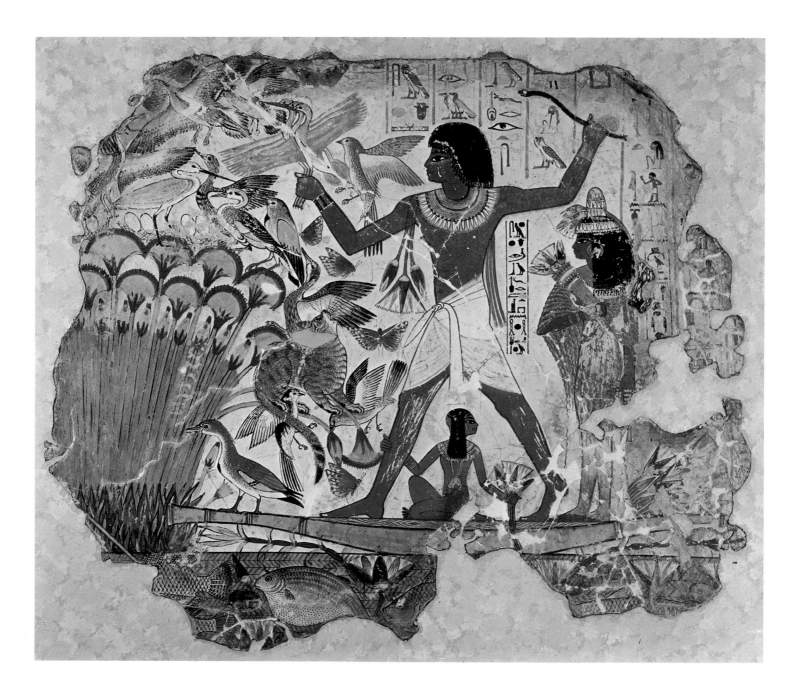

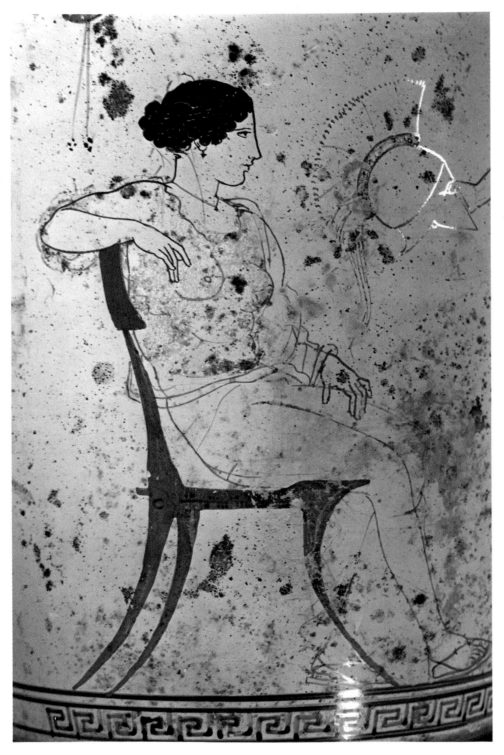

The Achilles painter (*c*. 450 BC)
The Departure of the Soldier
Vase painting (detail); height 8¼ in. (21 cm.)
Athens, National Archaeological Museum,
inv. 1818

We can glean some idea of the paintings and
drawings that must have been seen in
Ancient Greece – long since destroyed by
time – from the wealth of vase fragments
that have survived to the present day.
Typical of the decoration on the fine Attic
lekythoi (fifth-century BC white-ground tomb
vases) produced in Eritrea, is the linear
outlining filled in with colour-shading and
showing an increasing regard for chromatic
harmony. This type of painted pottery is
datable from a little after 450 to about
400 BC.
Bibliography: Robertson, 1959, pp. 140, 144

Etruscan painter (*c*. 530 BC)
Flight of the Masked Man
Tomb painting
Tarquinia, Tomb of the Augurs

The figure, which is portrayed in typical
outline drawing with flat washes in the
conventional colours, is part of the overall
decoration of the so-called Tomb of the
Augurs and dates back to about 530 BC. The
artist displays remarkable naturalness and
decorative sensitivity in this portrayal of a
fleeing man, to whose movements even the
naturalistic elements – both animal and
plant – adapt rhythmically to complete the
composition.
Bibliography: Pallottino, 1952, pp. 40–2

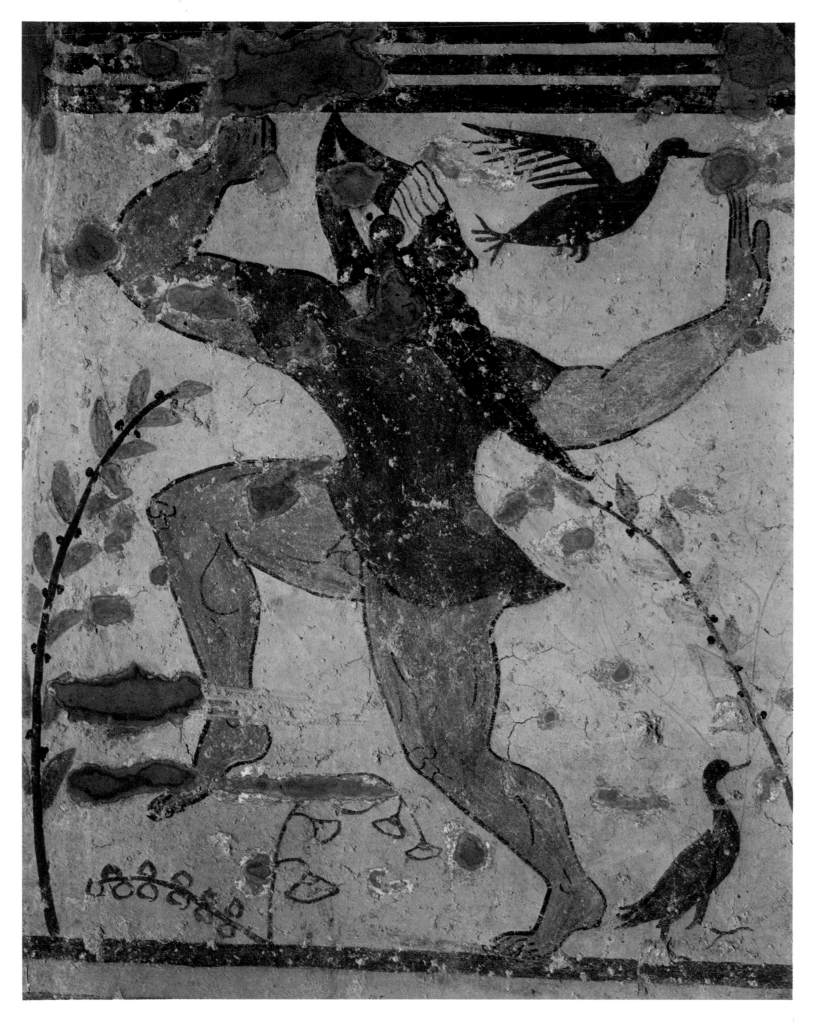

Asia and the Far East

Chou Fang (active 780–810). An artist at the Imperial Court until the end of the eighth century, when the An Lu-shan revolt destroyed the Emperor's power, Chou's pictures reflect the refinement, both thematically and compositionally, of the T'ang dynasty. He also painted portraits, erotic pictures and Buddhist scenes of which, however, no iconographic evidence remains today.

Hsü Tao-ning (first half of the eleventh century). Hsü was one of the greatest masters of Chinese landscape painting. His work, stylistically similar to that of Li Ch'êng, is at its most expressive in his handscroll, *Scenes of Fishing in a Mountain Stream*, which is in the Nelson–Atkins Gallery of Art, Kansas City.

Chao Meng-fu (Wu-hsing 1254–1322). A descendant of the Imperial house of Sung and a functionary of the court, he remained in the service of the Mongols when they came to power in 1260. He was a scientist, an outstanding calligrapher and a traditional artist of great refinement. Especially well known for his pictures of horses, he also painted landscapes, figures, flowers and bamboo.

Wu Chên (1280–*c*. 1350). One of the leading landscape artists of the Yüan dynasty, Wu Chên is best known for his paintings of bamboo. A poet and calligrapher, he frequently sought to incorporate these skills into his pictures. An artist of great talent and independence of style, he exerted considerable influence on subsequent generations of artists.

Tu Chin (active from *c*. 1465–87). A gifted poet and artist, Tu Chin was greatly influenced by the Chê school. His style, which is very elegant, is of an academic nature.

Kao (active somewhere between the end of the twelfth and first half of the fourteenth century). Almost the only thing known about this Japanese artist is that he was known as the monk Zen and that he was working at some time between the Kamakura (1185–1336) and Muromachi (1336–1573) periods. He is quite likely to have been one of the first artists in Japan to have learned the art of ink painting from Chinese works, and drawing his inspiration from the classical subjects of contemporary Chinese and Japanese art, such as the legendary Kanzan.

Andō Hiroshige (Tokyo 1797–1858). Originally a book illustrator, Hiroshige only became well known from 1826 with his *Views of Edo* which he followed with his *Fifty-three Stations on the Tōkaidō*, the eastern sea road joining Kyoto and Tokyo. He continued to produce pictures with a predominantly landscape theme, both as drawings and coloured engravings. Hiroshige's prints exercised considerable influence on European figurative art at the time when Impressionism was making itself felt.

Katsushika Nakaijma, known as Hokusai (Tokyo 1760–1849). A fine draughtsman and engraver, Hokusai concentrated on the landscape of Japan, the series *Thirty-six Views of Mount Fuji* being some of his best-known work in the West. He was also a portraitist, and some of his pictures depict the life of the people. His work became well known by the Impressionists in Paris, who were considerably influenced by it.

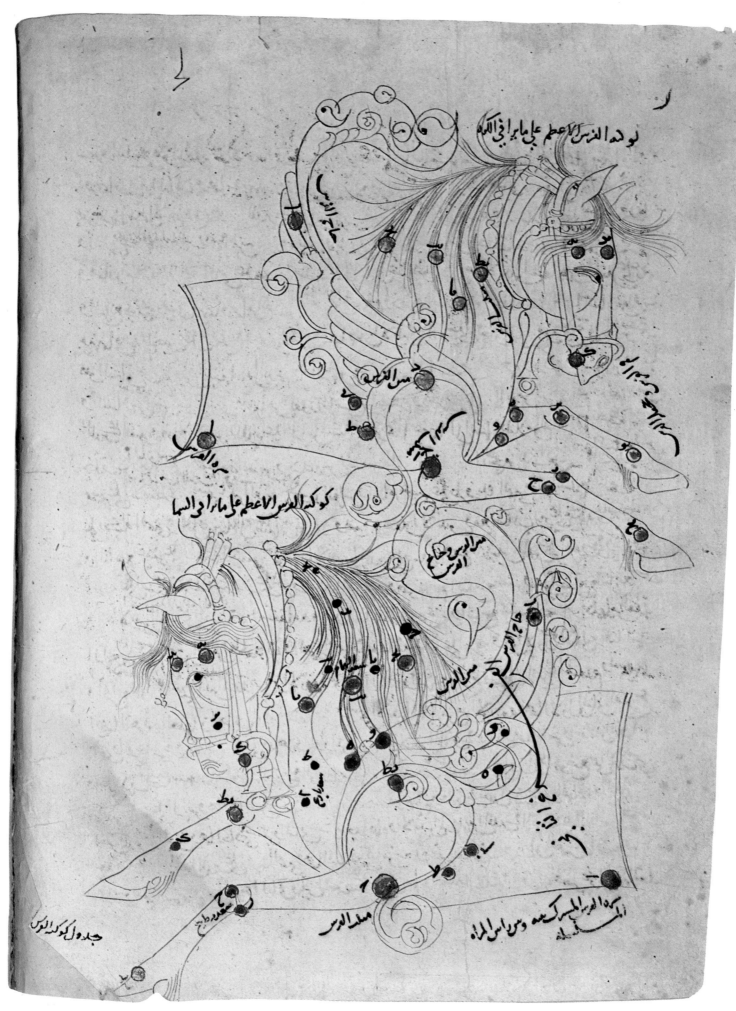

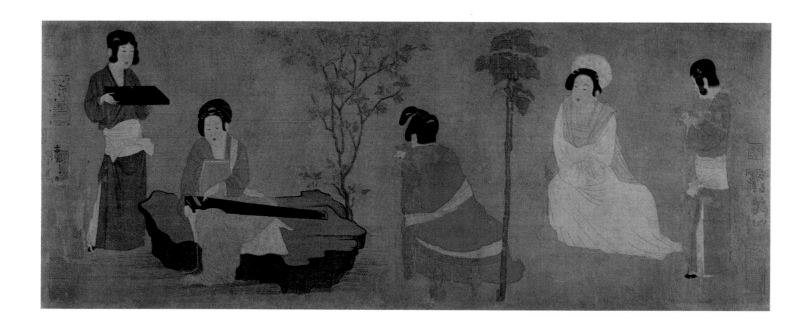

Persian painter? (*c.* 1300)
Pegasus
Miniature; $11\frac{1}{2} \times 17\frac{1}{2}$ in. (290 × 190 mm.)
London, British Museum, inv. Ar. 5323,
f. 30 (*v*)

This illustration is taken from a fourteenth-century manuscript, *The Book of the Fixed Stars*, by a Persian astronomer of the tenth century. Graphic and pictorial effects blend on the page in the double drawing of the constellations as they appear from the Earth, and as they would appear from the sky. The outlines are in black, with gold spots encircled in red to represent the individual stars.
Bibliography: Martin, 1912, I, p. 19; II, pl. XXXV, XXXIX

Chou Fang (active 780–810)
Ladies Taking Tea
Ink and colours on silk (handscroll);
$11 \times 29\frac{1}{2}$ in. (280 × 750 mm.)
Kansas City, Nelson-Atkins Gallery of Art, inv. 32–159/1

This work, in ink and colours on silk, is attributed to Chou Fang, a court painter of the T'ang dynasty, who worked in the late eighth and early ninth centuries. Characteristic of aristocratic art of this period is the serene atmosphere produced by a marked stylization of the natural features and perfect balance of the composition. The subject is one of the themes frequently depicted during this period: court scene showing ladies engaged in their favourite pastimes.
Bibliography: Moskowitz, 1963, n. 1097; Sickman-Soper, 1969, p. 115

Hsü Tao-ning (first half of the eleventh century)
Fishing in a Mountain Stream
Ink on silk (detail of handscroll); whole size $19 \times 82\frac{1}{2}$ in. (483 × 2100 mm.)
Kansas City, William Rockhill Nelson-Atkins Gallery of Art, inv. 33.1559

This scroll, of which only a section is reproduced here, is one of the best examples of the art of Hsü Tao-ning, a leading landscape artist of the Sung dynasty. The atmosphere of solitude and intense cold, the stylization of the sparse trees growing up the mountain slopes and along the ridges, and the continuous flowing lines of the mountain peaks emphasized with broad brush-strokes of diluted ink are all typical features of the work of this northern school.
Bibliography: Moskowitz, 1963, no. 1102; Sickman-Soper, 1969, pp. 139–40

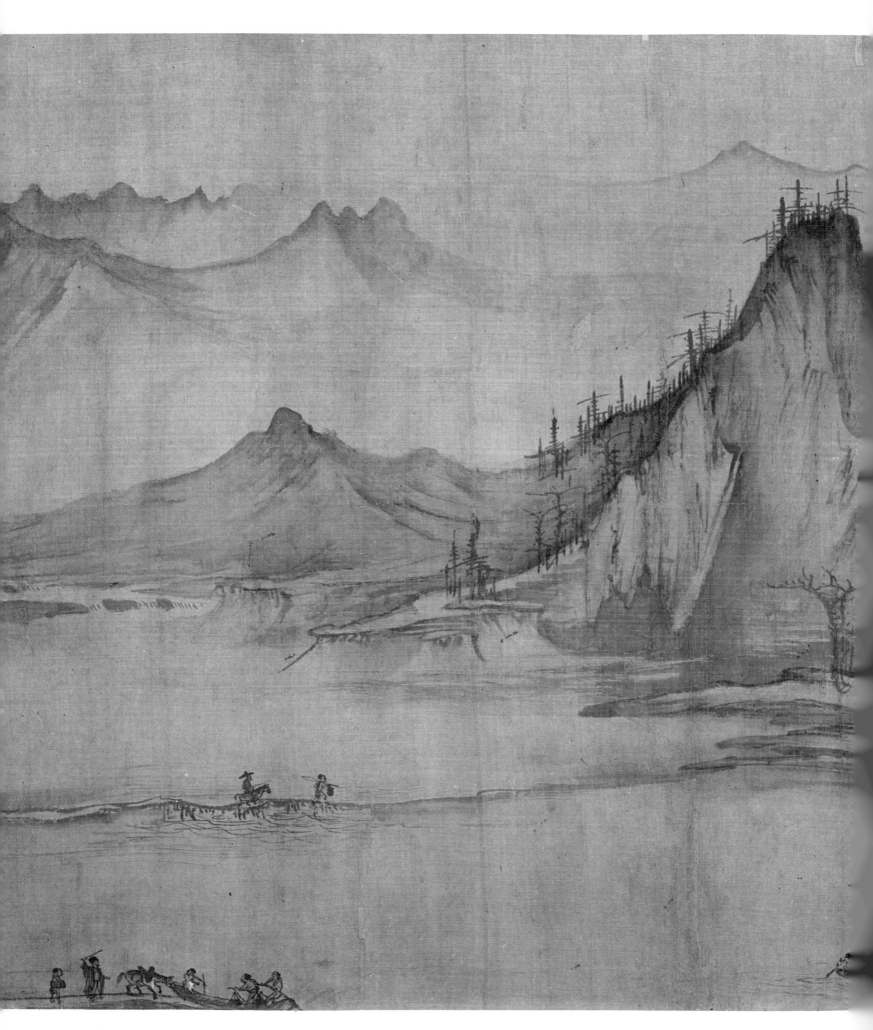

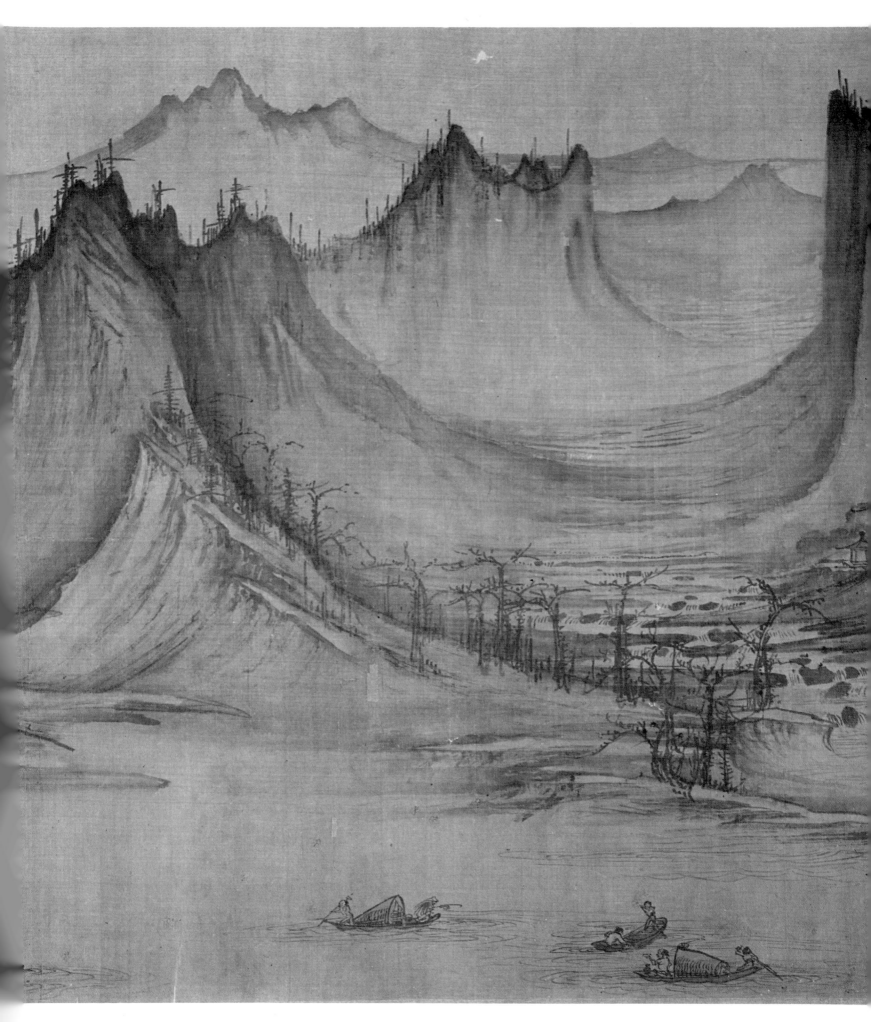

Chao Meng-fu (Wu-hsing 1254–1322)
The Sheep and Goat
Ink on paper (handscroll); 10 × 19 in.
(250 × 485 mm.)
Washington, DC, Freer Gallery of Art,
inv. 31.4

The fundamental feature of this folio is its
highly elegant and refined technique, which
can be seen in the different treatment given
to the fleece of the sheep and to the hair of

the goat. The sheep's wool has been marked
with patches of diluted ink, while the goat's
long hair has been drawn in with an almost
dry brush. The inscription on the left, by the
artist himself, is an integral part of the
picture, the abstract quality of the
calligraphy being in complete contrast to the
realistic representation of the animals.
Bibliography: Moskowitz, 1963, no. 1110;
Sickman-Soper, 1969, pp. 192–3

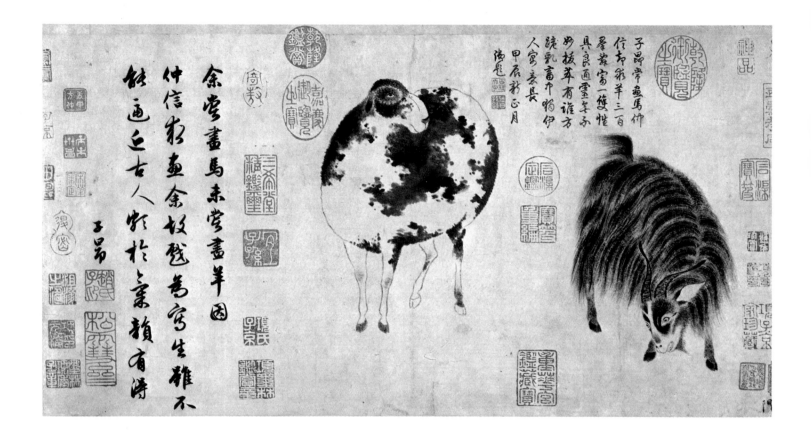

Wu Chên (1280–*c.* 1350)
Bamboos in the Wind
Brush and ink; 29½ × 21½ in.
(753 × 543 mm.)
Boston, Mass., The Museum of Fine Arts,
inv. 15.907

'He painted and wrote with joy', says Wu
Chên of himself at the end of the inscription,
almost as though to stress the impossibility
of excluding the calligraphic contribution

when considering the work. In spite of the
apparent simplicity of this drawing, it
involves a very skilful technique which
cannot permit changes of mind or errors.
Only thus can the artist achieve utter purity
of form, through complete linear control, in
the representation of one of his favourite
subjects.
Bibliography: Sachs, 1961, pl. 3

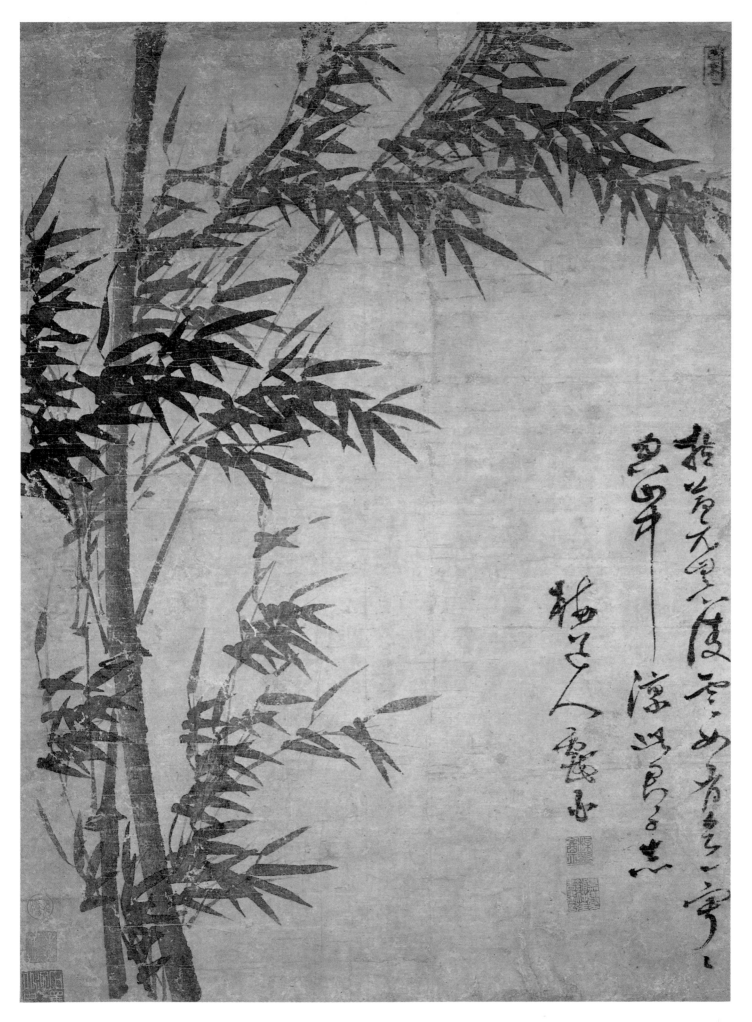

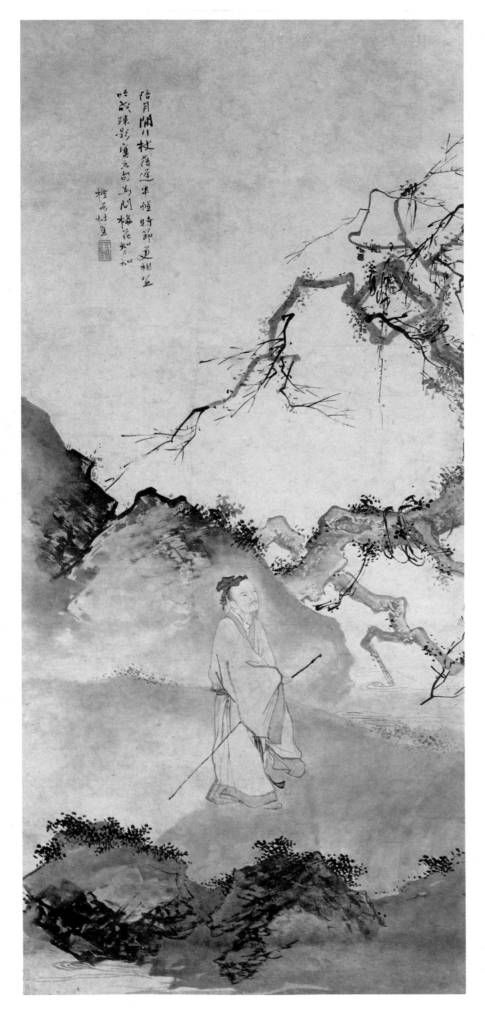

Tu Chin (active *c.* 1465–87)
The Poet Lin Pu Wandering in the Moonlight
Ink and light colours on paper (detail of
hanging scroll); 61¾ × 28½ in.
(1566 × 725 mm.)
Cleveland, Ohio, Cleveland Museum, J. L.
Severance Collection, inv. 54.582

The delicate sensitivity of Chinese Sung
painting is reflected in this representation of
the poet Lin Pu as he contemplates a
flowering plum-tree in the pale light of the
moon. Tu Chin was a profoundly cultured
artist, and it was due to his masterly
technique and a totally personal
interpretation that he was able to imbue his
art with the various painterly trends of the
time.
Bibliography: Moskowitz, 1963, no. 1115

Japanese painter (thirteenth century)
The Burning of the Sanjo Palace
Coloured ink on paper (detail of
handscroll); height 16½ in. (414 mm.)
Boston, Mass., The Museum of Fine Arts

The scene illustrates the night attack on the
Sanjo Palace at Kyoto in 1159. The influence
of the oldest and most important Chinese
art, which is quite evident in much of
Japanese art, is particularly apparent here in
the complex graphic and chromatic effect of
the tongues of flame. The figures of the
warriors look like sinister war-gods seen
through the pall of smoke.
Bibliography: Terukazu, 1961, p. 97

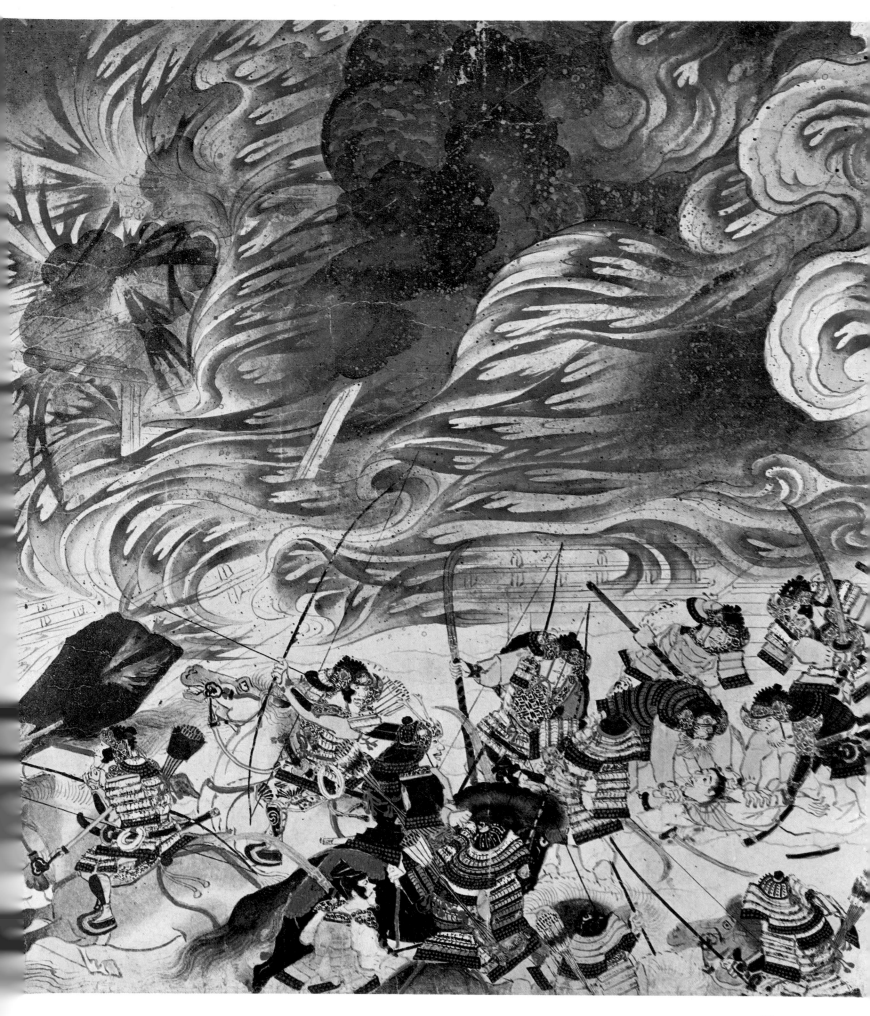

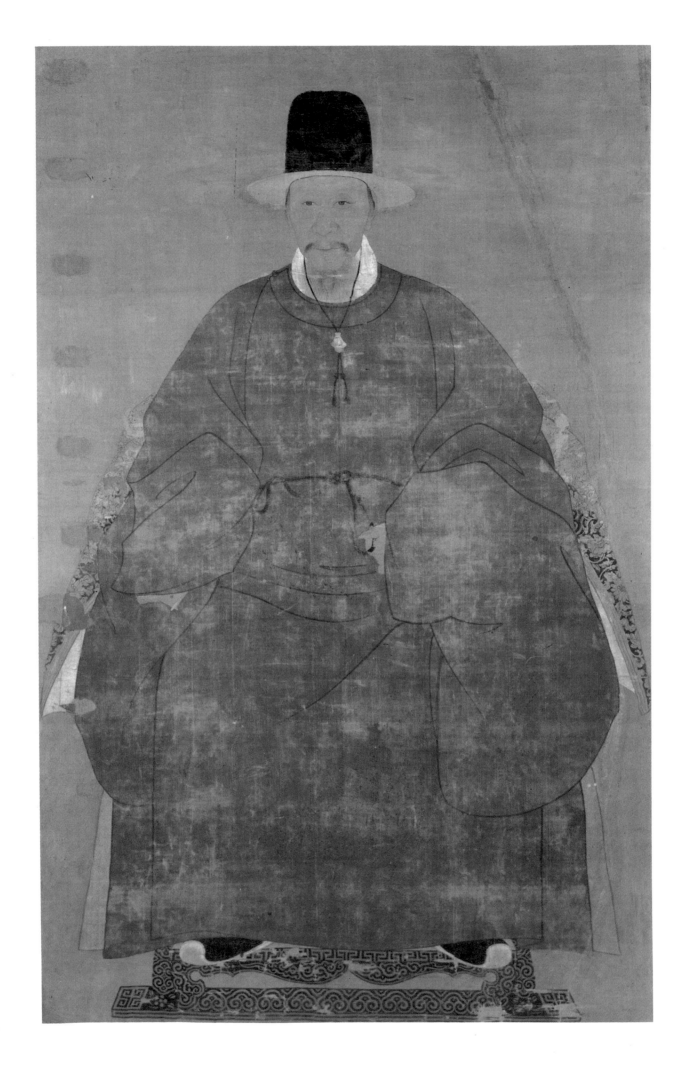

Painter of the Ming dynasty (1368–1644)
Portrait of a Chinese Dignitary
Ink and colour on silk; 60 × 37 in.
(1518 × 940 mm.)
Provenance: Denman Ross
Cambridge, Mass., Harvard University,
William Hayes Fogg Art Museum

The light, elegantly drawn lines and
watercolour wash – so typical of courtly art
in the Ming dynasty – have not prevented
this anonymous artist from achieving a
remarkably individualistic characterization
in this portrait. Works such as this show us
to what extent Chinese art aimed at a
faithful reproduction of reality, as opposed
to its usual adherence to conventionality.
Bibliography: Mendelowitz, 1967, p. 206

Kao (active somewhere between the end of
the twelfth and first half of the fourteenth
century)
Kanzan
Brush and ink on paper; $40\frac{1}{4} \times 12\frac{1}{4}$ in.
(1023 × 310 mm.)
Washington, DC, Freer Gallery of Art

A legendary Chinese hermit, Kanzan, has
been depicted by Kao in the best known of
his very rare works. The control of the
outline and tonal shadings, achieved through
the very expressive use of a diluted ink wash,
make this picture typical of the high
standard of graphic art in Japanese culture.
Bibliography: Moskowitz, 1963, no. 1128;
Swann, 1966, pp. 158–60

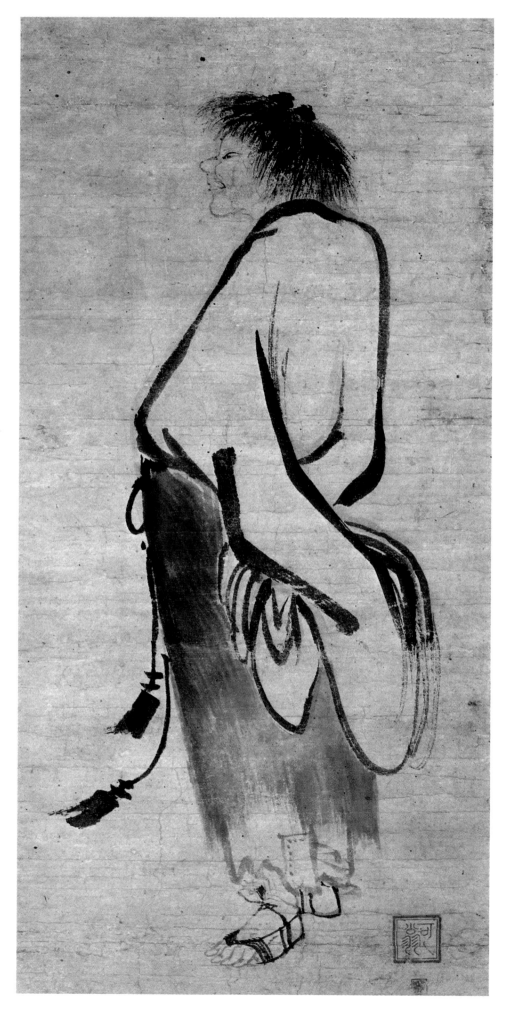

Andō Hiroshige (Tokyo 1797–1858)
Landscape with Mountain
Ink and colour on paper: 11 × 6½ in.
(279 × 169 mm.)
Washington, DC, Freer Gallery of Art

The work of Hiroshige and the fundamental
role played by colour exerted a strong
influence on the Impressionists. In this sheet,
taken from an album of sketches, in which
there are landscapes, figures and animals, the
artist has employed a wide range of cold
tones to bring the elegant, perfectly balanced
composition to life.
Bibliography: Moskowitz, 1963, no. 1141

Katsushika Hokusai (Tokyo 1760–1849)
Birds in Flight
Indian ink and pale yellow watercolour on
white Japanese paper; 10⅞ × 15 in.
(275 × 380 mm.)
Provenance: Pesci; acquired in 1925
Florence, Galleria degli Uffizi, inv. 99139

In this sheet, Hokusai has achieved an
exquisitely painterly effect by rapid,
fragmented brush-strokes and the use of ink
as a shading medium, enlivened by a few
delicate touches of colour. He is one of the
greatest exponents of the Ukiyo-e school.
The example of his work given here shows
just how well he could adhere to reality.
Bibliography: Kondo, 1980, no. 12

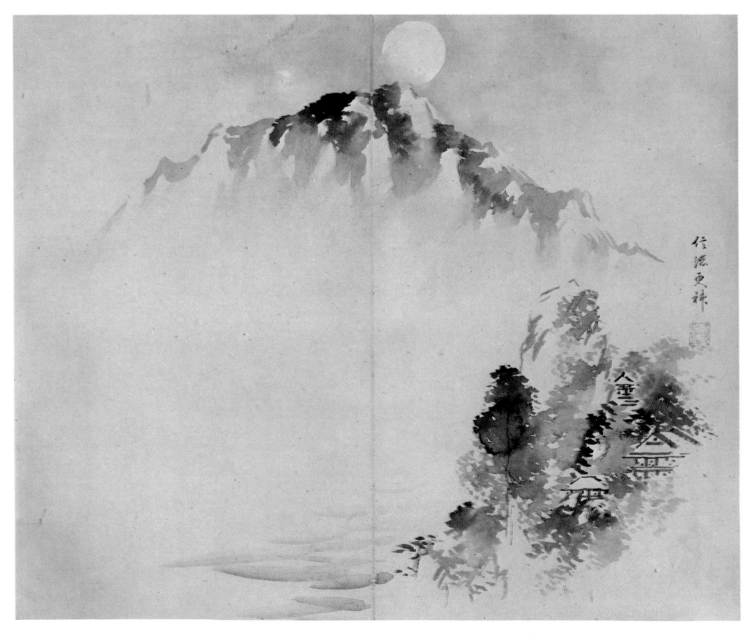

59

The Middle Ages in Europe

Taddeo Gaddi (Florence *c.* 1290–1366). Having worked with Giotto for many years and co-operated with the master in his later works, Gaddi remained his most faithful follower after Giotto's death. He inherited from the Giotto workshop a knowledge of graphic technique, and continued to keep the tradition alive, especially in his frescoes in the Baroncelli Chapel of Santa Croce.

Simone Martini (Siena 1284?–Avignon 1344). The earliest important work by Martini is his large fresco, *Maestà*, painted in 1315 in the Palazzo Pubblico of Siena, almost as a companion piece to the *Maestà* in the Cathedral for which his teacher, Duccio, had been commissioned about four years earlier. To his training under Duccio he added his own particular sensitivity to linear motifs, which he selected from among the most elegant examples of illuminated scrolls and oriental fabrics from France. In an atmosphere dominated by the *dolce stil nuovo* – a romantic style of poetic chivalry which prevailed in literature and music – he tended to find more graphic ways in which to express his art. Very little of his work in this field remains to us, however, except one or two miniatures and a small number of drawings. In his more mature years, Martini went to Assisi, where between 1323 and 1326 he painted a cycle of frescoes in the church of St Francis. In 1328 he painted another fresco in the Palazzo Pubblico in Siena, and in 1340 went to France where he became a painter to the Papal Court in Avignon.

Gentile da Fabriano (Fabriano *c.* 1370–Rome 1427). After his training in central Italy, where he had been on the fringe of the trend towards the international Gothic style, Gentile began a working life of continuous wanderings. We find him in Venice (*c.* 1408–19), Brescia (*c.* 1417), Florence (1423), Siena and Orvieto (1425), and finally Rome (1427), where he died. Familiar from the beginning with the linear qualities of the Gothic style, Gentile showed a predilection for elegant, decorative art. This is typified in the few works of his that remain to us such as the Holy Trinity altarpiece, painted in 1423, now in the Uffizi Gallery, Florence. From the rare examples of his graphic work, it is clear to see how important his influence must have been on such a great draughtsman as Pisanello, who collaborated with him in painting some large cycles of pictures and frescoes.

Giovannino de' Grassi (Milan?–d. 1398). A versatile artist, Giovannino was involved in later life as a master-builder in the great undertaking, begun in 1386, of the building of Milan Cathedral. He was both a sculptor and a painter, becoming especially well known for his elegant work in the new International Gothic style and for his connections with some of the Franco–Flemish Masters. Accustomed as he was to late Gothic naturalism, he often incorporated naturalistic motifs, such as plants, flowers and animals, into his work, in the graphic tradition he developed in Lombardy in his *Taccuini* ('Notebooks'), now in the Biblioteca Civica in Bergamo.

Antonio Pisano, known as Pisanello (Pisa 1395–Rome 1455). Having established himself in Verona, Pisanello produced his first works in the early 1420s, both as easel pictures in the International Gothic style and in the form of large frescoes which he painted in 1423 in the church of San Fermo, Verona. In the meantime, by about 1417 he had already completed several frescoes in the Doge's Palace in Venice, probably having had some connection there with the work being done by Gentile da Fabriano; unfortunately these have now all disappeared. His next assignment, in 1424, was in the Visconti castle in Pavia, followed by commissions in the courts of Ferrara, Rimini and Cesena. About 1440 he painted a series of frescoes in Sant'Anastasia, Verona, *St George and the Princess*. Between 1449 and 1455 he went to Naples and Rome, where he was to die. Although most of Pisanello's frescoes have been destroyed, an impressive corpus of his graphic work is extant, most of which is in the Louvre Museum, Paris. His incisive style covers a very wide range of themes including the nude, animals, landscapes and portraits.

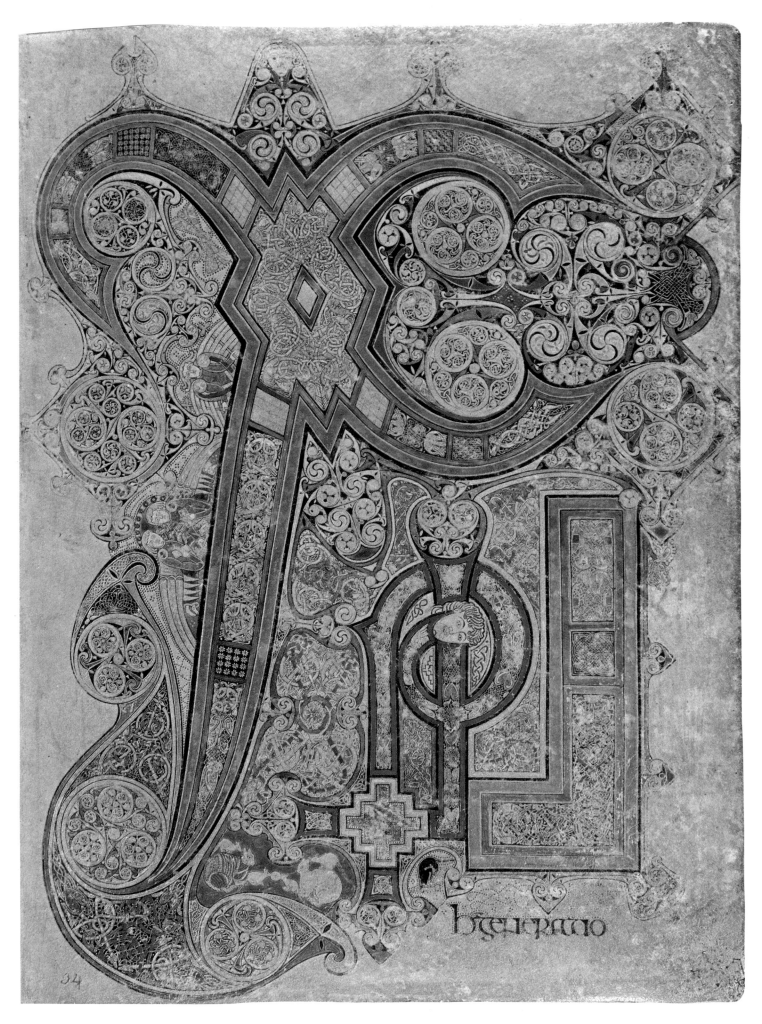

bgenerano

Hibernian Saxon painter (*c.* 800–10)
Book of Kells: Initial
Tempera on parchment; 13 × 10 in.
(330 × 250 mm.)
Provenance: Kells Monastery, Ireland
Dublin, Trinity College Library, inv. 58,
f. 34 (*r*)

This illuminated initial is to be found in St
Matthew's Gospel in the *Book of Kells*, so
named after the Irish monastery where it was
perhaps finished. Illustrated in a style
common to Ireland and Northumbria (cf.
the earlier *Lindisfarne Gospels*), it is thought

to have originated in the monastery of Iona,
and to have been taken to Kells when the
monks abandoned the island because of
Viking attacks (the last in 807). The art of
illuminating, which is closely related to the
technique of draughtsmanship, is a typical
manifestation of monastic culture in Western
Europe and Ireland. It resulted from the
grafting of local barbaric traditions on to the
more classic Byzantine substratum.
Bibliography: Nordenfalk, 1977, pl. 44

Reims painter (*c.* 820–30)
Utrecht Psalter
Pen and brown ink; about 12¾ × 9¾ in.
(327 × 248 mm.)
Utrecht, Bibliothek der Rijksuniversiteit

As in other contemporary works that mark
the passage from the illuminated book to the
illustrated book, this anonymous
draughtsman has with great vivacity and
realism translated scenes conjured up by the
Psalms in the Bible with nothing more than
swift strokes of his quill pen and ink.
Bibliography: De Wald, 1932, *passim*

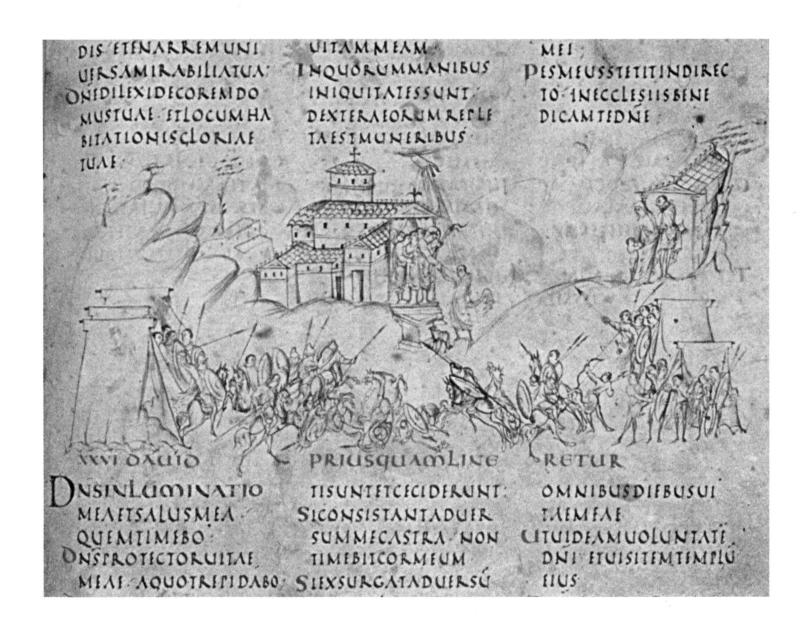

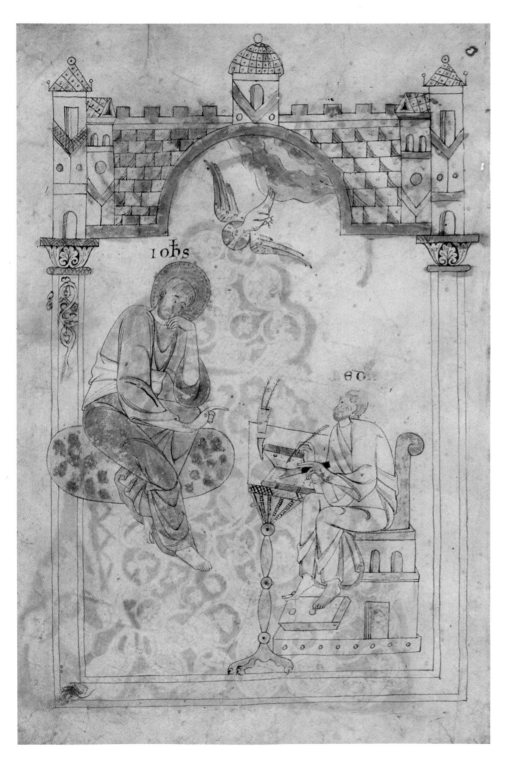

Austrian painter (first half of the twelfth
century)
The Venerable Bede
Pen and brown and red ink with watercolour
on parchment; $14 \times 9\frac{1}{4}$ in. (352 × 235 mm.)
Provenance: Rosenwald
Washington, DC, National Gallery of Art,
inv. B-17, 715

This sheet, which was probably a page from
a missal or choir-book, is identifiable as
being from an Austrian source, dating from
about 1140. The realistic background details
and expressive intensity of the figures are
accentuated by the special technique
employed of pen and ink and watercolour on
parchment.
Bibliography: Robison, 1978, no. 15

Taddeo Gaddi (Florence *c.* 1290–1366)
Presentation of the Virgin in the Temple
Brush, green-blue and black watercolour,
white and gold highlights with outlines in
metalpoint on specially prepared paper in
green; $14\frac{1}{2} \times 11$ in. (364 × 283 mm.)
Provenance: Vasari (?), Baldinucci,
Pandolfini and Strozzi; acquired in 1806,
following Napoleon's Italian conquests
Paris, Musée National du Louvre, inv. 1222.

This sheet is almost certainly the preliminary
study for one of the episodes in the fresco
cycle of the *Life of the Virgin* in the
Baroncelli Chapel in Santa Croce, Florence.
The artist has utilized the green colour of the
specially prepared paper to produce a
contrasting effect with the shade of
watercolour he has chosen, introducing
touches of white and gold to bring the scene
to life. The result is an architectural
composition in which the influence of Giotto
is clearly visible, both in its impressiveness
and in the importance given to its three-
dimensional qualities.
Bibliography: Berenson, 1961, no. 758;
Bacou-Viatte, 1968, pl. 1: Degenhart-
Schmitt, 1968, no. 22

Follower of Simone Martini (fourteenth century)
Allegory of Temperance
Silverpoint on specially prepared paper in red; 5¼ × 3¾ in. (134 × 94 mm.)
Berlin, Kupferstichkabinett, inv. 617

The existence of a similar figure in the frescoes of the Palazzo Pubblico in Siena has in the past caused this drawing to be attributed to the workshop of the Lorenzetti brothers. However, the delicacy of the strokes, elegant rhythm and flowing line are so reminiscent of the style of Simone Martini in such works as his *Anunciation* of 1333 in the Uffizi that it seems likely the artist may have been one of his close followers, working in the 1350s.
Bibliography: Degenhart-Schmitt, 1968, p. 43; Dreyer, 1979, pl. 1

Master of the *Parement de Narbonne* (second half of the fourteenth century)
An Archer
Brush and black ink on parchment; 10½ × 6¼ in. (267 × 160 mm.), irregularly shaped
Provenance: Ridolfi; Guise
Oxford, Christ Church, inv. 0002

This drawing was for a long time accredited to an Italian hand. However, it is stylistically very close – both in its brushwork technique and its chiaroscuro – to the grey figures painted on the silk altar-hanging of Narbonne, which was probably executed between 1374 and 1378 by an artist in the employ of Charles V of France. The original attribution is understandable, as something of the style of Simone Martini can certainly be detected both in the *Parement* and this drawing.
Bibliography: Paecht, 1956, p. 150; Meiss, 1967, p. 132; Byam Shaw, 1976, no. 1445

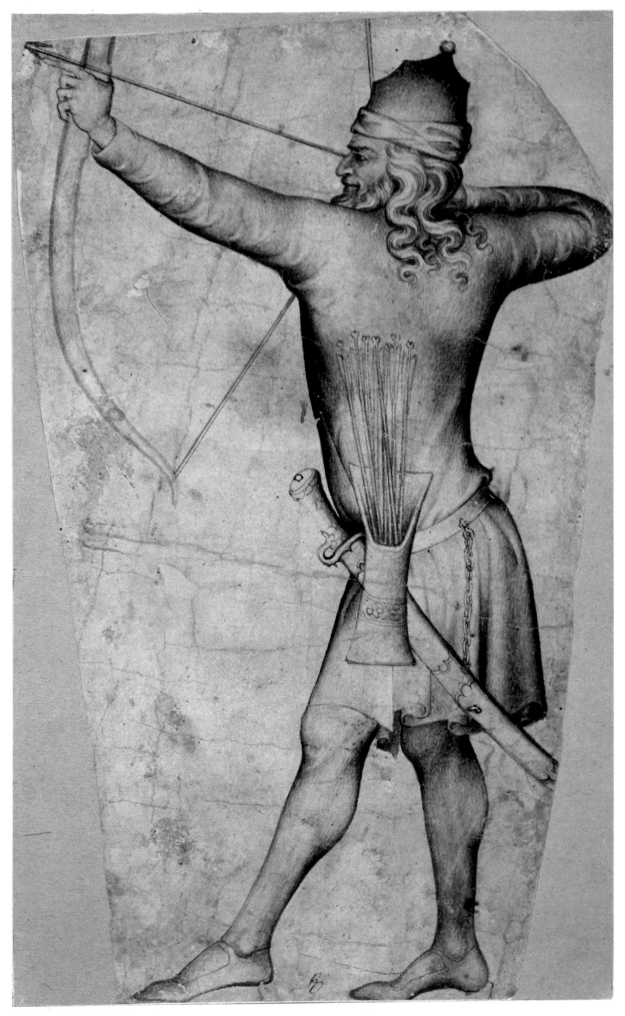

German painter (*c.* 1390)
The Education of Mary
Pen and greyish-black ink; $4\frac{7}{8} \times 5$ in.
(124 × 127 mm.)
Provenance: von Aufsess
Nuremberg, Germanisches
Nationalmuseum, inv. Hz 38 (*r*)

This sheet illustrates a rather unusual theme
in the German iconographic repertoire,
showing as it does the young Mary
concentrating on her reading, surrounded by
angels. The well-defined lines, delicate
hatching with the pen and accentuated
verticality, which characterize the whole
composition, are typical stylistic features of
northern Gothic art.
Bibliography: Wiegand, 1934–5, pp. 49 ff;
Halm, 1955–6, no. 2

Lombardy painter (beginning of the fifteenth century)
A Hunting Scene
Pen, brush and indian ink heightened with white on prepared green paper; $5\frac{7}{8} \times 7\frac{1}{8}$ in. (148 × 182 mm.)
Provenance: Esterházy
Budapest, Szépmüvézeti Múseum, inv. 1778

This drawing, in which great skill is displayed in the use of the pen and brush on prepared paper, is a fine example of the realistic style found in artists' illustrated notebooks, so typical of the Lombardy and International Gothic styles. The incisive lines, the scene set against surroundings taken from life and the controlled animation of the elegant figures of the horsemen, are all indications that it can be counted, both stylistically and chronologically, as being among the finest illustrated manuscripts of the time.
Bibliography: van Schendel, 1938, p. 55; Vayer, 1956, no. 6; Fenyö, 1965, no. 1

Gentile da Fabriano (Fabriano
c. 1370–Rome 1427)
Female Nudes and Other Figures
Pen on parchment; $7\frac{5}{8} \times 10\frac{3}{4}$ in.
(193 × 273 mm.)
Provenance: Resta
Milan, Biblioteca Ambrosiana, Cod. ms. F
214 lr., f. 13 (*r*)

Here the artist has used the Sarcophagus of
Mars and Rhea Sylvia (at one time in the
Basilica of San Giovanni in Laterano,
Rome, but now in the Palazzo Mattei) and
the Sarcophagus of Orestes (in the Palazzo
Giustiniani, Rome) as Antique exemplars
from which to make his drawings. The
pictorial delicacy apparent in some of
Gentile's other graphic works provides good
grounds for attributing this study to him as
well. He has achieved a perfect balance in
these figures between the classical motif and
Gothic linear execution.
Bibliography: Fossi Todorow, 1966, no. 185;
Degenhart-Schmitt, 1968, no. 129

Giovannino de' Grassi (Milan?–d. 1398)
Two Ladies with a Cithern
Ink and watercolour on parchment;
$10\frac{1}{8} \times 7\frac{3}{8}$ in. (258 × 187 mm.)
Provenance: Lotto; Tassi; Secco-Suardi
Bergamo, Biblioteca Civica, Codex VII 14,
f. 3 (*v*)

The linear rhythm and delicate haziness of
the colours are the main features of this
drawing, which is part of a *Taccuino*
('Notebook') of thirty-one sheets. The
illustrative elegance of the International
Gothic style blends in with the naturalistic
approach that can be seen in many of the
studies in which animals and plants are
featured. Most of the works in the collection
are by Giovannino de' Grassi, who was one
of the major Lombardy artists of the late
fourteenth century.
Bibliography: Toesca, 1912, pp. 298–306;
van Schendel, 1938, p. 60; [*de' Grassi*], 1961,
passim

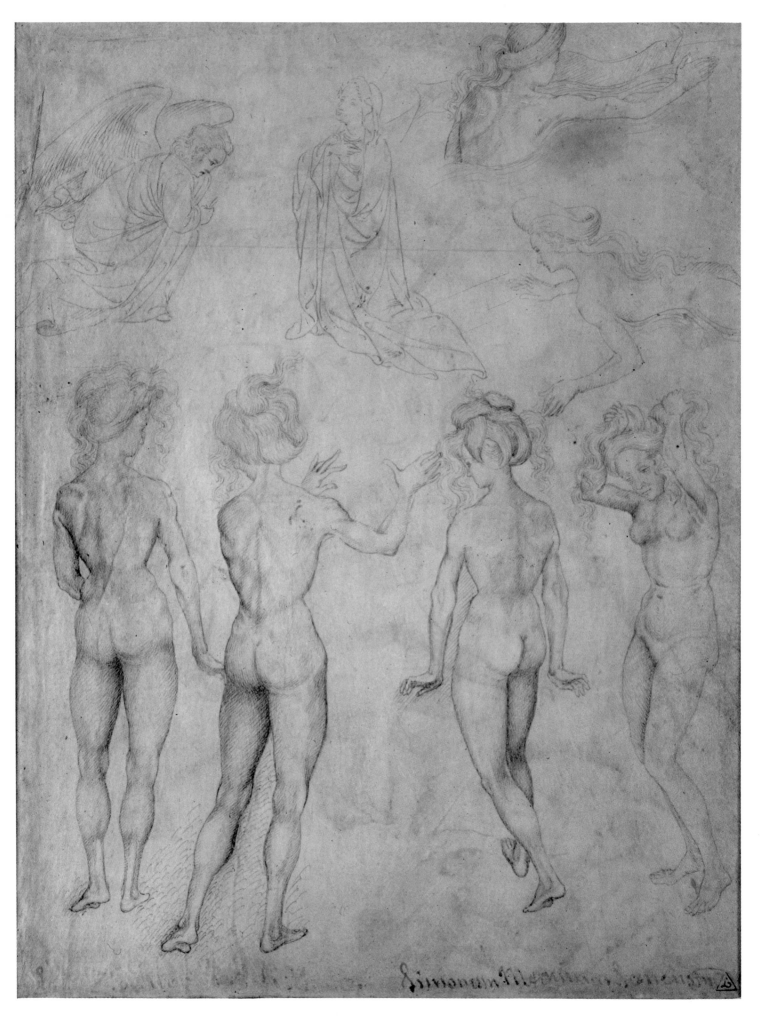

Pisanello (Pisa 1395–Rome 1455)
Studies of the Nude and an Annunciation
Pen and ink on parchment; $8\frac{3}{4} \times 6\frac{5}{8}$ in.
(223 × 167 mm.)
Provenance: Fries; Lagoy; Koenigs
Rotterdam, Museum Boymans-van
Beuningen, inv. I 520 (*r*)

The most remarkable aspect of this sheet is
the almost pre-Renaissance interest shown
by the artist in achieving a realistic and
sensual representation of female nudes, in
contrast with the still Gothically inclined,
refined quality of the figures of the Angel
and Virgin. Judging from the style, these
drawings are datable to the middle 1420s,
about the same time as Pisanello was
working on his fresco in San Fermo, Verona
(1424–6).
Bibliography: Degenhart, 1945, pp.
21, 24, 49. 72; Haverkamp, Bagemann, 1957,
no. 33; Fossi Todorow, 1966, no. 2

Pisanello
Studies of Costume and a Female Head
Pen and brown ink with watercolours,
silverpoint on parchment; $7\frac{1}{2} \times 9\frac{1}{2}$ in.
(183 × 240 mm.)
Provenance: Lagoy; Douce
Oxford, Ashmolean Museum

The most characteristic features of
Pisanello's drawings are the fact that he
worked from life, the linear stylization of his
pen-strokes and a decorative quality of
international appeal. The present sheet is
one of about forty by Pisanello, all
parchment, contained in the so-called
Taccuino di viaggio ('Travel Notebook') –
only partially Pisanello's work. They include
drawings made from Antique exemplars and
also some very lively representations of
animals.
Bibliography: Parker, 1956, no. 41; Fossi
Todorow, 1966, no. 190; Pignatti, 1976,
no. 1

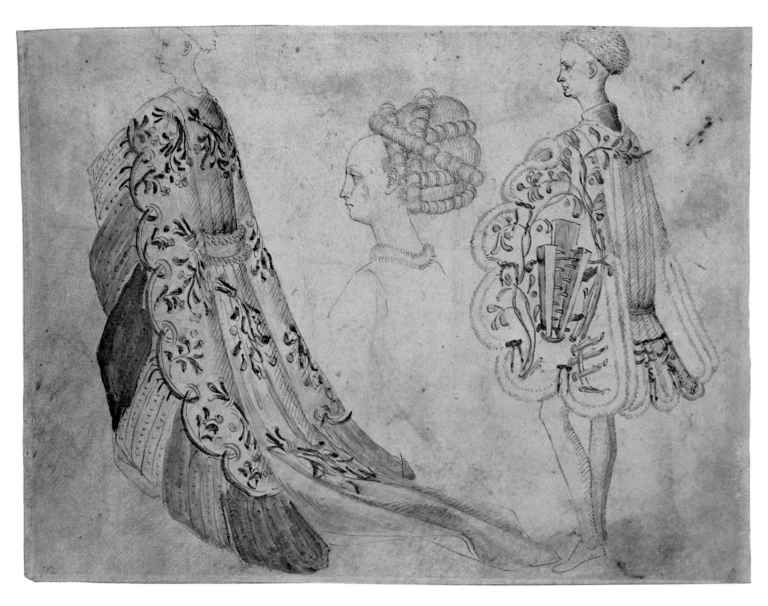

The Early Renaissance

Donato di Niccolò di Betto Bardi, known as Donatello (Florence 1386–1466). Donatello is regarded as the greatest Italian sculptor of the early Renaissance. Having served his apprenticeship in the workshop of Ghiberti, by the early part of the fifteenth century (1411–15) he was already using the new artistic forms in which to express himself. He visited Rome in the company of Brunelleschi and drew inspiration from the classical atmosphere without losing any of his own individual dramatic force. In 1445 he went to Padua, where he introduced the new idiom of the Tuscan Renaissance, only returning to Florence in 1452 to start work on the two dramatic pulpits for San Lorenzo, which were completed after his death by one of his pupils. Recent research into his work in the graphic field has revealed that here too he was a great innovator.

Paolo di Dono, known as Paolo Uccello (Florence 1397–1475). Having formed his style under the influence of Ghiberti in the late Gothic manner, Paolo then began experimenting in the field of perspective, following the principles of Brunelleschi. In 1425 he was called to Venice, where he worked for five years on the mosaics of St Marks. His next assignment was in Santa Maria del Fiore in Florence, a city in which he finally came under the patronage of the Medici family, for whom, some time after 1450, he painted his three famous 'Battles'. His graphic work, which was outstanding, covers every type of art-form from portraits to perspective sketches.

Benozzo di Lese, known as Benozzo Gozzoli (Florence 1420–Pistoia 1497). A pupil of Fra Angelico, Gozzoli later turned to painting contemporary scenes in large frescoes in the decorative International Gothic style. His masterpiece, which he executed in 1459, is in the Chapel of the Palazzo Medici in Florence and includes his famous *Journey of the Magi*, in which every face is a recognizable portrait of members of the Medici and other families connected with them. Gozzoli's tendency to depict real subjects meant that many of his remarkable pictures were virtually cleverly assembled portraits, involving a high degree of technical skill and draughtsmanship.

Antonio Benci, known as Pollaiolo (Florence *c.* 1426–Rome 1498). A sculptor, painter and goldsmith, Pollaiolo was influenced by Donatello and Andrea del Castagno, the latter's style being clearly evident in his animated linear draughtsmanship. A few examples of his drawings, most of which are rather small, can be seen in the Uffizi Gallery, Florence and in the National Gallery, London. His delineation of human features, whether the portraits were painted, sculpted or drawn, derived from his confident skill as a goldsmith.

Sandro Filipepi, known as Botticelli (Florence 1444–1510). The early works of Botticelli, which began to make his name while he was still being influenced by the 'functional' linearity of Pollaiolo and Verrocchio, left no doubt that here indeed was a master of outstanding graphic skill. From his very first Florentine works, he displayed an exquisitely decorative quality which reached its peak when, in about 1485, he painted for the Palazzo Medici what were to be his two most famous pictures, the *Birth of Venus* and *Primavera*. A few years later, probably in the 1490s, he completed his graphic masterpiece. This was a series of illustrative outline drawings for Dante's *Divine Comedy*, now among the most highly prized exhibits in the Kupferstichkabinett, Berlin. In later life, Botticelli was influenced by the preaching of Savonarola and restricted himself only to painting subjects with a strongly pietistic content, as though he were trying to refute his responsibility for the wonderful creatures he had created in a happier period of his life, when it had been enough for him to celebrate Beauty for its own sake.

Andrea di Cione, known as Verrocchio (Florence 1436–Venice 1488). Although primarily a sculptor, Verrocchio was also a painter and goldsmith. Most of his work was executed in Florence, but in 1479 he moved to Venice to undertake the equestrian monument of Bartolommeo Colleoni. Having completed all the preliminary work, he died before the statue had been cast. He was an outstanding draughtsman, especially as a portraitist, and imbued his drawings with a sense of volume by a complex use of chiaroscuro. He counted among his pupils Botticelli, Leonardo da Vinci and Perugino.

Filippino Lippi (Prato 1457–Florence 1504). Having completed the fresco cycle begun by Masaccio in the Brancacci Chapel of the church of Santa Maria del Carmine in Florence, Filippino Lippi worked in Rome

from 1488 to 1493. He then returned to Florence, where he specialized in painting altars in a rather elaborate style, and in 1502 executed the frescoes in the Strozzi Chapel in the church of Santa Maria Novella. A great many sheets of his graphic studies are extant, the drawings highlighted with particularly limpid – if rather affected – brushwork.

Domenico Bigordi, known as Domenico Ghirlandaio (Florence 1449–94). A prolific illustrator of Florence as it was at the time of that great Medici figure, Lorenzo the Magnificent, Ghirlandaio achieved his real masterpiece in the frescoes painted in the 1490s for the Tornabuoni family in the main chapel of the Florentine church of Santa Maria Novella. His training under the guidance of Fra Filippo Lippi – the father of Filippino – is apparent in his many folios, but particularly clear in the preliminary sketches for portraits, in which his outstanding painterly technique seems to compete with contemporary Flemish work represented in Florence by the *Portinari Triptych* of Hugo van der Goes.

Lorenzo di Credi (Florence 1459–1537). Having first been an assistant of Verrocchio, Lorenzo subsequently came under the influence of Perugino and Leonardo da Vinci, and was deeply involved in the prolific production of sacred works, especially in Tuscany. His numerous drawings show that he had a particularly sensitive approach to drawing from life, especially as a portraitist – a skill which seems to have derived largely from Verrocchio himself.

Pietro Vannucci, known as Perugino (Città della Pieve *c.* 1448–Fontignano 1524). Perugino, the leading Umbrian painter of the early Renaissance, may well have been a disciple of Verrocchio and was certainly influenced by Piero della Francesca in Urbino. In 1478 he went to Rome to play his part in painting the frescoes in the Sistine Chapel, in which he was involved for several years. Returning to Perugia, he was engaged from 1498 to 1500 in executing the frescoes in the Collegio del Cambio, where Raphael worked under him as his pupil. Among the later works of Perugino is his *Struggle between Love and Chastity*, which he produced for one of Isabella d'Este's private rooms, known as her *studiolo*, and which is now in the Louvre. Only a few sheets of Perugino's drawings are extant.

Luca Signorelli (Cortona *c.* 1450–1523). A pupil of Piero della Francesca, Signorelli was particularly influenced by sculptural styles in the tradition of Pollaiolo. Having completed his frescoes in the Casa Santa at Loreto in 1479, he went to work on the frescoes in the Sistine Chapel from 1481 to 1482. Between 1499 and 1502 he was in Orvieto to complete his masterpiece – the frescoes begun in the Cathedral more than fifty years earlier by Fra Angelico – based on stories from the Bible. Signorelli, a prolific draughtsman, handled the technique of chiaroscuro in a way that was to serve as an example to Michelangelo a quarter of a century or so later.

Jacopo Bellini (Venice 1396?–1470?). Despite the influence of the late Gothic art of Gentile da Fabriano, Bellini is regarded as the most important painter in the transition period leading up to the arrival of the Renaissance in Venice. He probably gained experience in Florence from 1423 on, but later moved to Verona (1436), Venice (1437), and Ferrara (1441). In 1460 Jacopo and his two sons, Gentile and Giovanni – also painters – were in Padua to paint the Gattamelata al Santo Chapel, which unfortunately no longer exists. Although most of his works on canvas and in fresco have been lost, evidence of his masterly touch can still be seen in two books of drawings, now in the Louvre and the British Museum, which were probably intended for use in the family workshop.

Andrea Mantegna (Isle of Cartura 1431–Mantua 1506). Having spent his formative years in a mid fifteenth-century Paduan workshop with Donatello and various Tuscan painters who remained there only briefly, for example Fra Filippo Lippi, Paolo Uccello and Andrea del Castagno, Mantegna assumed the role of chief advocate of the new Renaissance styles in Northern Italy. Between 1448 and 1455 he was working on the frescoes for the Ovetari Chapel in the church of the Eremitani in Padua, most of which was destroyed in 1944. From there he went to Verona and thence to Mantua, where he was appointed Court Painter to the Gonzaga family, a position he held until his death. From 1471 to 1474 he worked on what was to be his masterpiece, the Camera degli Sposi in the Ducal Palace, which records in frescoes the glories of the Gonzaga dukes. A fine engraver, Mantegna also left a great many pen drawings which were used as patterns by his contemporaries, Gentile and

Giovanni Bellini, by the younger generation of Emilian artists and even by Dürer.

Ercole de' Roberti (Ferrara *c.* 1450–*c.* 1496). The Mantegnesque style of painting greatly influenced de' Roberti through his association with the Mantuan painter's two distinguished pupils, Cosmé (Cosimo) Tura and Francesco del Cossa, of whom he was virtually the last follower. He executed one of the months (September) in a cycle of frescoes in the Palazzo di Schifanoia in Ferrara, then collaborated with Cossa in Bologna on the *Griffoni Polyptych* in the church of San Petronio (no longer extant). The later works of de' Roberti show a certain Venetian influence in an increased transparency of colour, seen, for example, on the large Brera altarpiece. His somewhat cubiform and vigorous style suggests considerable graphic preparation.

Marco Zoppo (Cento 1433–Venice 1478). On the advice of Donatello and of the 'impresario' Francesco Squarcione, Zoppo detached himself from the cultural atmosphere of Andrea Mantegna and remained with Squarcione until 1455, when he went to work in Bologna and Venice. The few drawings of his that remain to us show him to have kept within the narrow boundaries of the Mantegna style of chiaroscuro and plasticity.

Giovanni Bellini (Venice *c.* 1430–1516). The leading figure in the early Renaissance school of painting in Venice, as a young man Giovanni Bellini was strongly influenced by Andrea Mantegna. In his later life, however, he concentrated more on developing colouristic effects which became an increasingly vital aspect of his work. He always kept abreast of the times and up to date with new ideas and styles. The main milestones of his progressive development can be seen reflected in some famous altars: San Zanipolo (*c.* 1464), Pesaro (*c.* 1470), San Giobbe (*c.* 1478), Frari (1488), San Zaccaria (1505) and San Giovanni Crisostomo (1513). Giovanni thus created the bridge that linked the beginnings of the 'Paduan' Renaissance with the maturity of the early sixteenth century, when he was to have in his workshop such pupils as Giorgione and Titian. There are not more than about ten pen drawings which can be attributed with any certainty to Giovanni, but these show a strong Mantegnesque quality in their graphic style, in which the use of chiaroscuro is strongly emphasized.

Gentile Bellini (Venice 1429–1507). The son of Jacopo and elder brother of Giovanni, Gentile Bellini remained in charge of the workshop until he died. He concentrated mainly on painting large canvases, among which are the cycles for the Scuola di San Marco (1466–85), the Doge's Palace (1474 onwards), and the Scuola di San Giovanni Evangelista (1496–1500). Only the paintings in the last two have survived the years and are today in various art galleries as evidence of his faithful chronicling of the real life of the city. Gentile Bellini was a very well-known portraitist and in 1479 the Doge sent him to Constantinople in the service of Sultan Mahomet II. While there, he made a great many drawings from life of Turkish costumes, and these were to form the best part of his rather limited range of graphic works, together perhaps with a few sheets in his father's sketchbooks now in the Louvre and British Museum.

Vittore Carpaccio (Venice c. 1465–c. 1526). From his youthful contact with the school of Antonello, Carpaccio learnt how to use crystalline colour. His narrative realism, however, probably derived from a visit to Ferrara, where he would have seen works by painters who knew at first hand the art of Rogier van der Weyden and the spatial qualities of Piero della Francesca. Carpaccio devoted most of his time to painting large canvases, many of which were for some of the *Scuole* ('Confraternities'). Between 1490 and 1500 he executed a cycle of paintings illustrating the legend of St Ursula for the Scuola di Sant'Orsola and now in the Galleria dell' Accademia; in about 1504 he produced a painting for the Scuola degli Albanesi while between 1502 and 1507 also working on five cycles of paintings for the Scuola di San Giorgio degli Schiavoni; and from 1512 to 1520 he worked on paintings for Santo Stefano. Thereafter he went to work in Istria, where probably he died. He was a prolific draughtsman and would prepare a painting by first making sketches, both of the completely visualized work and of details of it, in various techniques, such as pen or brush with chiaroscuro effects on tinted paper.

Jan van Eyck (Maastricht c. 1390–Bruges 1441). The initiator of the great fifteenth-century Flemish school, Jan van Eyck, first started to gain recognition in 1420 with his work as a miniaturist on the manuscript, *Les Très Belles Heures*, known in English as the *Hours of Turin*. He then became Court Painter to Philip the Good of Burgundy and continued in the Duke's employ even after his return to Bruges, where he remained until his death. His well-known paintings, which include the *Adoration of the Lamb*, finished in 1432 as part of the Ghent altarpiece, and the *Arnolfini Marriage*, display a spiritual world of profound inspiration combined with a constant sense of realistic values – the very bases, in fact, for the school that was to develop throughout the century. Jan van Eyck also perfected an oil-painting technique – as distinct from the traditional egg tempera – which was to remain a particular feature of the Northern European schools for some time to come.

Antonello da Messina (Messina c. 1430–79). Having received his training in the Angevin court of Naples, where the Flemish influence was strong, Antonello learnt how to use the new oil-painting technique – as opposed to egg tempera – and at the same time how to depict reality as it actually appears through the lens of the eye. He concentrated, therefore, on portraits and small religious paintings such as *St Jerome in His Study*, now in the National Gallery, London. He was, for a short time, in Venice, where he experimented with a new architectural concept while working on the San Cassiano altarpiece. The idea, based on the experience of Piero della Francesca, resulted in the interweaving of his own spatial concept with the colouristic effects of Bellini. This work, which occupied Antonello from 1475 to 1476, thus served as an invaluable model for the last generation of fifteenth-century Venetian artists, for example Vivarini, Cima, Carpaccio and Lotto.

Jean Fouquet (Tours c. 1425–c. 1480). Fouquet was travelling in Italy between 1444 and 1447 when he arrived in Naples. During his journey, he became acquainted with a number of artists who were strongly influenced by the Flemish school. Among those he met were Domenico Veneziano, Piero della Francesca and Fra Angelico, and they certainly had a decisive effect on his own expressive style. On returning to France, he concentrated for a while on miniatures, in particular the *Book of Hours* of Étienne Chevalier. In his Melun diptych, which is now divided between Antwerp and Berlin, he had clearly advanced beyond late Gothic – the style which he had inherited – and established new bases in the trends being set in the Renaissance in France. Only a few drawings by Fouquet exist and these are mostly portraits.

Rogier van der Weyden (Tournai c. 1400–Brussels 1464). A follower, in his early days, of Robert Campin and Jan van Eyck, van der Weyden subsequently developed the ability to express his feelings in a dramatic way. This was as a result of a visit to Italy in 1450, when he acquired a new approach to spatiality under the influence of Piero della Francesca. Some of his most expressive works are the *Descent from the Cross* (also known as the *Deposition*), dated about 1435 and now in the Prado, Madrid, and a number of portraits. The precision of line gives rise to the belief that careful graphic preparation must have preceded the work, but there are almost no known examples of such preliminary drawings in existence. From 1435 until his death, van der Weyden worked mainly as official painter to the city of Brussels.

Konrad Witz (Rottweil c. 1400–Basle c. 1445). Witz was probably the greatest German–Swiss painter of the early fifteenth century, the same time that Flemish painting was at its height. His work shows a certain Italian influence in his solid handling of volume and in a tendency towards an architectural treatment of composition in his altarpieces which have mostly been split up and dispersed. Among the places where his works can be seen are Basle, Geneva and Nuremberg. A few rare examples of his graphic work were used in the production of engravings for which, as the fifteenth century advanced, the city of Basle was to become a very important centre.

Hieronymus Bosch ('s Hertogenbosch c. 1450–1516). Bosch was the last of the fifteenth-century Flemish painters. The strongly symbolistic themes that he pursued were linked to a religious awareness as well as to the popular traditions of the Netherlands. Examples of a fantastic and grotesque universe, his best-known paintings, such as the *Garden of Earthly Delights*, now in the Prado, display either a surrealistic approach or, as in *Proverbs*, *The Seven Deadly Sins*, an allusive one. His figurative world is based entirely on dreams and on the unconscious mind – the very ingredients of Surrealism.

Donatello (Florence 1386–1466)
Young Man Crowned with Laurel
Pen and brown ink with grey watercolour;
$11\frac{1}{4} \times 8$ in. (286×202 mm.)
Provenance: Vasari; Gautron de Robien;
Crozat
Rennes, Musée des Beaux-Arts, inv. C3–2

A stylistic analysis of the graphic work of
Donatello in relation to that of Mantegna
and Bellini has recently been carried out.
The drawing reproduced here bears the
inscription 'Donatello', probably written in
by Vasari. In the clean, sharp lines of the
drawing, there is a close resemblance to the
modelling of the bas-reliefs on the High
Altar of the Santo in Padua. The stance of
the young man is reminiscent of the bronze
David by Donatello in Berlin.
Bibliography: Degenhart-Schmitt, 1968,
no. 265

Paolo Uccello (Florence 1397–1475)
Profile of a Man in a Turban
Bistre and watercolour on white paper
against a brown background; $11\frac{3}{8} \times 7\frac{7}{8}$ in.
(290×200 mm.)
Florence, Galleria degli Uffizi, inv. 28 E

This vigorous drawing, which is remarkable
for the clearly defined character of the sitter,
is stylistically similar to several frescoed
heads in the Chiostro Verde of Santa Maria
Novella in Florence, the first attributable
work by Paolo Uccello and executed about
1431. As well as emphasizing the profile, the
artist has sought to introduce a volumetric
quality which was to be a strong feature of
his more mature artistic expression.
Bibliography: Berenson, 1961, no. 2766

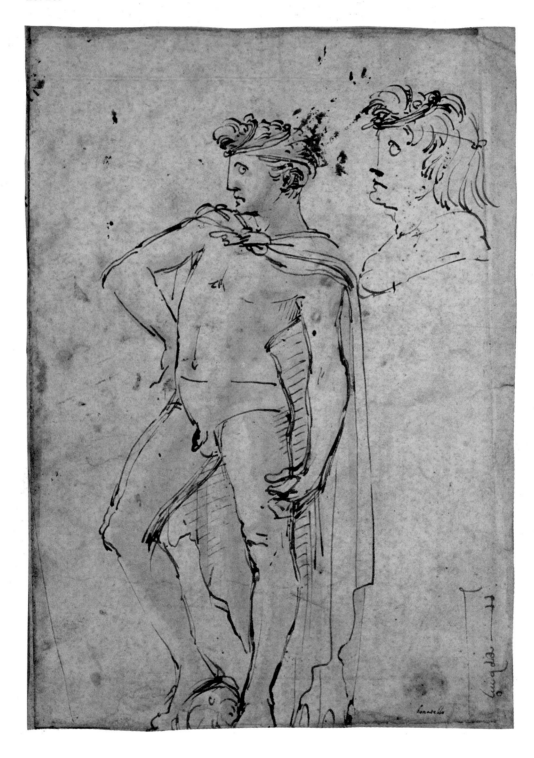

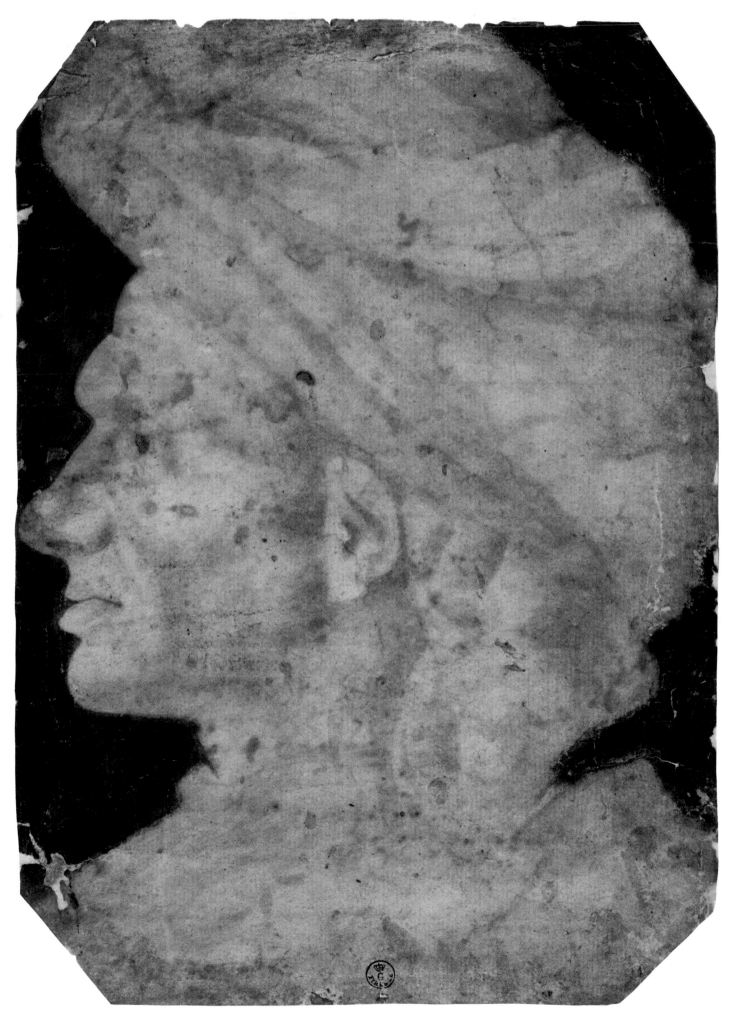

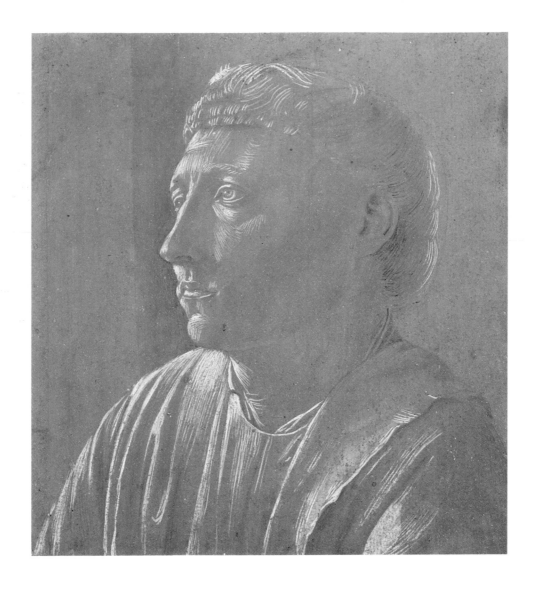

Benozzo Gozzoli (Florence 1420–Pistoia 1497)
Head of San Lorenzo (?)
Silverpoint heightened with opaque white-lead pigment on prepared orange-tinted paper; $7\frac{1}{8} \times 6\frac{1}{2}$ in. (181 × 167 mm.)
Windsor Castle, Royal Library, inv. 12812 (*r*)

The most remarkable quality of this head is the technique that produces the effects of light by means of the fine metalpoint lines on the prepared orange surface. On the *verso* of the sheet, the presence of several figures associated with the fresco *St Lawrence Receiving the Treasures of the Church and Distributing them to the Poor* (*c.* 1447–8), in the Niccolò V Chapel in the Vatican, gives rise to the assumption that this drawing, on the *recto*, may have been in preparation for another character in the series which was subsequently not included.
Bibliography: Popham-Wilde, 1949, no. 10; Berenson, 1961, no. 163

Antonio Pollaiolo (Florence 1426–Rome 1498)
Horseman and Fallen Enemy
Pen and bistre on tinted paper; $8\frac{1}{8} \times 8\frac{1}{2}$ in. (208 × 217 mm.)
Provenance: Vasari
Munich, Staatliche Graphische Sammlung, inv. 1908: 168

This drawing, although essentially linear in character, assumes a certain volume because it stands out against the brown background. In his *Lives of the Artists*, Vasari says of Pollaiolo: 'After his death a model was discovered for an equestrian statue of Francesco Sforza, Duke of Milan, which he did for Ludovico Sforza. There are two versions of this design in our book: in the one Verona is represented beneath, in the other the figure is in full armour and on a pedestal full of battle scenes he makes the horse tread upon an armed man. I have not yet been able to discover why these designs were not carried out.' The drawing reproduced here corresponds to the second version and could well have served as an exemplar for the well-known drawings by Leonardo da Vinci for the same monument, which never, in fact, materialized.
Bibliography: Berenson, 1961, no. 1908; Degenhart-Schmitt, 1967, no. 60; Ettlinger, 1978, cat. no. 33

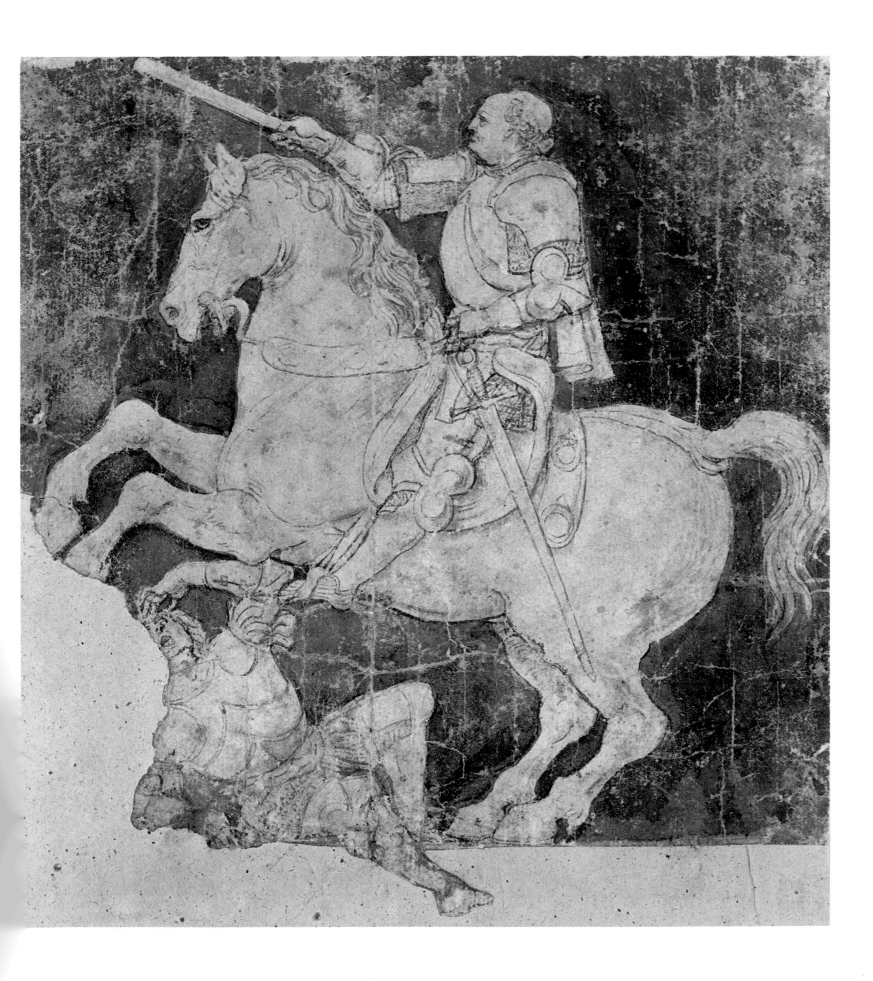

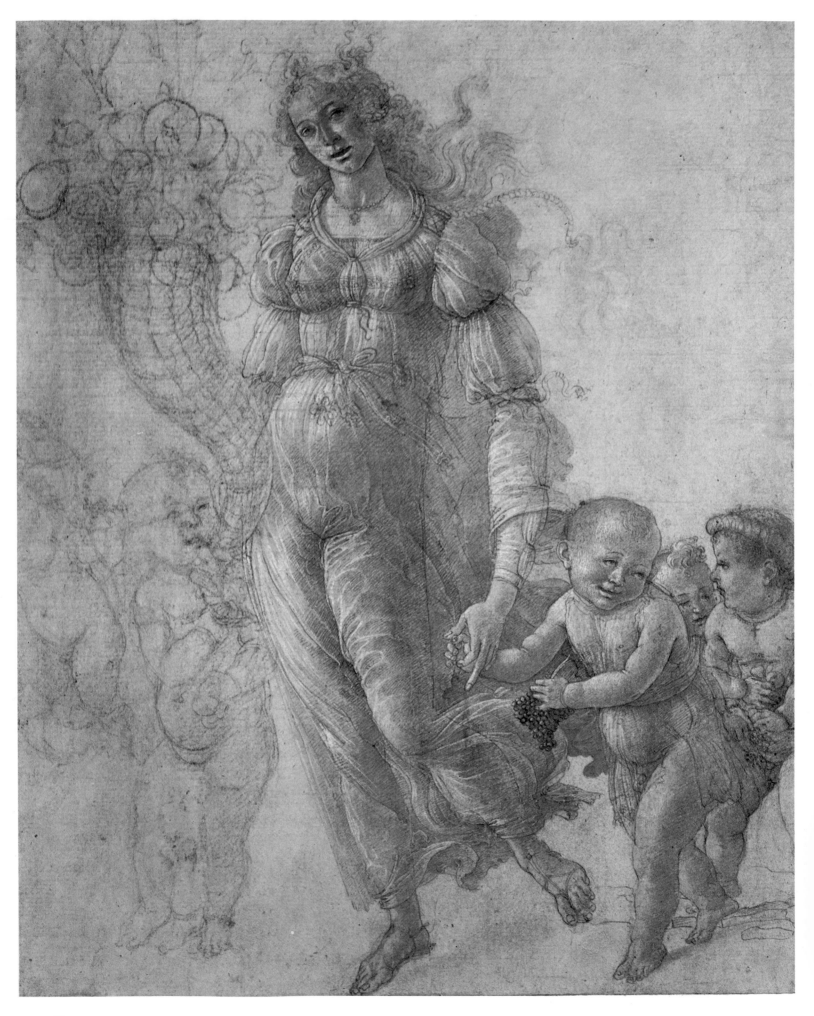

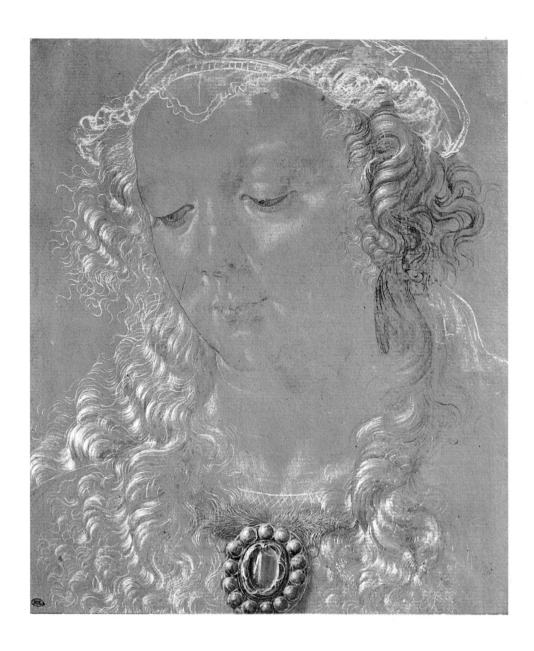

Sandro Botticelli (Florence 1444–1510)
Abundance or *Autumn*
Pen and brown ink with brown watercolour
wash, heightened with white, over black
chalk outlines on prepared paper tinted
pink; $12\frac{5}{8} \times 10$ in. (317 × 253 mm.)
Provenance: Vasari (?); Rogers; Morris
Moore; Robinson; Malcolm
London, British Museum, inv.
1895–9–15–447

Its close stylistic resemblance to the frescoes
(1481) in the Sistine Chapel enables this
drawing – which represents an allegory on
either Abundance or Autumn – to be placed
in Botticelli's Roman period or in the
immediately following years. The technique
is extremely elegant, producing soft
chiaroscuro effects through the calculated
over-laying of pencil, pen and brush on pink
paper.
Bibliography: Popham-Pouncey, 1950, no.
24; Bertini, 1953, p. 9; Berenson, 1961,
no. 567

Andrea del Verrocchio (Florence 1488)
Head of a Woman
Metalpoint heightened with grey and white
on prepared paper tinted pinkish-orange;
$10\frac{1}{2} \times 9\frac{1}{8}$ in. (267 × 233 mm.)
Provenance: Jabach; *Cabinet du Roi* (1671)
Paris, Musée National du Louvre, inv. 18965

Vasari in his *Lives of the Artists* states that
he possessed several drawings by Verrocchio
'done with much patience and a great deal of
wisdom, amongst which are some heads of
women with all the charm of feminity and
elaborate hairstyles whose beauty Leonardo
always imitated'. Such a description may
well be applied to this study with its elegance
of metalpoint line and in the luminous
delicacy of the touches of white on the tinted
paper.
Bibliography: Berenson, 1961, no. 1070c;
Bacou-Viatte, 1968, no. 8; Passavant, 1969,
App. 39

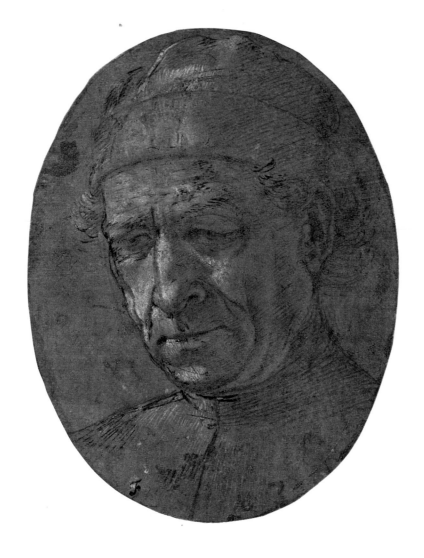

Filippino Lippi (Prato 1457–Florence 1504)
Head of an Old Man
Metalpoint heightened with white on prepared slate-grey paper; $7\frac{1}{2} \times 5\frac{1}{2}$ in. (190 × 140 mm.) oval
Provenance: Vasari (?); Flinck
Chatsworth, Devonshire Collection, inv. 705

The traditional identification of this head with the portrait of the sculptor Mino da Fiesole, who died in 1484, is due to the fact that Vasari – in whose collection the drawing probably was – reproduced it as such in the 1568 edition of *Lives of the Artists*. At one time it was believed to be by Lorenzo di Credi, but it has since been authoritatively associated with the style of Filippino Lippi.
Bibliography: Berenson, 1961, no. 1274B; Wragg, 1962-3, no. 35

Domenico Ghirlandaio (Florence 1449–94)
Head of an Old Man
Silverpoint highlighted with opaque white-lead pigment on prepared pink paper; $12\frac{1}{2} \times 11\frac{5}{8}$ in. (320 × 295 mm.)
Provenance: Vasari; Crozat; Tessin
Stockholm, Nationalmuseum, no. 1/1863

Vasari, in whose collection this drawing once was, is responsible for having reduced the sheet to an oval and for its insertion into a false frame in the Mannerist style, surrounded by four female figures. The narrative realism and expressive geniality of the works of Ghirlandaio – a painter of the rich Florentine bourgeoisie – are typified in this drawing.
Bibliography: Sirén, 1902, p. 26; Lauts, 1943, no. 112; Bjurström, 1969, no. 4

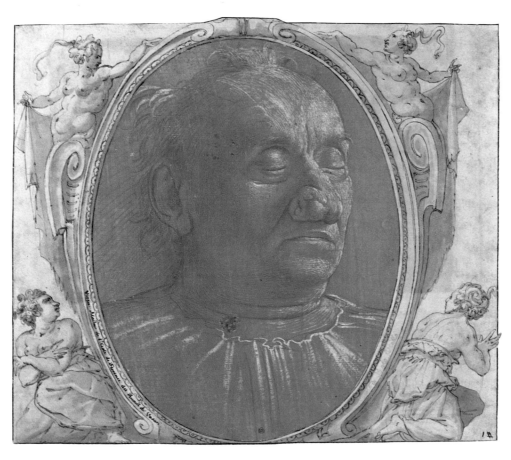

Lorenzo di Credi (Florence 1459–1537)
Head of a Woman
Silverpoint highlighted with opaque white-lead pigment on cream-coloured paper; $11\frac{3}{4}$ in. (230 mm.) in diameter.
Provenance: Wellesley; acquired in 1866
Dublin, National Gallery of Ireland, inv. 2069

A pupil of Verrocchio, aware of the naturalism of Leonardo and the elegance of Perugino, Lorenzo di Credi was constantly searching to achieve the ideal in charm and grace. In this *Head of a Woman*, the influence of Leonardo da Vinci is clearly discernible. There is the softness of the *sfumato* lines, the delicate and shapely technique of the handling of the silverpoint, and the subtle highlighting with white bodycolour in which Lorenzo shows himself indeed to be that 'diligent and fine draughtsman' that Vasari had already described.
Bibliography: J. Byam Shaw, 1928, p. 6; Berenson, 1961, no. 672 A; White, 1967, no. 4

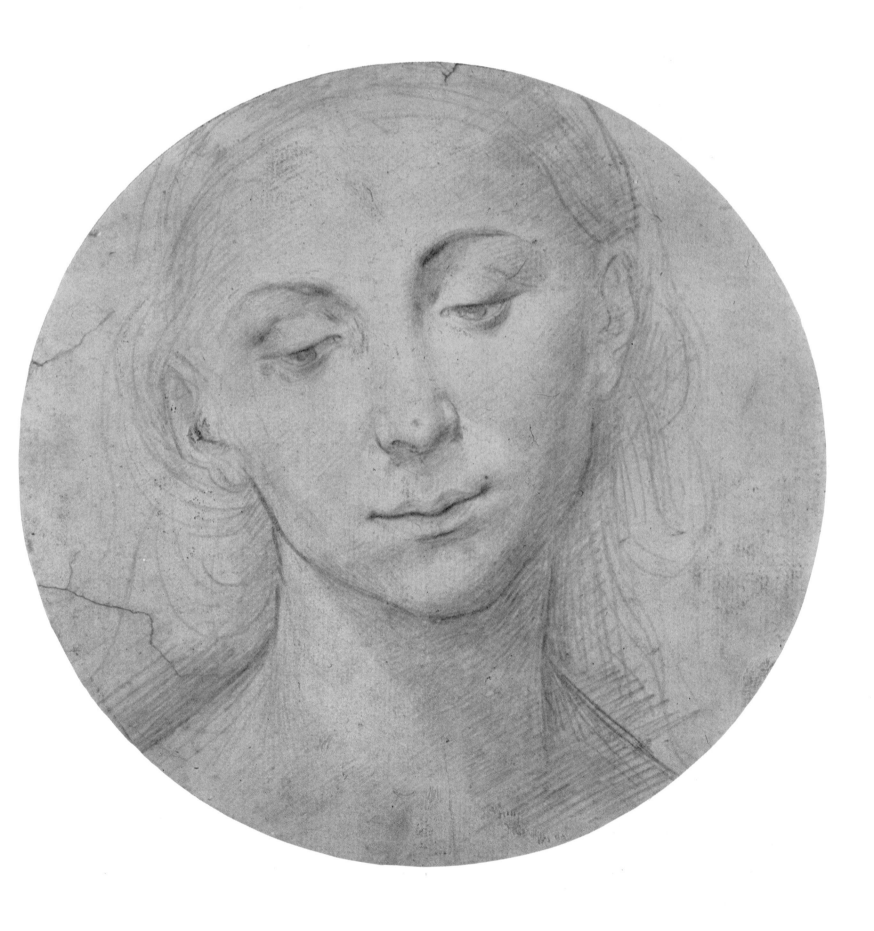

85

Pietro Perugino (Città della Pieve, *c.*
1448–Fontignano, 1524)
Studies of Men and of a Madonna
Silverpoint heightened with white-lead
pigment on yellowish-grey paper; 11 × 8 in.
(279 × 198 mm.)
Düsseldorf, Kunstmuseum, inv. 9 (*r*)

This exceptionally delicate sheet of studies
was probably in preparation for an
'Adoration of the Magi', and belongs to
Perugino's earliest period. The plasticity of
the figures is given an ethereal quality by the
luminous fluidity of the silverpoint lines,
with touches of light introduced by the
subtle use of opaque white-lead pigment.
Bibliography: Fischel, 1917, I, p. 15; Budde,
1930, no. 9; Grassi, 1956, no. 103

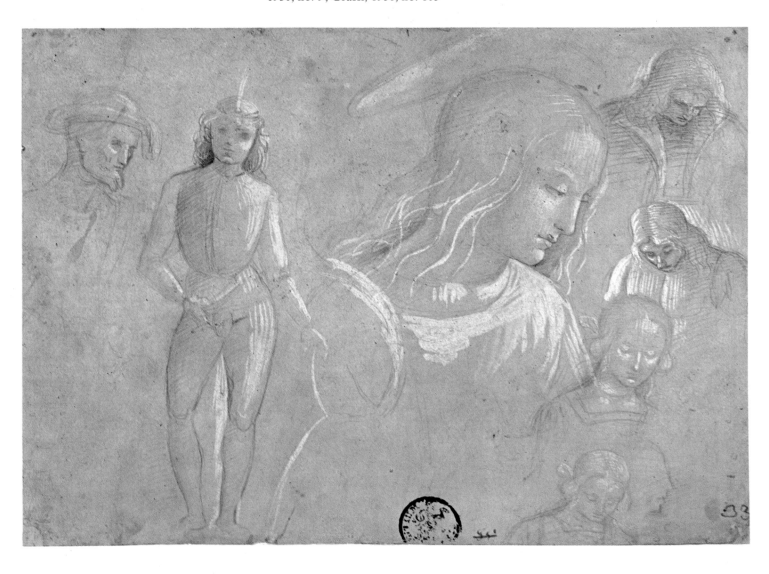

Luca Signorelli (Cortona,
1450–1523)
Hercules and Antaeus
Grey chalk; $11 \times 6\frac{1}{2}$ in.
(283 × 163 mm.)
Provenance: George III
Windsor Castle, Royal
Library, inv. 12805.

Luca Signorelli was
particularly concerned with
plasticity – in which he was
greatly influenced by the
Pollaiolo brothers – and
with the technique of
conveying a sense of
volume. This strong,
dynamic drawing in
charcoal, his favourite
medium, demonstrates this
clearly in its synthesis of a
Renaissance version of the
classical theme of the
struggle between Hercules
and the giant Antaeus.
Bibliography: Berenson,
1932, p. 177; Popham-
Wilde, 1949, no. 29;
Berenson, 1961, no. 2509 J

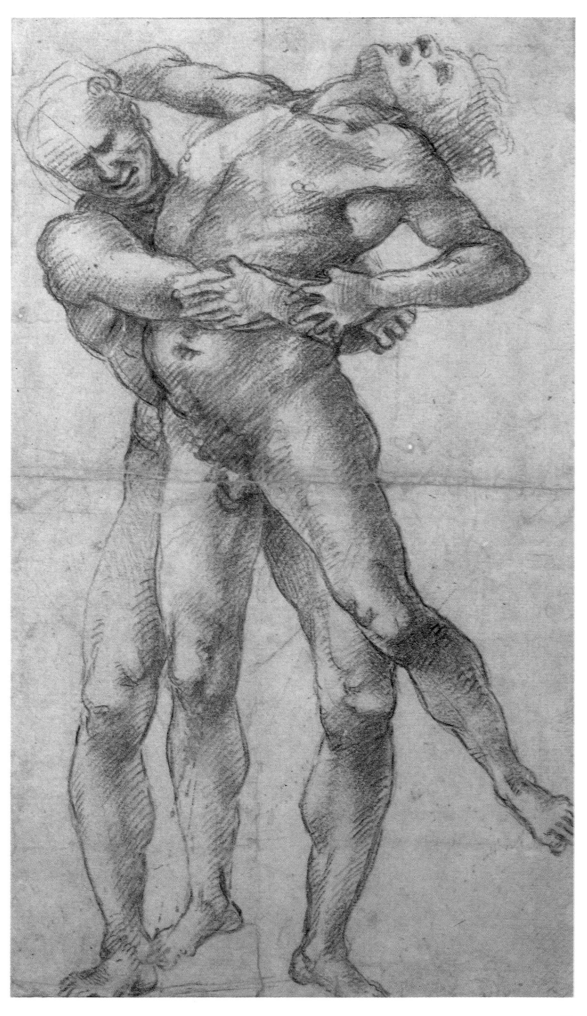

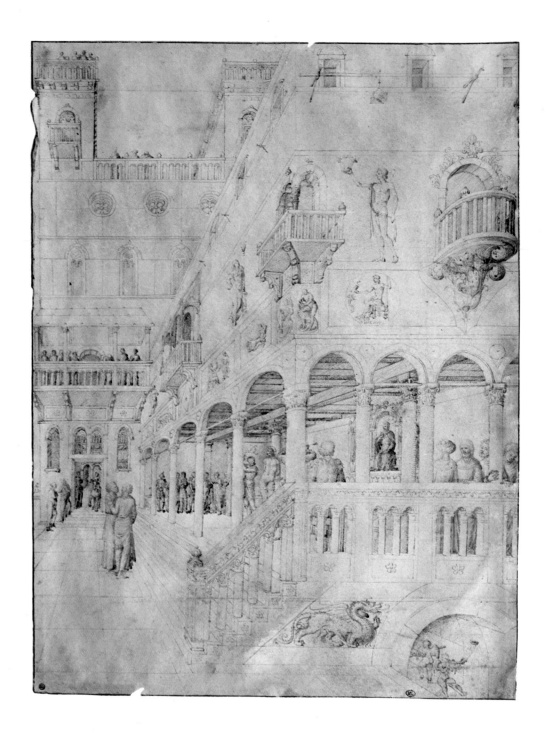

Jacopo Bellini (Venice *c.* 1396–*c.* 1470)
The Flagellation of Christ
Pen and reddish-brown ink on parchment;
15½ × 11½ in. (394 × 290 mm.)
Provenance: de la Salle
Paris, Musée National du Louvre, inv. 426

Here the biblical subject is relegated to a
subordinate role in order to draw the
viewer's attention to the architectural and
spatial qualities of an imposing palace (the
patron's?) with its richly decorated statues
and bas-reliefs. This sheet was detached, at
some unknown date, from one of Bellini's
Sketchbooks (*c.* 1450) in the Louvre. These
books of drawings by Jacopo are typical of
what was an integral part of the equipment
of a master artist's *bottega* ('workshop').
They were used both for instructive purposes
and in the preparation of commissioned
work, much like the 'pattern' books of the
Middle Ages.
Bibliography: Goloubew, 1908–12, II, pl. C;
Ricci, 1908, no. 29, pl. 31; Tietze, 1944,
no. 367

Andrea Mantegna (Isola di Cartura
1431–Mantua 1506)
Mars, Venus (?) and Diana
Pen, brown ink and brown watercolour with
touches of white and colour; 14½ × 12½ in.
(364 × 317 mm.)
Provenance: Strange; Metz; Heywood
Hawkins
London, British Museum, inv. 1861–8–10–2

The revival of interest in Antiquity, so
clearly displayed by Mantegna in his
completed works, is also apparent in this
drawing, which has the plasticity and
sculptural character of a classical bas-relief.
The mythological subject and stylistic
characterization of the figures suggest that
the drawing was executed during the 1490s,
in preparation for the painting of *Parnassus*
(now in the Louvre) for the *'studiolo'* of
Isabella d'Este.
Bibliography: Popham-Pouncey, 1950, no.
156; Tietze Conrat, 1955, p. 226

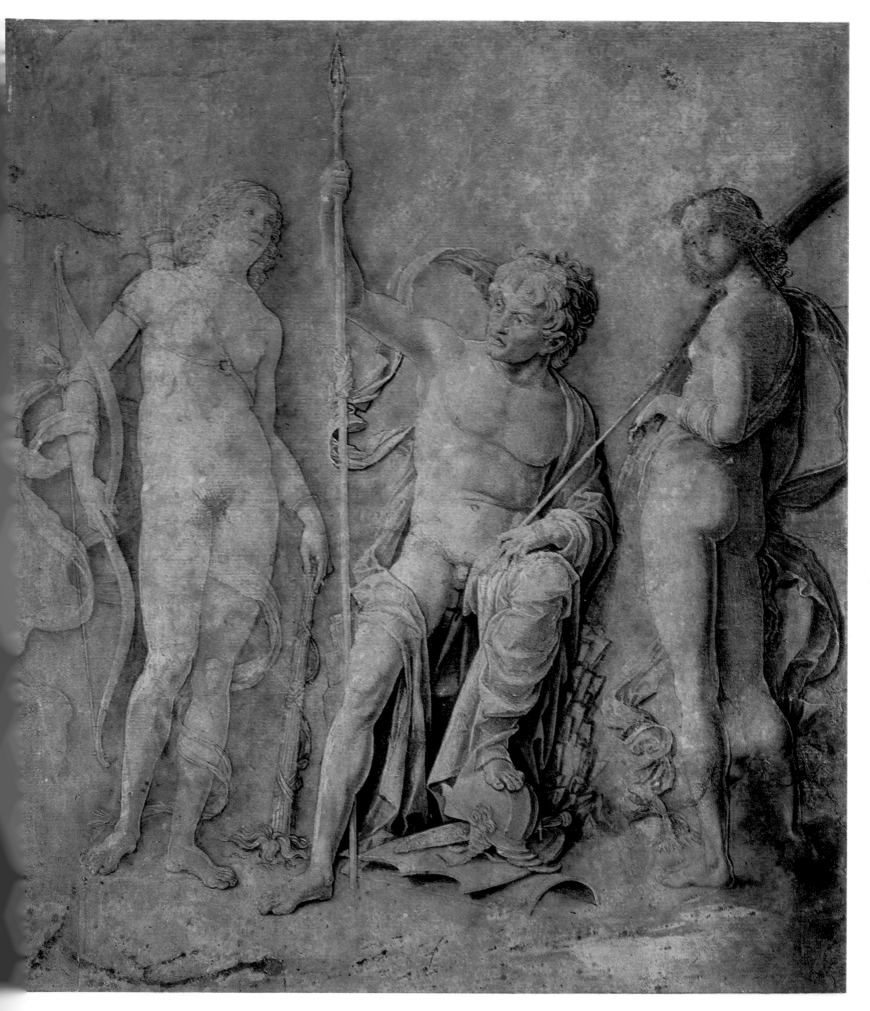

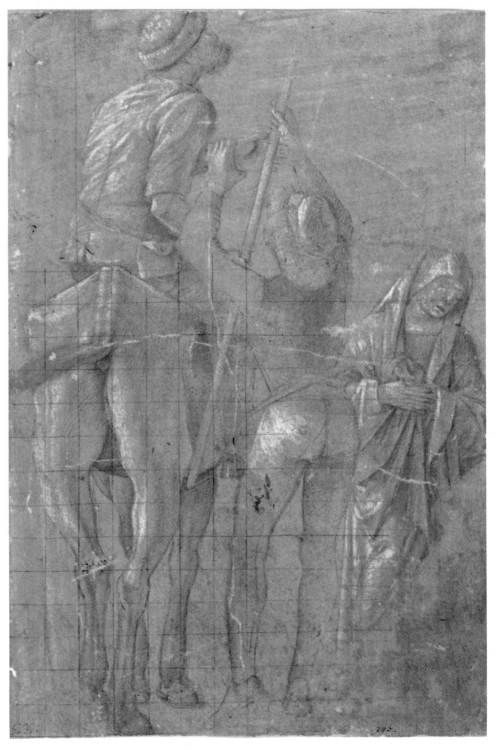

Ercole de' Roberti (?) (Ferrara *c.* 1450–96)
Studies for a Crucifixion
Pen and brown wash heightened with white
on grey-tinted paper; 9½ × 6⅜ in.
(240 × 161 mm.)
Munich, Staatliche Graphische Sammlung,
inv. 2144

By comparing it with similar works by the
same artist and various copies, this drawing
has been identified as being a preliminary
drawing for part of the lost *Crucifixion* in
the Garganelli Chapel of San Pietro in
Bologna, frescoed by de' Roberti between
1480 and 1486. Its graphic qualities are
remarkable and certainly bear a close
resemblance to de' Roberti's style in the way
that, both pictorially and constructively, the
plasticity of form overrides the linearity.
This drawing is in all probability a 'record'
of the work carried out, it being customary
for such records to be kept of commissions
executed by an artist's workshop.
Bibliography: Ruhmer, 1962, pp. 241–3;
Degenhart-Schmitt, 1967, no. 66

Marco Zoppo (Cento 1433–Venice 1478)
Six Studies of the Madonna and Child
Pen, brown ink and watercolour on pink-
tinted paper; 11½ × 7¾ in. (286 × 196 mm.)
Munich, Staatliche Graphische Sammlung,
inv. 2802 (*r*)

This sheet, which contains six pen-drawings
heavily hatched in the style of Mantegna,
probably comes from a sketchbook, where it
was quite usual to find several variations on
the theme of the Madonna and Child. The
setting of a richly decorated niche is
characteristic of Zoppo, a tradition beloved
in Mantua by Squarcione and in Ferrara by
Tura.
Bibliography: Degenhart-Schmitt, 1967, no.
85; Armstrong, 1976, no. D13

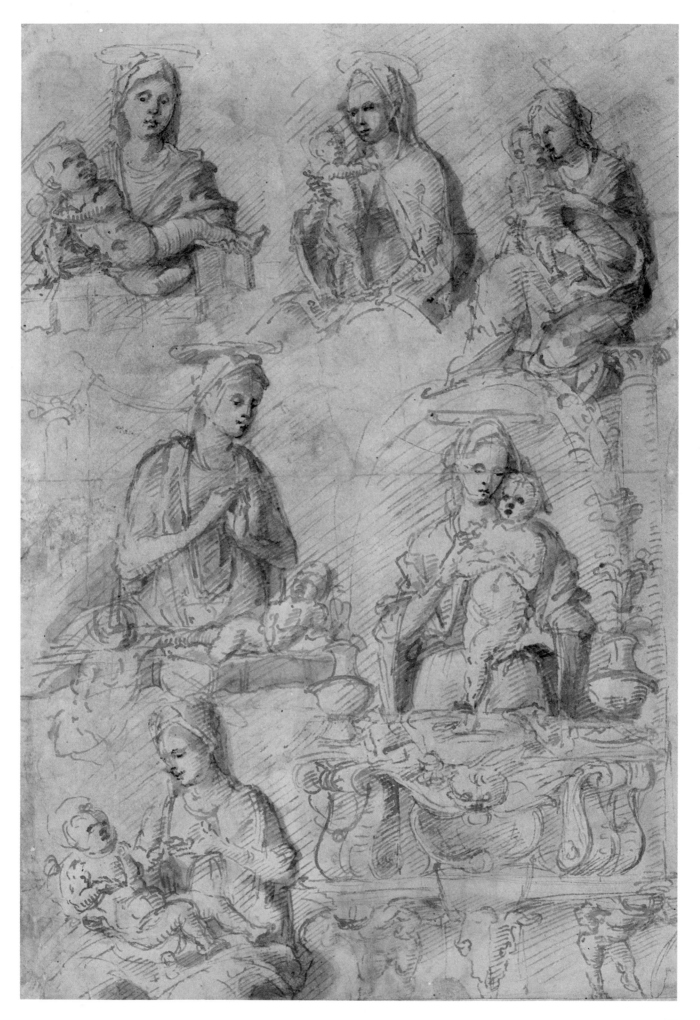

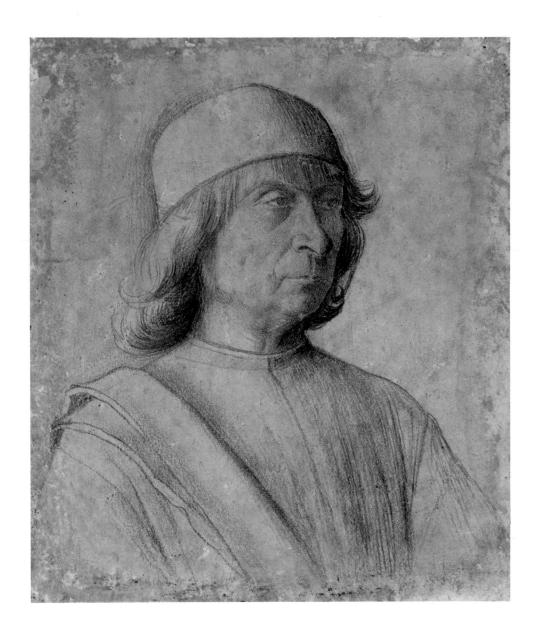

Giovanni Bellini (Venice *c.* 1430–1516)
Portrait of Gentile Bellini
Black pencil on mottled pale yellow paper;
9 × 7⅝ in. (230 × 194 mm.)
Provenance: von Beckerath; acquired in
1902
Berlin, Kupferstichkabinett, inv. KdZ 5170

A similar face also appears in the *Corpus
Christi Procession* in the Gallerie
dell'Accademia, Venice, painted by Gentile
Bellini himself in 1496, and is almost
certainly the same person. The handling of
the drawing is soft and painterly, in contrast
to the more intricate, incisive lines used by
Giovanni in other drawings such as his *Doge
Leonardo Loredan*, painted about 1501 and
now in the National Gallery, London. There
is certainly a resemblance, however, to a
portrait painted by Giovanni Bellini of his
brother about the same year, when Gentile
would have probably been in his early
seventies.
Bibliography: Tietze, 1944, no. A261;
Robertson, 1968, p. 110; Dreyer, 1979,
no. 13

Giovanni Bellini
Pietà
Pen and brown ink; 5⅛ × 7¼ in.
(130 × 183 mm.)
(cut irregularly)
Provenance: Vallardi; de la Salle; donated in
1878
Paris, Musée National du Louvre, inv. RF
436

The theme of the 'Pietà' recurs frequently in
both the graphic work and paintings of
Giovanni Bellini – one drawing each in the
Gallerie dell'Accademia, Venice, and the
Musée des Beaux-Arts, Rennes, and a
painting each in the Museo Correr, Venice,
and the Pinacoteca di Brera, Milan. In the
drawing reproduced here, the subject is
broadened considerably, the strongly defined
hatching emphasizing the qualities of pathos
and drama at the same time.
Bibliography: Tietze, 1944, no. 319; Bacou-
Viatte, 1968, no. 6; Robertson, 1968, p. 24

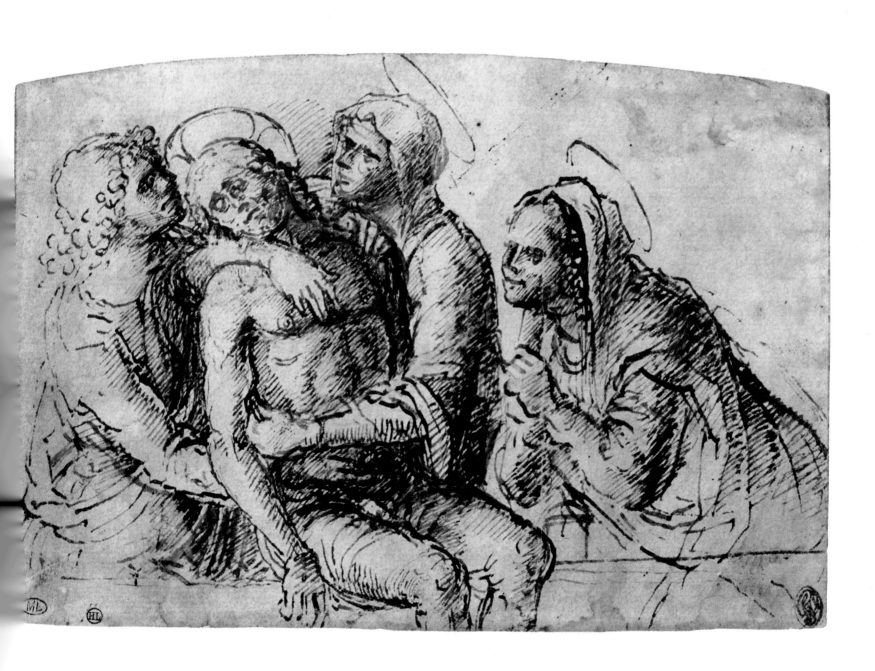

Gentile Bellini (Venice 1429–1507)
Procession in Campo San Lio
Pen and brown ink; $17\frac{1}{2} \times 23\frac{1}{4}$ in.
(442 × 591 mm.)
Florence, Galleria degli Uffizi, inv. 1293

The similarity of this drawing to the
Procession in Campo San Lio (Gallerie
dell'Accademia, Venice), painted by
Giovanni Mansueti for the *Cycle of the
Cross* in the Scuola di San Giovanni
Evangelista, gave rise in the past to the belief
that the study in the Uffizi was his work. It
is now known, however, that this series of
paintings was conceived and directed by
Gentile Bellini, into whose corpus of
drawings this sheet fits perfectly. It may well
have been an early working drawing of his
which was never completely finished.
Bibliography: Hadeln, 1925, p. 45; Tietze,
1944, no. 265

Vittore Carpaccio (Venice *c.* 1465–*c.* 1526)
Dream of St Ursula
Pen and brush in brown ink on pale yellow
paper; 4 × 4¾ in. (102 × 110 mm.)
Florence, Galleria degli Uffizi, inv. 1689F

More drawings by Carpaccio still survive
than by any other Venetian Renaissance
artist, and they include both studies of single
figures and whole compositions. The little
sketch reproduced here is a preliminary
drawing for the large painting of the *Dream
of St Ursula*, executed in about 1495 for the
Scuola di Sant'Orsola and now in the
Gallerie dell'Accademia, Venice. Even in its
rough state, there is a suggestion in the
drawing of how the relationship between
light and colour will be represented in the
painting.
Bibliography: Tietze, 1944, no. 604; Lauts,
1962, no. 11; Pignatti, 1972, pp. 11, 14, 18;
Muraro, 1977, p. 43

Vittore Carpaccio
Head of a Young Man
Black chalk, brush and brown ink
heightened with opaque white-lead pigment
on azure paper; 10½ × 7¾ in.
(265 × 187 mm.)
Provenance: Resta; Somers; Richardson
Guise
Oxford, Christ Church, inv. 0282

Experimentation in the tonal effects to be
achieved with a brush, highlighted in white
bodycolour on rather dark paper, is
characteristic of Carpaccio's graphic
technique during the second half of the
1490s – a period which coincided with a
similar phase being experienced by Albrecht
Dürer. This portrait of a young man, who is
usually assumed to be depicted in the
Ambassadors in the *Legend of St Ursula*
(now in the Gallerie dell'Accademia, Venice)
is generally regarded as one of the best
expressions of the artist's youthful period.
Bibliography: Tietze, 1944, no. 629; Lauts,
1962, no. 41; Byam Shaw, 1976, no. 710;
Muraro, 1977, p. 67

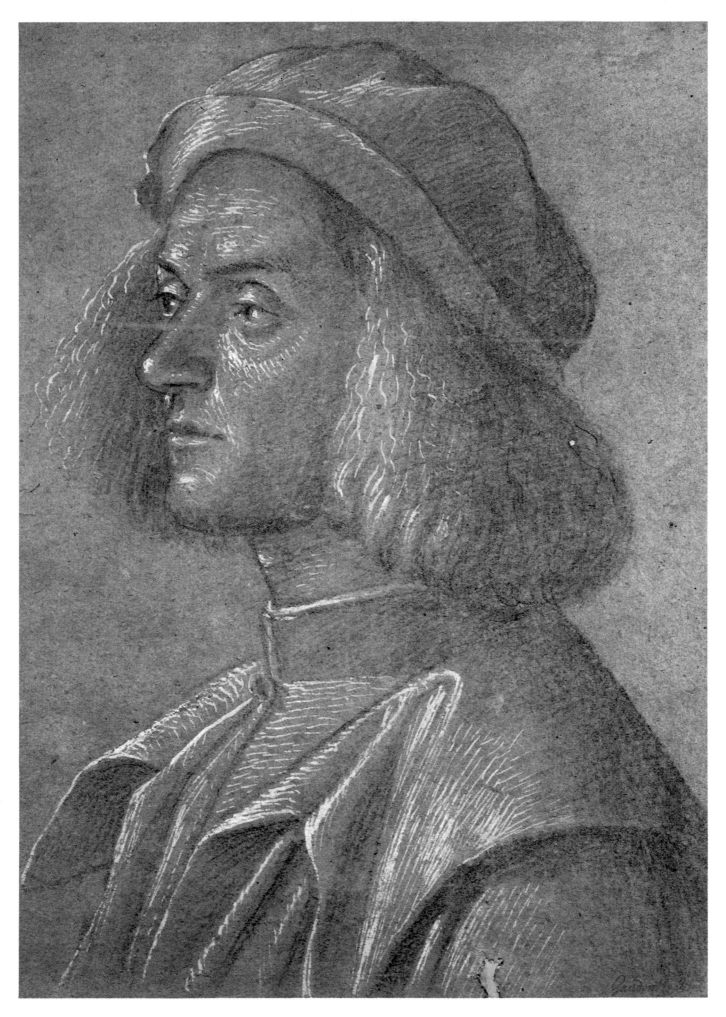

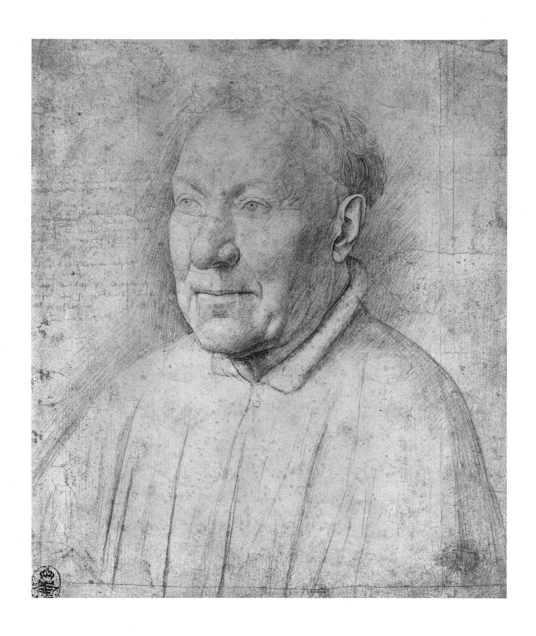

Jan van Eyck (Maastricht *c.*
1390–Bruges 1441)
Cardinal Nicola Albergati
Silverpoint on prepared paper tinted greyish-
white; 10⅝ × 7 in. (207 × 177 mm.)
Provenance: acquired in 1765
Dresden, Kupferstichkabinett

This study, a preliminary drawing for the
Portrait of Cardinal Albergati
(Kunsthistorisches Museum, Vienna), was
probably executed on the occasion of a visit
to Bruges by the Cardinal in December 1431.
There are some notes on the paper, written
by van Eyck himself in the Limburg dialect,
relating to the transformation of the drawing
into a painting. However, there is more truth
and individuality in the closely placed, fine
lines of the drawing than in the completed
picture.
Bibliography: Friedländer, 1967, p. 57

Antonello da Messina (Messina *c.* 1430–79)
Portrait of a Boy
Charcoal *sfumato* on brown paper;
13 × 10½ in. (330 × 269 mm.)
Provenance: Albert von Sachsen-Teschen
Vienna, Graphische Sammlung Albertina,
inv. 17611

The expressive vitality and balance of
construction make this study one of the best
examples of a drawn portrait within the
ambit of Venetian art in the early
Renaissance. Attribution to Antonello is
facilitated because of the quality of the light
and plasticity of line, both of which
characterize his style. The technique used in
this charcoal portrait closely resembles that
used in pictures of the 1480s, especially in
the *Portrait* in Berlin.
Bibliography: Stix-Fröhlich Bum, 1926,
no. 30; Benesch, 1964, no. 12; Koschatzky-
Oberhuber-Knab, 1971, no. 19

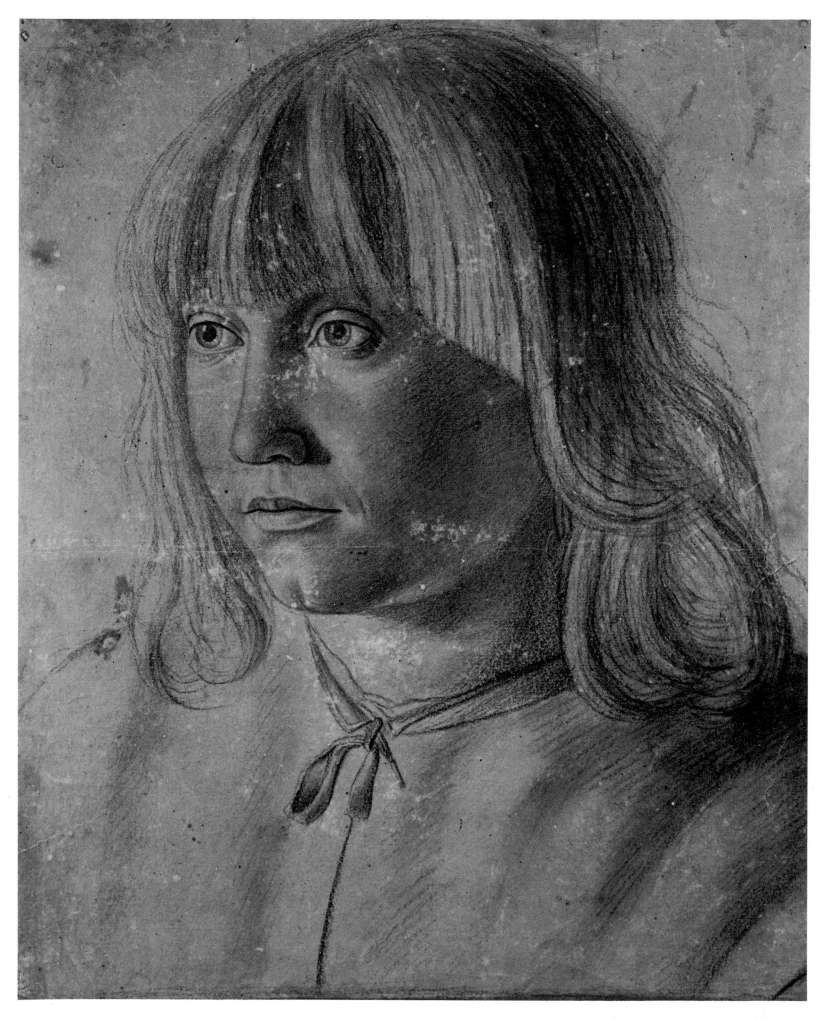

99

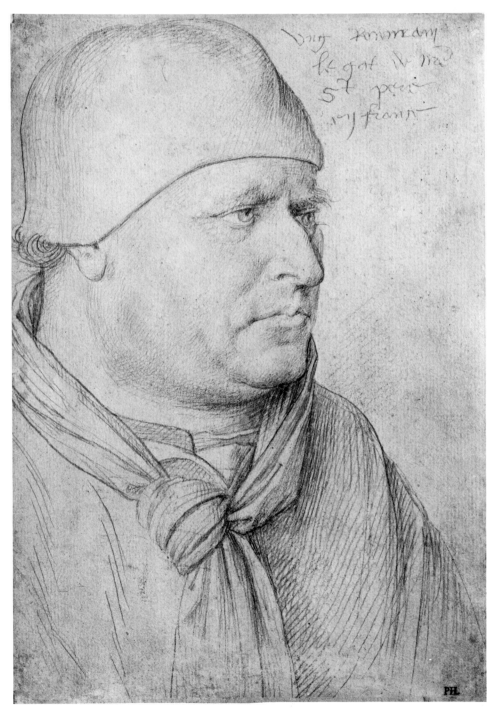

Jean Fouquet (Tours *c.* 1425–80)
Portrait of an Ecclesiastic
Silverpoint on prepared ivory-tinted paper;
$7\frac{3}{4} \times 5\frac{3}{8}$ in. (198 × 135 mm.)
Provenance: Lankrink; Heseltine;
Oppenheimer; Duveen; entered in 1949
New York, The Metropolitan Museum of
Art, Rogers Fund, inv. 49.38

Realism with a Flemish flavour joins with
Tuscan corporeity in this *Portrait of an
Ecclesiastic.* The sitter is probably
identifiable as Teodoro Lelli, Bishop of
Treviso, who left for France in 1464. Such a
date would therefore seem acceptable for
this delicate silverpoint drawing which bears
the inscription *'Ung Roumain legat de nostre
St pere en France'* ('A Roman legate of our
Holy Father in France').
Bibliography: Perls, 1940, p. 22, pl. 282;
Bean, n.d., no. 51

Rogier van der Weyden (Tournai
c. 1400–Brussels 1464)
Madonna and Child
Silverpoint on white prepared paper;
$8\frac{3}{8} \times 5$ in. (212 × 128 mm.)
Provenance: Coll. Francia Sett.; Cassirer &
Co.; Koenigs; van Beuningen; entered in
1941
Rotterdam, Museum Boymans-van
Beuningen, inv. N-9

This delicate silverpoint drawing, datable to
about 1450, is stylistically similar to that of
St Luke Painting the Virgin, c. 1515, by Jan
Gossaert (called Mabuse), which is in
Boston. The sculptural way in which the
figure is placed and the stiff treatment of the
drapery are typical of the style of van der
Weyden. Although his work reflected some
of the humanizing influence of the
Renaissance, he was still using stylistic
features from the late Gothic period. The
signature at the top right-hand corner of the
drawing is a fake.
Bibliography: Friedländer, 1926–7, pp.
29–32; Haverkamp Begemann, 1957, no. 3;
Sonkes, 1969, no. A4

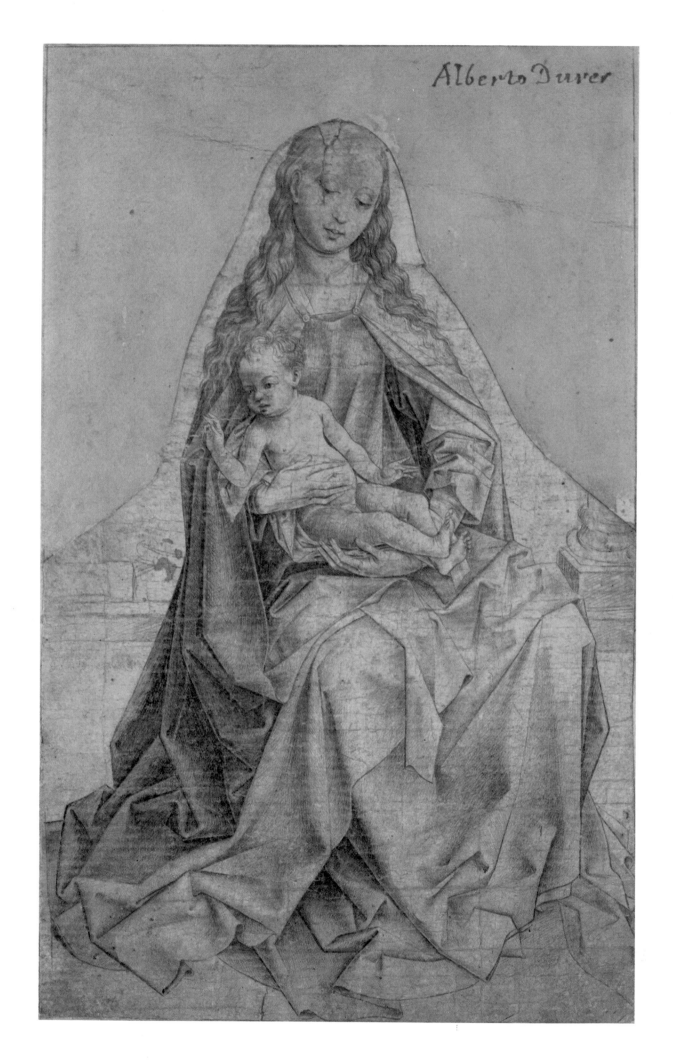

Alberto Durer

101

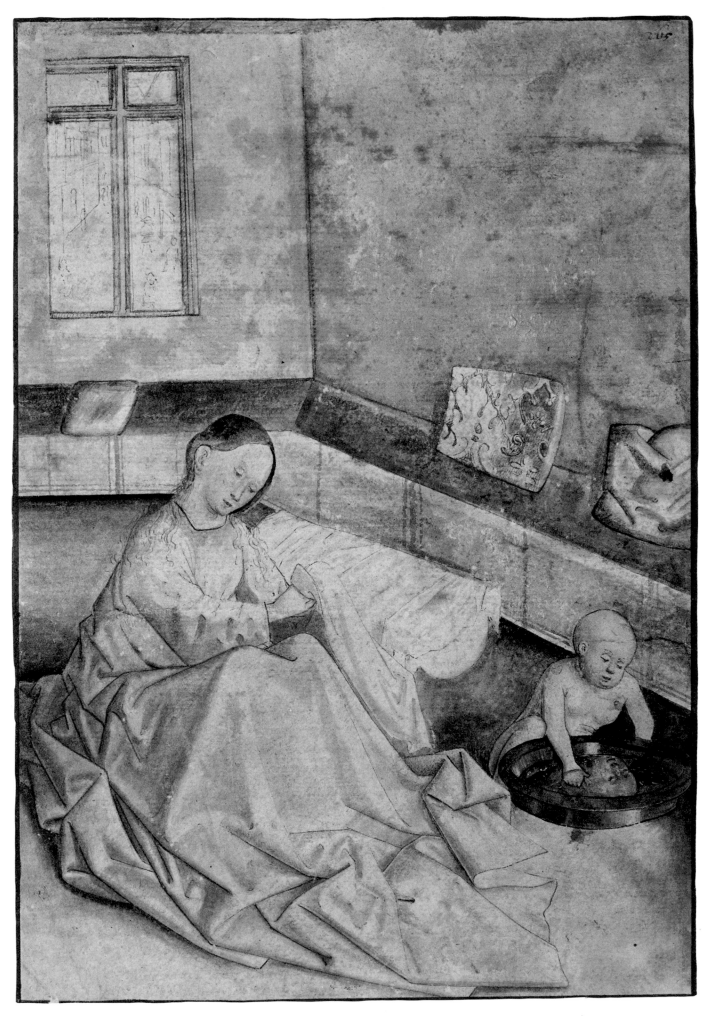

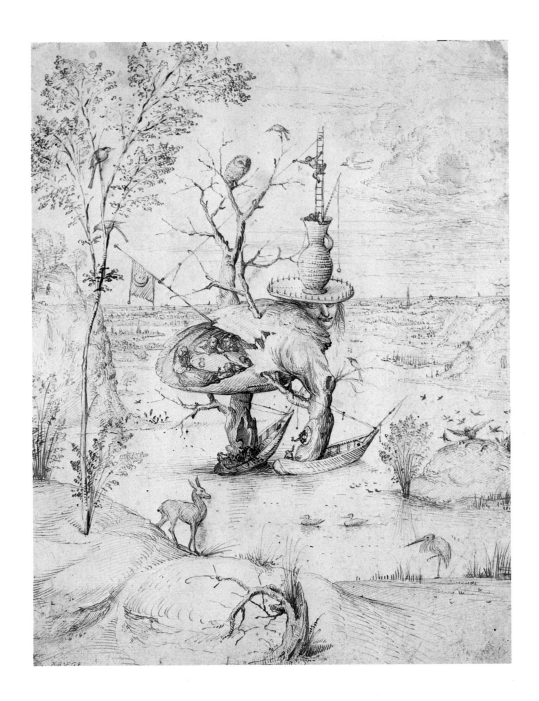

Konrad Witz (?) (Rottweil
c. 1400–Basle, c. 1445)
Madonna and Child
Pen and indian ink with touches of
watercolour; $11\frac{1}{2} \times 8$ in. (291 × 200 mm.)
Provenance: Nagler
Berlin, Kupferstichkabinett, inv. KdZ 1971

Konrad Witz worked in the transition period
between late Gothic and early Renaissance.
His pictures incorporate a realistic intimacy
– derived from the Flemish school – with a
deep awareness of linear perspective and
strong plasticity in the positioning of the
figures. With great sensitivity, Witz here
draws attention to the play of light by
making use of a few touches of watercolour.
Bibliography: Friedländer-Bock, 1921,
no. 1971; Gantner, 1943, no. 78; Halm,
1955–6, no. 18

Hieronymus Bosch ('s Hertogenbosch
c. 1450–1516)
The Tree-Man
Pen and bistre; $11 \times 8\frac{3}{8}$ in. (277 × 211 mm.)
Vienna, Graphische Sammlung Albertina,
inv. 7876

This drawing, produced during the last years
of Bosch's artistic activity, is typical of his
imaginative originality which grafted
symbolic and grotesque features on to
traditional Flemish subjects. On the basis of
an inscription that appears on a similar
drawing housed in Berlin, some research has
recently been carried out. This has led to the
subject being interpreted as a 'disguised' self-
portrait of the artist, whose face, gazing
back wistfully at the creatures on the bank
who can move about so freely, is that of the
tree-man who dominates the scene.
Bibliography: Benesch, 1928, no. 26; *idem*,
1964, no. 125; van Beuningen, 1973,
cat. no. 7

The High Renaissance in Florence and Rome

Donato di Pascuccio, known as Bramante (Monte Asdruvaldo 1444–Rome 1514). Although principally an architect, Bramante was also a painter. His development as a Renaissance artist depended upon his training at the court of Urbino, where he came under the influence of Piero della Francesca, as well as in Mantua, where he was able to appreciate the frescoes of Mantegna. Between the late fifteenth and early sixteenth centuries, Bramante was in the service of the Duke of Milan as one of his most distinguished architects. Here he was in a position to contribute knowledge gained from the greatest of Tuscan architects, Alberti and Brunelleschi. Among his more important assignments were his designs for the cathedral at Paviar and for the church of Santa Maria delle Grazie in Milan. From 1499 onwards he was in Rome, where in 1506 he presented his plans for the rebuilding of St Peter's Basilica.

Leonardo da Vinci (Vinci 1452–Amboise 1519). The greatest artist of the Italian Renaissance, Leonardo devoted his whole life to exploring every aspect of representational art. In 1472 he began to frequent the workshop of Verrocchio in Florence, where in the course of the next ten years he painted a number of works, the last being the now-famous *Adoration of the Magi* in the Uffizi Gallery. For three years, from 1482, da Vinci was in Milan to work on an equestrian monument of Ludovico Sforza (Ludovico il Moro), Duke of Milan. Between 1495 and 1497, still in Milan, he was painting the *Last Supper* in the church of Santa Maria delle Grazie. He then returned to Florence, where in 1503 he started work on the *Battle of Anghiari* in the Palazzo Vecchio, of which only a few preliminary drawings remain. Having returned to Milan in 1506, he stayed there for seven years, during which time he founded a school which thrived and continued to follow his teachings for a long time. In 1513 he went to work in Rome, but after four years made his way to France, where he remained, under the patronage of François I, until his death about two years later at Cloux near Amboise. Several of his best-known works had been with him in France; one of these was the *Mona Lisa* (*La Gioconda*), which subsequently went into the King's collection and thus into the Louvre. The graphic work produced by Leonardo was so extensive as to be almost impossible to describe briefly. He illustrated, with thousands of drawings, his codices on scientific and artistic subjects, and with equal care made preliminary studies of great accuracy for all his paintings.

Michelangelo Buonarroti (Caprese 1475–Rome 1564). A sculptor, painter and architect, Michelangelo was the central figure of the High Renaissance in Italy. His first drawings were copied from Giotto and Masaccio, thus revealing from the outset his powerfully humanistic inclination. In Rome he achieved immediate fame when his *Pietà* was first exposed to public gaze in the Basilica of St Peter in 1501. Returning to Florence as an established sculptor, he executed the famous sculpture of *David* (1504), as well as painting the *Doni Tondo*, regarded by many as his masterpiece. Summoned by Pope Julius II to Rome in 1505, and having overcome various problems and mishaps, Michelangelo painted the vaulted ceiling of the Sistine Chapel, working on it for four years (1508–12). His next task was to concentrate on the *Slaves* for the tomb of Julius II, after which he returned to Florence. There he started feverishly to work on plans for the façade of the church of San Lorenzo, but although he spent four years trying to get the marble he needed, his efforts were in vain. He planned and worked on the Medici Chapel and Library in the church of San Lorenzo from 1520 until 1534, when, seven years after Rome had been sacked, he returned to the city of the Popes, where he remained for the rest of his life. Among his greatest works, the *Last Judgement* on the altar wall of the Sistine Chapel (1541), and the Dome of St Peter's, together with his last *Pietà*s, were to be his final achievements. The vast amount of graphic work left by Michelangelo is now dispersed throughout the world.

Raffaello Sanzio, known as Raphael (Urbino 1483–Rome 1520). Having spent his early years under the guidance of Perugino, Raphael moved to Florence, where from 1504 to 1508 he was strongly influenced by Leonardo da Vinci. He was thus in contact with Michaelangelo as well as with the Venetian artists who came to Rome in order to develop further their technical and aesthetic approach to art. He was a prolific worker, and examples of his paintings include, from his Peruginesque period, the *Betrothal of the Virgin*, dated 1504, now in the Pinacoteca di Brera, Milan. Between

1508 and 1512 he painted for Popes Julius II and Leo X the three rooms in the Vatican known as the Stanze and generally regarded as his masterpiece. Among his last works were his portraits of *Baldassare Castiglione* (Louvre), *Pope Leo X* (Uffizi) and the famous *La Fornarina*, 'The Baker's daughter' (Galleria Nazionale di Roma). All his paintings were accompanied by graphic work using a wide variety of techniques in pen, sanguine and charcoal.

Andrea del Sarto (Florence 1486–1531). Although influenced at first by the work of Leonardo da Vinci and by the soft *sfumato* effects of Fra Bartolommeo, an influence seen for example in the *Madonna of the Harpies* (Uffizi) painted in 1517, Andrea soon developed an entirely individual style. He was particularly concerned with the effects of light and he also expressed strong lyrical tension. His numerous preliminary drawings, for which he used rather soft media, are exceptionally vigorous.

Fra Bartolommeo della Porta (Florence 1475–Pian di Mugnone 1517). This artist began his development at the period of transition between the late fifteenth-century styles and the new ideas of Leonardo da Vinci. After a few years, however, he reverted to the more mature forms of Michelangelo. While in Rome, Fra Bartolommeo made the acquaintance of Raphael. As a result, there is a distinct softening both in the composite structure of his pictures and in their colours, enabling him to achieve a vibrant, shaded effect as in his *Deposition*, painted about 1515 and now in the Palazzo Pitti. He was a tireless draughtsman and his figure studies display a strong plastic element.

Jacopo Carrucci, known as Pontormo (Pontormo 1494–Florence 1556). Having completed his training in 1514 in the workshop of Andrea del Sarto, Pontormo worked on his own for a few years. In the early 1520s, he had already begun to introduce Mannerism into Tuscan painting, but nevertheless executed a commission to decorate the Villa Medici at Poggio a Caiano; his composition of figures, freedom of form and subtle, elegant rhythm were quite exceptional at that time. Having worked on these frescoes from 1520 to 1521, he began to produce compositions of quite disconcerting expressiveness, in which feelings of restlessness and emotional intensity predominate. This has

even been described as a sense of exasperation, which may be true, for he seems to have become impatient with the softness that had hitherto prevailed in art. This was made apparent in his use of colour and light, the effects of which were often quite unreal, as in the *Supper at Emmaus* (1525) in the Uffizi Gallery and the *Deposition* (1526–8) in the church of Santa Felicità, Florence. His portraits have a clear-cut, dramatic quality which is often present in his numerous drawings, too.

Domenico Beccafumi (Montaperti *c.* 1486–Siena 1551). Beccafumi was active when Mannerism was just starting to penetrate into Tuscany, and the influence of Leonardo da Vinci on his style is apparent. This was probably transmitted through Giovanni Antonio Bazzi, called *Il Sodoma*, the best-known Sienese painter of the time, who had lived in Milan and Florence where he would certainly have seen the work of Leonardo. Beccafumi himself was in Rome from 1510 to 1512 and there studied the paintings of Michelangelo in the Sistine Chapel and those of Raphael in the Stanze. Luministic interpretation became a feature of Beccafumi's work and was apparent even in the many preliminary drawings that accompany his paintings.

Francesco Mazzola, known as Parmigianino (Parma 1503–Casalmaggiore 1540). When only twenty years old, Parmigianino made his début with a masterpiece by painting the *salotto* of Paola Gonzaga in Sanvitale castle at Fontanellato, near Parma. Although greatly influenced by Correggio, the young artist added his own individual stamp of exquisite elegance and Manneristic effects which were far more sophisticated than the older master. While in Rome, in 1524, he greatly admired the work of Michelangelo and of Raphael – his so-called *Madonna dal Collo Lungo* ('Madonna of the Long Neck') painted in about 1534 and now in the Uffizi Gallery, was inspired by the latter's style. Parmigianino occupies an outstanding position in Mannerist culture, not only through his painting but through his graphic work. He was also one of the earliest painter-etchers.

Antonio Allegri, known as Correggio (Reggio Emilia *c.* 1489–1534). While Correggio was clearly influenced by Mantegna in his early work he soon brought his style more in line

with the prevailing trend set by Leonardo da Vinci, Dosso Dossi and Raphael. His frescoes in the Camera di San Paolo, a room in the Convent of St Paul in Parma (1518–19) belong to the second period. This commission coincided with a visit to Rome which had plunged him into direct contact with many great works of the High Renaissance. His next task was to paint the frescoes inside the cupolas of the church of San Giovanni Evangelista and in Parma Cathedral, (1520–6). Although Correggio's style follows the main principles of Mannerism, it already seems to have something of the imaginative fantasies of the Baroque. The many preliminary drawings for his paintings also display similar imaginative freedom.

Niccolò dell'Abbate (Modena *c.* 1509–Fontainebleau 1571). The style of dell'Abbate stemmed from a Mannerist background, the leading components of which were Correggio, Parmigianino and Pordenone. From 1552 until his death he was working in Fontainebleau, where he executed a number of outstanding frescoes in the royal château. A prolific draughtsman, he used the Mannerist motifs to create most elegant and imaginative shapes.

Federico Barocci (Urbino 1528–1615). Having moved to Rome in 1555, Barocci became involved in the general trend of the time for the Mannerists to elaborate on the forms of Raphael. He developed a style which mainly followed the example of Correggio, whose well-known works, for example the *Rest on the Flight into Egypt*, he had studied closely in the Vatican. He produced a great deal of graphic material, the largest collections of his work being in the Uffizi Gallery, Florence, and in Berlin.

Luca Cambiaso (Moneglia 1527–Madrid 1585). Having started his working life in Genoa, he moved to Madrid in 1583. As a young man his style was based on the huge forms of Michelangelo and Pordenone (Palazzo Doria, Genoa) but he soon came into contact with the styles of Correggio and the Venetians as a result of which he adopted a lighter touch altogether, with a more flowing line.

Donato Bramante
(Monte Asdruvaldo
1444–Rome 1514)
St Christopher
Silverpoint
heightened with
opaque white-lead
pigment on azure
paper; $12 \times 7\frac{1}{2}$ in.
$(304 \times 192$ mm.)
Copenhagen, Royal
Collection

The strength and
monumental quality
of this powerful
figure of St
Christopher contrasts
movingly with the
lively drawing of the
tiny Christ Child
perched on his
shoulders. This sheet,
which is squared-up
for transference, may
have been prepared
for a fresco to be
painted in
accordance with the
traditional depiction
of the Saint –
protector against
sudden death – on
the façade of
churches.
Bibliography:
Popham, 1931, no.
151; Suida, 1953,
p. 30

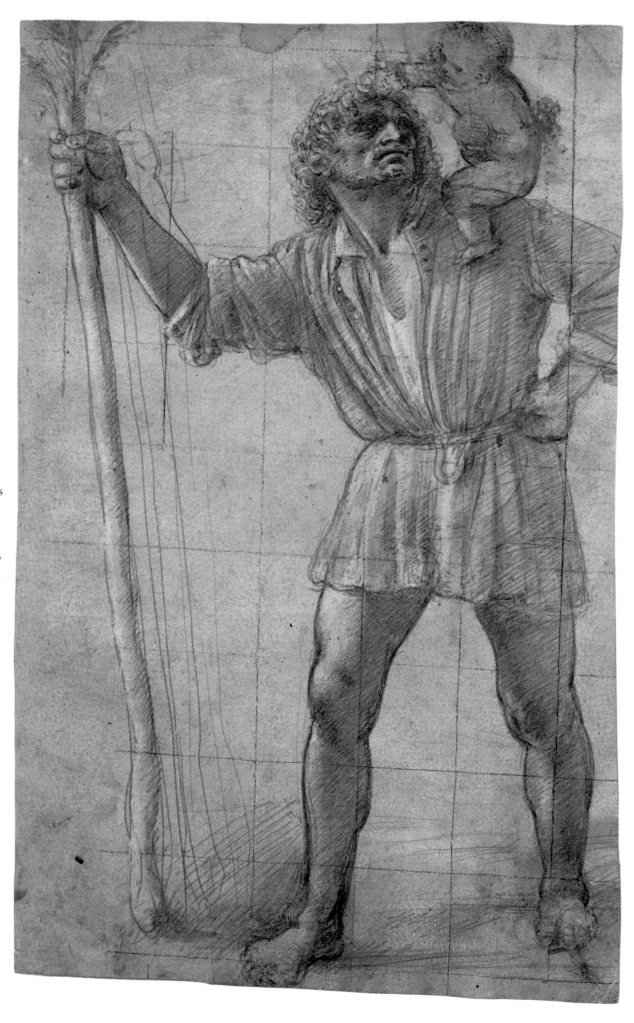

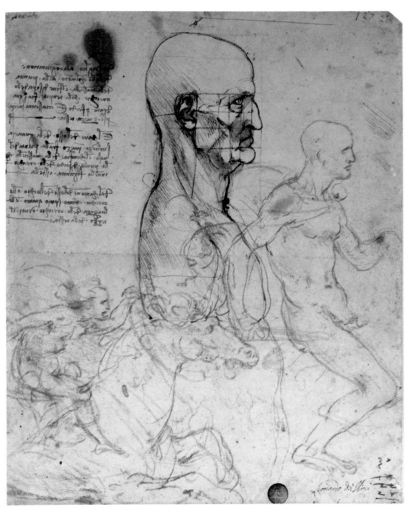

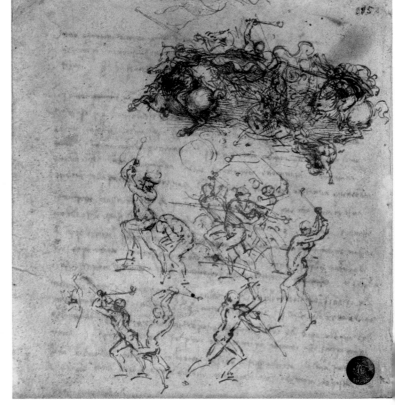

Leonardo da Vinci (Vinci
1452–Amboise 1519)
*Bust in Profile Marked up to Demonstrate
Proportions of the Human Head; also Study
of a Horse and Horsemen*
Pen, black pencil, sanguine and brown ink;
11 × 8¾ in (280 × 222 mm.)
Provenance: Bossi
Venice, Gallerie dell'Accademia, inv. 236 (r)

This folio includes a number of studies
which are partially superimposed on each
other. They are identifiable as belonging to
two different periods of Leonardo's artistic
activities: the well-defined profile in pen and
ink is datable to about 1490, while the horse
and horsemen, more flowingly sketched in
sanguine, were drawn nearer to the time of
his *Battle of Anghiari*, painted about 1503.
The long inscription on the left refers to the
grid of lines marked out to demonstrate the
measurements of the human head.
Bibliography: Popham, 1963, no. 191;
Cogliati Arano, 1980, no. 7

Leonardo da Vinci
*Scenes of Battle with Horsemen and Nude
Figures in Action*
Pen and brown ink; 5¾ × 6 in.
(145 × 152 mm.)
Venice, Gallerie dell'Accademia, inv. 215 A

These animated combat scenes, rapidly
sketched in pen-and-ink, were almost
certainly in preparation for his wall-painting
of the *Battle of Anghiari*, for which
Leonardo was commissioned by the Signoria
(the ruling body) of Florence in 1504. The
picture was never completed, however, and
the unfinished work soon deteriorated
because of the artist's unfortunate choice of
medium. Leonardo was trying to revive an
interest in the Antique technique of
encaustic work but it was a disaster. The
only clues that remain as to the composition
of the picture are to be found in the many
partial copies by other artists that remain to
us.
Bibliography: Popham, 1963, no. 192B;
Cogliati Arano, 1980, no. 13

Leonardo da Vinci
Study of the Drapery of a Woman's Dress
Metalpoint, charcoal, bistre and opaque
white-lead pigment on vermilion-tinted
prepared paper; 10⅛ × 7½ in.
(257 × 190 mm.)
Provenance: Corsini
Rome; Accademia Nazionale dei Lincei, on
loan to the Istituto Nazionale per la Grafica,
inv. F.C. 125770

This is an elegant study of drapery in which
Leonardo made use of a mixed technique on
the red preparation of the paper. It is similar
in style to some of his other paintings, in
particular the Virgin of the *Annunciation* in
the Louvre and of another *Annunciation* in
the Uffizi, both works which he produced
when quite young and datable to about the
middle of the 1470s.
Bibliography: Popham, 1946, p. 36, no. 1;
Berenson, 1961, no. 1082/b; Catelli Isola,
1980, no. 8

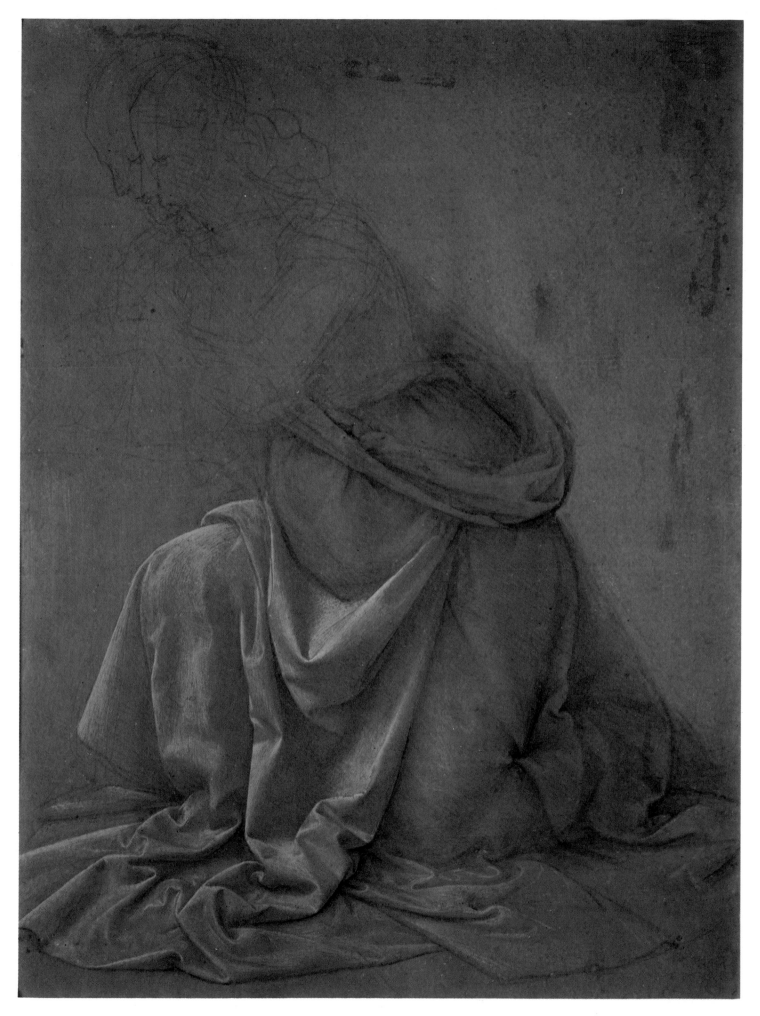

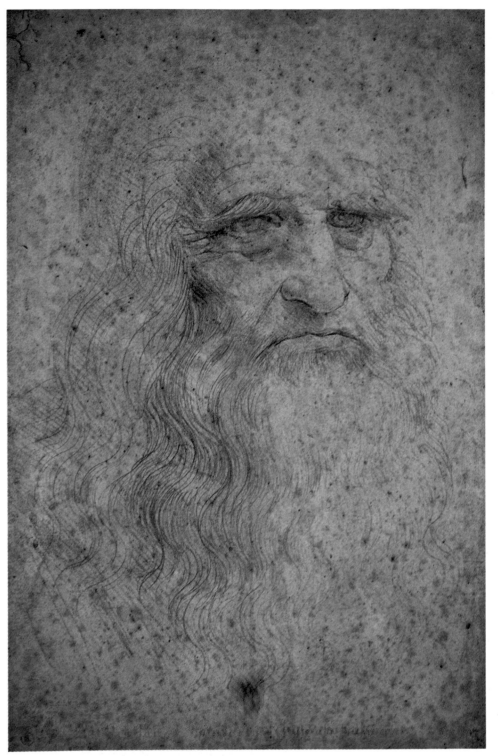

Leonardo da Vinci
Self-Portrait
Sanguine; $13\frac{1}{8} \times 8\frac{3}{8}$ in. (333 × 213 mm.)
Provenance: Volpato; Carlo Alberto (1840)
Turin, Biblioteca Reale, inv. 15571

This very famous drawing in sanguine is the
only authentic self-portrait of Leonardo and
is datable to between 1512 and 1516. It was
executed just before his departure for
France. The soft, painterly line, which is to
be seen in so many of the artist's works,
shows up well even in this folio in which the
master – only a little over sixty years of age
– has used it to produce an idealized portrait
of himself looking like a philosopher of
Antiquity.
Bibliography: Bertini, 1958, no. 229;
Popham, 1963, no. 154; Pedretti, 1975, no. 1

Michelangelo (Caprese 1475–Rome 1564)
A Head in Profile
Sanguine; $8 \times 6\frac{1}{2}$ in. (205 × 165 mm.)
Provenance: the Buonarroti family; Wicar;
Ottley; Lawrence; Woodburn
Oxford, Ashmolean Museum

This 'Head' has been given several datings
and in the past been identified with some of
the figures in the Sistine Chapel ceiling
(1508–12), mainly because of certain
similarities. Now, however, it has become
linked with the group of so-called 'finished
drawings', datable to around 1522. In these
sheets the draughtsmanship is so complete as
to justify each one being regarded as a work
of art in its own right. They were probably
executed by Michelangelo as gifts to be
presented to his admirers.
Bibliography: Parker, 1956, no. 315; Hartt,
1971, no. 363; Pignatti, 1976, no. 20

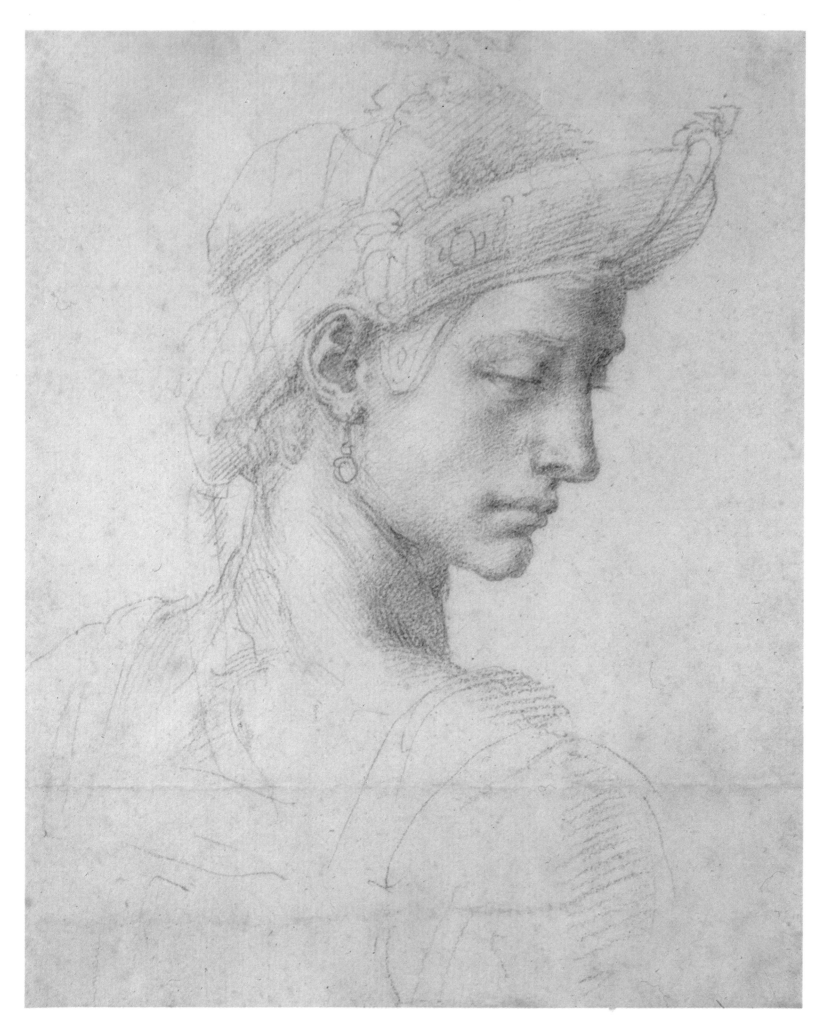

111

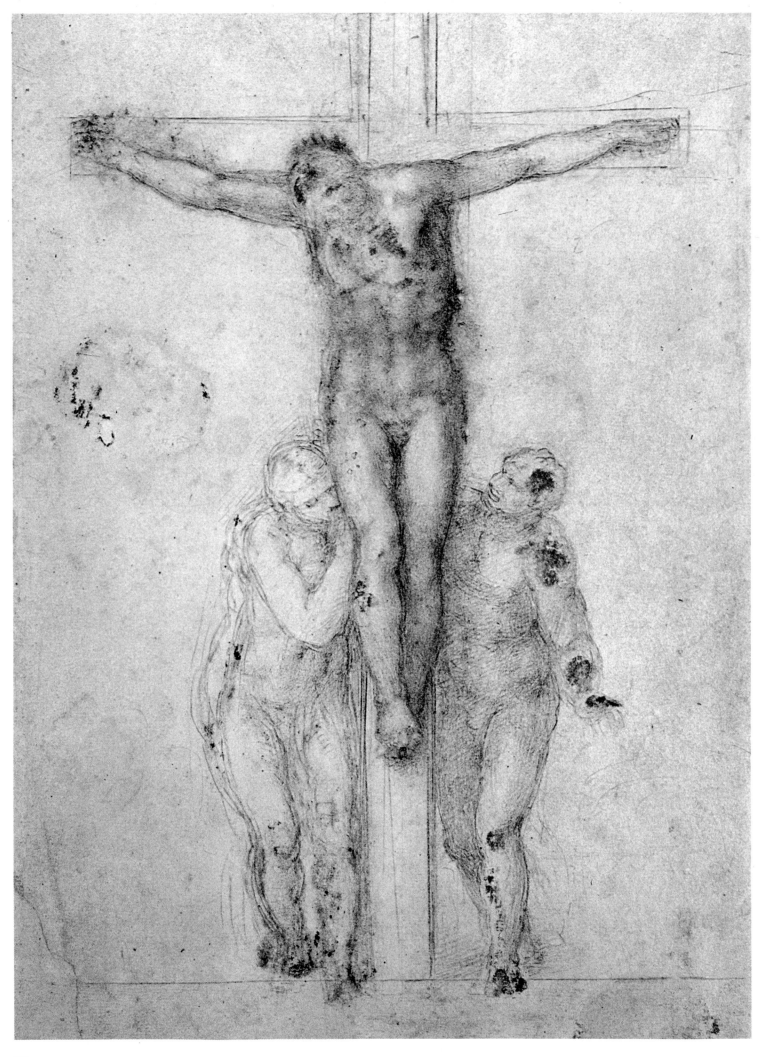

Michelangelo
Crucifixion
Black chalk and opaque white-lead pigment;
$16\frac{1}{4} \times 11$ in. (412×279 mm.)
London, British Museum, inv. W.82

This study for a 'Crucifixion' is probably the
last of a series of six associated with the later
phase of Michelangelo's work, between
about 1550–5. The religious sensibility of the
artist shows itself in the feeling of pathos
and tension of line that he achieves through
the complex readjustments of the figures,
both in going over the outlines again and in
using the white heightening agent to cover his
pentimenti and create emphasis.
Bibliography: Wilde, 1953, no. 82; Hartt,
1971, no. 429

Raphael (Urbino 1483–Rome 1520)
St Catherine of Alexandria
Charcoal heightened with white;
$23\frac{1}{8} \times 13\frac{5}{8}$ in. (587×346 mm.)
Provenance: Jabach; Cabinet du Roi (1671)
Paris, Musée National du Louvre, inv. 3871

The large size of this sheet, which is made up
of four pieces joined together, and the
pricked outlines for transfer indicate that
this was a preliminary cartoon for the *St
Catherine of Alexandria* in the National
Gallery, London. The classicism of the figure
of the Saint recalls the style of the female
figures in the Stanza della Segnatura in the
Vatican as well as of other works from
Raphael's Roman period.
Bibliography: Fischel, IV, 1923, no. 207;
Bacou-Viatte, 1975, no. 62

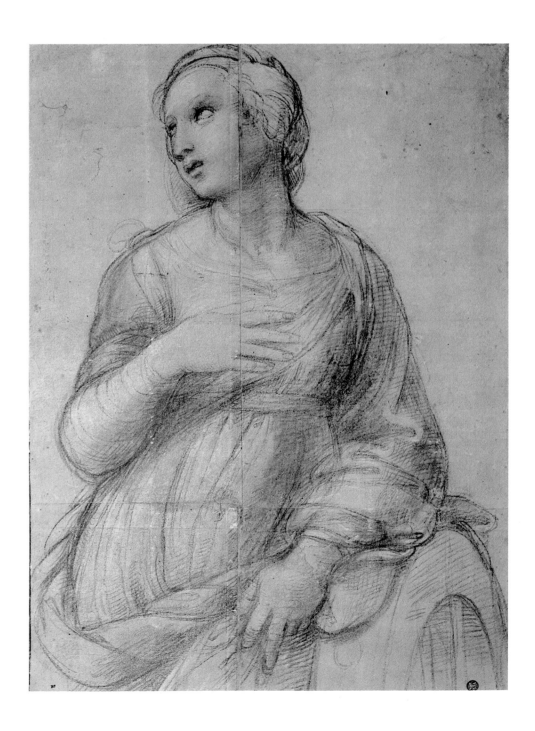

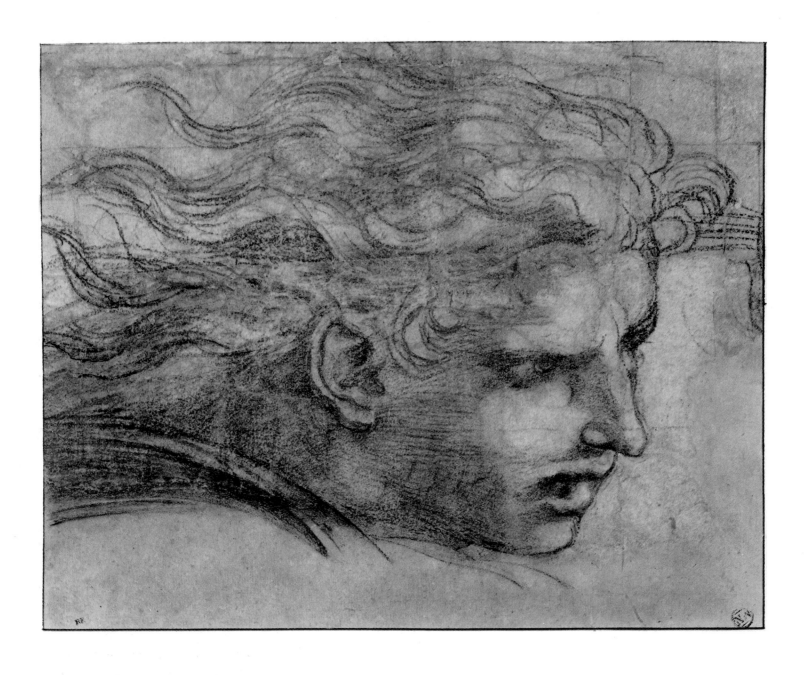

Raphael
Head of an Angel
Charcoal heightened with white on light
brown paper; 10½ × 13 in. (268 × 329 mm.)
Provenance: Crozat; Mariette; Cabinet du
Roi
Paris, Musée National du Louvre, inv. 3853

This drawing may well have been part of a
cartoon which Vasari mentions as having
been in the house of Francesco Massini in
Cesena. The subject refers to one of the two
angels who are expelling Heliodorus from
the Temple in Jerusalem (1511), depicted in
fresco in one of the Vatican's Stanze. The
dramatic effect of the windswept hair is
evidence of the extent to which Raphael was
influenced by the Michelangelesque pathos.
Bibliography: Oberhuber, IX, 1972, no. 401;
Bacou-Viatte, 1975, no. 64

Raphael
Woman Reading to a Child
Metalpoint heightened with white on
prepared grey-tinted paper; 7 × 5½ in.
(190 × 140 mm.)
Provenance: Lely; Duke of Devonshire
Chatsworth, Devonshire Collection, inv. 728

The theme of 'Mother and Child' is seen
here in an intimate, everyday context. The
drawing relates stylistically to the period
when Raphael was working on the
Miraculous Mass of Bolsena, and its
particularly finished quality enabled
Raimondo – or one of his pupils – to
transpose it into an engraving.
Bibliography: Fischel, VIII, 1942, no. 375;
Wragg, 1962–3, no. 57

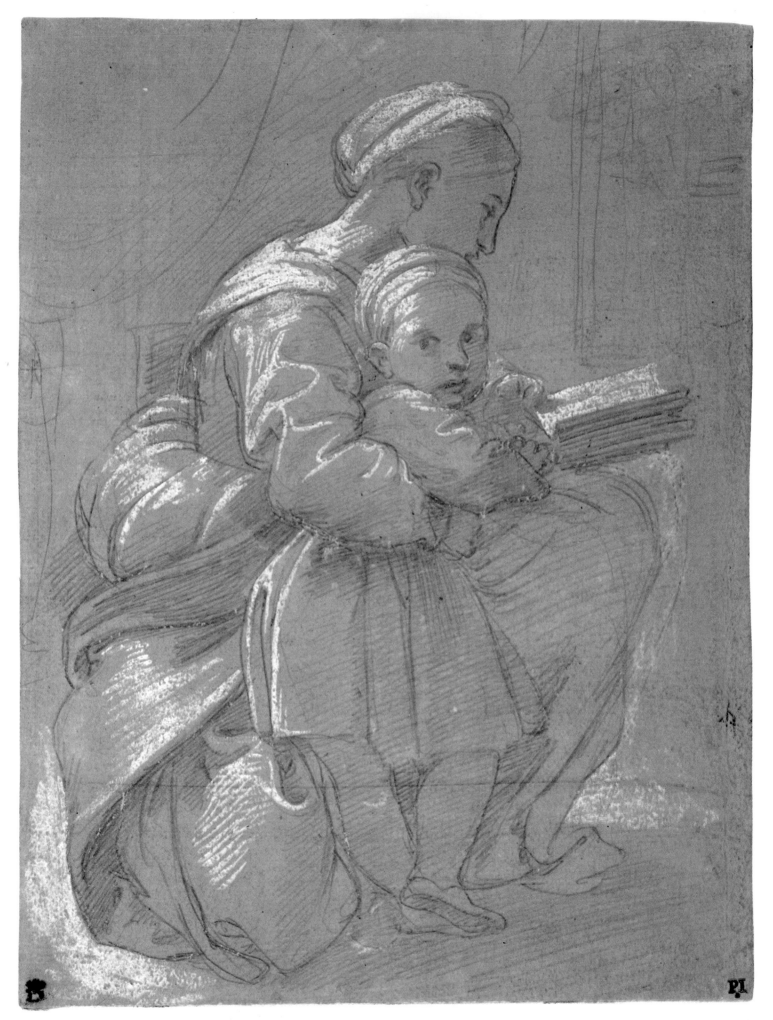

115

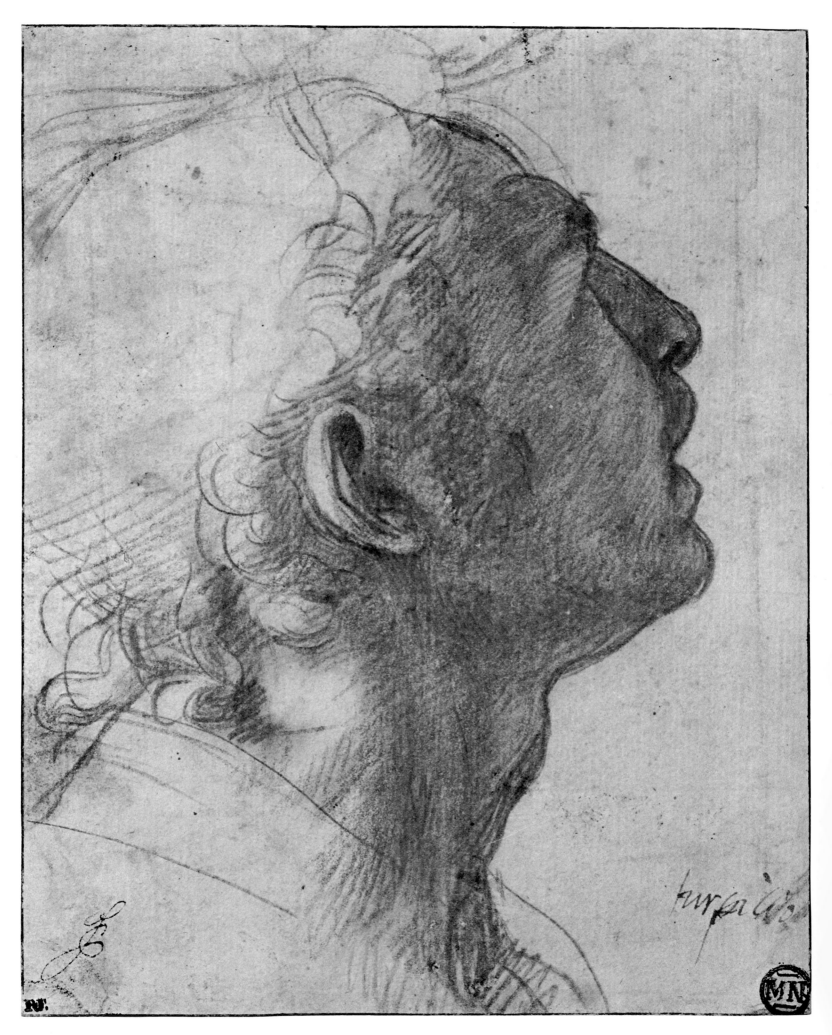

Andrea del Sarto (Florence 1486–1531)
Profile of a Head
Sanguine; $7\frac{5}{8} \times 6\frac{1}{8}$ in. (195 × 156 mm.)
Provenance: Cabinet du Roi
Paris, Musée National du Louvre, inv. 1685

The blend of Raphaelesque harmony with
the soft effect of the *sfumato* lines is the main
stylistic feature of this study, which was used
by the artist for two paintings. In one the
head corresponds to that of Joseph in del
Sarto's *Madonna of the Stairs* (Prado,
Madrid), datable to 1522–3, and in the other
to an Apostle in his Panciatichi *Assumption*
in the Palazzo Pitti, Florence. These
discoveries have made it possible, therefore,
to date this drawing to an earlier phase of
the artist's working life instead of as had
previously been believed, to his later years.
Bibliography: Berenson, 1961, no. 149;
Freedberg, 1963, pp. 110, 118; Shearman,
1965, I, p. 158; II, pp. 252, 374; Bacou-
Viatte, 1975, no. 68

Fra Bartolommeo (Florence 1475–Pian di
Mugnone 1517)
Head of an Elderly Man
Charcoal; $14\frac{7}{8} \times 10\frac{3}{8}$ in. (378 × 264 mm.)
Munich, Staatliche Graphische Sammlung,
inv. 2167 (*r*)

This drawing is characterized by the
markedly plastic quality of the fifteenth-
century Florentine tradition combined with
a soft *sfumato* effect which shows clearly the
influence of Leonardo da Vinci. The artist's
special skill as a draughtsman is clearly in
evidence. In addition to the pen, charcoal
was one of Fra Bartolommeo's favourite
media for his numerous studies; most of his
more successful experimental sketches were,
in fact, executed in charcoal.
Bibliography: Gabelentz, 1922, II, p. 139;
Berenson, 1961, no. 449; Degenhart-Schmitt,
1967, no. 11

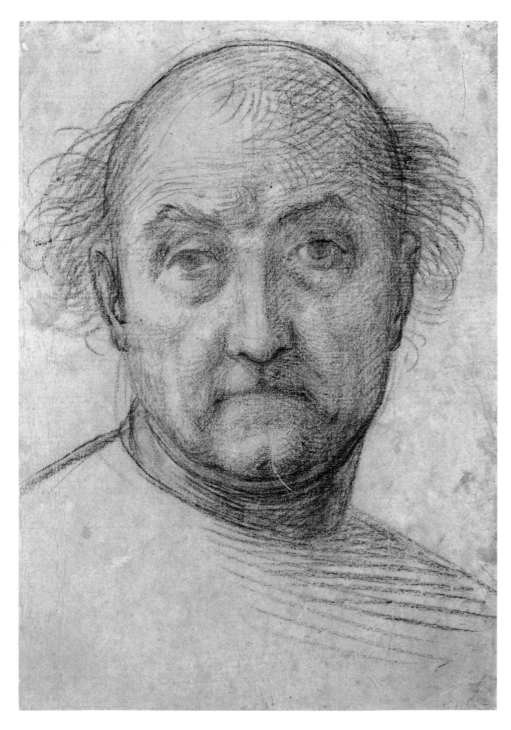

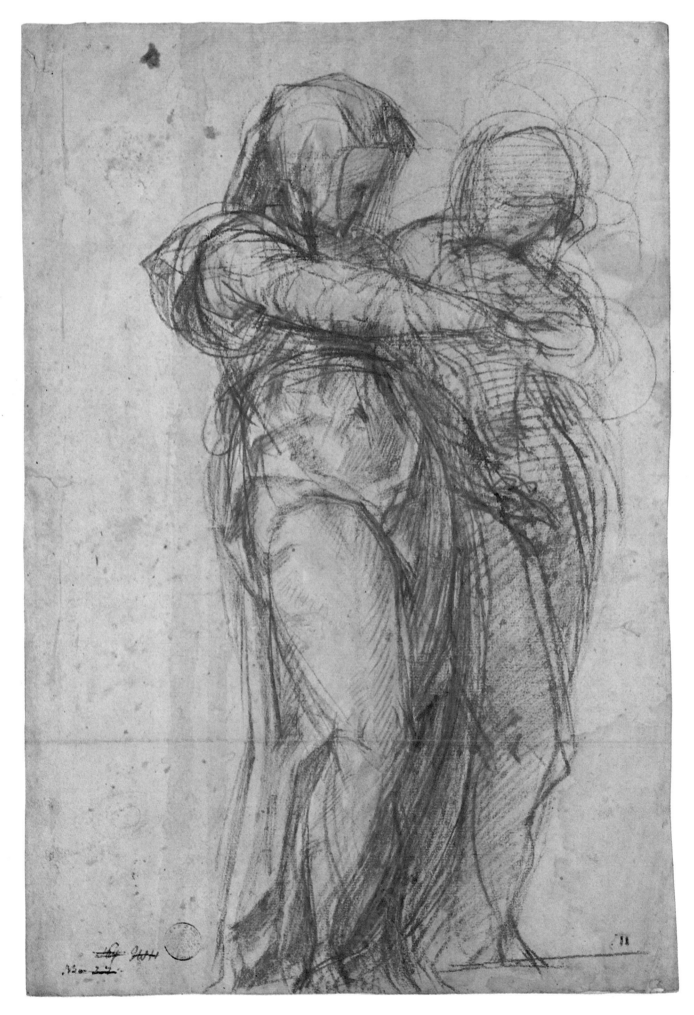

118

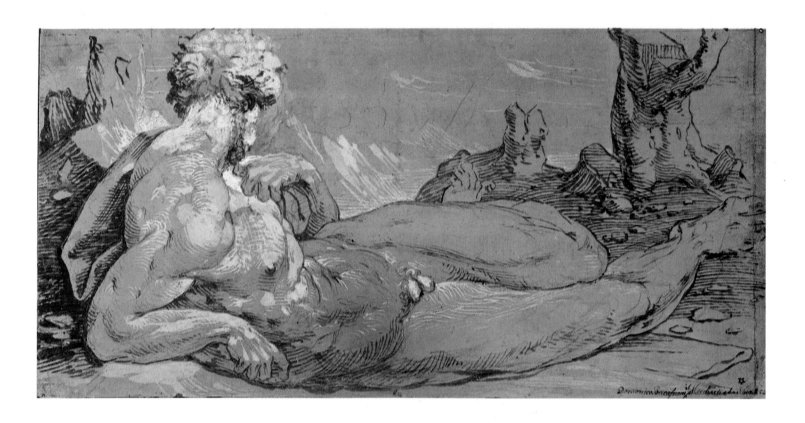

Jacopo Pontormo (Pontormo
1494–Florence 1556)
Two Veiled Women
Sanguine; $15\frac{1}{2} \times 10\frac{1}{8}$ in. (391 × 260 mm.)
Provenance: entered in 1822
Munich, Staatliche Graphische Sammlung,
inv. 14042 (*r*)

This drawing may have been a study for a
'Visitation' and belongs to the youthful
period of Pontormo's activities, under the
direct influence of his master, Andrea del
Sarto, to whom the picture was at one time
attributed. The vigorous, flowing strokes
with which the artist has sketched the two
female figures are already typical of the
Mannerist style.
Bibliography: Cox Rearick, 1964, no. 17;
Degenhart-Schmitt, 1967, no. 62

Domenico Beccafumi
(Montaperti *c.* 1486–Siena 1551)
Reclining Nude
Black pencil, brush and bistre, highlighted
with opaque white-lead pigment, and sharply
outlined with a stylus; $8\frac{3}{4} \times 17$ in.
(222 × 431 mm.)
Provenance: van Amstel; Albert von
Sachsen-Teschen
Vienna, Graphische Sammlung Albertina,
inv. 276

The pose adopted by this powerful male
figure, which strongly reveals the influence of
Michelangelo, suggests that it represents a
river deity. This drawing, so stylistically
similar to the cartoon of *Moses on Mt Sinai*,
was executed by Beccafumi for the floor of
Siena Cathedral and has a technical affinity
to his chiaroscuro prints which are datable
to the 1530s.
Bibliography: Stix-Fröhlich Bum, 1932,
no. 205; Samminiatelli, 1967, no. 122;
Koschatzky-Oberhuber-Knab, 1971, no. 33

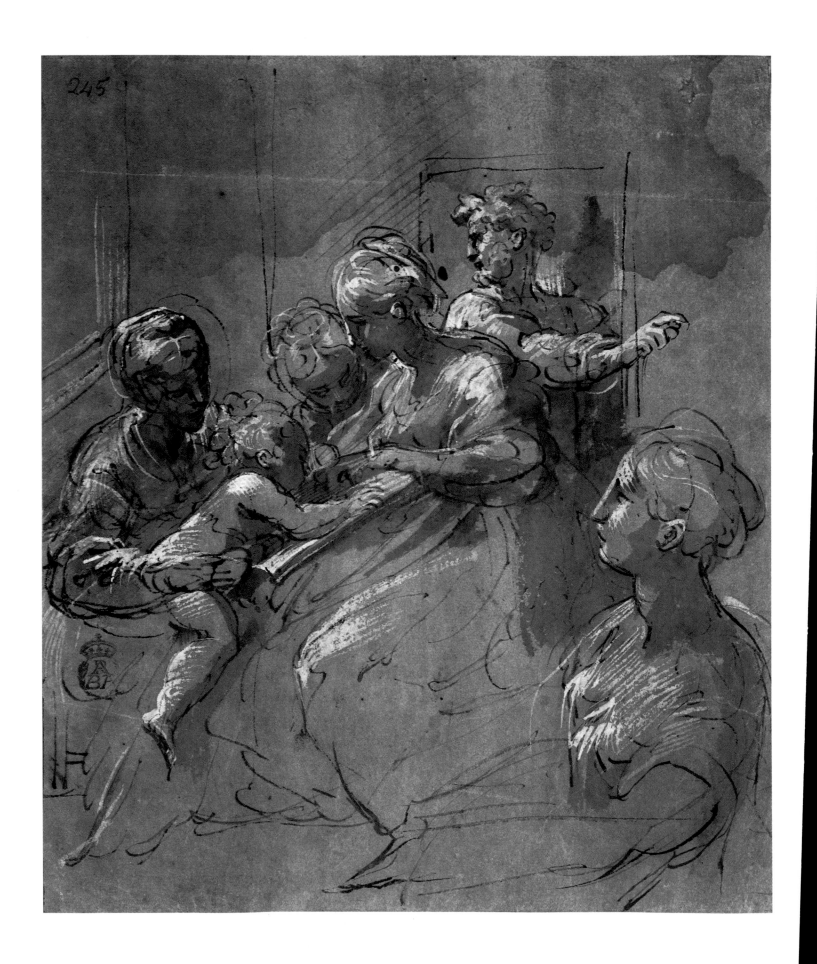

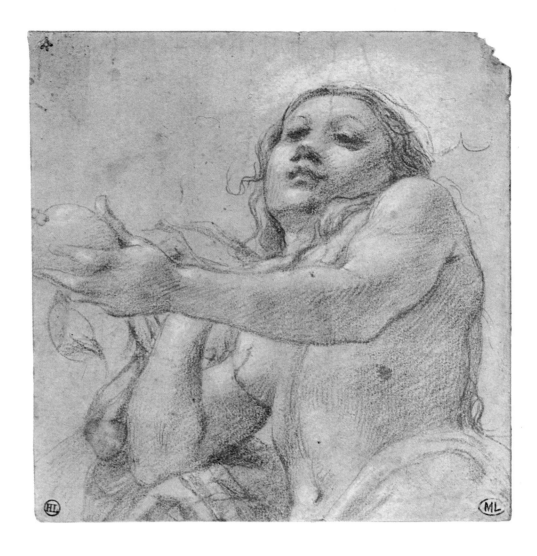

Parmigianino (Parma
1503–Casalmaggiore 1540)
The Mystical Marriage of St Catherine
Pen and brown ink, with sepia wash,
highlighted with opaque white-lead pigment
on pink-tinted paper; $8\frac{5}{8} \times 7$ in.
(219 × 178 mm.)
Provenance: Philip V of Spain; monastery of
Valparaiso
Madrid, Real Accademia de Bellas Artes de
San Fernando, inv. 158

Here the artist has sought to achieve
painterly and chromatic results through the
contrasting effects of watercolour wash and
white bodycolour on the tinted page. The
sheet is datable to Parmigianino's Roman
period or a little after (1525–7). His elegant
Raphaelism combined with the natural
Correggesque influence have created a
composition in which reality and humanity
give way to a calculated and complex
artificiality.
Bibliography: Pérez Sánchez, 1967, no. 115;
Popham, 1971, no. 279; Pérez Sánchez,
1977, no. 4

Antonio Correggio (Reggio Emilia *c.*
1489–1534)
Eve
Sanguine heightened with white; $4\frac{1}{2} \times 4\frac{1}{8}$ in.
(116 × 104 mm.)
Provenance: Lanière; de la Salle; acquired in
1878
Paris, Musée National du Louvre,
inv. RF 499

This study refers to the figure of Eve in the
frescoes in the dome of Parma Cathedral,
painted by Correggio between 1526 and
1528. It is characterized by a daring
foreshortening effect of *sotto in sù* (an angle
of perspective whereby objects seen from
below actually appear to be floating in
space.) Correggio used his favourite graphic
medium, sanguine heightened with white, for
this drawing in which the draughtsman has
achieved an extraordinary softness in its
painterly quality.
Bibliography: Popham, 1957, no. 53; Bacou,
1964, no. 17; Bacou-Viatte, 1968, no. 38

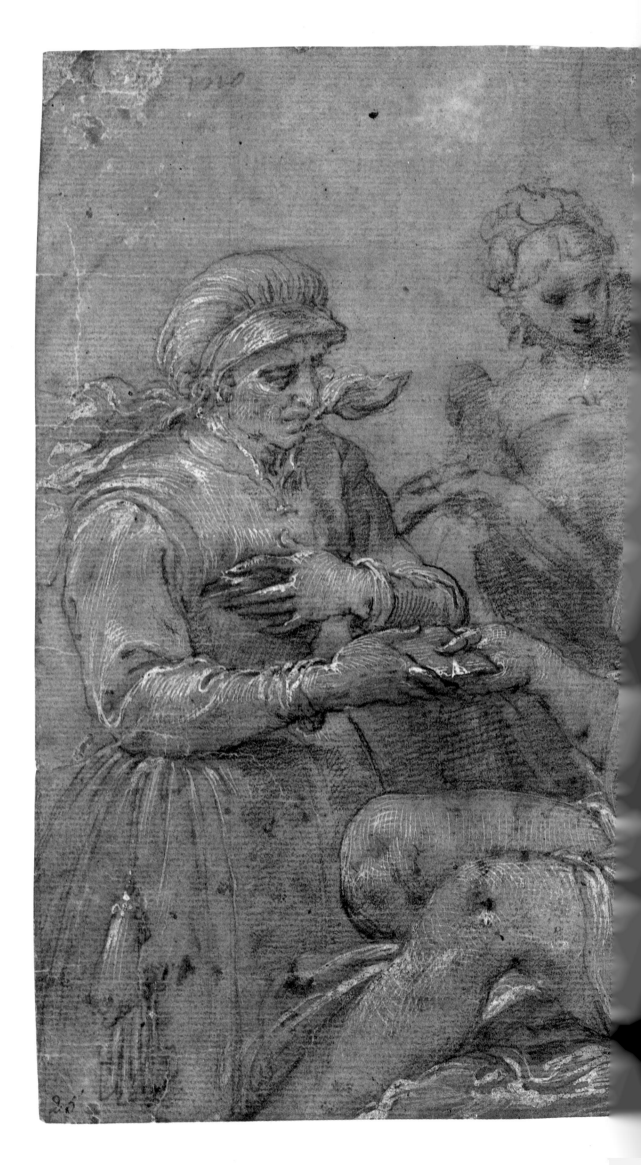

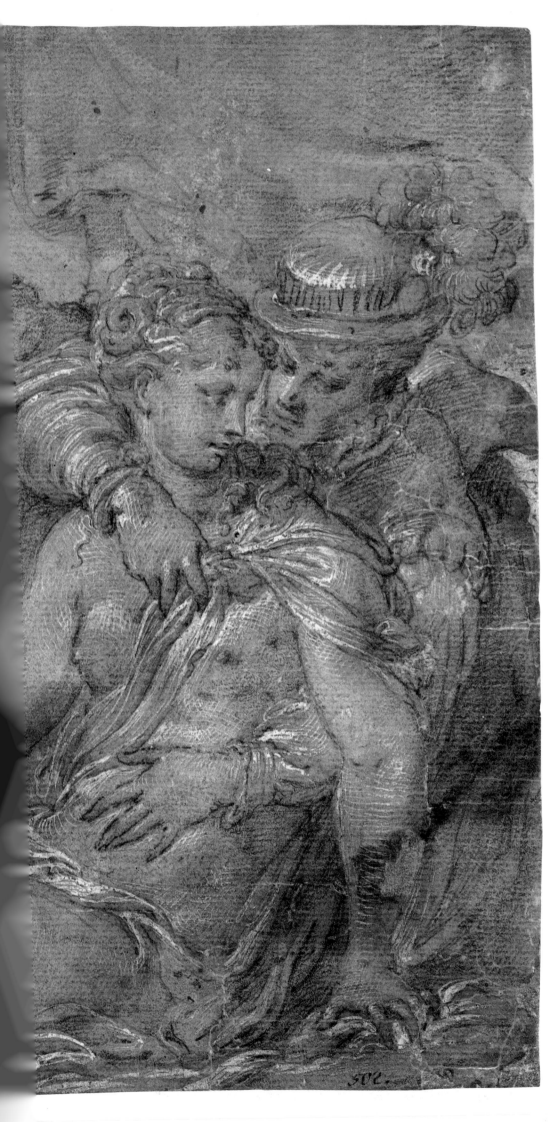

Niccolò dell'Abbate
(Modena *c.* 1509–Fontainebleau 1571)
Young Man Embracing a Naked Woman
Pen and bistre with white highlighting on
light brown paper; $7\frac{7}{8} \times 8\frac{5}{8}$ in
(199 × 220 mm.)
Provenance: Mannheimer
Munich, Staatliche Graphische Sammlung,
inv. 2250

This drawing was at one time believed to
belong to the artist's youthful period, but it
has recently been redated to his more mature
phase (1565–70). This decision has been
made both on considerations of stylistic
order and on the dress of the characters.
Typically Mannerist in composition, it
moves on different planes. This folio made a
considerable impact on the genre scene in
France.
Bibliography: Halm-Degenhart-Wegner,
1958, no. 70; Béguin, 1969, no. 64

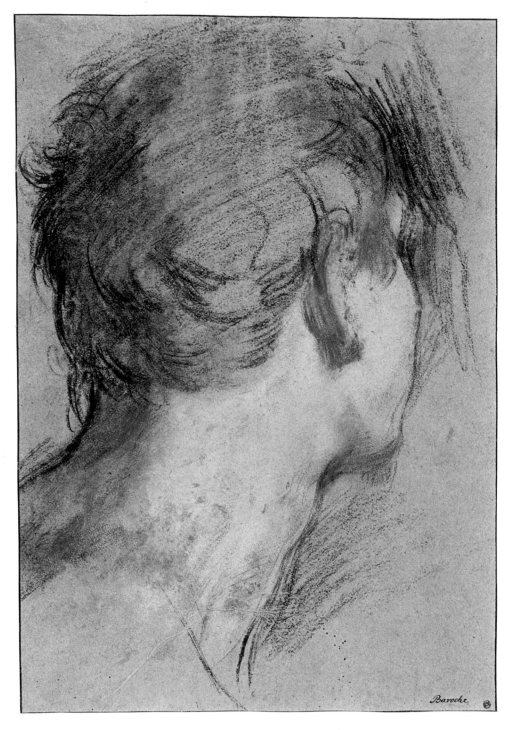

Luca Cambiaso (Moneglia
1527–Madrid 1585)
Venus Detaining Adonis
Pen and brown ink on white paper;
$13\frac{3}{4} \times 9\frac{7}{8}$ in. (350 × 250 mm.)
Provenance: Biggal; Chancey; acquired in
1901
Florence, Museo Horne, inv. 5580

Venetian and Correggesque influences,
echoes of Raphael and a tension already
presaging the Baroque style are all fused into
the art of Luca Cambiaso. His drawings,
with their 'cubistic' style characterized by
broken, vigorous lines and a remarkable
dynamism, are indicative of the artist's
interest in trying to capture the movement of
figures within the spatial limitations of a
piece of paper or canvas.
Bibliography: Ragghianti Collobi, 1963, no.
99

Federico Barocci (Urbino 1528–1615)
Head in Profile
Three coloured chalks (the technique known
as *'aux trois crayons'*) on azure paper;
$14\frac{3}{8} \times 10$ in. (365 × 254 mm.)
Provenance: Chechelsberg; Crozat; Tessin;
Kongl. Biblioteket; Kongl. Museum
Stockholm, Nationalmuseum, inv. 462/1863

The contrasting effects in this drawing of the
coloured chalks on azure paper seem to be
striving to achieve the plasticity of the
Roman tradition. It is a preliminary study
for the head of the shepherd who can be
seen on the left of the *Circumcision* of 1590 –
now in the Louvre, Paris – painted by
Barocci for the Compagnia del Nome di
Gesù in Pesaro.
Bibliography: Sirén, 1917, no. 165; Olsen,
1962, p. 186, (lower) no. 43; Bjurström,
1970–1, no. 17

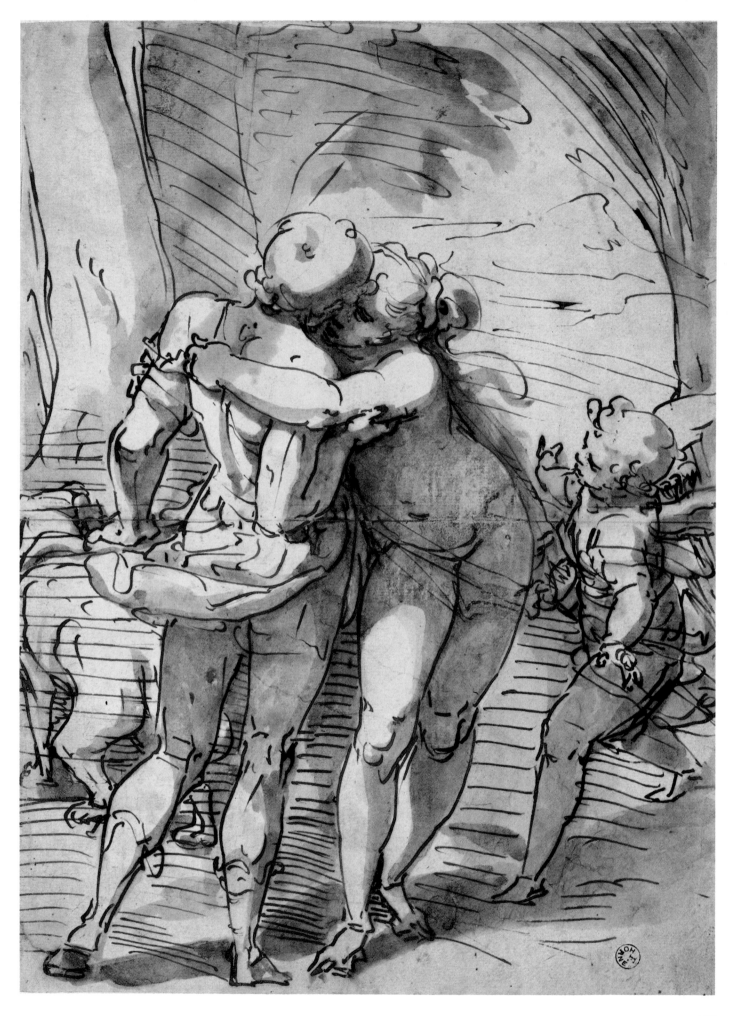

125

The Sixteenth Century in Venice

Giorgio da Castelfranco, known as Giorgione (Castelfranco Veneto 1477?–Venice 1510). Giorgione became associated with the Bellini workshop at the age of twenty. To it he brought – through his own innovative talent – a lyrical naturalism which was, at the same time, in tune with the humanistic atmosphere of the early sixteenth century. Very few documented works remain to us: the *Tempest* in Venice, the *Venus* in Dresden, the *Three Philosophers* (or *Three Magi*) in Vienna, and several portraits. Stricken with the plague when only about thirty-three years old, he nevertheless succeeded, in his short working life, in bringing about some fundamental revolutionary changes in the artistic theme. These can be seen in the thematic, linguistic and technical differences in painting before and after his influence had made itself felt. He introduced the principles of a lyrical and naturalistic approach to art and emphasized the tonal effects of colour, preparing the way for the very much freer style that was to characterize sixteenth-century Venetian painting as the use of oils came to be better understood and enjoyed. Drawings by Giogione are few and those there are relate mainly to graphic work for Giovanni Bellini's paintings. This rarity may well be due to the eminently painterly nature of his pictures.

Lorenzo Lotto (Venice 1480–Loreto 1556). Lotto received his training under the Bellini brothers, then at the age of twenty-three went to Treviso. During his four-year stay in this Veneto town, his development was complicated by influences from Lombardy and Northern Europe; his youthful works were particularly inspired by the realism of Dürer, as seen in his *Bishop de'Rossi*, in Naples, and his Asolo altarpiece of 1506. He completed the great altar at Recanati in 1508 before going to Rome, where his style underwent a complete transformation from his having seen the work of Raphael. He left Rome for the Marches, living from 1513 to 1526 in Bergamo, where he painted altarpieces for the churches of San Bartolomeo and San Bernardino, and produced designs for the intarsia-work in the Cathedral. After a short stay in Venice, where his altarpiece *St Nicholas of Bari in Glory* for the church of Santa Maria del Carmelo (1529) was badly received by the critics, he wandered between Treviso and the Marches in search of commissions but met with little success. He recorded this part of his life in a strange little book which he called *Libro di spese diverse*

('Book of various expenditures'). When he was seventy-two he entered a monastery in Loreto, where he died four years later. A solitary artist, unfortunate in the lack of understanding the revolutionary nature of his painting met with, Lotto is recognized today as a portraitist of outstanding quality and stylistically the precursor of Mannerist disquietude. A great many of Lotto's drawings are extant, mostly taken from life, which show that he had an unusual talent for illustration.

Sebastiano Luciani, called del Piombo (Venice *c.* 1485–Rome 1547). This artist spent his early working years in Venice, under the influence of Giorgione. During this period (1508–11) he completed two paintings for the organ of San Bartolommeo a Rialto and an altarpiece for the high altar of San Giovanni Crisostomo. He then moved to Rome where he assisted in the decoration of the Villa Farnesina, in the stylistic range of Raphael and Michelangelo. In 1529 the title of the Papal Seal was conferred on him, hence the name by which he was known, *del piombo* ('of the leaden seal'). From that moment he never moved out of Rome again, and indeed died there eighteen years later. He was above all a great portraitist. He revived the principles of design used by Raphael, combining them with the rich colouristic effects of the Venetians.

Tiziano Vecellio, known as Titian (Pieve di Cadore *c.* 1490–Venice 1576). Having been brought up in Venice, Titian spent his artistically formative years under the guidance of the Bellini brothers and Giorgione. Some of his work bears a close resemblance to that of the latter, especially his *Concert Champêtre* (or *Pastorale*) in the Louvre. He also put the finishing touches to a number of Giorgione's works after the latter's rather sudden death. One of these was the *Venus* now in the Gemäldegalerie, Dresden. Titian then reigned supreme among the Venetian painters and his position was left in no doubt when he was commissioned to paint the *Assumption* altarpiece for the church of Santa Maria Gloriosa dei Frari, which he completed between 1516 and 1518. He was then summoned to the castle of Ferrara to decorate the Camerino di Alabastro for Duke Alfonso, the pictures for which are now in Madrid and London. Titian was appointed to the office of Painter to the State, which included the privilege of being the

official portraitist of the Doges. He also executed a number of works, one of which was another altarpiece for the Frari, the *Madonna of the Pesaro Family*; this was nominally intended as an expression of thanksgiving, but was in fact a means of glorifying the donors. It was completed in 1526. In 1530 Titian met the Holy Roman Emperor, Charles V, in Bologna, where he was made a Knight of the Empire as a token of imperial appreciation of a series of portraits. By 1545 he was in Rome as a guest of the Farnese family; while there, he painted the elderly Pope Paul III, both as sole subject and with his two nephews. Michelangelo praised Titian's masterly handling of colour but regretted the lack of interest Venetian artists showed in *buon disegno* by which he meant both drawing and design in the sense of composition, this last including a meaning that developed in Mannerist Italy *c.* 1540–1600 under the influence of Neoplatonism and the notion of the Platonic Idea – that of the ideal vision or *disegno interno* the artist had of his work before beginning it. The term had mystical overtones: an analogy was drawn between the activity of the artist and that of the Creator which found expression in the anagram *Disegno, segno di Dio*, 'Design is the sign of God'. Having returned to the Imperial Court of Augsburg in 1548, Titian painted a portrait of the Emperor and of his son who, when Charles V abdicated about eight years later, became Philip II of Spain. Titian had become his favourite artist and devoted himself almost entirely to working for the Spanish king. In the last years of his life Titian changed his style, as can be seen from his *Pietà*, which remained unfinished due to the artist's death from the plague in 1576. During these final years he executed his pictures without contours, moulding shapes with patches of colour and tortuous effects of light in a kind of 'magical impressionism' which only serves to emphasize his amazing imaginative capacity. Titian was deeply interested in the graphic element in art, whether producing his own xylographs (i.e. an early type of wood-engraving in which the woodcut produced a design in white lines on a predominantly black ground) or looking at reproductions of his pictures made by other engravers. There are about fifty of his drawings extant which can be closely related to the stylistic development of his painting.

Domenico Campagnola (Venice 1500–Padua 1564). Domenico was a follower of Giulio Campagnola, from whom he learnt to use the engraving technique that had gained so much popularity as it spread southwards from the Germanic States. He then developed a style that so closely resembled that of Titian that their work was often confused. He in fact co-operated with Titian on the frescoes in the Scuola del Santo in Padua, as well as on other frescoes in the same city. In later life Domenico Campagnola returned largely to graphic work, especially landscape compositions in which he developed, albeit somewhat rigidly, a number of Titian's motifs.

Giovan Antonio de'Sacchis, known as Pordenone (Pordenone *c.* 1484–Ferrara 1539). Having remained in Venice for some time under the influence of Giorgione, Pordenone painted his first major work, the *Madonna della Misericordia*, in the town of his birth. He then moved on into central Italy and Rome, where he found himself irresistibly fascinated by the work of Michelangelo. On leaving Rome, he returned to Venice, dividing his time between that city and Ferrara (1520), where he performed the task of an innovator by introducing the Tuscan–Roman culture into his own area, to an extent that even impressed Titian. Pordenone's numerous preliminary drawings, especially those for Cremona Cathedral (1522) demonstrate clearly the close linguistic link between his work and that of Michelangelo. He remained in Emilia for quite a long time, working on frescoes at Cortemaggiore and Piacenza, gradually adopting much of the Mannerism of Correggio. Towards the end of his life, Pordenone returned to Venice, where he executed two major works. One was in the Sala dello Scrutinio (no longer extant) in the Doge's Palace. The other is his *Annunciation*, completed in 1537, for the church of Santa Maria degli Angeli on Murano. His last days, however, were spent in Ferrara.

Andrea Meldolla, known as Schiavone (Zadar *c.* 1520–Venice 1563). From his earliest working days as an artist, Schiavone found himself in tune with Mannerism through the prints of Parmigianino. He therefore devoted a great deal of his own talents to engraving and his drawings are numerous. Having left his native land of Dalmatia when quite young, he first made a name for himself by painting large *cassoni*. He is better remembered, however, for such works as those in the Old Library of St Mark's, painted in 1556, in which the style is elegantly Mannerist. Towards the end of his brief life, Schiavone seems to have returned to his fascination for Titianesque emphasis on colouristic effects, while still maintaining his linear accentuation.

Jacopo da Ponte, known as Bassano (Bassano *c.* 1517–1592). Having spent his pupilage in Venice under the guidance of Bonifacio dei Pitati, in about 1540 Jacopo returned to his birthplace, Bassano, never to leave it again. He nevertheless succeeded in retaining close cultural links with Venice, where he ranked among the best artists of his day. His most interesting phase occurred while he was developing a feeling for Mannerism, through the prints of Parmigianino (*The Beheading of the Baptist*, *c.* 1550, Copenhagen). His thematic material developed a particularly rustic flavour, with considerable importance given to landscape, as in his various 'Adorations' of the Magi and of the shepherds, which almost established the basic requirements for an autonomous category. The later works by Bassano, such as the *Baptism of St Lucille* (1581), contain a strange luministic quality, especially the nocturnal effects. Such a large output of paintings implies considerable graphic preparation, and numerous examples of this survive. There is some discussion, still unresolved, as to which of these were the real preliminary 'cartoons' and which the 'records' made purely to be distributed among the various workshops run by the artists' sons and nephews.

Jacopo Robusti, called Tintoretto (Venice 1518–1594). The most important of the Venetian Mannerists, Tintoretto from his earliest days drew heavily for his style on the work of Michelangelo and Parmigianino, achieving a dynamic quality and linear skill heightened by effects of light and changing chromatic values that to the Venetian eye were strangely 'modern'. This was especially true of his *Miracle of St Mark Rescuing a Slave* which caused quite a scandal when it was first revealed in 1548. It soon came to be accepted, however, and paved the way for several commissions for the Confraternities (*scuole*) such as the Scuola di San Marco (1560) and the Scuola di San Rocco (1564–87). The poetic instinct in Tintoretto led him to represent his religious motifs with dramatic exultation in a popular and pro-

foundly emotive way. His painting technique was rapid and confident, but to achieve this he worked out the details in a number of preliminary drawings, for which he would even use artificially lit lay figures. His greatest works, the *Battle of Zadar* and the *Paradise*, were painted in the Doge's Palace in about 1590, while the *Last Supper* in the church of San Giorgio Maggiore was executed in the last year of his life.

Domenico Tintoretto (Venice *c.* 1560–1635). The son of Jacopo, and his father's most faithful collaborator, he frequently kept the more realistic and descriptive parts – including the landscape – to do himself. His style can best be seen in the numerous sheets of drawings, executed in brush-blobs of ink and heightened with white bodycolour, especially in rustic themes taken from life.

Domenikos Theotocopoulos, known as El Greco (Candia 1541–Toledo 1614). Trained from 1560 onwards among the *madonneri* of Venice, the modest, anonymous producers of images of the Madonna, El Greco was greatly influenced by the work of Michelangelo, seen on a visit to Rome in 1569. In 1577 he went to Spain and remained in Toledo for the rest of his life. El Greco used colours much as he had seen them used in Venice to express the highly emotional religiosity of Catholic and anti-reformist Spain. His major works were inspired by a disturbing mysticism, for example the *Disrobing of Christ*, painted in 1579 and now in Munich, and the *Burial of Count Orgaz*, painted in 1596 for the church of Santo Tomé in Toledo. They seem to represent a hallucinated humanity reaching out towards visions of a celestial world. The few drawings that are attributed to him are notable for their dependence on Tintoretto – whose work El Greco followed closely as a young man – and their relationship to his paintings.

Jacopo Negretti, known as Palma Giovane ('the Younger') (Venice 1544–1628). Greatnephew of Palma Vecchio ('the Elder'), Jacopo received his youthful training in Urbino and Rome, thus ensuring his development along Mannerist lines. At the age of twenty-six, he returned to Venice as an assistant to Titian and found himself called upon to do all kinds of painting, as there were no longer any great masters available. He worked in the Doge's Palace, the Oratorio dei Crociferi (1583–91), the Scuola

di San Fantin (*c.* 1600) and innumerable other religious buildings. He was a tireless painter and thousands of his drawings are extant, often bound as notebooks (preserved in Munich and London), all of them having served as studies and preliminary work for his paintings.

Paolo Caliari, known as Veronese (Verona 1528–Venice 1588). Having spent his formative years in Verona, he had been vulnerable to the Mannerist influences of nearby Mantua, where Giulio Romano was painting, and of Parma, where Correggio and Parmigianino had their workshops. He soon moved to Venice and in 1551 painted the altarpiece for the church of San Francesco della Vigna. After working for about a year (1553–4) in the Doge's Palace, he executed some very successful paintings in the Old Library of St Marks (1556). He had in the meantime begun the decoration of the church of San Sebastiano, which he completed in 1570 after fifteen years' work with canvases and frescoes. This undertaking became one of his masterpieces. During the years 1559 to 1560, Veronese was working on his wonderful frescoes in the Villa Barbaro (now Villa Volpi) designed by Palladio on the mainland at Maser. His colouristic effects reached their peak of perfection here, with colour and draughtsmanship coming together to provide a happy combination of luminosity. He spent his later years repainting some of the Doge's Palace after the great fire. In the Sala del Collegio he painted the ceiling and also a huge canvas celebrating Venice's victory over Lepanto (1576–7), and nine years later completed his *Triumph of Venice* in the Sala di Maggior Consiglio. Veronese had a large workshop and could therefore call upon the collaboration of several assistants in the execution of his huge projects. As a result, the graphic aspect of his work was very important, as it was necessary to have patterns, cartoons for frescoes and records of completed work. There is thus a wide range of techniques in the drawings, ranging from lightning pen-sketches to elaborate chiaroscuro brushwork on tinted paper and large figure sketches in pastels.

Carletto Caliari (Venice 1570–96). The son of Paolo, Carletto was also one of his assistants, along with his brother Gabriele and his uncle Benedetto. Besides the few paintings identified as his, Carletto is notable for a series of portraits executed in different shades of

pastel. It is these that reveal his careful, detailed style, similar to that of Bassano whose pupil he was.

Federico Zuccari (Zuccaro) (Sant'Angelo in Vado *c.* 1540–Ancona 1609). Younger brother of the better-known Taddeo Zuccari, Federico was an architect and treatise writer as well as a fine painter. He can be categorized as a late Roman Mannerist; the main characteristics of his work are the importance of the drawing and the surprising contrasts of his changing colours. After working with his brother on the frescoes of the Palazzo Farnese and of the Sala Regia in the Vatican, he completed the dome (started some years before by Vasari) of the cathedral of Santa Maria del Fiore in Florence. After working for some time in Spain and England, he returned to Rome, where in 1593 he established the Accademia di San Luca and where, five years later, he was made a prince.

Giorgione (Castelfranco 1477?–Venice 1510)
A Shepherd Boy
Sanguine on yellowed paper; 8 × 11½ in.
(203 × 290 mm.)
Provenance: Resta; Böhler; Koenigs
Rotterdam, Museum Boymans-van
Beuningen, inv. I-485

The fine hatching of this drawing, which is
still in the Bellini tradition, blends in with
the meticulously clear-cut depiction of the
landscape, with its distinct German
derivation. The scenery is stylistically akin to
that of the *Madonna* in Leningrad, while the
figure of the shepherd in the foreground
bears a distinct resemblance to the figures in
the *Tramonto* ('Sunset') in London. The
sheet has been damaged due to an unwise
attempt by Resta to clean it with warm
water.
Bibliography: Tietze, 1944, no. 709;
Haverkamp Begemann, 1957, no. 38;
Pignatti, 1978, no. 15

Lorenzo Lotto (Venice 1480–Loreto 1556)
Head of a Woman
Silverpoint, brushwork in opaque white-lead
pigment on pale blue paper; 8⅜ × 5½ in.
(211 × 138 mm.)
Provenance: Bossi
Venice, Gallerie dell'Accademia, inv. 114

A realism which is typical of Lotto
characterizes this 'Head' so delicately
sketched in silverpoint. The marked
influence of Dürer in the clear-cut
representation of the features contrasts
strongly with the Bellini tradition within
which Lotto spent his formative years; it
would seem, therefore, that this drawing
belongs to his more youthful phase, and is to
be dated to about 1506 when he was
painting such pictures as his *Ritrattino*
('Little Portrait') in Bergamo.
Bibliography: Tietze, 1944, no. 324; Pignatti,
1973, no. 9; *Giorgione a Venezia*, 1978, p. 76

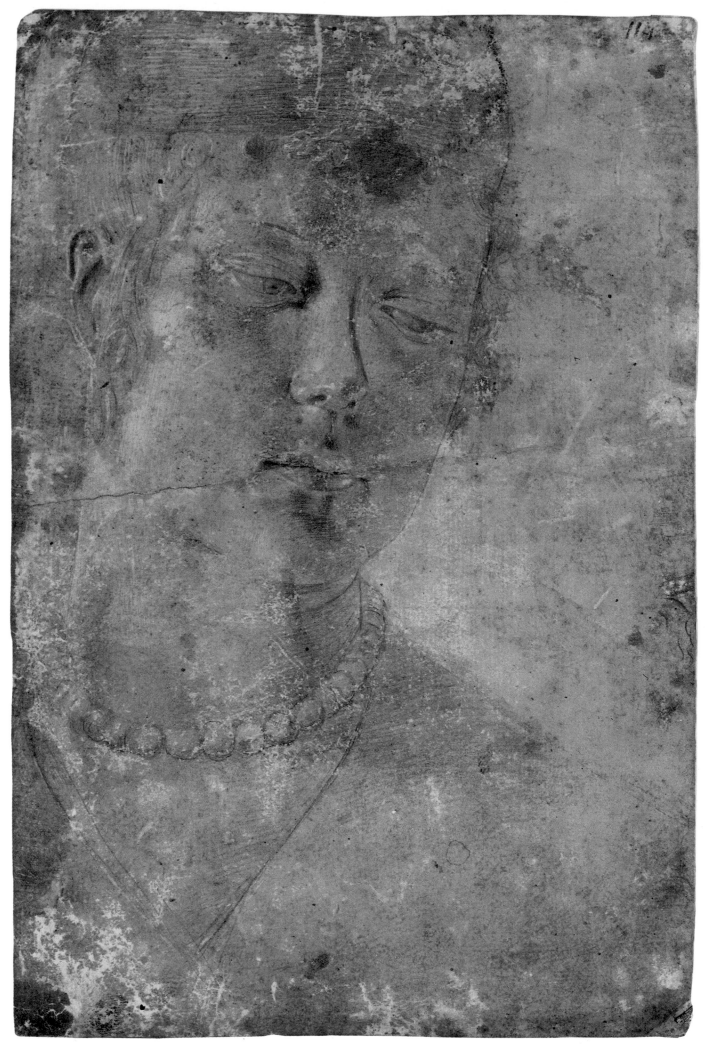

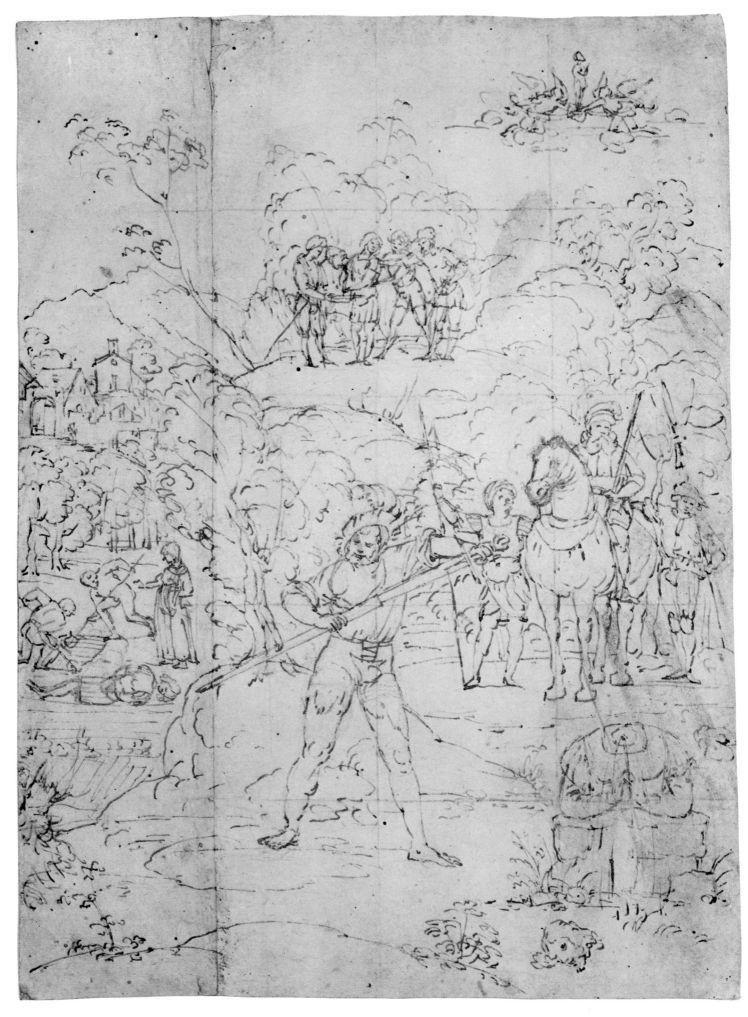

132

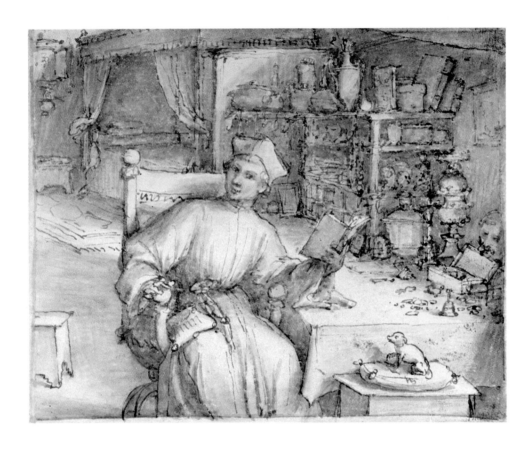

Lorenzo Lotto
Martyrdom of Saint Alexander of Bergamo
Pen and brown ink, squared in black chalk;
$10\frac{5}{8} \times 7\frac{3}{4}$ in. (271 × 197 mm.)
Provenance: Calmann
Washington, DC, National Gallery of Art,
Ailsa Mellon Bruce Fund, inv. B-25, 789

The stylistic similarity of these sketches to
two known studies for the intarsia-work in
Bergamo Cathedral make it possible to date
this folio – probably part of a sketchbook
long since lost – to the 1520s, when Lotto
was working in Bergamo. The fable-like
narrative tone and meticulous portrayal of
character which stamp the frescoes executed
in 1524 in the Villa Suardo, Trescore, can be
seen reflected in this sheet, whose subject
matter is drawn from the same source.
Bibliography: [Overhuber], 1974, p. 64;
Pignatti, 1974, no. 12; Robison, 1978, no. 41

Lorenzo Lotto
Prelate in His Study
Pen, brush and brown ink highlighted with
opaque white-lead pigment; $6\frac{3}{8} \times 7\frac{3}{4}$ in
(162 × 198 mm.)
Provenance: Phillips; Fenwick
London, British Museum, inv. 1951-2-8-34

The lively and detailed portrayal of indoor
domestic objects is one of the more
outstanding features of Lotto's work. This
can be seen particularly in paintings from
about 1525, such as his *Annunciation* in
Recanati. The fragmentary lines and
emphasis on the play of light suggest that
this folio belongs to the artist's mature
phase.
Bibliography: Popham, 1951, p. 72;
Pouncey, 1965, p. 15; Pignatti, 1970, pl. XIII

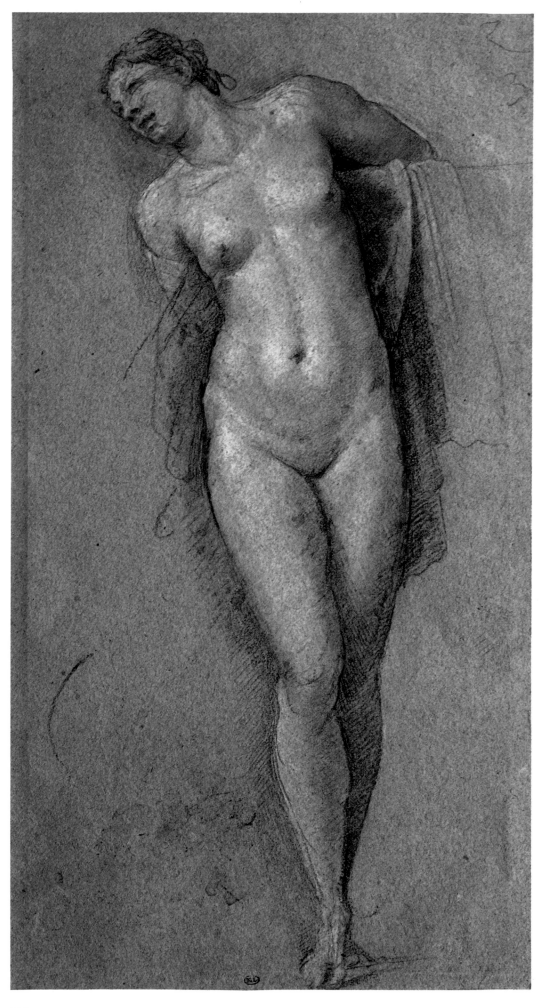

Sebastiano del Piombo (Venice *c.* 1485–Rome 1547)
Nude Woman Standing
Black chalk heightened with white on azure paper; $14 \times 7\frac{3}{8}$ in. (353 × 189 mm.)
Provenance: Jabach; Cabinet du Roi (1671)
Paris, Musée National du Louvre, inv. 10.816

This female nude can be related, with a few changes, to the figure of the saint herself in the *Martyrdom of St Agatha* (Pitti Palace, Florence), painted in 1520. During this period of his work, Sebastiano achieved his three-dimensional quality – which he had derived from Michelangelo – by means of a particularly painterly representation which is typically Venetian in style, as is the technique of using black chalk heightened with white on azure paper.
Bibliography: Pouncey, 1952, p. 116; Berenson, 1961, no. 2497 c; Bacou-Viatte, 1975, no. 69

Titian (Tiziano Vecellio) (Pieve di Cadore *c.* 1490–Venice 1576)
Portrait of a Young Woman
Black chalk heightened with white chalk on yellowed sky-blue paper; $16\frac{1}{2} \times 10\frac{3}{8}$ in. (419 × 264 mm.)
Provenance: Fondo Mediceo-Lorenese (?)
Florence, Galleria degli Uffizi, inv. 718E (*r*)

This drawing is a fine example of Titian's preference for black chalk or charcoal on azure paper for his figure studies. Stylistically, it is very similar to the dense brushwork of his Paduan frescoes, which were completed in 1511. Even in this youthful work, Titian was striving to achieve that soft, painterly quality that was to typify his more mature drawings.
Bibliography: Tietze, 1944, no. A1899; Rearick, 1976, no. 16; Pignatti-Chiari, 1979, pl. XII

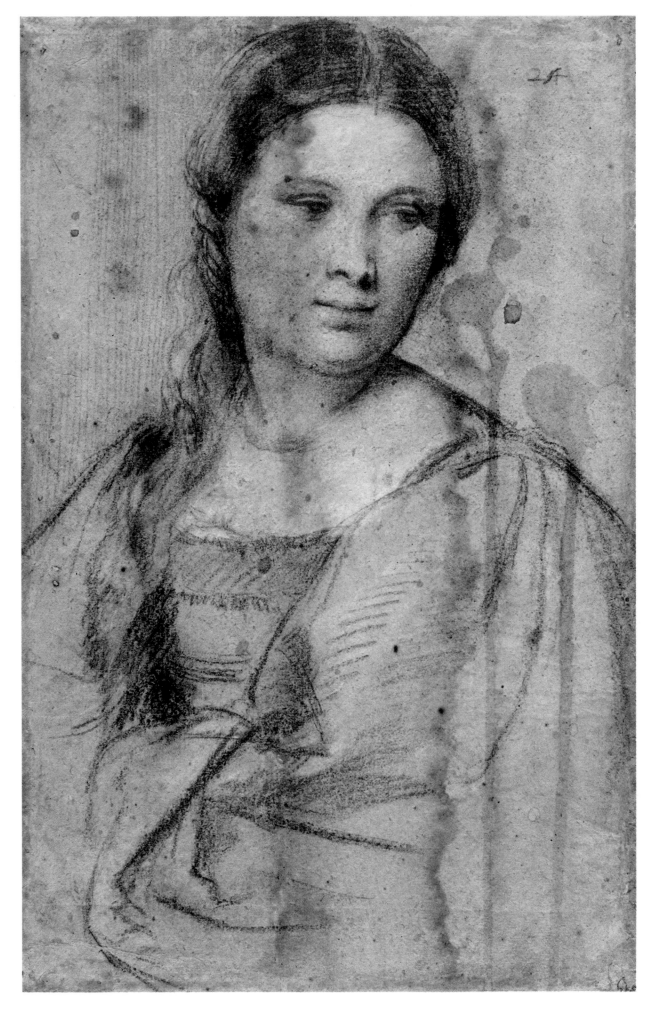

136

Titian (Tiziano Vecellio)
Mythological Couple Embracing sometimes
called *Jupiter and Io*
Charcoal highlighted with opaque white-lead
pigment on azure paper; $9\frac{3}{4} \times 10\frac{1}{4}$ in.
(252 × 260 mm.)
Provenance: Richardson; Ricketts; Shannon
Cambridge, Fitzwilliam Museum, inv. 2256

The significance of this scene remains a
mystery, as does the relationship of the
drawing to any specific work by Titian. It

undoubtedly belongs to his late phase, as is
clear from the vigorous strokes and violent
shafts of light and shadow which emphasize
the vitality of movement. In the 1550s, when
he was already well over sixty, he tended
towards an increasingly painterly style in his
graphic work, the plastic form dissolving
into pure effects of light.
Bibliography: Tietze, 1944, no. 1886;
Oberhuber, 1976, no. 43; Pignatti-Chiari,
1979, pl. XLIV

Titian (Tiziano Vecellio)
*Pastoral Landscape with Nude Woman
Asleep*
Pen and brown ink highlighted with opaque
white-lead pigment; $7\frac{5}{8} \times 11\frac{3}{4}$ in.
(195 × 298 mm.)
Chatsworth, Devonshire Collection, inv. 64

The broad, open-air feeling of the
composition, combined with a carefully
descriptive representation of Nature, are the

fundamental characteristics of a series of
landscape scenes drawn by Titian and
datable to the 1560s. The artist had long
since abandoned the Germanic graphic style
that had influenced him as a young man and
in this late stage of his life was concentrating
on essentially painterly effects with skilful
balance of warm lights and deep shadows.
Bibliography: Byam Shaw, 1969, no. 68;
Oberhuber, 1976, no. 46; Pignatti-Chiari,
1979, no. LIII

RF.

138

Domenico Campagnola
(Venice 1500–Padua 1564)
The Judgement of Paris
Pen and brown ink; $9\frac{3}{4} \times 7\frac{7}{8}$ in.
(248 × 200 mm.)
Provenance: Jabach; Cabinet du Roi (1671)
Paris, Musée National du Louvre, inv. 5519

This work by Domenico Campagnola was
for a long time attributed to Titian. Apart
from certain Northern characteristics, with
particular echoes of Dürer, it displays
uncertainties in anatomical construction and
lack of plasticity typical of the
draughtsmanship of a young man who was
still influenced by the production of
engravings in 1517 to 1518, although his
graphic style is demonstrably more free. He
had already begun to sketch in a
background landscape, and this was to
become a fundamental element in his
subsequent graphic work.
Bibliography: Tietze-Tietze Conrat, 1939,
pp. 451–3; Tietze, 1944, no. 537; Bacou-
Viatte, 1968, no. 47

Pordenone (Pordenone
c. 1484–Ferrara 1539)
Martyrdom of St Peter, Martyr
Sanguine; $9\frac{5}{8} \times 8\frac{1}{8}$ in. (244 × 207 mm.)
Provenance: Flinck; William, 2nd Duke of
Devonshire
Chatsworth, Devonshire Collection, inv. 746

This drawing, with its clean-cut lines in
sanguine, is given a painterly effect by means
of heavily hatched shadows. It is associated
with the *modello* (i.e. a small version of the
proposed final work) which Pordenone
entered for the competition promoted by the
church of San Zanipolo in Venice (1526–8)
for a painting on the subject of 'St Peter,
Martyr'. Titian actually won. Drawings such
as this were typical of Pordenone's creative
process; he not only studied the
relationships between masses but also
stressed any foreshortenings, light and
details of costume. He was the first artist to
introduce the principles of Mannerism into
the Venetian area.
Bibliography: Strong, 1902, no. 24; Wragg,
1962–3, no. 51; Cohen, 1980, p. 66

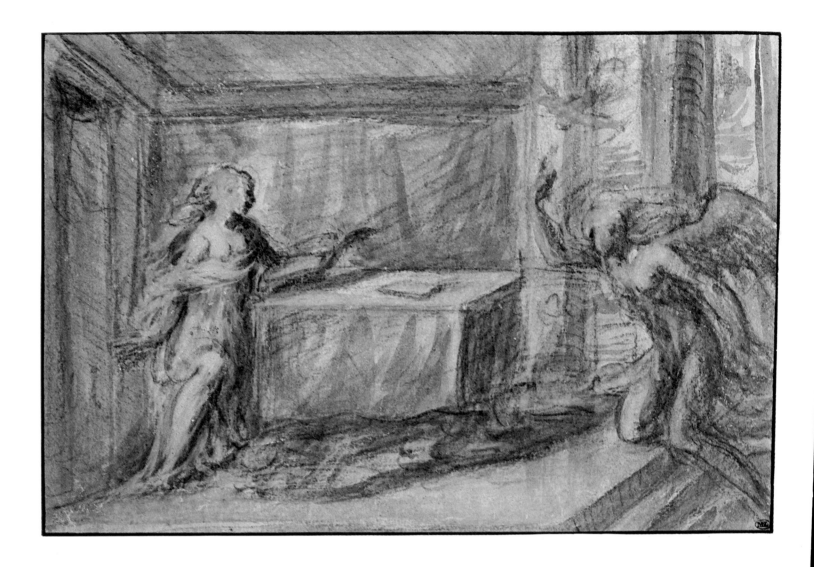

Andrea Schiavone
(Zadar *c*. 1520–Venice 1563)
The Annunciation
Black chalk, brush and light brown ink
heightened with white on yellow paper;
$6\frac{5}{8} \times 9\frac{5}{8}$ in. (170 × 246 mm.)
Provenance: entered during the Revolution
Paris, Musée National du Louvre, inv. 9954

The typical flowing line achieved by
Schiavone in his late Mannerist phase,
illustrated in this drawing, can be related to
the paintings he executed in 1550 for the
chancel of the church of Santa Maria del
Carmelo, which includes an 'Annunciation'.
The use of charcoal and watercolour on
yellow paper gives the impression of painting
en camaïeu (or *grisaille*), a feature which can
be seen in many of the drawings he executed
on coloured paper in the latter part of his
life.
Bibliography: Bacou, 1964, no. 102; Bacou-
Viatte, 1968, no. 62

Jacopo Bassano (Bassano *c*. 1517–92)
Head of a Woman
Brush and brown, grey, red and white oils
on brownish paper; $14 \times 9\frac{7}{8}$ in.
(353 × 249 mm.)
Provenance: de Ligne; Albert von Sachsen-
Teschen
Vienna, Graphische Sammlung Albertina,
inv. 17656

The plastic force and interest in the
psychological aspect are the main
characteristics of this expressive portrait of a
woman, executed in a particular brush-and-
oil technique on brownish paper which
provoked doubt as to the correct attribution.
It nevertheless remains one of the
masterpieces among Bassano's vigorous and
expressive graphic works.
Bibliography: Stix-Fröhlich Bum, 1926,
no. 71; Arslan, 1960, p. 380; Koschatzky-
Oberhuber-Knab, 1971, no. 65

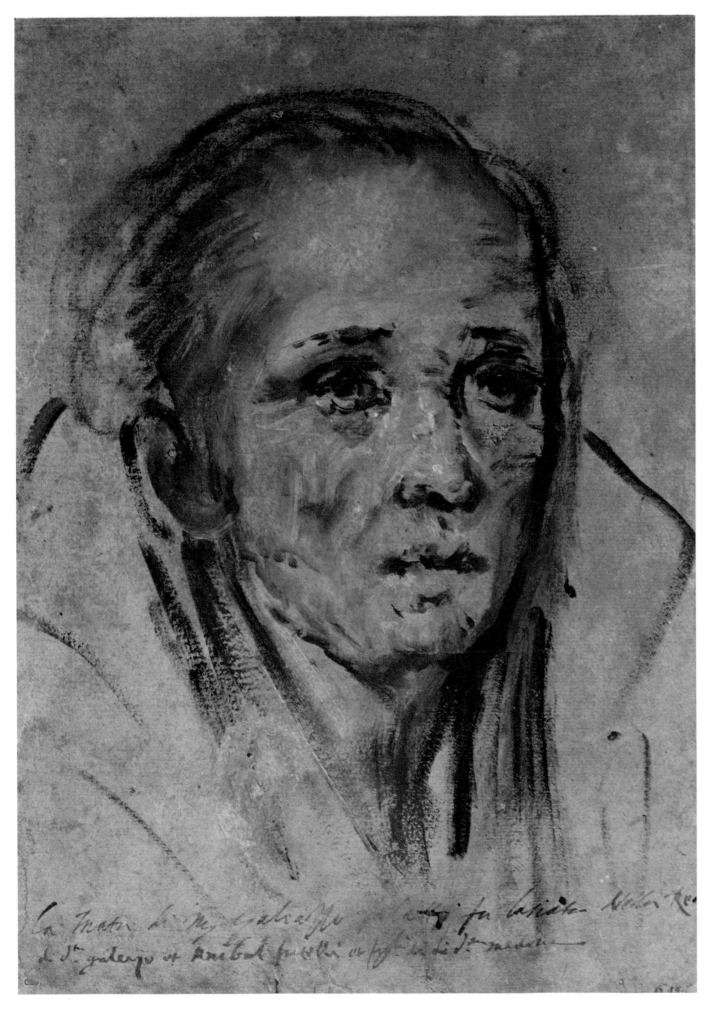

La Matre di Ms Galeasso _____ ___ fu laside Nellis Re
d. S. galeasso et Anibal fratelli ___ __ si d. ____

Jacopo Bassano
The Flagellation
Coloured chalks on azure paper; 16 × 21 in.
(407 × 535 mm.)
Provenance: Borghese; Marignane;
Calmann
Washington, DC, National Gallery of Art

A preparatory work for the *Flagellation* in
the Gallerie dell'Accademia, Venice, this
exceptional drawing carries the inscription
'1568/da agost 1º' ('1568/about 1 August')
and is the first example in Jacopo's work of
a preliminary study in coloured chalks. He
took full advantage of the possibilities
offered by the medium by producing a
complete impression of the finished painting,
indicating the relationships of coloured areas
as well as the chiaroscural and plastic effects.
Bibliography: Tietze, 1944, no. 163; Rearick,
1962, p. 525

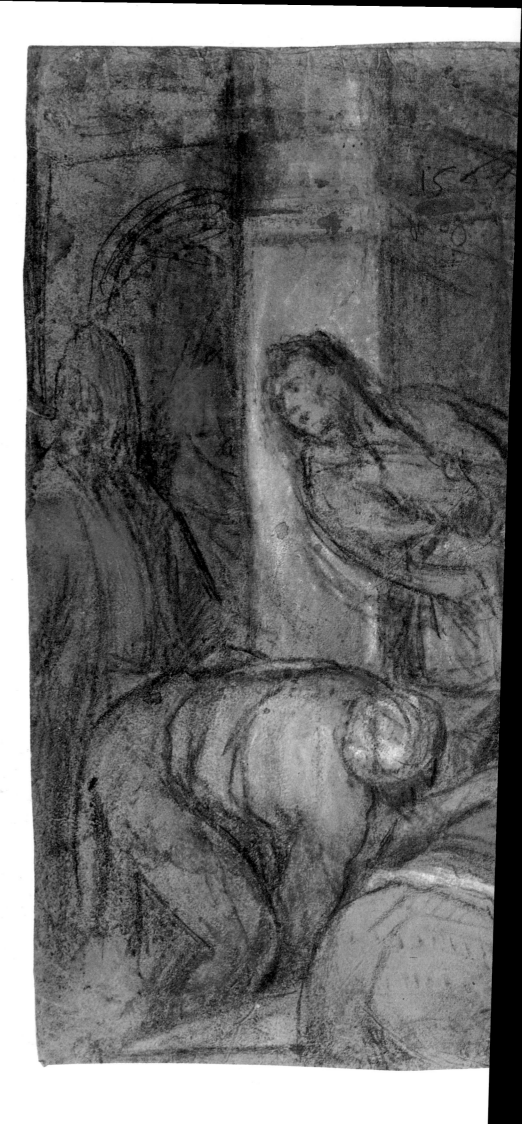

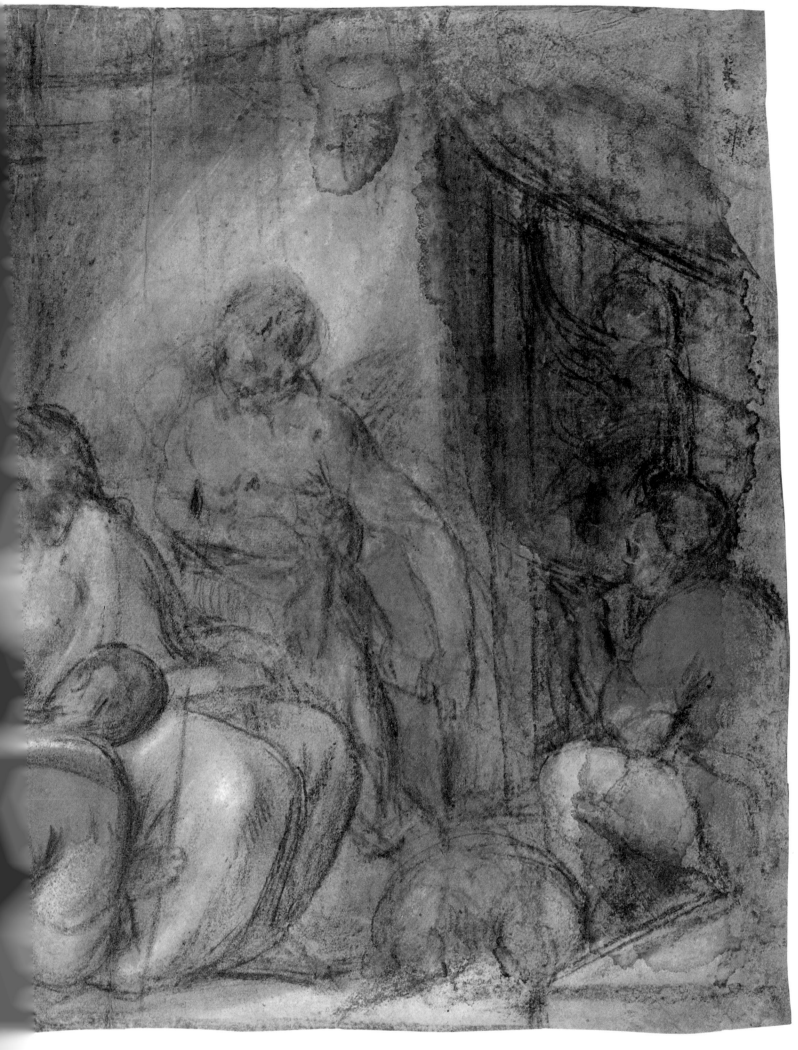

143

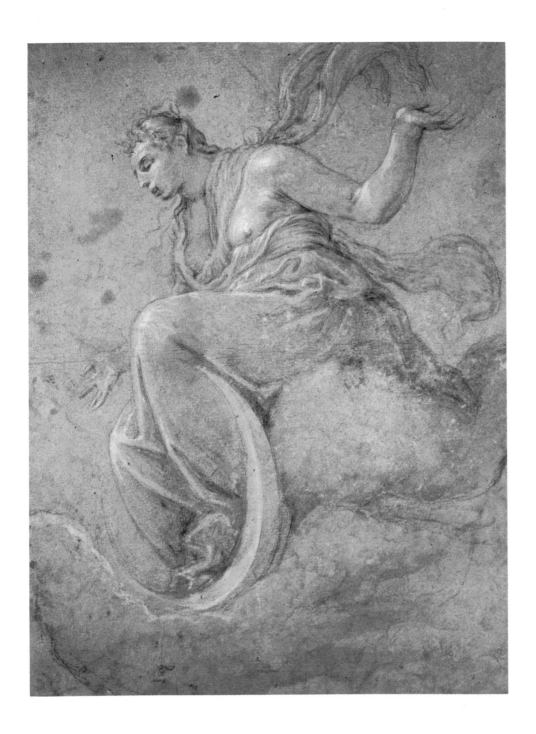

Jacopo Bassano
Diana
Black chalk heightened with white on azure
paper; 20 × 15 in. (508 × 379 mm.)
Provenance: Lely; Guise
Oxford, Christ Church, inv. 1341

This drawing, which is of a very high
pictorial standard, represents an unusual
subject in the repertoire of Bassano and
probably relates to a Diana who appeared
among the clouds in a performance of *The
Sacrifice of Iphigenia*. The remarkable size of
the sheet and speed of line suggest that it is a
preliminary cartoon in the artist's own hand
rather than a record to be retained in the
workshop to be filed away as evidence of
work done.
Bibliography: Ballarin, 1969, p. 107; Byam
Shaw, 1976, no. 751; Pignatti, 1976, no. 44

Jacopo Tintoretto (Venice 1518–94)
An Archer
Black chalk on light brownish paper;
14 × 8½ in. (354 × 218 mm.)
Florence, Galleria degli Uffizi, inv. 12929 F

This drawing is the preliminary study for
one of the archers in the *Battle of Zadar* on
which Tintoretto worked 1584–7 for the Sala
dello Scrutinio in the Doge's Palace. It has
been squared-up for enlargement. As in the
majority of his preliminary studies, the artist
has sought above all to convey the
impression of the figure in movement. This
he does by making use of a characteristic
sequence of curved lines which seem to
express amazing energy.
Bibliography: Tietze, 1944, no. 1590; Rossi,
1975, p. 20

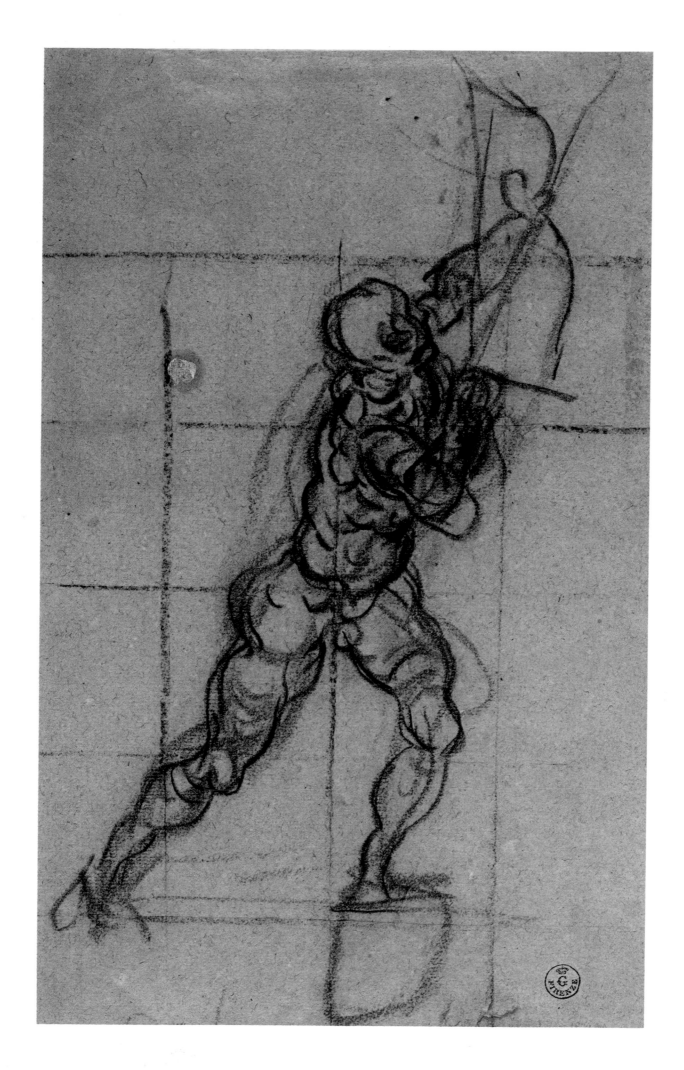

145

Jacopo Tintoretto
Venus, Vulcan and Mars
Pen and brush with black ink, highlighted
with opaque white-lead pigment on azure
paper; 8 × 10¾ in. (202 × 272 mm.)
Provenance: Pacetti; entered in 1843
Berlin, Kupferstichkabinett, inv. 4193

This study, which is a preliminary drawing
for the painting now in the Alte Pinakothek,
Munich, is unique in the graphic work of
Tintoretto, both in its technique and
composition. Whilst it is therefore difficult to
date it accurately solely on the basis of style,
nevertheless the plasticity of the figures and
accentuation of the light seem to indicate a
date when he would certainly have been no
older than about thirty-two.
Bibliography: Tietze, 1944, no. 1561; Rossi,
1975, p. 15; Dreyer, 1979, no. 37

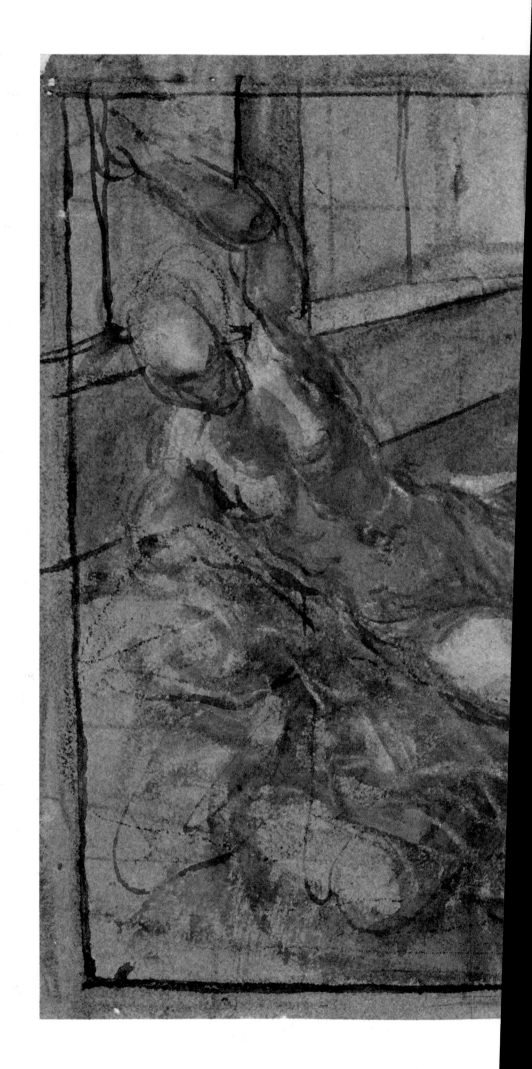

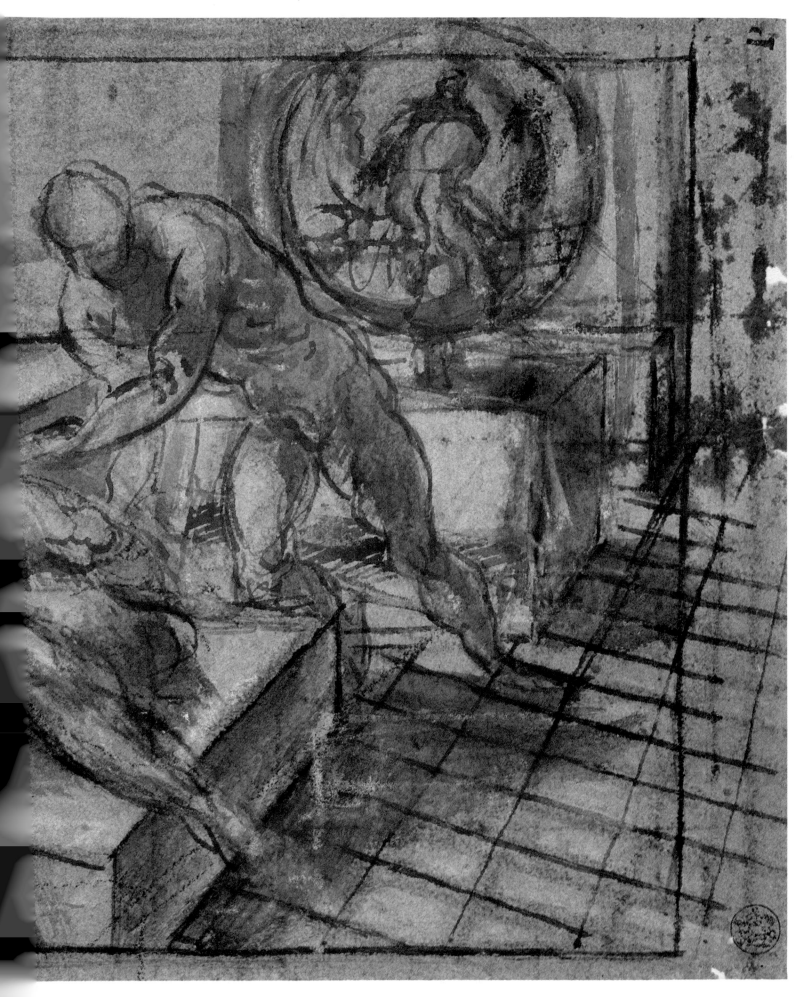

Domenico Tintoretto (Venice *c.* 1560–1635)
Rustic Scene
Charcoal and brush, grey tempera and
opaque white-lead pigment on light azure
paper; $9\frac{7}{8} \times 14\frac{1}{8}$ in. (250 × 360 mm.)
Provenance: Simonetti, entered in 1910
Florence, Museo Horne, inv. 5934

This drawing, which may well be a study
from life, can be related to background
events in several of Domenico's *Scenes in the
Life of St Mark*, which he painted towards
the end of the 1580s for the Confraternity of
the Scuola di San Marco. The influence of
the experimentation carried out by his
father, Jacopo, for his huge canvases in the
lower chamber of the Scuola di San Rocco,
can clearly be seen in its luminosity which
already savours of the Baroque.
Bibliography: Tietze, 1944, no. 1509;
Ragghianti Collobi, 1963, no. 114; Pignatti,
1970, pl. XVII

El Greco (Candia 1541–Toledo 1614)
A Study from 'Day' by Michelangelo
Black and white chalks with watercolour on
azure paper; $23\frac{1}{2} \times 13\frac{5}{8}$ in. (598 × 346 mm.)
Provenance: Vasari; Mannheimer
Munich, Staatliche Graphische Sammlung,
inv. 41597

This rare drawing, for which the artist used
the Michelangelo sculpture *Day* as his
exemplar, was almost certainly executed by
El Greco during his short stay in Venice
1570, while under the influence of
Tintoretto. The sheet was originally
horizontal, but Vasari reduced it to its
present dimensions so that it would conform
to the sizes of the volumes in his own
collection.
Bibliography: Baumeister, 1929, p. 201;
Wethey, 1962, II, p. 151; Halm-Degenhart-
Wegner, 1958, no. 45; Pérez Sánchez, 1970,
pl. II

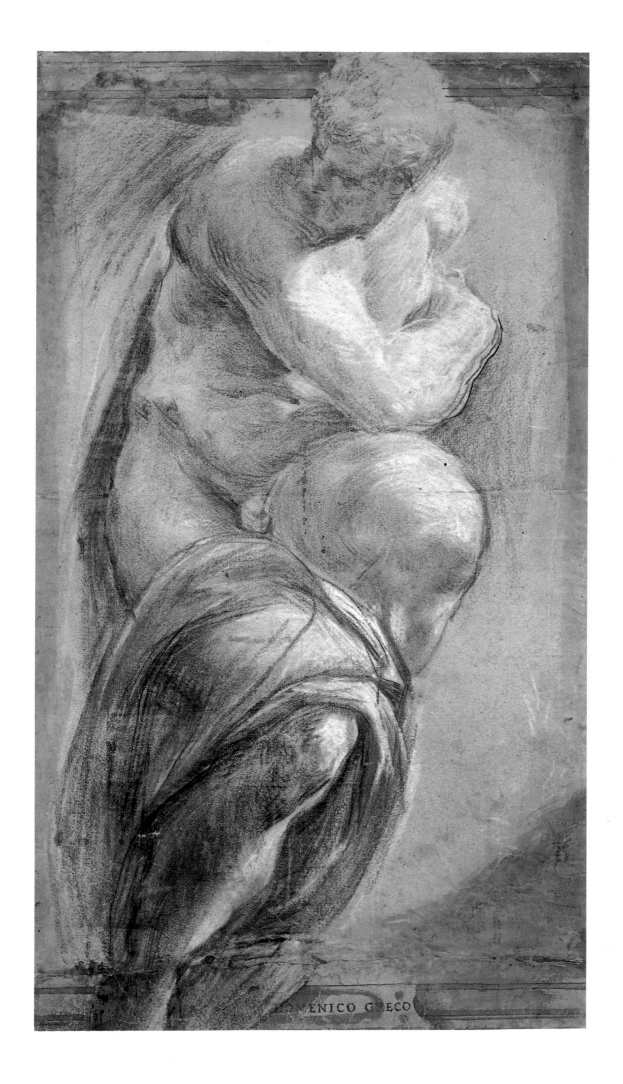

Jacopo Palma (il)
Giovane (Venice 1544–1628)
The Deposition
Pen and watercolour wash heightened with
gold on greenish-grey paper; $8\frac{3}{4} \times 5\frac{1}{2}$ in.
(223 × 140 mm.)
Provenance: Lagoy; Wildenstein
Chicago, Art Institute of Chicago, Kate. S.
Buckingham Fund, inv. 1962.376

This drawing is stylistically datable to about
1600. Its finished appearance and rather
unusual technique of pen and watercolour
wash, heightened with gold on coloured
paper, make the picture a work of art in its
own right. Such polish leads to the
supposition that Palma probably intended it
for some connoisseur collector.
Bibliography: Joachim, 1963, no. 7; Pignatti,
1974, no. 33

Paolo Veronese (Verona 1528–Venice 1588)
A Sheet of Studies
Pen and brown ink; $12 \times 8\frac{1}{4}$ in.
(305 × 210 mm.)
Provenance: Lely; Guise
Oxford, Christ Church, inv. 0341

This sheet is covered with a great many very
lively sketches in pen and brown ink, and
annotated in the artist's own hand. The
studies, which are on both sides of the paper,
nearly all relate to the *Coronation of the
Virgin*, now in the Gallerie dell'Arte in
Venice but originally in the church of
Ognissanti (All Saints') in the same city. This
was a work undertaken by Veronese late in
life, and a great deal of the painting was
clearly done by his workshop assistants.
Bibliography: Tietze, 1944, no. 2128; Byam
Shaw, 1976, no. 793; Pignatti, 1976, no. 45

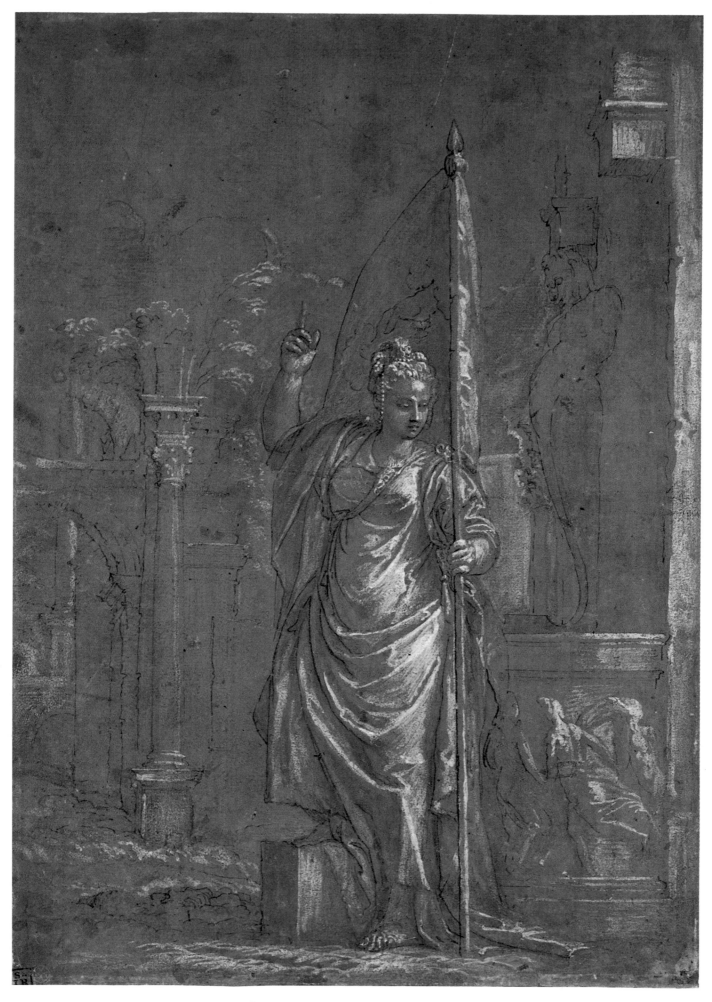

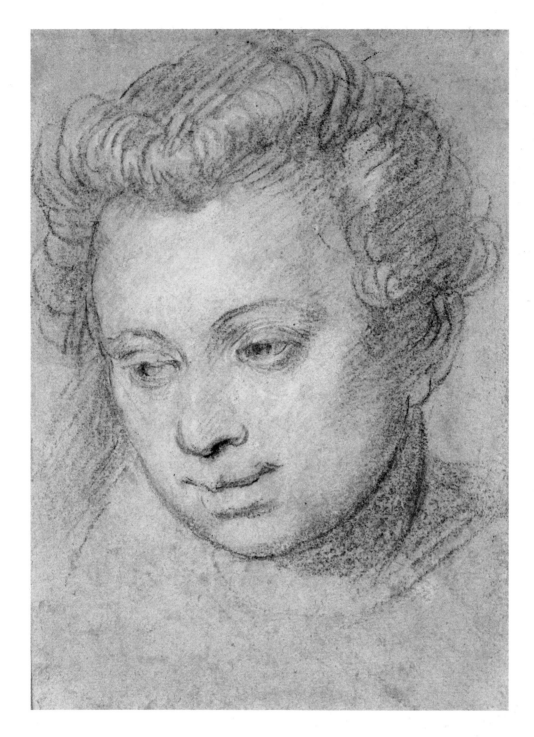

Paolo Veronese
Victory
Pen and bistre highlighted in white on prepared grey-azure paper; $15\frac{1}{4} \times 10\frac{7}{8}$ in. (386 × 276 mm.)
Provenance: Reynolds; Fries; Albert von Sachsen-Teschen
Vienna, Graphische Sammlung Albertina, inv. 1636

In its perfection of form and technique, Veronese has achieved in this allegorical figure one of his most successful expressions of graphic virtuosity. The accent on luminosity with its changing effects, together with the sensuality, so typical of the artist's major works, are the most outstanding qualities of this fine example of chiaroscuro.
Bibliography: Stix-Fröhlich Bum, 1926, no. 112; Tietze, 1944, no. 2187; Koschatzky-Oberhuber-Knab, 1971, no. 66

Paolo Veronese
Head of a Woman
Black and white chalk on azure paper; $10\frac{1}{2} \times 7\frac{1}{4}$ in. (267 × 185 mm.)
Provenance: Blake
Chicago, Art Institute of Chicago, Gift of Mrs Tiffany Blake, inv. 1962.809

Chalk studies from life are rarities in the vast corpus of Veronese's graphic work. There is no doubt, however, that this delicate 'Head' is the work of the master himself. Its soft half-tone effect and the luminosity of the white heightening are reminiscent of the chromatic classicism of the frescoes which he completed in Maser about 1560.
Bibliography: Tietze, 1944, no. 2097; Joachim, 1963, no. 5; Pignatti, 1974, no. 22

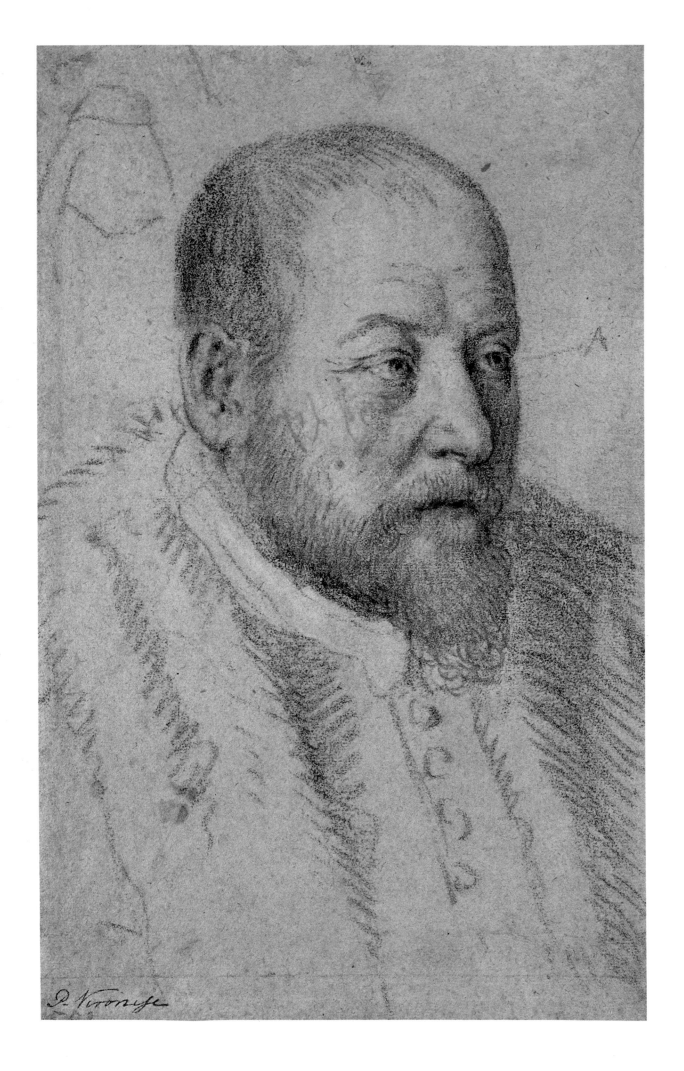

P. Veronese

154

Carletto Caliari (Venice 1570–96)
Head of a Man
Black, brown and red chalk with traces of
white on grey-azure paper; 11¾ × 7 in.
(288 × 179 mm.)
Provenance: Sagredo (?); West; Lawrence;
Warwick; entered in 1936
Oxford, Ashmolean Museum

Carletto Caliari, the son of Paolo Veronese,
spent some of his early years in the
workshop of Jacopo Bassano, hence the
graphic style of some of his 'Heads'. It was
this influence that led to his coloured pencil
portraits in the Marignane Collection having
been attributed to Leandro Bassano.
Bibliography: Parker, 1936, p. 27; Tietze,
1944, no. 230; Parker, 1956, no. 111

Federico Zuccari (Sant'Angelo in Vado
c. 1540–Ancona 1609)
*Taddeo Zuccari as a Boy in the House of
Giovanni Piero 'il Calabrese'*
Pen, brush and brown ink; 11 × 10⅝ in.
(277 × 271 mm.)
Florence, Galleria degli Uffizi, inv. 10993F

A great sense of liveliness and realistic
spontaneity distinguishes this sheet, through
the vibrant effects of light achieved in the
brushwork. The scene illustrates an incident
in the apprenticeship of the artist's brother,
Taddeo, with Giovanni Piero, known as *'il
Calabrese'*. This study is one of a number
which relate to a series of paintings depicting

incidents in the life of the young Taddeo
(1529–66); they were probably conceived by
Federico to decorate a room in his palazzo
on the Pincian Hill in Rome.
Bibliography: Heikamp, 1957, p. 205; Gere,
1966, no. 75

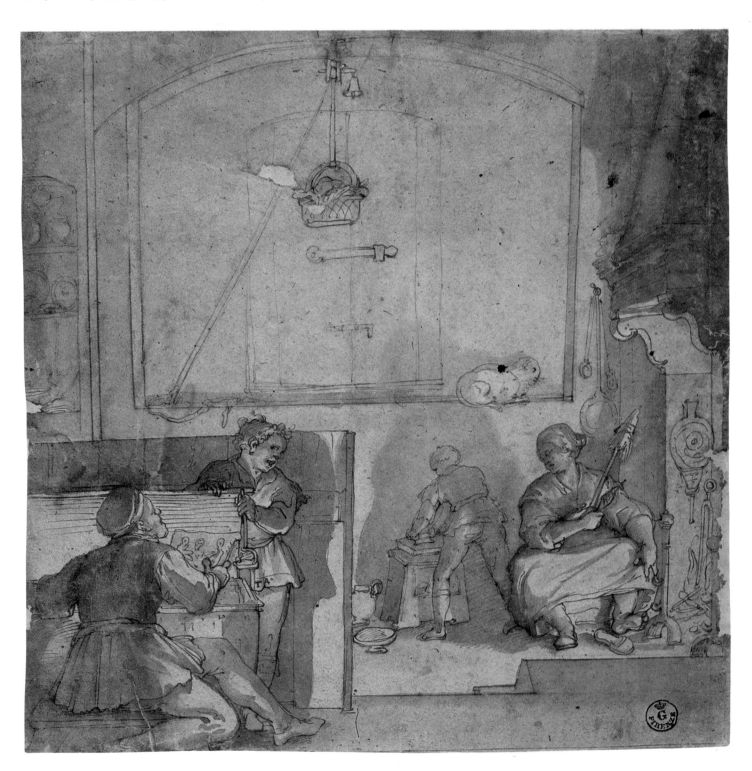

155

The Sixteenth Century in Northern Europe

Martin Schongauer (Colmar 1453–Breisach 1491). Martin, who came from a family of goldsmiths, did much to develop the art of engraving. Dürer learnt a great deal from his work in the formation of his own skills, although they never met. Schongauer's paintings link the Germanic late Gothic styles with the improved spatial and chromatic organization of the Flemish artists. The only reasonably well-attested example of his work is the *Madonna in the Rose Garden* in the church of St Martin, Colmar, painted in 1473.

Albrecht Dürer (Nuremberg 1471–1528). The son of a goldsmith, Dürer was inspired by the engravings of Schongauer and it was not long before he had evolved a style for himself that was both realistic and at the same time outstanding in form and imagination. At first he concentrated mainly on metal engraving and xylography – a method of wood-engraving that produced a white line – of which his *Apocalypse*, executed in 1498, is a fine example. A visit to Venice 1494–5 brought him into contact with the spirit of the Renaissance, an influence that can be seen both in prints and drawings such as *Adam and Eve* and in his painting *Adoration of the Magi* (1504), now in the Uffizi Gallery, Florence. Having returned to Venice, in 1505, he completed the *Feast of the Rose Garlands* (1506) for the church of San Bartolomeo (but now in Prague) as well as numerous portraits and Madonnas. Somewhat influenced by Bellini, he in his turn had a considerable effect on younger Venetian artists such as Giorgione, Lotto and Titian by depicting his subjects realistically, as the eye actually saw them. Once he had returned to Nuremberg, Dürer did not leave there again except for a short visit in 1520 to Flanders on business. All his mature works were painted for his own city, including *All the Saints*, now in Vienna, and the *Four Apostles* now in Munich. One of the greatest and most prolific draughtsmen that has ever lived, Dürer used the graphic medium as much to satisfy his enquiring mind by working from life – there are many notebooks full of anatomical studies – as to produce working drawings for his paintings. He also executed a number of finished sheets which were intended for collectors, and these were often hand-coloured in watercolour by the artist himself. It is, in fact, mainly through his graphic work that the impact of Dürer's influence has been felt in Western art.

Lucas Cranach the Elder (Kronach 1472–Weimar 1553). As a young man, Lucas Cranach the Elder moved to Vienna where he worked as a portraitist and painter of secular subjects such as his *Venus and Cupid* in the Borghese Gallery, Rome. In 1505 he became Court Painter in Wittenberg to the Electors of Saxony and concentrated more on religious paintings. Among other achievements, he decorated the castles of Coburg, Lochau and Torgau. Cranach was greatly influenced by Dürer in his engravings, although he emphasized the decorative aspects to a greater extent.

Albrecht Altdorfer (?1480–Regensburg (Ratisbon) 1538). Altdorfer is known to have been working in Ratisbon from 1505, when he concentrated on depicting natural scenes. His landscapes are filled with minute and interesting detail, as in his *Wooded Landscape with Castle* and *Alexander's Victory*, now in Munich. The fairy-tale atmosphere of his compositions can also be felt in his numerous drawings, which were particularly useful in spreading his type of Germanic realism in Europe, outside the boundaries of the Germanic States.

Mathis Neithardt-Gothardt, known as Grünewald (Würzburg *c.* 1480–Halle 1528). Very little is known of Grünewald's life. Between 1512 and 1515 he painted the large folding altarpiece for a church in Isenheim (known today as Colmar) which, though he was only thirty-five, proved to be his first masterpiece. He was in the employ of the Archbishop-Elector of Mainz until 1526, when he was suspected of Lutheran sympathies and was compelled to leave. Having escaped to Frankfurt in straitened circumstances, he moved on a year later to Halle, where he was to die. Grünewald had great individualism as an artist. Although he frequently distorted forms in an almost unreal way, he was able to convey emotions with tremendous violence of expression. Even in his few surviving drawings his ability to depict the plastic element, often by making use of chiaroscuro effects on tinted paper, is remarkable.

Hans Baldung, known as Grien (Schwäbisch-Gmünd *c.* 1484–Strasbourg 1545). Having spent his formative years in the Dürerian atmosphere of Nuremberg, he moved to Strasbourg in 1506 and in 1512 to Freiburg, where he remained for about five years.

Grien was a painter of both sacred and secular themes whose subjects were inclined to be macabre and allusive in their expressiveness. His engravings and chiaroscuro drawings on green paper were particularly disturbing in their aggressiveness.

Niklaus Manuel Deutsch (Berne *c.* 1484–1530). Deutsch was greatly influenced by Dürer thematically, both in his more trenchant work as well as in his visionary style. In 1516 he went to Italy as a soldier of fortune, at the same time absorbing something of the Renaissance at first hand. His graphic work has an exceptionally spontaneous quality and he left a great many sheets of pen drawings as well as a series of engravings.

Urs Graf (Solothurn *c.* 1485–Basle 1528). A goldsmith and engraver, Urs Graf went to live in Basle in 1509. He was a rover, however, moving from one war-zone to another with the German–Swiss *lansquenets* (mercenary soldiers), especially in Italy. He took advantage of his surroundings by building up a unique collection of drawings from life and war. Most of these are now in the Basle Museum. Although his initial inspiration came from Dürer, he developed a linear style of his own, often zigzagging, which he embellished with imaginary ornamentation. Outstanding among his many engravings is the *Passion* engraved in 1506.

Lucas Hugenszoon, known as Lucas van Leyden (Leyden 1489/94–1533). Although Lucas was originally an engraver, influenced mainly by the work of Dürer (*The Circular Passion*, 1509), he also specialized in portraits and religious paintings. After staying for a year in Antwerp (1521–2), during which time he met Dürer, his work began to reflect the Romanist culture that had been imported by Mabuse and Jan van Scorel. It had acquired a more flowing, less dramatic, expressiveness than his early pictures, and his *Last Judgement*, painted in 1527 and still in Leyden, is a fine example.

Hans Holbein the Younger (Augsburg 1497–1543). The eldest son of the German painter of the same name, Holbein the Younger was greatly influenced by his first visit to Italy in 1517. From the Lombardy region he returned to Basle, where he lived with his brother, full of enthusiasm for some of the techniques he had seen being developed there – particularly

in the rendering of perspective – in what was by then the High Renaissance. His first important commission was the frescoed decoration on the façade of the house belonging to the government-appointed Mayor, von Hertenstein, in Lucerne, where he lived from 1517 to 1519. Holbein was also developing his skill as a portraitist: here his ability not only to catch the likeness but also to depict psychological depth was outstanding, as is particularly evident in his *Erasmus of Rotterdam*, in Basle. He was in addition an engraver and draughts man, producing sheets of finished drawings specifically to sell to connoisseur collectors. Having completed a commission to paint frescoes – long since vanished – in the Council Chamber in Basle, in 1526 he went to England, where he worked for about eighteen months. On returning to Basle he found that religious disputes were even more rife than when he had previously been there, and in 1531 he returned to England, remaining there for the rest of his life. In London he painted a number of portraits and was employed extensively by Henry VIII as Court Portraitist. Some of the greatest masterpieces of his time – *Henry VIII* in the Galleria Nazionale, Rome, is among them – came from his brush, and there are eighty-five of his drawings for portraits in the Royal Collection, Windsor, alone.

Pieter Bruegel the Elder (Breda? *c.* 1528–Brussels 1569). Having received his training in Brussels, where he attended the studio-workshop of Coecke, he soon became independent. He was particularly interested in depicting the life of ordinary Flemish people. In 1552 to 1553 Bruegel visited Italy, but it had little impact on him and he returned with his own individual poetic attitude still intact. It was on his return that he began to produce his scenes of the people, among which are his well-known series called *Proverbs*, painted in 1559 and now in Berlin, as well as his *Seasons*, 1565, in Vienna. He was a prolific draughtsman, especially in landscape sketches, and it was in this way that he kept a record of all his travels in Flanders and abroad.

Hendrik Goltzius (Mühlbracht 1558–Haarlem 1617). Goltzius was less than twenty years old when he started to produce small, skilfully engraved portraits. His next venture was to reproduce, as prints, the paintings of Bartholomeus Spranger. From 1590 to 1591

he was in Italy and on his return broadened his range of engravings by reproducing some of the works of such masters as Raphael, Parmigianino and Dürer. He was primarily a portraitist and a great many of his drawings relating to this side of his work still survive.

François Clouet (Tours *c.* 1510–Paris 1572). The son of Jean Clouet, whom he succeeded as Court Painter in France, he perfected the technique of executing portraits in pastel, using the '*aux trois crayons*' technique in which a combination of three different colours is used. The psychological insight and graphic elegance displayed in these drawings place them among the most distinguished examples of mid sixteenth-century work in Europe. Among the great names who patronized François Clouet was Catherine de'Medici.

Martin Schongauer
(Colmar 1453–Breisach 1491)
Madonna and Child with a Carnation
Pen and brown ink; $9 \times 6\frac{1}{4}$ in.
$(227 \times 159$ mm.)
Provenance: Nagler; entered in 1835
Berlin, Kupferstichkabinett, inv. 1377

One of the major fifteenth-century German engravers, Martin Schongauer was greatly influenced in his work by Rogier van der Weyden. In this folio there is a blending of the monumental with a feeling of gentle sweetness which clearly illustrates the similarity between the work of the two artists. The drawing also has about it the style of an engraving, with its minute attention to detail and fine, clean line of the pen which bring the aristocratically idealized figure to life.
Bibliography: Friedländer-Bock, 1921, p. 77; Rosenberg, 1923, p. 27; Halm, 1955–6, no. 17

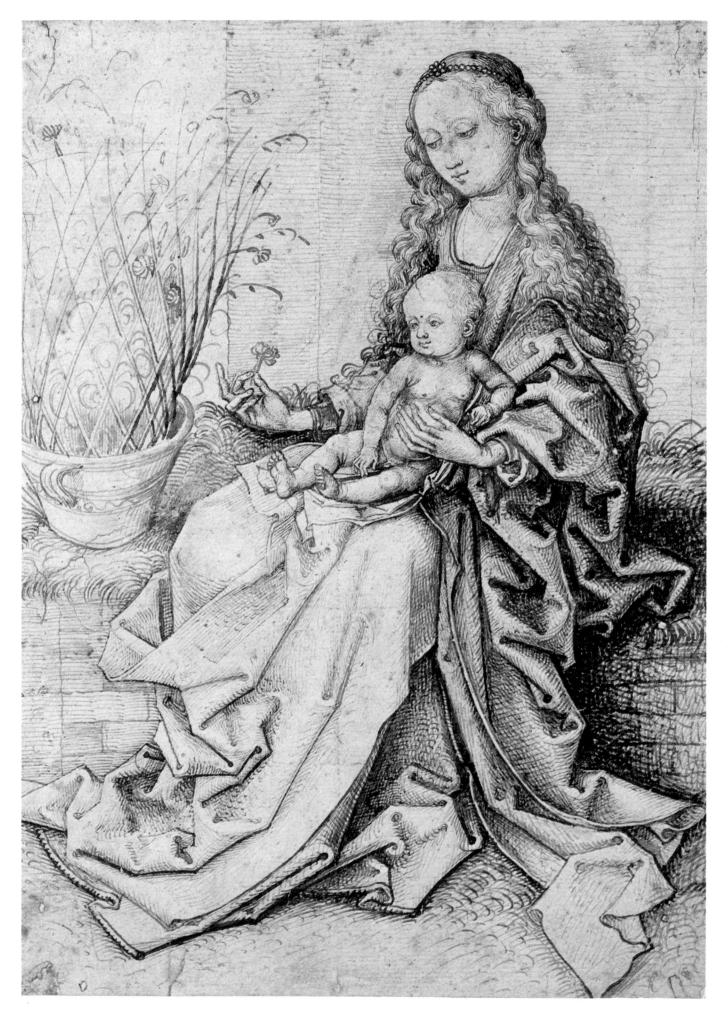

Albrecht Dürer (Nuremberg 1471–1528)
View of Arco
Watercolour and gouache with monogram in brown ink; $8\frac{3}{4} \times 8\frac{3}{4}$ in. (221 × 221 mm.)
Provenance: Jabach; Prioult; Cabinet du Roi
Paris, Musée National du Louvre, inv. 18.579

This landscape, in watercolour and gouache, is generally dated to the period of Dürer's first visit to Venice in 1495. It is inscribed in black ink, in his own hand, *Fenedier Klawsen* ('Venetian outpost'). The fortress at Arco, at the northern tip of Lake Garda, was conquered by the Venetians in 1483 and totally destroyed in 1703. Today, apart from this record of it, only the ruins remain.
Bibliography: Bacou-Calvet, 1968, no. 4; Strauss, 1974, no. 1495/31.

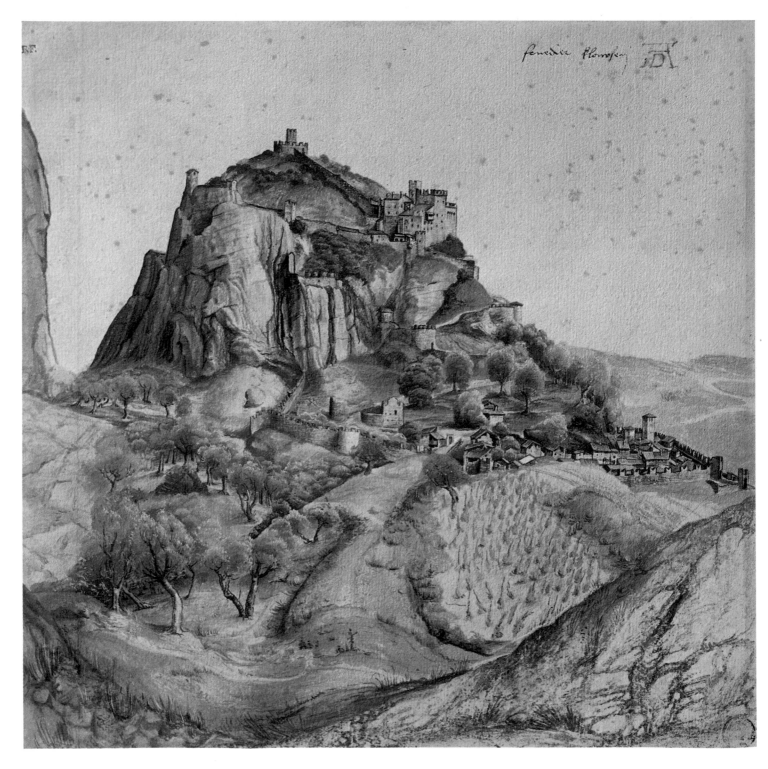

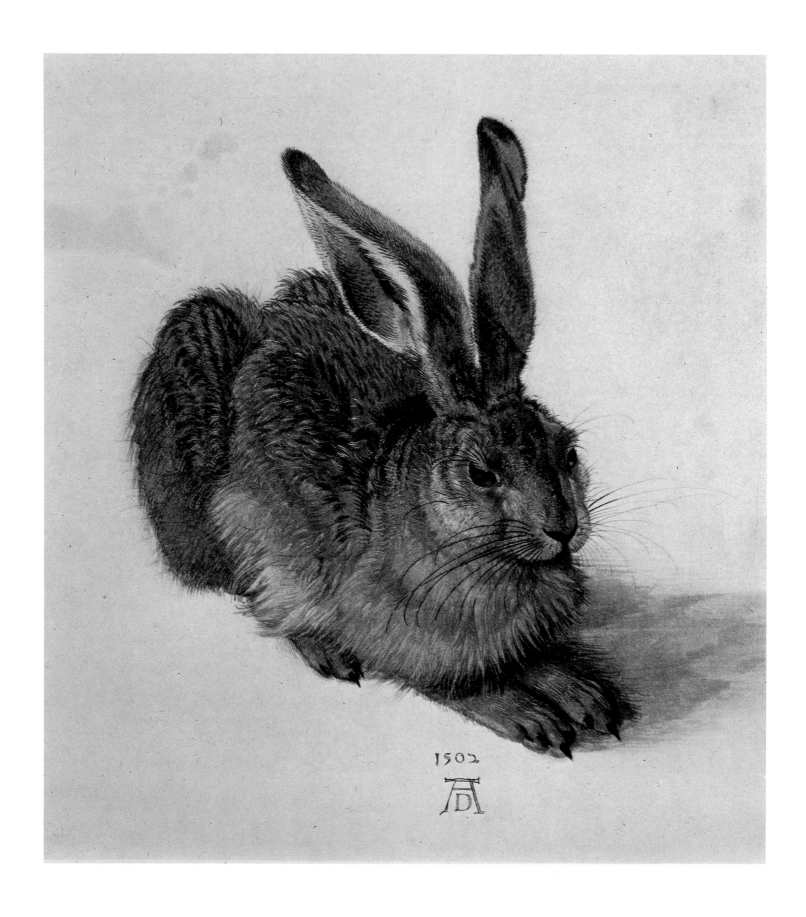

Albrecht Dürer
A Hare
Watercolour with tempera highlights on slightly foxed greenish-yellow paper; $9\frac{7}{8} \times 8\frac{7}{8}$ in. (251 × 226 mm.)
Provenance: Imhoff; Imperial collections Vienna, Graphische Sammlung Albertina, inv. 3073

Breathtaking in its delicacy of brush-line in watercolour and tempera highlighting, this work – with its accurate depiction of the animal's fur – is one of the most famous of Dürer's studies from life. The meticulous treatment of detail in no way detracts from the spontaneity of the whole, making it so much more than a mere scientific study.

Bibliography: Tietze-Benesch, 1933, no. 49; Winkler, 1936, no. 248; Strauss, 1974, no. 1502/2

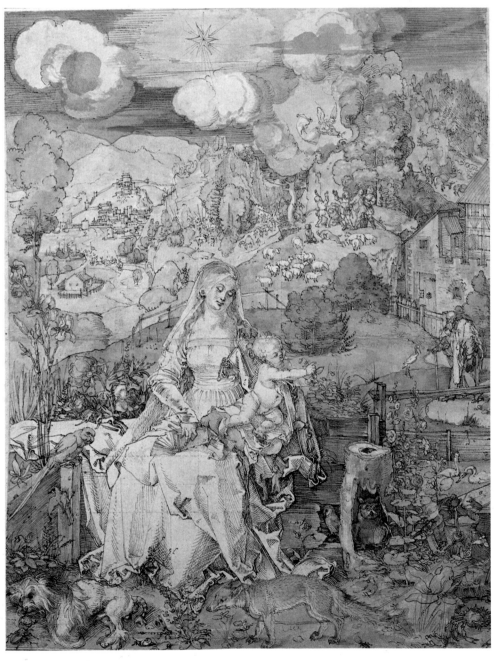

Albrecht Dürer
Madonna of the Animals
Pen, black ink and watercolour; $12\frac{5}{8} \times 9\frac{1}{2}$ in.
(321 × 243 mm.)
Provenance: Rudolph II
Vienna, Graphische Sammlung Albertina,
inv. 3066

Although this sheet bears some resemblance
to the *Life of Mary* engravings executed by
Dürer in about 1503 – the use of
watercolour giving the picture a finished
appearance – the style is also somewhat
reminiscent of a wood-engraving. The whole
scene is pervaded by an air of *intimisme* in
which the animals surrounding the Virgin
and Child tend to become almost the real
subject of the composition, a preliminary
free-style study of which is housed in Berlin.
Bibliography: Tietze-Benesch, 1933, no. 50;
Winkler, 1936, no. 296; Strauss, 1974,
no. 1503/22

Albrecht Dürer
The Large Tuft of Grass
Watercolour and gouache on yellowed
paper; $16\frac{1}{8} \times 12\frac{1}{2}$ in. (410 × 315 mm.)
Provenance: Imperial collections
Vienna, Graphische Sammlung Albertina,
inv. 3075

Another fragment from Nature, studied with
a keen spirit of observation from an unusual
viewpoint at ground level. Dürer has
depicted, with great accuracy, each type of
plant in the piece of turf. He proves his great
technical mastery in this work in the tonal
shading of the greens and browns, as well as
in the picture's almost glassy limpidity,
which recalls some of the Flemish painters.
Bibliography: Tietze-Benesch, 1933, no. 54;
Winkler, 1936, no. 346; Strauss, 1974,
no. 1503/29

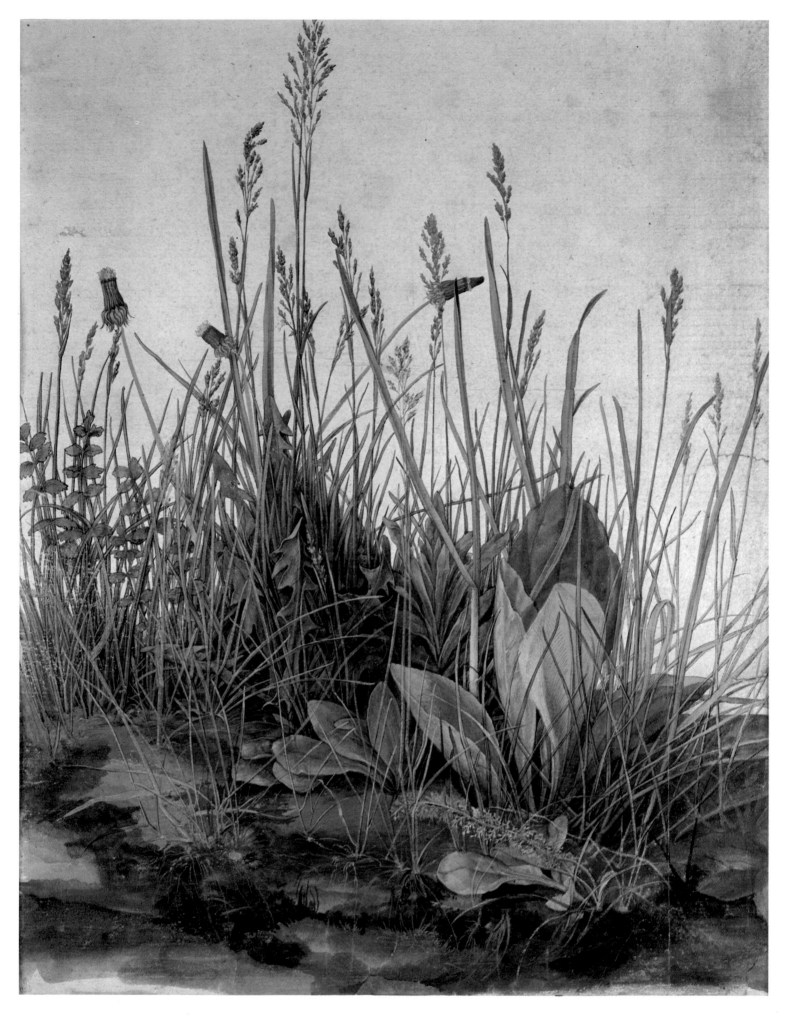

163

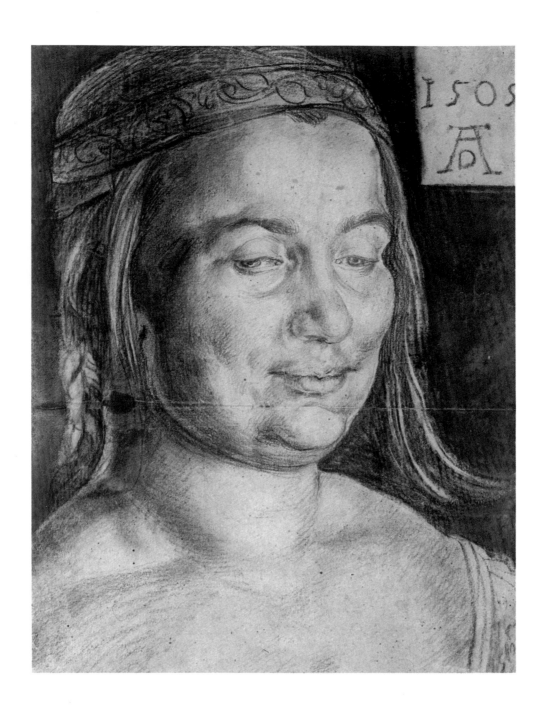

Albrecht Dürer
Head of a Woman
Charcoal with olive green watercolour
background, added afterwards; $13\frac{3}{4} \times 10\frac{1}{2}$ in.
(350×266 mm.)
Provenance: Campe; Vieweg; Eisler;
Koenigs; van Beuningen
Rotterdam, Museum Boymans-van
Beuningen, inv. MB 1947/T 17

This charcoal drawing, which bears Dürer's
monogram and the date of 1505, is executed
on paper that the artist used during his stay
in Venice. The subject is usually said to be a
Slavonian peasant because of the woman's
hairstyle. The way in which Dürer has used
the charcoal indicates his desire to produce a
realistic drawing through strong
characterization and outline shading.
Bibliography: Winkler, 1936, no. 371;
Haverkamp-Begemann, 1957, no. 6; Strauss,
1974, no. 1505/28

Lucas Cranach the Elder
(Kronach 1472–Weimar 1553)
Head of a Man in a Fur Hat
Brush and watercolour, accentuated with a
pen; $7\frac{5}{8} \times 6\frac{1}{8}$ in. (193×157 mm.)
Provenance: acquired in 1937
Basle, Öffentliche Kunstsammlung,
inv. 1937.21

This drawing, of which there is another
version in London, is datable to the early
years of Cranach the Elder in Wittenberg
between 1505 and 1506, because of the
obvious similarity with his youthful
xylographic style. The technique used by the
artist was one he had developed for himself;
rather than draw the portrait he would first
do the painting with brush and watercolour,
afterwards using a pen to emphasize certain
parts of it.
Bibliography: Landolt, 1972, no. 39

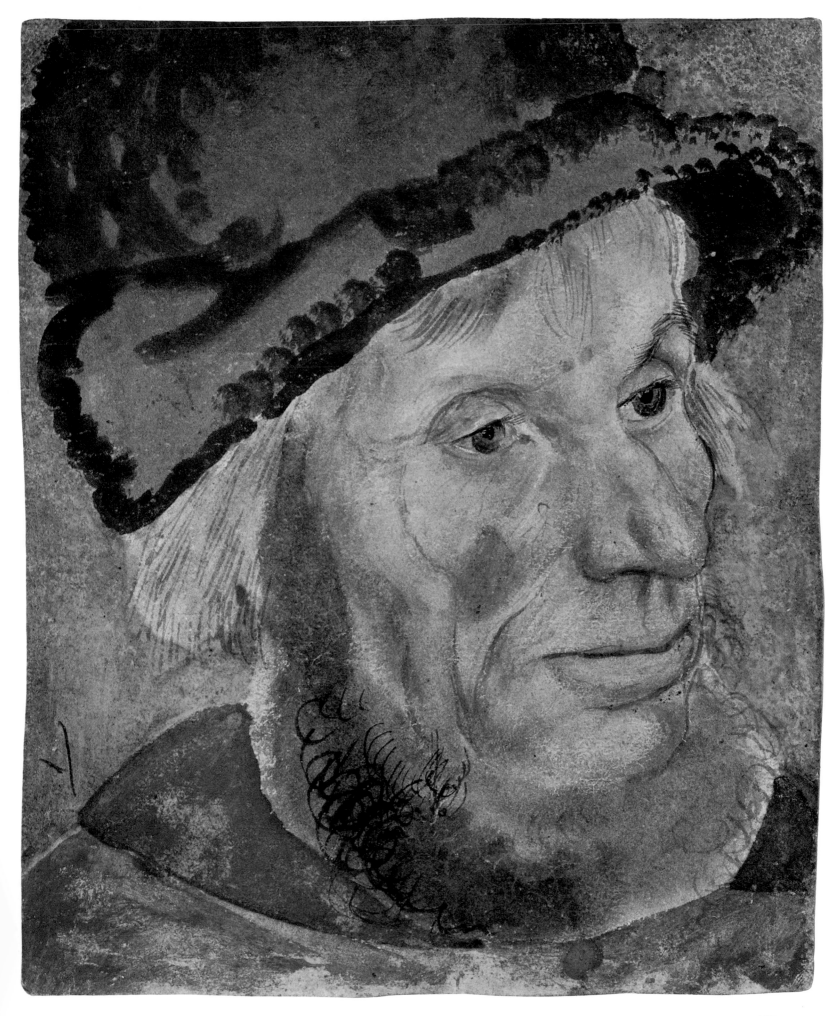

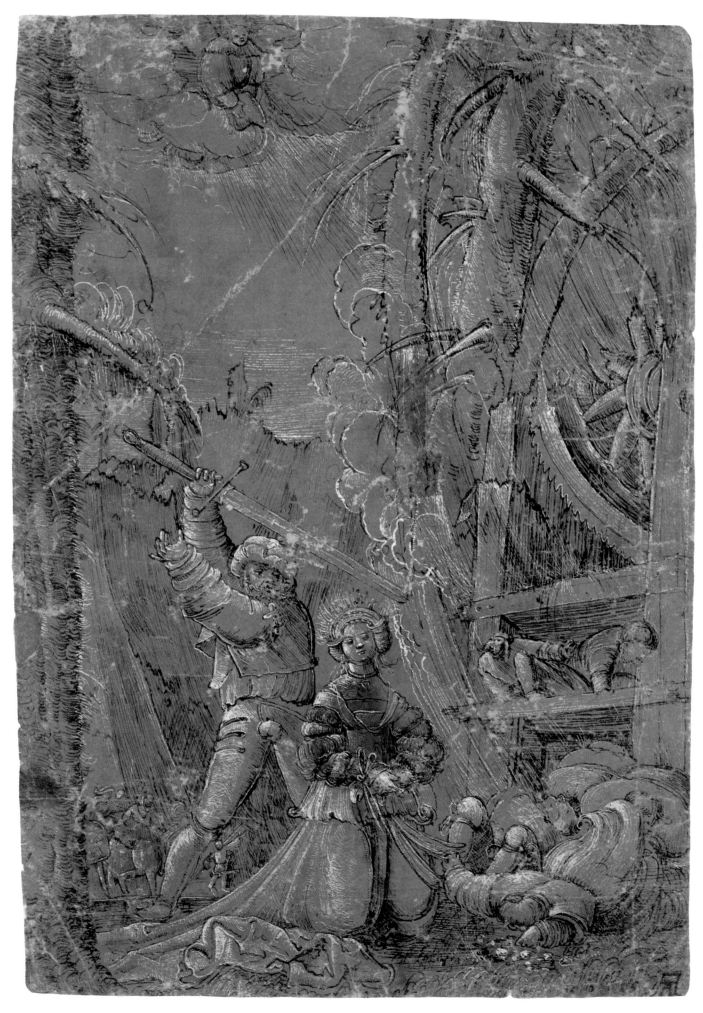

Albrecht Altdorfer (?c. 1480–Regensburg
(Ratisbon) 1538)
Martyrdom of St Catherine
Pen and black ink, heightened with white on
brown paper; $8\frac{1}{8} \times 5\frac{1}{2}$ in. (207 × 141 mm.)
Munich, Staatliche Graphische Sammlung,
inv. 5637

The graphic tension created by the style of
drawing, with light – touched in with the
point of the brush – emerging from the
tinted ground of the paper, all help to build
up a dramatic atmosphere which at the same
time is full of enchantment. This is typical of
Altdorfer's religious works, in which figures
and scenery seem to blend into a strangely
imaginative focal point.
Bibliography: Winzinger, 1952, no. 15;
Halm-Degenhart-Wegner, 1958, no. 29

Mathis Grünewald
(Wurzburg *c.* 1480–Halle 1528)
Three Heads
Black chalk on ivory paper; $10\frac{3}{4} \times 7\frac{7}{8}$ in.
(272 × 199 mm.)
Provenance: Nagler
Berlin, Kupferstichkabinett

A remarkable freedom and breadth of
execution, arising from the artist's use of
chalk rather than the more usual pen, are the
main qualities of this drawing, placing it in
the late period of Grünewald's work. There
have been a variety of interpretations of the
subject, but it should most probably be
identified as a kind of demoniacal trinity.
Bibliography: Friedländer-Bock, 1921,
no. 1071; Schönberger, 1948, no. 35;
Behling, 1955, no. 38

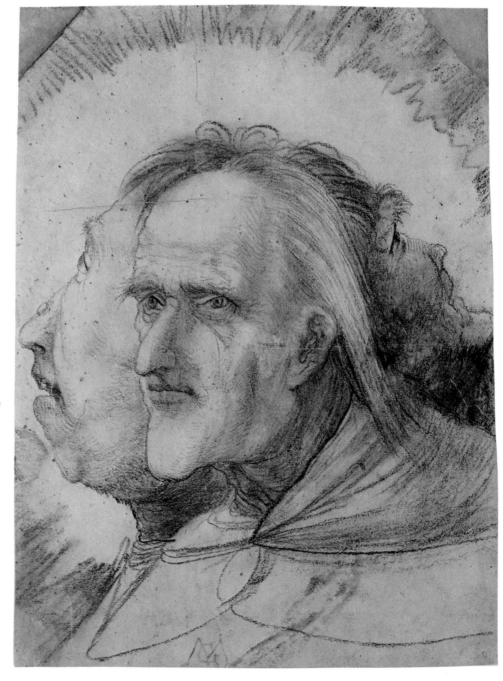

Hans Baldung Grien (Schwäbisch-Gmünd
c. 1484–Strasbourg 1545)
The Woman and Death
Pen and brown ink, highlighted with opaque
white-lead pigment on prepared brown
paper; 12 × 8 in. (306 × 204 mm.)
Berlin, Kupferstichkabinett, inv. 4578

The work of Baldung Grien actually evolved
from the austere style of Dürer but took a
macabre path. In the folio illustrated here,
which is signed with the artist's monogram
and dated 1515, the effect of both the
chiaroscuro and the light on the brown
paper helps to stress the contrast between
the sensual female figure and the gruesome
personification of Death.
Bibliography: Koch, 1941, no. 67; Gerszi,
1970, pl. XIII

Niklaus Manuel Deutsch
(Berne *c.* 1484–1530)
Allegory of Death
Pen and indian ink heightened with white on
gold-ochre prepared paper; 12¼ × 8¼ in.
(310 × 210 mm.)
Provenance: Amerbach
Basle, Öffentliche Kunstsammlung,
inv. U.X.6

The theme of this work is obscure, although
it is patently a finished work and carries the
artist's monogram with the Swiss dagger.
The female figure has been identified
variously as Nemesis, Fortune or, more
probably, an allegorical creature
representing the transcience of life. The
rather solemn influence of Dürer is still
present, although the verism of Baldung
Grien is also apparent.
Bibliography: Hugelshofer, 1967, no. 16;
Landolt, 1972, no. 49

Urs Graf (Solothurn *c.* 1485–Basle 1527/28)
A Couple Seen from Behind
Pen and indian ink; $8\frac{1}{4} \times 6$ in.
(210 × 152 mm.)
Provenance: Amerbach
Basle, Öffentliche Kunstsammlung, inv.
U.X.57

Realism is one of the most typical features of
Urs Graf's folios. His drawings consist
mainly of figures and are autonomous works
rather than preliminary studies or
commercially directed in any way. The
impassable rear view of this middle-class
couple out for a walk presented to us by the
artist is characteristic of his ironic way of
observing the world.
Bibliography: Hugelshofer, 1967, no. 9;
Landolt, 1972, no. 59

Urs Graf
Portrait of a Noblewoman
Pen and indian ink; $10 \times 8\frac{1}{8}$ in.
(254 × 208 mm.)
Provenance: Amerbach
Basle, Öffentliche Kunstsammlung,
inv. 1927.111

The strongly emphasized linear quality,
exaggerated curves and deliberate
overstressing of the decoration on the dress
of this woman are the most remarkable
stylistic features of this drawing – one of the
richest in detail in the whole of Urs Graf's
work. In his pursuit of linear effects,
however, the artist has not overlooked the
plastic qualities, which he has succeeded in
conveying in a deeply sensual way.
Bibliography: Hugelshofer, 1967, no. 8;
Landolt, 1972, no. 62

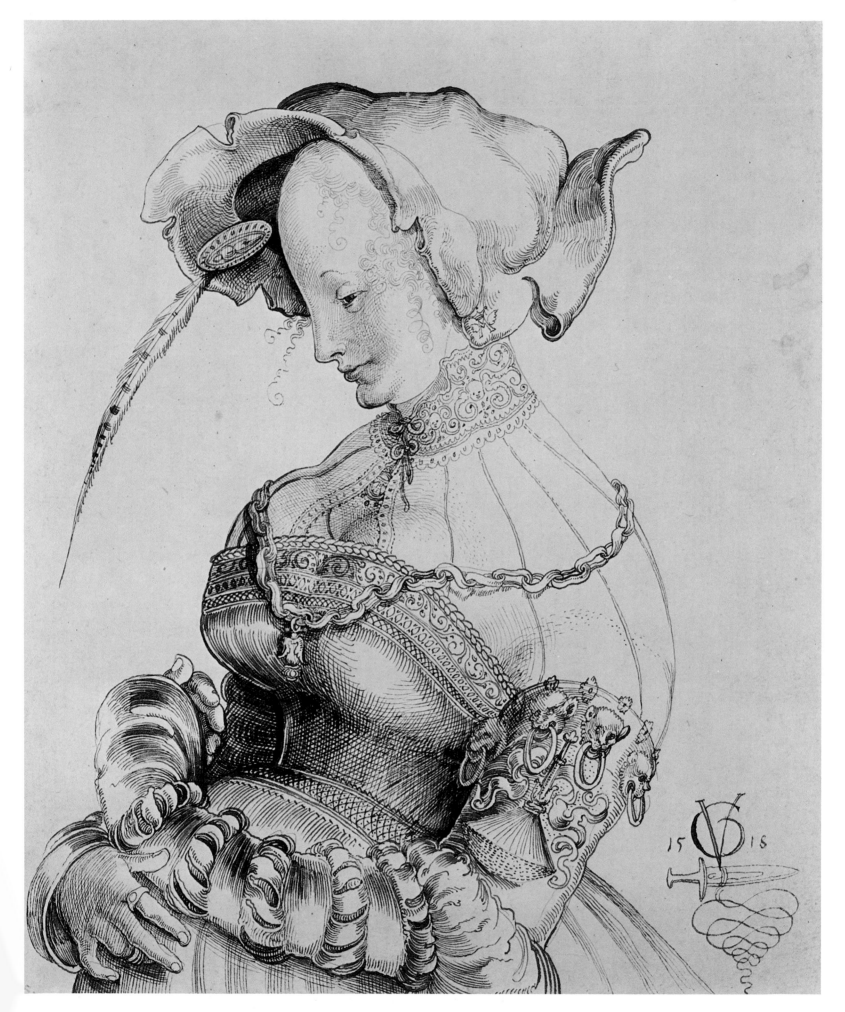

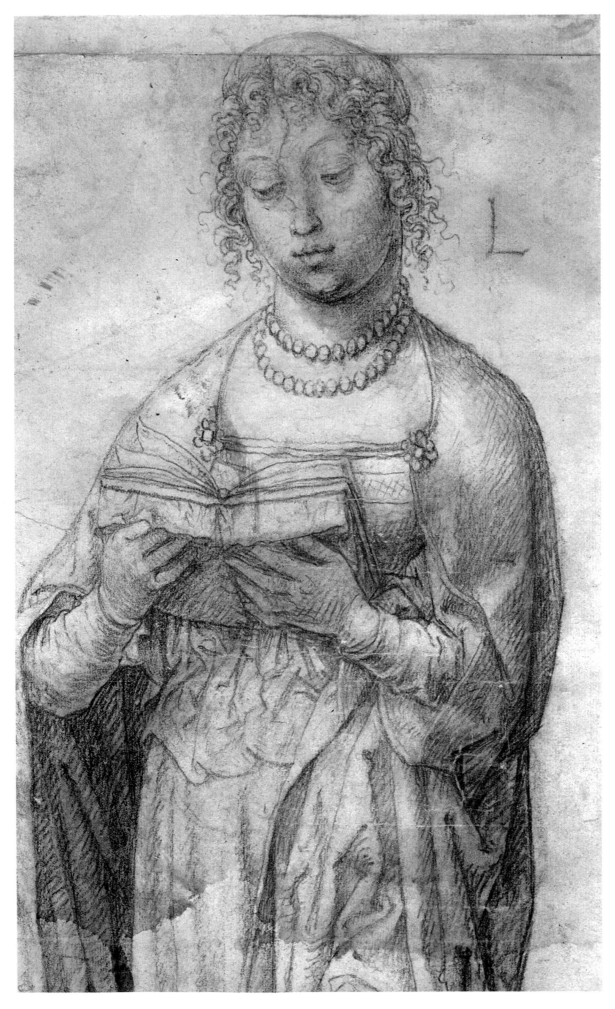

Lucas van Leyden
(Leyden 1489/94–1533)
Young Girl Reading
Black chalk; $12\frac{1}{2} \times 7\frac{1}{2}$ in.
(316×192 mm.)
Vienna, Graphische
Sammlung Albertina,
inv. 17550

This drawing, completed
at the top with a strip of
paper added afterwards,
carries the monogram 'L'.
The drawing is of a
particularly high quality,
despite its rather poor
state of preservation.
Stylistically, *Young Girl
Reading* can be related to
the engraving of *St
Catherine* executed by
Lucas in 1520, just before
he met Dürer, by whom
he was to be profoundly
influenced.
Bibliography: Benesch,
1928, no. 60; Friedländer,
1963, no. 24; Benesch,
1964, no. 129

Hans Holbein the
Younger (Augsburg 1497–
London 1543)
Portrait of a Noblewoman
Black and coloured
chalks; $21\frac{3}{4} \times 15\frac{1}{4}$ in.
(552×388 mm.)
Provenance: Amerbach
Basle, Öffentliche
Kunstsammlung,
inv. 1662.35

Expressiveness and
balance of form are the
distinguishing features of
Holbein's portraits. There
is a softer, more relaxed
quality in his drawing
than in that of any other
contemporary artist.
These characteristics are
apparent even in this
chalk study, dated 1527,
which was a preliminary
drawing for his *Portrait of
Mary Guildford*, now in
the Museum of Fine Arts,
St Louis, the companion
to which, *Portrait of Sir
Henry Guildford*, is in the
Royal Collection at
Windsor.
Bibliography: Glaser,
1924, no. 48;
Hugelshofer, 1967, no. 36

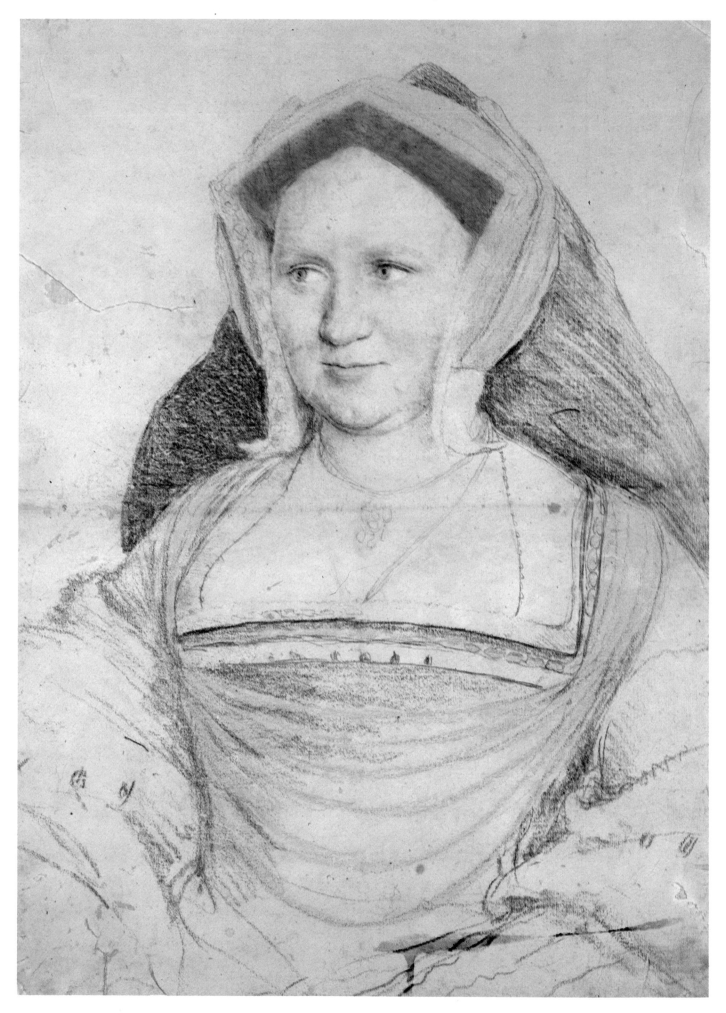

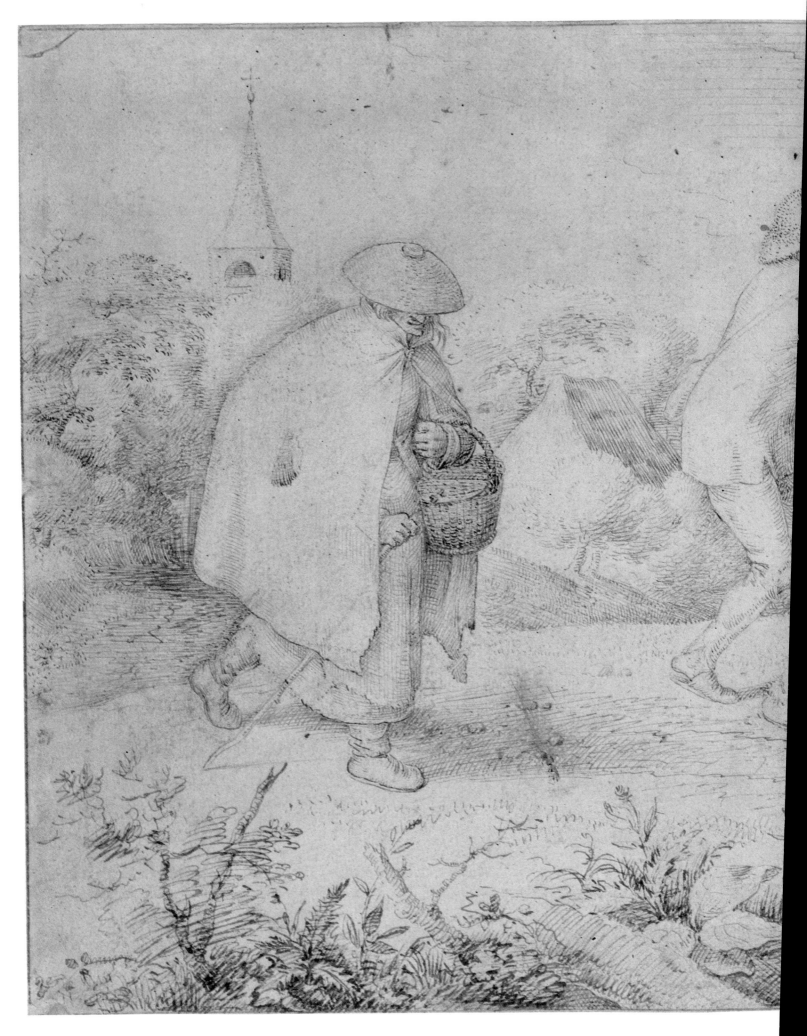

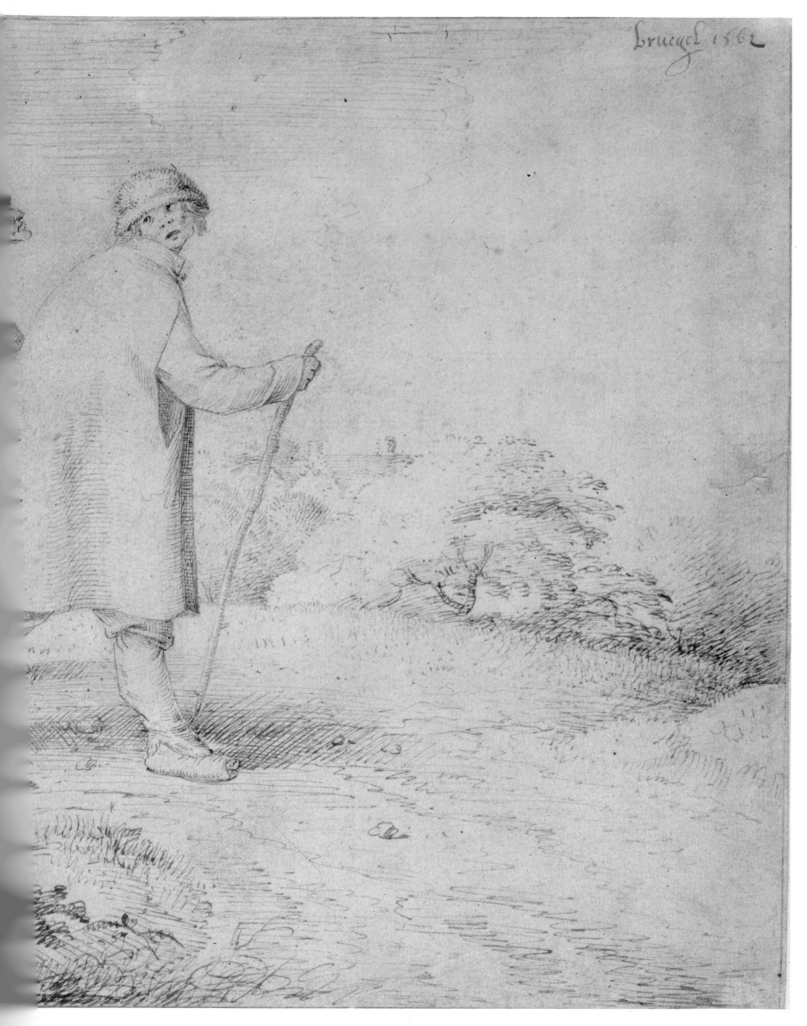

Bruegel 1562

175

On pages 174–5:
Pieter Bruegel the Elder
(Breda? c. 1528–Brussels 1569)
The Blind Leading the Blind
Pen and two shades of brown ink;
7½ × 12¼ in. (192 × 310 mm.)
Berlin, Kupferstichkabinett, inv. K.d.Z. 1376

This drawing, signed in the top right-hand
corner 'bruegel 1562' is stylistically akin to
Bruegel's landscapes of the same period.
There is the same delicacy of drawing, effects
of light and shade, and spatial freedom.
Apart from his painting of 1568, which is in
Naples, the artist used the theme of blind
people again for a picture now lost but
documented as having been in a collection at
Besançon, France, in 1607.
Bibliography: Bock-Rosenberg, 1931, no.
1376; Münz, 1961, no. 46; Winner, 1975,
no. 84

Pieter Bruegel the Elder
View of the Ripa Grande
Pen and various shades of brown ink;
8⅛ × 11⅛ in. (208 × 283 mm.)
Chatsworth, Devonshire Collection, inv. 841

According to the autograph inscription 'a
rypa', this typical sketch from a travel
notebook depicts a view of the Ripa Grande,
the canal wharf on the left bank of the river
Tiber. It is datable to the period of the
artist's visit to Rome during his tour of Italy
in about 1553. Sheets such as this mark the
origin of the modern 'view', so characteristic
of the Dutch and Flemish schools.
Bibliography: Münz, 1961, no. A24; Wragg,
1962–3, no. 77; Winner, 1975, no. 26

Hendrik Goltzius
(Mühlbracht 1558–Haarlem 1617)
Daphne
Pen and brown ink over sanguine and black
chalk; 9½ × 4⅞ in. (239 × 123 mm.)
Munich, Staatliche Graphische Sammlung,
inv. 21.085

The influence of Italian Mannerism is
apparent in this drawing. Goltzius had
become aware of this trend both through the
work of a contemporary painter,
Bartholomeus Spranger, and by having been
in direct contact himself with Italian
Mannerists while touring Italy in the early
1590s. A linear elegance, so reminiscent of
Parmigianino, and a special technique of
emphasizing sanguine with pen and ink are
the main characteristics of this *Daphne*.
Bibliography: Halm-Degenhart-Wegner,
1958, no. 68; Reznicek, 1961, no. XXX

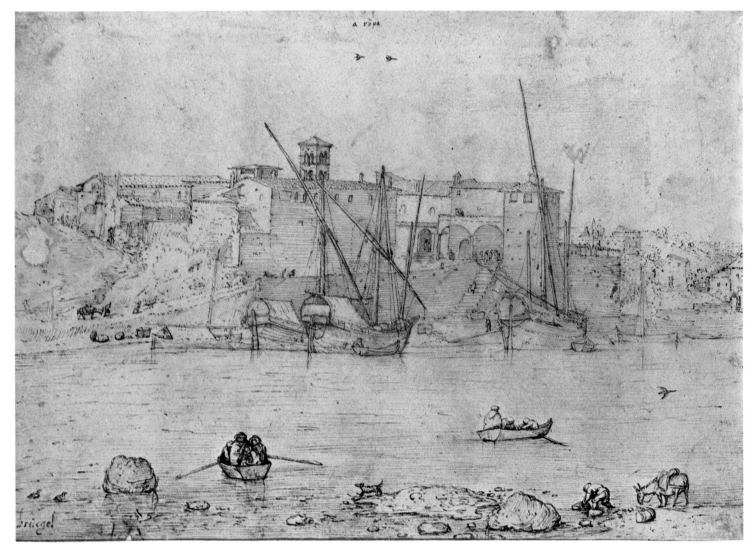

177

Hendrik Goltzius
Landscape with Trees
Pen, brush and brown ink with touches of
colour on azure tinted paper; $11\frac{1}{8} \times 7\frac{7}{8}$ in.
(284×200 mm.)
Provenance: Harzen
Hamburg, Hamburger Kunsthalle,
inv. 21977

This drawing was probably inspired by
similar sheets of landscape seen by Goltzius
in Italy and is one of the first examples of its
kind in Dutch art. By using touches of
colour over fine pen and brush outlines, the
artist has achieved a delicate painterly effect
which is accentuated by the azure of the
paper.
Bibliography: Reznicek, 1961, no. 397

François Clouet (Tours *c.* 1515–Paris 1572)
Portrait of a Gentleman
Black and red chalks (*sfumato*); $12\frac{3}{4} \times 8\frac{3}{4}$ in.
(324×222 mm.)
Provenance: unknown collector
Vienna, Graphische Sammlung Albertina,
inv. 11185

The coloured chalk portrait on paper was a
style widely used in sixteenth-century French
artistic circles, both as a preliminary study
for a painting and as an independent work
of art. François Clouet, Court Painter to
François I from 1540 onwards, and admired
and protected by the Queen Mother,
Catherine de' Medici, was one of the most
distinguished artists in this field.
Bibliography: Meder, 1922, no. 1; Benesch,
1964, no. 205

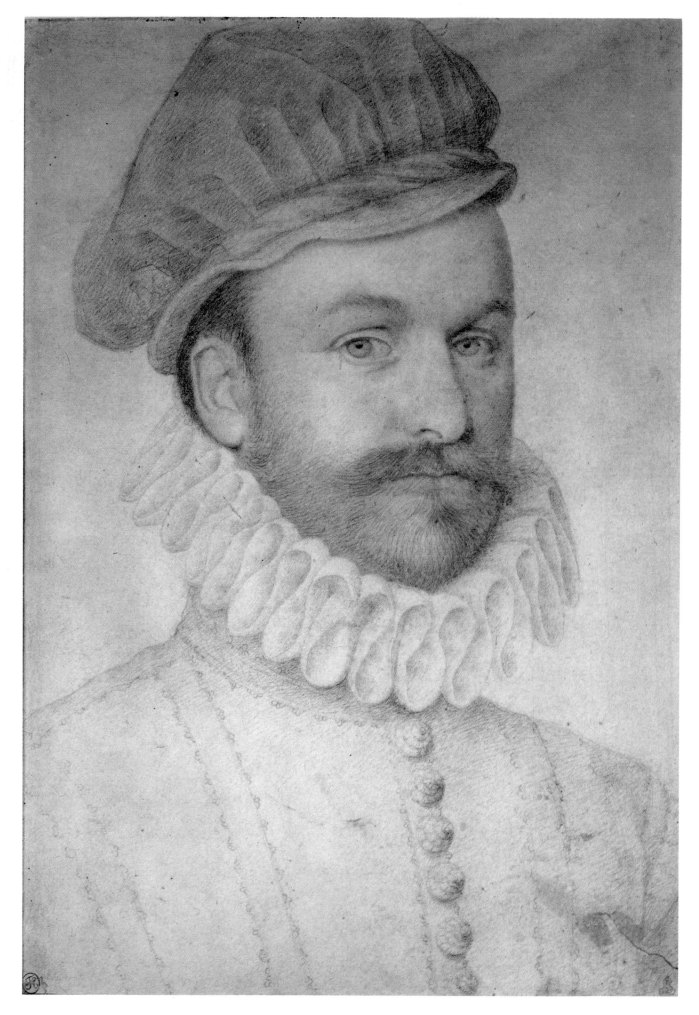

179

The Seventeenth Century in Italy

Ludovico Carracci (Bologna 1555–1619). Ludovico, with his cousins Agostino and Annibale, founded the dynasty of artists who marked a fundamental turning-point in Italian art at the beginning of the seventeenth century. His formative years were spent in the Emilian and Venetian regions of Italy, and these influences can be seen in his early works in the Palazzo Fava in Bologna (1583–4). The themes of his paintings were all religious, with a strong tendency to dramatic pathos. His main works are in Bologna where he established a teaching academy, students of which were to become the greatest Bolognese painters after the Carracci cousins. The masterpiece of Ludovico and his pupils was the decoration of the church of San Michele in Bosco, completed in about 1602.

Agostino Carracci (Bologna 1557–Parma 1602). Agostino, a cousin of Ludovico, was an engraver and draughtsman. His engravings were mostly reproductions of the great traditional Emilian and Venetian painters. He collaborated with his brother, Annibale, on the frescoes in the Gallery of the Palazzo Farnese in Rome (1596–9) but afterwards went to Parma, where he worked until the end of his life.

Annibale Carracci (Bologna 1560–Rome 1609). The most important of the three Carracci, Annibale, had a particularly strong feeling for colour. His masterpiece is in the Gallery of the Palazzo Farnese in Rome (1596–9), with its exaltation of classical values as seen through the eyes of Raphael and Michelangelo. Annibale was a very fine draughtsman and left a great many sheets of drawings. As the seventeenth century progressed, these were to make an invaluable contribution to the continuing development of artists of the stature of Rubens.

Guido Reni (Bologna 1575–1642). Reni developed his style in the Carracci Academy, where he learnt how to interpret the classical spirit of form. Afterwards he visited Rome, where his interest in Raphael increased tremendously, as evidenced by his frescoes in the church of San Gregorio Magno (al Celio) and in the Quirinale (1610). The culmination of Reni's classicism was reached in his *Aurora* (*c.*1614) in the Casino Rospigliosi in Rome. He then returned to Bologna, where he worked until his death, creating a style that was graphically rhythmical and delicate in its use of harmonizing, misty shades.

Francesco Montelatici, called Cecco Bravo (Florence 1607–Innsbruck 1661). After working for the Medici on the Palazzo Pitti (Sala degli Argenti, 1638–9), Cecco moved to Austria, dying in Innsbruck at the age of fifty-four. A talented draughtsman, he was especially interested in developing a graphic style that was typically Baroque.

Giovan Francesco Barbieri, called Guercino (Cento 1591–Bologna 1666). Although Guercino had originally based his style on that of the Carracci family and of the Venetian school, when he moved to Mantua in 1616 it became much more akin to the styles of Rubens and Domenico Fet(t)i. Through the influence of these two artists, Guercino was already unwittingly preparing himself for the impact of Caravaggio's dramatic force, which he was to see for himself during a visit to Rome that began in 1612. His masterpieces from this period are *Aurora* and *Notte* with their strongly contrasting lighting effects. Once he was back in Bologna, the overwhelming academic atmosphere, plus the classicist influence of Reni, seems to have had a dampening effect on his lively imagination. Guercino was a particularly fine draughtsman. He had a flowing linear style which was to make a decisive contribution to the development of the draughtsmen of the eighteenth century.

Gian Lorenzo Bernini (Naples 1598–Rome 1680). Despite the fact that, in deference to his father, Bernini had begun his working life as a sculptor, he became the greatest architect in seventeenth-century Rome. In 1623 he completed his *David*, followed by *Apollo and Daphne*, for the villa of Cardinal Scipione Borghese. He designed the spectacular scenic altar in the Basilica of St Peter (1624), decorated some of the Roman squares with highly imaginative fountains, and built the portico of St Peter's, his masterpiece (1656). His few drawings are mostly portraits or self-portraits in which the handling of the plastic effect is surprisingly obvious.

Simon Vouet (Paris 1590–1649). A long stay in Rome (1516–27) enabled Vouet to absorb a great deal from the influence of the Carraccesque school, Guido Reni, Guercino and, not least, the dramatic Caravaggio. Having returned to France, he infused into

the painting of his country a most elegant form of classicism. He possessed exceptional technical skill, and this can be seen clearly in such beautiful drawings as his *Presentation in the Temple* (1541), now in the Louvre.

Pietro Berrettini, known as da Cortona (Cortona 1596–Rome 1669). The most important artist in seventeenth-century Rome, da Cortona was under the patronage of Pope Urban VIII and his family, the Barberini. Amongst other highly prestigious works, he painted the huge fresco in the salon of the Palazzo Barberini (1633–9). He also worked for the Medici in the Palazzo Pitti, Florence, where he decorated several of the rooms in glowing colours (*The Golden Age*, 1637). He returned to Rome where he executed the frescoes in the Palazzo Pamphili. Pietro was also the architect of three churches in Rome: SS. Martina e Luca, Santa Maria in via Lata and Santa Maria della Pace.

Nicolas Poussin (Les Andelys 1595–Rome 1665). Nicolas Poussin fulfilled his dream of going to Italy in 1620 but he had to return to France. However, he went to Rome in 1623 where he worked until his death, with a brief interval in Paris to decorate the Apollo Gallery in the Louvre (1538–40). His paintings illustrate classical themes (*Narcissus and Echo*, Louvre, 1630), frequently with a predominating landscape, which he interprets with pre-Romantic sentimentalism (*Orpheus and Eurydice*, Louvre, c. 1650). Poussin was a great draughtsman, both in his preliminary sketches and in his drawings from life.

Claude Gellée known as Claude Lorraine (Champagne 1600–Rome 1682). Claude spent most of his life in Rome. He modelled much of his work on the Carracci and was also influenced by the Northern masters, who led him into representative realism and imbued him with a preference for landscapes. Drawings were very important to his method; as he painted in his studio, he would work from them as though they were notes taken from life. He also made drawings of 195 of his paintings and preserved them in the *Liber Veritatis* (British Museum) as a permanent record of his work, in order to protect himself against imitators.

Carlo Maratta (Camerino 1625–Rome 1713). With the protection of the art critic Bellori, Maratta soon made an impression in the artistic circles of Rome, where he found himself influenced by the post-Carraccesque trend and where he also attended the school of Andrea Sacchi. Pope Alexander VII had expressed his admiration of Maratta's *Sant'Agostino* in the church of Santa Maria dei sette dolori. He became a most generous patron, commissioning works for the churches of Santa Maria della Pace, Il Gesù and Santa Maria del Popolo. Perhaps even more remarkable were his portraits, which he executed with a graphic incisiveness that made him one of the most remarkable draughtsmen of Baroque Rome.

Giambattista Gaulli known as Baciccio (Genoa 1639–Rome 1709). One of the most active painters in Rome in the latter half of the seventeenth century, Baciccio was befriended by Bernini. Particularly outstanding in his decoration of the ceiling of Il Gesù (1679) and of the Santi Apostoli (1707), both of which are of spectacular theatricality. Through Sebastiano Ricci and Giovanni Pellegrini, his drawings played an important part in the development of eighteenth-century Venetian painting.

Pier Francesco Mola (Coldrerio 1612–Rome 1666). Mola spent his formative years in Rome, influenced both by the classicism of the Carracci and the late Mannerism of such artists as the Cavaliere d'Arpino, whose pupil he was. A meticulous draughtsman, he would frequently go out into the countryside to draw landscapes from life in order to incorporate them later into his paintings (*San Brunone*, Doria Pamphili Gallery).

Mattia Preti (Taverna 1613–Valletta 1699). The appearance of Preti on the Neapolitan scene during the second half of the seventeenth century brought new trends to Southern Italy. A Calabrian by birth – he was known as '*il Cavaliere Calabrese*' – Preti had been greatly influenced, during a stay in Rome, by the painting of Guercini and of the Venetian school. The result is apparent in such dramatic and intricate compositions as his *Feast of Absalom* in Naples. Preti also worked in Rome in the churches of San Carlo ai Catinari and Sant'Andrea della Valle before dedicating himself completely to the service of the Order of Malta, moving to Malta in 1661 and spending the rest of his life there. His artistic language relies heavily on a strong basis of draughtsmanship and there are numerous drawings extant which demonstrate his extensive use of chiaroscuro in the composition of his works.

Luca Giordano (Naples 1634–1705). Having learnt a great deal as a boy from the virtuosity of Mattia Preti, Luca Giordano developed an extremely lively and quick artistic language of his own, to such an extent that he earned the nickname of '*Fapresto*' (Does it quickly!). He undertook two journeys to Venice, one which lasted from 1650 to 1654, and the other in 1667, in order to work on altarpieces in the church of Santa Maria della Salute. During these visits he naturally came into contact with the Venetian colourists, and as a result modified his style, opening the way to several new commissions. Among the great decorative projects which he undertook were the ceiling of the Ballroom of the Palazzo Medici–Riccardi in Florence, ceilings in the Escurial commissioned by Carlos II, and the Cappella di San Martino in Naples, by which time his style was already somewhat in the Rococo vein.

Bernardo Strozzi (Genoa 1581–Venice 1644). Inspired by the Baroque style of Sorri, Strozzi showed a particular interest in the rich, sumptuous painting of Rubens and van Dyck (Palazzo Carpaneto, Sampierdarena). He was a Capuchin monk, but after some rather obscure legal misadventures fled to Venice, where he worked from 1630 until his death. In this city he acted as an important mediator for the Baroque style, imposing its heavy, sensual use of colour on both sacred works (*St Sebastian*, San Beneto, Venice) and secular (*Girl Playing a Cello*, Dresden). His many drawings, which are often in sanguine, share the iridescent heavy impasting and the flowing, deft handling of strokes seen in his paintings.

Giovanni Benedetto Castiglione, known as Grechetto (Genoa 1610–Mantua 1665). Having travelled a great deal between Rome, Bologna, Parma and Venice, this artist absorbed a broad spectrum of experience of seventeenth-century art. He evolved a style which tended to express itself mainly in pastoral scenes, both in paintings and in brilliant engravings such as his *Crib* in the church of San Luca, Genoa (1645). The large number of his drawings, shows that he also spent a considerable amount of time in producing graphic work for connoisseurs.

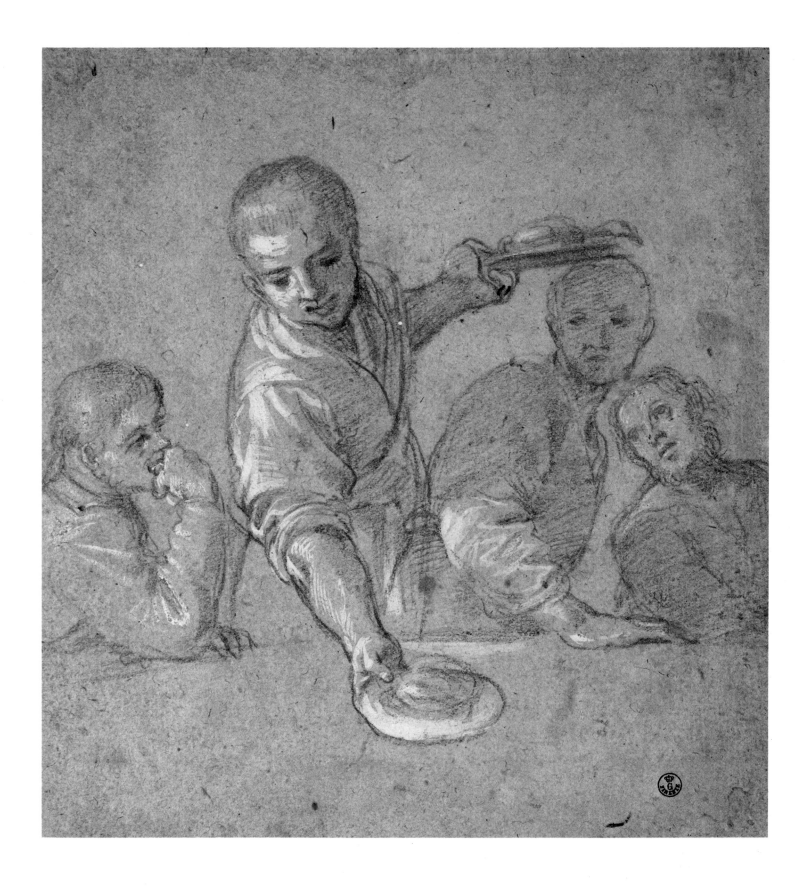

Ludovico Carracci (Bologna 1555–1619)
Four Figures for the Fresco 'St Peter in the House of Simon the Tanner'
Sanguine with highlighting in opaque white-lead pigment on yellowish-grey (originally azure) paper; $11\frac{1}{2} \times 10\frac{1}{2}$ in. (290 × 264 mm.)
Florence, Galleria degli Uffizi, inv. 761 E

A preliminary drawing for the fresco in the guest-rooms of the monastery of San Michele in Bosco, completed in 1591. There is a close relationship between the style of this study and Venetian drawing of the same period, both in the technique of using sanguine highlighted with white bodycolour on coloured paper, and in the realistic feeling of the surroundings, so reminiscent of Palma the Younger.
Bibliography: Mahon, 1956, no. 8; Forlani, Tempesti-Petriolo Tofani, 1972, no. 72

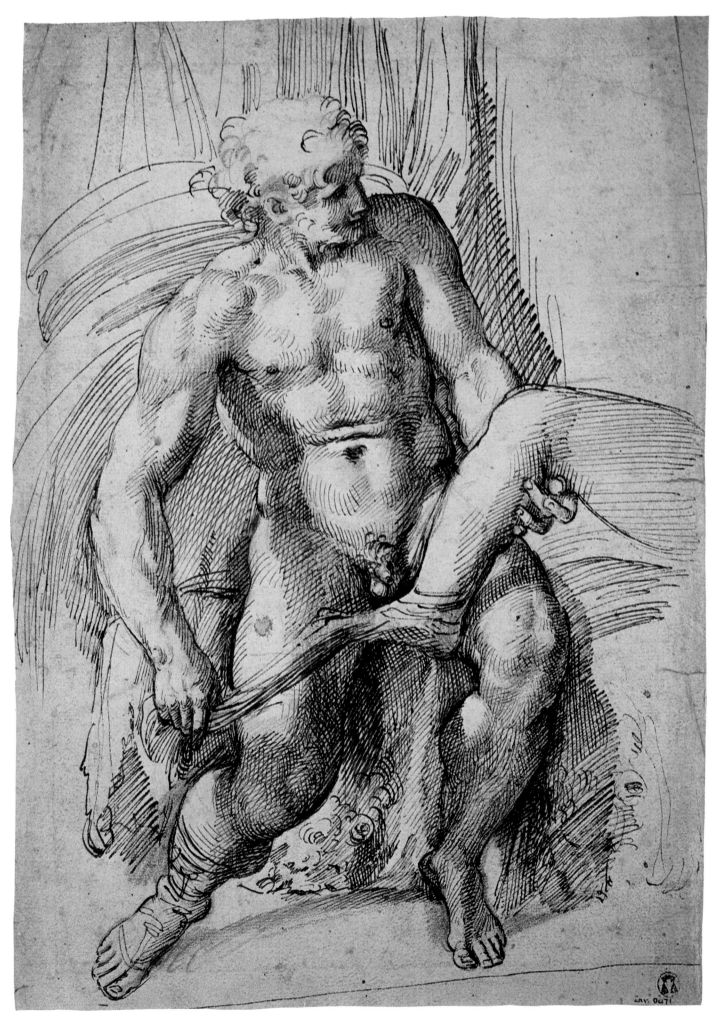

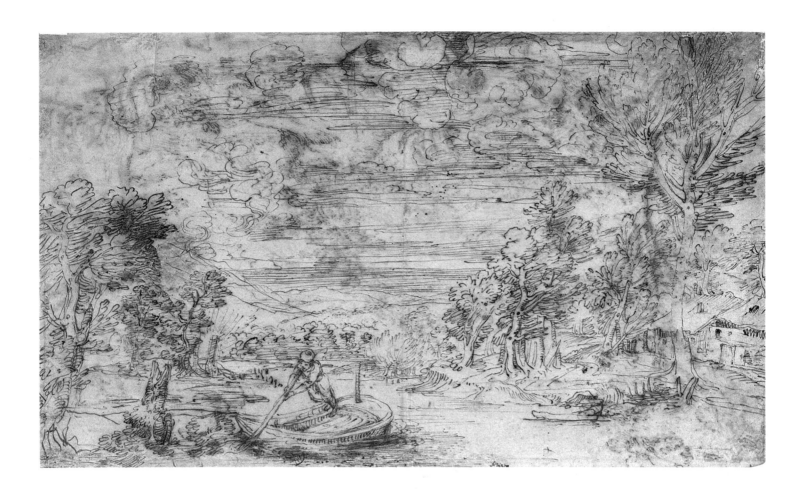

Agostino Carracci
(Bologna 1557–Parma 1602)
Anchises and Venus
Pen and brown ink over sanguine;
$14\frac{1}{2} \times 10$ in. (370 × 255 mm.)
Provenance: Guise
Oxford, Christ Church, inv. 0471

This drawing was almost unknown until a
few years ago. It is undoubtedly a
preliminary study for the fresco *Anchises and
Venus* on the ceiling of the Gallery in the
Palazzo Farnese, Rome, usually attributed
to his brother Annibale. The modelling of
the figure of Anchises, rendered with cross-
hatching, is typical of the engraving
technique used by Agostino. There is
therefore room for doubt as to the actual
author of the picture, which was executed
between 1597 and 1600.
Bibliography: Byam Shaw, 1976, no. 930;
Pignatti, 1976, no. 57

Annibale Carracci
(Bologna 1560–Rome 1609)
Landscape with River and Boat
Pen and brown ink; $9\frac{7}{8} \times 16\frac{1}{4}$ in.
(250 × 413 mm.)
Provenance: Hanns Scheaffer Galleries, Los
Angeles
Los Angeles, County Museum of Art,
inv. 59.33 (*r*)

This drawing, which is datable to around
1595, shortly before Annibale's departure for
Rome, is in the tradition of the 'landscape-
protagonist' – that is to say, it is the
landscape itself that is the important element
in the picture. Having originated in the
Venetian area, the style was given
considerable impetus by Titian in his later
graphic work. In fact, this drawing was once
attributed to Titian, as is borne out by an
old inscription on the *verso*.
Bibliography: Feinblatt, 1958, pp. 10–17;
Schulz, 1968, no. 34

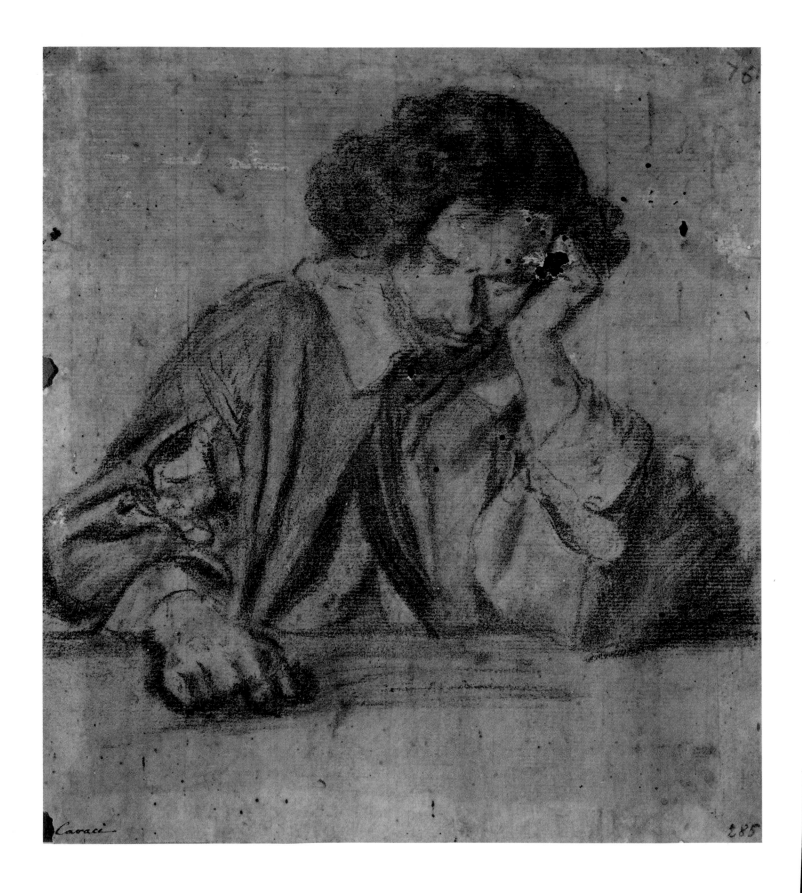

Annibale Carracci
Portrait of a Pensive Man
Black chalk on white paper; $8\frac{1}{8} \times 7\frac{3}{8}$ in.
Provenance: Bossi
Venice, Gallerie dell'Accademia, inv. 285

Stylistically, the high standard of technique
and remarkably expressive realism of this
drawing are not far removed from the late
sixteenth-century Bolognese period, as can
be seen, for example, in the portraits by
Giovanni Gabrielli in the Royal Collection,
Windsor, and in the Albertina, Vienna. On
the other hand, the clothes that the subject is
wearing might indicate a rather later date, in
keeping with the Flemish-Dutch
surroundings.
Bibliography: Fogolari, 1913, no. 83;
Pignatti, 1973, no. 15

Annibale Carracci
A Cripple Boy
Sanguine and wash; $10\frac{1}{2} \times 8\frac{7}{8}$ in.
(264 × 225 mm.)
Chatsworth, Devonshire Collection, inv. 443

This study carries an inscription at the top
right-hand side, probably in the artist's own
hand, *'Non so se Dio m'aiuta'* ('I don't know
if God will help me'). It is one of Annibale's
youthful works, dating to about the middle
of the 1580s. In this picture of a young boy
who is sick, sad and deformed, Annibale has
touched notes of verism that are in some
ways reminiscent of similar figures painted
by Caravaggio during the same period.
Bibliography: Mahon, 1956, no. 224; Byam
Shaw, 1976, no. 27

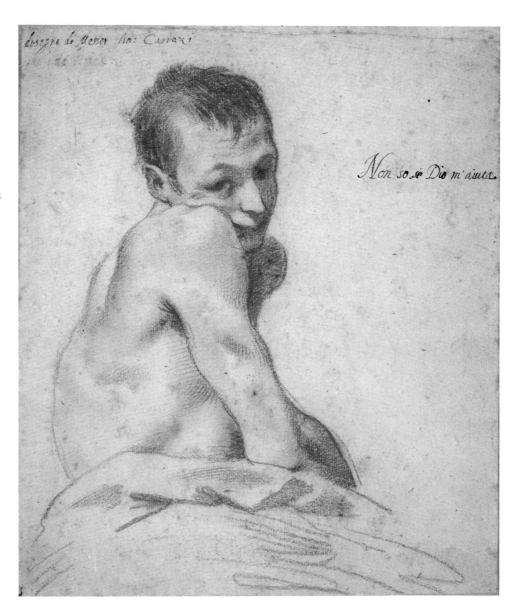

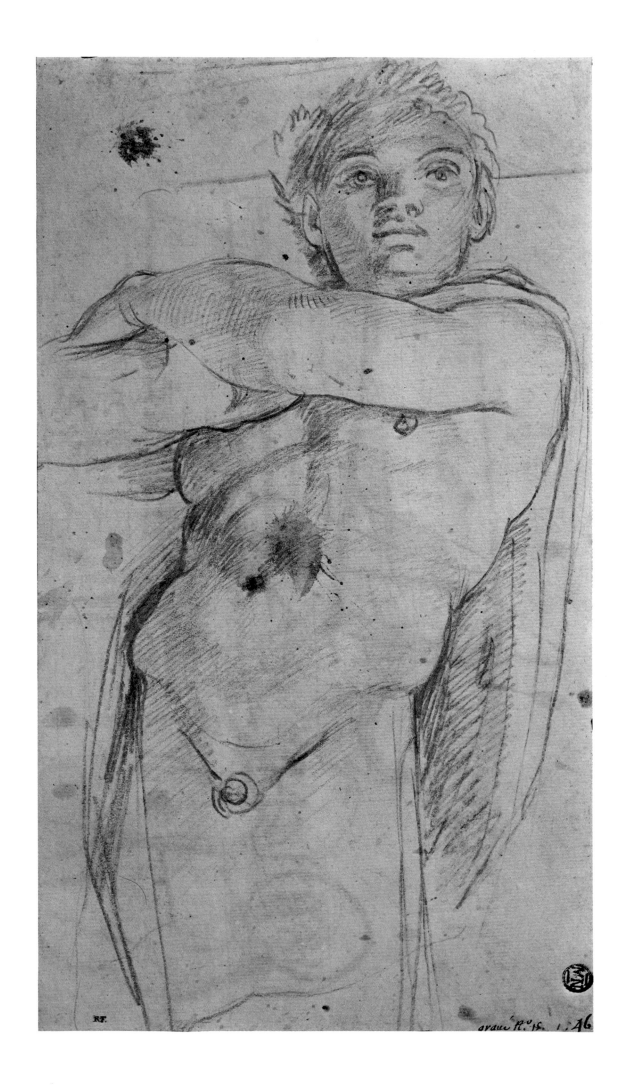

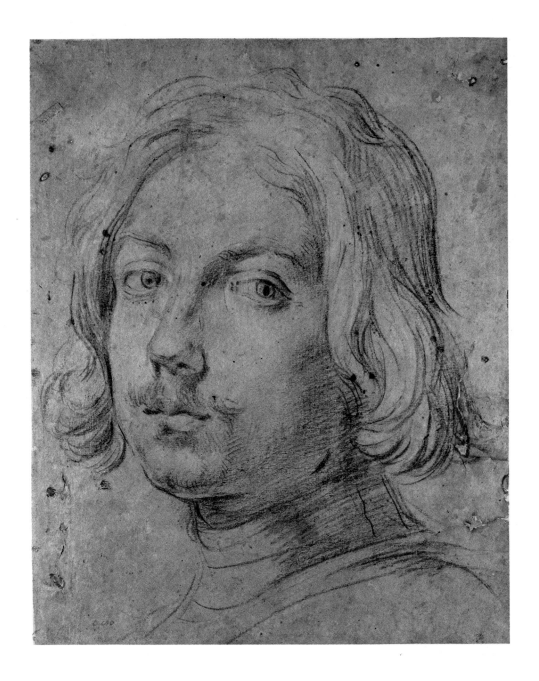

Annibale Carracci
Study for an 'Atlas'
Sanguine: $13\frac{1}{2} \times 7\frac{5}{8}$ in (345×195 mm.)
Provenance: Mariette; Cabinet du Roi
Paris, Musée National du Louvre, inv. 7363

A luminous classicism, in the style of Paolo
Veronese, characterizes this study for the
figure of Atlas standing in the right-hand
corner of Annibale's fresco *Polyphemus and
Acis*. It is one of the few known sanguine
drawings, prepared for this great project for
the Gallery of the Palazzo Farnese. Through
his masterpiece, completed between 1597
and about 1604, Annibale hoped to bring
about a complete restoration of Classical
and Renaissance culture.
Bibliography: Mahon, 1956, no. 187; Bacou,
1961, no. 79; Bacou-Viatte, 1968, no. 78

Guido Reni (Bologna 1575–1642)
Study for the Head of St Procolo
Black chalk with touches of red and white;
$13\frac{3}{8} \times 10\frac{1}{4}$ in. (338×260 mm.)
Provenance: Resta; Somers; Guise
Oxford, Christ Church, inv. 0528

In 1631 the Senate of Bologna commissioned
Reni to design a processional standard, the
so-called *Palio del Voto* (Pinacoteca
Nazionale, Bologna), in gratitude to the
Holy Virgin for the city's liberation from the
terrible effects of the plague. This drawing,
in which the calm refinement of the artist
stands out, is the head of one of the patron
saints of Bologna, Procolo. In the finished
work, this figure is on the extreme right.
Bibliography: Cavalli-Gnudi, 1954, below,
no. 35; Byam Shaw, 1976, no. 966; Pignatti,
1976, fig. 36

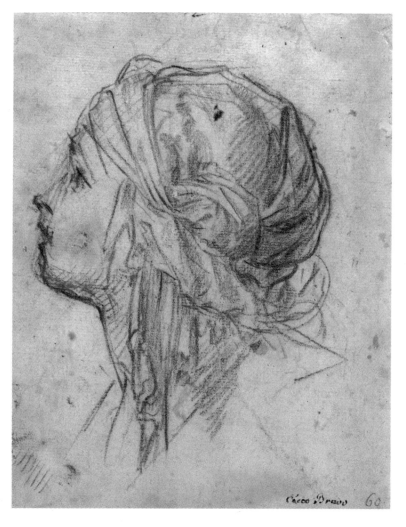

Cecco Bravo (Florence 1607–Innsbruck 1661)
Profile of a Young Girl
Sanguine; 8 × 6⅜ in. (205 × 160 mm.)
Provenance: Gaburri; Judvine
Stuttgart, Staatsgalerie Stuttgart, inv. c. 71/2110

The art of Cecco Bravo developed in the wake of the sixteenth-century late-Mannerist tradition in Tuscany. He did few head studies, and the example illustrated here is particularly interesting. Gaburri, a contemporary collector and critic, had several in his collection and praised them particularly for the *'brio'* ('verve') and the *'spirito inarrivabile'* ('matchless spirit') with which they were executed.
Bibliography: Masetti, 1962, p. 67; Thiem, 1977, no. 356

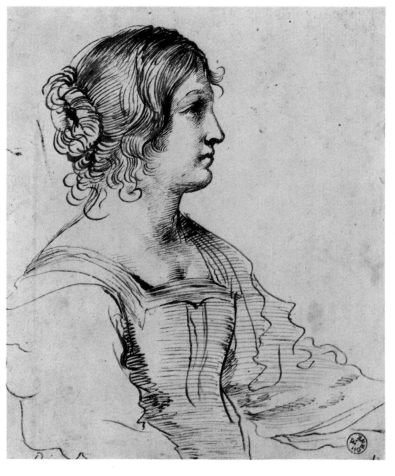

Guercino (Cento 1591–Bologna 1666)
Bust of a Woman in Profile
Pen on ivory paper; 7½ × 6½ in. (192 × 165 mm.)
Florence, Horne Collection, inv. 5583

Guercino's drawings have remained among the most consistently sought after by collectors through the centuries. In the important example of his graphic work illustrated here can be seen the sensuality of his soft, Raphael-inspired drawing. He achieved this effect through using flexible pressure on his pen combined with a more incisive and veristic use of hatched shading.
Bibliography: Ragghianti Collobi, 1963, no. 76

Guercino
The Mystical Marriage of St Catherine
Black chalk, pen, brush and brown ink; 10 × 8 in.
(256 × 203 mm.)
Provenance: acquired in 1939
Oxford, Ashmolean Museum

This drawing is the preliminary study for *The Mystical Marriage of St Catherine*, now in the Mahon Collection, London, and probably identifiable as the painting Guercino executed in 1620 for the Cavalier Piombino of Cento. Recalling the corporeity achieved by Caravaggio, the artist has tried to portray a feeling of chiaroscuro through a patchy effect of brush and ink wash combined with great emphasis on light, with a fairly realistic result.
Bibliography: Parker, 1956, no. 856; Mahon, 1969, no. 53; Pignatti, 1976, no. 59

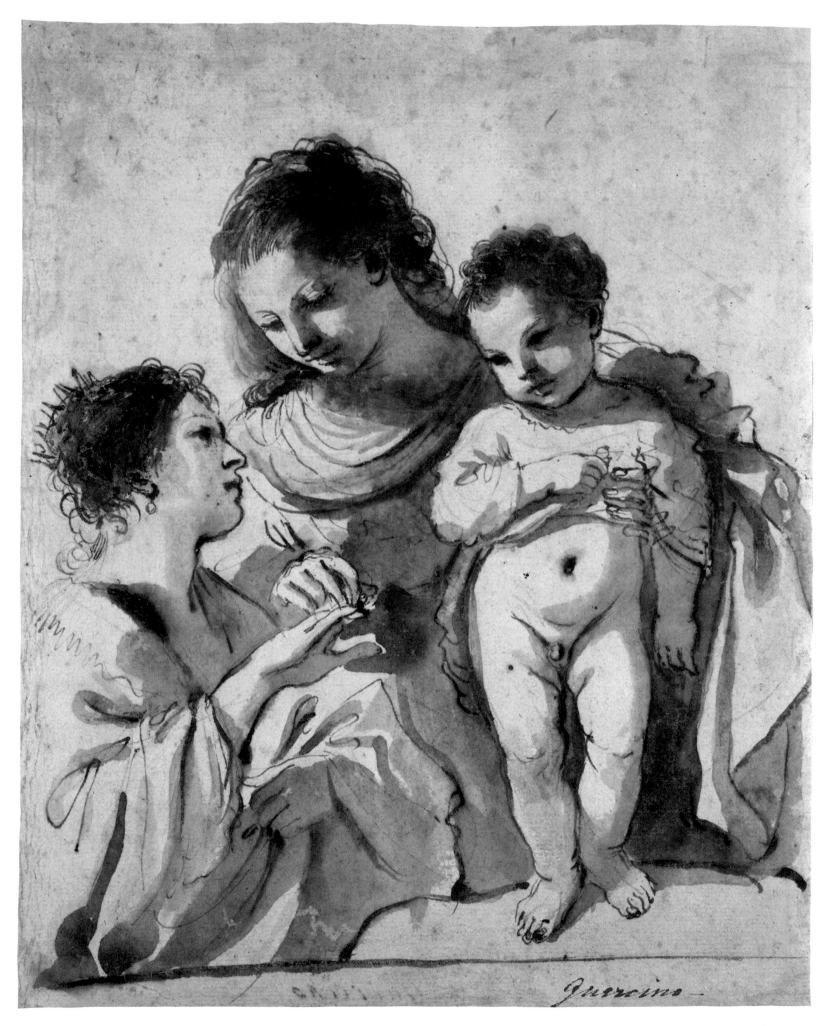

Guercino

191

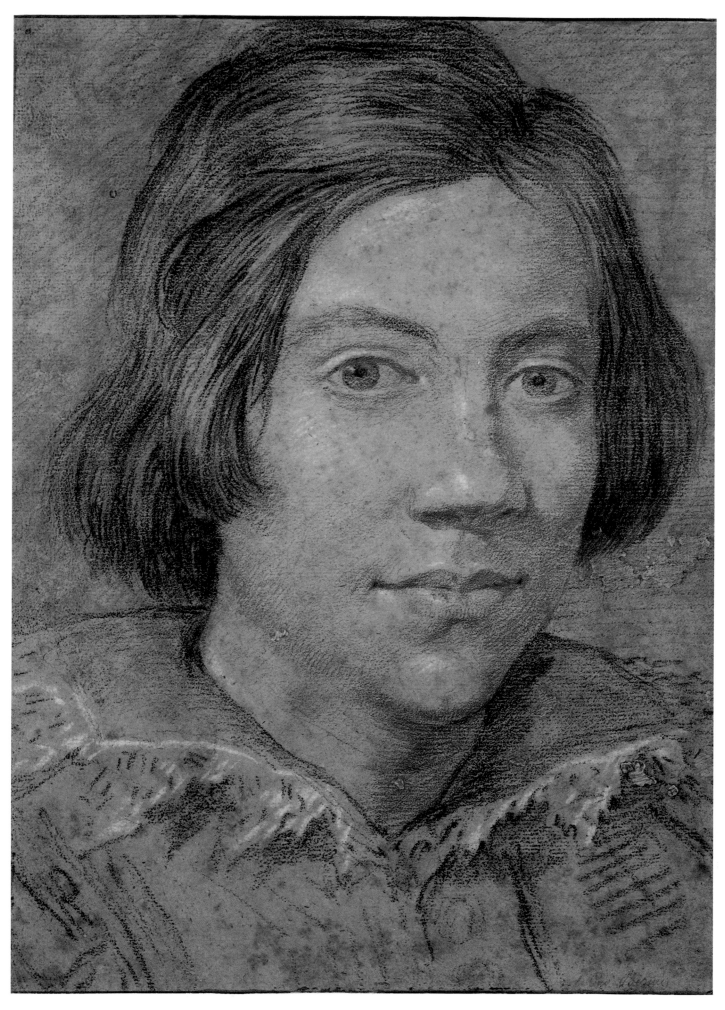

192

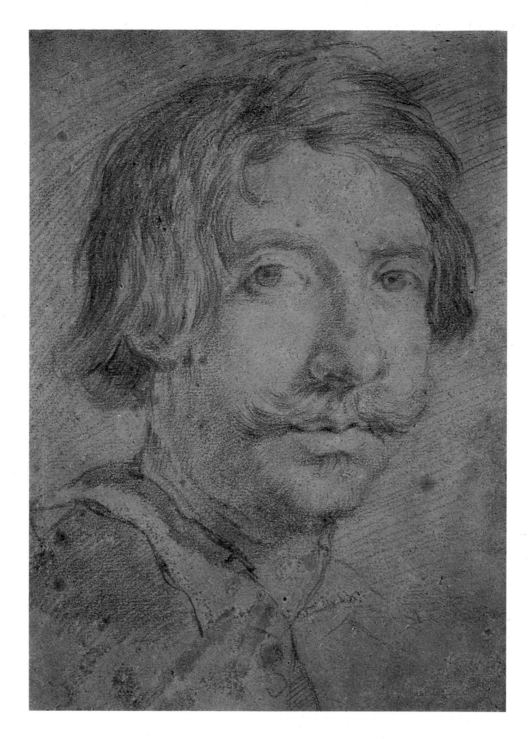

Gian Lorenzo Bernini
(Naples 1598–Rome 1680)
Portrait of a Young Man
Black chalk and sanguine heightened with
white; 12½ × 9 in. (317 × 231 mm.)
Provenance: Ailsa Mellon Bruce Fund
Washington, DC, National Gallery of Art,
inv. B-25, 774

This fascinating picture of a young man
under twenty could be the very first self-
portrait of Bernini, according to a recent
attribution by Washington's National
Gallery. If this is so, it means that we now
have a drawing executed prior to 1620,
characterized by a dry realism with
Caravaggesque overtones.
Bibliography: Robison, 1978, no. 70

Gian Lorenzo Bernini
Self-Portrait
Sanguine heightened with white chalk on
lightweight, pale brown paper; 11¾ × 8⅛ in.
(299 × 208 mm.)
Provenance: Hope; entered in 1947
Oxford, Ashmolean Museum

By making full use of the particular qualities
that are innate in the graphic medium he has
chosen, the artist has achieved a rather
unusual luminous effect, as in a painting,
through the *morbidezza* of his technique, i.e.
the soft edges and fusion of tones. This self-
portrait, of which there are numerous
versions, seems from its style to belong to
the same period, that is, the mid 1630s, as
the bust of Costanza Buonarelli in the
Museo Nazionale (Bargello), Florence.
Bibliography: Wittkower, 1951, p. 55;
Parker, 1956, no. 793; Pignatti, 1976, no. 63

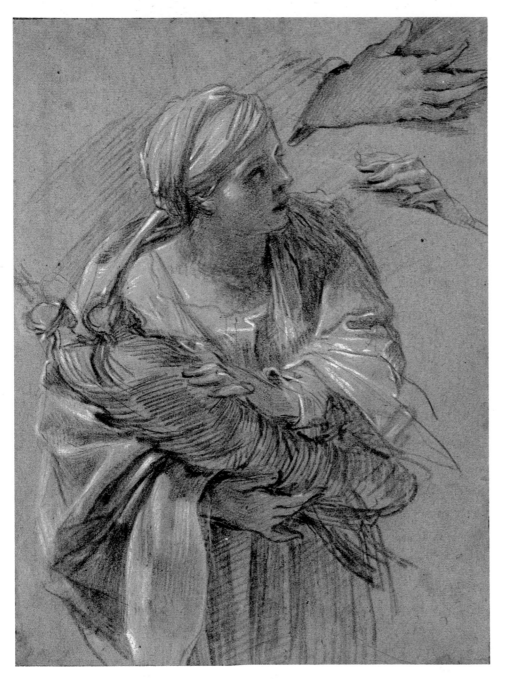

Simon Vouet (Paris 1590–1649)
Woman Carrying Two Sculptures and *A Study of Hands*
Black chalk heightened with white on azure paper; 11 × 9 in. (278 × 230 mm.)
Provenance: the London art market (1971)
Washington, DC, National Gallery of Art, Ailsa Mellon Bruce Fund, inv. B-25, 646

As a result of spending some years in Italy, Vouet developed a naturalism of style – derived from Caravaggio – which he combined with late Mannerist influences and a Venetian feeling for colour. The technique of this black chalk study, heightened with white on azure paper, although typical of the Venetian school, is rarely found in Vouet's graphic corpus.
Bibliography: Rosenberg, 1972, no. 149; Robison, 1978, no. 67

Pietro da Cortona
(Cortona 1596–Rome 1669)
Head of a Young Man
Black chalk and opaque white-lead pigment on cerulean blue paper; 15⅜ × 10 in. (390 × 252 mm.)
Florence, Galleria degli Uffizi, inv. 13913 F

A soft, painterly style characterizes this study, which refers to the young dancer who appears in the right-hand background of the *Golden Age*, one of four frescoes representing the Gold, Silver, Bronze and Iron Ages of mankind commissioned for the Galleria Palatina of the Palazzo Pitti, Florence. Even in this sheet, Pietro da Cortona's personal interpretation of Carraccesque classicism is apparent; typical of the artist's work, this is the style that made him one of the main protagonists of Baroque art.
Bibliography: Briganti, 1962, pp. 216, 300, fig. 171; Campbell, 1965, no. 16

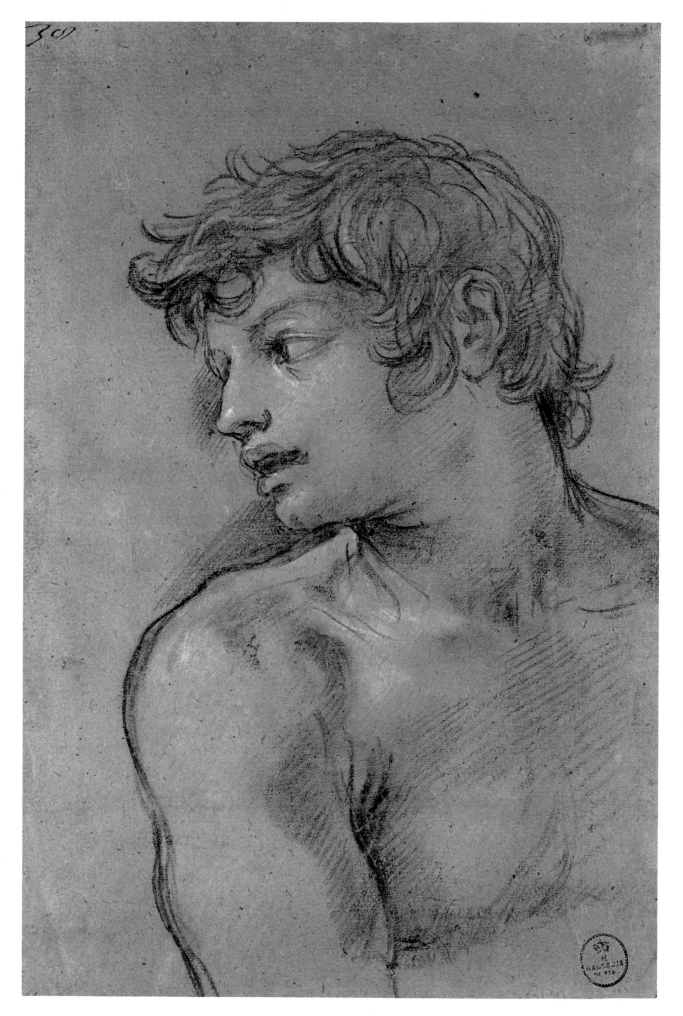

Nicolas Poussin
(Les Andelys 1594–Rome 1665)
The 'Ponte Molle' (Molle Bridge) near Rome
Pen, brush and bistre over metalpoint;
7⅜ × 10 in. (187 × 256 mm.)
Provenance: Crozat; Mariette; de Ligne
Vienna, Graphische Sammlung Albertina,
inv. 11443

The influence of the great sheets of
Titianesque landscapes is apparent in the
wide spacing of this composition, so
characteristic of studies of the Roman
countryside about 1640. The contrast
between the broad brush-strokes, used to
draw in the trees in the foreground, and the
minute, rather dainty treatment in pen given
to the distant scene brings this work – which
has so much depth of atmosphere – to life.
Bibliography: Friedländer-Blunt, 1939–74,
IV, G3; Benesch, 1964, no. 211

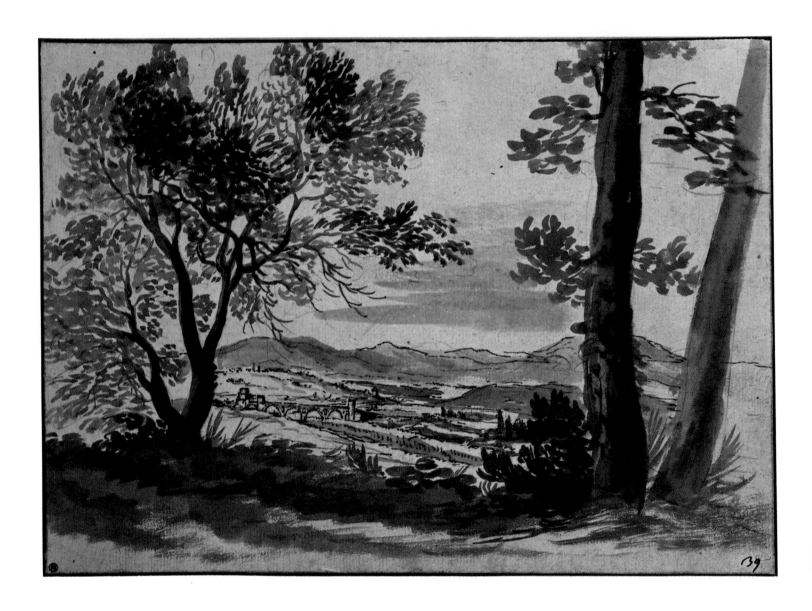

Nicolas Poussin
Medoro and Angelica
Sanguine, pen, brush and bistre; $8\frac{1}{2} \times 8\frac{5}{8}$ in. (215 × 219 mm.)
Provenance: Crozat
Stockholm, Nationalmuseum, inv. 2431/1863

Classical myths, High Renaissance literature, the impressiveness of the great Titianesque canvases and the artist's own love of Nature are all fundamental to the Classicism of Poussin. Sheets such as this one with *Medoro and Angelica* can be dated to the early years of his stay in Rome (1625–30). They are characterized by a graphic technique that creates a pictorial effect of great luminosity.
Bibliography: Friedländer-Blunt, 1939–74, III, B25; Sachs, 1961, pl. 51

On pages 198–9:
Claude Lorraine
(Champagne 1600–Rome 1682)
Landscape with Diana and Callisto
Pen and brush in grey and brown wash, heightened with white over outlines in black chalk; $9\frac{1}{4} \times 15\frac{1}{2}$ in. (235 × 393 mm.)
Provenance: Duke of Devonshire
Chatsworth, Devonshire Collection, inv. 945

The landscapes of Claude can be compared with those of Poussin; there is also a strong link with the classicism of the Carracci, especially in the naturalistic aspect of Claude's work. This particular drawing, which is signed, belongs to his later period and relates to sheets of his *Liber Veritatis*, dated to about 1665. From 1635 onwards, the artist systematically reproduced all his own pictures to protect himself against possible copies and imitations.
Bibliography: Roethlisberger, 1968, no. 950; Byam Shaw, 1969, no. 118

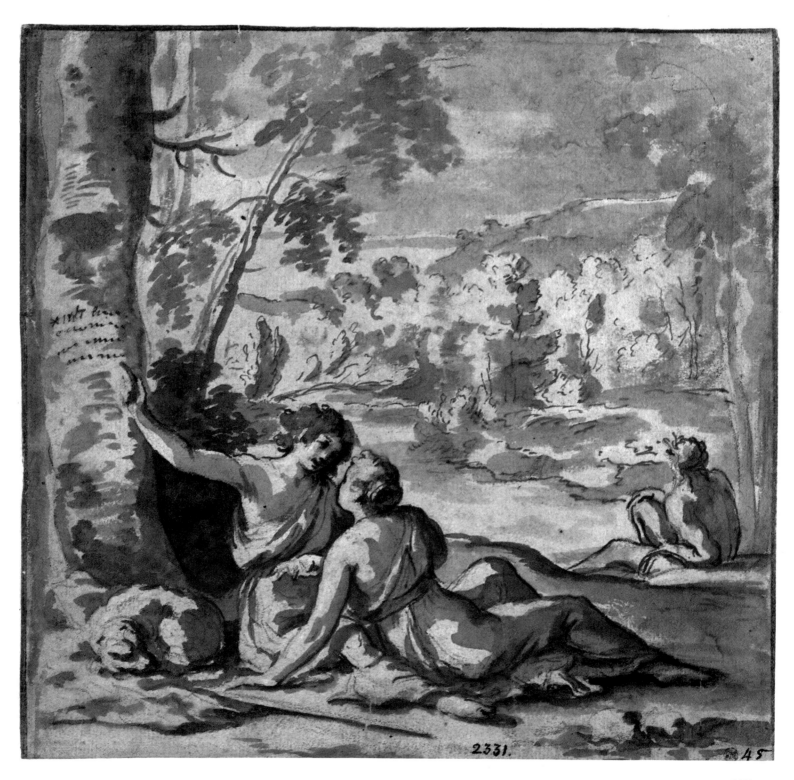

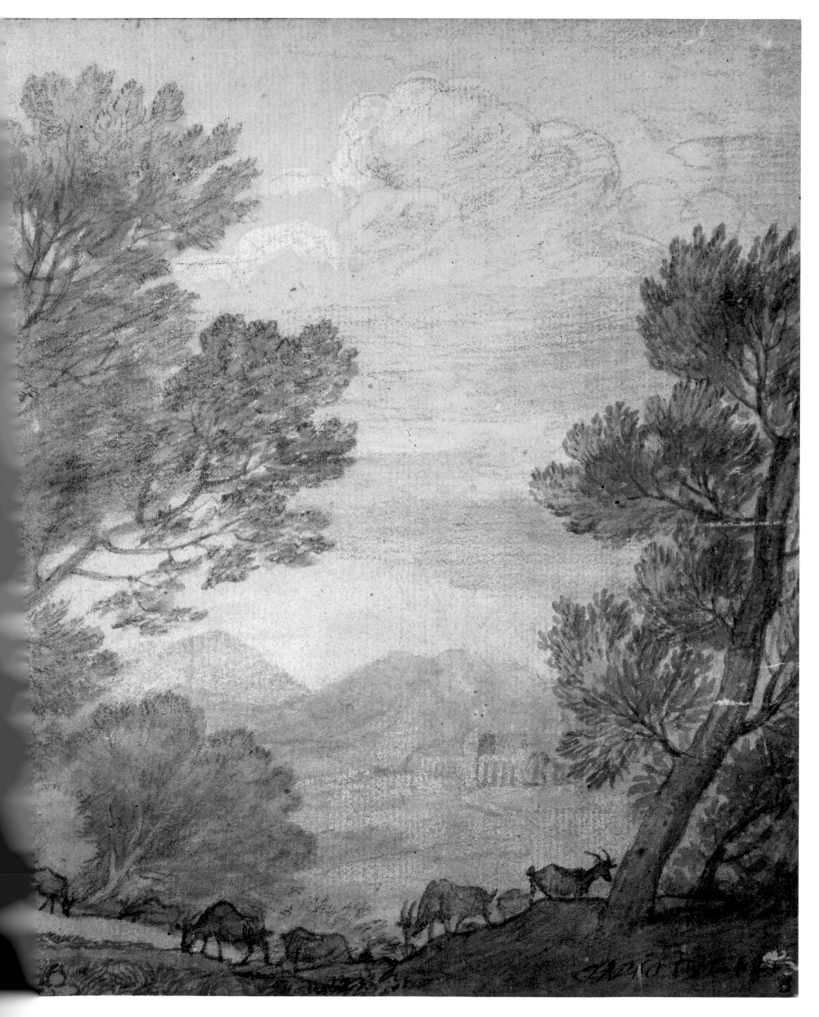

199

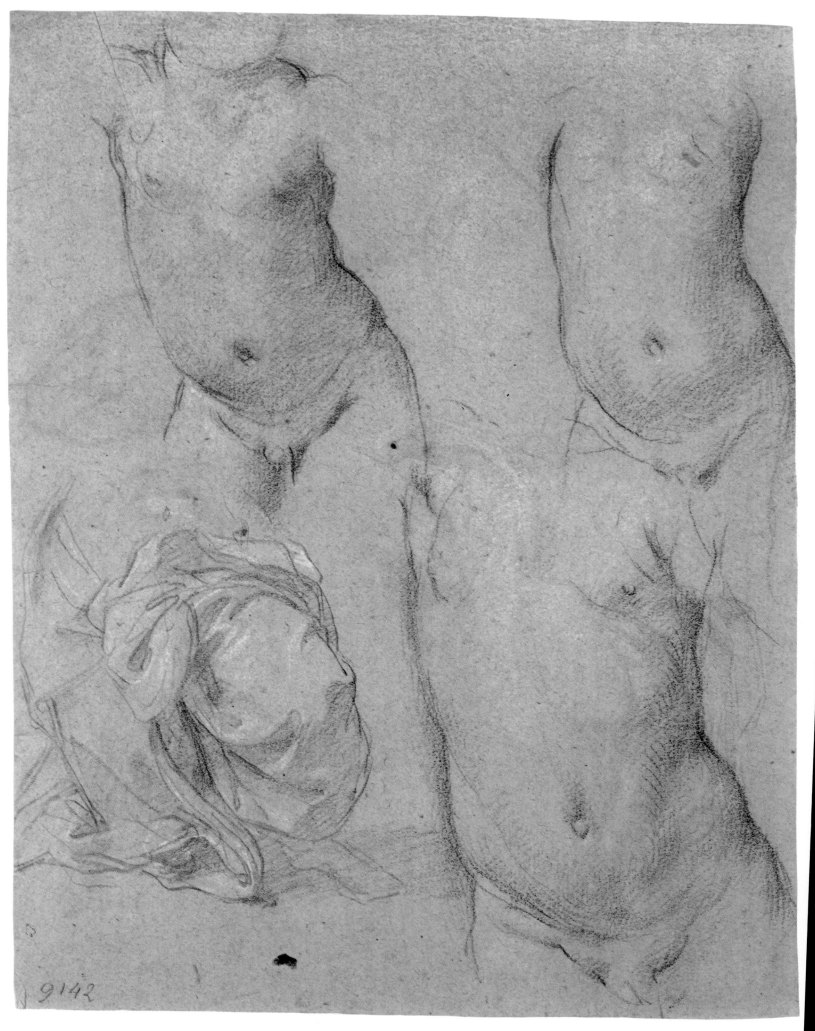

9142

200

Carlo Maratta (Camerino 1625–Rome 1713)
Studies of Figures and Drapery
Black chalk heightened with white
brushwork on azure paper; $10\frac{5}{8} \times 8\frac{3}{8}$ in.
(270 × 212 mm.)
Munich, Staatliche Graphische Sammlung,
inv. 2689

A formal classicism, inspired by
Carraccesque academism, typifies this folio,
which includes several nude studies and
drapery executed in black chalk on azure
paper. These are preliminary drawings for
the *Madonna of the Rosary*, a late work in
the more conformist style that was current in
Roman painting in the 1690s, executed for
the oratory of Santa Zita, near Palermo,
Sicily, in 1695.
Bibliography: Degenhart-Schmitt, 1967, no.
44

Baciccio, Giovanni Battista Gaulli
(Genoa 1639–Rome 1709)
Study of a Dead Child
Sanguine, heightened with white; $7\frac{1}{2} \times 10$ in.
(195 × 254 mm.)
Provenance: Turner; entered in 1944
Oxford, Ashmolean Museum

This drawing is taken from the altarpiece
painted about 1663 to 1666 for the church of
San Rocco in Rome. It is the earliest
surviving drawing by Baciccio and
demonstrates some of the more progressive
tendencies of the period. The soft, flowing
lines with which the artist has defined the
form of the dead child are indicative of the
transition from Baroque to Rococo.
Bibliography: Parker, 1956, no. 850;
Enggass, 1964, fig. 101; Pignatti, 1976,
no. 65

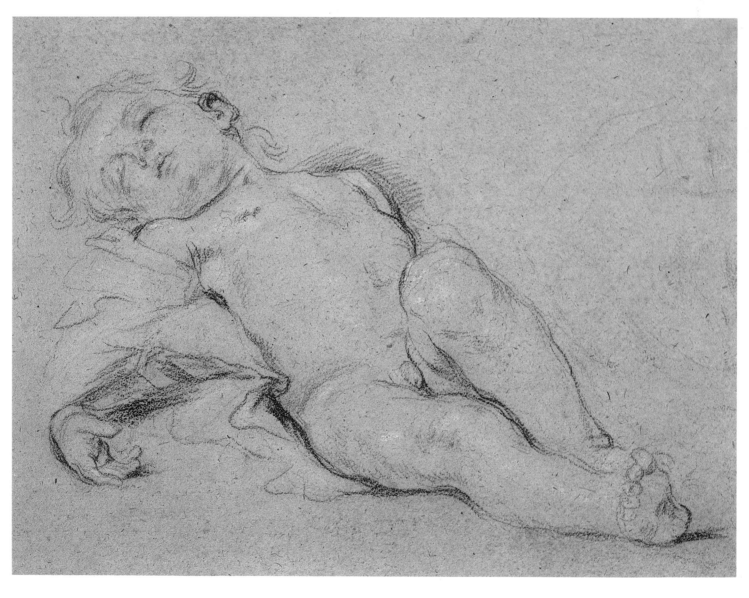

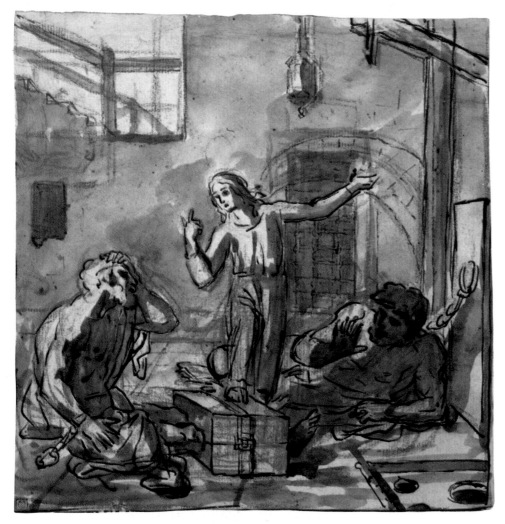

Pier Francesco Mola
(Coldrerio 1612–Rome 1666)
Joseph Interpreting His Dreams
Pen and brown ink, brown wash over
sanguine and black chalk; $7 \times 6\frac{7}{8}$ in.
(180×173 mm.)
Provenance: Mather
Princeton, NJ, University Art Museum,
Frank Jewett Mather Jr Collection,
inv. 52–167

The use of brown watercolour wash to
provide a link for the various elements of the
composition, in which the outlines had first
been rapidly and sparingly sketched in pen,
is a technique frequently found in Mola's
drawings. By this means the artist was able
to convey the impression of real light,
creating an evocative interior scene.
Bibliography: Bean, 1966, no. 54

Mattia Preti (Taverna 1613–Valletta 1699)
Roman Charity
Sanguine; $11\frac{1}{2} \times 8\frac{5}{8}$ in. (290×220 mm.)
Provenance: Turnor, entered in 1944
Oxford, Ashmolean Museum

The theme of *Roman Charity* is linked with
some of Preti's paintings. Despite the rapid
style of drawing, the result is soft and
painterly because sanguine has been used.
This technique, combined with black chalk,
was one of the artist's favourites. Preti was
an exponent of the Neapolitan verism that
derived from the school of Caravaggio.
Bibliography: Parker, 1956, no. 926;
Pignatti, 1976, no. 68

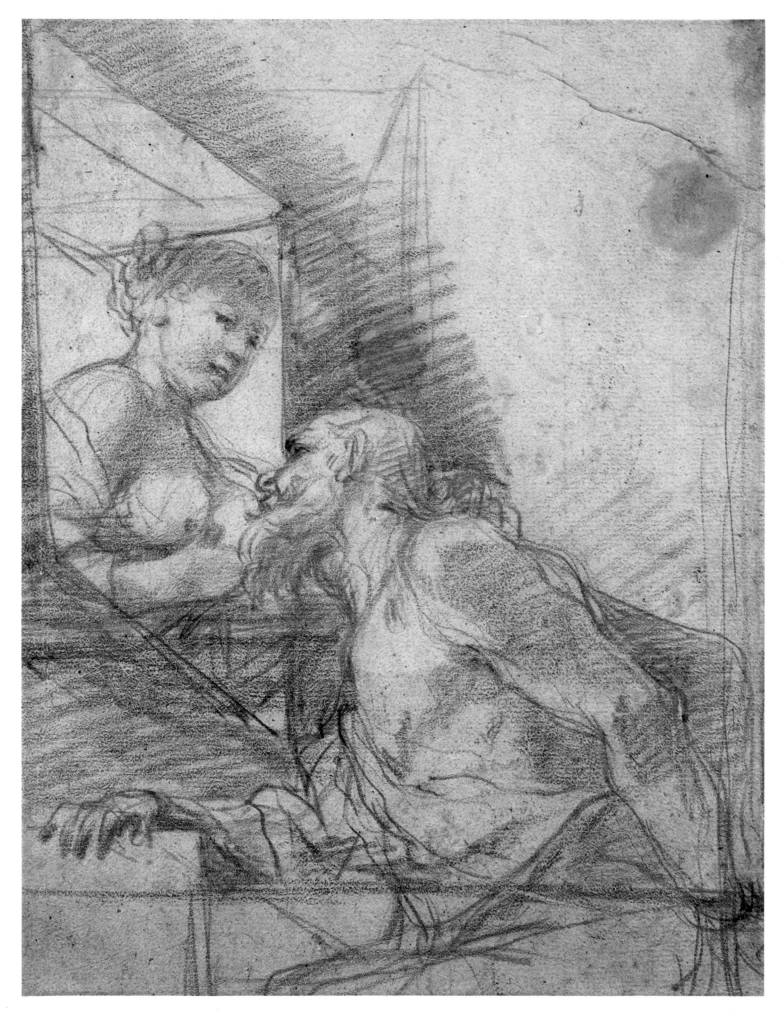

203

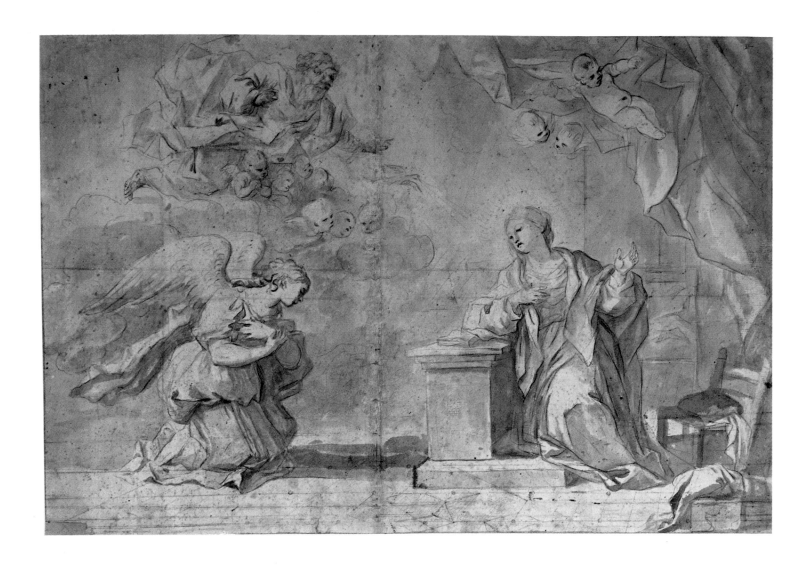

Luca Giordano (Naples 1634–1705)
Annunciation
Black chalk, pen, brush and bistre, with
brown and grey wash; 18 × 26½ in.
(457 × 671 mm.)
Vienna, Graphische Sammlung Albertina,
inv. 14232

The tendency to over-emphasize the
decorative aspect, which brings any work of
art very close to the spirit of Rococo, is
typical of the late output of Luca Giordano.
This drawing can be dated to the 1690s
because of the way Giordano has used light,
in an attempt to produce a painterly effect
through a graphic medium.
Bibliography: Stix-Spitsmüller, 1941,
no. 609; Ferrari-Scavizzi, 1966, II, p. 268,
fig. 67

Bernardo Strozzi (Genoa 1581–Venice 1644)
Head of a Man in Profile
Charcoal; 10 × 8½ in. (256 × 217 mm.)
Provenance: Correr
Venice, Museo Correr, inv. 1626

This drawing emanates from Strozzi's
mature phase, at the end of his Genoese
period or the beginning of his Venetian
activities in about 1630. The artist blended
the knowledge he had gained from Rubens
and van Dyck with a Venetian feeling for
colour which can be seen in the soft,
painterly quality of this folio. There is a
comparable drawing, *Head of a Bearded
Man*, in the Uffizi Gallery, Florence.
Bibliography: Pignatti, 1973, no. 20

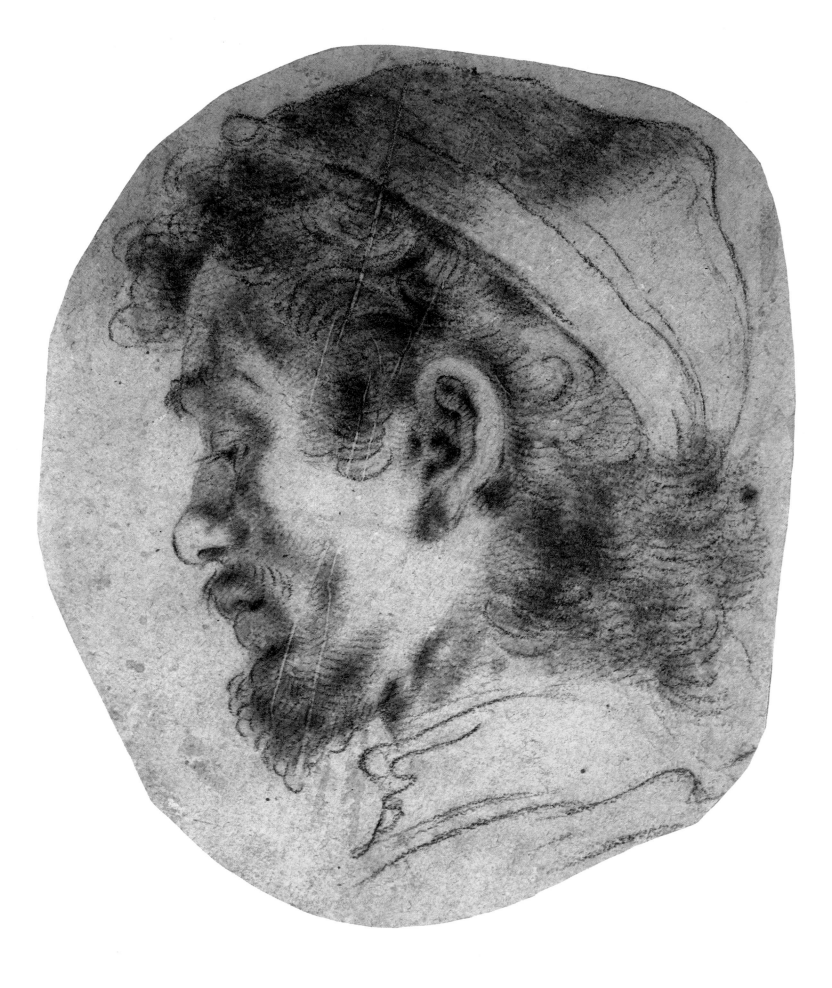

Grechetto (Genoa 1616–Mantua 1665)
*Rachel with Jacob's Children and his
Animals*
Brush, turpentine and oil on paper;
14¾ × 21 in. (375 × 532 mm.)
Provenance: Mariette
Vienna, Graphische Sammlung
Albertina, inv. 14419

The biblico-pastoral scene was very dear
to Grechetto. In it he succeeded in
combining a religious subject with a
genre scene, and the drawing in brush
and oil illustrated here is typical of this.
Similar sheets by this artist, in which a
few colours have been used to produce
a chiaroscuro effect, seem to be
complete, independent works of art. He
invented the monotype process.
Bibliography: Delogu, 1928, p. 59,
no. 31; Stix-Spitzmüller, 1941, no. 514;
Benesch, 1964, pl. IV

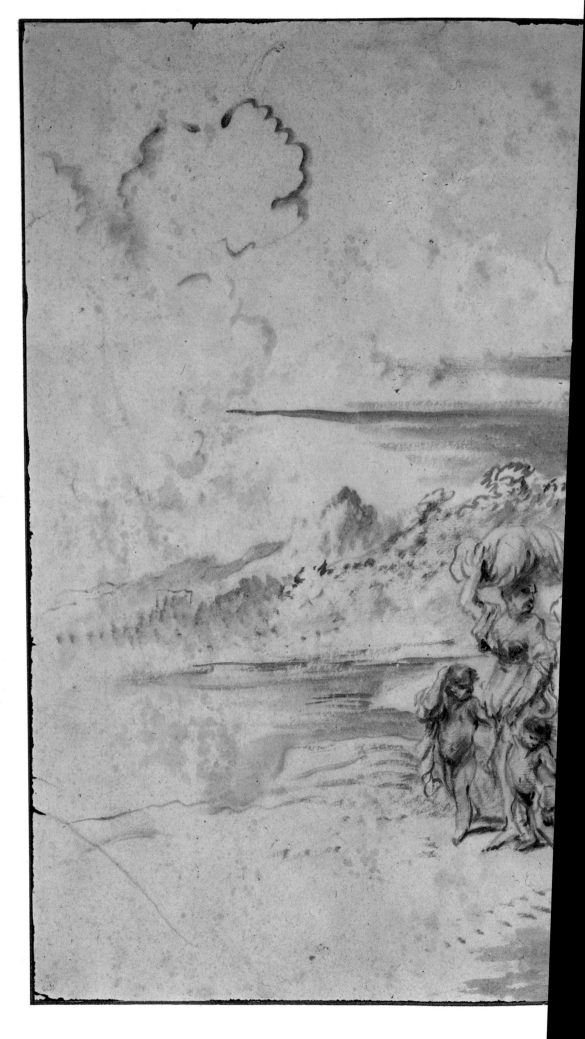

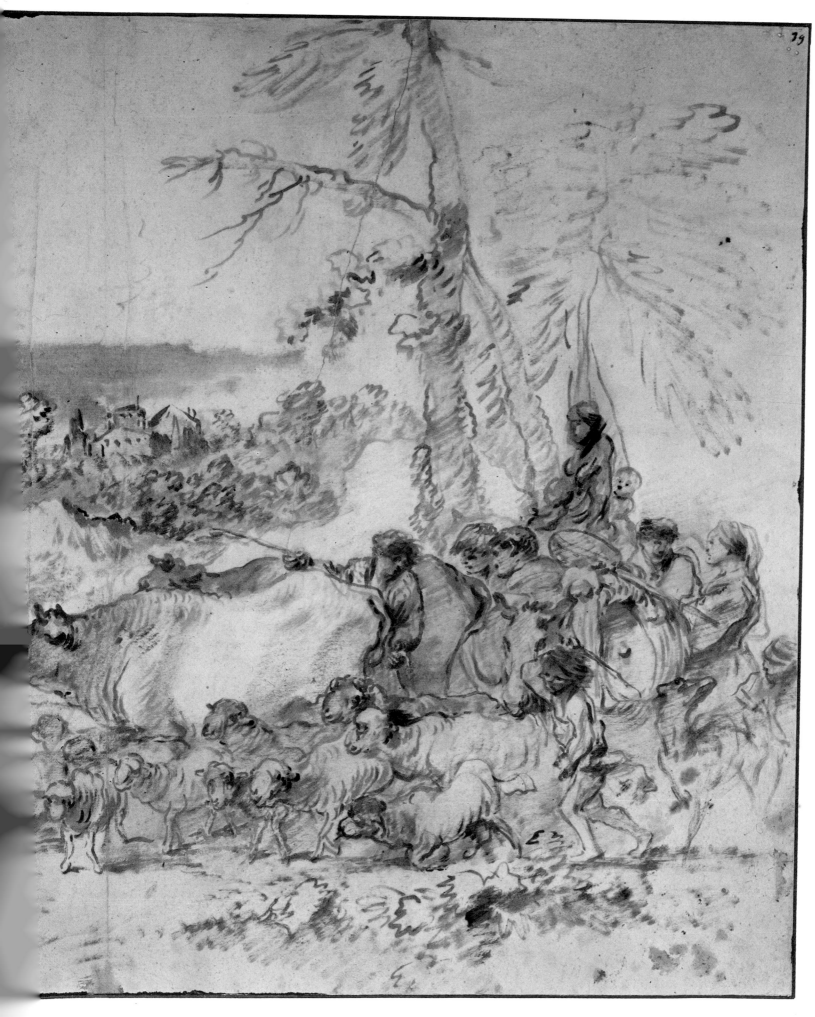

The Seventeenth Century in the Low Countries, France and Spain

Pieter Paul Rubens (Siegen 1577–Antwerp 1640). Rubens was born in Germany of Flemish parents who returned to Antwerp when he was about twenty. There, in 1590, he began to study painting. In 1600 he set off on a long tour of Italy, visiting Venice, Rome, Mantua, Genoa and Florence. Eight years later he returned to Antwerp, where he married and began work on his famous canvases for the Cathedral. A great favourite in Flemish high society, he brought a rich, festive atmosphere into the hitherto rather solemn Flemish school. His work reached its peak in its portraits and large decorative paintings like those he produced in 1621 for Marie de' Medici for the Palais de Luxembourg, Paris (now in the Louvre). His wife having died in 1626, he remarried four years later to begin a final, very happy phase of his life. Among other countries, he went to England where he did some fine paintings before returning to Antwerp for the last time. He was as tireless in his graphic work as he was in his painting, all his preliminary drawings being taken from life.

Jacob Jordaens (Antwerp 1593–1678). As did Rubens, Jordaens drew his inspiration from the school of Caravaggio and from the strong feeling for colour of the Venetians. There was, however, added stress on the corporeity of his subjects and a totally objective thematic veracity, a fine example of this being his *Peasant with a Satyr*, now in Munich. From among his vast output, his most remarkable works are those painted around 1630 when he was experimenting with the effects of light, as in his *Fertility of the Earth* in Brussels.

Anthony van Dyck (Antwerp 1599–London 1641). A pupil of Rubens in 1618, van Dyck toured Italy from 1621 to 1627, during which time he visited Rome, Bologna and Venice. Returning to Antwerp, he became Court Painter to the House of Orange, working particularly as a portraitist. At the age of thirty-three he went to England, where he remained almost uninterruptedly until his death only nine years later. Van Dyck's sketchbooks have been preserved in the British Museum, London. From them can be seen how carefully he studied all the great masters of the past. He was especially drawn to the Venetian artists, on whose delicate handling of changing colour he based his own artistic language.

Rembrandt Harmenszoon van Rijn (Leyden 1606–Amsterdam 1669). It was through his fellow artists returning from Rome that Rembrandt became familiar with the achievements of the Caravaggio school. From his earliest working days, he developed a realistic style in which the modelling was largely created by the effects of light. In 1631 Rembrandt moved to Amsterdam, where he set to work on a grand scale, mainly as a portraitist and painter to the Guilds. His masterpiece during this phase was his so-called *Night Watch* – originally entitled *The Militia Company of Captain Frans Banning Cocq* – which he painted in 1642. He was a prolific engraver and an outstanding draughtsman, his sheets of drawings running into thousands. The final period of Rembrandt's life was sad. He had become the victim of an increasing lack of understanding and this, combined with some unfortunate family problems, reduced him to a state of solitude and poverty. His work was to be admired and emulated for centuries to come, however, not only for its technical qualities but for its tragic search for truth and lofty moral conscience.

Leonard Bramer (Delft 1596–1674). Bramer owed his formation as an artist to his experiences during a long tour of Italy undertaken between 1614 and 1616. He remained in Rome for a few years, working with Adam Elsheimer, from whom he learnt to produce dramatic contrasts of light and shade, apparent even in his drawings. At the age of thirty-three he returned to Delft, where he was commissioned to paint the ceiling of the castle. So far as his graphic work is concerned, Bramar left a number of sketchbooks, such as his preparatory drawings for his *Lazarillo de Tormes* and *Passion of Christ*. He was also an outstanding engraver.

Adriaen van Ostade (Haarlem 1610–85). A pupil of Frans Hals, van Ostade devoted his work mainly to themes relating to the life of country folk. His style was very painterly and the influence of Rembrandt gradually becomes more apparent with maturity. He also learnt a great deal about the effects of light through Rembrandt's engravings, a medium van Ostade himself also employed.

Aelbert Cuyp (Dordrecht 1620–91). The son and pupil of the portraitist Jacob Gerritsz, Cuyp concentrated mainly on bucolic scenes

into which he introduced peasant figures and animals with effective realism.

Hendrick Avercamp (Amsterdam 1585–Kampen 1634). Avercamp is the Dutch master whose work most closely resembles that of Bruegel the Elder in the rendering of landscape animated by small figures. The whole picture, however, is depicted in a suspended atmosphere that enables the artist's meticulous and precise graphic work to be seen to its best advantage.

Francisco de Zurbarán (Fuente de Cantos 1598–Madrid 1664). From 1629 Zurbarán worked mainly in Seville, where he acted as an artistic interpreter of the austere religiosity of the time. He decorated the Buen Retiro Palace (1634–6) in Madrid, the monastery of Guadalupe and the Carthusian monastery in Jerez with paintings of impressive solemnity. In the latter part of his life, Zurbarán worked almost exclusively for churches and monasteries in Latin America.

Charles Le Brun (Lebrun) (Paris 1619–90). Having spent his formative years in Rome under the guidance of Simon Vouet and Nicolas Poussin, Le Brun became the most important artist in the France of Louis XIV, the Sun King. His rhetorical, classicized art had its greatest scope for expression in the palace of the Tuileries and at Château de Versailles. A fine example of his work in this connection is his *Chancellor Séguier*, painted in 1660 and now in the Louvre. Le Brun held a number of high administrative offices and was President of the French Academy of Painting and Sculpture from 1663 to 1690, Director of the Gobelins' tapestry factory and impresario for royal ceremonies.

Jacques Callot (Nancy 1592–1635). Callot received his training in Italy, partly in Rome and partly in Florence, from 1609 to 1612. His chief skill was as an etcher and he held such a unique position in this field that it has never been challenged. In his *Caprices* of 1617, he illustrated some of the strange and grotesque aspects of the life of the people. Later, having returned to France, at the age of forty-one he etched his masterpiece, *Les Grandes Misères de la Guerre*. This was etched in a serpentine style with whiplash, sweeping lines for which Callot had prepared a number of impressive drawings in pen and brush.

Jusepe de Ribera, called Spagnoletto (Játiva de Valencia 1591–Naples 1652). Ribera was in Naples in 1616 and found the style of Caravaggio very much to his taste. He adopted a *tenebroso* style of painting – deeply shadowed and low-keyed – which soon spread throughout Sicily and the south of Italy. Ribera's paintings are full of expressive verism through themes that are often rough and vulgar, such as his *Silenus* in Naples. His last works were all executed for Naples, one of the most important being the *Communion of the Apostles* in the Carthusian monastery of San Martino.

Pieter Paul Rubens
(Siegen 1577–Antwerp 1640)
Three Caryatids
Sanguine, brush and red ink, highlighted
with opaque white-lead pigment; $10\frac{1}{2} \times 10$ in.
(269 × 253 mm.)
Provenance: Happaert; Lankrink; Koenigs
Rotterdam, Museum Boymans-van
Beuningen, inv. V-6

Profoundly influenced as a young man by
Italian art, Rubens made numerous copies
and free interpretations of various of its
aspects, including this drawing whose subject
is related to a work by Primaticcio. His use
of sanguine, delicately brushed over with red
ink, already determined the plastic effect that
was to characterize his style.
Bibliography: Burchard-d'Hulst, 1956, no.
100; Haverkamp-Begemann, 1957, no. 28;
Eisler, 1964, pl. 40

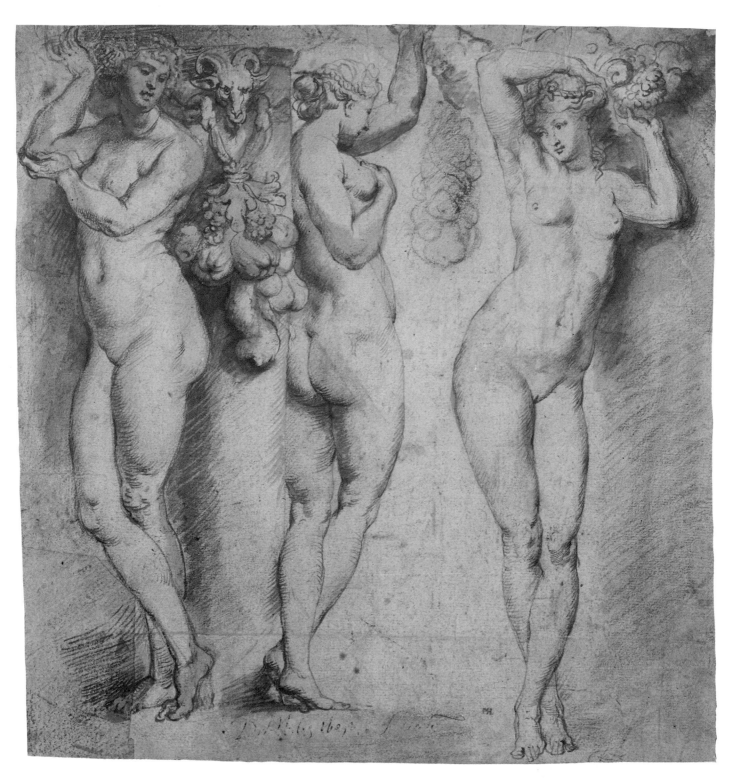

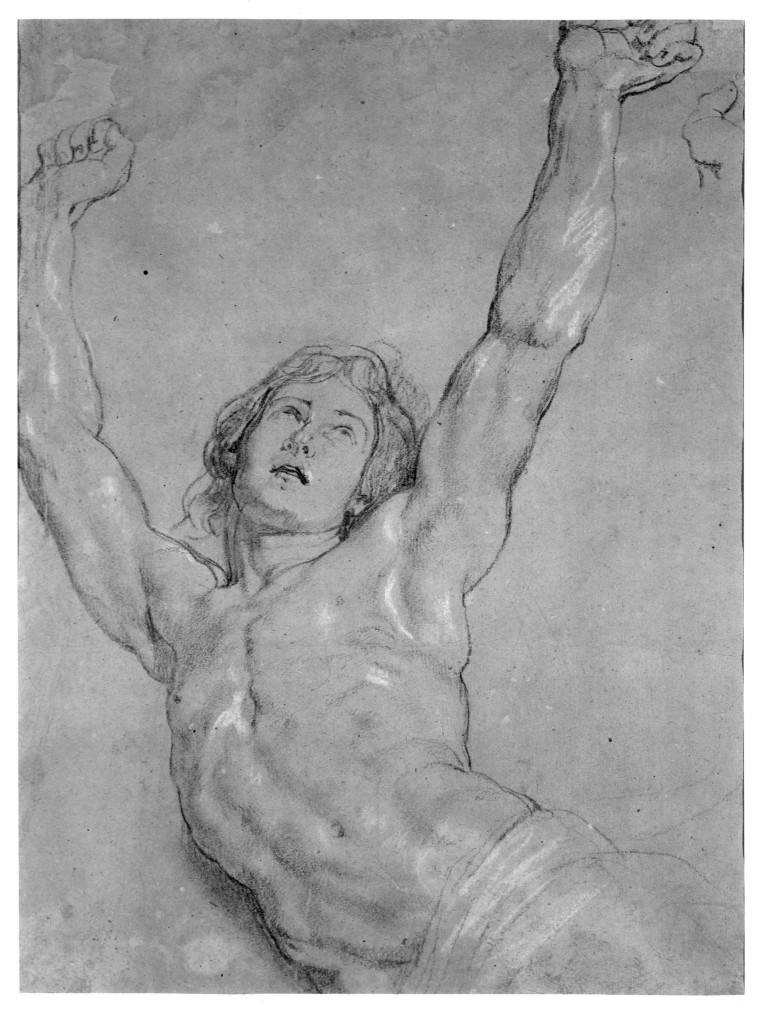

212

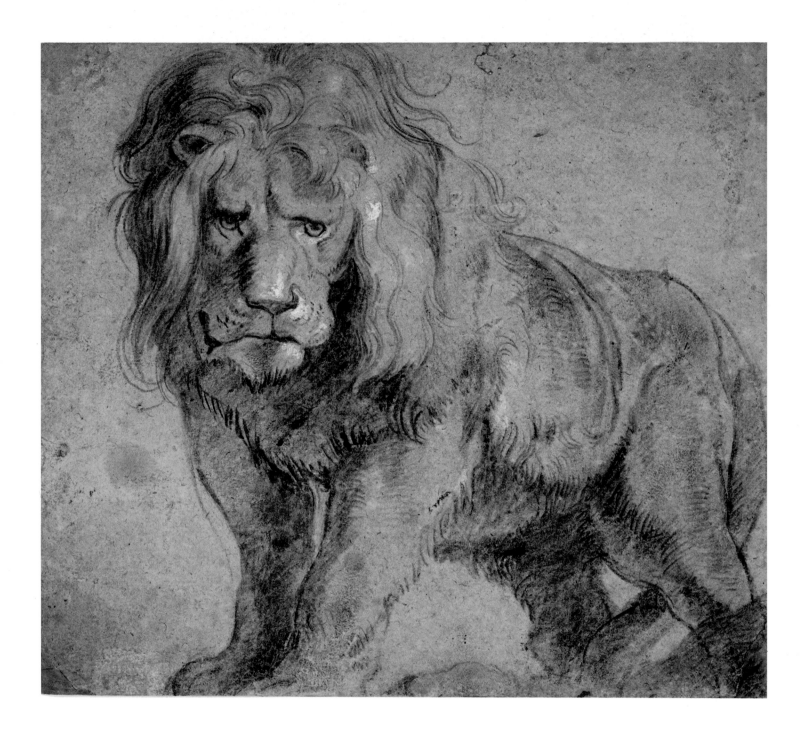

Pieter Paul Rubens
Study for Christ Raising the Cross
Black chalk heightened with white on pale
yellow paper; $15\frac{3}{4} \times 11\frac{3}{4}$ in. (400 × 298 mm.)
Provenance: de Wit (?); Böhm; Weisbach;
Sachs
Cambridge, Mass., William Hayes Fogg Art
Museum, Gift of Meta and Paul J. Sachs,
inv. 1949.3

This preliminary study from life for the
figure of Christ in the *Raising of the Cross*
which Rubens painted for Antwerp
Cathedral (1610–11), reveals the direct
influence of the Classicism of the school of
Carracci, which had fascinated Pieter Paul
while he was in Italy. The figure of Christ, so
rhythmically outlined with a soft line of
black chalk, is enhanced by the vigorous
plasticity of the modelling.
Bibliography: Mongan Sachs, 1946, no. 483;
Burchard-d'Hulst, 1963, no. 55

Pieter Paul Rubens
Lion
Black and yellow chalks heightened with
white; $10 \times 11\frac{1}{8}$ in. (254 × 282 mm.)
Washington, DC, National Gallery of Art,
Ailsa Mellon Bruce Fund, inv. B-25, 377

The powerful plasticity of this magnificent
figure of a lion is emphasized by the complex
technique employed known as *aux trois
crayons*, which enables three colours of chalk
to be combined – in this case, black, yellow
and white – in the chromatic rendering of
the animal's coat. There are two similar
sheets in the British Museum which relate to
the picture *Daniel in the Lions' Den* – at one
time in the Hamilton Collection – which
were included in a list of paintings sent by
Rubens to Dudley Carleton in 1618. This
seems to justify the dating of this study,
therefore, to between 1615 and 1620.
Bibliography: Robison, 1978, no. 63

213

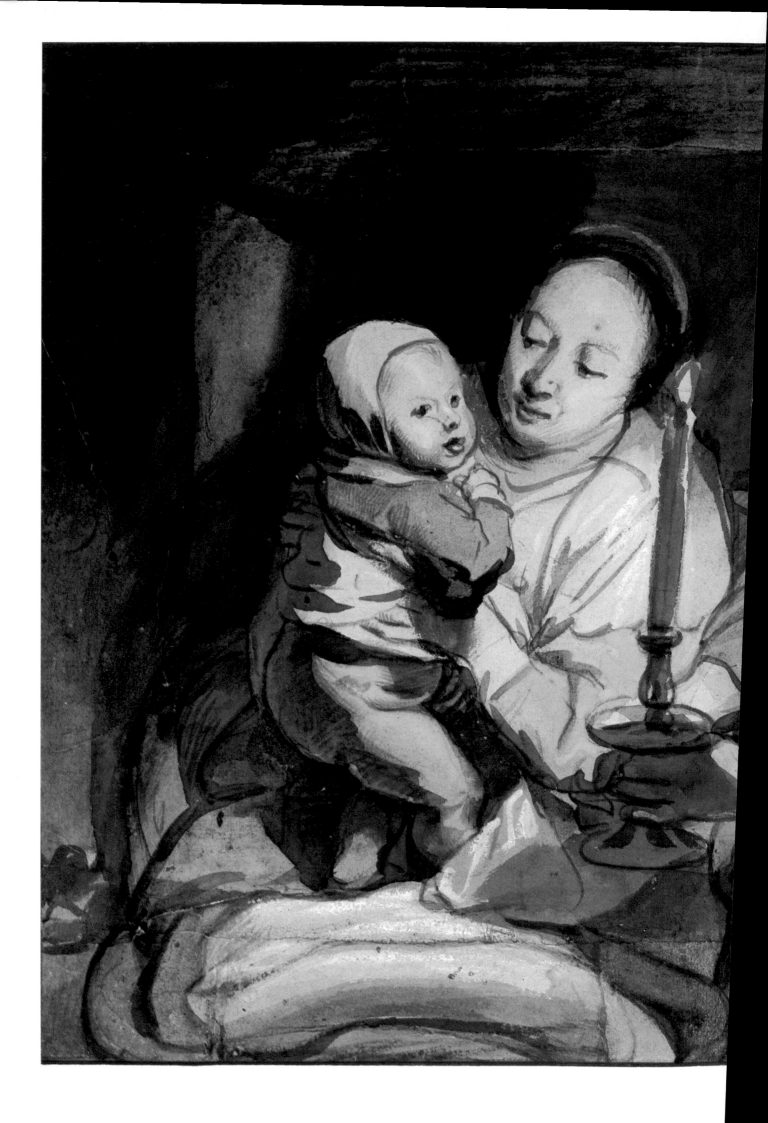

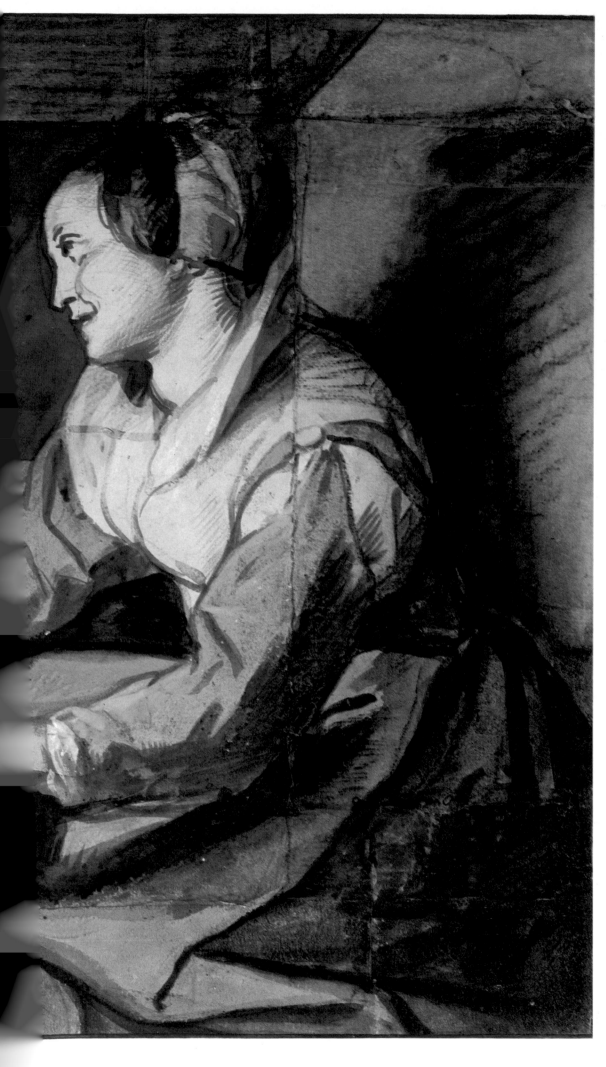

Jacob Jordaens
(Antwerp 1593–1678)
Two Women and a Child in Candlelight
Watercolour, brush and bistre heightened with white over black chalk and sanguine; $14 \times 18\frac{7}{8}$ in. (357 × 479 mm.)
Vienna, Graphische Sammlung Albertina, inv. 15126

One of the major exponents of Dutch Caravaggism, Jordaens' realistic themes and his pursuit of striking effects of light and shade are the most outstanding features of his work. In this work, which was executed in his late twenties, and in a similar one in the Louvre, he reveals his fondness for an intimate theme set in candlelight.
Bibliography: Schönbrunner-Meder, 1896–1908, no. 725; d'Hulst, 1956, no. 32; Benesch, 1964, pl. XV

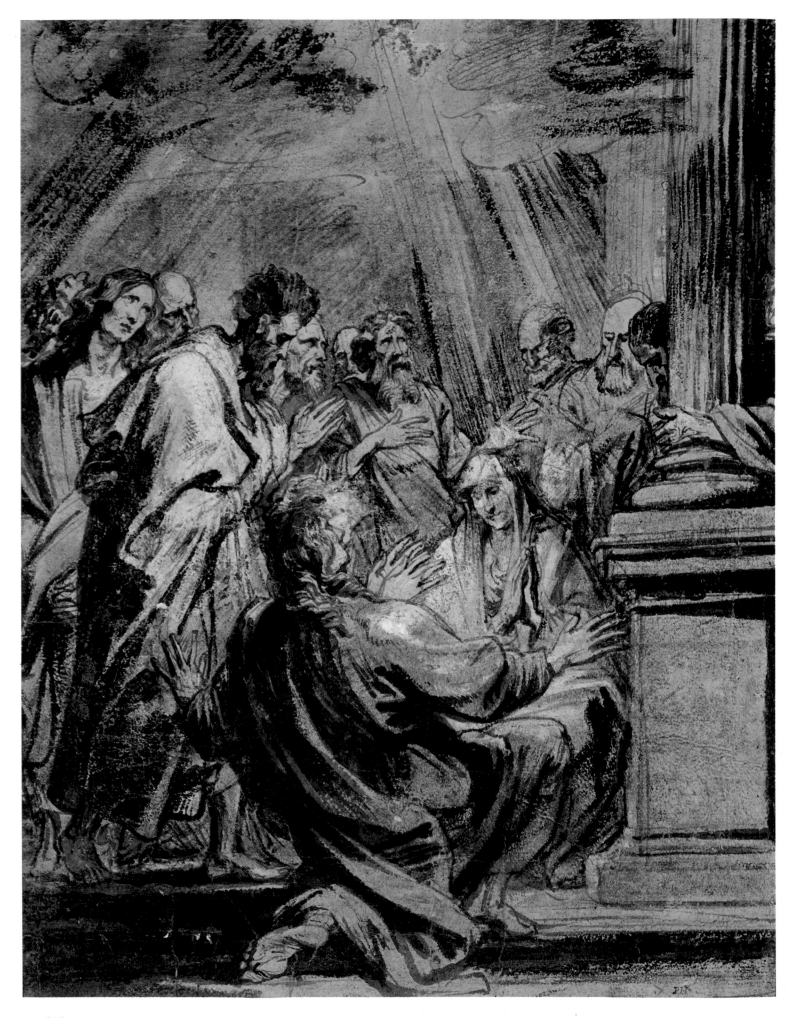

216

Anthony van Dyck
(Antwerp 1599–London 1641)
Pentecost
Pen, brush and bistre, watercolour
heightened with white; $13\frac{3}{8} \times 10\frac{1}{4}$ in.
$(340 \times 260 \text{ mm.})$
Provenance: Lankrink
Vienna, Graphische Sammlung Albertina,
inv. 7574

This drawing is signed in the lower left-hand
corner, although nothing is legible except the
word *'fecit'*. It is one of several pen and
brush studies executed by van Dyck, in
addition to some charcoal drawings of
details, for his Potsdam *Pentecost*, datable to
about 1620. The ecstatic attitudes of the
figures, which are thrown into relief by the
strong luministic effects, are characteristic
features of the painter's youthful phase.
Bibliography: Meder, 1923, pl. 13; Vey,
1962, no. 66; Benesch, 1964, pl. XIV

Anthony van Dyck
Portrait of Puteanus
Black chalk and brown wash; $9\frac{1}{2} \times 6\frac{7}{8}$ in.
$(242 \times 173 \text{ mm.})$
Provenance: Hudson, Malcom
London, British Museum, inv. 1895-9-15-
1069

There is a painting in Raleigh, North
Carolina, signed *'van dyck f.'*, which
corresponds to this drawing. The blending of
media in chalk and brush has enabled the
artist to produce an extremely vital and
realistic portrait of a great contemporary of
van Dyck. He was Eerryck de Putte, known
as Puteanus, a historian and philologist,
who lived from 1574 to 1646.
Bibliography: Hind, 1923, no. 32; Vey, 1962,
no. 255

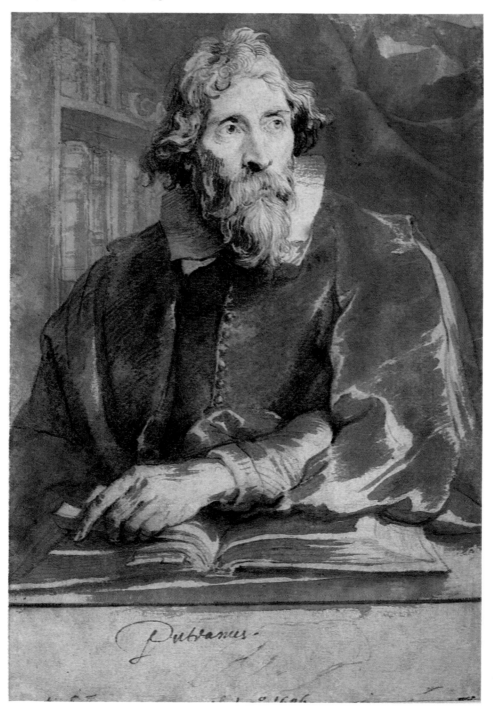

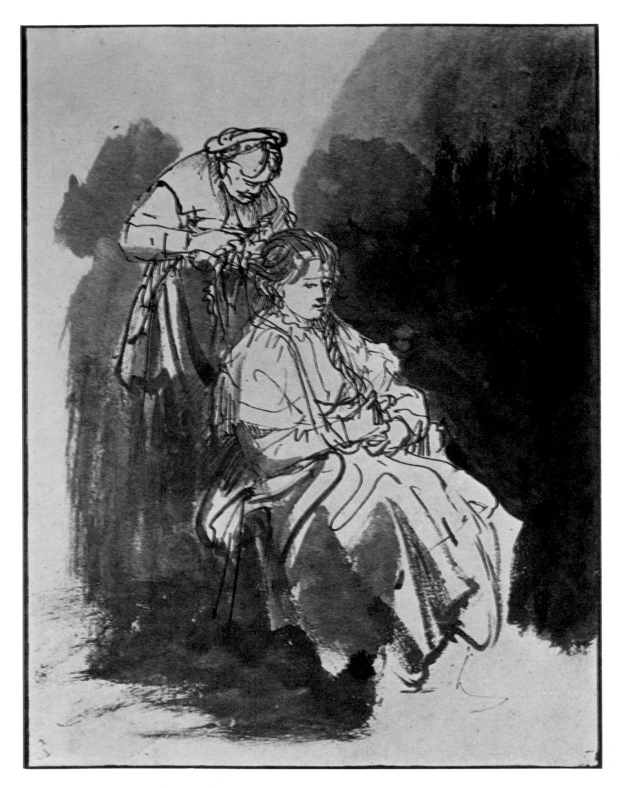

Rembrandt
Seated Nude Woman
Pen and brush, bistre,
black chalk and
charcoal; $11\frac{3}{8} \times 7\frac{1}{2}$ in.
(288 × 191 mm.)
Provenance: Spencer;
Russel; Heseltine;
Koenigs
Rotterdam, Museum
Boymans-van
Beuningen, inv. R-2

This drawing is one of a
series of nudes executed
by Rembrandt in the
latter part of his life,
between about 1650 and
1660. His complete
mastery of technique
allowed him to achieve
an exquisitely painterly
quality emphasized by
the marked contrasts of
light, which make the
white, sensual figure
stand out strongly
against the background
darkness. The model
may well be
Rembrandt's second
wife, Saskia.
Bibliography: Benesch,
1957, no. 1114

Rembrandt (Leyden 1606–Amsterdam 1669)
A Woman and Her Hairdresser
Pen and bistre, with bistre and indian ink
wash; $9\frac{1}{8} \times 7$ in. (233 × 180 mm.)
Vienna, Graphische Sammlung Albertina,
inv. 8825

The play of light and shade, reproduced by
skilful brushwork over a rapidly penned
outline, makes this one of the most
important of all the studies of domestic
subjects executed by Rembrandt in
Amsterdam in the early 1630s. This drawing is
probably datable 1632–4 and it is not
unlikely that it provided the inspiration for
his *Bathsheba Bathing*, painted in 1632, now
in the National Gallery of Canada, Ottawa.
Bibliography: Benesch, 1954, no. 395; *idem*,
1964, pl. XVII

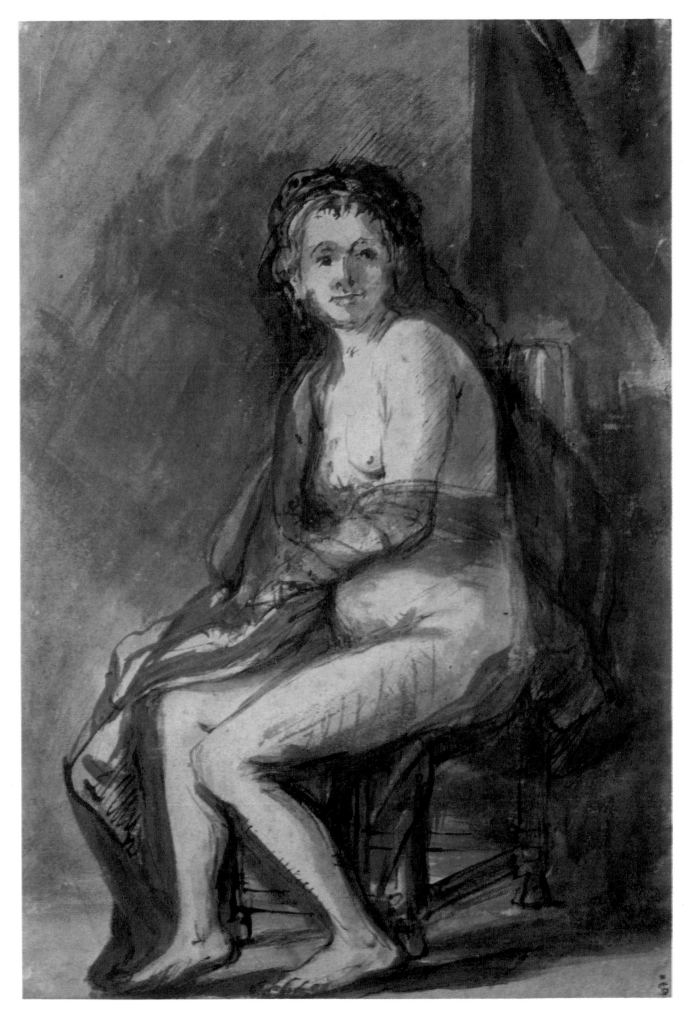

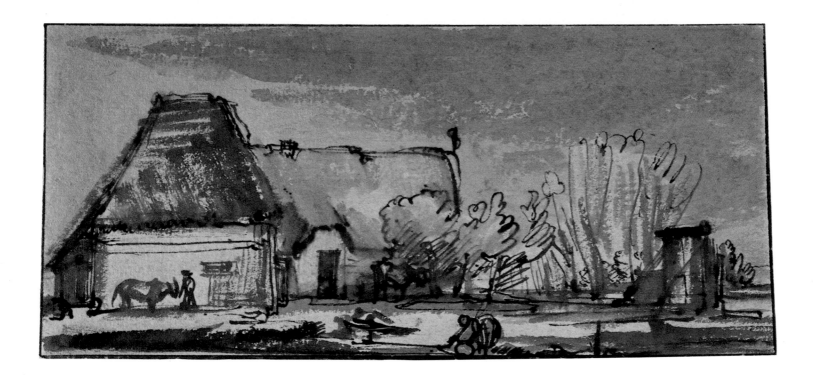

Rembrandt
Landscape with Farmstead
Pen and brush with brown ink; $4\frac{1}{4} \times 9$ in.
(108 × 229 mm.)
Haarlem, Teylers Stichting

This is a drawing that relates to
the artist's landscapes painted as a young
man. Here, too, Rembrandt has made use of
the mixed technique of pen and brush to
animate his portrayal of rustic life. The
atmospheric effect is emphasized by the
graduation of expressive energy which
decreases from the forcefulness of the
foreground – drawn in by pen over the ink
brushwork – to the lightly brushed-in trees
in the background.
Bibliography: Benesch, 1954, no. 473;
Regteren Altena, 1958, no. 62

Rembrandt
Pensive Woman
Brush and brown ink wash with touches of
opaque white-lead pigment; $6\frac{1}{2} \times 4\frac{7}{8}$ in.
(165 × 122 mm.)
Provenance: de Piles (?); Crozat; Tessin,
Kongl. Biblioteket; Kongl. Museum
Stockholm, Nationalmuseum, inv. 2085/1863

The model for this drawing, which is datable
to between 1655 and 1659, is almost
certainly Hendrickje Stoffels, the painter's
companion during his last years. The rapidly
drawn outline, executed with few brush-
strokes – which gives the portrait an
exceptional three-dimensional vigour – was
completely opposed to the analytical
tendency of contemporary bourgeois
realism.
Bibliography: Benesch, 1957, no. 1102;
Bjurström, 1970–1, no. 82

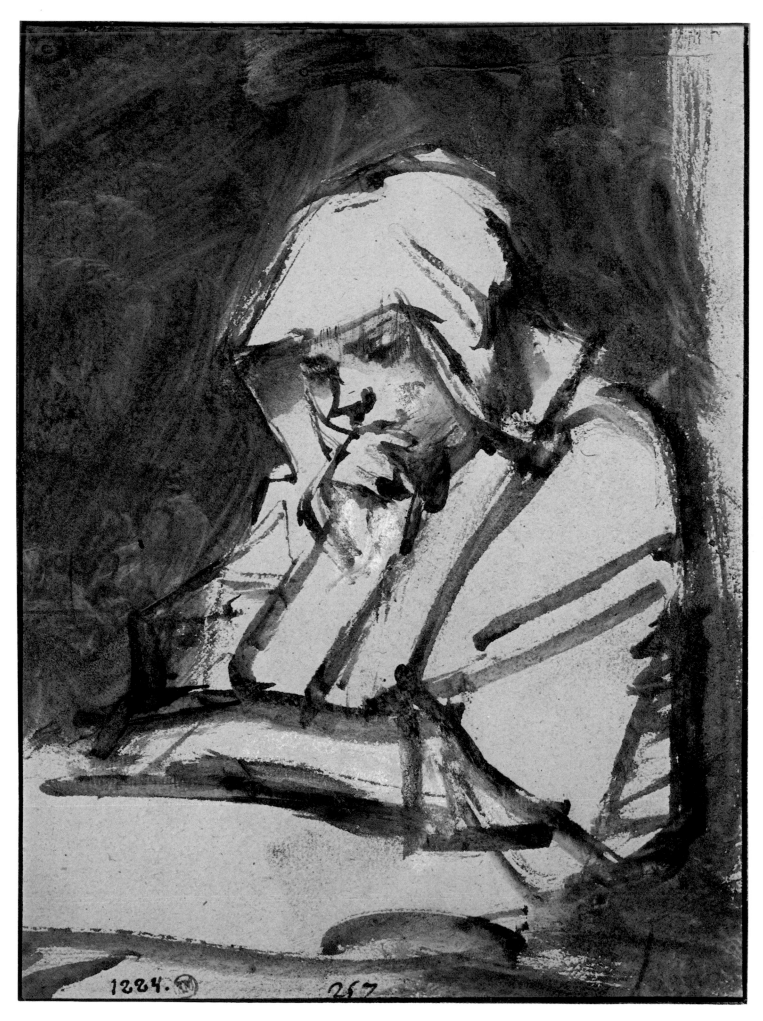

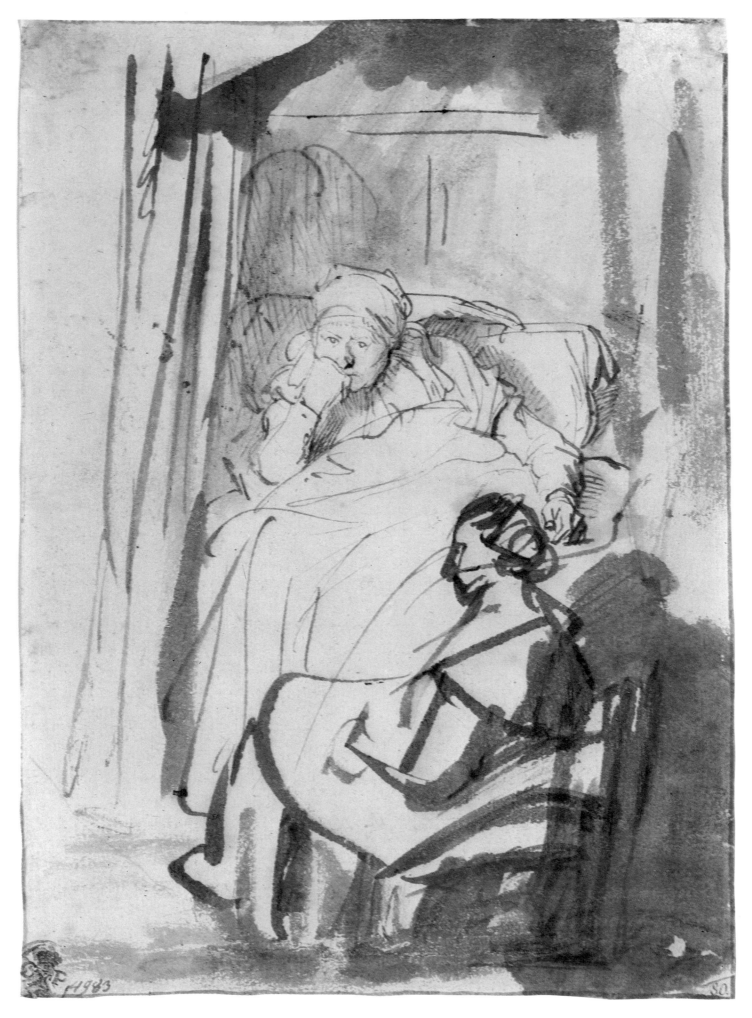

222

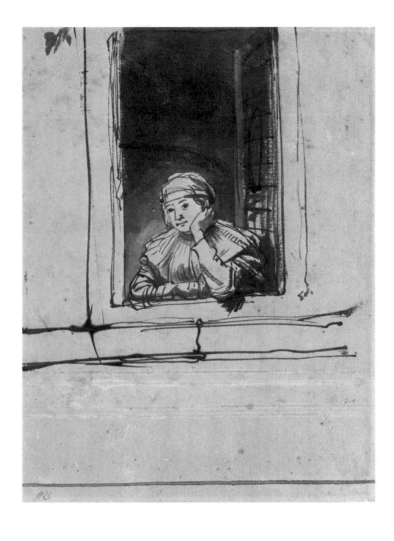

Leonard Bramer (Delft 1596–1674)
Woman with doll
Brush with black and grey indian ink,
heightened with white on grey paper;
$8\frac{1}{2} \times 6\frac{3}{4}$ in. (216 × 171 mm.)
Provenance: Gasc; Gigoux; Chennevières
Amsterdam, Prentenkabinet, Rijksmuseum,
inv. 09:16

This sheet, on whose *verso* there is another
study of the same subject, carries the
inscription *'elck heeft sijn eigen/pop'*
('everyone has their doll'). This is
fundamental to an interpretation of the
theme, which alludes to human weakness
and was inspired by a well-known book of
proverbs. The drawing is characterized by a
realistic *intimisme* and executed with broad
strokes of the pen in black and grey ink.
Bibliography: Wichmann, 1923, no. 159;
Boon, 1972, no. 21

Rembrandt
Saskia at the Window
Pen and brush with brown ink; $9\frac{1}{4} \times 7$ in. (236 × 178 mm.)
Provenance: de Vendè; Dimsdale; Lawrence; Esdaile; Bale;
Heseltine; Bonn; Cate: Koenigs; van Beuningen; entered in 1941
Rotterdam, Museum Boymans-van Beuningen, inv. R-131

A domestic scene, with his wife at the window bathed in sunshine, is
caught with spontaneous immediacy by the rapid strokes of
Rembrandt's pen, making the long white areas stand out against the
background. Saskia, who was married to Rembrandt on 10 June
1634, was to be the favourite model for his extremely lively studies
of everyday life. Indeed, this type of picture seemed to interest
Rembrandt no less than his most important commissions for
religious paintings and for portraits.
Bibliography: Benesch, 1954, no. 250; Haverkamp Begemann, 1957,
no. 20; Regteren Altena, 1958, no. 58

Rembrandt
Saskia in Bed with Pupil-Assistant at the Bedside
Pen, brush and watercolour, bistre and indian ink; $9 \times 6\frac{1}{2}$ in.
(228 × 165 mm.)
Provenance: Comtes Palatins du Rhin; Mannheimer
Munich, Staatliche Graphische Sammlung, inv. 1402

This scene, which is datable to around 1635, is perhaps the finest of
the family studies from this period because of the well-balanced
composition and the skilful play of light and shadow. The intimate
character of the scene is stressed; the 'Cubist' way in which the
assistant is depicted in a few brush-strokes gives the figure of Saskia
– drawn with such meticulous penmanship – so much more
importance.
Bibliography: Benesch, 1954, no. 405; Halm-Degenhart-Wegner,
1958, no. 83

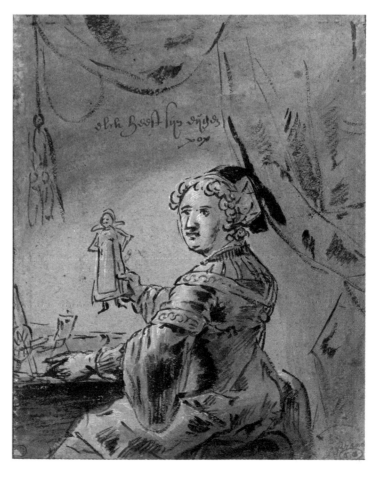

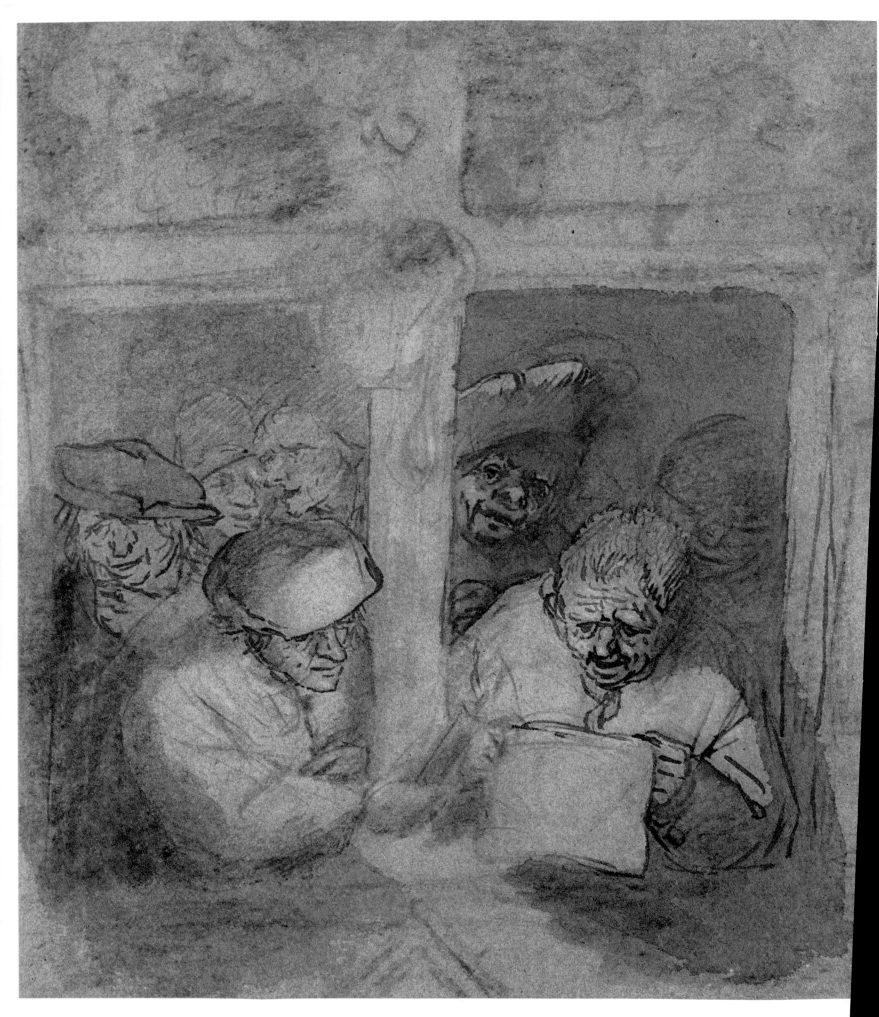

224

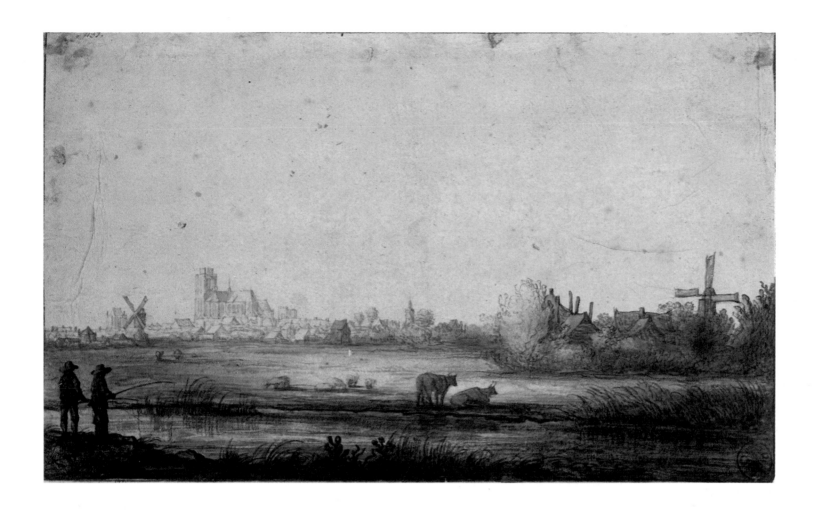

Adriaen van Ostade (Harlem 1610–85)
Readers in the Tavern
Bistre, pen and ink over black chalk with
wash on azure paper; $8\frac{1}{2} \times 7\frac{1}{2}$ in.
(217 × 190 mm.)
Provenance: Oppenheimer
Berlin, Kupferstichkabinett, inv. K.d.Z.
16533

One of the lesser seventeenth-century Dutch
masters, van Ostade frequently drew on the
humble inns and peasantry for his subjects.
In this rapidly executed, spontaneous
drawing – the first to have been produced by
the artist for a print (*c.* 1667) – the influence
of Rembrandt is apparent in the particularly
incisive strokes which outline the figures
against the azure ground of the paper.
Bibliography: Godefroy, 1930, no. 19;
Trautscholdt, 1960, p. 269

Aelbert Cuyp (Dordrecht 1620–91)
View of Dordrecht from the South
Black chalk, brown pen and black and
yellow brush; $7\frac{5}{8} \times 12\frac{1}{4}$ in. (193 × 310 mm.)
Provenance: Mannheimer
Munich, Staatliche Graphische Sammlung,
inv. 1865

Serene views of the Dutch countryside,
populated with animals, are the most typical
and delightful of Aelbert Cuyp's artistic
output. In this landscape, in which the
turrets and roofs of Dordrecht appear in the
distance, the artist has succeeded in
achieving an extremely realistic and
impressive atmospheric effect, due to his
subtle sensitivity in chiaroscural contrast.
Bibliography: Schmidt, 1884, no. 129; Halm-
Degenhart-Wegner, 1958, no. 88

On pages 226–7:
Hendrick Avercamp
(Amsterdam 1585–Kampen 1634)
Fishermen in a Polder
Pen, brown ink and watercolour over pencil;
$7\frac{5}{8} \times 12\frac{1}{4}$ in. (193 × 311 mm.)
Provenance: Albrechts; Ploos van Amstel;
Kops; de Vos; gift of V. Rembrandt
Amsterdam, Prentenkabinet, Rijksmuseum,
inv. A241

This drawing, which carries the artist's
monogram in the lower left-hand corner, has
every appearance of being a finished work. A
realistic note unites the various motifs of
which the scene is made up; Avercamp does
not restrict his interest to episodes of
everyday life but rather seeks a countryside
setting in which the details depicted so
meticulously in the foreground are echoed in
ever-decreasing definition in the background.
Bibliography: Moes, 1905–6, I, no. 2;
Welcker, 1933, no. T12; Boon, 1972, no. 1

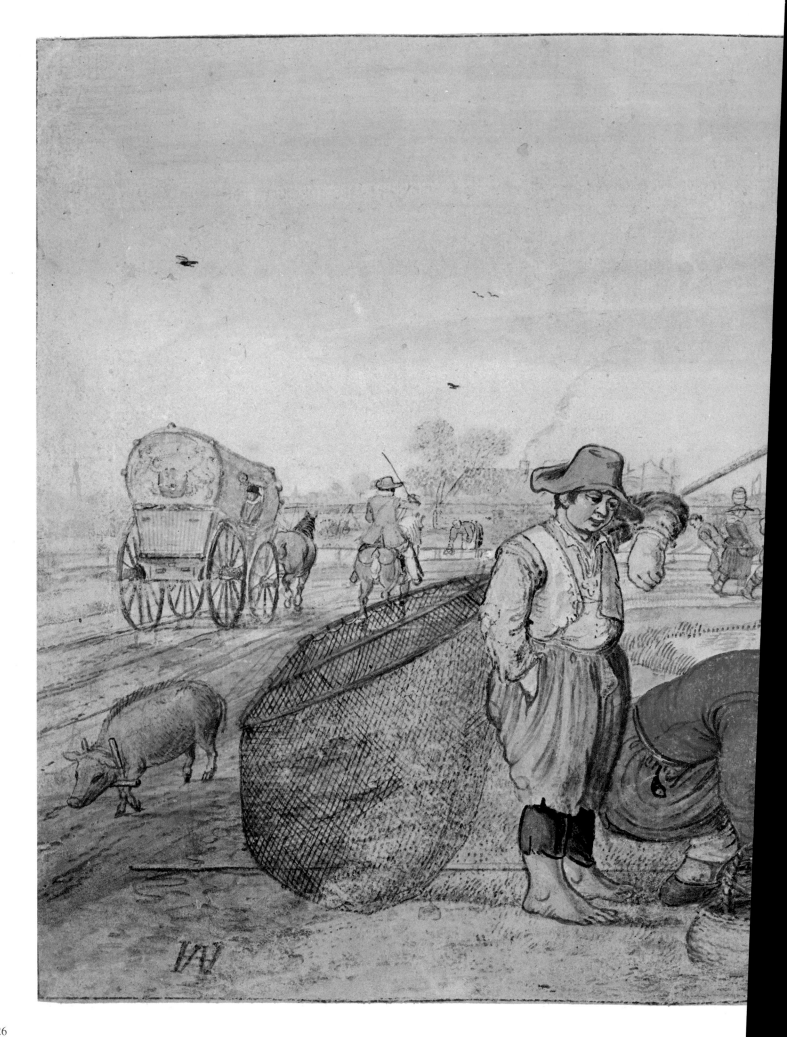

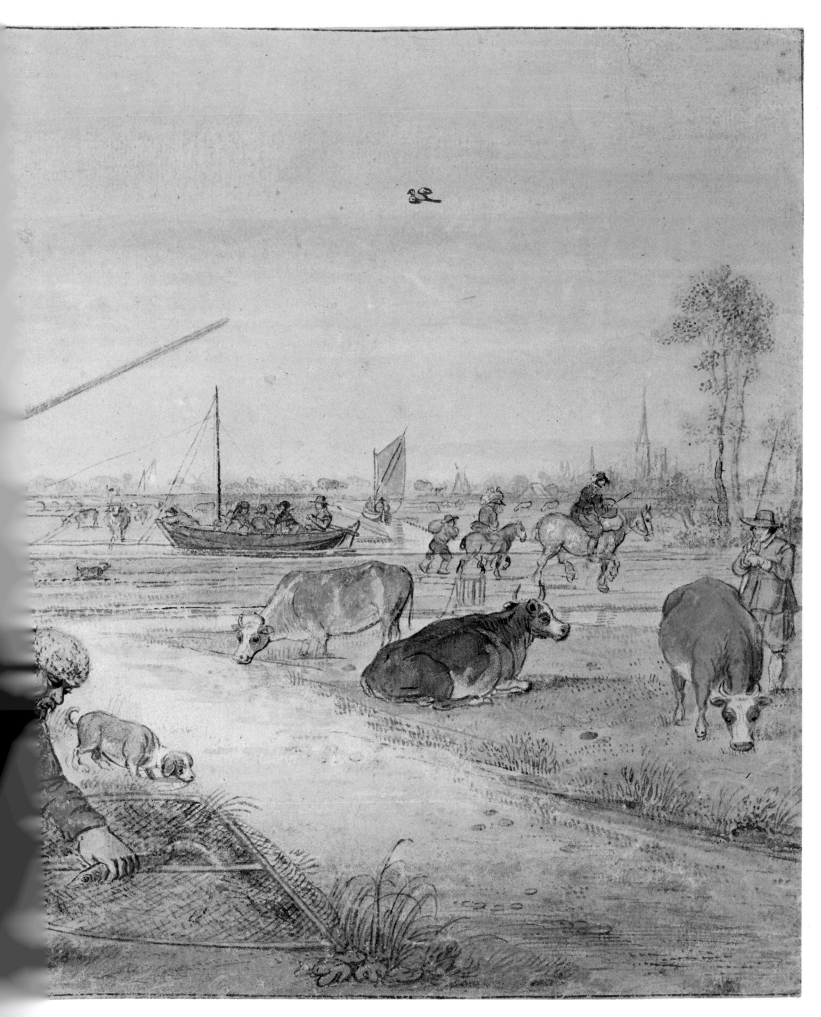

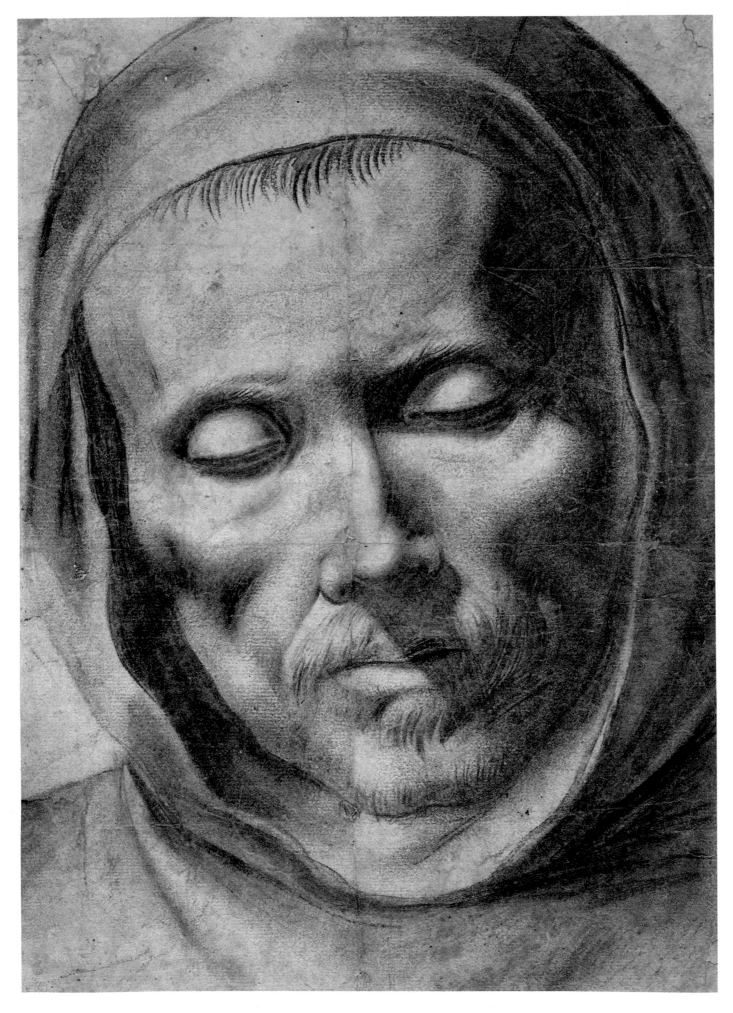

228

Francisco de Zurbarán
(Fuente de Cantos 1598–Madrid 1664)
Head of a Monk
Black chalk and brush with grey ink on pale
yellow paper; 11 × 7⅝ in. (280 × 194 mm.)
Provenance: de Madrazo
London, British Museum, inv. 1895-9-15-873

There is something of Caravaggio's influence
in the *Head of a Monk*, although it is
distinguished by a profound realism, so
typically Spanish, as well as by a strangely
expressive force. Zurbarán, by reinforcing
his vigorous black chalk drawing with light
brushwork shading, has tended mainly to
stress the painterly effect by means of strong
chiaroscural contrast.
Bibliography: Soria, 1953, no. 34

Charles Le Brun
(Paris 1619–90)
The Nations of Asia
Black chalk heightened with white and traces
of sanguine on several sheets of beige paper
joined together; 6⅝ × 9¼ in. (168 × 235 mm.)
Paris, Musée National du Louvre, inv. 29976

This drawing is squared up with black chalk
for transference, as it refers to one of the
four *Nations of the World* frescoes executed
by Le Brun on the walls of the *Escalier des
Ambassadeurs* (Great Staircase) at Versailles
between about 1674 and 1679. This was just
one expression of the Sun King's
determination to surround himself and his
Court with as much beauty and magnificence
as possible, thus setting the scene for the
elaborate decoration of nearly all the palaces
in Europe. The staircase was destroyed in
1752, and the working drawings are
therefore of fundamental importance in
gaining any knowledge of how it must have
looked.
Bibliography: Guiffrey-Marcel, 1912–13, no.
5747; Bacou, 1974, no. 33

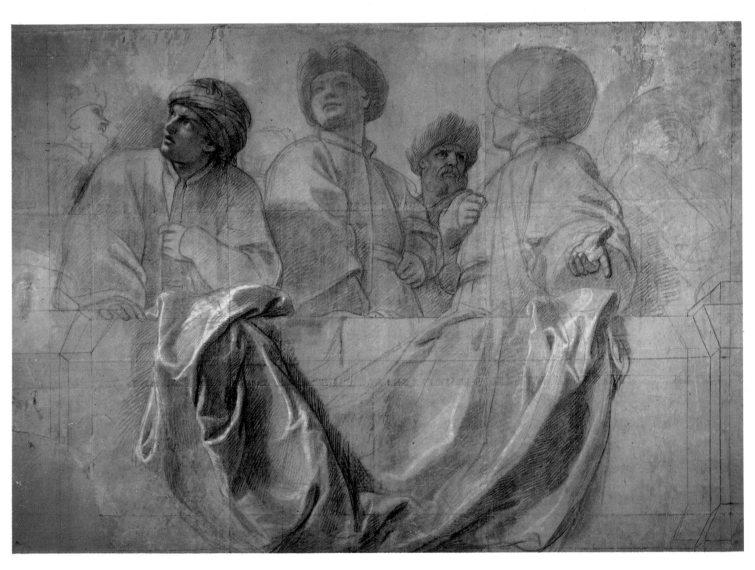

Jacques Callot
(Nancy 1592–1635)
The Capturing of Christ
Brush and brown wash over black chalk;
4 × 8½ in. (100 × 215 mm.)
Provenance: Mariette; Duke of Devonshire
Chatsworth, Devonshire Collection, inv. 409

A nocturnal setting with violent contrasts of
light characterize this brush-drawing which,
although one of a series of studies produced
for engraving, was in fact never printed.
Callot's rich graphic output, so remarkable
for its originality of invention and amazing
technical skill, exercised a fundamental
influence on seventeenth-century engravers,
among whom was Stefano della Bella.
Bibliography: Ternois, 1961, no. 577; Byam
Shaw, 1969–70, no. 111a

Jusepe de Ribera
(Játiva de Valencia 1591–Naples 1652)
St Irene (?)
Sanguine heightened with white on pale
yellow paper; 12¼ × 8⅛ in. (310 × 206 mm.)
Provenance: Guise
Oxford, Christ Church, inv. 1074

Ribera's interpretation of Caravaggesque
realism into a low-keyed tenebrism is typical
of the work of this artist who, although born
in Spain, was active mainly in Naples. This
study in sanguine is characterized by strong
verism. It is signed *'Joseph à Ribera Hisp.ˢ f.'*
and seems to relate to a *St Irene Tending St
Sebastian*, similar in style to the painting of
the same subject in Leningrad.
Bibliography: Mayer, 1923, p. 210; Brown,
1972, p. 7, n. 2; Byam Shaw, 1976, no. 1497

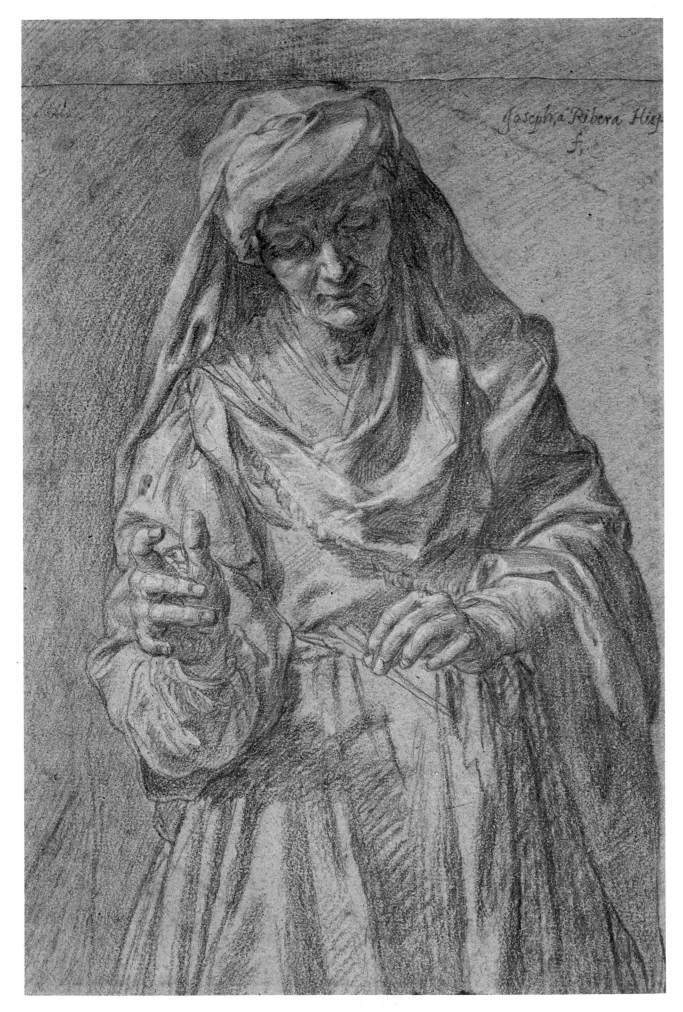

Joseph a Ribera Hisp f

231

The Eighteenth Century in Italy

Sebastiano Ricci (Belluno 1659–Venice 1734). After a long tour of Italy lasting from 1680 to 1706, during which he followed the path of late Baroque painting from Bologna to Parma, Rome and Florence, Ricci developed an artistic language of his own. This involved the sparing use of colour and a light, airy style of composition – both elements that were to form the basis of the new linguistics of Rococo. From 1712 to 1715 Ricci was working in London; the year 1719 he spent painting in Paris and 1724 saw him in Turin, whence he finally returned to Venice. Such diffuse activity meant that his pictures were influential over a wide area in the formation of a new generation of eighteenth-century artists. Ricci was a prolific draughtsman, and whole albums of his drawings are preserved in Venice and in the Royal Collection, Windsor.

Gian Antonio Pellegrini (Venice 1675–1741). In the footsteps of Sebastiano Ricci, Pellegrini also undertook a tour of study in Italy, visiting Florence, Rome and Naples. He soon acquired the expansive graphic style and verve in the handling of colour that distinguished the early Rococo masters, especially Luca Giordano. He carried the message of the new decorative linguistics to England (1708–13), thence to Holland, Germany and Paris (1714–20). He produced a great deal of graphic work on which his paintings were based.

Gian Antonio Guardi (Vienna 1699–Venice 1761). Gian Antonio was one of a family of painters which included his two younger brothers, Francesco and Nicolò. His father, Domenico – who lived in Vienna until the end of the seventeenth century – was also an artist, although nothing remains of his work. Once he had moved to Venice, Domenico did not live long, and Gian Antonio took over the responsibility of the studio-workshop, thus becoming master-painter over his two brothers. Under his direction, they began to copy well-known works by Tintoretto, Ricci, Piazzetta, and so on as well as painting family portraits on behalf of the well-known collector, Marshal Schulemburg. By this time, Gian Antonio was in contact with the leading artists of the Venetian Rococo period, especially Sebastiano Ricci, Pellegrini and Gian Battista Tiepolo, who was to marry his sister, Cecilia. From the 1740s Gian Antonio's work developed an individual quality, quite different from that of the other

members of the Guardi workshop. He succeeded in creating some genuine masterpieces in the Rococo idiom which are characterized by the exceptional lightness of their touch and the elusive airiness of their colours. Many of his works were designed to decorate interiors, like luminous tapestries, for example the *Gerusalemme Liberata* in the National Gallery of Art, Washington; on ceilings, paintings such as the *Aurora*, now in the Cini Collection, Venice, radiated dazzling luminosity. His masterpiece, however, will always be the balcony of the organ-loft in the church of the Archangel Raphael executed with sweeping strokes and brilliant colours in a style that seems to herald the radiant palette of Turner. In the meantime, Francesco was pursuing his own artistic career. He was specializing in small views, *vedute*, of Venice and was certainly doing so very successfully, being regarded as a successor to Canaletto. There are about a hundred known drawings by Gian Antonio in existence. Whilst his style was moulded on that of Ricci, he tended towards a much freer Rococo picturesqueness.

Gaspare Diziani (Belluno 1689–Venice 1767). Having first worked in Germany, Diziani was active in Venice from 1710 onwards. He adopted the contemporary decorative style led by Ricci and Pellegrini, and produced a great deal of work for the churches of Venice and surrounding areas. He was a prolific draughtsman: there is a vast collection of his drawings in the Museo Correr, Venice. His graphic work can be regarded as among the most outstanding to have been produced in the Rococo style.

Donato Creti (Cremona 1671–Bologna 1749). A pupil of the elegant Pasinelli, Creti was considerably influenced by the Carracci, whose work he was able to study in the Palazzo Fava, where he was resident painter to the Fava family. His mature style, which can be seen in the *Dance of the Nymphs* in the Palazzo Venezia, Rome, is a delicate synthesis of classicist refinement and Rococo affectedness. His numerous drawings fully illustrate the complex make-up of this artist and show how he achieved such stylistic charm in his finished works.

Gian Battista Piazzetta (Venice 1683–1754). Having first studied under his father, who was a sculptor, Gian Battista was considerably influenced in his early years by the

group of late seventeenth-century Venetian painters, including Zanchi and Langetti, known as the Tenebristi. Piazzetta's feeling for this type of low-key, shadowy style was strengthened after a visit to Bologna, where he came into contact with the work of Guercino and with Giuseppe Crespi. In the early 1720s Piazzetta painted his *Martyrdom of St James the Great* in the church of San Stae and his *Glory of St Dominic* on the ceiling of the church of San Zanipolo, both in Venice. He then formed his own workshop, including among his assistants Angeli, Maggiotto and Cappella. Their work was on traditionalist lines in opposition to the unbridled decorativeness of Rococo and the brilliant compositions of the somewhat younger Giambattista Tiepolo. The master-painter became increasingly academic in his work, a tendency which was furthered by the wide circulation of drawings and engravings from his studio, and in 1750 founded a school of painting which was continued by his followers. The best work by Piazzetta is in the more popular, veristic field, for example his *Fortune-teller* in Venice. Here he had freed himself from the weight of the late Baroque tradition and had begun to point the way to modern Realism.

Marco Ricci (Belluno 1676–Venice 1730). Nephew of the great decorator Sebastiano Ricci, Marco from boyhood collaborated with his uncle on stage sets, making scenery and costumes, in particular during a long visit to England with Pellegrini (1708–12). At the same time, he showed a growing interest in monument and landscape painting. He concentrated particularly on these themes during a stay in Rome when he had the opportunity to get to know the work of great seventeenth-century landscapists such as Poussin, Claude Lorraine and Salvator Rosa. Another strong influence in his turning towards landscape painting came when he made the acquaintance of the Genoese artist Alessandro Magnesco. In 1716 Marco returned to Venice, where he concentrated largely on graphic work, drawing and engraving landscapes which had a Romantic flavour and which greatly interested Piranesi, then at the outset of his fascination with etching. In recent times, whole albums of drawings by Marco Ricci have been taken apart and disposed of piecemeal. They contained some of the most natural and impressive of all eighteenth-century landscape drawings.

Alessandro Magnasco (Genoa 1667–1749). Although Magnasco painted a number of works with a religious theme during a short stay in Milan, a visit to Florence gave him the idea of trying some popular and dramatic subjects such as had been used by Jacques Callot and were still being used by Giuseppe Crespi. As a result, he specialized in landscape and indoor scenes with satirical motifs, especially on monastic life. In these, his graphic work, which was particularly lively, was combined with strong colours.

Francesco Zuccarelli (Pitigliano 1702–Florence 1788). Zuccarelli spent his formative years in Rome under the influence of such landscape artists as Locatelli and such painters of ruins as Pannini, but when his work took him to Venice in 1732 his style underwent considerable modification. His use of colour became more elegant, with delicate pastel shading, and he became the greatest exponent of the pictorial Arcadia now regarded as typical of the mid eighteenth century in Venice. He also worked in England for a number of years, during which time he established himself in the world of art and probably exercised some influence on the English landscapist Richard Wilson. Examples of his landscapes are in the Royal Collection, Windsor, and other important galleries. In his graphic work, Zuccarelli displayed an essentially painterly approach; this is particularly apparent in his sketchbook of the Tassi Counts of Bergamo which has survived almost intact to this day.

Gian Battista Tiepolo (Venice 1696–Madrid 1770). Having received his training in Venice with Bencovich and Piazzetta, by the early 1720s Giovanni Battista had already gained for himself the position of master in his own right. He worked mainly in fresco decoration, in Venice (Gli Scalzi), Udine (Archbishop's Palace) and Milan, Bergamo and Vicenza. In about 1747 he decorated the Palazzo Labia, Venice, and between 1750 and 1753 executed what was probably his finest work in the Residenz of the Prince-Bishop of Würzburg. After his return to Venice, he was commissioned to paint various altarpieces and frescoes, but in 1761 he was invited to the Villa Pisani at Strà, on the mainland, where he painted the magnificent ceiling that can still be seen today. Subsequently he went to Madrid, where he decorated the huge ceilings of the royal palace. His death in Spain

heralded the end in Europe of the elaborately decorative Rococo style, which had undoubtedly reached its peak in his work. In executing his frescoes, Gian Battista was supported by several assistants from his workshop; he made a great number of preliminary drawings from which they could work, and many volumes of these have survived the centuries. There are thousands of items altogether, and it is sometimes quite difficult to distinguish the hand of the master from drawings done by his assistants, foremost amongst whom were his two sons, Gian Domenico and Lorenzo. Gian Battista also holds an important place as an engraver, his series of *Capricci* ('Caprices') and *Scherzi* ('Jests') being masterpieces among eighteenth-century etchings.

Gian Battista Piranesi (Mogliano Veneto 1720–Rome 1778). Having been in Venice as a youth, where he had been able to study the graphic skills of Marco Ricci and Tiepolo, Piranesi in 1740 moved to Rome, where he was to work for the rest of his life. Apart from a few brief periods when he practised as an architect, Piranesi devoted himself entirely to engraving, depicting mainly the archaeological and architectural landmarks of Rome in several truly remarkable series of etchings. Many of the drawings which relate to this work are extant, executed mostly in pen and ink, apart from some folios from his youth, on which he used pencil for architectural plans and a very few figures. A highly romanticized view of the ruins of Rome emerges from these folios, although they were drawn with the objective precision that already presaged the Neoclassical movement.

Pietro Longhi (Venice 1702–85). Although Longhi had trained in the school of Balestra, his youthful work had little merit and shows clearly that he was not attracted towards painting in the rather elaborate decorative style that was then fashionable. A visit to Bologna when he was about twenty-eight, however, brought him into contact with the intimate style and lively touch of Giovanni Crespi. This gave him the spur he needed. He began to concentrate on the 'conversation piece' type of picture, depicting high Venetian society in all its public and private aspects. With an amazing stylistic constancy, his little canvases thus offer a completely faithful account of the contemporary patrician lifestyle. His drawings are extremely

interesting, demonstrating as they do a connection with the international fashion for the *tableau de genre* so popular in France. The majority of these sheets are now in the Museo Correr in Venice, which acquired them direct from the artist's son, Alessandro, himself a painter and portraitist, well-known towards the end of the eighteenth century.

Antonio Canal, called Canaletto (Venice 1697–1768). Being the son of a theatrical scene-designer, Canaletto devoted himself entirely to work for the theatre, both in Venice and Rome, until he was twenty-two. From 1720, however, he began to concentrate solely on cityscapes, taking for his theme the topography of his beautiful native city with its festivals and architectural extravagances. At first, he tended to follow Marco Ricci, the painter of ruins, but soon came under the influence of the well-balanced work of Luca Carlevaris with its squared-up perspective. The rich English 'milords', on their Grand Tours of Europe, were enchanted by his *vedute* ('views') and became his main clients. Joseph Smith, a merchant who was to become the English Consul in Venice, acted as his patron and agent, arranging for the sale of paintings in England, including many to King George III which are now in the Royal Collection at Windsor. The Duke of Buckingham and the Duke of Bedford (whose descendants still live at Woburn Abbey) also ordered *vedute* from Canaletto by the dozen. Between 1746 and 1755 Canaletto was working in England, where he painted numerous masterpieces, such as his *View of Oxford* in the National Gallery, London, before returning to Venice. Somewhat tardily, the Venice Academy finally opened its doors to him in 1765, but he was to die only three years later. Graphic work played an important part in Canaletto's life. Between 1741 and 1744 he issued a series of thirty-five etched *vedute* which he dedicated to Consul Smith, and several hundred drawings have been identified, about half of them in the Royal Collection, Windsor Castle.

Francesco Guardi (Venice 1712–93). The younger brother of Gian Antonio, until about 1740 Francesco divided his time in the workshop between making copies and producing decorative and religious paintings. When Canaletto left for England, Francesco replaced him in Venice as a painter of *vedute* ('views') and, from that stage in his life, devoted himself almost entirely to this type of work. In the 1770s he completed the twelve *Feste ducali* (Venetian Festivals) taken from the prints by Canaletto-Brustolon, nearly all of which are in the Louvre. In 1782 he was commissioned by the Republic of Venice to paint a series of pictures as a record of the state visit of the Archduke Paul of Russia and Maria Feodorowna; these were executed in a style that was suddenly free of the Canaletto influence in its sensitive freedom of stroke and whimsical imaginativeness – the *Concert for the Ladies*, now in Moscow, is a particularly fine example. Before embarking on any painting, Guardi, a prolific draughtsman, made a complete sketch of quite remarkable detail, executed in short, impetuous strokes of the pen or brush. He also made a number of large finished drawings for connoisseurs. The largest collection of his work is in the Museo Correr in Venice, which received it through a great-grandson of the artist.

Gian Domenico Tiepolo (Venice 1727–1804). Having worked with his father since boyhood, Gian Domenico was able to imitate his technique perfectly, to the point where it became impossible to distinguish whose hand had been at work in the frescoes and large canvases. All this time, however, he had been developing his own individual talent; this tended towards the bizarre and was based on a palette of cold colours in shades that are typically chalky. This can be seen in some of his less important frescoes, such as those painted in 1757 in the guest-rooms of the Villa Valmarana in Vicenza, as well as in little canvases depicting popular subjects, like the 'Masked Balls' in the Louvre and in Barcelona. Gian Domenico accompanied his father to Würzburg and Madrid, working closely with him all the time, and in later life – about 1792 – he completed most of the decoration in the family's country home at Zianigo, with caricatures of all kinds of people including clowns and tumblers. These frescoes have now been transferred to the Ca' Rezzonico in Venice. A keen engraver, he produced the original series of both the *Way of the Cross* and the *Flight into Egypt* as etchings. Hundreds of his drawings are in existence, but the attribution is often questionable due to the similarity between the work of Gian Domenico and that of his father, Gian Battista.

Sebastiano Ricci
(Belluno 1659–Venice 1734)
Landscape with Figures
Black pencil, pen and brush, brown ink and
sepia; $14\frac{1}{2} \times 20\frac{1}{2}$ in. (370×520 mm.)
Provenance: Zanetti; Cernazai; Dal Zotto
Venice, Gallerie dell'Accademia,
inv. S.R. p. 54

There is a broad, open feeling about this
composition which combines with the artist's
desire to depict certain effects of light; this
he does with rapid, disjointed strokes of the
pen accentuated by brushwork shading.
Such outstanding qualities leave no doubt
that this drawing is completely autograph. It
belongs to Ricci's later period, dating from
the same time – about 1729 – as the four
'Landscapes' at Hampton Court on which he
worked with his nephew, Marco.
Bibliography: Morassi, 1926, p. 263;
Pignatti, 1973, no. 24; Rizzi, 1975, no. 121

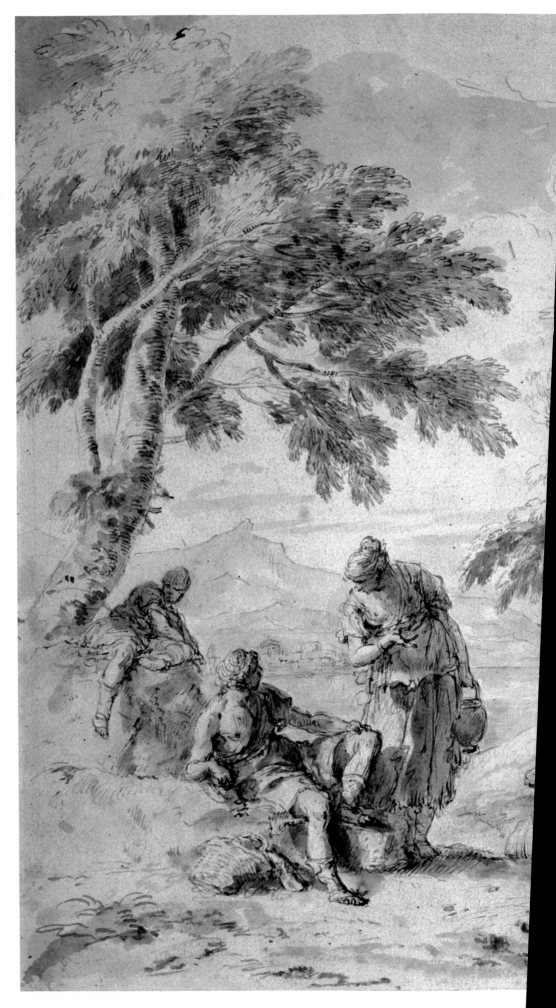

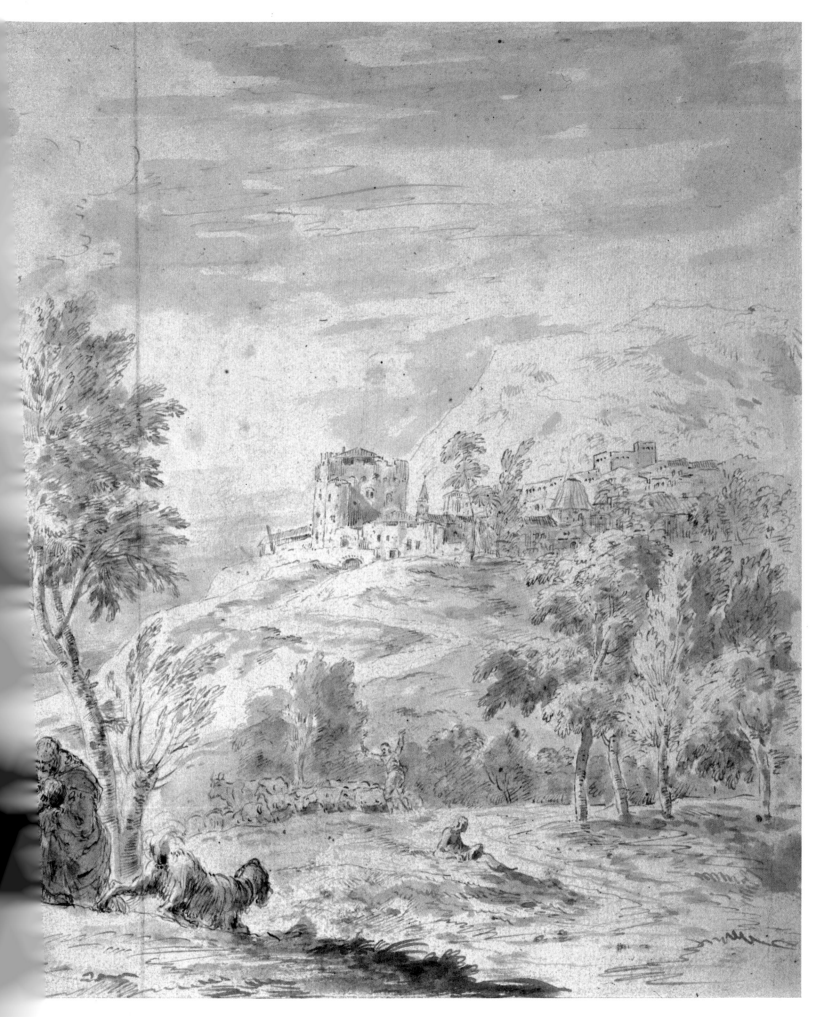

Gian Antonio Pellegrini
(Venice 1675–1741)
The Body of Darius Brought before Alexander
Pen and sepia ink over pencil; $10\frac{3}{4} \times 15\frac{5}{8}$ in.
(274 × 398 mm.)
Provenance: Salvotti; Fiocco
Venice, Fondazione G. Cini, inv. 30.012

This study, which is a preliminary drawing
for part of Pellegrini's large canvas of the
same name (Cassa di Risparmio Collection,
Padua), belongs to the artist's youthful
period, prior to his departure for London.
The imposingly tall figures are sketched in
with a flowing, entangled line that gives this
animated composition its life. The influence
of Baciccio, under which the artist came
during his year's stay in Rome (1700–1), is
evident.
Bibliography: Bettagno, 1959, no. 64; *idem*,
1963, no. 51; Pignatti, 1973, no. 26

Gian Antonio Guardi
(Vienna 1699–Venice 1760)
The Casino
Pen and brown wash over pencil;
$11\frac{5}{8} \times 20\frac{3}{8}$ in. (295 × 516 mm.)
Provenance: Schwabach; Blake
Chicago, Art Institute of Chicago, Gift of
Tiffany and Margaret Blake, inv. 1944.579

This drawing, which is almost identical to
the painting in the Ca' Rezzonico attributed
to Francesco, actually has the signature
'Ant. Guardi' on the *verso*; as this is in
eighteenth-century handwriting, it cannot be
doubted. This gives rise to the surmise that it
was drawn by Gian Antonio and then
copied on to canvas by Francesco, which
was normal practice in their workshop. The
flowing graphic style and lightness of touch
are typical of Gian Antonio.
Bibliography: Joachim, 1963, no. 18;
Pignatti, 1974, no. 54; Morassi, 1975, no. 56

239

Gian Antonio Guardi
The Triumph of Virtue
Black chalk, pen and brush with sepia wash;
9⅞ × 17¾ in. (250 × 450 mm.)
Provenance: Meissner; Morassi; entered in
1966
Venice, Museo Correr, inv. 8221

This drawing is part of a large group relating
to the decoration of a ceiling, the theme of
which is explained by this autograph
inscription: *'La Virtù guerriera
trionfante/tirata dal tempo/che la conduce al
tempio/con la fama che la corona di lauro e la
compagna con la tromba'* ('Virtue, the
triumphant warrior/pulled by Time/who
takes her to the temple/with Fame who
crowns her with laurel and accompanies her
on the trumpet.'). The presence of the
signature *'Giovan Antonio Guardi veneto
pitore'* (G.A.G. Venetian painter') on the
verso makes this sheet – which is stylistically
similar to paintings such as the Cini *Aurora*
– one of the most important documents in
his work. It is datable to between 1750 and
1760.
Bibliography: Pignatti, 1967, pl. VII;
Morassi, 1975, no. 40

Gaspare Diziani
(Belluno 1689–Venice 1767)
Costumes for Rowers
Charcoal, pen, sepia ink, coloured chalks on
straw-coloured paper; 6¼ × 4¾ in.
(158 × 120 mm.)
Provenance: Vason
Venice, Museo Correr, inv. 5791

The use of coloured chalks over a sketch in
charcoal and pen makes the two costumes
being studied seem almost alive. As
indicated by the inscriptions, which are
probably in Diziani's own hand, they were
being designed for the *barcaroli* (boatmen)
and *sonatori* (musicians) taking part in a
bissona (an eight-oared Venetian gondola).
This sheet has been attributed to Diziani,
although no similar drawings are known, on
the basis of a stylistic comparison with a
picture by him in the Ca' Rezzonico, Venice,
the *Feast of St Martha*, painted in about
1750.
Bibliography: Pignatti, 1964, no. 22; Zugni
Tauro, 1971, fig. 350; Pignatti, 1973, no. 36

Donato Creti
(Cremona 1671–
Bologna 1749)
Male Nude Sleeping
Brush and brown and white
oil on thick paper;
11 × 16⅛ in. (280 × 410 mm.)
Provenance: Fernandez-
Duran
Madrid, Museo del Prado,
inv. F.D. 2179

Almost a monochrome
sketch, this is a preliminary
study for one of the paintings
to go over a door which were
executed by Creti for
Marcantonio Collina
Sbaraglia in the 1720s, and
which are now in the
Pinacoteca Comunale,
Bologna. An academic
classicism in the tradition of
Carraccio and an echo of
Guido Reni's influence are
the basic stylistic
components of this elegant
sleeping nude.
Bibliography: Pérez Sánchez,
1977, no. 64

244

Gian Battista Piazzetta
(Venice 1683–1754)
Portrait of Marshal Schulemburg
Black and white chalks on ivory paper;
19¾ × 15 in. (501 × 379 mm.)
Provenance: Schulemburg and his heirs; P.
Drey Gallery
Chicago, Art Institute of Chicago, Joseph
and Helen Regenstein Collection,
inv. 1971.325

A famous man in his day, the Marshal
(1661–1747) commissioned numerous
portraits of himself as gifts for his friends; to
cite only two, there is the canvas in the Ca'
Rezzonico, Venice, and the drawing by

Castello of Milan. He was one of the most
prominent figures in the eighteenth-century
Venetian collecting world and his collection
included thirteen pictures and at least
nineteen drawings by Piazzetta. The incisive
quality of the drawing shown here, which is
datable to around 1740, has been obtained
by the use of black and white chalks on
ivory paper to produce an exquisitely
painterly *sfumato* effect.
Bibliography: Morassi, 1952, pp. 85–91;
Joachim, 1974, no. 4

Gian Battista Piazzetta
Girl with a Rose
Charcoal highlighted with opaque white-lead
pigment on yellowish-grey paper;
14⅝ × 10⅝ in. (373 × 270 mm.)
Provenance: Bossi
Venice, Gallerie dell'Accademia, inv. 304

The special qualities of this sheet lie in its
elegance of expression combined with a
luminous and sensual atmosphere.
Stylistically, it is datable to around 1740. In
his handling of the charcoal, with frequent
highlights of bodycolour, Piazzetta has
created an illusion of colour through a
delicate chiaroscuro.
Bibliography: Pallucchini, 1956, p. 54;
Pignatti, 1973, no. 43

Marco Ricci
(Belluno 1676–Venice 1730)
Landscape with Water-Mill
Pen and sepia ink; 8⅝ × 9⅜ in.
(220 × 238 mm.)
Provenance: Brass; entered in 1964
Venice, Museo Correr, inv. 8220

A difficult drawing to date, this may once
have belonged to the Cernazai volume in
Belluno. Similar scenes, with a Titianesque
theme and characterized by a neo-sixteenth-
century feeling, recur quite frequently in
Ricci's work from his youthful phase right
up to the period of engraved prints during
the last decade of his life.
Bibliography: Pilo, 1961, pp. 172 ff; Pignatti,
1964, no. 60; *idem*, 1973, no. 56

Alessandro Magnasco
(Genoa 1667–1749)
Landscape with Figures and Musicians
Brown wash heightened with white over
black chalk on yellowish paper; 18⅜ × 14½ in.
(466 × 370 mm.)
Provenance: de Giuseppe; Wertheimer;
Slatkin
Chicago, Art Institute of Chicago, Joseph
and Helen Regenstein Foundation,
inv. 1962.585

The linear tension produced by brushwork
over charcoal was a technique that suited the
'demoniacal' art of Magnasco particularly
well. Scenes populated by bizarre figures of
monks, soldiers, vagabonds and masked
people, in which the influence of Jacques

Callot's engravings can be detected, form the
basis of all his compositions. Whilst the
themes are similar, however, the artist's
treatment of them was always different.
Bibliography: Scholz, 1967, p. 239; Joachin,
1974, no. 2

247

Francesco Zuccarelli
(Pitigliano 1702–Florence 1788)
Landscape with Figures
Pen and dark brown ink, grey wash
heightened with white; 12¼ × 18½ in.
(310 × 468 mm.)
Detroit, Detroit Institute of Art, Octavia W.
Bates Fund, inv. 34.156

In complete contrast to the naturalism of
Marco Ricci, Zuccarelli's handling of the
Venetian landscape – he was Tuscan by
birth but Venetian by upbringing – shows a
distinct tendency to the idyllic with an
Arcadian flavour. His subtle elegance and
refined touch are the basic features of his
best drawings, of which this is one.
Zuccarelli spent several years in England,
returning to Venice in 1771, and it would
seem that this drawing can be dated to about
that time.
Bibliography: Vitzthum, 1970, no. 84;
Pignatti, 1974, no. 97

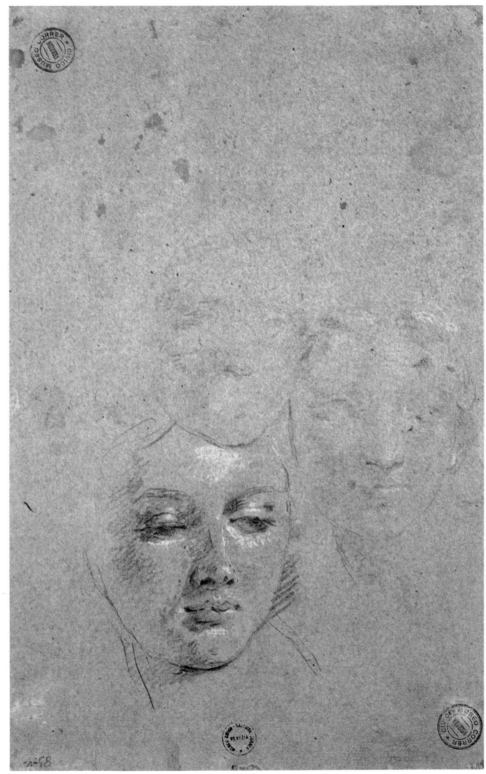

Gian Battista Tiepolo
(Venice 1696–Madrid 1770)
Portrait of a Young Girl
Black chalk highlighted with opaque white-
lead pigment on azure-grey paper;
$17\frac{1}{2} \times 11\frac{1}{4}$ in. (445 × 285 mm.)
Provenance: Gatteri
Venice, Museo Correr, inv. 1741

His drawings on blue paper form a
particularly interesting group within the vast
graphic output of Gian Battista. With only a
few skilful chalk lines, highlighted here and
there with bodycolour, the artist has put life
into the delicate, refined face of this young
girl. Datable to 1752, this study is part of the
Gatteri Sketchbook and was drawn in
preparation for a detail in the fresco *America*
on the great staircase of the Kaisersaal in the
Residenz in Würzburg (1753).
Bibliography: Sack, 1910, nos. 595–944;
Lorenzetti, 1946, fig. 83 v; Pignatti, 1973,
no. 48

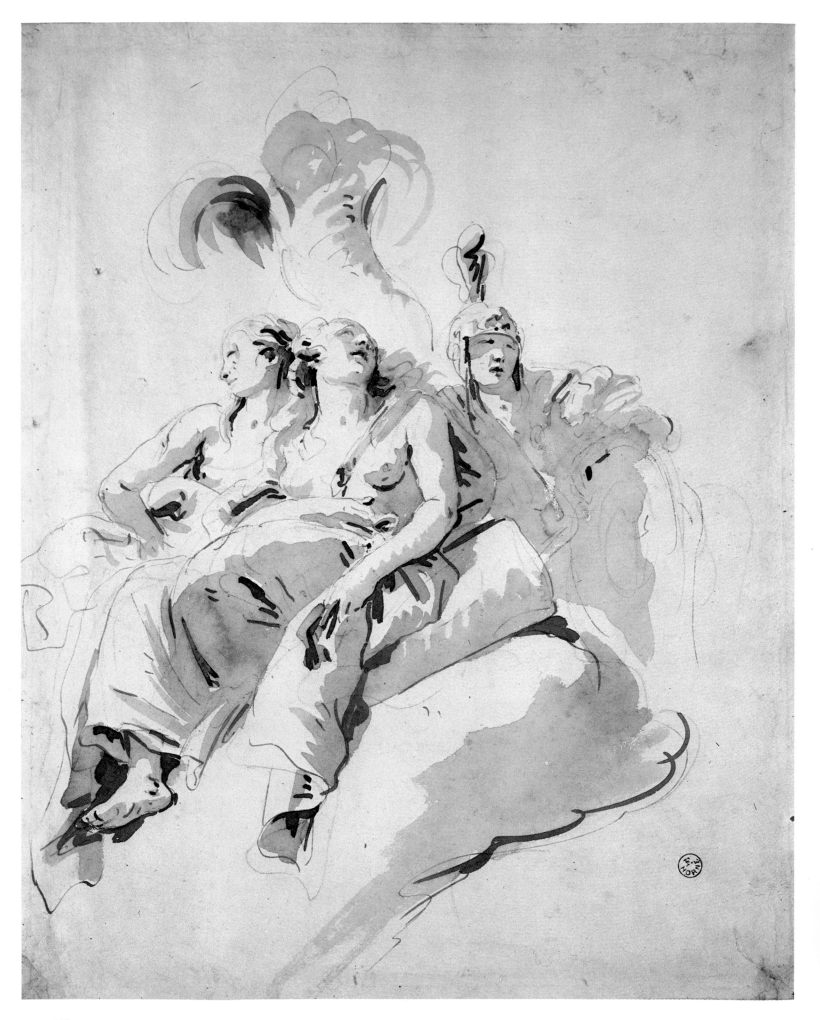

250

Gian Battista Tiepolo
Two Goddesses and Minerva (?) Seated on Clouds
Pen, brush and bistre on white paper;
$13\frac{1}{2} \times 10\frac{5}{8}$ in. (345 × 270 mm.)
Florence, Museo Horne, inv. 6318

The most remarkable feature of this sheet is its air of diffused sunshine and iridescence, very much in the idiom of Veronese. The contrast between the rough surface areas of the paper and the shadows deepened by brushwork produces a feeling of dazzling luminosity. Stylistically, this study may well belong to the more mature period of Tiepolo's life, datable to about 1740, when he was engaged on the frescoes in the Palazzo Clerici in Milan.
Bibliography: Hadeln, 1927, no. 55; Pignatti, 1951, no. 47; Ragghianti Collobi, 1963, no. 130

Gian Battista Piranesi
(Mogliano Veneto 1720–Rome 1778)
Architectural Fantasy
Pen, brush and brown ink over sanguine;
$14\frac{3}{8} \times 19\frac{7}{8}$ in. (365 × 505 mm.)
Provenance: Abingdon; entered in 1935 through Sadler Fund
Oxford, Ashmolean Museum

This majestic interior of an imaginary Roman building, with pillars, flights of stairs and arches, belongs to the period when Piranesi had reached full maturity and is signed by him. It is typical of the sketches he drew from his imagination, in which Rococo agility and the new romantic trend towards ruins and archaeological fragments come together in a language of transition, comparable in many ways with that of Francesco Guardi.
Bibliography: Parker, 1956, no. 1039; Pignatti, 1976, no. 72; Bettagno, 1978, no. 33

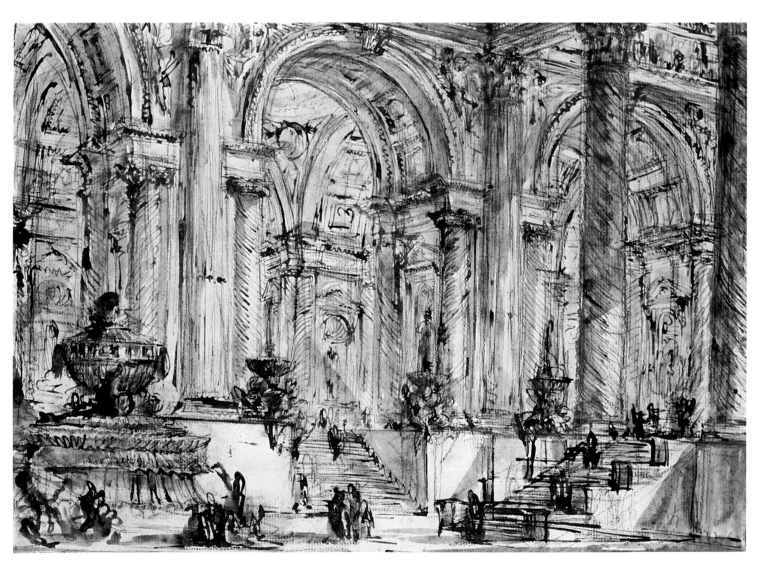

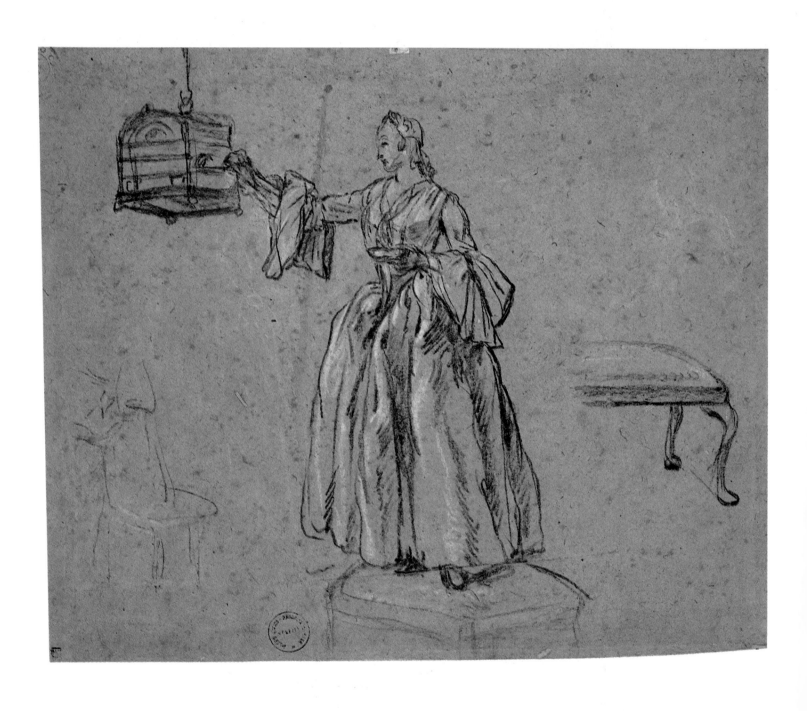

252

Pietro Longhi (Venice 1702–85)
Girl with a Birdcage
Charcoal highlighted with opaque white-lead
pigment on brown paper; $11\frac{1}{4} \times 13\frac{3}{8}$ in.
(285 × 338 mm.)
Provenance: Correr; entered in 1830
Venice, Museo Correr, inv. 510

Although this sheet has every appearance of
being a preliminary study, it does not link up
with any known painting by Longhi. A
diffused luminosity and softness of line,
together with the chromatic effects achieved
in the *sfumato* use of charcoal heightened
with bodycolour, are its main features. The
style suggests a date of between 1755 and
1760.
Bibliography: Pignatti, 1968, p. 123; *idem*,
1973, no. 75

Canaletto
(Venice 1697–1768)
*The Piazzetta Looking South towards San
Giorgio Maggiore*
Pen and brown ink; $9 \times 6\frac{5}{8}$ in.
(230 × 170 mm.)
Provenance: Cagnola; entered in 1949
Venice, Gallerie dell'Accademia

Abbreviated marks, almost like shorthand
symbols, drawn with a metal pen,
characterize the *verso* of folio 2 of
Canaletto's *Sketchbook*. This contains 138
pages of studies of Venetian scenes (*vedute*),
datable to the years 1728 to 1730. A drawing
of the same subject is in the Royal
Collection at Windsor, where the
corresponding painting can also be found. It
is thus possible to trace the artist's creative
process from the first rough notes to the
completed picture.
Bibliography: Pignatti, 1958, p. 29; *idem*,
1973, no. 64; Constable-Links, 1976, p. 630

Canaletto
The Islands of Sant'Elena and La Certosa
Pen and brown ink with grey ink wash over
pencil; 6⅛ × 13¾ in. (155 × 350 mm.)
Provenance: Smith; George III
Windsor Castle, Royal Library, inv. 7488

Canaletto produced a series of 'finished'
sheets, datable to the end of the 1730s,
which belonged originally to Consul Smith's
Collection. As can be seen from this
example, they are particularly remarkable
for their minutely detailed draughtsmanship,
which is at the same time painterly and
sensitive to the effects of light, emphasized
by the use of the brown and grey inks. This
view, which is one of three seen from the
Motta di Sant'Antonio, depicts the lagoon
looking east across the present *quartiere* of
Sant'Elena with the island of La Certosa and
its church to the left and the monastery of
Sant'Elena to the right.
Bibliography: Parker, 1948, no. 67; Pignatti,
1969, pl. XXV; Constable-Links, 1976,
no. 650

Francesco Guardi
(Venice 1712–93)
Plan of Ceiling Decoration
Pen and brush, sepia ink and watercolour
washes; $10\frac{5}{8} \times 15\frac{1}{2}$ in. (270 × 395 mm.)
Provenance: Masson; entered in 1925
Paris, École des Beaux-Arts

This sheet belongs to a series of studies for a
ceiling, of which one is in the Museo Correr
in Venice and another in Plymouth. They are
typical preliminary designs, in the Rococo
style, for painted and coloured stucco
decoration. The female figure, which may be
Diana, is based on models by Gian Antonio,
but the energetic, rather fussy style is typical
of the late period of Francesco's work.
Bibliography: Pignatti, 1967, pl. XLVII;
Morassi, 1975, no. 459

Francesco Guardi
View of St Mark's Basin
Black chalk, pen and brown ink, brown
wash; 13¾ × 26⅝ in. (349 × 676 mm.)
Provenance: Ashburnham
New York, The Metropolitan Museum,
Lehman Collection

The preliminary work for many of
Francesco's 'finished' drawings, which were
destined to be sold as souvenirs to visiting
foreigners, often proves to be extremely
complex in its multiplicity of viewing points.
This view of the Basin is a good example of
this, characterized as it is by the convexity of
the horizon – so typical of the artist's later
works. With its strange atmospheric
luminosity, it certainly comes into the same
category as the best of Guardi's paintings.
Bibliography: Pignatti, 1967, pl. LXII; Bean-
Stampfle, 1971, no. 193; Morassi, 1975,
no. 294

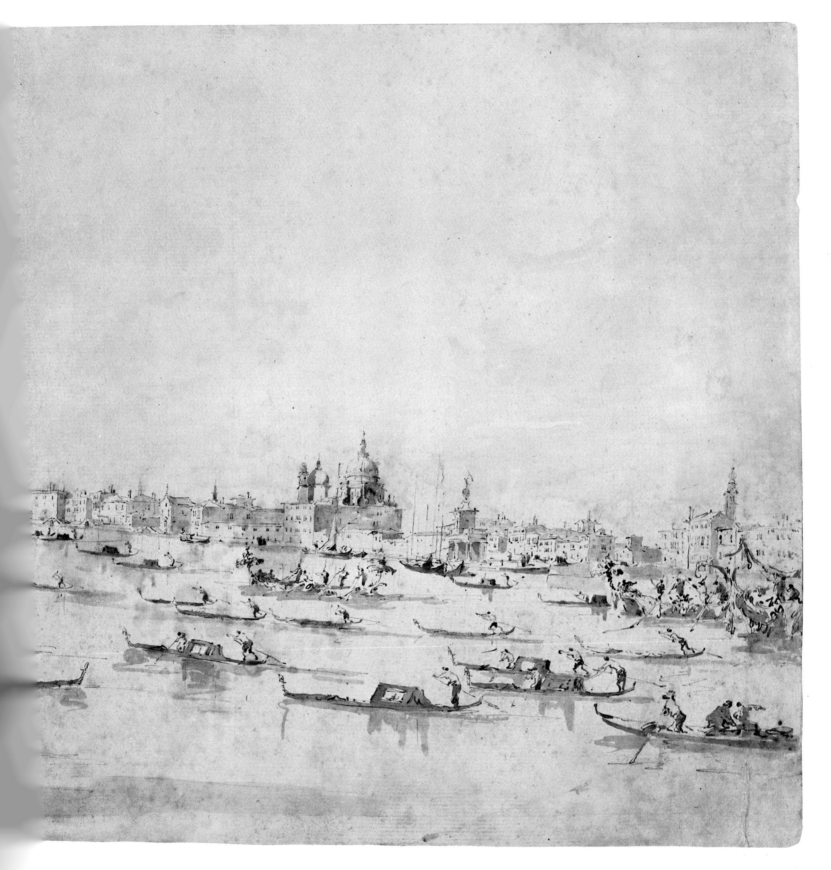

257

Sala dei nobili H. Gradenigo a Carpoxano coll'apparato sui nasato alle nozze del Gradegnac.

Venice

Francesco Guardi
Banquet at the Polignac Wedding
Black pencil, pen and sepia ink, watercolour
wash; 10¾ × 16½ in. (275 × 419 mm.)
Provenance: Zoppetti; Correr
Venice, Museo Correr, inv. 29

A series of *modelli*, similar to the sheet
reproduced here, was produced by
Francesco for a prospective client, recording
the Polignac wedding in the Villa Gradenigo
at Carpenedo on 6 September 1790. The
relevant paintings, however, were apparently
never executed. Guardi succeeded in
depicting events just as they happened by
means of his blotchy but rapid pen-sketching
from life, which he would then work over in
watercolours.
Bibliography: Pallucchini, 1943, no. 100;
Pignatti, 1967, pl. LVII; Morassi, 1975,
no. 318

Francesco Guardi
La Fenice
Pen and sepia ink, brush and grey ink;
7⅝ × 10 in. (195 × 254 mm.)
Provenance: Correr
Venice, Museo Correr, no. 724

This sheet, which bears the inscription
Fenice in the lower left-hand corner, is
datable to after the opening of the theatre on
16 May 1792. The drawing is therefore one
of the last to have been done by the artist,
since he died on 1 January 1793. Although
only a sketch, it epitomizes – in what might
be regarded as a 'last message' – the pre-
Romantic features that were already
appearing in Guardi's work.
Bibliography: Pallucchini, 1943, no. 87;
Pignatti, 1967, pl. LXVII; Morassi, 1975, no.
404

Gian Domenico Tiepolo
(Venice 1727–1804)
Concertino (The Little Concert)
Charcoal, pen and sepia ink, sepia wash;
14¾ × 19⅞ in. (375 × 505 mm.)
Provenance: Cantalamessa
Venice, Museo Correr, inv. 6042

The majority of the great 'caricatures' by
Giadomenico are datable to around 1790.
Imprinted as they are with the realism that
had emerged at the end of the century, they

can be linked in many respects with the
satirical work of such artists as Hogarth.
The *Concertino* ('Little Concert'), which is
signed and dated *'Dom. Tiepolo f. 1791'*, is
one of the most significant examples of its
type, both in the subject and in the
'tremulous' line which is so characteristic of
drawings by this artist.
Bibliography: Mariuz, 1971, pl. 27; Pignatti,
1973, no. 83

259

The Eighteenth Century in France, England and Spain

François Lemoine (Le Moine, Le Moyne) (Paris 1688–1737). Brought up in the wake of the Grand Manner of Le Brun and the Académie Royale, Lemoine had already been impressed by the paintings by Ricci and Pellegrini that he had seen in Paris. When in 1723 he had the opportunity of going to Italy, he devoted much time to studying the work of the Carracci family and of the Venetian school. As a result, his own style developed an elegantly decorative quality in tune with the eighteenth-century mood, and he painted several series of frescoes in châteaux from Saint-Sulpice to Versailles.

Jean Antoine Watteau (Valenciennes 1684– Nogent-sur-Marne 1721). Watteau began his working life as a scene-painter among the small Flemish antiquarians and copyists of Paris. It was not long, however, before a well-known collector of drawings, P. J. Mariette, introduced him into the elegant world of artistic decorators of the aristocratic Parisian residences, as a result of which he painted a number of pictures, in the *rocaille* manner, in the châteaux of Meudon and la Muette. His style became more refined after he had made a close study of some of Rubens' work in the Palais de Luxembourg (1707–8), as well as of the great Venetian masters, which he was able to do from the Crozat Collection. He was received by the Académie Royale in 1712 and became the idol of Parisian society, which competed for his *fêtes galantes*. He was the first official painter of this genre. The best example of this type of work is probably his so-called *Embarkation for the Island of Cythera* – Watteau seldom gave his paintings a title and this one seems unfortunate as it appears to depict a return *from* the island – which he had submitted to the Académie in 1717. Countless drawings bear witness to the close attention he gave to his model and to the innate elegance of his artistry. Watteau had contracted pulmonary tuberculosis when little more than a boy and died when only thirty-seven in Nogent-sur-Marne.

Maurice Quentin de la Tour (St Quentin 1704–88). Having seen the work of Rosalba Carriera in Paris in 1720, la Tour decided to adopt pastels as his own medium. He soon became famous for penetrating and trenchant portraits such as *La Pompadour* in the Louvre. His prolific output of drawings has nearly all been collected in the museum of his native St Quentin.

François Boucher (Paris 1703–70). A pupil of Lemoine, Boucher improved his graphic ability by working as an engraver in the school of Cars and by transforming the works of Watteau into etchings. During a visit to Italy in 1727 he was particularly impressed by the work of Correggio, whose thematic sensuality appealed to Boucher and was to become an important feature of his own art both in paintings and in drawings especially executed for connoisseurs. He was a protégé of Mme de Pompadour and decorated her residences as well as the châteaux of Crécy and Bellevue, paintings from which are now in the Frick Collection, New York, and the Wallace Collection, London. In 1765 Boucher was nominated First Painter by the King and appointed Director of the Académie Royale. He also supplied the tapestry-making centres of Beauvais and Gobelin with some cartoons. He was an extremely versatile artist, using his great talents to further the lighthearted, powdered and painted atmosphere of the French Rococo style in every possible way.

Jean-Baptiste-Siméon Chardin (Paris 1699– 1779). Chardin became successful in 1728, when he exhibited a still life of fish entitled *The Ray*. This was greatly admired for its realism, which astounded all who saw it, accustomed as they were to the affectation of Rococo painting. As a result, the artist found himself received into the Académie Royale, whereupon he immediately began painting pictures with bourgeois themes, in the category of 'conversation pieces', such as *The Governess* in Glasgow and *The Grace* in the Louvre. His skilful use of dragged and scumbled colour gave a softened, refined air to this work, and his tenuous areas of shadow are reminiscent of the great seventeenth-century Dutch masters. Indeed, Chardin deliberately used the technique of *intimisme* in order to evoke this echo in his still lifes, for example in *Still life with smoker's nécessaire*. As his sight faded, he used pastels nearly all the time and produced a great many portraits in these coloured chalks.

Jean-Étienne Liotard (Geneva 1702–89). Having spent his formative years in Paris, Liotard was influenced both by Chardin – through whom he developed a leaning towards genre subjects and a feeling for the truth – and by pastellists such as la Tour, who encouraged him as a portraitist. A great

traveller, he found himself in the Levant, England, Holland and Germany, taking every opportunity to portray much of what he saw as realistically as he could in pastels.

Jean-Baptiste Greuze (Tournus 1725–Paris 1805). Greuze's moral and educative aesthetics sprang from the atmosphere of the period in which Diderot was producing his dictionary-encyclopaedia. His subjects, rather like those of Chardin, came from the bourgeois world, but the public soon tired of paintings with dismal themes such as *The Prodigal Son* and *The Broken Pitcher* (both in the Louvre) and turned their backs on him. His loss of popularity reduced him to poverty and he died unmourned. Greuze's skill as a draughtsman was outstanding in its freshness of touch and rapid liveliness of expression, especially in his pastel-work.

Jean-Honoré Fragonard (Grasse 1732–Paris 1806). Having spent five years, from 1756 to 1761, completing his studies in Rome in the company of Charles-Joseph Natoire and Hubert Robert, Fragonard returned to Paris. There he devoted himself tirelessly to the study – by means of copies drawn by other artists – of the greatest masters of the Rococo period. He was in fact to be the last great exponent of this style, although he chose playful, witty scenes that are often erotic. The atmosphere in Europe was already changing, however, with the high-minded ethics of Rousseau and the incipient classicism of the Age of Enlightenment. The Revolution, of course, put an end to further commissions from the aristocracy. Fragonard possessed great technical skill, which is as apparent in his painting as in his drawing; his handling of brush, pen or pencil was swift, sparkling and incisive, and his use of colour delicate and light-hearted, as in his *La Chemise Enlevée* ('Stolen Shift'), now in the Louvre. In later life he devoted more time to painting portraits in which he succeeded in catching the expression of his subject with great sensitivity and complete honesty, as in his *Young Girl Reading* in the National Gallery of Art, Washington.

Hubert Robert (Paris 1733–1808). Robert spent the years between 1754 and 1765 studying in Europe. During this time he concentrated mainly on landscapes and ruin-painting, having become a great admirer of the work of Giovanni Battista Piranesi and Giovanni Paolo Pan(n)ini, with whom he made friends. After his return to Paris in 1765, Robert began to broaden his range by painting everyday scenes and views of Paris, such as his *Pont-au-Change* in the Musée Carnavalet, Paris. In the sketchbooks of his travels he recorded – in meticulously detailed yet delightful drawings in sanguine – many of the scenes that he was later to transfer on to canvas.

Thomas Gainsborough (Sudbury 1727–London 1788). At the beginning of his career Gainsborough had decided he wanted to be a landscape-painter – a conviction from which he did not swerve while working out his pupillage under the French illustrator and engraver, Hubert Gravelot. From 1750, however, he devoted most of his time to portrait painting, an example of which is *Mr and Mrs Andrews* in the National Gallery, London. In 1759 he moved to Bath, where he became the most fashionable portraitist in that very fashionable city, only to return to live in London in 1774 so that he could better compete with Sir Joshua Reynolds. Gainsborough's sitters show clearly that they are part of the aristocratic world, and his style of presentation of them already presages the Romantic era that was to follow. Their dreamy attitudes and the delicately *sfumato* technique employed by the artist seem almost to evoke the equally grandiose conceptions of a van Dyck. He left a great many landscape drawings in which the English countryside is perpetuated in all its gentle harmony, with a suggestion here and there that recalls the compositions of the great seventeenth-century landscapists from Rubens to Ruysdael.

Richard Wilson (Penegoes 1713–Colomondie 1782). A fine landscape painter, Wilson depicted the English and Welsh countryside in a way that recalls the classical proportions of Claude Lorraine. More than this, he enhanced his work by adopting a technique of light which he had learnt by having seen the work of Salvator Rosa in Italy, as well as though the influence of his friend, Francesco Zuccarelli, who taught him about the special quality of light in Venice. Wilson, in turn, was able to introduce Zuccarelli into the aristocratic world of English society.

Thomas Rowlandson (London 1756–1827). A fine draughtsman and book-illustrator – he did the engravings for *The Vicar of Wakefield* by Oliver Goldsmith in 1784 – Rowlandson devoted most of his talents to caricaturing the customs and politics of the day with great good humour, quite unlike the bitter satire of William Hogarth who had preceded him.

Francisco Goya y Lucientes (Fuendetodos 1746–Bordeaux 1828). After a difficult start, Goya went to Rome in 1770 to complete his preparation for life as an artist. He was particularly impressed by the style of Pompeo Bat(t)oni and by that of the Venetian school. On returning to Madrid in 1775, he was engaged in drawing cartoons for the royal tapestry-makers and also began to build up a reputation as a portrait-painter. In 1789 Carlos IV appointed him *primer pintor de cámera* (i.e. principal painter to the King). Three years later, however, he contracted a serious nervous disorder as a result of which he lost his hearing. His bitter despair found an outlet in a series of etchings entitled *Los Caprichos* ('Caprices') which portray the most tragically wretched aspects of Man's existence. Subsequently, the war with France – when Napoleon's army invaded Spain – gave him the idea for *The Disasters of War*; this series of etchings is still one of the great achievements in engraving of all time. The war also inspired Goya to paint some masterpieces of dazzling reality such as *The Shootings of May 3rd 1808*, now in the Museo del Prado, Madrid. When the Bourbon kingdom was restored in 1814, Goya shut himself away in his world of deafness and worked, in his desperation, on a series sometimes known as the *Black Paintings*, as well as producing some very disturbing portraits. In 1824 he abandoned Spain for Paris and then went on to Bordeaux to spend his last years. In the graphic field, Goya's best known engravings are the *Tauromaquia* ('Bullfighting') series. He also left a great many drawings, mostly in pen and brush, all of which are of an impressive Realism and which became the pattern for the nineteenth-century French school.

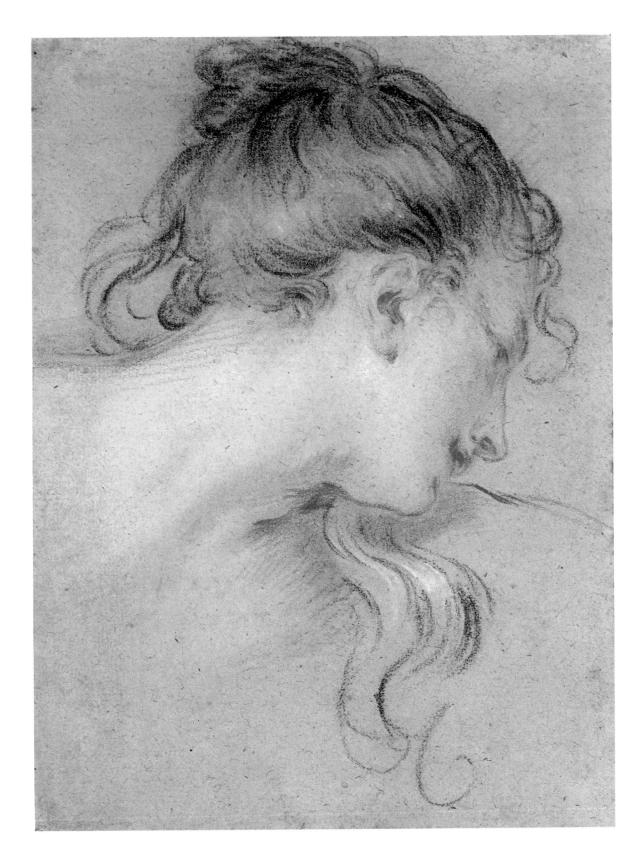

François Lemoine
(Paris 1688–1737)
Head of a Woman
Black chalk and sanguine heightened with
white; 9¼ × 6½ in. (234 × 165 mm.)
Provenance: the London art market;
Dillenberger
Berkeley, Calif., University Art Museum,
Gift of Mr and Mrs John Dillenberger in
memory of their son Christopher Karlin

The tradition of the French 'Grand Manner'
(*grand goût*) and the influence of the
Carracci, whose work Lemoine had admired
so much while in Italy, are the basic
components from which the inspiration for
this luminous, decorative picture were
drawn. An exquisite preliminary study for
the head of Omphale, it relates to *Hercules
and Omphale*, in the Louvre, which in its
elegant, sensual classicism is one of
Lemoine's best paintings.
Bibliography: Rosenberg, 1972, no. 79

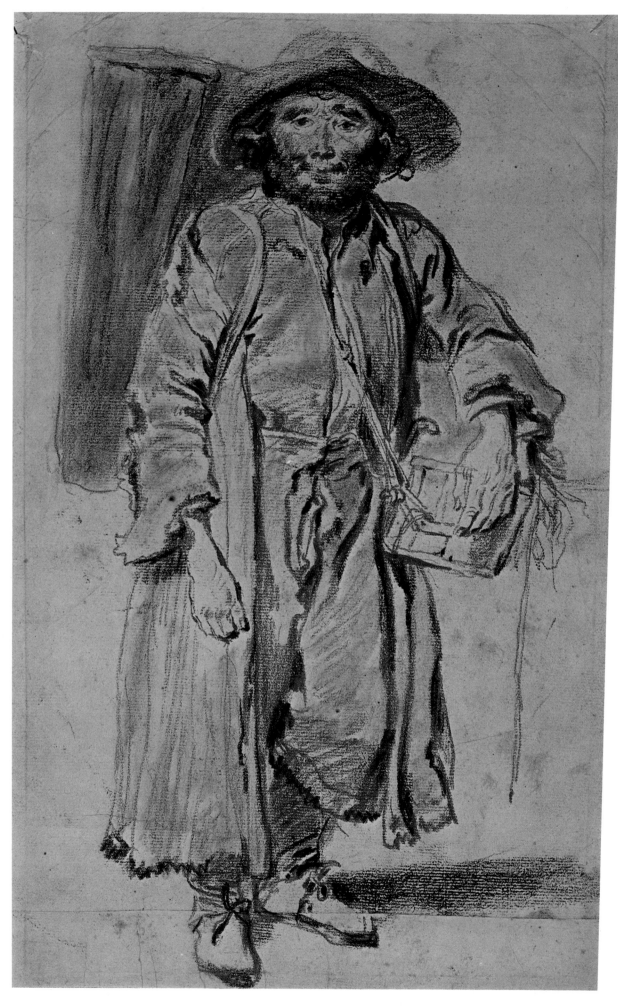

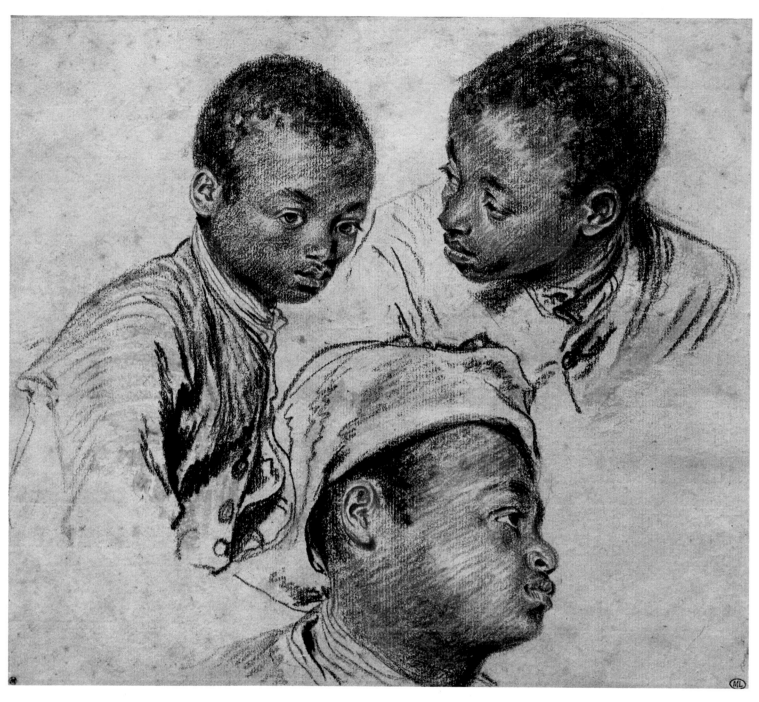

Jean Antoine Watteau
(Valenciennes 1684–Nogent-sur-Marne
1721)
The Savoyard
Sanguine and black chalk on ivory paper;
$14\frac{1}{8} \times 8\frac{7}{8}$ in. (360 × 224 mm.)
Provenance: de Julienne; Grimaldi;
Kavanagh; Regenstein
Chicago, Art Institute of Chicago, Helen
Regenstein Collection, inv. 1964.74

The characteristic features of this sheet are
the artist's striving for chromatic effects
combined with a *morbidezza* of style to
produce results which recall Rembrandt's
handling of chalks. It is datable to Watteau's
late phase. The artificial, mannered style of
the painter of *fêtes galantes* has given way,
in this representation of a Savoyard pedlar,
to a much more humble subject, appealing
to Watteau's genuine artistry. He has
imbued the drawing with a realism
reminiscent of the Dutch school.
Bibliography: Parker-Mathey, 1957, no. 492;
Joachim, 1974, no. 26

Jean Antoine Watteau
Three Negro Heads
Black chalk and two shades of sanguine,
highlighted with white chalk and touches of
watercolour; $9\frac{1}{2} \times 10\frac{1}{2}$ in. (241 × 266 mm.)
Provenance: Mariette; James; Bonn; David-
Weill; entered in 1937
Paris, Musée National du Louvre, inv. 28721

A veiled sense of melancholy combined with
a vigorous yet delicate handling of the black
chalk and sanguine are a typical
combination to be found in many of
Watteau's best drawings. And *Three Negro
Heads* certainly comes into this category.
The heads appear in several paintings such
as his *Pastoral Concert* (*Concert Champêtre*),
engraved by Claude Audran in 1727, and
The Music Party, engraved in reverse by P.
Aveline and renamed *Les Charmes de la Vie*.
Bibliography: Bouchot-Saupique, 1952–3,
no. 68; Parker-Mathey, 1957, no. 730

Jean Antoine Watteau
Three Figures of Seated Women
Red, black and white chalks on grey-brown
paper; $10\frac{1}{4} \times 14\frac{1}{2}$ in. (260 × 370 mm.)
Provenance: Spencer; Coxe; Esdaile; James;
Josse; Groult; Wildenstein
Chicago, Art Institute of Chicago, Joseph
and Helen Regenstein Foundation,
inv. 1958.8

This drawing may well be one of the first
examples of Watteau's use of the *aux trois
crayons* technique in which a combination of
three coloured chalks – red, black and white
– is employed. This is a typical sheet of
studies with figures that the painter would
gradually incorporate into his compositions.
The figure on the left appears – with
variations – in *L'Accord Parfait* (private
collection), while the guitar player is seen in
the centre of *Le Bal Champêtre* (*Les Plaisirs
du Bal*), in the Dulwich Picture Gallery,
London.
Bibliography: Parker-Mathey, 1957, no. 831;
Joachim, 1974, no. 27

Jean Antoine Watteau
Nude Woman on a Divan
Red and black chalk on very pale bluish-
grey paper; $8\frac{7}{8} \times 10$ in. (225 × 254 mm.)
Provenance: Salting
London, British Museum, inv. 1910-2-12-99

A subtle, refined sensuality permeates this
drawing of a young nude woman which is
one of several preliminary studies for the
painting called *A Lady at her Toilet* (Wallace
Collection, London), datable to about 1717.
The rounded lines and soft, painterly effect
of the drawing clearly indicates the innate
quality of Watteau's work, which found its
true source of inspiration in Titian and
Rubens rather than in the academic
classicism of Poussin.
Bibliography: Parker-Mathey, 1957, no. 523

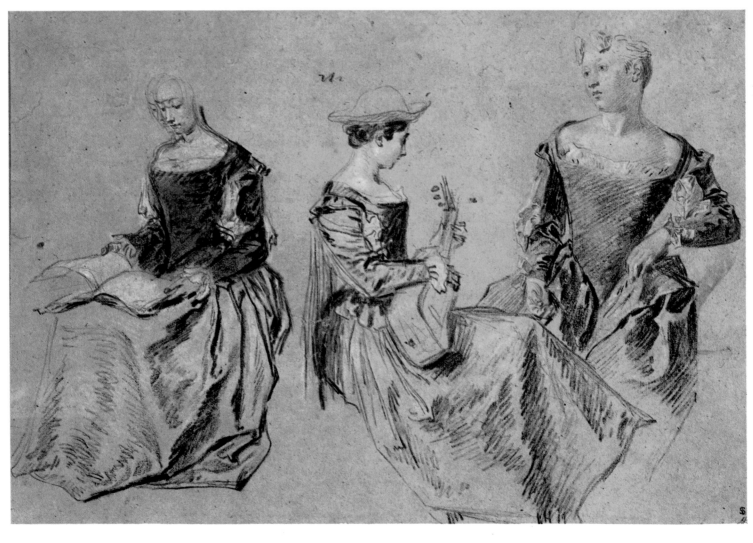

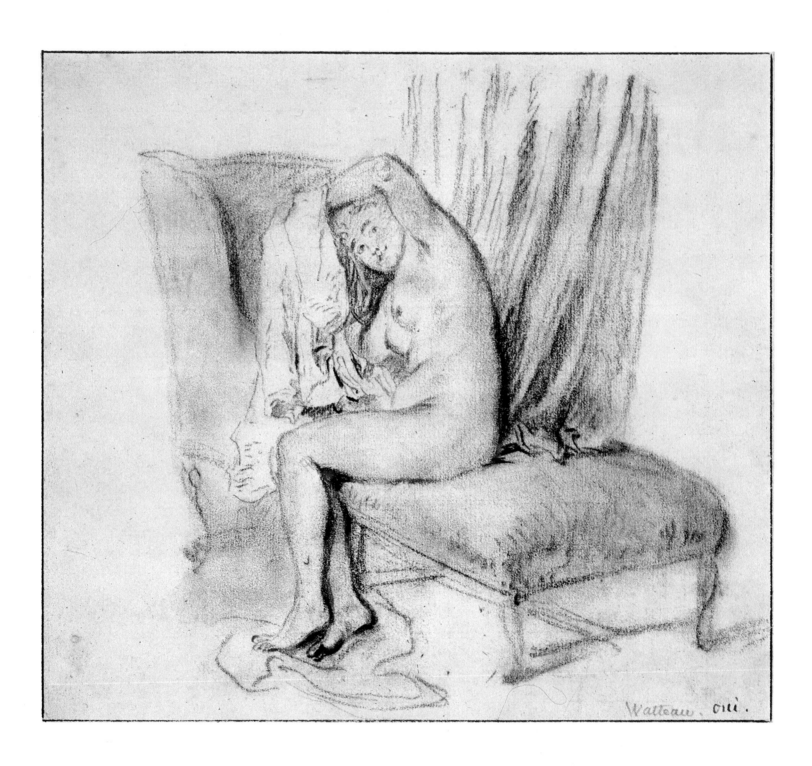

Watteau. orii.

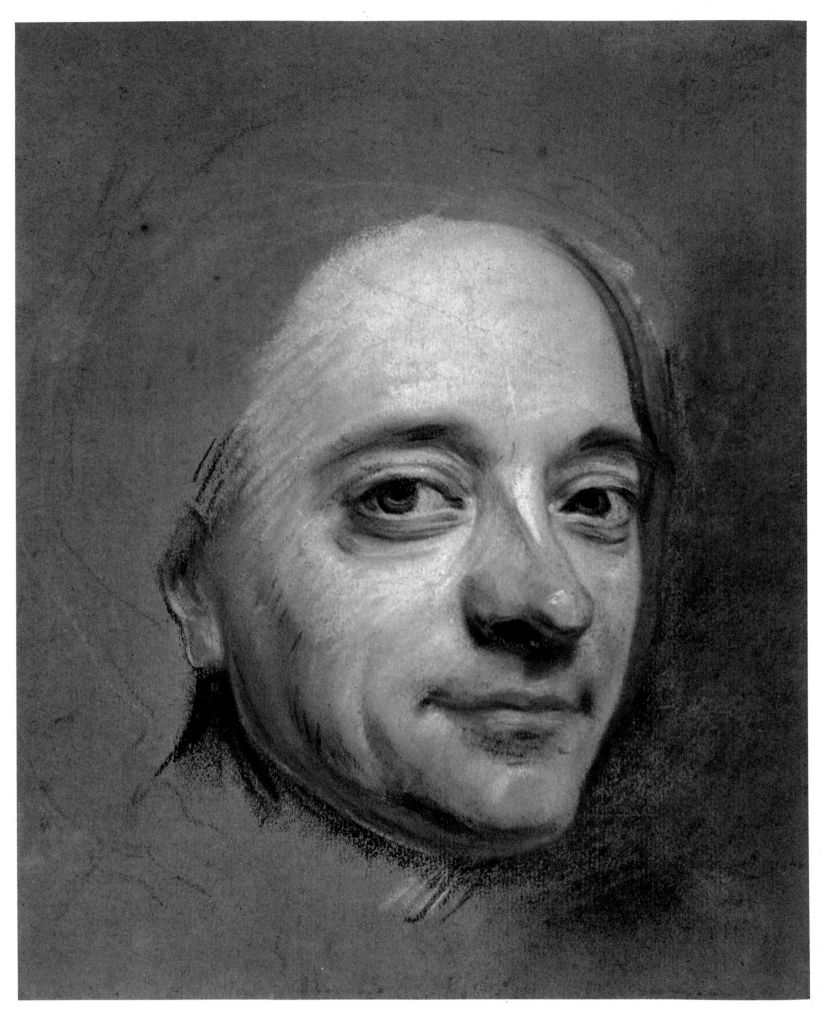

268

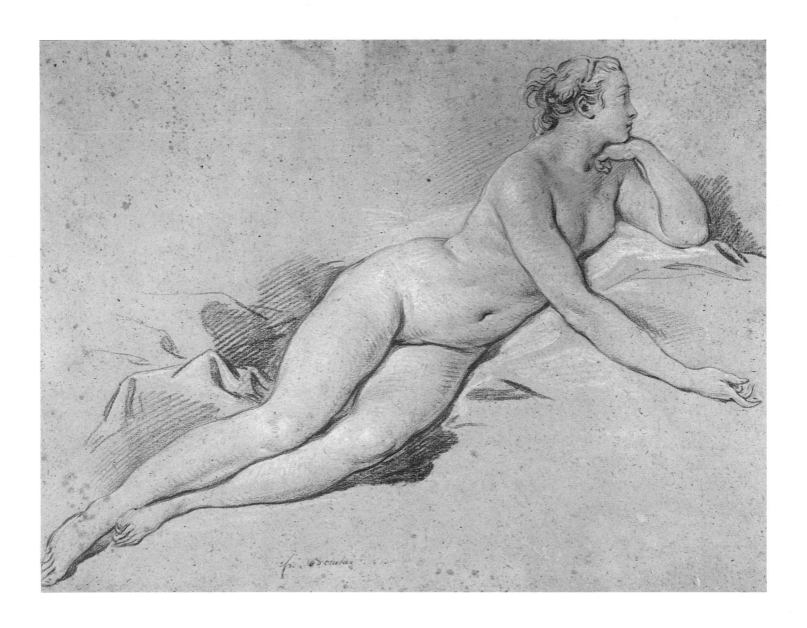

Maurice Quentin de la Tour
(St Quentin 1704–88)
Self-Portrait
Pastels on greenish paper; $12\frac{7}{8} \times 9\frac{1}{2}$ in.
(325 × 240 mm.)
Provenance: Carrier; Becq de Fouquières;
David-Weill
Chicago, Art Institute of Chicago, Joseph
and Helen Regenstein Foundation,
inv. 1959.242

The pastel portraits by la Tour of the
important people of his day are extremely
realistic, not only in their physical
appearance but also in the shrewd insight
that is apparent into their psychological
make-up. They received great acclaim when
he exhibited them in the Salon du Louvre
from 1737 to 1773. They included numerous
self-portraits, and this was one of them; it is
datable to about 1737, showing him when
still quite a young man, and was probably
left unfinished deliberately.
Bibliography: Fleury-Brière, 1920, pp. 32–3,
no. A; Edwards, 1961, pp. 2–4; Joachim,
1974, no. 46

François Boucher
(Paris 1703–70)
Reclining Nude Woman
Sanguine heightened with white on beige
paper; $12\frac{1}{2} \times 16\frac{3}{8}$ in. (315 × 415 mm.)
Provenance: Kann; Durlacher; Brown;
Sachs
Cambridge, Mass., William Hayes Fogg Art
Museum, inv. 1078; 1927

This sheet is a significant example of the
graphic work of Boucher, an exquisite
interpreter of the Rococo style in
contemporary society. Although linked to
many of the artist's erotic and mythological
pictures, this was intended as a preliminary
drawing for the figure of Venus in his
Education of Cupid, which Boucher painted
in 1738 as an over-door panel for the hôtel
of the Count of Langonnay (now in the
County Museum, Los Angeles). The
extraordinarily glowing effect was produced
by Boucher through his skilful use of white
highlights over the soft, voluptuous,
sanguine modelling.
Bibliography: Mongan-Sachs, 1946, no. 596;
Ananoff, 1966, no. 471; Shoolman Slatkin,
1974, no. 35

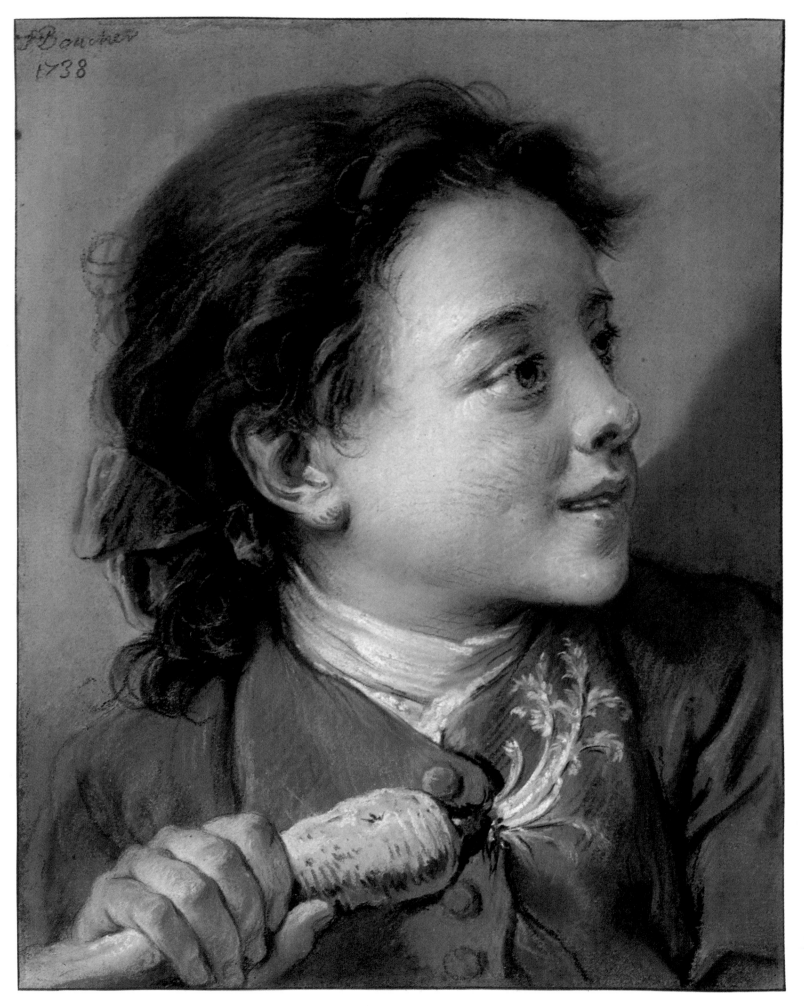

270

François Boucher
Portrait of a Boy with a Carrot
Pastels on yellowish paper; $12\frac{1}{8} \times 9\frac{1}{2}$ in.
(308 × 243 mm.)
Provenance: Dezallier d'Argenville; de
Boisset; Bruun-Veergard; private collection;
Slatkin
Chicago, Art Institute of Chicago, Joseph
and Helen Regenstein Foundation,
inv. 1971.22

Boucher was probably attracted to trying his
hand at working in pastel after having seen
the work of Quentin de la Tour at the
latter's 1737 exhibition in the Salon du
Louvre in Paris. There were several pastel
portraits in it, amongst which was one of
Mme Boucher. This animated portrait of a
boy with a carrot – a theme which, dear to
the artist, was to recur in more than one
picture – seems to have been one of
Boucher's first essays in this new medium
judging by the signature and date 'F.
Boucher 1738'.
Bibliography: Michel, 1906, no. 2395;
Shoolman Slatkin, 1974, no. 32; Joachim,
1974, no. 30

François Boucher
Landscape with Bridge and Stream
Black and white chalks on azure paper;
$11\frac{7}{8} \times 17\frac{1}{2}$ in. (300 × 443 mm.)
Provenance: Gigoux; de Fourquevaulx;
Delestre; Wildenstein
Chicago, Art Institute of Chicago, Joseph
and Helen Regenstein Collection,
inv. 1960.206

There are numerous sheets such as this in
which Boucher depicted scenes from Nature
using the technique of *intimisme* usually
reserved for interiors. Each one is finished
and a work of art in its own right. Drawings
of this type are probably datable to about
the middle of the 1730s, at about the same
time – 1734 – as he began designing for the
tapestry-makers of Beauvais.
Bibliography: Michel, 1906, no. 1950;
Shoolman Slatkin, 1974, no. 57; Joachim,
1974, no. 32

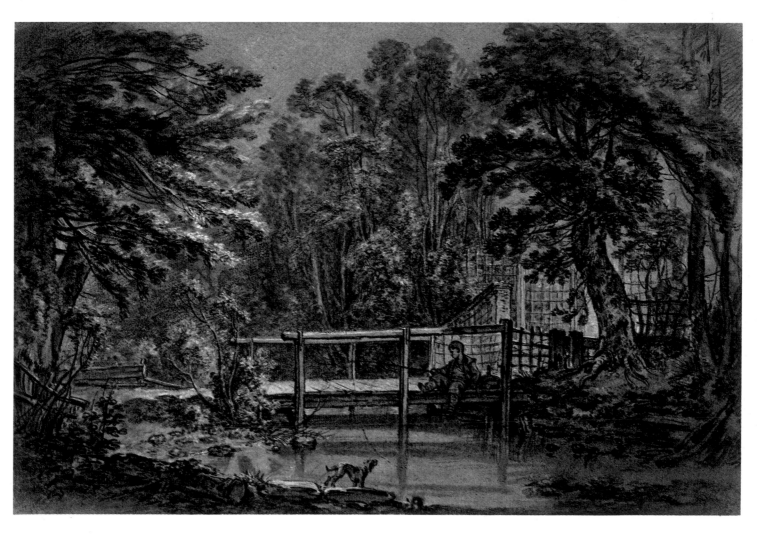

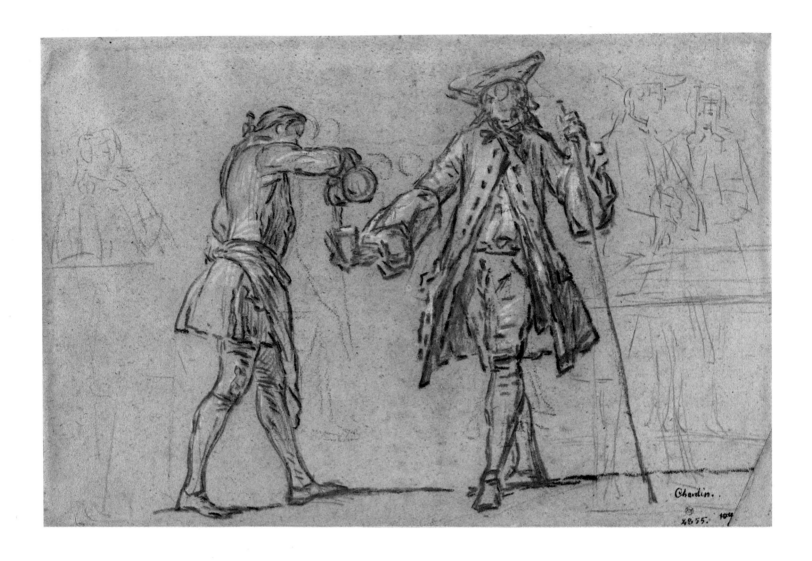

Jean-Baptiste Siméon Chardin
(Paris 1699–1779)
A Servant Pouring Wine for a Gentleman
Sanguine and black chalk heightened with
white on grey-brown paper; $9\frac{3}{4} \times 14\frac{1}{2}$ in.
(247 × 370 mm.)
Provenance: Tessin; Kongl. Biblioteket;
Kongl. Museum
Stockholm, Nationalmuseum, inv. 2962/1863

This study, which is characterized by rapid,
effective strokes – a style that had
considerable influence on the work of Pietro
Longhi – relates to a painting called *The
Game of Billiards*, now in the Musée
Carnavalet in Paris, whose autograph has in
the past been under debate. The drawing is
one of the most outstanding of the young
Chardin's work as a draughtsman and this
was confirmed when Tessin, a Swedish
collector with impeccable judgement, bought
it somewhere between 1739 and 1741.
Bibliography: Bjurström, 1970, no. 55;
Rosenberg, 1979, no. 2

Jean-Baptiste Siméon Chardin
*Portrait of Françoise-Marguérite Pouget
Chardin*
Pastels on canvas-backed paper; 18 × 14¾ in.
(455 × 375 mm.)
Provenance: David; de Loriol; de Biron;
Wickes; Wildenstein
Chicago, Art Institute of Chicago, Helen
Regenstein Collection

Chardin in his later years abandoned oils
almost completely to concentrate on
portraits in pastel. They are imbued with a
deep sense of humanity and played an
important role in the artist's more mature
work. This exquisite drawing in pastel is very
similar to a picture exhibited by Chardin in
the Salon du Louvre in 1775 entitled *Portrait
of My Wife, Françoise-Marguérite Pouget*,
signed and dated 'Chardin 1776'. The
delicate chromaticity over such subtle base
colours gives this portrait a charm all its
own.
Bibliography: Joachim, 1974, no. 29;
Rosenberg, 1979, no. 137

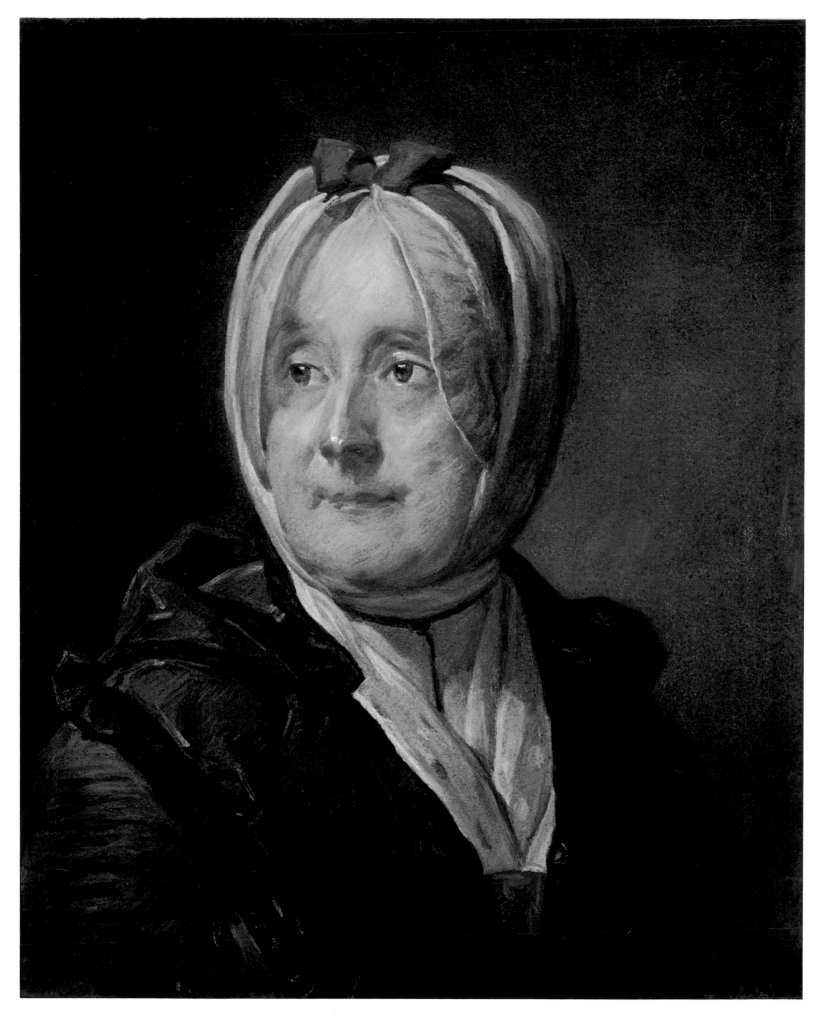

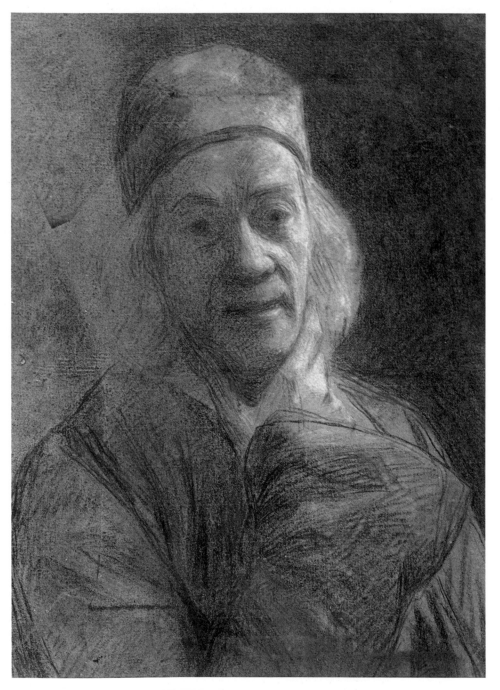

Jean-Étienne Liotard (Geneva 1702–89)
Self-Portrait in Old Age
Charcoal heightened with white chalk and
sanguine; $19\frac{3}{8} \times 14\frac{1}{8}$ in. (490 × 358 mm.)
Geneva, Musée d'Art et d'Histoire,
inv. 1960.32

Liotard's pastel drawings, which displayed a
more realistic approach than most of the
work being produced by the great
contemporary French masters, were
fundamental to his art. There is a note of
intense verism in this *Self-Portrait* which
served as a preliminary drawing for a
painting executed in 1775 which is also in
Geneva.
Bibliography: Hugelshofer, 1967, no. 63;
Loche-Roethlisberger, 1978, no. 281[1]

Jean-Baptiste Greuze
(Tournus 1725–Paris 1805)
Head of a Young Woman
Pastel and sanguine, heightened with white
on red-tinted paper; $13\frac{1}{2} \times 10\frac{3}{8}$ in.
(342 × 262 mm.)
Vienna, Graphische Sammlung Albertina,
inv. 12771

Greuze reflected in his work the artistic taste
of late eighteenth-century France. His
subjects were based on bourgeois motifs,
inspired by sentimental and moralistic
attitudes, in contrast to the erotic and
mythological themes of the excessively
decorative Rococo period. In this study of a
head, which Greuse used as a preliminary
drawing for his painting *The Shared Meal* –
at one time in the Duke of Praslin's
collection – the artist has achieved a
remarkable immediacy in the fluidity of the
pastel and sanguine lines.
Bibliography: Meder, 1922, no. 21; Benesch,
1964, no. 220

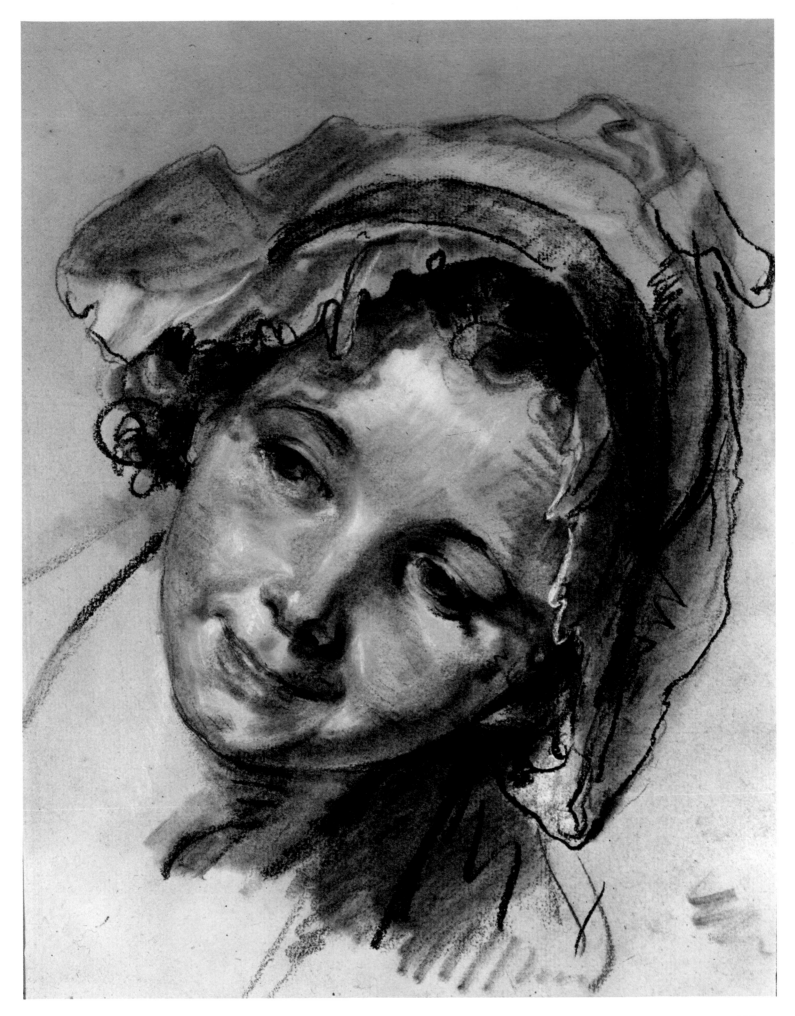

Jean-Honoré Fragonard
(Grasse 1732–Paris 1806)
Bergeret's Picnic
Sanguine; $11\frac{1}{4} \times 12\frac{7}{8}$ in. (285 × 325 mm.)
Provenance: F.R. Coll.; Owen; Koenigs
Rotterdam, Museum Boymans-van
Beuningen, inv. F.I. 155

This sheet, dominated by the four oak trees,
dates back to the second tour of Italy that
Fragonard made in the company of Bergeret
de Grandcourt from 1773 to 1775. His
masterly use of sanguine has created a
painterly effect that is rich in vibrations
which, in the play of light and shade, seems
almost to presage the achievements of
Impressionism.
Bibliography: Bouchot-Saupique, 1952–3,
no. 87; Haverkamp Begemann, 1957, no. 63;
Ananoff, 1961, no. 334

Jean-Honoré Fragonard
Two Women in Conversation
Brush and brown wash over black chalk;
$11\frac{1}{8} \times 8\frac{1}{8}$ in. (282 × 208 mm.)
Provenance: Chabot and de la Mure or
Desmaretes; anonymous; Denon; Paulme;
Lugt; Koenigs
Rotterdam, Museum Boymans-van
Beuningen, inv. F.I. 228

This sheet could appropriately be described
as a 'drawing-painting'. It is datable to the
end of the 1770s and depicts Fragonard's
wife, Anne Marie Gérard, whom he married
in 1769, and her sister Marguérite, in the
intimate atmosphere of the artist's own
studio. The broad brown brushwork creates
exciting contrasts of luminosity which imbue
the scene with a particular fascination.
Bibliography: Haverkamp Begemann, 1957,
no. 65; Ananoff, 1961, no. 722; Niemeijer,
1974, no. 45

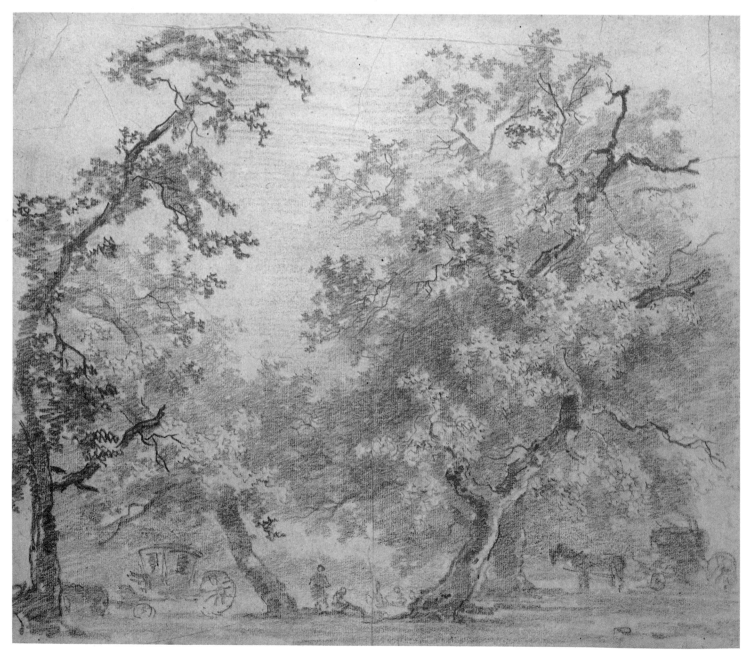

276

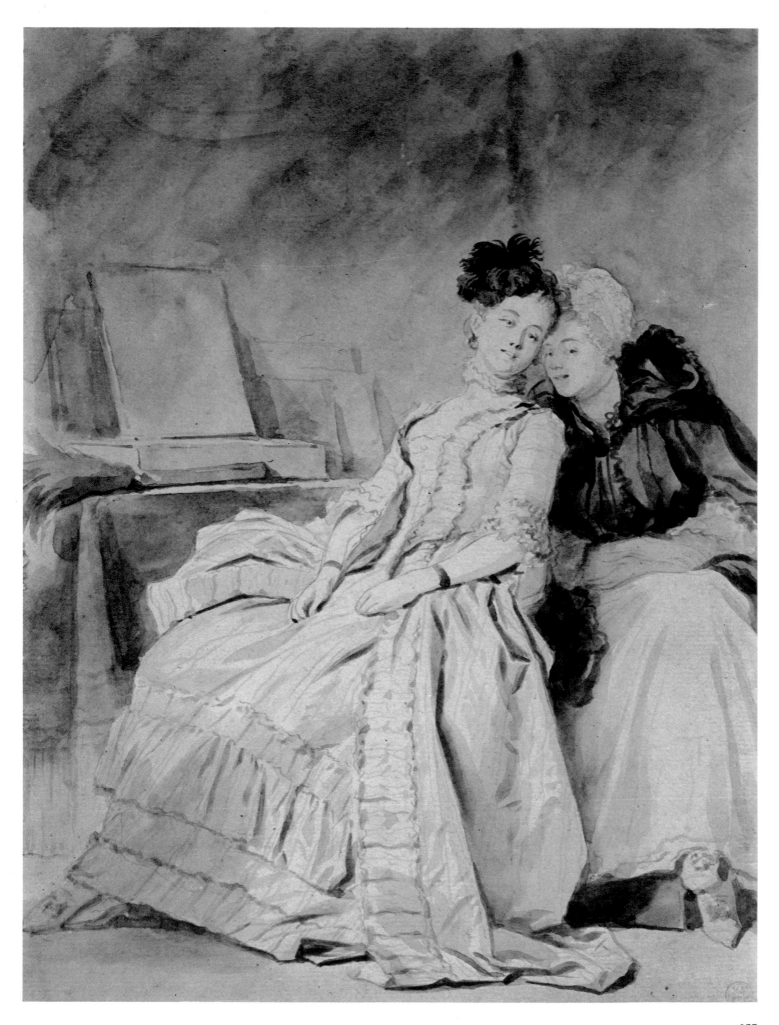

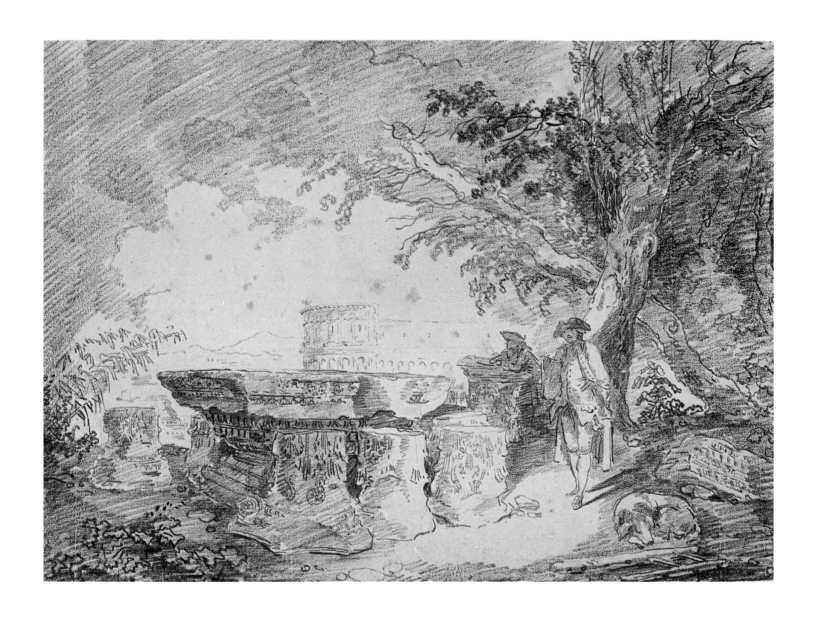

Hubert Robert
(Paris 1733–1808)
The Coliseum Seen from the Palatine Hill
Sanguine; $13\frac{1}{8} \times 17\frac{5}{8}$ in. (335 × 447 mm.)
Provenance: Veyrenc
Valence, Musée des Beaux-Arts, inv. D72

Robert made the acquaintance of Piranesi
during his eleven-year stay in Italy
(1754–65), and the friendship that sprang up
between the two artists was to prove very
important to him. His numerous drawings in
sanguine, with their ancient buildings and
ruins, populated with tiny figures, were
produced during this period. They certainly
indicate the great attraction Robert felt for
the Romantic type of view *'a capriccio'*, i.e.
quasi-topographical subjects with real or
imaginary ruins.
Bibliography: Loukomski-Nolhac, 1930, pl.
16; Beau, 1968, no. 8

Thomas Gainsborough
(Sudbury 1727–London 1788)
A Woman Seen from Behind
Black chalk and stump, heightened with
white chalk on greyish-brown paper;
$19\frac{1}{4} \times 12$ in. (488 × 304 mm.)
Provenance: Gainsborough; Briggs; Lane;
Donaldson; Buchanan; Lesser; Mott;
entered in 1959
Oxford, Ashmolean Museum

Traditionally the artist's wife would be
recognizable in a study of a female figure
such as this. From her style of dress the
sheet might be dated to around 1760 to
1770, but there is absolutely no clue as to
her identity. Nevertheless the drawing is
exquisitely painterly in its *sfumato* treatment
of black chalk heightened with white and is
reminiscent of the best of Gainsborough's
full-length portraits in its flowing, elegant
draughtsmanship.
Bibliography: Hayes, 1970, no. 30; Garlick,
1979, no. 37

279

Thomas Gainsborough
Landscape with Cattle at the Watering-Place
Black chalk and stump, heightened with
white chalk; $9\frac{3}{8} \times 12\frac{1}{2}$ in. (238 × 317 mm.)
Provenance: von Mallaman
Dahlem, W. Berlin, Staatliche Museen
Preussischer Kulturbesitz, inv. 4409

The natural talent which Gainsborough
possessed as a landscapist, expressed here in
a poetic interpretation of the English
countryside, was most nearly paralleled by
the seventeenth-century Dutch landscape-
artists. This sheet is clearly reminiscent of
similar subjects depicted by Rubens; in it,
the artist has achieved an intense, painterly
vibration in his skilful use of black chalk
illuminated with white highlights.
Bibliography: Woodall, 1939, no. 418;
Hayes, 1970, no. 792

Richard Wilson
(Penegoes 1713–Colomondie 1782)
Signora Felice Bocca Stretto
Black chalk and stump on white paper;
6½ × 9 in. (163 × 228 mm.)
Provenance: gift of Chambers Hall 1855
Oxford, Ashmolean Museum

This rapid, lively chalk sketch, which bears
the autograph inscription '*Sig.ra Felice Bocca
Stretto*', is datable to the period when
Richard Wilson was active in Italy, from
about 1750 to 1756. One of Britain's first
great landscapists, he was also able to
capture a likeness very quickly, emphasizing
his sitters' most salient features extremely
effectively.
Bibliography: Garlick, 1979, no. 55

Thomas Rowlandson (London 1756–1827)
*The Apple-Seller (Baking and Boiling
Apples)*
Reed pen and reddish-brown ink with
watercolour over pencil; 11 × 8½ in.
(278 × 217 mm.)
Provenance: Douce; Bodleian Library;
University Galleries; entered in 1863
Oxford, Ashmolean Museum

A brilliant caricaturist and competent
draughtsman, Thomas Rowlandson is the
most important representative of eighteenth-
century English satire apart from William
Hogarth (1697–1764). In this drawing the
outlines were executed with a reed pen and
the whole then lightly hand-coloured with
wash, the usual technique of this artist. The
style of the drawing is comparable to that of
the series *Cries of London*, published in 1799.
Bibliography: Paulson, 1972, no. 15;
Garlick, 1979, no. 49

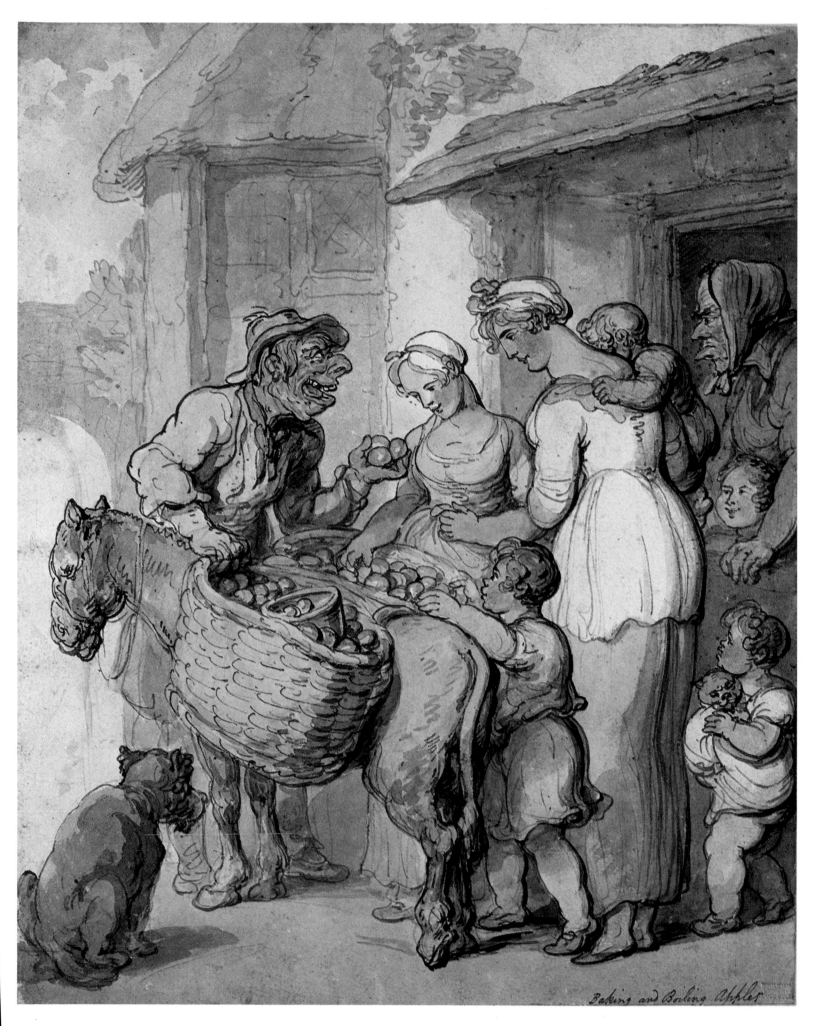

Baking and Boiling Apples

283

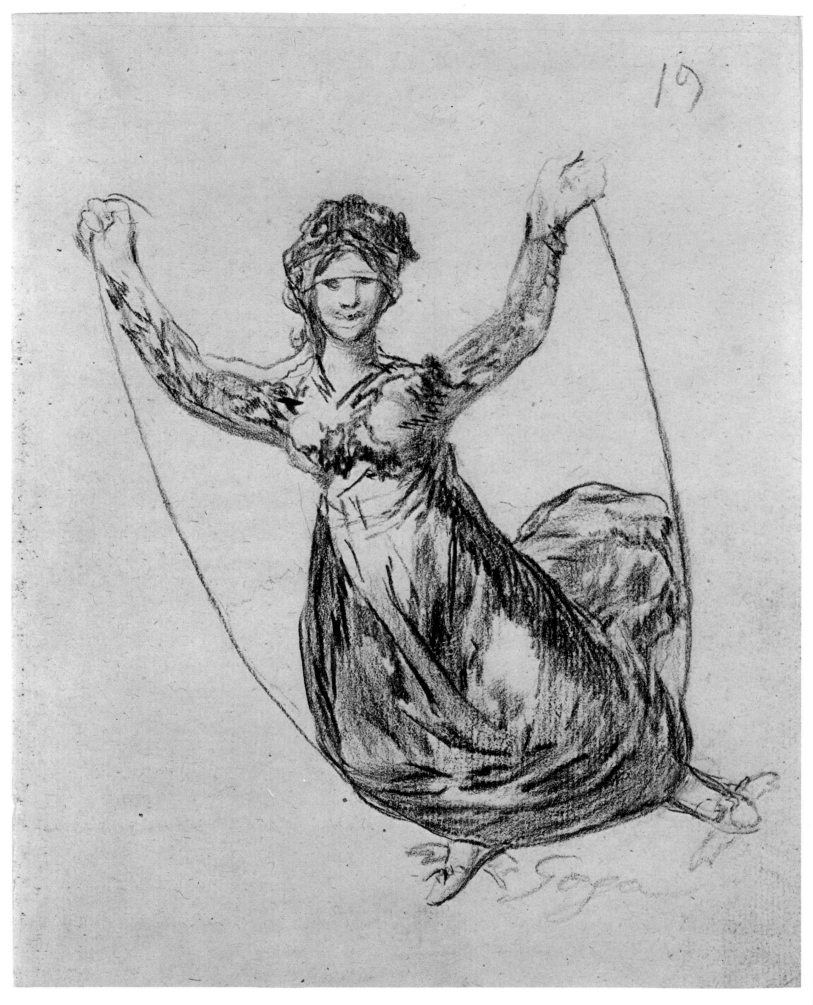

Francisco Goya
(Fuendetodos 1746–
Bordeaux 1828)
Girl Skipping
Black chalk; $7\frac{3}{4} \times 6\frac{1}{8}$ in.
(192 × 155 mm.)
Provenance: Savile;
Colnaghi & Co. (1923)
Ottawa, National Gallery
of Canada, inv. 2996

This drawing in black chalk
– which may have been a
preparatory study of a
witch – with its detached,
expressionistic style,
belongs to the last phase of
Goya's work after his
departure in 1824 for
Bordeaux. The figure '19'
that appears in the top
right-hand corner shows
that the sheet belongs to
album 'H', many folios
from which are in the
Prado Museum in Madrid
as well as in a collection in
Berlin.
Bibliography: Popham-
Fenwick, 1965, no. 306;
Gassier, 1973

Francisco Goya
Masks for Holy Week 1794
Brush and grey and black
inks on pink paper;
$8\frac{1}{2} \times 5\frac{1}{4}$ in. (215 × 134 mm.)
Provenance: Roth
Pasadena, Norton Simon
Inc. Museum of Art, inv.
M. 74.4.2 D

Within Goya's huge
graphic corpus, the drawing
takes on a fundamental
role, not only in a
preparatory capacity for
engravings but also – and
most importantly – as an
independent means of
expression. In this sheet,
which belongs to the artist's
youthful period and comes
from his *Madrid Album*,
there seems to be an echo
of Gian Domenico Tiepolo
not only in the subject but
in the vibration of the
brush-stroke and the
painterly effects created by
the artist through the
skilfully applied gradations
of ink.
Bibliography: Gassier,
1973, I. no. B80

From Neoclassicism to Realism

Antonio Canova (Possagno 1757–Venice 1822). One of the most outstanding of the Neoclassical sculptors, Canova received most of his training in Venice at the end of the Rococo period. There is plenty of evidence for this in the numerous sketches and rough plans from his early years, which are preserved in several groups in the museum at Bassano. Having moved to Rome in 1781, Canova found himself in an atmosphere of Neoclassicism and it was not long before he had made a name for himself with the papal tombs in the Basilicas of the Holy Apostles and of St Peter. He was appointed official sculptor to the Napoleonic Empire but, despite his open adherence to Neoclassicism – so earnestly championed by the French painter, Jacques Louis David, and the Danish sculptor, Bertel Thorwaldsen – continued to show a sensitivity and rhythmic elegance in his work that still reflected its Venetian origins.

Angelica Kauffmann (Chur 1741–Rome 1807). After having spent her formative years in Rome under the influence of Neoclassicism, Angelica Kauffmann went to London where she worked from 1761 to 1781 in the elegant atmosphere of the artistic decorators who were employing the then fashionable Adam style. In spite of this, her drawings and portraits in oil display a deep-rooted leaning towards the Venetian handling of colour and a style of drawing that displays the soft, refined influence of Correggio.

Pierre-Paul Prud'hon (Cluny 1758–Paris 1823). At the age of twenty-six, Prud'hon was studying in Italy, unable to decide during the five years he remained there whether to adopt the soft style of the Correggio tradition or the formal harmony of Raphael. But it was Annibale Carracci's drawings that were to be the models for his chiaroscuro sheets, which display a remarkably painterly quality. Having been appointed Court Portraitist to Napoleon, he turned to classical themes in allegorical and historical paintings such as his *Psyche*, now in the Louvre. Yet, despite having to pander to fashionable taste, he never lost that unbounded delicacy of touch which, although still redolent of the eighteenth century, was linked to the graphic tradition of François Boucher.

Élisabeth Vigée-Lebrun (Paris 1755–1842). This very successful portraitist acquired her taste for themes of a rather refined, sentimental nature from Jean Baptiste Greuze. Her work already savoured of the Romantic era to come, and her portrait-painting was soon known throughout Europe. Her best works were executed in pastel, in which she seems to have recaptured in her colours a fresh quality that could only have stemmed from Venice and was perhaps inspired by Rosalba Carriera.

Jacques-Louis David (Paris 1748–Brussels 1825). Official painter to the Revolution and thus to Napoleon, David put his genius, educated in Roman Classicism, at the service of libertarian ideology. One of his most acclaimed paintings was his *Oath of the Horatii*, painted in Rome in 1784 and exhibited in Paris the following year. David had, in fact, spent his earlier years, up to 1775, studying and working in Rome. While there he had been strongly influenced by the work of the Carracci and by that of Guido Reni, from whose paintings he derived a brilliant and luminous range of colours as well as developing an incisive style of drawing. A fine portraitist, he excelled both in the psychological interpretation of his sitters and in brilliant draughtsmanship, as exemplified by his *Madame David*, in the Louvre. After the defeat of Napoleon at Waterloo, David went into voluntary exile to Brussels, where he spent the rest of his life painting historical subjects, as he had done in his younger days.

Felice Giani (San Sebastiano Monferrato 1758–Rome 1823). Possibly the most important Italian artist of the Neoclassical period, Giani's influence in the peninsula is comparable to that of David in France. He started, at the age of twenty, by decorating the Palazzo Doria, Rome, in various sophisticated Neo-Mannerist styles. Subsequently finding that the current trend was more towards Neoclassicism, he began to follow the artistic canons of this style in his own work. Commissions arrived from all directions and he found himself working in Faenza, Rome, the Hermitage in St Petersburg (now Leningrad) and Paris. In later life, when he worked at Montmorency, he seems already to have been developing a Romantic style approaching that of Delacroix and Géricault. Giani produced a great many drawings relating to his frescoes and from these it is plain to see that his inclination was towards the culture of the late eighteenth century.

Jean-Auguste-Dominique Ingres (Montauban 1780–Paris 1867). Having studied under Jacques-Louis David in 1797, he won the Prix de Rome in 1806 and devoted himself almost entirely to studying Raphael. His graphic and painting style was inspired by the harmony of the great sixteenth-century artists but subtly tinged with a contemporary spirit. The influence of his earlier models is apparent in the work he produced during his long stay in Rome, where he did some decorative work at the Villa Aldobrandini in the Quirinal, in Naples and in Florence, where between 1820 and 1824 he painted the *Vow of Louis XIII* for Montauban Cathedral. After returning to Paris for a short time, he went back to Rome to take up an appointment as Director of the French Academy, which he held from 1834 to 1841. Ingres' reputation rests mainly on his portraiture, for which he did a great deal of preparatory drawing to produce works of perfect balance.

Henry Fuseli (Johann Heinrich Füssli) (Zurich 1741–London 1825). After studying theology in Switzerland, Fuseli went to London where he was befriended by Sir Joshua Reynolds, who encouraged him to become a painter. With this advice in mind he went to Italy, where he stayed from 1770 to 1778, studying and copying Michelangelo in whom he saw the rebirth of the classical spirit. His painting portrays a troubled world peopled with nightmarish creatures, as in his picture *The Nightmare*, now in the Goethe Museum, Frankfurt. His watercolour drawings are often tinged with ambiguous and sensual meanings.

William Blake (London 1757–1827). Poet, painter, Blake found himself working in an atmosphere of pre-Romanticism that was sensitive to the haunted inventions of Füssli, with whom he shared an admiration for Michelangelo. This is evident in the watercolour drawings with which he illustrated his own and other people's poems, including Dante's *Divine Comedy*, on which he worked from 1824 to 1827.

John Constable (East Bergholt 1776–London 1837). As a young man, Constable used Claude Lorraine, Richard Wilson and Thomas Gainsborough as his lodestars, but soon began to concentrate solely on landscapes. Having exhibited in Paris in the 1820s, he made a great contribution to the evolution of that group of landscape-painters

known as the Barbizon School while, conversely, his success was waning in his own country. Constable's way of analysing nature by making innumerable drawings (most of them in the Victoria and Albert Museum, London) and painting pictures from the same spot is proof enough of his single-minded attachment to the truth, which anticipates the Impressionist movement.

Joseph Mallord William Turner (London 1775–1851). Having completed his training in the Royal Academy Schools in London, Turner concentrated on watercolours and during the early decades of the nineteenth century was painting views and landscapes. He had already begun to work in oils in the late 1790s, however, and the year 1819 saw him in Italy for the first time. He was deeply impressed with the strong feeling for colour expressed by Venetian artists, which enabled them to translate into paint the wonderful effects of light to be seen in Venice. He was intoxicated by this new poetic quality and began to use his paint to catch the changing moods of the shimmering, dazzling luminosity that seemed able to absorb and dissolve the most solid of forms. He painted a number of very beautiful pictures while still in that city, continuing to develop the style after his return to England, a fine example being his *Snowstorm at Sea*, in the National Gallery, London. A prolific artist, his graphic work kept pace with his painting but it has been split up into a great many groups, mainly among the London museums.

Dante Gabriel Rossetti (London 1828–Birchington-on-Sea 1882). One of the founders of the Pre-Raphaelite Brotherhood, Rossetti was both an artist and a poet, one of his dearest wishes being to revive the style of Fra Angelico. His female portraits have a refined and sometimes elusive air about them. He was a particularly able draughtsman, which is apparent in his numerous drawings, in many of which there is an echo of Ingres.

John Ruskin (London 1819–Coniston, 1900). A well-known and highly influential art critic, Ruskin was one of the leading advocates of the 'Neo-Gothic' style which became fashionable about the middle of the nineteenth century. His predilection was for the Primitive Italian artists who had already been brought back into favour by the Pre-Raphaelite movement. Ruskin used his skill as an architectural draughtsman to

illustrate his own books, of which *The Stones of Venice*, written between 1851 and 1853, is one of the most memorable.

Eugène Delacroix (Charenton-Saint-Maurice 1798–Paris 1863). Although Delacroix had been a pupil of Jacques-Louis David in a Neoclassical atmosphere, he soon became totally absorbed in the counter-movement of Romanticism. Indeed, it was with his work that the Romantic movement reached its peak, and when in 1824 he presented his *Massacre at Chios* in the Salon du Louvre the new trend was confirmed, with its violent colours, composite dynamism and exceptional intensity of expression. During a tour of Spain and Morocco in 1832, a whole new world of ideas and subjects was opened up to him by the luminous, enchanted atmosphere of the Mediterranean. He became the most fashionable artist in Parisian society and carried out decorative work in several of the most important buildings, including the Palais Bourbon and the Palais du Luxembourg, as well as painting the ceiling of the Salon d'Apollon in the Louvre. He was a friend of such great writers and musicians as Charles Baudelaire, George Sand and Fréderic Chopin.

Honoré Daumier (Marseilles 1808–Valmondois 1879). Daumier worked as a cartoonist on Parisian satirical journals and became particularly proficient in lithography. He was frequently in disfavour with King Louis Philippe because of his bitter attacks on him and his Ministers, but with the return of the Republic he reverted mainly to caricatures. From 1860 onwards he also did a certain amount of painting characterized by broad, impetuous brushwork, reminiscent of the style of Fragonard, of which his *Don Quixote* (1868) in Munich is a typical example.

Jean-François Millet (Gruchy 1814–Barbizon 1875). Having spent some of his formative years in the atmosphere of academic painting, in 1848 Millet began to concentrate on themes depicting the life of the peasantry, imbuing his work with a new sense of realism. The following year he moved to Barbizon where he became part of the school of painters that gained its name from this little village in the Forest of Fontainebleau. Here he devoted himself to extolling, through his work, the simple, poetic life of the fields, as for example in *The Gleaners* (1857), now in

the Louvre. In his drawings, too, Millet paid great attention to realistic effects and natural light, in anticipation of the Romantic and Impressionist movements.

Jean-Baptiste-Camille Corot (Paris 1796–1875). A tour of study in Italy between 1825 and 1828 proved decisive in Corot's development as a landscapist. The Roman countryside offered him a great many subjects to be painted from life and he depicted them in the seventeenth-century style of Poussin and Claude Lorraine. Alternating between his native land and his beloved Italy, Corot produced during the 1840s an increasing number of Roman landscapes, gaining himself a very high reputation as a successful artist in the process. A fine draughtsman, in his latter years he developed a freedom of style in his representation of village scenes and figures that was fully understood by the Impressionists.

Winslow Homer (Boston, Mass. 1830–Scarboro 1910). Homer began his working life as an illustrator on the magazine *Harper's Weekly*, devoting himself mainly to lithography, which he used as a supportive technique to photography. After spending a year (1866–7) in Paris, he toured other European countries, finding himself particularly enamoured of pre-Impressionist painting. Once back in the United States, he concentrated on drawing and painting marine subjects in an uninhibited, realistic style.

Gustave Courbet (Ornans 1819–Vevey 1877). A revolutionary by temperament, Courbet took part in political strife as a result of which he was exiled to Switzerland and at his death his works dispersed. He appeared at a fundamentally important moment in the nineteenth-century French school during its transition from Romanticism to Realism around the 1850s. The effects of colour and light achieved by Courbet, which reflect the influence of the great sixteenth-century Venetian and seventeenth-century Dutch masters, were vitally important in the development of the younger generation of artists who were so soon to become exponents of Impressionism.

Eugène Boudin (Honfleur 1824–Deauville 1898). Having been influenced by the Realism of Courbet, Boudin concentrated mainly on painting marine subjects from life,

which he did with pre-Impressionist sensitivity. Claude Monet became his pupil in Le Havre in 1853 and they both exhibited at the First Impressionist Exhibition of 1874, in the studio of the photographer Nadar. Boudin's style is fresh and crisp, maintaining even in his paintings the immediacy of his numerous sketches.

Antonio Fontanesi (Reggio Emilia 1818–Turin 1882). After a provincial training in Piedmont, in 1855 Fontanesi went to Paris, where he found the inspiration he needed to devote himself to applying Realism to the representation of Nature. He admired Corot and the Barbizon painters, and in England he came to know Turner and Constable. On his return to Turin in 1869, where he was to teach landscape-painting at the Accademia, he produced his most inspired works, one of which, *April*, painted in 1873, is now in the Gallerie d'Arte Moderna in Turin. The intimate Romanticism of Fontanesi's style is apparent even in his numerous drawings, many of which he painted in watercolour.

Giovanni Fattori (Leghorn 1825–Florence 1908). After training in an atmosphere of historical painting, Fattori allied himself with the Tuscan group, the *Macchiaioli*. He developed a rapid style of painting, with strong contrasts between light and shade which were built up in areas of colour, as in his *Rotunda of Palmieri*, painted in 1866 and now in the Galleria d'Arte Moderna in the Palazzo Pitti, Florence. Fattori was also a watercolourist and etcher, for which he adopted a sober, economical style based on a clear-cut expressive line.

Giovanni Segantini (Arco 1858–Schafberg 1899). Segantini drew his inspiration from the spirit of the *Scapigliatura*, a clique of rather Bohemian writers in Lombardy, and from the Divisionism of France in his painting of natural subjects, rendered in light values. Having moved to the Grisons canton of Switzerland, he took great delight in the natural surroundings and produced some of his most important works there, for example *The Two Mothers*, now in the Galleria d'Arte Moderna in Milan. His tendency to imbue his subjects with allegorical and symbolic meanings, with a strongly sentimental content, increased over the years.

Tranquillo Cremona (Pavia 1837–Milan 1878). Although greatly influenced by the

soft, *sfumato* painting by Carnovali, Cremona discovered – while staying in Venice – some 'patterns' for paintings of the sixteenth century whose density of colour he tried to emulate. In Milan he frequented the rather Bohemian literary haunts of the *Scapigliati* as a result of which he felt the need to paint increasingly dynamic, *Intimist* pictures, which tended to become blurred, and rainbow-hued, as for example in *The Ivy*, in the Galleria d'Arte Moderna, Turin.

Guglielmo Ciardi (Venice 1842–1917). After an early and successful spell of working in the '*Macchiaioli*' style, Ciardi turned to landscape-painting. His handling of colour is especially effective, sometimes reminiscent of the eighteenth-century tradition in his views of the lagoon, for example his *Giudecca Canal*, now in the Gallerie d'Arte Moderna in Venice. He used his talent for drawing to make rough sketches, in pen or pencil, to record 'on the spot' impressions of the countryside, which he did with exquisite clarity.

Mariano Fortuny y Carbó (Reus 1838–Rome 1874). Of Catalonian origin, this artist moved to Rome in 1857 and remained there for the rest of his life. He developed a Romantic language, often illustrative, which was at its best in his brilliant drawing and painterly techniques.

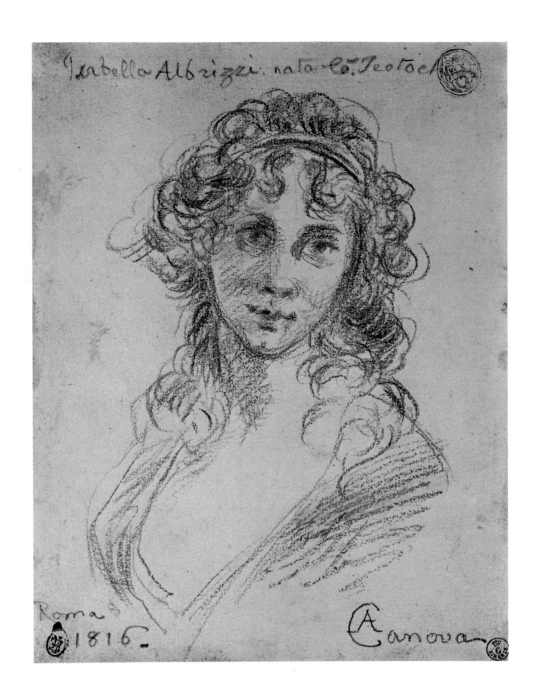

Antonio Canova
(Possagno 1757–Venice 1822)
Isabella Albrizzi
Sanguine; $9\frac{1}{2} \times 7\frac{1}{8}$ in. (241 × 182 mm.)
Florence, Galleria degli Uffizi, inv. 19232 F

The soft sanguine strokes and elegant flow
of the line characterize this portrait of
Isabella Albrizzi, née Teotochi. It is signed
'A. Canova' and dated '1816' but differs
considerably from the cold, Neoclassic
perfection of the artist's sculptural works of
the same period, linking it more to the late
eighteenth-century Venetian tradition of
painterliness.
Bibliography: Muraro, 1953, no. 100

Angelica Kauffmann
(Chur 1741–Rome 1807)
Portrait of a Woman in a Lace Bonnet
Coloured chalks; $9 \times 7\frac{3}{4}$ in. (227 × 187 mm.)
Provenance: Pacetti; entered in 1844
Berlin, Kupferstichkabinett, Staatliche
Museen, inv. 4613

Delicate rococo influences pervade the
slightly Neoclassic style of this coloured
chalk drawing. Its detachment from the
conventional portraiture of the time clearly
illustrates the artist's awareness of the new
requirements of the rising middle classes.
Angelica Kauffmann well knew how to
interpret current trends and held a place in
the front rank in the world of Roman
Neoclassical art.
Bibliography: Friedländer-Bock, 1921, p.
198; Möhle, 1947, p. 47; Halm, 1955–6,
no. 120

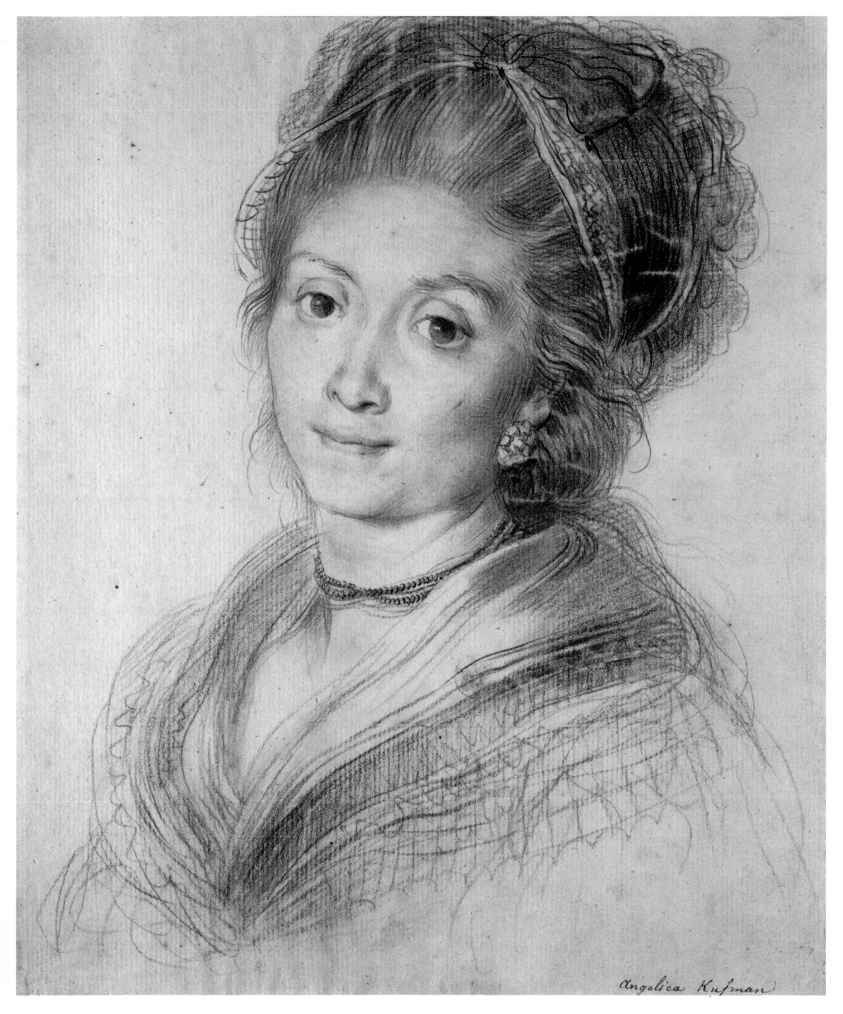

Angelica Kaufman

291

Pierre Paul Prud'hon
(Cluny 1758–Paris 1823)
The Fountainhead
Black and white chalk; $21\frac{1}{4} \times 15\frac{3}{8}$ in.
Williamstown, Mass., Sterling and Francine
Clark Art Institute, inv. 833

A very skilful draughtsman, Prud'hon
succeeded in blending into his drawings a
delicacy that still savoured of the eighteenth-
century Neoclassic influence of Canova. One
of the most delightful illustrations of the new
evaluation of drawing in relation to colour
that emerged from the Neoclassic theories is
to be found in this exquisitely drawn study.
In it, the artist has used his chalks in a
particularly subtle way to achieve a wide
gamut of tonal values ranging from pure
white, through the greys, to black.
Bibliography: Mendelowitz, 1967, p. 155,
fig. 7-2

Élisabeth Vigée-Lebrun
(Paris 1755–1842)
A Young Girl
Pastel and azure chalk; 11×8 in.
(278×205 mm.)
Paris, Musée National du Louvre, inv. 33269

The sentimentalism that came with the end
of the eighteenth century is to be found at its
most typical in the pastel portraits of
Élisabeth Vigée-Lebrun, Court Painter to
Marie Antoinette. There is a formal balance
in the portrayal of this young girl's face that
is characteristic of the Neoclassic style, with
its *sfumato* use of pastel and azure chalk.
Bibliography: Sutton, 1949, no. XLVI

Jacques-Louis David
(Paris 1748–Brussels 1825)
The Princess Murat and Pauline Borghese
Pencil on ivory paper; 9¼ × 7 in.
(236 × 178 mm.)
Provenance: Winthrop
Cambridge, Mass., William Hayes Fogg Art
Museum, inv. 1934.1815.12

This sheet belongs to one of two books of
sketches made from life and entirely devoted
by David to the preparation of the huge
celebratory painting *Coronation of Napoleon*,
commissioned by the Emperor as a record of
his coronation on 3 December 1804. As the
autograph inscription says, it is an *étude
pour les princesses Murat et Borghese*,
squared-up for transfer to the painting itself,
in which the Princess Murat and Pauline
Borghese appear on the left-hand side.
Bibliography: Moskowitz, 1963, no. 792

Felice Giani
(San Sebastiano Monferrato
1758–Rome 1823)
Sacrifice to Aesculapius
Pen and bistre with outlines in black pencil;
23⅝ × 15 in. (600 × 380 mm.)
Provenance: Santarelli
Florence, Galleria degli Uffizi, inv. 9906 S

This study, which is inscribed *'Sacrificio a
Esculapio'*, relates to the decoration in the
Palazzo Milzetti, Faenza, undertaken by
Giani in 1802. Its Neo-Mannerist style is
expressed in the flowing linearity and
dynamic pen-strokes with which the artist
has drawn the elegant, elongated figures.
Bibliography: Santarelli, 1870, p. 676, no.
26; Mattarozzi, 1965, no. 15; Del Bravo,
1971, no. 1

26 – *Gianni – Cart. 103.*

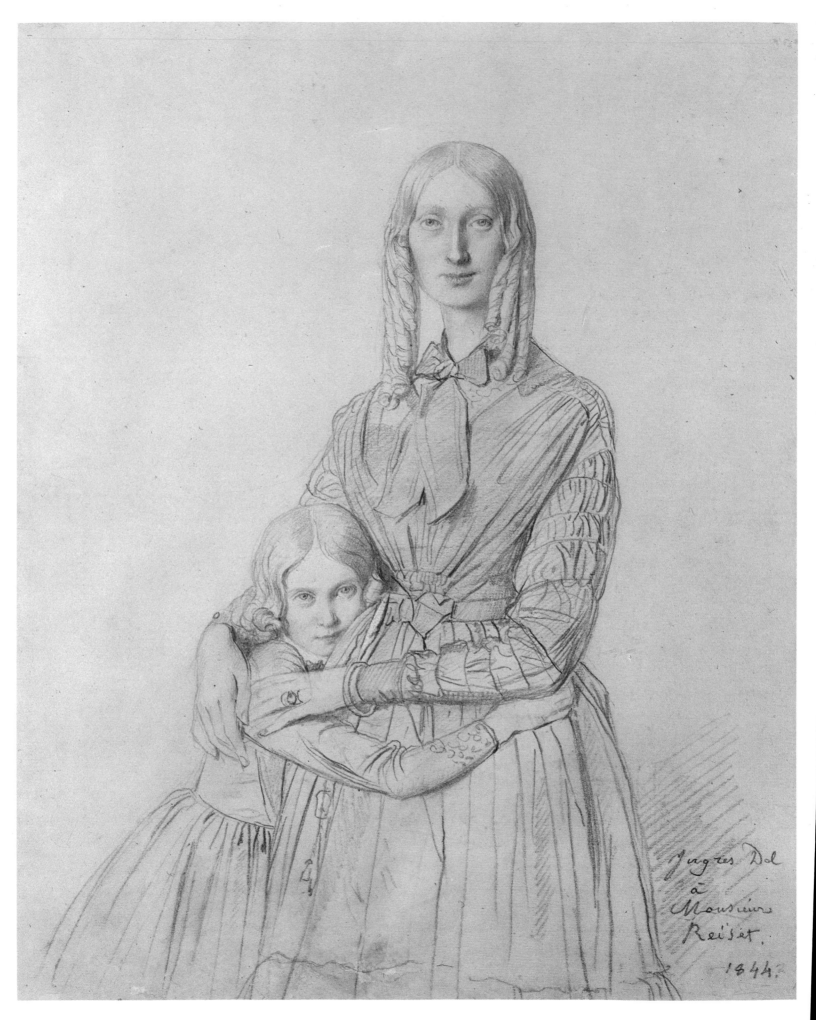

Jngres Del
à
Monsieur
Reiset.

1844.

Jean-Auguste-Dominique Ingres
(Montauban 1780–Paris 1867)
Portrait of Madame Reiset
Pencil and white chalk; $12\frac{1}{4} \times 9\frac{5}{8}$ in.
(312×246 mm.)
Provenance: Ségur-Lamoignon; Amelot;
Pasquier; Hendecourt; Koenigs
Rotterdam, Museum Boymans-van
Beuningen, inv. F-II–168

A portraitist to the French upper middle
classes, Ingres reveals in his work a subtle
insight into the mind of his model combined
with acute observation of reality. The fine
attention to detail shown in the outlines,
which are drawn in pencil with the clear-cut
quality of a pen, is the most remarkable
feature of this portrait of mother and
daughter, dated 1844.
Bibliography: Haverkamp-Begemann, 1957,
no. 68

Jean-Auguste-Dominique Ingres
Adam and Eve
Pencil; $5\frac{3}{8} \times 11$ in. (390×281 mm.)
Provenance: Haro; Winthrop
Cambridge, Mass., William Hayes Fogg Art
Museum, inv. 1943.861

Ingres' love for the perfection of Classical
Greek sculpture is expressed in these two
idealized studies of the nude which were
preliminary drawings for his *Golden Age* in
the Château Dampierre. The sinuous line of
the contours prevails over the delicate
indications of modelling on the bodies in a
harmonious balance that is both rhythmic
and integrating.
Bibliography: Sachs, 1961, pl. 56; Mathey,
n.d., no. 47

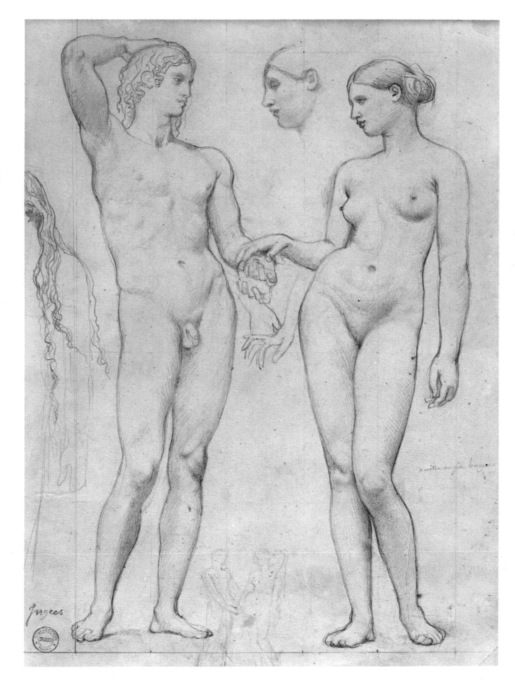

297

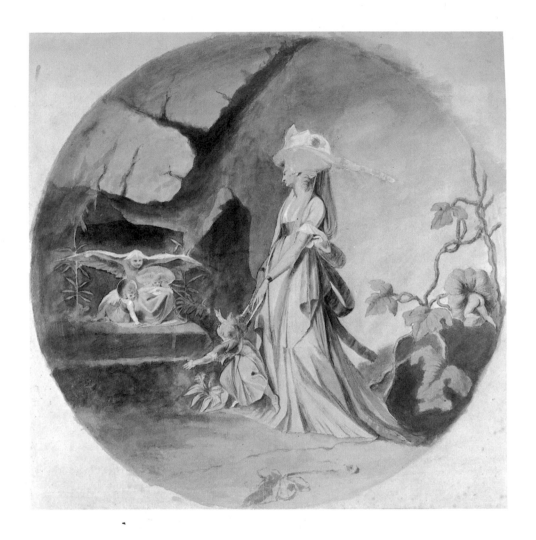

Henry Fuseli (Johann Heinrich Füssli)
(Zurich 1741–London 1825)
Mamillius and a Lady
Pen and ink with watercolour; 19⅜ in.
(490 mm.) (diameter)
Zurich, Kunsthaus, inv. 1914/42

An irrational element of fantasy dominates
the work of Fuseli. The drawing reproduced
here is datable to between 1785 and 1790,
and was inspired by Shakespeare's *The
Winter's Tale*, Act II, Scene i, depicting
characters who are typical of the artist's pre-
Romantic inspiration. The technique of
using watercolour on a disc against a plain
ground was a favourite means of expression
for Fuseli, who was able to produce some
weird effects with it.
Bibliography: Ganz, 1954, no. 18;
Hugelshofer, 1967, no. 78; Schiff, 1973,
no. 825

William Blake
(London 1757–1827)
Queen Katherine's Dream
Watercolour; 12⅝ × 13½ in. (320 × 343 mm.)
Provenance: Rosenwald
Washington, DC, National Gallery of Art,
inv. B-11,197

William Blake's work is probably the most
typical of the pre-Romantic poetry of the
sublime. His youthful study of the Gothic
style and his admiration for Michelangelo
were fundamental to his art. In his
watercolours, such as this one datable to
about 1825, the Michelangelesque power
melts into an extenuated linearity in which
the figures gradually drift away with the
ascending motion of the spiral composition.
Bibliography: Robison, 1978, no. 91

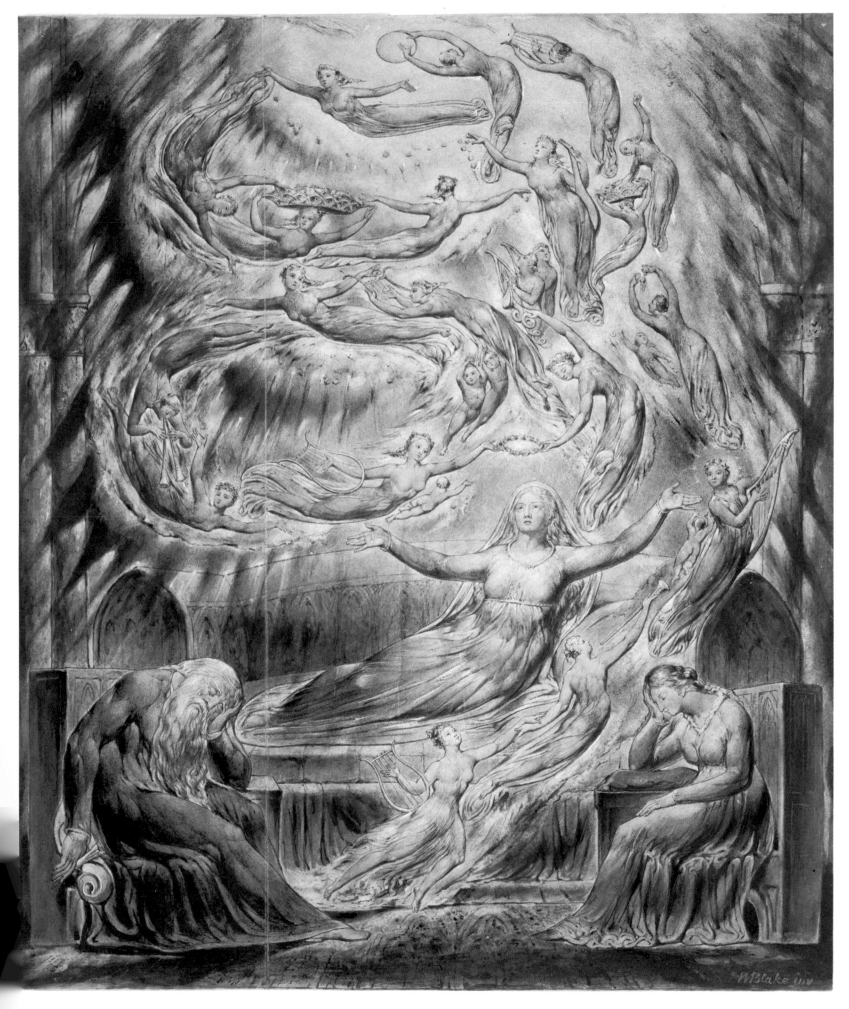

John Constable
(East Bergholt 1776–London 1837)
Flatford, Dedham Vale
Pencil; $8\frac{3}{4} \times 13$ in. (221 × 329 mm.)
Provenance: Christie's; entered in 1892
Dublin, National Gallery of Ireland,
inv. 2057

This pencil study bears the inscription
'Flatford, Oct.r 5 1827' and some notes on
the colours Constable proposed to use in the
projected painting. It belongs to a series of
album sheets drawn by Constable while
staying at Flatford Mill, East Bergholt,
Suffolk, during the summers of 1810 to 1816.
The artist's acute observation of Nature, of
which every aspect is reproduced faithfully
according to the hour and the season, is the
most important characteristic of his
landscapes.
Bibliography: White, 1967, no. 72

Joseph Mallord William Turner
(London 1775–1851)
View of St Mark's Basin
Watercolour; $8\frac{1}{2} \times 12\frac{1}{2}$ in. (218 × 319 mm.)
Provenance: Vaughan; entered in 1900
Dublin, National Gallery of Ireland, inv.
2426

The city of Venice and its lagoon, with the
play of light and diffusion of reflected shapes
on the water, inspired many of Turner's best
works. By using a special watercolour
technique, as in the sheet illustrated here,
datable to about 1835, he achieved an
unusual interweaving of colour and light to
create intensely lyrical atmospheric effects.
Bibliography: Finberg, 1930, p. 160; White,
1967, no. 78

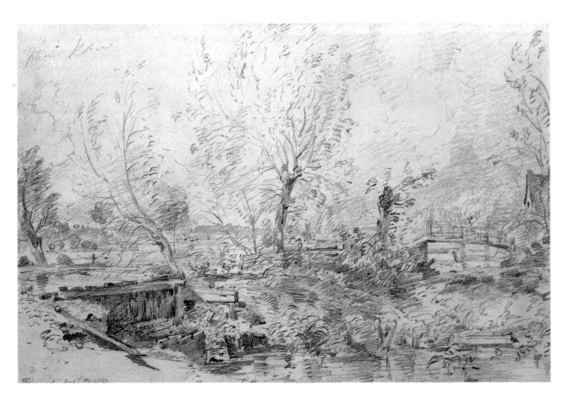

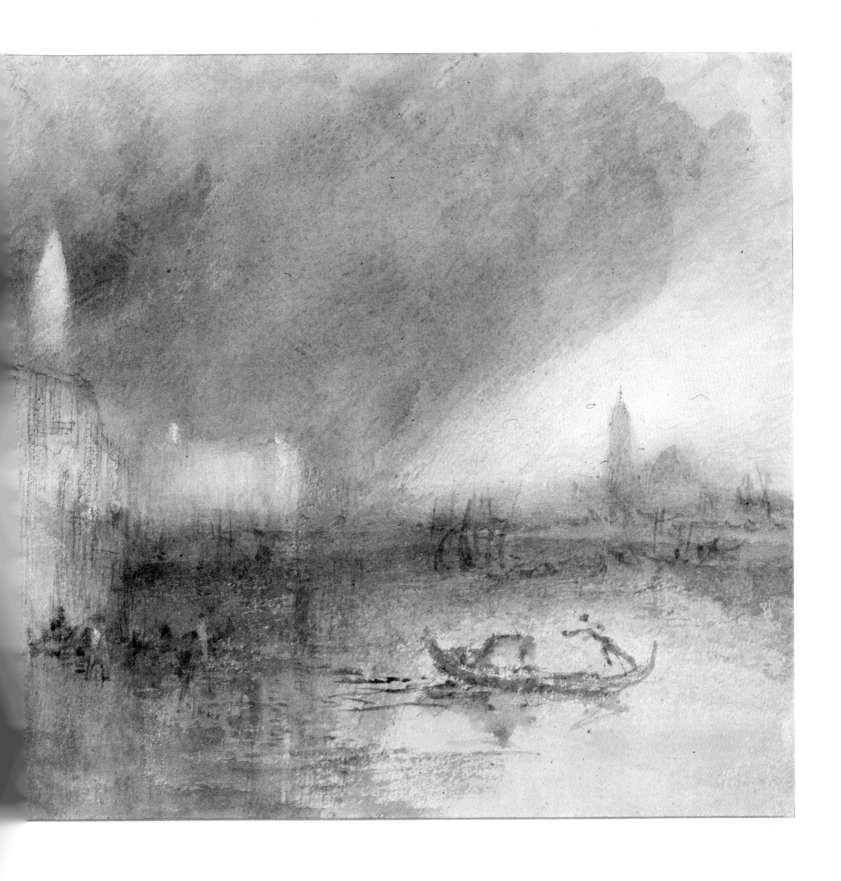

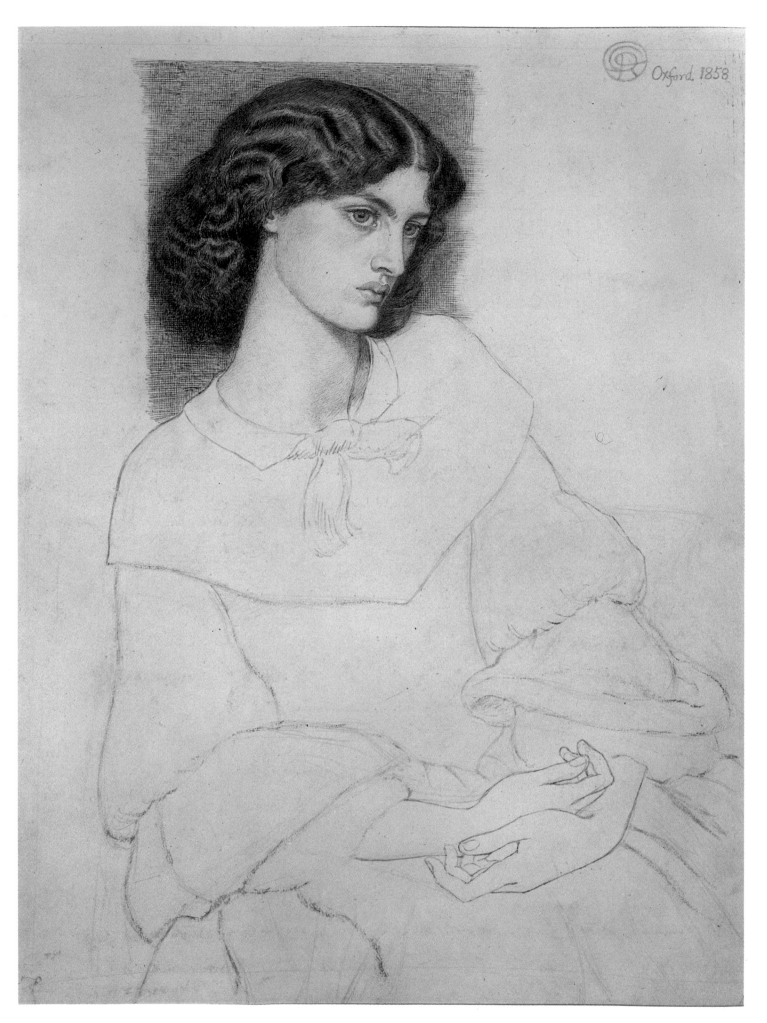

Oxford 1858

302

Dante Gabriel Rossetti
(London 1828–Birchington-on-Sea 1882)
Portrait of Jane Burden
Pen and ink; $19\frac{3}{8} \times 14\frac{7}{8}$ in. (492 × 376 mm.)
Provenance: Rossetti sale; entered in 1883
Dublin, National Gallery of Ireland, inv.
2259

This sheet is characterized by a subtle,
harmonious draughtsmanship in keeping
with its Pre-Raphaelite elegance.
Monogrammed and dated 'D.G.R. Oxford,
1858', this study relates to the frescoes of
Queen Guinevere which Rossetti painted for
the Oxford Union and was probably the first
portrait of Jane Burden to have been
executed by the artist.
Bibliography: Ironside-Gere, 1948, p. 33;
White, 1967, no. 85

John Ruskin
(London 1819–Coniston 1900)
Byzantine Arches in Venice
Pen, watercolour and gouache over pencil on
grey paper; $11\frac{3}{8} \times 17\frac{3}{8}$ in. (290 × 440 mm.)
Provenance: Norton; entered in 1901
Boston, Mass., Isabella Stewart Gardner
Museum

This drawing, which depicts part of the
decoration of the Palazzo Loredan in
Venice, is one of over 600 studies executed
by Ruskin in preparation for his book *The
Stones of Venice*, which he was writing from
1851 to 1853. He worked in pen over a basic
pencil drawing and then in watercolour to
achieve as realistic a representation as
possible of the subject's essential features.
Bibliography: Hadley, 1968, no. 16

Eugène Delacroix
(Charenton-St-Maurice 1798–Paris 1863)
Tiger
Watercolour; $5\frac{3}{4} \times 10$ in. (145 × 252 mm.)
Provenance: Rosenwald
Washington, DC, National Gallery of Art,
inv. B-B-6398

In this watercolour the artist has stressed all
the force of the wild animal in repose

through his portrayal of muscular power. It
is datable to about 1830, for although
Delacroix did not visit Morocco until 1832
he had already produced a great many
studies of tigers, lions and leopards, which
he was able to observe closely in the Jardin
des Plantes in Paris.
Bibliography: Price, 1961, no. XXX;
Robison, 1978, no. 95

Honoré Daumier
(Marseilles 1808–Valmondois 1879)
The Picture Connoisseurs
Pen and brush, grey and brown inks
heightened with white on ivory paper;
19½ × 15½ in. (493 × 392 mm.)
Provenance: Bollet; private collection;
Wildenstein
Chicago, Art Institute of Chicago, Joseph
and Helen Regenstein Foundation, in
Memory of Frank B. Hubachek, inv. 1968.1

It is difficult to date Daumier's works in
view of the fact that only one of his
paintings and none of his drawings or
watercolours carry a date. In the paper itself,
however, there is a watermark that indicates
1869, which is particularly interesting as this
would denote that this notable sheet belongs
to the late period of the artist's activities.
The theme appears more than once in
Daumier's work.
Bibliography: Maison, 1968, no. 390a;
Joachim, 1974, no. 70

Jean François Millet
(Gruchy 1814–Barbizon 1875)
The Shepherdess
Black and coloured chalks, charcoal and
stump; 11 × 16 in. (278 × 406 mm.)
Provenance: Atger; Petit; Kimball; Heine
Cincinnati, Cincinnati Art Museum, Gift of
Emilie L. Heine in memory of Mr and Mrs
John Hauck, inv. 1940.985

Here Millet has created a vivid image of one
aspect of rural life, caught in an atmosphere
of suspension between myth and reality that
is typical of all his work. To achieve this
effect the artist has used his coloured chalks
with great care, without covering the first
black outlines. Millet began to depict the
conditions of the peasant classes as a result

of the social unrest of 1848, and this was to
exert a fundamental influence on Realism in
nineteenth-century French painting.
Bibliography: Souillié, 1900, p. 93; Holme,
1902–3, pl. M47; Spangenberg, 1978, no. 72

Jean-Baptiste Camille Corot
(Paris 1796–1875)
The Forest of Compiègne
Crayon and pen on grey paper; 15¾ × 10⅝ in.
(400 × 270 mm.)
Provenance: Robaut
Lille, Musée des Beaux-Arts, inv. 1182

Sensitivity to light values is the essential
quality of Corot's landscapes, which display
a style that in many ways anticipates the best
aspects of Impressionism. That Corot was
indeed striving to achieve just such an effect
is apparent here in the mixed techniques of
crayon and pen used to emphasize the
vibration of light in the foliage of the trees.
Bibliography: Robaut, 1895–1905, IV, no.
2719

Winslow Homer
(Boston, Mass.
1830–Scarboro 1910)
The Herring Net
Black pencil and white chalk
on green paper; $16\frac{5}{8} \times 20\frac{5}{8}$ in.
(422 × 523 mm.)
New York, Cooper-Hewitt
Museum, inv. 1916-15-2

Primarily a painter of
seascapes, Winslow Homer
was one of the major
nineteenth-century American
artists. A little of the French
influence that remained with
him after his tour of Europe in
1866 to 1867 can be seen in the
rapid black and white strokes
that animate this spontaneous
and realistic picture.
Bibliography: Moskowitz,
1963, no. 1044

310

Gustave Courbet (Ornans 1819–Vevey 1877)
Self-Portrait with Pipe
Charcoal; 11 × 8 in. (277 × 203 mm.)
Provenance: Desavery (?); Castagnary (?);
Stonborough; Roger-Marx
Hartford, Conn., Wadsworth Atheneum

The romantically inspired preference for
shadow and a strikingly realistic
characterization are the salient features of
this sheet. Courbet demonstrates in this
Self Portrait an extremely skilful charcoal
technique that has enabled him to achieve
the effect of an unusually rich impasto in the
gradation of chromatic values from the pure
white of the areas in full light to the smudgy,
sfumato black of the background shadow.
Bibliography: Leger, 1948, p. 30; Aragon,
1952, p. 204 below no. 38; Malvano, 1966,
pl. 2

Eugène Boudin
(Honfleur 1824–Deauville 1898)
Ladies on the Beach
Watercolour over pencil indications;
4½ × 9 in. (114 × 228 mm.)
St Louis, Mo., The St Louis Museum of Art,
inv. 109.1939

This delicate watercolour dated ''65' is a
variation of one of Boudin's favourite
themes, on this occasion depicted on a
beach. In his preference for settings *'en plein
air'* ('in the open air') – which he passed on
to Monet – and the luminous vibrancy of his
colours, Boudin shows himself to have been
a perceptive forerunner of the Impressionist
movement.
Bibliography: Moskowitz, 1963, no. 848

Antonio Fontanesi
(Reggio Emilia 1818–Turin 1882)
A Couple by the Trees
Black pencil on pinkish-grey paper;
$8\frac{5}{8} \times 5\frac{3}{8}$ in. (220 × 137 mm.)
Provenance: Banti; entered in 1913
Florence, Galleria degli Uffizi, inv. 91281

The originator of the nineteenth-century
Piedmontese school, Fontanesi shows a
delicate *intimisme* and an elegance of rhythm
in the composition of his work. His
preference for romantically luministic effects,
emphasized by an essentially painterly
technique, is evident here in the flowing lines
of black pencil on coloured paper.
Bibliography: Del Bravo, 1971, no. 121

Giovanni Fattori
(Leghorn 1825–Florence 1908)
The Nun
Pencil on yellowed grey card; $12\frac{1}{2} \times 9\frac{5}{8}$ in.
(317 × 246 mm.)
Florence, Galleria degli Uffizi, inv. 1046
G.A.M. (*v*)

There are many paintings by Fattori on
subjects relating to military life and it is to
one of these, *The Italian Field after the
Battle of Magenta*, now in the Galleria
d'Arte Moderna, Florence, that this pencil
study refers. Its incisive line and dazzling
luminosity are characteristic of this artist's
work. The figure of the nun did not appear
in the first sketch of 1859 but only in the
definitive version completed in 1861.
Bibliography: Del Bravo, 1971, no. 93 v

Giovanni Segantini
(Arco 1858–Schafberg 1899)
Two Women in a Landscape
Black pencil, coloured pencils and white
chalk; $7\frac{1}{2} \times 11\frac{1}{2}$ in. (190 × 290 mm.)
Milan, Castello Sforzesco

Although this drawing may be dated to the
later phase of the artist's work (1896), there
is certainly an echo of the great, luminous
expanses of his youthful period to be seen in
the composition. It therefore seems
allowable to surmise – from the way in
which the coloured pencils have been used –
that the artist subsequently retouched the
picture to bring it within the more advanced
interpretation of Divisionism, also known as
Pointillism.
Bibliography: Budigna, 1962, pl. I

Tranquillo Cremona
(Pavia 1837–Milan 1878)
Four Young Girls
Watercolour on paper; $19\frac{3}{4} \times 13\frac{3}{4}$ in.
(500 × 350 mm.)
Milan, Castello Sforzesco

A work that belongs to the artist's later
years – it carries his initials, 'TC' in the form
of a monogram – this sheet is one of
Cremona's most successful expressions of
'painterliness'. He had by this time joined
the Lombardy *'scapigliatura'* group and was
experimenting with the modern effects of
Tachism. This involved making use of the
blurred softness of watercolour outlines, on
fairly absorbent paper, to bring about the
disintegration of shapes and to transform
them into pure effects of light and colour.
Bibliography: Nicodemi, 1933, pp. 79, 229

315

Mariano Fortuny (Reus 1838–Rome 1874)
Portrait of the Artist's Wife at Portici
Watercolour heightened with white over
pencil on grey paper; 19⅜ × 14⅞ in.
(492 × 378 mm.)
London, British Museum, inv. 1950-5-20-6

Fortuny painted this watercolour of his wife
at Portici, just south of Naples, in the last
year of his life. He was extremely skilful in
the use of the brightest of colours in his
Intimist paintings, which unfortunately were
often executed on a level of rather superficial
elegance.
Bibliography: Gere, 1974, no. 374; Ciervo,
n.d., pl. 100

Guglielmo Ciardi (Venice 1842–1917)
The First Snows
Pencil heightened with white on paper;
9⅛ × 17⅛ in. (233 × 435 mm.)
Venice, Galleria d'Arte Moderna

This sheet, which is signed by the artist and
datable to 1886, is a typical representation of
the first mountain chains that overlook the
plain of Treviso, whitened with the early
winter snows. In it Ciardi has succeeded,
with his clear-cut, crisp pencil lines, in
capturing the crystalline clarity of the
atmosphere.
Bibliography: Menegazzi, 1977, no. 1

Impressionism and Post-Impressionism

Claude Monet (Paris 1840–Giverny 1926). Himself a pupil of Eugène Boudin, Monet gradually built up around him a group of young, talented painters who were to further the cause of painting '*en plein air*' ('out of doors'). In 1874 the Impressionists, as they became known, organized their first public exhibition in Paris, in the studio of the photographer Nadar, thus signalling the beginning of their artistic revolution. Monet also worked in London from 1900 to 1909, and in Venice from 1909 to 1912, all the time widening his understanding of the techniques on which was founded the theory of light, so important to the Impressionists.

Edouard Manet (Paris 1832–83). As a young man, Manet trained himself to paint by studying the great masters whose work was so highly regarded in the Louvre, among them Titian and Velasquez. He also learnt a great deal from the work of Goya and Courbet, whose realism he greatly admired. In 1862, against all the conventions of the Académie Royale, he produced his *Déjeuner sur l'Herbe*, exciting a scandal which only served to reinforce his conviction that he was justified in pursuing this new means of expression. He thus found himself the leader of an avant-garde group that included Monet, Pissarro, Sisley and Renoir – the founders of Impressionism. Having finally achieved recognition, Manet continued to infuse his canvases with warm, glowing colours, as in his *Bar at the Folies-Bergère* (1881) in the Courtauld Institute Galleries, London. He was also a fine graphic artist, his favourite materials being coloured *crayons* and pastels, which he used mainly for portrait sketches of remarkable freshness.

Edgar Degas (Paris 1834–1917). Brought up in wealthy bourgeois surroundings, Degas adopted the avant-garde Impressionist style. He concentrated on indoor scenes, however, especially scenes of theatre life, in which he sought to express movement and light in the same terms as the devotees of '*plein air*'. Degas was an outstanding draughtsman, using the graphic medium a great deal in his efforts to explore movement and the effect of light on the human body. In carrying out his investigations into the techniques involved in using such materials as soft pencils, pastels and *crayons*, he made numerous drawings of ballet dancers and nudes, as well as producing several portraits.

Pierre-Auguste Renoir (Limoges 1841–Cagnes-sur-Mer 1919). Inspired by the work of Gustave Courbet and Edouard Manet, Renoir allied himself to the Impressionist group. His main interest was in studying the effects of natural light '*en plein air*' on the human form. To this end, graphic techniques were very important to him and pastels were his favourite material, as they offered him a poetic alternative to painting on canvas.

Paul Cézanne (Aix-en-Provence 1839–1906). Despite his academic education, Cézanne soon shed its influence to join the Impressionist group. An innovator at heart, it was not long before he was substituting for the '*plein air*' theory a more calculated view of Nature which seemed as though he were trying to delve into its internal geometry. A tireless draughtsman, he would draw the same scene over and over again – his *Mt Sainte Victoire* is a case in point – in his efforts to capture all its plastic and chromatic qualities. He thus anticipated the Cubists' approach to the reality of Nature, which before long was to be consciously carried on by Georges Braque and Pablo Picasso.

James Abbott McNeill Whistler (Lowell, Mass. 1834–London 1903). Having left America for Europe when he was twenty-one, Whistler spent most of his life between Paris and London. In Paris he was fascinated by the poetry of the Impressionists' tenet of '*plein air*', and later by the symbolic stylization of such Japanese artists as Katsushika Hokusai and Andō Hiroshige. Whistler was a fine etcher who left many drawings executed in a thread-like and evocative line.

Giuseppe de Nittis (Barletta 1846–Saint Germain-en-Laye 1884). De Nittis began his training as a painter when he was already twenty-one years old, as a result of coming into contact with the '*Macchiaiolo*' group in Florence. Very soon he moved to Paris, where, apart from some brief visits to Italy and London, he was to spend most of his life. Having taken part in the first Impressionist exhibition in Nadar's studio in 1874, he was caught up in the most vital movement ever to have emerged in French painting. He adopted the '*plein air*' technique of Monet, but without completely abandoning a certain innate corporeity in his pictorial material, as can be seen in his *Bois de Boulogne* in the Museo Nazionale di Capodimonte, Naples. It is in his graphic work rather than in his

painting that the Tuscan influence on de Nittis' *Tachism*, or 'blob' technique, is most evident.

Federico Zandomeneghi (Venice 1841–Paris 1917). Having been involved with Garibaldi's bid to unify Italy in 1860, Zandomeneghi began his artistic career by producing works with a popular message. By then he was in Florence, working with the '*Macchiaioli*' group, but after a few years he moved permanently to Paris, where he joined the Impressionists. His graphic work is notably similar to that of Degas and Renoir.

Odilon Redon (Bordeaux 1840–Paris 1916). Until 1890, Redon worked solely in the graphic media of drawings and lithographs, depicting images conjured up from the weird world of his imagination. Subsequently, however, he produced paintings with a symbolic, often almost surrealistic, character.

Georges Seurat (Paris 1859–91). Seurat made his début in Paris at the Salon des Artistes Indépendants in 1884, with his *Bathers at Asnières*, a painting from which it was plain that he was a supporter of a Divisionist technique, based on the most up-to-date theories of the breakdown of light and shadow into complementary colours. It was followed in 1886 by *Sunday on the Island of La Grande Jatte*, which he had prepared with a number of graphic studies from life. With this painting Seurat established an important position for himself in the history of art – as the term 'Neo-Impressionism' coined to describe his own work and that of his followers recognizes – standing at the threshold of Art Nouveau and the Symbolism of Paul Gauguin and Vincent van Gogh.

Auguste Rodin (Paris 1840–Meudon 1917). Having been deeply impressed by the work of Michelangelo while on a tour of Italy in 1875, Rodin developed a style of sculpturing in which the conceptions of light, as interpreted by the Impressionists, contributed to the creation of a dynamic animation. Undoubtedly the most celebrated sculptor of his time, his studio in Paris – now the Musée Rodin – was renowned throughout Europe. Although his production was perhaps excessive, there is a primitive force in the sculpture of Rodin that is undeniable. It can be seen, too, in the many drawings he made while preparing to work on a new sculpture; as he studied his models, he would draw them from life before translating the results into three-dimensional forms.

Paul Gauguin (Paris 1848–Hiva-Oa, Marquesas Islands 1903). Having spent most of his childhood in South America, Gauguin went to sea for six years as a deck-hand. After wandering the world in this way, he settled in Paris, where he worked as a stockbroker for twelve years. He then spent some years in Brittany, but his wanderlust was too strong: leaving his family behind, he went on his travels again, spending several years in Tahiti. His painting, which has a very literary flavour, always showed a tendency towards Symbolism, although he was well aware of the trends and achievements of the major contemporary French artists. Gauguin was a prolific engraver, using a combination of woodcut and white-line work. In his use of the graphic medium he tended towards a strong emphasis of the linear quality which is not only typical of Japanese draughtsmanship but comes close to the style of Art Nouveau and subsequently to that of the Fauves.

Vincent van Gogh (Groot Zundert 1853–Auvers-sur-Oise 1890). The son of a Protestant Dutch pastor, van Gogh's first experiences as a draughtsman came while he was living a life of hardship as a missionary among the miners of the Borinage in Belgium, having tried in vain to find employment that would allow him to live in Paris. Deciding to become a painter, in 1880 he moved to Brussels, and spent a happily creative season in Nuenen, after serious family trouble that had upset his already weak mental stamina. In 1886 he was in Paris, where he came into contact with members of the Impressionist movement, before settling down in Arles. Here he produced several masterpieces, including his *Self-Portrait*, painted in May 1890, and now in the Louvre. He was by this time in a special nursing home at Auvers-sur-Oise, following a series of breakdowns, and on 27 July, tragically, he took his own life. Van Gogh, who left more than eight hundred drawings and engravings, invariably accentuated the graphic character of his work and was clearly aware of the various implications of Symbolism and Art Nouveau.

Henri Marie Raymond de Toulouse-Lautrec (Albi 1864–Malromé 1901). As a consequence of a childhood accident, one of Toulouse-Lautrec's legs was semi-paralyzed and so, prevented from running about with other children, he started to draw when still very young. His favourite artist was Degas, whose work he used as a model, and he also admired the linear rhythms of Japanese prints. He lived in a Bohemian atmosphere in Montmartre, which he portrayed in all its aspects in drawings and lithographs as well as paintings. His theatre and cabaret posters were – and still are – famous and have immortalized many figures who played a part in the gay Parisian life.

Ferdinand Hodler (Berne 1853–1918). Although influenced by Impressionism in his earliest work, Hodler soon changed his style to the more consciously decorative *Jugendstil*, the German term for Art Nouveau, both in his painting and drawing, characterized by a fusion of the linear and the monumental.

Aubrey Beardsley (Brighton 1872–Mentone 1898). Having formed his style under strong Pre-Raphaelite influences, Beardsley devoted his graphic skill mainly to illustrations for great magazines such as *The Studio* and for books such as Oscar Wilde's *Salome*. His drawings and engravings, which were sometimes quite emancipated in their sensuality, are drawn with a thread-like, elegantly flowing line, with stunning calligraphic effects in the Art Nouveau manner.

Georges Barbier (Paris 1895–1935). A designer of theatrical costumes, Georges Barbier was best known in the 1920s, still in the grip of Art Nouveau. He designed costumes mainly for members of Diaghilev's Russian Ballet in Paris.

Gustav Klimt (Vienna 1862–1918). A devotee of decorative and applied art since boyhood, his linear and essentially decorative style indicates the use of exceptionally skilful techniques, with precious materials over the surfaces. In 1898 Klimt helped to found the Viennese *Sezession* movement, an offshoot of Art Nouveau whose aim was to break away from the established academic bodies and encourage new artistic trends. A fine illustrator, Klimt was also able to express his artistic talents in the graphic field in xylography (white-line wood-engraving) and lithography.

Claude Monet (Paris 1840–Giverny 1926)
The Church at Varengeville
Black *crayon*; $12\frac{5}{8} \times 16\frac{1}{2}$ in. (320 × 420 mm.)
Paris, private collection

In 1882 Monet portrayed the church at
Varengeville in a picture for the Smith
Collection in Houston, Texas, subsequently
using the same subject in two other versions.
The drawing reproduced here is the
preliminary study for one of these, identified
by the two trees in the foreground. This is
one of only a few drawings by this artist, its
fluent use of *crayon* linking the style with a
traditional technique that is still reminiscent
of the eighteenth century. The modern
Impressionist can certainly be detected,
though, in the flashes of white that give the
effect of light fragmented into dazzling
patches of iridescence.
Bibliography: Huyghe-Jaccottet, 1956, no.
107

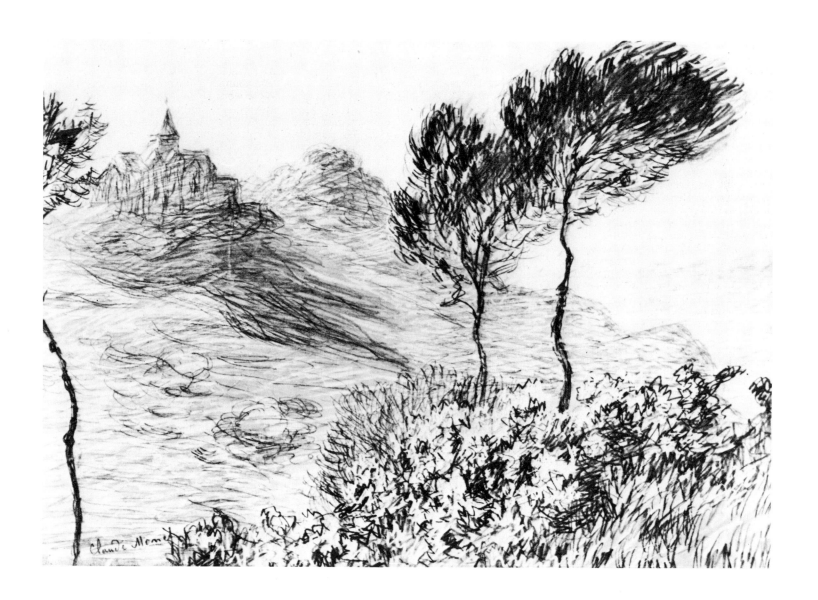

Claude Monet
Fishermen in Two Boats
Black *crayon*; 10 × 13½ in. (256 × 344 mm.)
Provenance: Sachs
Cambridge, Mass., Fogg Art Museum,
Harvard University, Meta and Paul J. Sachs
Bequest, inv. 1965.312

This is one of Monet's rare drawings; it is
signed 'Claude Monet' and relates to a
picture dated 1882 called *Fishermen on the
Seine at Poissy*, now in the Belvedere in
Vienna. By using a special technical device,
in the form of a graphic (or Hebraic) granite
tablet, the artist has succeeded in bringing
out the luminous vibration of the reflections
on the water which, although characteristic
of his paintings, is an even greater
achievement in black and white.
Bibliography: Mongan, 1949, p. 182;
Moskowitz, 1963, no. 874

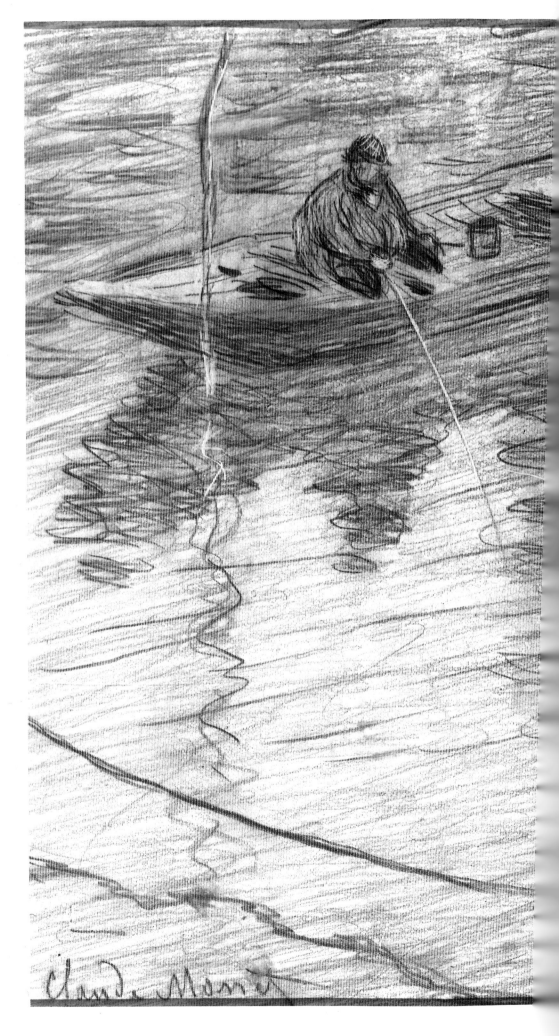

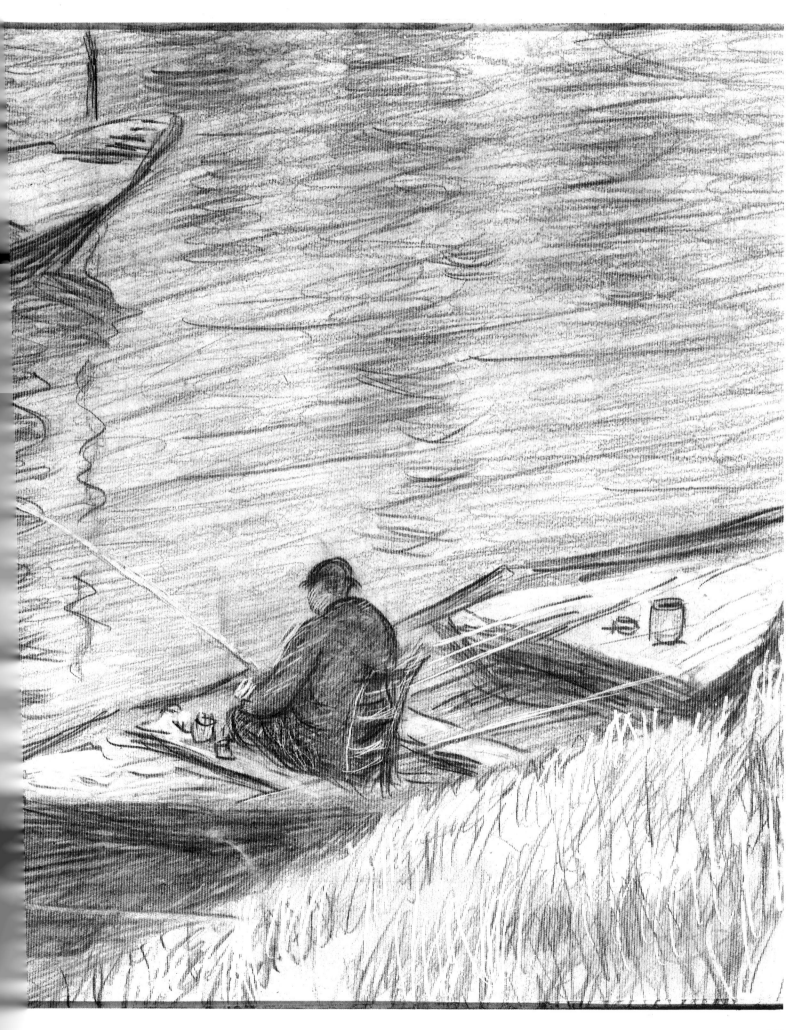

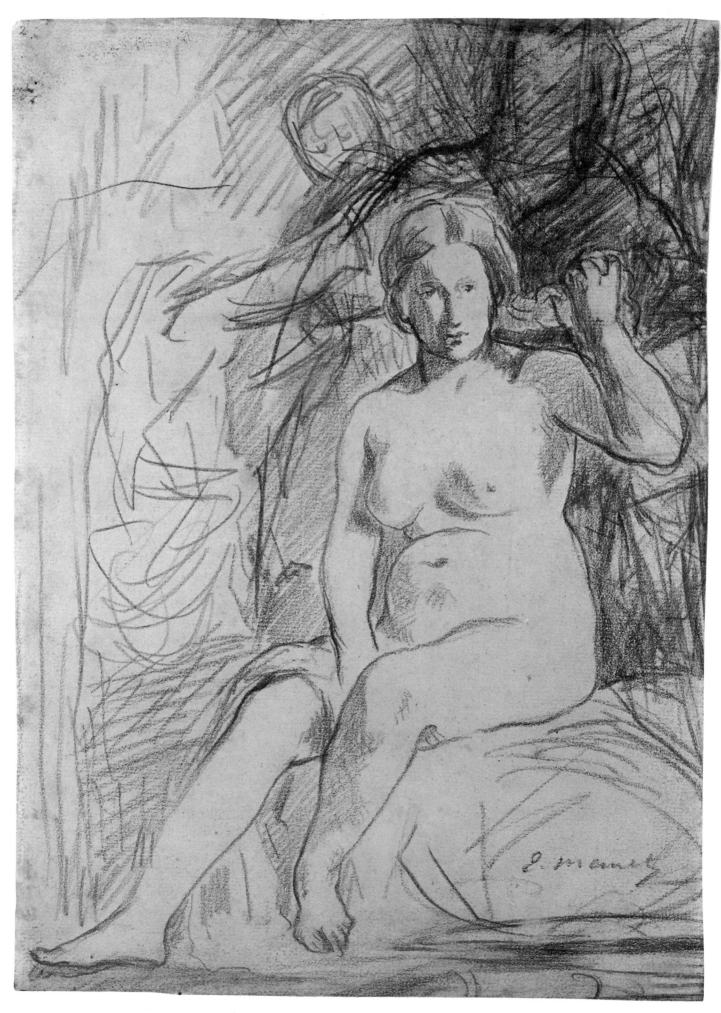

324

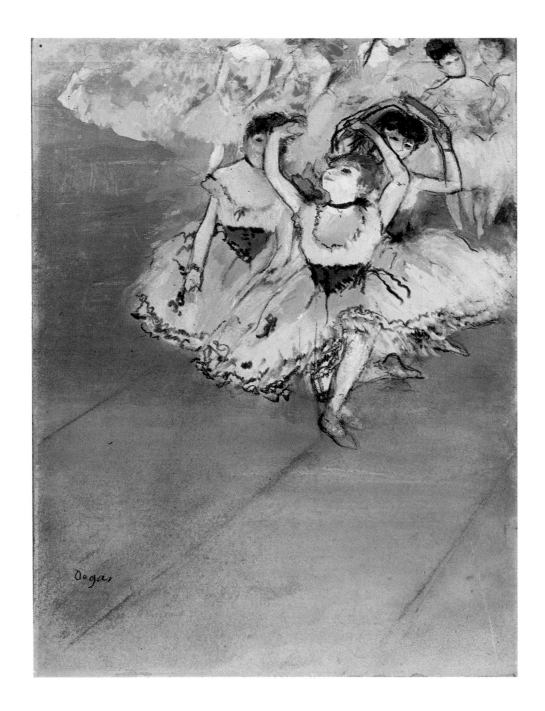

Edouard Manet (Paris 1832–83)
Seated Nude Woman
Sanguine on ivory paper; $11 \times 7\frac{7}{8}$ in.
$(280 \times 200 \text{ mm.})$
Provenance: Pellerin; Guérin; Indig-Guérin;
Wildenstein
Chicago, Art Institute of Chicago, Helen
Regenstein Collection, inv. 1967.30

Manet's links with tradition are especially
apparent in his drawings, as here, where the
influence of Rembrandt's graphic work can
clearly be seen. The plastic modelling of the
nude, which is stylistically akin to the artist's
1862 etchings, seems to absorb the effects of
the light through the way in which the pale
as well as the mellow tones of the sanguine
have been used.
Bibliography: de Leiris, 1969, no. 186;
Joachim, 1974, no. 73

Edgar Degas (Paris 1834–1917)
Ballerinas
Black *crayon*, pastel and tempera (?) over
pencil; $8\frac{3}{4} \times 6\frac{1}{2}$ in. $(223 \times 167 \text{ mm.})$
Provenance: Marx; Kélékian; Genthe;
Carstairs; Hanna
Cincinnati, Art Museum, Gift of Mary
Hanna, inv. 1946.105

The ballet appears constantly in Degas'
work from 1872; he used the setting as a
starting-point for some formal research into
finding a way to achieve a balance between
the luminous chromatic effects of an
Impressionist painting and the French
representational tradition. In this sheet,
which is signed 'Degas' and is datable to
around 1879, the artist has extended his
experiment into a technical area by
superimposing tempera and pastel.
Bibliography: Browse, 1949, no. 135;
Dwight, 1952, pp. 8–11; Spangenberg, 1978,
no. 38

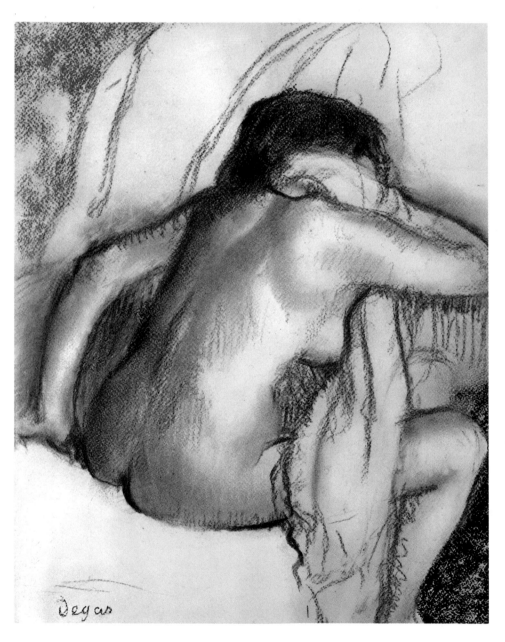

Edgar Degas
After the Bath
Charcoal and pastel; $17\frac{1}{8} \times 13$ in.
(435×332 mm.)
Provenance: Sachs
Cambridge, Mass., Fogg Art Museum,
Harvard University, Meta and Paul J. Sachs
Bequest, inv. 1965.259

The extreme linear simplification of this
female nude has produced a drawing that is
almost a pure example of a study in
chromatic values. The artist has gone over
the basic charcoal lines in flowing brown,
red, green and azure pastel strokes which
imbue the figure with a strong sense of
plasticity and volume.
Bibliography: Pečirka, 1963, pl. 59

Pierre-Auguste Renoir
(Limoges 1841–Cagnes-sur-Mer 1919)
Study for 'The Bathers'
Pencil, sanguine, black and white chalks
retouched with brush on ochre paper;
$38\frac{7}{8} \times 25\frac{1}{4}$ in. (985×640 mm.)
Provenance: Hébrard; Brewster
Chicago, Art Institute, Kate L. Brewster
Bequest, inv. 1949.514

This drawing is one of many preliminary
sketches for one of the most famous of
Renoir's paintings, *Les Grandes Baigneuses*
(Carrol S. Tyson Collection, Philadelphia),
which he completed in 1885. The artist seems
still to have been influenced by the elegance
of Ingres, as is apparent here in the linearity
of the figure, although this does not prevent
the colour from vibrating freely in the
atmosphere.
Bibliography: Rewald, 1946, no. 41;
Joachim, 1963, no. 113

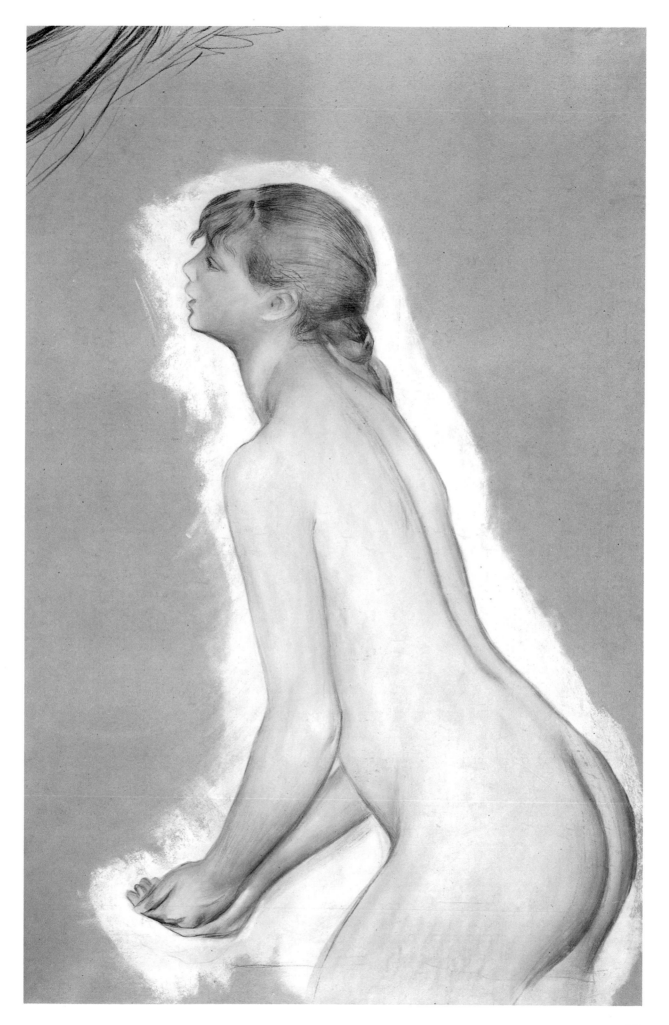

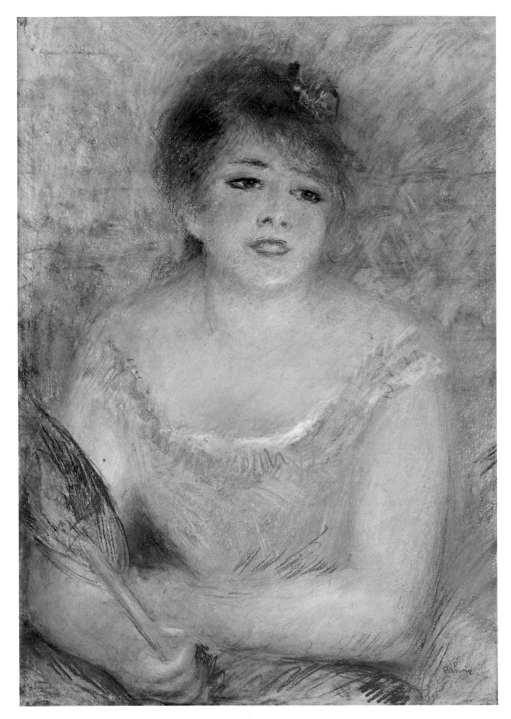

Paul Cézanne (Aix-en-Provence 1839–1906)
Female Nude, Figure and Self-Portrait
Black chalk and pencil on white paper;
$19\frac{5}{8} \times 12\frac{5}{8}$ in. (498 × 322 mm.)
Rotterdam, Museum Boymans-van
Beuningen, inv. F-II-122

The formal precision of Cézanne's work is
expressed even in these drawings, in which
the artist has built up the forms with
detached, confident strokes while keeping
only to the essential lines. The sheet as a
whole includes a number of studies, amongst
which is a copy made by Cézanne in the
Louvre of the sculpture *Psyche abandoned*,
by Augustin Pajou. Judging by the *Self-
Portrait*, it is datable to about 1879-82; it is
a fine likeness and closely resembles Renoir's
pastel portrait of Cézanne made in 1880.
Bibliography: Venturi, 1936, no. 1479;
Bouchot Saupique, 1952–53, no. 163

Pierre-Auguste Renoir
Mademoiselle Jeanne Samary
Pastel on paper; $27\frac{1}{2} \times 18\frac{3}{4}$ in.
(697 × 477 mm.)
Provenance: Chavasse; Mayer; Gold
Gallery; Reid and Lefèvre; Knoedler;
Hanna
Cincinnati, Art Museum, Mary Hanna
Bequest, inv. 1946.107

In his pastels as in his paintings, Renoir's
first concern seems to have been to represent
the effects of light in his impressionistic style
and knowledgeable handling of
complementary tones. In this portrait of
Jeanne Samary, the young Comédie
Française actress who modelled for him so
often between 1877 and 1880, the artist
reveals the secret of the framework on which
his figure drawing was built, which goes
right back to Titian and the other great
sixteenth-century Venetian painters.
Bibliography: Meier-Graeffe, 1929, p. 108;
Spangenberg, 1978, no. 106

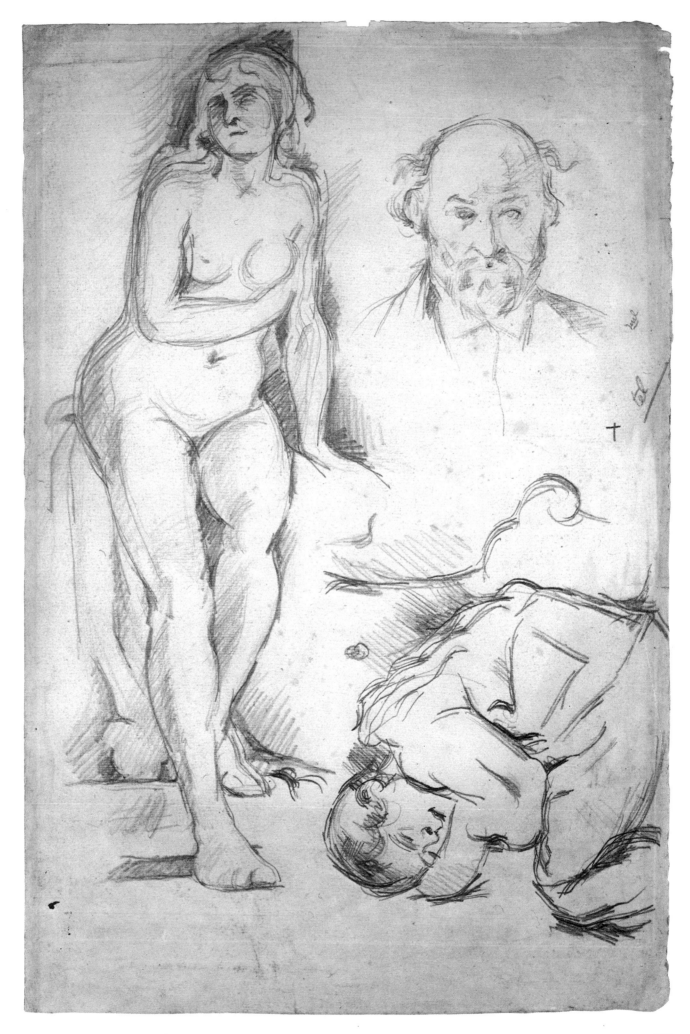

329

Paul Cézanne
Black Château
Pencil and watercolour; $14\frac{1}{8} \times 20\frac{7}{8}$ in.
(360 × 528 mm.)
Provenance: Cassirer; Koenigs; entered in
1930
Rotterdam, Museum Boymans-van
Beuningen, inv. F-II-212

In his landscapes, in which the artist often
repeats the same themes – as this one of the
Black Château – Cézanne often under-plays
the shapes, merely indicating their presence
with a subtle hatching in pencil and a few
brushfuls of discreetly placed watercolour.
In contrast with the Impressionists, he does
not delve into the colouristic effects of light
but creates space and volume with it.
Bibliography: Venturi, 1936, no. 1034;
Haverkamp Begemann, 1957, no. 82

James Abbott McNeill Whistler
(Lowell, Mass. 1834–London 1903)
Woman Reading
Charcoal and white chalk on brown paper;
$6\frac{5}{8} \times 5$ in. (168 × 127 mm.)
Washington, DC, Freer Gallery of Art,
Smithsonian Institution, inv. 05.145

The masterly handling of charcoal, recalling
the flowing lines of Degas, creates an
impressive effect of artificial light
surrounding the woman who reads with such
concentration. American by birth, Whistler
lived in both Paris and London while
developing – under the influence of the
recently arrived Japanese prints – a language
that presaged the arrival of the decorative
linearity to be known as Art Nouveau.
Bibliography: Moskowitz, 1963, no. 1041

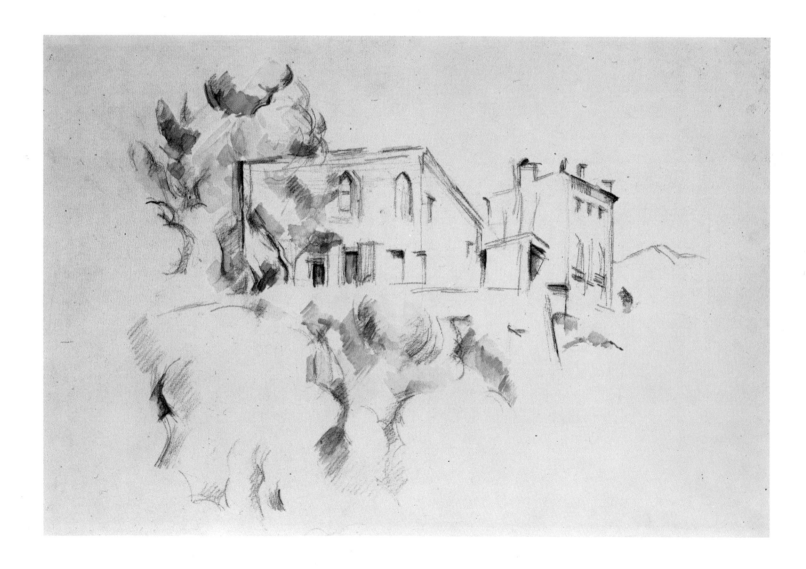

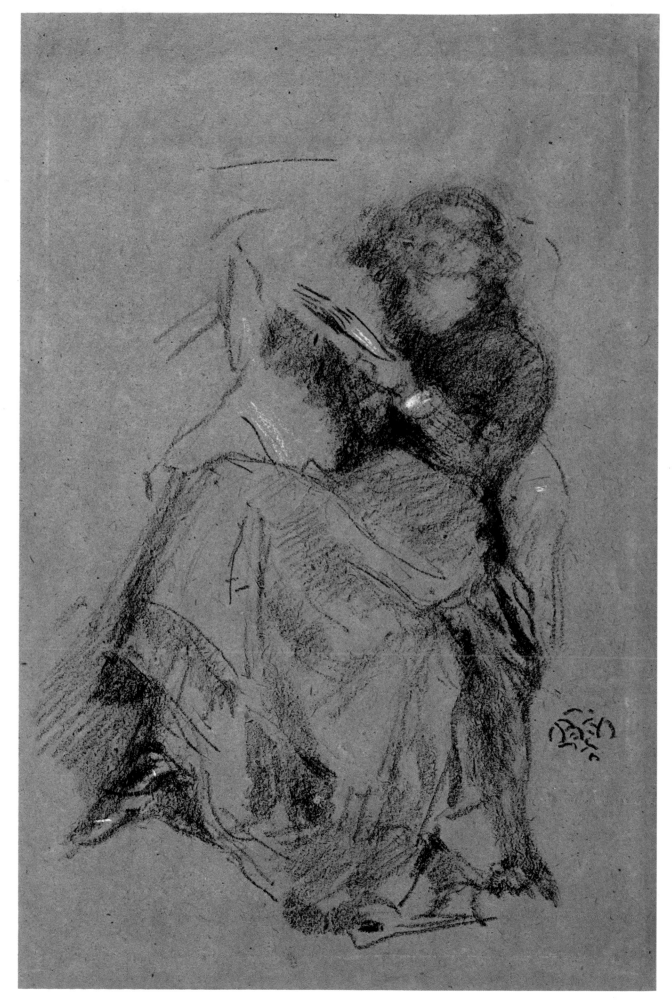

Giuseppe de Nittis
(Barletta 1846–St Germain-en-Laye 1884)
Poplars in Water
Indian ink and watercolour on yellowed
white card; $12\frac{7}{8} \times 9\frac{7}{8}$ in. (326 × 251 mm.)
Provenance: Martelli
Florence, Uffizi Gallery, inv. 599 G.A.M.

An accentuated graphic linearity
characterizes this sheet, datable to 1878
when the artist was friendly with Martelli in
Paris the drawing bears the dedication
'all'amico Diego – De Nittis' ('to my friend
Diego – De Nittis'). This type of
watercolour, obviously inspired by the
elegant stylization of Japanese prints,
probably represents the most worthwhile
aspect of this painter's work.
Bibliography: C. del Bravo, 1971, no. 126

Federico Zandomeneghi
(Venice 1841–Paris 1917)
The Leg-of-Mutton Sleeve
Pastel; $15\frac{3}{4} \times 19\frac{3}{4}$ in. (400 × 500 mm.)
Milan, private collection

In this delicate pastel drawing, which
belongs to Zandomeneghi's more mature
period, the artist's handling of the chromatic
vibrations developed in the azure tones is
quite remarkable. From 1874 he worked for
more than forty years in Paris. Here he came
under the influence of the Impressionists,
having formed a friendship with both Renoir
and Degas, which had a determining effect
on his artistic development as a painter.
Bibliography: Cinotti, 1960, pl. XI

Odilon Redon
(Bordeaux 1840–Paris 1916)
The Spider
Charcoal on yellow paper; 19½ × 15⅜ in.
(495 × 390 mm.)
Paris, Musée National du Louvre, inv. 29932

Fundamental to Redon's work is his
absolutely personal language and, until 1890,
total rejection of colour. In his lithographs
as well as in his black and white drawings –
such as this monstrous spider with the
humanoid leer brought out by Redon as a
print in 1887 – he developed an art of such
imaginative, symbolic quality that entitles
him to be regarded as a precursor of
Surrealism.
Bibliography: Bouchot Saupique, 1952–3,
no. 170

Georges Seurat
(Paris 1859–91)
Profile of a Woman
Conté crayon on ivory paper; 18⅞ × 12⅜ in.
(479 × 314 mm.)
Provenance: Davies; Rockefeller
New York, Museum of Modern Art, Abby
Aldrich Rockefeller Bequest

This study relates to the female figure that
appears in the centre of *Sunday on the Island
of La Grande Jatte* – now in the Art
Institute, Chicago – which was the second of
the large works designed by Seurat between
1884 and 1886 to demonstrate his theories of
complementary colours and static qualities.
The rigorous *pointilliste* technique that was
to be applied to the painting seems almost to
have been anticipated by the unusual graphic
effect produced by the Conté crayon on the
textured paper.
Bibliography: Rich, 1935, no. 3; Dorra-
Rewald, 1959, no. 138

Auguste Rodin
(Paris 1840–Meudon 1917)
Female Nude
Pencil and watercolour; 16 × 12 in.
(404 × 306 mm.)
Chicago, Art Institute of Chicago, Alfred
Stieglitz Collection, inv. 49.900

It is easy to see this is the drawing of a
sculptor because of the overriding
concentration on the plastic and volumetric
values of the female figure. This
characteristic is further stressed by the
contrast between the flat way in which the
watercolour has been applied and the light
pencil strokes that indicate the gauzy nature
of the background drapery.
Bibliography: Mendelowitz, 1967, p. 414

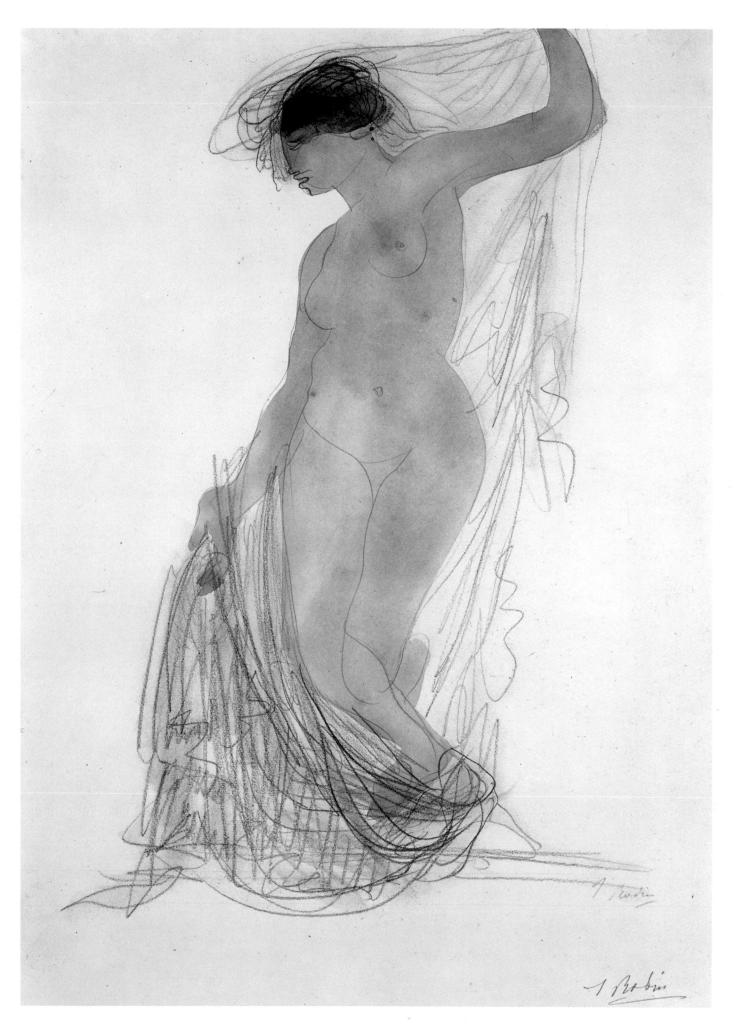

Paul Gauguin
(Paris 1848–Marquesas Islands 1903)
Nave Nave Fenua
Brush with black ink and watercolour;
$16\frac{1}{2} \times 10\frac{1}{4}$ in. (419 × 260 mm.)
Provenance: Rosenwald
Washington, DC, National Gallery of Art,
Rosenwald Collection, inv. B-14, 393

This watercolour relates to Gauguin's
Tahitian experience and was painted
between his first return to Paris in 1893 and
his second – and final – departure for the
island two years later. The inscription, *'pas
écouter li li menteur'* ('Do not listen to the
liar'), suggests the meaning implied in the
composition. The influence of the indigenous
art in the South Sea Islands, which Gauguin
interpreted and modified in the light of his
own European culture, was the determining
factor in his work.
Bibliography: Robison, 1978, no. 105

Paul Gauguin
Portrait of a Young Breton Peasant Girl
Pencil, black and red *crayon*, black
watercolour; $8\frac{7}{8} \times 13\frac{1}{2}$ in. (224 × 344 mm.)
Provenance: Vignier; Sachs
Cambridge, Mass., Fogg Art Museum,
Harvard University, Meta and Paul J. Sachs
Bequest, inv. 1965.283

The date of this sheet is uncertain but it
must be between 1889 – when Gauguin,
escaping from Paris, sought refuge in
Brittany in order to paint – and 1895, when
the artist left France for ever. The simple but
clear-cut expressiveness of the girl,
emphasized by the contrasting flat colours
used so uniformly, make this one of
Gauguin's most moving drawings.
Bibliography: Mongan-Sachs, 1946, no. 690;
Rewald, 1958, no. 14; Leymarie, 1960, no. 27

Vincent van Gogh
(Groot Zundert 1853–Auvers-sur-l'Oise
1890)
Canal with Washerwomen
Pen and ink; $12\frac{1}{2} \times 9\frac{1}{2}$ in. (315 × 240 mm.)
Otterlo, Kröller-Müller State Museum

This emblematic drawing, dated 1888, is
characterized by its Neo-Impressionist style.
The lively brushwork, so rich in light and
colour, which was typical of van Gogh's
paintings at the end of his Parisian period
and in the early phase of his stay in Arles, in
the French Midi, seems to find new life in
these well-defined ink lines drawn with a
reed pen.
Bibliography: de la Faille, 1970, no. 1444;
Liebermann, 1973, no. 32; Hulsker, 1980,
no. 1507

Vincent van Gogh
The Girl with the Ruffled Hair
Black chalk and brush with grey and white
watercolour; $17\frac{1}{8} \times 9\frac{7}{8}$ in. (435 × 250 mm.)
Provenance: van Gogh; Kröller-Müller
Otterlo, Kröller-Müller State Museum

Van Gogh's existential anxiety finds
expression in this portrait of a young girl,
who was probably a daughter of Sien, the
prostitute who was befriended by the artist
about 1882. This black and white technique,
which tends to produce painterly effects, was
just a part of the experimentation he was
carrying out at that time.
Bibliography: Regteren Altena, 1958, no.
143; de la Faille, 1970, no. 1007; Hulsker,
1980, no. 299

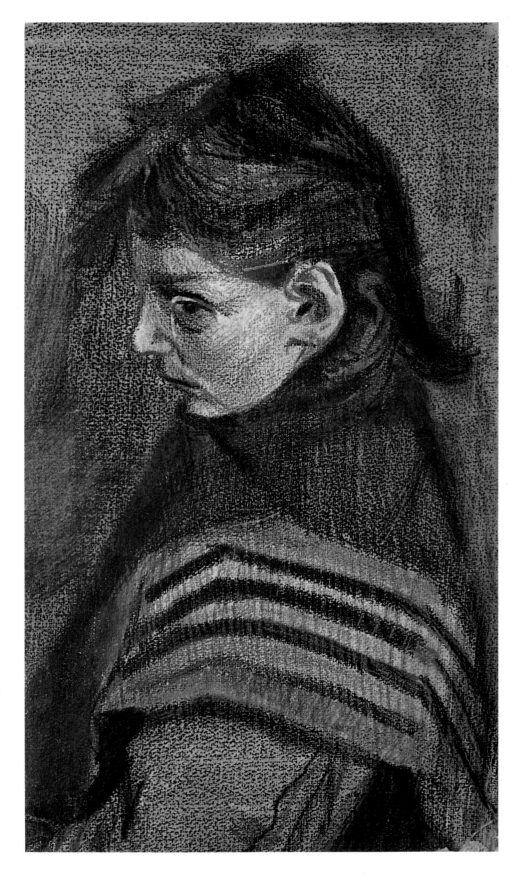

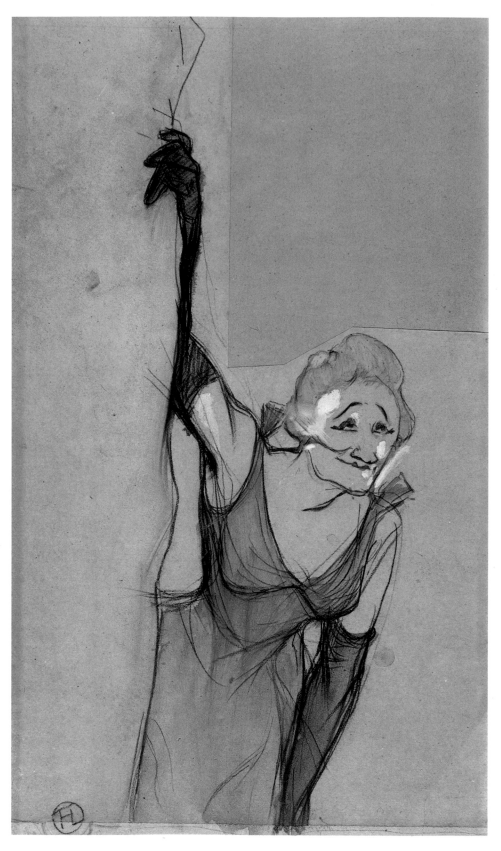

Henri de Toulouse-Lautrec
(Albi 1864–Malromé 1901)
Yvette Guilbert Takes a Curtain Call
Pastel and watercolour; $16\frac{3}{8} \times 9$ in.
(416 × 229 mm.)
Providence, Rhode Island, Rhode Island
School of Design, Gift of Mrs Murray S.
Danforth, inv. 35.540

In 1894 Toulouse-Lautrec made an album of
lithographs for Yvette Guilbert, one of the
védettes (star performers) of the Tout-Paris.
The singer is portrayed in a number of
studies which, whilst emphasizing her
vivacious, witty personality, portrayed her
eccentric appearance in such a veristic way
as to cause some embarrassment among her
friends. This particular study, in which the
pastel lines encroach unashamedly on the
areas of colour, was executed in preparation
for a painting now hanging in the Musée
Albi which is one of the artist's most
important late works.
Bibliography: Mack, 1938, fig. 27;
Moskowitz, 1963, no. 910

Henri de Toulouse-Lautrec
Mademoiselle Cocyte
Pencil and sanguine heightened with white;
$13\frac{3}{4} \times 10$ in. (350 × 255 mm.)
Provenance: Heim; Blot: Bergaud; Duhem
Chicago, Art Institute of Chicago, Joseph
and Helen Regenstein Collection,
inv. 1965.14

The world of the cabaret, with its wide
variety of characters – often portrayed with
pitiless verism in all their squalor and
vulgarity – typifies most of the work of
Toulouse-Lautrec. This sketch was made
towards the end of his life when he was in
Bordeaux; with only a few lines in pencil
and sanguine, the artist has achieved a
strongly expressive portrait, in a well-
balanced, formal stylization.
Bibliography: Dortou, 1971, no. D4 642;
Joachim, 1974, no. 77

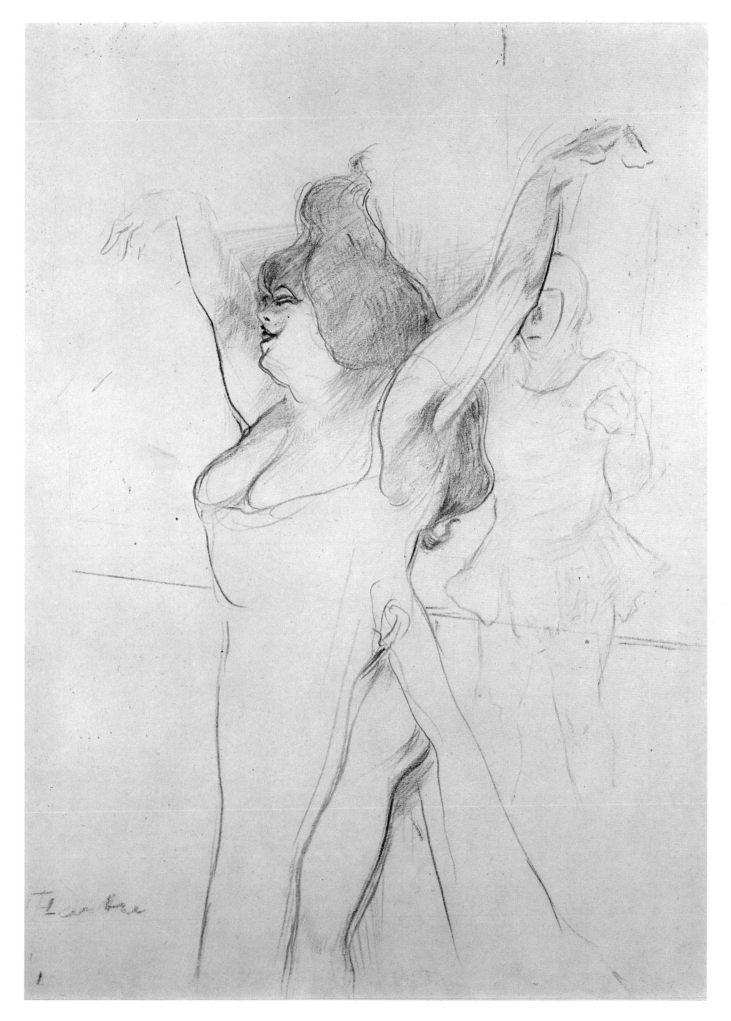

341

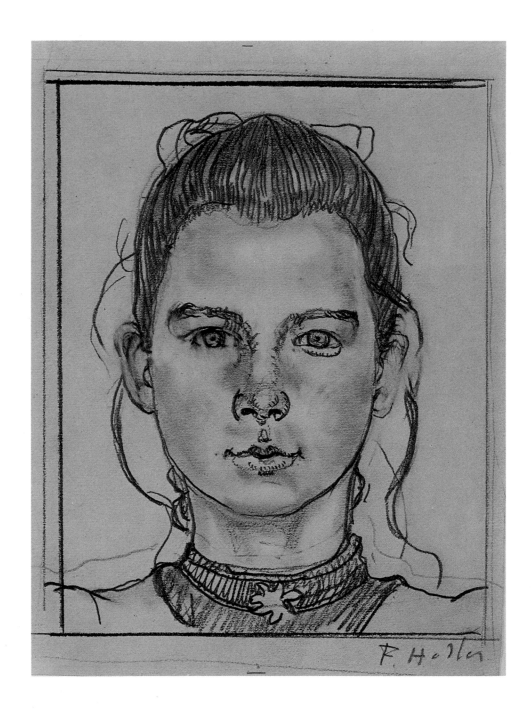

Ferdinand Hodler
(Berne 1853–Geneva 1918)
Portrait of a Young Girl
Pencil – *sfumato*; $7\frac{7}{8} \times 6\frac{1}{8}$ in. (199 × 155 mm.)
Basle, Oeffentliche Kunstsammlung,
inv. 1926.56

In the vast graphic output of Ferdinand
Hodler, one cannot but be aware of the
complexity of its development. Styles range
from Impressionism to Symbolism, finally
crystallizing into the forms of Art Nouveau.
This portrait, signed and dated 1910, is
characterized by a particularly firm yet
plastic pencil line.
Bibliography: Hugelshofer, 1967, no. 100

Aubrey Beardsley
(Brighton 1872–Mentone 1898)
'J'ai baisé ta bouche' (*'I kissed your mouth'*)
Pen and ink; $10\frac{7}{8} \times 5\frac{3}{4}$ in. (276 × 146 mm.)
Princeton, NJ, University Library, Gallatin
Beardsley Collection

The Pre-Raphaelite style and a great
admiration for Japanese prints are the basic
components of Beardsley's elegant Art
Nouveau linearity. The pen-and-ink
draughtsmanship is stylized, clear-cut and
entirely without chiaroscuro. This drawing
was probably the deciding factor in the
decision to commission Beardsley to
illustrate Oscar Wilde's *Salome* in 1894 – a
partnership which resulted in an unusually
close relationship between illustrations and
text for a modern book.
Bibliography: [Marillier], 1899, ed. 1967, pl.
64

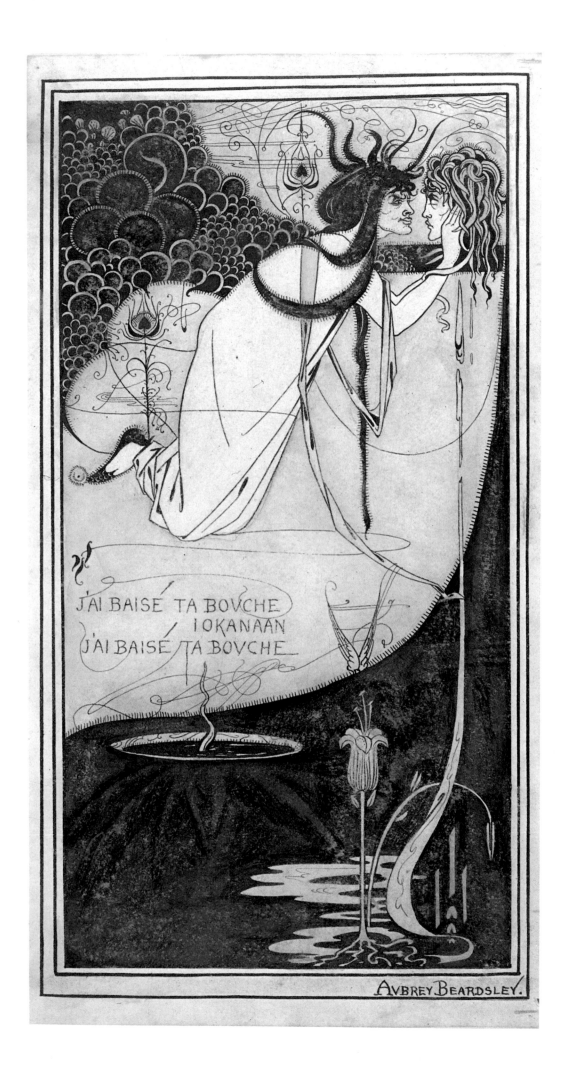

J'AI BAISÉ TA BOVCHE
IOKANAAN
J'AI BAISÉ TA BOVCHE

AVBREY BEARDSLEY.

Georges Barbier (Nantes 1882–?1932)
Le Tapis Persan (The Persian Carpet)
Gouache, gold and silver over pencil;
$12\frac{1}{4} \times 10$ in. (311 × 254 mm.)
Provenance: Wildenstein
Cincinnati, Art Museum, inv. 1921.190

This drawing relates to the studies executed
by Barbier in 1920 for the costumes and
stage designs for the ballet *Le Tapis Persan*
by Jean Nouguès. Decorative linearity
blends with a stylized Persian motif in an
exquisite formal balance worthy of a
technique that used not only gouache but
also touches of gold and silver to make the
costumes for the two leading dancers more
impressive.
Bibliography: Flamant, 1924, pp. 180–1;
Spangenberg, 1978, no. 11

Gustav Klimt (Vienna 1862–1918)
Profile of a Woman Reading
Pencil; $21\frac{1}{2} \times 12\frac{5}{8}$ in. (545 × 322 mm.)
Vienna, Graphische Sammlung Albertina,
inv. 23.541

This drawing is probably datable to about
1911, when Klimt was working on the frieze
for the Palais Stoclet in Brussels (1909–11).
The elongated, sinuous figures, the taste for
decorative and symbolic features – mainly
identifiable in the spiral motifs derived from
Byzantine mosaic art – as well as a marked
tendency to two-dimensionality constitute
the more typical characteristics of this
stylistic phase.
Bibliography: Breicha, 1978, no. 152

From Cubism to the Present Day

Henri Matisse (La Cateau 1869–Cimiez 1954). Matisse began to draw with coloured *crayons* during a period of convalescence when he was twenty-one. As a result, he went to work in the artist's quarter of Paris, where he came into contact with Auguste Rodin, Camille Pissarro and Paul Signac. In 1905 he became one of the founders of the group that became known as '*Les Fauves*' ('the Wild Beasts'), of which he came to be the leader. At the age of about forty Matisse retired to the French Riviera, where he produced some of his most joyful pictures, including the decoration of the chapel of the Dominican convent at Vence in 1951. His work, during this latter period especially, has a luminous quality and is rich in brilliant and pure colours. His drawings, which are often coloured, display great strength in their formal composition, presenting a valid alternative to Cubism in their vitality.

Georges Braque (Argenteuil 1882–Paris 1963). In Paris from 1900 onwards, Braque started following the Impressionists and the Fauves. Soon, however, he was developing the ideas of Cézanne and from 1908 beginning to devise the poetical basis of Cubism with his friend, Pablo Picasso. His favourite themes were still-lifes of musical instruments and domestic objects, which he depicted both in paintings and in a great many drawings, often using a composite technique which incorporated collage. In his later work Braque sometimes seems to have gone beyond Cubism to achieve a more classic, restful expressiveness, occasionally verging on Abstractionism.

Pablo Picasso (Malaga 1881–Mougins 1973). The son of an art teacher, Picasso began to draw when he was very young. From Barcelona, where his family had settled, he went to Paris and Madrid, returning to Paris to live in 1901. He made the acquaintance of Henri Matisse in 1906 and about two years later got to know Georges Braque. A kind of working partnership developed between Picasso and Braque, and they produced the first Cubist works together. Up to then, that is during his Blue and Pink Periods, Picasso had painted only realistic subjects. He made use of every known technique and was at once a draughtsman, engraver, sculptor, painter and potter. His life was one of inexhaustible activity, enriched by his constant seeking after new ways of dealing with shapes. During the Spanish Civil War,

Picasso became politically involved in the struggle against Francoism and painted his famous *Guernica*, for which he prepared a great many graphic studies. His sensitive illustrations of modern poetry consist of engravings and drawings that clearly demonstrate his masterly handling of line, which, although fine, is full of vibrant vitality.

Fernand Léger (Argentan 1881–Paris 1955). Léger's first important artistic experience was in the realms of Cubism, in which he made a particularly dynamic impact with his geometric composition and de-composition of the image. He frequently used themes relating to the industrial and mechanical aspects of modern life to great effect.

Amedeo Modigliani (Leghorn 1885–Paris 1920). At the age of twenty-one Modigliani moved to Paris, where he remained, apart from a few brief periods, for the rest of his life. From 1909 onwards he seems to have become totally immersed in negro sculpture, the influence of which is particularly apparent in his drawings and three-dimensional work. He neglected his painting almost entirely, especially portraiture, until an art dealer named Zborowski persuaded him to return to his brushes and canvases. Within a few years Modigliani had produced hundreds of paintings which have a distinctive linear style with a profound rhythmic quality.

Kasimir Malevich (Kiev 1878–Leningrad 1935). From 1907 to 1912 Malevich was inspired in his painting by a Russian Neo-Primitive style that tended to break shapes down into geometrical blocks, with a strong emphasis on colour. He then progressed through Cubism and Futurism, using typical 'trick' effects in the form of collages, superimpositions, and so on. Because of official opposition to Abstract Art, Malevich emigrated to Germany. He later returned to Russia, but in 1930 was arrested and obliged to restrict his artistic expression to the realistic forms of traditional painting.

Oskar Kokoschka (Pöchlarn 1886–Montreux 1980). Having started painting in the atmosphere of the Vienna *Sezession*, Kokoschka turned – with his contributions to Herwarth Walden's magazine *Der Sturm* – towards Expressionism and the 1911 *Blaue Reiter* movement (named after a picture of Kandinsky's, *The Blue Rider*). Kokoschka's

charcoal drawings and lithographs were intensely realistic, too, and he expressed his bitter opposition to Nazism in graphic work that was both grotesque and full of irony.

Georges Rouault (Paris 1871–1958). Rouault was attracted by the poetic approach of Gustave Moreau and developed an intensely dramatic style in which colour was laid between heavy lines, giving a nocturnal effect. From 1910 he painted subjects drawn from street life, such as prostitutes and clowns. He was also a prolific lithographer and etcher.

Carlo Carrà (Quargnento 1881–Milan 1966). A signatory of the Futurist Manifesto in 1910, and a contributor to such avant-garde journals as *La voce* and *Lacerba*, Carrà in 1916 joined Giorgio de Chirico's *Pittura metafisica* (Metaphysical Painting) movement. An example of his painting in this style is *The Engineer's Mistress* in the Mattioli Collection, Milan. In his landscapes, Carrà pursued a more classic line, with a simplification of form that is almost primitive, recalling that early period of the *Valori Plastici* (Plastic Values) movement in the tradition of Giotto and Masaccio.

Marc Chagall (Vitebsk 1887). In spite of the Cubist sympathies he acquired in Paris as a young man, Chagall soon turned to highly imaginative surrealistic forms in which he evoked his ancestral Russian culture with scenes from village life in paintings, drawings and lithographs. Although he was at first sympathetic towards the aims of the Russian Revolution, he was in 1922 obliged to emigrate and went to Paris, where he continued to paint. After some years he found himself being persecuted once again, this time by Nazism, and in 1941, at the invitation of the Museum of Modern Art in New York, went to the United States, returning to Paris in 1947. Among the large works executed in the latter part of his life are the decorations for the New York Metropolitan Opera House (1966).

Umberto Boccioni (Reggio Calabria 1882–Verona 1916). A leading figure in Italian Futurism, Boccioni studied in Rome with Giacomo Balla in the early 1900s. He then moved to Milan, where he sought to capture the life of the modern city in drawings and paintings that certainly caught its linear dynamism. He signed the Futurist Manifesto

with Filippo Marinetti in 1910 and did all he could to spread its aesthetic ideas throughout Europe.

Gino Rossi (Venice 1884–1947). In his short career, which was interrupted in 1927 by the onset of madness, Gino Rossi went through most of the phases of French Post-Impressionism. From the early 1900s onwards his work shows a resemblance to that of Gauguin and of the Nabis – a late nineteenth-century group in Brittany devoted to flat, pure colours who put great importance on subject matter. Rossi's next phase took him into Cubism, with heavy graphic constructions that recall Cézanne. Finally he was to adopt the arabesque style of Matisse's middle period, although quite unable to achieve that great artist's superb luminous quality.

Giorgio Morandi (Bologna 1890–1964). Morandi lived and worked in the most austere isolation, meditating mainly on the great Renaissance masters on whom he drew for the classical spirit that pervades his interesting still lifes. He was a draughtsman and etcher of outstanding talent whose work seems to echo that of Corot and Cézanne.

Pio Semeghini (Quistello 1878–Verona 1964). Semeghini studied and worked in Paris until 1914. Later he was to spend long periods on the island of Burano, in the Venetian lagoon, where – with Moggioli and Gino Rossi – he formed a group of artists who called themselves the *Ca' Pesaro*. Semeghini's sensitive talent for painting, expressed in a language of delicate, almost evanescent colours, often also found an outlet in coloured pencils, which he used to great effect.

Filippo Tibertelli, called De Pisis (Ferrara 1896–Milan 1956). A poet and writer, De Pisis started painting in 1944; he concentrated mostly on still lifes and landscapes. He associated himself with the various avant-garde movements in Italy, although without any real conviction, remaining faithful throughout to a poetical Post-Impressionism in which the importance of form was paramount. De Pisis lived in Paris from 1925 to 1940, moving thence to Milan and later Venice.

Alberto Viani (Quistello 1906). Viani is a sculptor of large figures positioned pictorially in space, which give the appearance of relating solely to the plastic abstractions of

Jean (Hans) Arp. In fact, Viani has preserved his Venetian roots intact in a sculptural form that never lost sight of Man's physical reality or of his life in coloured space. Viani is a fine draughtsman whose line-drawing conveys a sense of intensely meaningful plasticity, in a blending of profoundly classical rhythms.

Giacomo Manzoni, known as Manzù (Bergamo 1908). Besides being one of Italy's leading sculptors, Manzù is an excellent draughtsman and engraver, expressing himself in Post-Impressionist terms with a synthetically modern cultural outlook. A sensitive, intimate portraitist, he also devoted a great deal of time to such gigantic schemes as the doors of the cathedrals of Salzburg and Rotterdam, as well as the great bronze doors for the Basilica of St Peter in Rome.

Marino Marini (Pistoia 1901–Viareggio 1980). In his sculpture, Marini sought to achieve a synthesis between an archaic positioning of masses and a meaningful expressionistic strength. This approach is also apparent in his graphic work, with its violent linear characters. This artist's favourite theme of horse and rider lends itself to infinite variations which, on the one hand, recall the archaism of the millenary Chinese terracotta figures and, on the other, conjure up an abstract conception of form.

Paul Klee (Münchenbuchsee 1879–Muralto 1940). Initially Klee belonged to the Jugendstil movement, as it was known in Germany but which elsewhere was called Art Nouveau. He published a series of etchings and monotypes while under the influence of the Parisian Symbolists; as a result of this contact he found much in common with Wassily Kandinsky, whose theories on abstract art he absorbed and passed on to the students of the Bauhaus in Weimar, where he taught from 1920 onwards. In 1933 he returned to Switzerland in order to escape from the Nazi threat. He settled in Berne, where most of his work is now preserved.

Wassily Kandinsky (Moscow 1866–Neuilly-sur-Seine 1944). Having decided at the age of thirty to become a painter, Kandinsky became a student at the Academy of Fine Arts in Munich. His earliest works were mainly landscapes, both on canvas and as drawings and xylographs (i.e. white-line wood-engravings). From 1909 onwards, the artist showed an increasing tendency to

detach himself from Nature and to become more and more abstract, in a musical harmony of lines and brilliant, luminous colours. He thus became the father of contemporary Abstract Art within the Blaue Reiter movement, defending his revolutionary ideas on art with books and pamphlets.

Piet Mondrian (Amersfoort 1872–New York 1944). Mondrian began by painting landscapes. In 1911 he went to Paris, where he found himself drawn to Cubism and changed his naturalistic style into a geometry of colours and shapes. Six years later in Holland he founded the magazine *De Stijl* as the organ for Neo Plasticism, his own name for the style of abstract painting he had evolved, which was two-dimensional and had as its basic elements straight lines meeting at right angles and a limited number of primary colours. He moved to New York in 1940 and died there four years later.

Max Ernst (Brühl 1891–? 1976). After being involved with the Blaue Reiter group in Munich in 1919 Max Ernst started the Dada movement. In this, art was turned inside out; it was seen as a crazy amusement – a medium for going beyond all limits of normality – and found expression in eccentric montages and collages. From 1921 onwards, Ernst was drawn towards Surrealism, on which he wrote a treatise. From 1939 to 1953 Ernst lived in the United States, where he exerted a powerful influence both on painting and on the graphics of Abstract Expressionism.

Joan Miró (Barcelona 1893). In 1919 this artist was working along similar lines to Picasso, but later turned to the freer forms of Dadaism and Surrealism. His paintings, as well as his numerous lithographs and drawings – which represent one of the milestones of modern Abstract Expressionism – should be interpreted with this in mind. After the Second World War, Miró went to the United States, where, in addition to his studio work, he devoted himself to producing large ceramic and mural decorations such as those in the UNESCO headquarters, New York.

Salvador Dalí (Figueras 1904). Having started out in Spain as a Cubist and Futurist, Dalí has subsequently concentrated on surrealist modes of expression under the inspiration of Freud's theories on the meaning of dreams. In 1939 he settled in the United States, where he has produced a great many

paintings and a vast amount of graphic work, all based on the motifs of Surrealism, of which he has become the leading exponent.

Anton Zoran Music (Gorizia 1909). After studying in Zagreb and Madrid, and producing his first works in Venice, Music devoted himself to a poetic evocation of the Dalmatian atmosphere, painted with carefully dried materials and drenched with light. From 1952 onwards, Music was working in non-representational styles, studying above all the effect of light in evanescent and iridescent perspectives. Lastly, to add to his prolific output of drawings and lithographs, as well as paintings, he has re-evoked the tragic experience of the extermination camp at Dachau, bringing its newly burnt colours into the stricken landscapes of rocks and cities.

Graham Sutherland (London 1903–80). This artist's origins were in the field of graphic art, especially as a book illustrator in the style of Blake. It was not long, however, before he was approaching Surrealism, with a strong bias towards material subjects. He has covered a wide range of themes, from those which are inspired by reality seen as a disturbing nightmare, to those that deal with the unconscious mind.

Gino Bonichi, known as Scipione (Macerata 1904–Arco 1933). Having studied in Rome under Mafai, Scipione instigated a gradual revival of the artistic languages of the late Renaissance and the Baroque. He made his début in 1925 with works of profound dramatic import like his *Cardinal Decano* (1929–30), in the Galleria d'Arte Moderna, Rome. In the graphic field, he openly confessed to his interest in a Neo-Baroque revival at an Expressionist level.

Alberto Giacometti (Stampa 1901–Chur 1966). One of the leading sculptors of our time, Giacometti also devoted himself to painting and the graphic arts. He worked in Paris from 1922 onwards, in contact with all the most modern styles but never allowing himself to be deflected from his own, which especially in his graphic work assumes an incisive character as the artist strives for a painterly *sfumato* effect.

Max Beckmann (Leipzig 1884–New York 1950). Max Beckmann lived and worked in the Expressionist movement in Berlin and

Düsseldorf until the Nazi persecution of 1937, when he emigrated to Holland. From there he went to the United States, where he eventually died. During his later period his dramatic, chiaroscuro graphic work became much softer and he tended to use shapes that lent themselves to expressive colouring.

Henry Moore (Castleford 1898). From his period of study spent in London at the Royal College of Art, Henry Moore was fired by the desire to revive an archaic world, with sculpture still in pure volume, which he retained unchanged throughout his long career. Although he was aware of all the artistic movements that had succeeded one another in the twentieth century, Henry Moore stayed firmly with his re-conquest of the classical spirit. This is apparent, too, from his accurate and patient graphic study of the natural subject which only later would he transform into an apparently non-figurative three-dimensional object such as his *Reclining Figure* (1930) in the National Gallery of Canada, Ottawa. In the graphic field, his *Shelter Sketchbook*, which he drew from life in the London underground shelters during the air raids in 1940, is undoubtedly his best-known work.

Georg Grosz (Berlin 1893–New York 1959). Georg Grosz made his début as a satirical draughtsman in 1917. This was with a collection of violently anti-bourgeois drawings aimed at the corrupt ruling class. He continued to produce political satires, both paintings and graphic works, until he was denounced as a 'degenerate artist' by the Nazi regime and forced to leave Germany. Emigrating to the United States in 1932, he settled in New York, where he was to spend the rest of his life. Here he continued to produce drawings, engravings and paintings, and was a major influence on the generation of American Realists.

Roy Lichtenstein (New York 1923). One of the originators of Pop Art *c.* 1959–60, Roy Lichtenstein shared in the aesthetic viewpoint which was directed at the dangerous tendency to glorify the mass media, with all their power to negate the survival of the individual. In making use of the glibly expressive idiom of modern pictorial advertising, Lichtenstein's drawings and engravings stand for our vainly dreamed hopes of a real life which is being overwhelmed by the bewildering turmoil of the Machine Age.

349

Henri Matisse
(Le Cateau 1869–Cimiez 1954)
Spanish Lady with Fan
Charcoal and stump; 20 × 15⅞ in.
(510 × 402 mm.)
Provenance: presented to the Musée du
Luxembourg by the artist
Paris, Centre Georges Pompidou, Musée
National d'Art Moderne, inv. LUX 1074 D

This is the working study prepared by
Matisse for his *Spaniard, Harmony in Blue*
painted in 1923 and now in the Metropolitan
Museum, New York. 'Odalisque' and
'Spanish lady' themes recur frequently in the
work of Matisse's maturer years, as though
he were using them as a medium through
which to achieve chromatic harmony, as in a
musical composition.
Bibliography: Monod Fontaine, 1979, no. 36

Georges Braque
(Argenteuil 1882–Paris 1963)
Still Life
Sanguine; 17⅛ × 24 in. (435 × 610 mm.)
Paris, private collection

In his youthful Cubist period, Braque used
drawing as a means of analyzing, in detail,
the breakdown of shapes. In this perspective
study of a table, drawn in 1919, the objects
are drawn over shadow to give the
characteristic three-dimensional and
simultaneous effects of the artist's new
aesthetic theory.
Bibliography: Ponge-Descargues-Malraux, p.
135; Leymarie, 1975, no. 47

352

Pablo Picasso
(Malaga 1881–Mougins 1973)
Two Female Figures
Pencil; 20 × 16 in. (510 × 410 mm.)
Provenance: Earl Beatty; entered in 1953
Dublin, National Gallery of Ireland, inv.
3271

In the ten years between 1915 and 1925,
Picasso developed a style of painting and
drawing strongly reminiscent of Classicism,
although he was at the same time deeply
involved in what was later to be called
Analytical Cubism. As is indicated by the
inscription, *'12–13 Avril 1925 Picasso'*, this
drawing corresponds chronologically to his
Cubist painting of the *Three Dancers*. It is
almost as though Classicism and Cubism
have become reconciled in the flowing
outlines and sculptural quality of the pencil
strokes, in contrast with the dynamic volume
of the composition.
Bibliography: Zervos, 1952, no. V5; White,
1967, no. 105

Pablo Picasso
Fernande Olivier
Charcoal: 24⅛ × 18 in. (612 × 458 mm.)
Provenance: Waldeck
Chicago, Art Institute of Chicago, inv.
51.210

A feeling of monumentality and expressive
power in his use of the graphic medium
reveal Pablo Picasso's exceptional qualities
as a portraitist. He drew this likeness of
Fernande Olivier in 1906 when, having come
to the end of his Pink Period, the artist was
already experimenting with Cubism. He used
this style for *Les Demoiselles d'Avignon*,
which was probably started at the end of the
same year.
Bibliography: Joachim, 1963, no. 154

Pablo Picasso
Guernica
Pencil on white paper; $9\frac{1}{2} \times 17\frac{7}{8}$ in.
(241×454 mm.)
New York, Museum of Modern Art

This drawing, which contains several differences – some quite significant – from the final painted version, is one of a number of preparatory studies by Picasso for his *Guernica*, now in the Prado, Madrid. In this large canvas, with its allusive and symbolic language, the painter has expressed his condemnation of the destruction of the little Spanish town of Guernica that took place on 9 May 1937; in effect, it symbolizes a protest against the horror and destruction brought about by war anywhere.
Bibliography: Mendelowitz, 1967, p. 233

Fernand Léger (Argentan 1881–Paris 1955)
Mother and Child
Crayon; $11\frac{7}{8} \times 15\frac{3}{8}$ in. (300 × 390 mm.)
Philadelphia, Museum of Art, A. E. Gallatin
Collection, inv. 52-61-69

This drawing, as the autograph and date
'F.L. 24' affirm, belongs to the advanced
phase of what Léger himself described as his
'époque mécanique' ('mechanical era'). In this
and similar works, the artist is seeking a
definition of the relationship between the
plane and space. To this end, he has created
a complex series of relationships in the
various component parts; here, for instance,
the human figure itself – hitherto absent
from Léger's work – is considered essentially
from the point of view of its three-
dimensional qualities.
Bibliography: Cassou-Leymarie, 1972, p. 48
and no. 102

Amedeo Modigliani
(Leghorn 1884–Paris 1920)
Seated Nude Woman
Pencil; $16\frac{3}{4} \times 9\frac{7}{8}$ in. (425 × 250 mm.)
Provenance: Swift van der Marwitz
Chicago, Art Institute, Gift in memory of
Tiffany Blake, inv. 1951.22

The sinuosity of pure line characterizes this
late pencil nude, datable to 1918, which is in
the series dedicated to Jeanne Hebuterne.
The accentuated linearity has a certain
affinity with some the drawings by Matisse,
which also relate to his contact with the
Fauves.
Bibliography: Joachim, 1963, no. 158

356

357

Kasimir Malevich
(Kiev 1878–Leningrad 1935)
They are Going to Church
Pencil on paper; 5½ × 4 in. (140 × 99 mm.)
Paris, Centre Georges Pompidou, Musée
National d'art Moderne, inv. AM 1975-227

The deep attachment of the Russian people
to religion was already a favourite theme of
Malevich in the years 1911 to 1912 and he
has used it again in this drawing datable to
after 1930. An accentuated geometrical style,
directly related to Cubism, characterizes the
figures of the peasants.
Bibliography: Andersen, 1978, vol. IV, p.
256; Martin, 1978, no. 17

Oskar Kokoschka
(Pöchlarn 1886–Montreux 1980)
Study for 'The Concert'
Lithographic pencil; 26½ × 19⅛ in.
(675 × 487 mm.)
Tutzing, Hahn Collection

The artist has made full use here of the
technical possibilities offered by the broad,
clean line of the lithographic pencil to
emphasize, in an expressionistic way, the
psychological aspect of the model. As the
autograph note *'Kokoschka – 1920 – für
Concert'* indicates, this study from 1920
relates to the 'Concert' theme on which
Kokoschka produced a series of lithographs.
Bibliography: Oskar Kokoschka, 1966, no.
60

Georges Rouault (Paris 1871–1958)
Prostitute in Front of a Mirror
Watercolour; 28½ × 21¾ in. (724 × 552 mm.)
Paris, Centre Georges Pompidou, Musée
National d'Art Moderne, inv. AM 1795 D

This watercolour, in its polemic
aggressiveness and the strongly contrasting
tones of the colours in which the figure is
painted, is indicative of Rouault's burning
Expressionism when he was about twenty-
five. Although exhibiting with the Fauves at
this time, he remained aloof from their
research into form for its own sake in order
to confront a controversial social topic.
Bibliography: Moskowitz, 1963, no. 935

359

Carlo Carrà (Quargnento 1881–Milan 1966)
Head of a Girl
Ink on light brown paper; $13\frac{3}{4} \times 7\frac{1}{2}$ in.
(350 × 190 mm.)
Milan, Castello Sforzesco

It was Carrà himself who named this
geometrical study *Testa di fanciulla* ('Head
of a Girl'), which is signed and dated '916',
that is 1916, the year in which he began to

be drawn to Metaphysical Painting.
Sculptures similar to this 'Head' often
appear in paintings by Carrà, such as *The
Inebriated Gentleman*, which dates from 1916
and is now in the Frua Collection, Milan, or
The Engineer's Mistress of 1921, in the
Mattioli Collection, Milan.
Bibliography: Carrà, 1977, no. 179; Massari,
1978, no. 25

360

Marc Chagall (Vitebsk 1887)
The Anniversary
Pencil; 9 × 11½ in. (229 × 292 mm.)
Provenance: presented by the artist
New York, Museum of Modern Art

Realism and Symbolism blend in this
fascinating pencil drawing, signed and dated
'Chagall 1915 7/7'. It is squared-up because
the artist produced it as a preliminary study
for the first of a series of paintings to
celebrate family occasions. There are two
painted versions of this sheet, both of which
are in New York – one, dated 1915, in the
Museum of Modern Art, the other, 1915–23,
in the Guggenheim Museum.
Bibliography: Moskowitz, 1963, no. 953

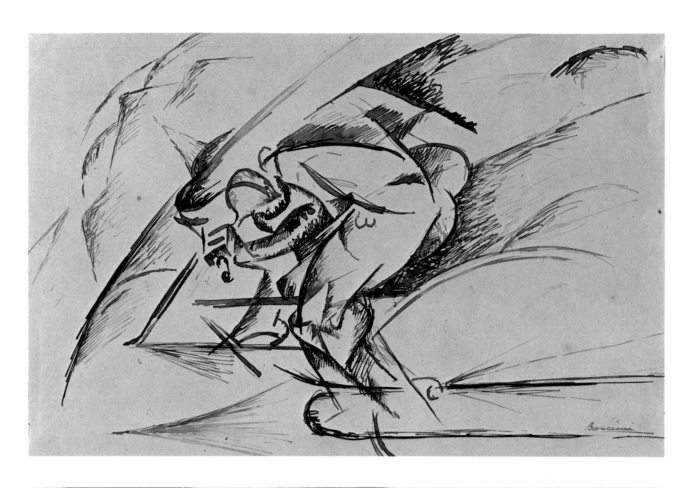

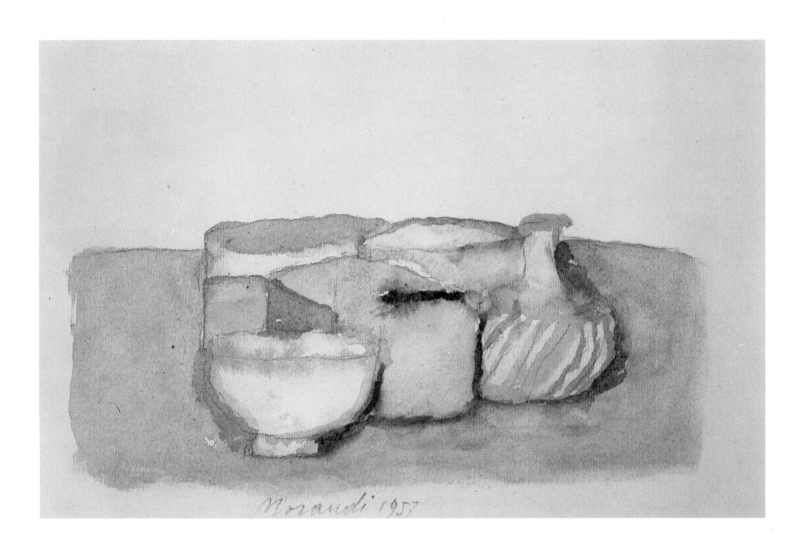

Umberto Boccioni
(Reggio Calabria 1882–Verona 1916)
Dynamism of a Cyclist
Pen and brush with ink hatching;
$8\frac{1}{4} \times 12\frac{1}{8}$ in. (211 × 309 mm.)
Milan, Castello Sforzesco

One of the leading exponents of the Futurist movement in the field of the figurative arts, Umberto Boccioni founds his artistic expression on the concepts of dynamism and simultaneity. This pen and brush study bears a close resemblance to another version of the same subject that appeared in *Lacerba* on 1 October 1913.
Bibliography: Ballo, 1964, no. 554; Fezzi, 1973, no. 23

Gino Rossi
(Venice 1884–Sant'Artemio di Treviso 1947)
Breton National Dress
Pencil; $9 \times 11\frac{1}{4}$ in. (230 × 285 mm.)
Venice, private collection

This sheet belongs to the period beginning in 1907 that the artist spent in Brittany. Rossi's contact there with the strongly delineated painting and three-dimensional use of colour of the group known as the Nabis, as well as his acquaintance with the linear style of Art Nouveau, greatly increased his graphic fluency.
Bibliography: Unpublished

Giorgio Morandi
(Bologna 1890–1964)
Still Life
Watercolour; $7\frac{7}{8} \times 11\frac{7}{8}$ in. (200 × 300 mm.)
Venice, private collection

The many 'Still Lifes', drawn, painted and engraved, which were inspired by the style of Cézanne, have a symbolic purpose in Morandi's art. They provide him with the means to explore the values of shapes and spatial relationships of material things, without ever losing his extraordinary awareness of the pictorial value of form, in an atmosphere where even the most subtle chromatic effect vibrates.
Bibliography: Leymarie, 1968, no. 16; London Exhibition, 1970–1, no. 82; Paris Exhibition, 1971, no. 82

363

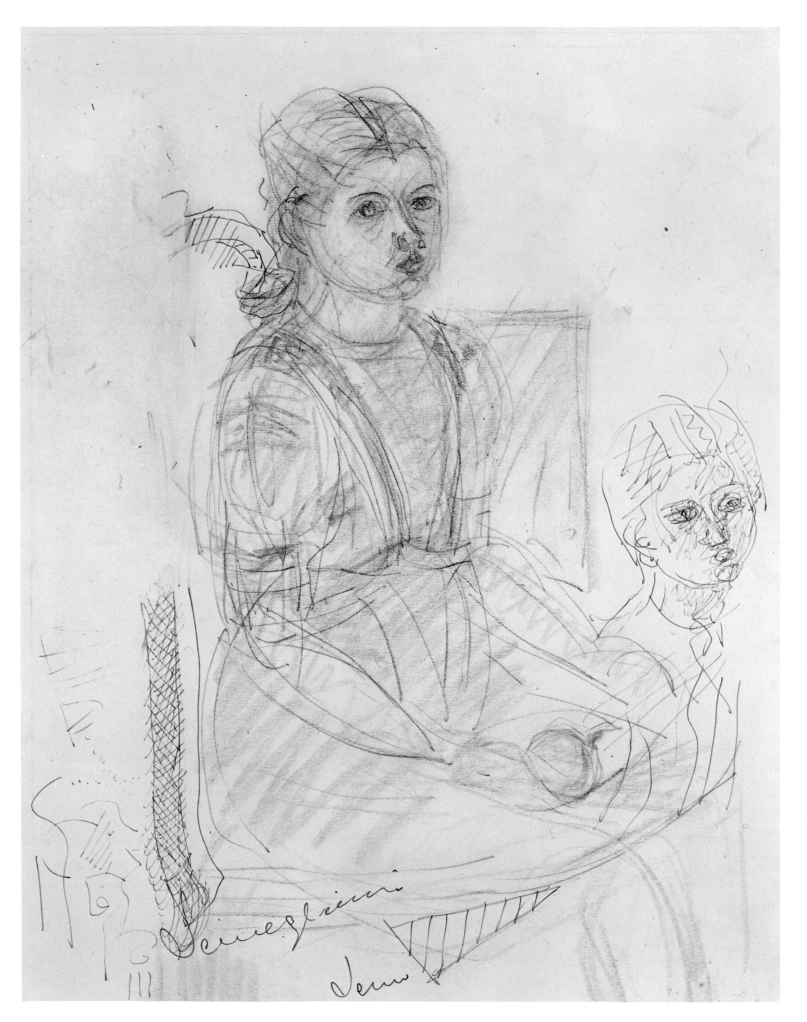

364

Pio Semeghini (Quistello 1878–Verona 1964)
Little Girl with Fruit in Her Lap
Pencil, pen and pastels; $8\frac{1}{4} \times 11$ in.
(210 × 280 mm.)
Verona, Semeghini Collection

Impressionism and the influence of Cézanne, combined with the Lombardic-Venetian chromatic tradition, are at the root of Pio Semeghini's artistic expression. In his works, which are characterized by an intensely lyrical vein, the colour seems to melt away, leaving the shape transformed into effects of pure light.
Bibliography: Magagnato, 1979, no. 173

Filippo De Pisis (Ferrara 1896–Milan 1956)
Portrait of Pirandello
Ink wash on paper; $19\frac{3}{8} \times 13\frac{7}{8}$ in.
(490 × 350 mm.)
Venice, private collection

In this incisive portrait of Luigi Pirandello, executed in 1930, De Pisis has adopted a rapid, spontaneous technique that permits no uncertainties or changes of mind. With a few decisive strokes of his brush he has created an intensely expressive likeness that has skilfully captured the sitter's personality.
Bibliography: Valsecchi, 1971, no. 8; Birolli, 179, p. 191

Alberto Viani
(Quistello 1906)
Figure
Pen and black ink;
$27\frac{3}{8} \times 19\frac{3}{8}$ in.
(695 × 491 mm.)
Venice, private collection

This study is in the same
style as the artist's most
recent group of sculptures
which, especially those of
the 1970s, tend towards
the straightforward
Naturalism typical of his
early work. The linear
quality of his penmanship
shows the influence of
Ingres and Rodin.
Bibliography: unpublished

Giacomo Manzu
(Bergamo 1908)
*The Painter and His
Model*
Pencil; $14\frac{1}{8} \times 18\frac{7}{8}$ in.
(358 × 478 mm.)
Ardea, Friends of Manzú
Collection

The theme of the artist
and his model, a favourite
of Manzù since he was a
young man, is returned to
here in 1959. The work of
a sculptor, this drawing is
characterized by its plastic
rhythm and the play of
light on the smooth
surfaces of the female
nude in contrast with the
background figure, drawn
in with a few, decisive
strokes.
Bibliography: Rewald,
1966, p. 93

Marino Marini (Pistoia
1901–Viareggio 1980)
Composition in Red
Tempera on card;
$15\frac{1}{4} \times 9\frac{3}{8}$ in.
(287 × 238 mm.)
Milan, Castello Sforzesco

The 'rider and horse'
theme that recurs
constantly in Marini's
work from 1935 to 1960
returns in this
Composition in Red, which
is signed at centre bottom
'Marino 1950'. Ignoring
plasticity in favour of
two-dimensionality, the
artist has reached the
limits of abstraction,
without losing the
characteristic
expressiveness of his style.
Bibliography: Precerutti,
Garberi, 1973, D81

Paul Klee
(Münchenbuchsee 1879–Muralto 1940)
Symbiosis
Pencil; $19 \times 12\frac{5}{8}$ in. (482 × 320 mm.)
Berne, Felix Klee Collection

Paul Klee's graphic work is closely linked
with his painting, as in both media he is
searching for an 'absoluteness' of form. In
fact, his drawing – which is often executed in
thread-like lines – depicts images that assail
his whole poetic world in an unstable
balance between reality and its projections
into the realms of dreams, fantasy and
magic.
Bibliography: Grohmann. 1959, p. 175

Wassily Kandinsky
(Moscow 1866–Neuilly-sur-Seine 1944)
Study for 'Improvisation 160 b'
Watercolour; $14\frac{3}{4} \times 21\frac{5}{8}$ in. (375×550 mm.)
New York, Solomon R. Guggenheim
Museum, Hilla Rebay Collection, inv.
190.127

This 1912 watercolour, in which the artist
has abandoned Representationalism, belongs
among the early results of his research into
the abstract qualities of colours and shapes,
begun in 1910 with his *First Abstract
Watercolour* and developed along parallel
theoretical lines. Blotches of deep colour,
transparent blurring and linear tracks, create
a feeling of space in movement which is
typical of the whole series of paintings called
'Improvisations'.
Bibliography: Zander Rudenstine, 1976, p.
248

Piet Mondrian
(Amersfoort 1872–New York 1944)
The Sea
Charcoal and gouache; $3\frac{1}{2} \times 4\frac{7}{8}$ in.
(90 × 123 mm.)
Venice, Peggy Guggenheim Collection

This symbolic drawing, dated 1914, is one of
a series of works which demonstrate the
progressive process of abstraction followed
by Mondrian in his representation of
Nature. It was, indeed, through this – as he
declared many years later – that he had
come to understand how to capture
'extensiveness, calm and unity' by making
use of 'a multiplicity of crossed verticals and
horizontals' to convey the 'plastic function'
of the sea, the sky and the stars.
Bibliography: Guggenheim, 1942, p. 54;
Seuphor, 1956, p. 125 and cat. 229

Max Ernst (Brühl 1891–Paris 1976)
Motherhood
Pencil heightened by white chalk on orange
paper; 19 × 12 in. (479 × 308 mm.)
Provenance: Levy
New York, Museum of Modern Art, Gift in
memory of William B. Jaffe

Max Ernst became involved in Surrealism
after he had moved to Paris. A remarkable
fluidity of line characterizes this study which
he produced as a preparatory drawing for
his *Surrealism and Painting* in the Copley
Collection, Longport-sur-l'Orge. In the
drawing, the artist has made use of the
traditional technique of black pencil
heightened with white to give life to this
mysterious and inscrutable symbol of
motherhood.
Bibliography: Lieberman, 1961, no. 228

371

Joan Miró (Barcelona 1893)
The Family
Black and red chalks on emery paper;
29½ × 41 in. (750 × 1040 mm.)
Provenance: Mitchell
New York, Museum of Modern Art

This composition dates from 1924, the year
in which Miró began to associate himself
with the Surrealist movement through his
friendship with André Masson. The work
seems like a revaluation of the unconscious:
in a world of dreamlike images, it is laden
with allusions and symbolism, the figures of
the father, mother and son becoming like
menacing insects.
Bibliography: Penrose, 1970, no. 24

Salvador Dalí (Figueras 1904)
Study for 'The Madonna of Port Lligat'
Chinese ink and watercolour; 7½ × 5½ in.
(190 × 140 mm.)
Paris, private collecdion

In his drawing as in his painting, Dalí's
underlying ideology is based on
Metaphysical and Cubist impressions with
vigorous grafts of psychoanalytical theory.
Thus the artist combines – especially in his
drawings – the most delirious fantasy, as in
this preparatory study for one of Dalí's best-
known paintings, *The Madonna of Port
Lligat*, in Lady Beaverbrook's collection in
Canada.
Bibliography: Descharnes, 1962, p. 176

Zoran Music (Gorizia 1909)
Women with Animals
Lithographic pencil; $15\frac{3}{8} \times 20\frac{1}{2}$ in.
(390 × 520 mm.)
Venice, private collection

An intensely expressive lyricism characterizes
this drawing, which dates back to 1948.
Making use of the mellow effect of his
lithographic pencil, the artist has illustrated
a scene from one of his favourite themes –
the Istrian countryside seen in its various
aspects and with its traditional figures. The
sfumato quality that typifies Music's painting
is already visible in the softness of the pencil-
line and in the superimposing of almost two-
dimensional forms in an undefined space.
Bibliography: *Zoran Music*, 1980, p. 18

Graham Sutherland (London 1903–80)
Beetles II (with Electric Lamp)
Conté crayon and watercolour; 26 × 20 in.
(660 × 510 mm.)
London, Marlborough Fine Art Gallery

The artist's intensely expressed sorrow at the
horrible devastation of cities, portrayed in
his wartime work, was followed by an
interest in the representation of Nature from
a viewpoint in which reality and the
unconscious come together. The result of
this new inspiration was his *Bestiary* in 1950,
a Surrealistic transposition of the Gothic
theme that was subsequently to be used as
the basis for the huge tapestry in Coventry
Cathedral.
Bibliography: Arcangeli, 1973, no. 170

Scipione
(Macerata 1904–Arco 1933)
The Cardinal
Pen and black ink on brown paper;
13 × 9¼ in. (330 × 235 mm.)
Provenance: Falqui
Rome, Galleria d'Arte Moderna

This portrait of a Cardinal, datable to 1929,
was produced at the most intense phase of
Scipione's brief life. In it, the Expressionism
so typical of his style achieves one of its
greatest moments. The characterization of
the sitter is brought out graphically in the
accentuation of some of the significant
details, such as the tremulous hands and the
great cross on his breast.
Bibliography: Marchiori, 1944, no. 5;
Bucarelli, 1954, no. 23

Alberto Giacometti
(Stampa 1901–Chur 1966)
Head of a Man in an Interior
Lithographic pencil on pale yellow paper;
15⅜ × 11 in. (387 × 280 mm.)
Provenance: Thaw
New York, Museum of Modern Art

The negation of balance between form and
space that distinguishes the sculptural work
of Giacometti, reducing volume with a linear
network, reappears overwhelmingly in his
drawings and paintings. Typical of this style
is the 1951 study shown here, in which the
contours of the human figure are broken
down to imbue the image with a sense of
dramatic torment.
Bibliography: Lord, 1971, no. 65

Max Beckman
(Leipzig 1884–New York 1950)
Carnival in Naples
Brush and indian ink, black crayon and
white chalk; $43\frac{1}{2} \times 27\frac{3}{8}$ in. (1105×695 mm.)
Provenance: Blake
Chicago, Art Institute, Gift of Tiffany and
Margaret Blake, inv. 1948.5

After his traditional training in a late
Impressionist environment, Beckman after
the First World War adopted a rather acid
Veristic style. It is in this phase that his more
aggressive drawings belong, characterized by
the typically heavy, insensitive line of
German Expressionism. The artist continued
to produce work in this cultural mould
virtually until his late period, when he
achieved a more mature compositional
balance.
Bibliography: Joachim, 1963, no. 145

Henry Moore (Castleford 1898)
Madonna and Child
Grey watercolour, wax crayon, pen, ink and
charcoal heightened with white; $8\frac{7}{8} \times 6\frac{7}{8}$ in.
(225×175 mm.)
Cleveland, Ohio, Museum of Art, Hinman
B. Hurlbut Collection, inv. 313.47

A dramatic expressiveness characterizes
most of the graphic and sculptural
production of Henry Moore. In his *Madonna
and Child*, with its essentially plastic form,
positioned in space, the artist offers a very
personal interpretation of religious feeling.
Moore has used a complex technique here to
achieve such subtle tones in the black and
white range.
Bibliography: Watrous, 1957, p. 37

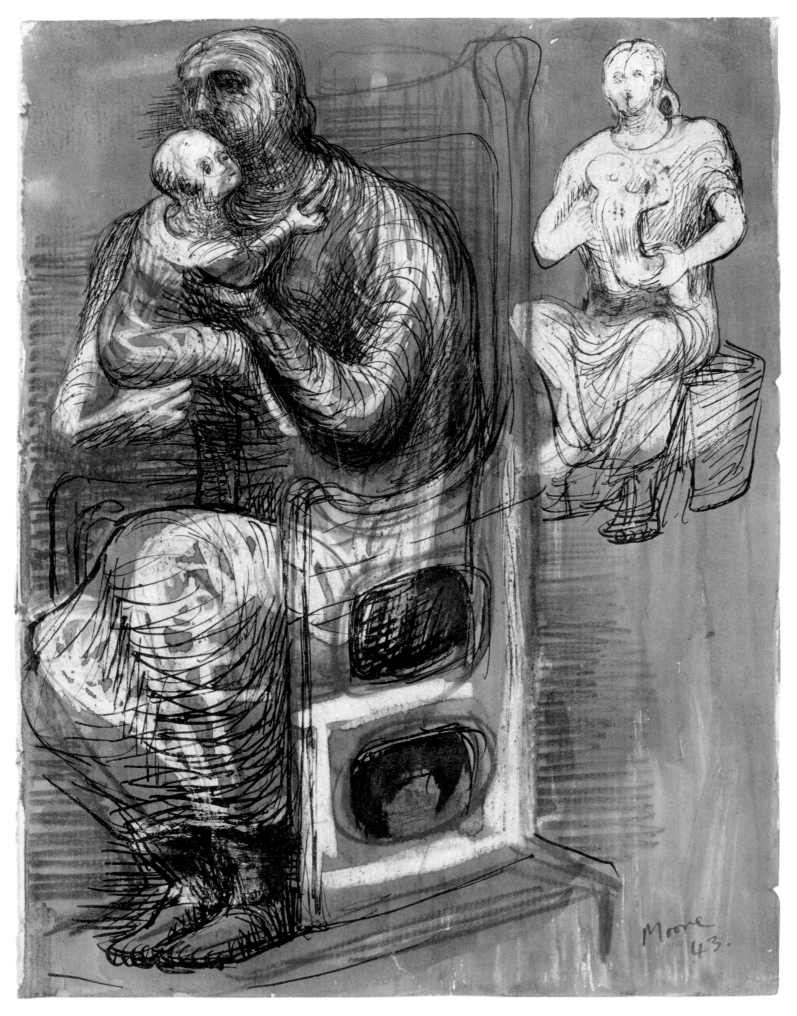

379

Georg Grosz (Berlin 1893–New York 1959)
The Survivor
Pen and indian ink; 19 × 25 in.
(482 × 635 mm.)
Provenance: a gift of the Print and Drawing
Club
Chicago, Art Institute of Chicago, inv.
39.311

A remarkably incisive line, achieved by an
extremely varied handling of pen and ink,
characterizes this 1937 drawing by Grosz.
He had clearly left the caricatures of his
youth behind him. In the figure of the
survivor, the artist synthesizes the atrocious
and dramatic aspects of war in his use of
Realism in an expressionistic form.
Bibliography: Baur, 1954, p. 47–9 and no.
110; Mendelowitz, 1967, p. 354

Roy Lichtenstein (New York 1923)
Any Man (Him)
Pencil and retouching on paper; 22 × 17 in.
(558 × 431 mm.)
Provenance: L. Castelli Gallery; Byron
Gallery
St Louis, Mo., Art Museum, Eliza McMillan
Fund, inv. 138:1972

The impossibility of reconciling the aesthetic
experience with the superficiality of mass-
communication media, especially comic-strip
stories, is at the root of the analyses carried
out by Lichtenstein. The drawing
reproduced here is symbolic of the critical
process that is only satisfied by the
enlargement of individuals, who are isolated
from their context and reproduced in half-
tone just as in the normal printing process.
Bibliography: Waldman, 1970, p. 98, no.
64/2

The Techniques of Drawing

That an artist should adopt one particular technique rather than another for his creative work is self-evident. And the technique he chooses will depend on what it is he needs to express. How does he make up his mind? Essentially, such a decision becomes an act of poetry and must respond to the artist's own, deeply felt need. So far as drawing is concerned, however, the choice is also conditioned by an historical factor represented by technology. We know, for instance, that certain graphic techniques have flourished only at certain periods, while others have virtually disappeared into oblivion. At the same time, chemical and physical discoveries have exerted a profound influence on materials used in draughtsmanship.

In this brief resumé of the various materials and media that can and have been used, the first consideration must be the supports on which drawings can be made, from stone to parchment,

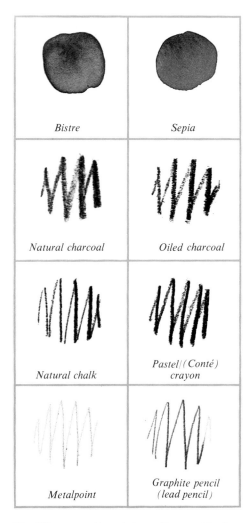

Bistre	*Sepia*
Natural charcoal	*Oiled charcoal*
Natural chalk	*Pastel/(Conté) crayon*
Metalpoint	*Graphite pencil (lead pencil)*

The different graphic techniques, illustrated by J. Meder in Die Handzeichnung. Ihre Technik und Entwicklung, *Vienna, 1923*

paper and various rigid materials. Then come the instruments and the materials, which can be divided into dry and wet. In the former category are: stones, metal points, charcoal, chalks, pastels and pencils; in the latter, ink, watercolour and tempera. Finally, there are the practical considerations of drawings to be remembered. These relate not only to the process itself but also to the preservation of the work produced.

SUPPORTS

From the moment when a drawing first came to be regarded as a mobile object, the problem arose as to the type of support on which it could be produced. Having abandoned the walls of caves and cliff-faces, the draughtsmen of Antiquity

began to make use of stones and pottery tiles. In the Middle East and Egypt, however, a preference was shown for clay slabs or sheets of dried papyrus, while the Greeks and Romans drew on prepared wooden tablets. Even before the time of Christ the first parchment was in use, obtained from animal skins treated with chalk and smoothed with pumice-stone. Such parchment lent itself well to any type of drawing, especially with the reed or quill pen.

Paper was invented by the Chinese in the first century before Christ, but did not make its appearance in Europe for another thousand years. Then it slowly took the place of parchment, which was so much more costly and difficult to prepare. Paper was obtained from a pulp, derived from vegetable cellulose or rags, damped, pounded and placed in thin layers over a grid the size of the sheet required. This layer of pulp was detached from the

Vertical threads and horizontally laid wires, with watermark, in a sheet of paper made in Venice in the eighteenth century (from T. Miotti, Il collezionista di disegni, *Venice, 1960, fig. 10)*

grid when the moisture had drained away, and laid out between two superimposed felt blocks, which were then brought together under pressure to squeeze out the remaining moisture. The final stage involved dipping the sheet into animal glue, known as 'size', to give it strength. A sheet of paper produced in this way would retain a transparent impression of the grid on which it had been placed in the first stage, giving a woven appearance. The grid itself consisted of widely spaced vertical metal threads and closely placed horizontally laid wires which served to keep the cellulose pulp in place as it was taken from the trough in which it had been broken down. The transparent woven design was produced where the layer of pulp was slightly thinner over the threads and laid wires. The grids varied slightly, of course, from one paper-maker to another, thus making it possible to trace the source of the paper and its age.

Trade marks, known as 'watermarks', were produced in the same way, by twisting fine wire into the required design and inserting the motif into the grid. Many transparent symbols can still be seen and the designs are limitless: such things as moons, arrows, lions, elm-trees and letters of the alphabet were used and are of great help in identifying the makers.

The original surface of the paper can be seen in some drawings although it may have undergone various preparatory processes in order to make it more artistically attractive. According to Cennino Cennini, in his fourteenth-century treatise on art, *Il Libro dell'Arte*, paper on which metalpoint was to

be used was specially prepared with a basis of finely ground minerals or powdered bone mixed with agate dust. It was possible to tint this foundation by dissolving the colours in size or gum arabic, which also served to give more body to the paper. The paper itself could also be tinted in brown, indigo, pale blue, grey or a reddish colour.

INSTRUMENTS AND MATERIALS

The oldest 'dry' graphic instrument is a stylus or metalpoint, which may be made of lead (graphite), silver or gold and is usually used on prepared paper. The Romans used it on their writing-tablets and, centuries later, medieval scribes were drawing lines on parchment preparatory to laboriously transcribing the early books with their reed pens or decorating the initials of codices.

As an artist's instrument, the stylus is the oldest. It is mentioned by Boccaccio (1313–75), who

Various watermarks, illustrated by C. M. Briquet in Les Filigranes, *Paris, 1930*

praises Giotto's skill in this technique. Botticelli and Leonardo da Vinci worked in silverpoint, as did Dürer and the great fifteenth-century Flemish masters. As the painterly effect became more favoured, due to the influence of the Venetian school – including, therefore, the Baroque – metalpoint fell almost completely into disuse, only to reappear occasionally in some of the rather more refined work from the same period.

In using metalpoint (*punta metallica, Silberstift, pointe de métal*), the most important factor is the ground preparation. Only lead (graphite) will produce a mark on unprepared paper; all the others require a special surface on which a mark will be made when pressure is applied, for no colour comes from the metalpoint itself. This surface is achieved by dissolving powdered lead (plumbago) in water or linseed oil with size and then brushing several layers of the resultant mixture over the page. In former times, the preparatory coating could have been made from substances containing calcium carbonate or calcium phosphate, such as bone, eggshells or sea

shells. Particularly sought after was powdered horn, stag-horn being the most highly prized.

It is almost certain that one of the oldest drawing media – charcoal – originally came from the dying embers of some primitive fire. The best charcoal is obtained from the slow burning of rather fine sticks of wood, willow-wands being especially suitable. The mark made by charcoal (*carboncino, Kohle, charbon*) is quite soft, as though it had been painted, but it has the disadvantage of instability, which means that few drawings from the early masters have survived to the present day. In order to 'fix' a charcoal drawing, it is necessary for it to be sprayed or vaporized with gum arabic. Alternatively, the charcoal stick itself can be dipped in linseed oil, which produces a particularly painterly effect: because of this, it was a favourite medium of such Venetian artists as Tintoretto and Bassano. Its use

Different types of metalpoint, illustrated by J. Watrous in The Craft of Old Master Drawings, *Madison, 1967*

can be detected by the presence of a slight oily smudging on the edges of the lines, where more pressure has been applied or where the paper has a rougher surface.

Charcoal was greatly favoured for sketches and preliminary drawings because of its smoothness of application, and it was particularly used in cartoons for frescoes. Finished works have rarely been executed in charcoal because of its crumbly consistency. It is distinguishable from 'black chalk', which is a manufactured composite substance, by its more transparent mark, which tends towards grey rather than a definite black. The material known as 'Italian chalk' (*pietra d'Italia,* lit. 'Italian stone') is a clayey schist from the Piedmont region; it produces a grey-black mark and is inclined to be confused with charcoal. It is recognizable under a microscope, however, because of the better blended impasto it produces on rough-surfaced paper and the slight lifting of the paper's surface due to the harder crystals it contains. Many of the great draughtsmen, including Raphael and Michelangelo, used it in preference to any other medium.

Natural chalk (*gesso, Kreide, pierre*) is another widely used graphic material. As long ago as the Renaissance, artists were finding it in its natural state and cutting pieces of mineral down into small

sticks: calcium (white), carbon (black), haematite (sanguine) and brick-clay (ochre and grey). Among the great artists who showed a distinct preference for natural black chalk were Michelangelo and Andrea del Sarto; in the eighteenth century, Watteau also favoured it, as well as using sanguine and various related shades.

As the seventeenth-century artists became increasingly aware of their need for less friable, more closely compacted chalks, an artificially produced substitute started to be produced – the pastel. Natural pigments were ground down into powder and mixed with gum arabic or animal glues. By the eighteenth century a wide range of colours was already being used by such artists as Rosalba Carriera, François Boucher and Fragonard, the tradition continuing right up to Impressionists such as Degas.

Since the time of Leonardo, draughtsmen had

Detail from Rogier van der Weyden's St Luke Painting the Virgin, *in the Alte Pinakothek, Munich*

been trying to give greater malleability to chalk in their desire to produce a more painterly effect with it, by mixing pigments with oily materials – such as olive oil or beeswax – rather than glues or gum. The result did not have very wide appeal, however, and it was not until the beginning of the nineteenth century that these man-made coloured chalks, called *crayons* by the French, began to attract attention. They were greatly favoured by French artists and their use was to continue right up to Picasso in the modern version – the lithographic pencil.

The year 1560 saw the discovery of graphite. This non-metallic chemical element, with its basis of blacklead, was quarried for the first time in Borrowdale in Cumberland. It did not become generally used, however, until the middle of the following century, when it virtually replaced metalpoint, already fallen into almost total disuse. The new medium gave a well-defined yet fine line; to overcome its brittleness, it was mixed with gums and resins, and formed into long, thin sticks known as 'leads' which were protected all round by the two halves of a longitudinally cut stick of cedarwood, stuck together, to create the modern lead-pencil (*matita, Stift, crayon noir*).

Towards the end of the eighteenth century real English graphite (plumbago) was in short supply because of the Napoleonic Wars in Europe. As a result, a 35-year-old Frenchman, Nicolas Jacques Conté, invented a substitute for the pure graphite pencil by mixing refined graphite with clay to create the Conté crayon. The Conté leads were so amenable to adjustments of pressure that the artist found himself with a medium which would adapt easily to his requirements of 'hardness' and 'softness' that they are still the basis for most

graphic work. Nearly all the nineteenth- and twentieth-century artists, from Ingres to Delacroix and van Gogh to Picasso, have used lead-pencils and/or Conté crayons.

The instruments that have proved most suitable for use with liquid graphic materials are the pen and the paintbrush, which can be used with various types of ink. The earliest references to a pen (*penna*, *Feder*, *plume*) relate to calligraphy and, therefore, to artistic drawing. During the centuries of our own era, three main types of pen have evolved, according to the material from which they have been made – a reed, a feather and metal. The reed pen, which was employed in the scrivening of manuscripts as far back as the seventh century, consisted of a fine piece of reed, tapered to a point on one side, with fins cut out and separated by a groove to give maximum elasticity and to hold the ink. It made a rather broad but uniform stroke

Ink is the most usual colouring medium for application with a pen or brush, and types vary according to the colour required. The blackest is called 'indian' – or 'chinese' – ink and is obtained from very dark, rather oily carbon substances (lampblack) mixed with gum; it produces an intense black mark which is particularly resistant to light. When diluted with water, it can be used for areas of greyish shading. More widely used, however, was iron-gall ink. This first came into being as a writing medium but soon became used for artistic purposes as well, due to its ease of preparation and low cost. It was made from the gall-nut, found quite extensively in Turkey and the Middle East; after being ground to a fine powder, it was mixed with gum arabic. Its black colour tends towards a greyish-violet and sometimes to a very dark brown. Iron-gall ink was sometimes mixed with vitriol, which was inclined to burn

methods by which a design for a painting or sculpture can be built up by the artist according to the style he wishes to employ, however rough the sketch. Of course, there are a few drawings that seem to fit the layman's belief in flashes of inspiration. In these, the originality is such that they must indeed be regarded as the result of a completely spontaneous and independent creative compulsion.

While considering such 'first impressions', or creative sketches, some thought should also be given to the true preliminary drawing into which so much patient work has invariably gone. Very often one small detail alone will have been studied and repeated drawings made of it before the artist has felt sufficiently confident to incorporate it into a much larger, more permanent composition. Here, in the preparatory stages, can be detected the elements that are part of the artist's graphic style

Top: marks obtained with charcoal, chalk and crayon (pastel). Above: various pen-strokes. Left to right: metal pen (1–4), goose-quill (5–6), reed pen (7–10). From J. Watrous, The Craft of Old Master Drawings, *Madison, 1967*

which was as suitable for hatching as it was for chiaroscuro effects. Artists have favoured the reed pen throughout the ages, from Dürer to van Gogh, Matisse and Grosz. The quill pen, which was widely used between the fifteenth and eighteenth centuries, was usually made from a goose-feather or from that of a swan, crow or rook. Used by more artists than any other instrument, it became the main means of expression, in their graphic work, for such great draughtsmen-painters as Rembrandt and Giambattista Tiepolo.

The brush (*pennello*, *Pinsel*, *pinceau*) is used to do a quick outline or to shade in his drawing with a colour wash. The most favoured brushes are fine and soft, made of badger- or squirrel-hair.

Left to right: goose-quill, crow-quill, swan-quill. From J. Watrous, The Craft of Old Master Drawings, *Madison, 1967*

through the paper, leaving holes in the areas that were intended to be more heavily inked. Bistre was made from wood soot – preferably beechwood – mixed with gum and came into use after the sixteenth century. It gave a luminous, transparent brown appearance which sometimes tended towards grey. The fourth type of ink, known as sepia, also produced a brown colour. It was made from the liquid contained in the ventral sac of cuttlefish and gave a distinctive dark, opaque brown.

Draughtsmen use several other colouring materials besides inks, for example watercolour, tempera and oils. It is quite common to find that sketches on paper have been drawn in umber and heightened with bodycolour (i.e. opaque white-lead pigment).

At this point, it is evident that the borderline has been reached between the concept of drawing and that of painting. However, when the masters have used paper as the support, their work needs to be kept under the specially controlled conditions of Print Rooms in order to survive. The category therefore inevitably includes a number of pictures in which the more painterly techniques have actually been employed.

THE PRACTICAL SIDE OF DRAWING
The layman's concept of the artist is frequently of someone who, overwhelmed from time to time by a sudden inspiration, will suddenly grab a piece of paper and dash off a sketch which will crystallize his 'first impression' of the subject and then be worked up into a masterpiece. Such a romantic idea is, of course, seldom realized in the day-to-day life of any artist.

By studying graphic works that have survived the centuries, we are given a glimpse into the

Various European Collectors' marks. From Il collezionista di disegni *by T. Miotti, Venice, 1960*

but they have been subjected to a great deal of patient work on the easel or, in the case of frescoes, from the scaffolding. Sometimes such drawings will have been enlarged into cartoons, that is to say, into the graphic medium by which the model is to be translated into a painting. These frequently have great expressive force in themselves, for they have been drawn by the hand of the master at the moment of creation.

Lastly, there is the type of drawing that was prepared expressly for the discerning collector. This may have been in the form of the great album sheets of such artists as Piazzetta, Tiepolo or Canaletto or some of the highlighted chiaroscuro drawings executed with the point of the brush in the German and Swiss tradition by Dürer, Baldung Grien and Graf. Then there were the masters who, like Veronese, found it necessary to compile a *liber veritatis* in which they could assemble copies of all their own works for use by their assistants and pupils in their workshops.

The methods used in each workshop for translating a drawing into a painting had a notable effect on the types of work carried out. Apart from their influence on the preliminary drawings or on the cartoons, they also affected the squaring-up. This was a system whereby a grid of lines was ruled in over the original drawing in order to facilitate its enlargement into cartoons and subsequent transfer on to canvas, or in the case of frescoes, *intonaco* – the final layer of plaster applied to enough wall for a day's stint, on which the master and probably several of his assistants would all work together, while it was still damp. It was this very technique that led to the development of other characteristic graphic forms. In creating a fresco, the image was transferred from the cartoon – usually produced on thick paper – on to the pictorial support by means of techniques which entailed the production of a succession of drawings. This led to the evolution of a sort of auxiliary cartoon known as a *spolvero*, produced by pricking all the lines of the drawing so that very fine charcoal dust could be blown through the holes (pounced) to leave a delicate black tracing on the *intonaco*. Another method was to draw the picture directly on to the

damp *intonaco* with the point of a nail, to give a slightly indented outline. The results of both these methods were then reinforced by the artist with charcoal and over these pale grey marks he would fill in more detail in a reddish-brown, earthy colour called *sinopia*, by which name this type of drawing has itself now come to be known. *Sinopie* were nearly always used in the case of frescoes, but seldom on canvas. They were applied with a brush to the plaster, which would already have been scored to receive the thin layer of *intonaco* to be frescoed. It is only in recent years, as techniques of restoration have improved, that the *sinopie* have been discovered underneath medieval frescoes.

During the course of their ordinary work, other types of drawings also played their part in the production of the studio-workshops. For instance, there are a great many sheets in existence which were drawn by the pupils, often representing motifs from or complete copies of the master's works. Sometimes copies such as these are easily recognizable because they were traced on to oiled (tracing) paper or very fine, transparent cotton fabric. In these cases, the remains of the red sealing wax used to attach the tracing sheet to the original can still be seen at the four corners. Sometimes, if a soft medium such as sanguine had been used in the original drawing, the pupils were able to make a counter-proof of it, under pressure, by moistening the paper slightly.

PRESERVATION AND CATALOGUING

It is often possible to learn quite a lot from a drawing, apart from its intrinsic artistic or technical qualities, through its history in the hands of collectors and museums. The first visible feature is the writing that is often found on very old sheets of drawings. Only rarely does the artist sign a working drawing, and the signs and symbols that do appear usually suffice only to document its passage through various collections. Even the opinions of knowledgeable collectors are not always in agreement in identifying the artist. A very old inscription, however, is of remarkable value and is never dismissed out of hand when the attribution of a previously unknown drawing is in question.

Many collectors kept their drawings between paperboard covers, with an indication as to their attribution. Vasari and Mariette mounted their collections in albums, one drawing being laid on each side of every page and surrounded by a decorative border; their valuable inscriptions are still useful in tracing the history of these drawings.

Another very important element in the history of draughtsmanship is the collector's mark, usually stamped in ink but seldom embossed, which indicates past (and sometimes present) ownership. The most authoritative work on the subject is *Les Marques de Collections de Dessins et D'Estampes* by Frits Lugt published in Amsterdam in 1921, with a Supplement in 1956.

When it is a question of determining the attribution of a drawing, the ground becomes decidedly uncertain. If no documentation exists which puts authorship beyond dispute, the task of establishing it becomes one solely of stylistic research. It can be arrived at only by a process of induction and comparison, basing all argument wherever possible on drawings of which attribution is firmly acknowledged, and comparing their style and technique with those of the work under scrutiny. Not even the similarity of a drawing of a known painting or sculpture can be decisive proof in itself. Quite the opposite, in fact, for a really marked resemblance may well indicate a copy. The only way in which an attribution can authoritatively be made is by following in the steps of the great connoisseurs, who were frequently also great collectors, and having sufficient knowledge of the artist's hand to be able to recognize its work shining through the darkness of anonymity.

The Great Graphic Collections

In the history of Art, more interest has always been shown in the formation of private and public collections of drawings than in the other figurative arts. Many sculptures and paintings have remained in their original setting to this day, or at least in some suitable surroundings where the public can enjoy them, whereas drawings have become sadly reduced in number over the centuries. Once they left the artists' own hands, many were lost either by destruction or by neglect. The very material on which they had been executed – which was usually of a papery nature – combined with the total lack of respect with which so many were treated over a very long period, meant that it was easy for them to disappear without trace.

In spite of such adverse conditions, collectors have managed to ensure the survival of a great many drawings for the benefit of generation after generation, whether these have been kings or princes, noblemen or private connoisseurs, antiquarians or – in more recent times – public companies and government-supported organizations.

The first question that springs to mind is: when did the earliest collections start to be made? Apart from a few indirect references by classical writers, who suggest that collecting had its origins long before the history of our civilization, there is practically no documentation relative to it before the Renaissance in the Tuscan region of Italy. It was at the Florentine court of Lorenzo de' Medici (1442–92) that the first groups of drawings were put together, but unfortunately they were to be dispersed later. Giorgio Vasari, also from Tuscany, was a painter himself, but is now best remembered as an art historian who wrote the famous '*Le Vite de' più eccellenti Architetti, Pittori e Scultori italiani ...*' (commonly known in English as *Lives of the Artists*). He lived from 1511 to 1574 and made a collection of several hundred sheets of very great quality, covering the period from the fourteenth to sixteenth centuries. Mounted in albums on stiff paper, each with its own decorative frame by Vasari and attested by him, with its attribution well displayed, these drawings really formed the first 'Drawings Room' in history. Unfortunately, they were sold when Vasari died, although many have since reappeared in major collections as part of which they have found their way into repositories such as the Uffizi and the Louvre.

The great Tuscan and Roman artists of the Renaissance greatly attracted the interest of collectors. We know, for instance, that thirteen books of drawings by Leonardo da Vinci were found in the possession of one of his followers, Francesco Melzi, who was born when Leonardo was forty-three and lived for fifty-one years after his death. These sketchbooks were broken up in the 1600s, however, only one group of nearly 800 drawings being kept together; these, having passed through the hands of various English collectors, eventually found their way into the Royal Collection at Windsor Castle.

An important collection of drawings by Michel-angelo was kept for some time by his heirs in Florence, but was eventually split up, a large number of items going to France into the care of Wicar and thence to the Louvre, another group to the British Museum in London. However, a few remained in Michelangelo's family home, the Casa Buonarroti, in Florence, where they can still be appreciated.

In the case of Raphael, not even his own collection of drawings was to remain intact. Many found their way into the hands of the Medici family and thus – via the collection of Timoteo Viti (1470–1523) – to the Uffizi Gallery, while others went to England where they were dispersed into various museums.

No really important collections were made of the drawings of the great sixteenth-century Venetian artists. Even the drawings from Veronese's workshop, which remained in the hands of his heirs until the seventeenth century, were separated and dispersed.

The seventeenth century, however, was the period when the really great collections were made, especially in Italy and France. Carlo Ridolfi (1594–1658), himself a painter, collected a particularly important group which was later taken to England, where it was to form the greater part of the nucleus of the collection at Christ Church, Oxford. At about the same time, the dismemberment of the fine collection of Ludovico Moscardo of Verona took place; this had been started at the end of the seventeenth century and had been particularly rich in examples of North Italian, especially Venetian, works. Many of these drawings went to the Louvre Museum in Paris, the Albertina Gallery in Vienna and into the private collections of Frits Lugt and Janos Scholz.

The fate of a collection made by Filippo Baldinucci (1624–96) of Florence was more fortunate as it entered the Louvre almost intact in 1906; it contains over 1200 drawings, mainly covering the Tuscan schools from their origins up to the seventeenth century. Among other historic collections worthy of especial mention was that of the erudite Padre Sebastiano Resta (1635–1714), from which the 'Portable Gallery' remained intact and is now preserved in the Pinacoteca Ambrosiana, Milan.

The most important private French collections were also formed in the seventeenth century, but nearly all were broken up, despite the efforts of their owners to find a secure home for them in the Royal Collections. That of Jabach (1610–95), the banker, was sold due to a business failure in which its owner was involved, but it was reconstituted by Jabach himself when he had set his affairs to rights; on his death, the more important sheets entered the French royal collections and thus, eventually, the Louvre Museum. Pierre Crozat (1665–1740) had also collected about 19,000 drawings in his attempt to have representatives of every century, but his efforts went for nothing when his collection was broken up after his death, only a small part being rescued and entering the Louvre. P. J. Mariette (1694–1774), the most cultured connoisseur of eighteenth-century Europe, owned at least 2,000 drawings of great rarity, and these, too, were put up for auction when he died. Many of them can be seen today in major collections all over the world.

The English collections also grew apace during the seventeenth century, one of the most outstanding being that of King Charles I (1600–49), with its well-known drawings by Leonardo da Vinci, Michelangelo and Raphael. Although it was auctioned after his execution, at least part of it found its way back into the Royal Collection at Windsor. Many of the seventeenth-century English painters were also collectors, among them Sir Peter Lely (1618–80). Jonathan Richardson (1665–1745) collected about 5,000 items, mostly by Italian artists, and one of the richest collections of all was started by William Cavendish, 2nd Duke of Devonshire (1665–1729). This has been added to by succeeding generations and is preserved in the family seat of Chatsworth House (Derbyshire) today. The tradition of English collecting was continued into the

eighteenth century through the enthusiasm of other painters, for example Sir Joshua Reynolds and Sir Thomas Lawrence. The latter succeeded in amassing several thousand sheets, but his collection suffered the fate of so many others and was scattered in all directions after his death in 1830. A similar disaster had overtaken Reynolds' collection in 1794.

In Central Europe the fashion for collecting was particularly prevalent between the eighteenth and nineteenth centuries, although it never reached the level of importance that it achieved in France and England. For German artists the most important collections were those of Staedel – now in Frankfurt – and Duke Albert of Saxe-Teschen, whose drawings formed the basis of the Albertina Gallery in Vienna. In Hungary, there was the collection of the Esterhàzy Counts, part of which is in the Szépmüvészeti Múseum in Budapest.

During the same period, great private collections were being built up in Italy, especially in the North. Teodoro Correr (1750–1830), for instance, collected about 2,000 sheets and these were to form the basis for the exceptionally fine collection of Venetian drawings in the present Museo Correr in Venice. Still in Venice, it was a Milanese collector named Bossi (1775–1815) whose private collection so enriched the Gallerie dell'Accademia; included in it were some outstanding examples of work by Leonardo da Vinci and Michelangelo.

Fortunately, while so much of Italy's heritage was leaving the peninsula, Santarelli (1801–86) bequeathed his collection, consisting of 125,000 sheets, to the Uffizi Gallery; Riva gave his collection to the museum in Bassano, and Antonio Canova's half-brother, the Abbé Sartori, left over 2,000 sheets of Canova's drawings to the same museum, representing the greater part of all the graphic works of this outstanding sculptor.

It is difficult, nowadays, to keep pace with the innumerable graphic collections being formed. Some of the more outstanding collections, however, must be mentioned: those of Koenigs of Haarlem; van Beuningen of Rotterdam; Morgan, Lehman, Scholz and Heinemann of New York; Frits Lugt of Amsterdam, now in the Musée des Beaux-Arts, Paris; and of Fiocco and Cini in Venice.

A 'Prints and Drawings Room' or 'Department' of some importance is now a familiar part of museums and galleries in nearly every city in the world, most of them formed by the merging of private collections, sometimes over a period of centuries. For a long time the most important in Italy has been the Gabinetto di Disegni in the Uffizi Gallery, Florence; in it are more than 50,000 drawings from all periods and all schools, but with strong Italian representation. Also in Florence are the drawings in the Museo (Fondazione) Horne, which includes some wonderful examples by Tiepolo, while in the Marucelliana are seventeenth-century Tuscan drawings. In the Gabinetto Nazionale delle Stampe (National Drawings and Prints Room), Rome, the drawings are mainly by Tuscan and Roman artists, but they also include some important ones by draughtsmen from other countries. In Venice, there are the Gallerie dell'Accademia with about 1,700 drawings, mainly by Italian artists, including Leonardo da Vinci and Canaletto; there is also the Gabinetto di Disegni in the Museo Correr, where the eighteenth-century Venetian masters, including Tiepolo, Guardi and Longhi, predominate. In Milan, the Pinacoteca Ambrosiana contains more than 10,000 sheets representing all schools.

Of all the European collections, outside Italy, the most important is undoubtedly to be found in the Louvre, where there are more than 100,000 drawings covering every school and every period. The Prints and Drawings Departments of the British Museum and Victoria and Albert Museum in London almost equal the Paris museum in quantity, while the Royal Collection in Windsor Castle cannot be overlooked, as it houses drawings by Leonardo da Vinci, Michelangelo, the Carracci and Canaletto, to name but a few. The Ashmolean Museum in Oxford also has drawings by Raphael,

Michelangelo and the Carracci family.

One of the oldest collections is in the Albertina Gallery in Vienna with 40,000 examples of every school and country, many of which are of a very high standard. The collection in the Kupferstich-kabinett in Berlin is also very rich in drawings, of which it has about 30,000, and is particularly important for its representation of all the European draughtsmen. The Print Rooms in Düsseldorf and Frankfurt are of a similar size and, with the Graphische Sammlung of Munich, are among the most important in Germany. Finally, a little farther to the north-east, is the Hermitage, Leningrad, where more than 40,000 drawings – including some of the great collections of eighteenth- and nineteenth-century artists' work from Central Eastern Europe – are preserved in the collection started by Catherine II, Empress of Russia, during the second half of the eighteenth century.

The graphic collections in the United States of America, although of comparatively recent origin, are now of exceptional importance, due largely to the shrewd choice of examples of really outstanding merit. The most important are in the Morgan Library and Metropolitan Museum of New York; the Fogg Art Museum, Harvard University, Cambridge (Mass.); the Art Institute of Chicago; the Museum of Art, Philadelphia; and the National Gallery of Art, Washington, DC. In addition, a number of private collections are becoming public, for example, the Lehman and Heinemann in New York, and the rather strange collection belonging to Janos Scholz now being transferred to the Morgan Library in New York. Despite the fact that the United States has arrived last on the scene of graphic art, American collectors are showing more interest in drawings than collectors of perhaps any other country, recognizing as they do that it is the most direct way to become familiar with the style of any artist.

Historical notes on the major collections

AUSTRIA
Vienna, Graphische Sammlung Albertina
This gallery was named in the eighteenth century after its founder, the Archduke Albert of Saxe-Teschen (1738–1822). In 1920 it was enlarged to include the graphic collections of the Austrian National Library as well as those from the Kutschera-Woborsky Collection and others. There are now about 40,000 drawings in the care of the Albertina, among which the artists most represented are Dürer from Germany, Rembrandt, Rubens and van Dyck from the Netherlands, and Callot, Claude Lorraine and Watteau from France. The Italian collection is important for its examples of the Tuscan and Venetian masters, Michelangelo, Raphael and Tiepolo.

FRANCE
Paris, Musée National du Louvre, Cabinet des Dessins
King Louis XIV was the founder of this collection. He acquired the collection of the banker, Jabach, in 1671; this consisted of over 5,000 items and was truly comprehensive in its range of periods, styles and nationalities. In the eighteenth century, part of the collections of Mariette entered the Cabinet, to be followed by several expropriated collections such as those of the Florentine family of Strozzi and the Vallardi's. There are over 90,000 drawings, including examples of all the schools, although the most widely represented are naturally the French artists. There are two particularly fine Italian collections, one being the *Codice Vallardi* of graphic work by Pisanello and the *Libro di Disegni* by Jacopo Bellini.

GERMANY
Berlin, Staatliche Museen, Kupferstichkabinett
Founded in 1830 by von Humboldt, this Print Room subsequently benefited from a collection

from Rome of about 10,000 items belonging to Pacetti, as well as those of Beckerath and the Duke of Hamilton. There were over 22,000 items in all, covering all the major schools. Among the most outstanding groups were the Botticelli drawings illustrating Dante's *Divine Comedy*, as well as graphic work by Dürer, Rembrandt, Tiepolo and the eighteenth-century French artists.

Düsseldorf, Kunstmuseum, Kupferstichkabinett
This collection contains more than 30,000 drawings, with particular emphasis on German artists, seventeenth- and eighteenth-century Italians and contemporary masters.

Frankfurt, Staedelsches Kunstinstitut
Founded in the eighteenth century by Staedel, the collections of Grambs and Passavant were soon added to it. Among the 16,000 drawings, especially noteworthy are those from the Low Countries and the eighteenth-century French artists as well as examples by Dürer, Raphael, Bellini, Canaletto and Tiepolo.

Munich, Staatliche Graphische Sammlung
Originating in the eighteenth century, when the collections of the Electors Palatine formed its nucleus, it now houses more than 30,000 sheets. The most important groups consist of drawings by Rembrandt and by such Italian Renaissance artists as Fra Bartolommeo, Michelangelo, Titian and Raphael, with examples of work by German artists of the same period.

GREAT BRITAIN
Chatsworth, Devonshire Collection
Among the great family collections that have survived to this day, that of the Dukes of Devonshire is particularly remarkable. Accommodated in Chatsworth House, built between 1687 and 1706, and in Devonshire House, London, this fine graphic collection was founded by William, the second Duke, around 1723, when he was about fifty-eight. It was based on the collection of Nicolaes Anthoni Flinck of Rotterdam, from which came the wonderful series of Rembrandt drawings. In addition, there was the *Liber Veritatis* of Claude Lorraine, the book of van Dyck sketches, and sheets of drawings by da Vinci, Michelangelo, Raphael, Titian, Correggio, Carpaccio and Dürer. The collection also includes a number of architectural drawings, including many by Andrea Palladio.

Edinburgh, National Gallery of Scotland, Department of Prints and Drawings
The Department of Prints and Drawings was established in 1860 when Lady Murray bequeathed her collection to the Gallery. Two more main collections were subsequently to follow, those of Watson (1881) and David Laing (1910). The Italian section, which has only recently been catalogued, comprises more than 1,000 sheets; some of these, from between the sixteenth and eighteenth centuries, are very important drawings. Particularly notable are the groups by Allegrini, Pompeo Batoni and some eighteenth-century Scottish artists.

London, British Museum, Department of Prints and Drawings
Although prints and drawings were housed in the Museum since its early days – it was founded in 1753 – the Print Room became an independent entity from 1808 onwards. The original provenance of the drawings was the collections of Sir Hans Sloane and Payne Knight, but sheets continued to be brought in until the holding amounted to more than 50,000 items. The outstanding features of the collection are its examples of the Dutch school, with Rubens and Rembrandt; and of the Italian, with Bellini, da Vinci, Michelangelo, Raphael, Jacopo and Domenico Tintoretto, Canaletto and Piranesi. The Germans are represented by albums by Dürer and Holbein, and there are drawings by English artists from the eighteenth century through to Turner.

London, Victoria and Albert Museum, Department of Prints and Drawings
Founded by Queen Victoria and the Prince Consort in 1857, this collection has now reached more than 50,000 sheets, many of which relate to the industrial arts. Especially notable are the collections of Chinese and Japanese graphic work, and of eighteenth-century English drawings.

Oxford, Ashmolean Museum, Drawings Room
Although the collection of graphic work in this museum – named after its founder, Elias Ashmole – dates only from 1908, it has earned great respect for its careful selection of examples of all the schools. Especially important are the Raphael drawings from the Lawrence Collection and the Carracci family's folios from the Ellesmere Collection. Also notable are the examples of English work from the Chambers Hall Collection and the European drawings from the Douce Collection, both acquired later.

Windsor Castle, Royal Art Collection, Drawings Room
This collection was originated by King George III (1751–1820), who amalgamated the collections of King Charles II with those of Cardinal Albani and Consul Smith. The group of 400 drawings by Leonardo da Vinci is the most important in the world, while in close second place are the groups of drawings by the Carracci family, Michelangelo, Raphael, Holbein and Avercamp.

ITALY
Florence, Gabinetto dei Disegni degli Uffizi
The collections made in the seventeenth century by the Medici and Lorena families, to which those of the Santarelli, Martelli and Poccianti families were later to be added, created the foundation for this wonderful assemblage of drawings. All the schools are represented, although those of Italy not unnaturally predominate. The Tuscan school is particularly in evidence, with fine examples of the work of Botticelli, Leonardo da Vinci, Fra Bartolommeo, Michelangelo and Raphael, as is the Venetian school with drawings by Carpaccio, Titian, Tintoretto and Palma il Giovane (Palma the Younger). There is also a splendid collection of ornamental drawings.

Milan, Pinacoteca Ambrosiana, Drawings
Although there are now several thousand sheets of drawings here, the collection originated in the 'Portable gallery' of the eighteenth-century collector Padre Sebastiano Resta. Of especial interest is the *Codice Atlantico* of Leonardo da Vinci's drawings and notes, and the Dürer and Rubens groups.

Rome, Gabinetto Nazionale delle Stampe
This collection was housed in the Palazzo Farnesina until it was transferred to the Palazzo Poli near the Trevi Fountain. There are more than 20,000 drawings in the collection, which originated in the eighteenth-century collections of Cardinal Neri Corsini and Tomaso Corsini, and also those of the Fagnani and Pio families. The material covers a wide field, although its strongest area is in its seventeenth-century Tuscan and Roman drawings.

Venice, Gallerie dell'Accademia, Drawings
Founded at the beginning of the nineteenth century at the same time as the Gallery, the collection of graphic work is based mainly on the provenance of the painter, Bossi, and contains about 2,500 drawings. Its most important possessions are its group of da Vinci drawings, the *Quaderno di Raffaello* (Raphael's *Notebook*) and the numerous eighteenth-century folios amongst which are groups of drawings by Pittoni, Ricci and Canaletto, including the latter's famous *Quaderno di Schizzi* (*Sketchbook*).

Venice, Museo Correr, Gabinetto delle Stampe e Disegni
Founded in 1830 with material collected by Teodoro Correr and from the Museo Civico, this still makes up the greater part of the collection. Later were added the collections of Molin, Zoppetti, Gamba, Manfredini, Gatteri, Molmenti and Musatti. There are now over 8,000 sheets here, amongst which are about 1,000 architectural drawings. The strongest area of the collection is in eighteenth-century Venetian work, with about 1,000 really outstanding drawings, representing nearly all the artists of the period. Also of especial interest are the numerous groups of drawings by Guardi, Tiepolo, Diziani, Longhi, Pittoni, Gaspari and, from the nineteenth century, Caffi, Bertoja and Bagnara.

THE NETHERLANDS
Amsterdam, Rijksmuseum, Prentenkabinet
Having originated in 1799 with the collections of Prince William of Orange and Baron van Leyden, the collection was subsequently enlarged by the deGroot Bequest and the Lichtenstein, Mannheimer and Fodor Collections. The Dutch school is especially well represented, with particular emphasis on Rembrandt.

Haarlem, Teylers Stitchting, Drawings
In this museum, founded in 1778, the collection of graphic work stems from the folios once belonging to the Duke of Bracciano and Queen Christina of Sweden. The main features of the collection, however, are its numerous drawings by Rembrandt and Claude Lorraine, and twenty-five of Michelangelo's work from the Lestevanon Collection.

Rotterdam, Museum Boymans-van Beuningen, Drawings
Founded in the early nineteenth century, the Museum Boymans lost almost its entire collection of Italian drawings in a fire. However, the purchase in 1935 of the Koenigs Collection has restored it to its original importance, representing as it does all the European schools. Perhaps its best known possession is represented by the two albums (more than 500 sheets) of drawings by Fra Bartolommeo, which had belonged to the Duke of Weimar.

SPAIN
Madrid, Accademia Reale di San Fernando, Drawings
The Accademia, which was created in 1752, possesses a rich but little known collection of drawings, the majority of which are Italian. The first large acquisition was the Procaccini Collection, which contained many works from the late seventeenth- and early eighteenth-century Roman artists, especially Carlo Maratta. Subsequently a great many Spanish drawings from the seventeenth century onwards were acquired. Amongst the most interesting sheets, however, are those by seventeenth-century Bolognese artists such as the Carracci family, Guercino and Reni.

Madrid, Biblioteca Nacional, Fine Arts Section
There are more than 30,000 drawings, representing all the European schools, in this collection, which originated in 1867. It was first housed in the Biblioteca Reale (Royal Library), where its nucleus consisted of the collections of an erudite collector, Valentin Carderera y Solano, with sheets by Goya and the Italian artists up to Tiepolo. Another important acquisition was the Madrazo Collection with its numerous drawings by Carlo Maratta.

Madrid, Museo del Prado, Drawings
Since the foundation of the museum in 1819, an important collection of drawings has been built up which is, unfortunately, still little known. The original source of these works was the Royal Collection, which contained about 700 items, predominantly Spanish or by artists who worked at Court. There is a particularly important collection of drawings by Goya, and about 3,000 drawings bequeathed to the Collection by Fernandez Durán in 1931, including sheets by Cambiaso and some eighteenth-century Bolognese painters.

SWEDEN
Stockholm, Nationalmuseum, Print Room
This collection originates from a group of drawings emanating in 1866 from the Count of Tessin, who in the previous century had acquired numerous folios from the great French collector Pierre Crozat. Several subsequent bequests, consisting of the Sergel, Anckarswärd and Cronstedt Collections, have made the Stockholm Print Room particularly strong in architectural drawings, with more than 20,000 items.

HUNGARY
Budapest, Szépmüvészeti Múzeum, Print Room
This collection, which contains more than 5,000 items, originated in the nineteenth century from the collection of the Princes Esterhàzy. To it were subsequently added the Delhaes, Kleinberger, Meller and Majovszky collections. Its main importance is in the German area, with Dürer, and in the Dutch, with Rembrandt. French artists of the nineteenth century are also well represented.

USSR
Leningrad, Hermitage, Print Room
This collection originated with the acquisition in 1768 of the Count of Brühl's Collection by Catherine II, Empress of Russia. To this the Kobenzl, Yusopov, Divoff and Grassi Collections were subsequently added. In 1924 the drawings from the Academy of Fine Arts in St Petersburg (Leningrad) also entered the Hermitage's Print Room, and today it contains about 40,000 sheets of drawings. Amongst the more important entries have been the Jacques Callot album, with more than 800 sheets and drawings by Tiepolo, Quarenghi and Greuze.

USA
Cambridge, Mass., Harvard University, Fogg Art Museum, Drawings
Founded in 1895, the museum contains a collection of about 1,000 drawings of a very high standard. They represent all the European schools and have entered the museum from the Randall, Loeser, Winthrop and Sachs Collections. Especially notable are the nineteenth-century French drawings and those by Rembrandt, Tiepolo and Guardi.

Chicago, Art Institute of Chicago, Drawings
Founded in 1911, the Art Institute of Chicago has a collection of about 15,000 drawings, representing all the main artists. The main sources – Gurley, Wrenn, Brewster and Regenstein – have been particularly rich in nineteenth-century French drawings, in addition to drawings by Rembrandt, Guardi and Piazzetta.

New York, Cooper-Hewitt Museum, Drawings
This collection is based on a bequest of Sarah and Eleanor Hewitt in 1859; it was subsequently enlarged by drawings from the Cooper Union Museum, which was particularly strong in ornamental and architectural drawings from all the European schools. The entire collection now consists of about 30,000 sheets of drawings.

New York, Metropolitan Museum, Department of Drawings
Having formed a nucleus of drawings with the Vanderbilt and Biron Collections when the museum opened in 1870, the Department of Drawings was subsequently enlarged by the acquisition of the Havemayer, Rogers, Sinsheimer, Hyde and Heinemann Collections. There are excellent examples of all the schools and among the best known groups are those of Tiepolo, Guardi, Goya, Ingres and the Impressionist masters.

New York, Pierpont Morgan Library, Prints and Drawings
This collection of graphic work, which was built up after the death of its founder, Pierpont Morgan, in 1913, consists of more than 3,000 sheets, most of which stem from the Fairfax Murray Collection. Among the best known groups of drawings are works by Piranesi and Robert Adam.

Bibliography

This bibliography represents a selection of the material available, with particular reference to the artists and drawings covered in this volume.

Sources and Theory
This section is ordered chronologically to provide a comprehensive view of critical treatises and theories on drawing in general.

Teophylus Presbyter, *Schedula diversarum artium* (12th century), edited by A. Igl, Vienna 1874

V. de Honnecourt, *Livre de portraiture* (13th century), edited by H. R. Hahnloser, Vienna 1935

C. Cennini, *Il libro dell'arte* (*The Craftsman's Handbook*) translated Daniel V. Thompson, Jr., New Haven, N.J., 1961

L. B. Alberti, *Della pittura* (1436), edited by L. Mallé, Florence 1950

L. Ghiberti, *I Commentari* (post 1447), edited by O. Morisani, Naples 1947

P. della Francesca, *De prospectiva pingendi* (c. 1474), edited by G. Nicco Fasola, Florence 1942

L. da Vinci (end 15th–beginning 16th century), cf. R. P. Richter, *The Literary Works of Leonardo da Vinci*, 3rd ed., New York 1970

A. Dürer (end 15th–beginning 16th century), cf. P. Vaisse, *Dürer, Lettres et écrits théoriques traité des proportions*, Paris 1964; H. Rupprich, *Dürer Schriftlicher Nachlass*, Berlin 1969

P. Pino, *Dialogo di pictura* (Venice 1548), edited by R. and A. Pallucchini, Venice 1946

A. F. Doni, *Disegno partito in più ragionamenti*, Venice 1549

G. Vasari, *Lives of the artists*, London 1960

L. Dolce, *Dialogo della pittura intitolato l'Aretino*, Venice 1557

R. Borghini, *Il Riposo . . .* (Florence 1584), edited by M. Rosci, Milan 1967

G. P. Lomazzo, *Trattato dell'Arte della Pittura* (Milan 1584), edited by R. Ciardi, Florence 1974

G. B. Armenini, *De' Veri Precetti della Pittura* (Ravenna 1587), edited by S. Ticozzi, Milan 1820

Trattati d'arte del Cinquecento fra Manierismo e Controriforma, edited by P. Barocchi, Bari 1960–2

Scritti d'arte del Cinquecento, edited by P. Barocchi, Milan–Naples 1971–77, Turin 1979

C. van Mander, *Schilderboeck*, Haarlem 1604

F. Zuccaro, *L'idea de' scultori, pittori e architetti* (Turin 1607), edited by D. Heikamp, Florence 1961

C. Ridolfi, *Le Maraviglie dell'Arte* (Venice 1648), edited by D. von Hadeln, Berlin 1914–24

M. Boschini, *La carta del navegar pitoresco* (Venice 1660), edited by A. Pallucchini, Venice 1966

J. van Sandrart, *Teutsche Academie der elden Bau-, Bild- und Mahlerei Künste*, Nuremberg 1675

C. Malvasia, *Felsina pittrice. Vite de' pittori bolognesi* (Bologna 1678), edited by M. Bascaglia, Bologna 1971

F. Baldinucci, *Vocabolario toscano dell'arte del disegno* (Florence 1681), in Opere di F. Baldinucci, vols. II, III, Milan 1809

F. Baldinucci, *Notizie de' Professori del disegno* (Florence 1681 and 1728), edited by F. Ranalli, Florence 1845–47

H. Gautier de Nîmes, *L'art de laver ou nouvelle manière de peindre sur le papier*, Lyon 1687

R. de Piles, *Cours de Peinture par principies*, Paris 1708

J. Richardson, *An Essay on the Theory of Painting*, London 1715–25

P. J. Mariette, *Réflexions sur la manière de déssiner des principaux peintres*, Paris 1741

A. Dézailler d'Argenville, *Abregé de la vie des plus fameux peintres et de la manière de connaître les dessins et les tableaux*, Paris 1745–52

K. H. von Heinecken, *Idée générale d'une collection complète d'estampes avec une dissertation sur l'origine de la gravure et sur les premiers livres d'images . . .*, Vienna 1771

F. Milizia, *Dizionario delle belle arti del disegno* (Bassano 1787), in Opere complete di F. Milizia, edited by A. Cardinali, Bologna 1826–7

J. Schlosser Magnino, *Die Kunstliteratur*, Vienna 1924

J. D. Ingres, *Notes et pensées*, in Ingres, sa vie, ses travaux, sa doctrine, V. Delaborde, Paris 1870

E. Delacroix, *De l'enseignement du dessin* in Oeuvres Littéraires, ed. Elie Faure, Paris 1923

J. Ruskin, *The elements of drawing and the elements of perspective*, London 1859

C. Blanc, *Les arts du dessin*, Paris n.d.

A. Pope, *The language of Drawing and Painting*, Cambridge 1921, 1931, 1949

B. Degenhart, *Zur Graphologie der Handzeichnung*, in Kunstgeschichtliches Jahrbuch der Bibliotheca Hertziana, 1937, pp. 223 ff.

L. H. Heyndenreich, *Literaturbericht: B.D. 'Zur Graphologie der Handzeichnung'*, in Zeitschrift für Kunstgeschichte, 1938, pp. 163 ff.

C. L. Ragghianti, *Sul metodo nello studio dei disegni*, in Le Arti, Oct.–Nov. 1940, pp. 9 ff.

L. Grassi, *Il concetto di schizzo, abbozzo, macchia, 'non finito' e la costruzione dell'opera d'arte*, in Studi in onore di P. Silva, Florence 1957, pp. 110 ff.

W. Kandinsky, *Point, ligne, plan*, Paris 1970

J. Ittens, *Le dessin et la forme*, Paris 1973

P. Rawson, *Drawing. The Appreciation of Arts*, Oxford 1973

General Works
Besides these general works, other relevant material is contained in specialist magazines (Old Master Drawings, Master Drawings, etc.). Only the titles of such periodicals are quoted in this section: individual articles dealing with drawings in this book are listed in the **Specific Works** *section.*

J. Adhémar, *Le dessin français au XVIe siècle*, Lausanne 1954

M. Almagro, *Ars Hispaniae, vol. I, Arte Prehistorico*, Madrid 1947

W. Ames, *Les plus beaux dessins italiens*, New York 1964

A. Ananoff, *Les dessins anciens regardés de près*, in Connaissance des Arts, July 1965, pp. 84 ff.

G. Aurenhammer, *Die Handzeichnung des 17. Jahrhunderts in Österreich*, Vienna 1958

G. Bataille, *La peinture préhistorique. Lascaux ou la Naissance de l'Art*, Geneva 1955

S. Béguin, *Il Cinquecento francese. I Disegni dei Maestri*, Milan 1970

O. Benesch, *Venetian Drawings of the Eighteenth Century in America*, New York 1947

B. Berenson, *Drawings of the Florentine Painters*, London 1903

W. Bernt, *Die Niederländischen Zeichner des 17. Jahrhunderts*, Munich 1957

Biblioteca di disegni, Alinari, Florence

H. Boeckoff–F. Winter, *Das grosse Buch der Graphik*, Brunswick 1968

K. G. Boon, *De Tekenkunst in de zeventiende eeuw*, Utrecht 1955

F. Boucher – P. Jaccottet, *Le dessin français au XVIIIe siècle*, Lausanne 1952

C. M. Briquet, *Les Filigranes. Dictionnaire historique des marques du papier dès leur apparition vers 282 jusqu'en 1600*, Geneva 1907, New York 1966

R. Carrieri, *Il Disegno Italiano Contemporaneo*, Milan 1945

J. Cassou–P. Jaccottet, *Le dessin français au XXe siècle*, Lausanne 1951

M. Chiarini, *I disegni italiani di paesaggio*, Treviso 1972

W. Cohn, *Chinese Painting*, New York 1948

Collana Disegnatori Italiani, edited by R. Pallucchini, Aldo Martello Editore, Milan 1971–7

L. Collobi Ragghianti, *Il Libro de' Disegni del Vasari*, Florence 1974

G. De Fiore, *Dizionario del Disegno*, Brescia 1967

B. Degenhart, *Europäische Handzeichnungen aus fünf Jahrhunderts*, Zürich 1943

B. Degenhart, *Italienische Zeichnungen des frühen 15. Jahrhunderts*, Basle 1949

B. Degenhart, *Italienische Zeichner der Gegenwart*, Berlin 1956

B. Degenhart–A. Schmitt, *Corpus der Italienischen Zeichnungen 1300–1450*, Berlin 1968

Die Meisterzeichnungen, series edited by W. Hugelshofer, Freiburg 1928–36

A. De Witt, *Il disegno dei macchiaioli*, in Emporium, 1937, pp. 545 ff.

C. T. Eisler, *I Maestri del Disegno. Fiamminghi e Olandesi*, Milan 1964

C. Eisler, *La mano, il segno*, Milan 1976

M. W. Evans, *Medieval Drawings*, London 1969

C. Farina, *La Pittura Egiziana*, Milan 1929

O. Fischel, *Die Zeichnung der Umbrer*, in Jahrbuch der Königlich. Preussischen Kunstsammlungen, 1917, pp. 1–72 and 1–188

O. Fischer, *Die Zeichnung des frühen und hohen Mittelalters*, Munich 1951

O. Fischer, *Geschichte der deutschen Zeichnung und Graphik*, Munich 1951

A. Forlani, *I disegni italiani del Cinquecento*, Venice n.d.

A. Forlani Tempesti, *Capolavori del Rinascimento. Il primo Cinquecento toscano. I Disegni dei Maestri*, Milan 1970

M. Fossi Todorow, *L'Italia dalle origini a Pisanello. I Disegni dei Maestri*, Milan 1970

P. Ganz, *Handzeichnungen schweizerischer Meister des 15. bis 18. Jahrhunderts*, Basle 1904–7

K. Garzarolli Thurnlackh, *Die Barockehandzeichnung in Österreich*, Zürich–Vienna–Leipzig 1928

J. Gere, *Il Manierismo a Roma*, I Disegni dei Maestri, Milan 1971

T. Gerszi, *Capolavori del Rinascimento tedesco. I Disegni dei Maestri*, Milan 1970

O. H. Giglioli, *Disegno. Raccolte di disegni*, in Enciclopedia Italiana, XII (1932), pp. 11 ff.

L. Grassi, *Storia del disegno*, Rome 1947

L. Grassi, *Il disegno italiano dal Trecento al Seicento*, Rome 1956

L. Grassi, *I disegni italiani del Trecento e Quattrocento. Scuole fiorentina, senese, marchigiana, umbra*, Venice n.d.

A. Griseri, *Il disegno*, in Storia dell'arte italiana Einaudi, vol. IX, pp. 187 ff.

P. Guggenheim, *Art of this Century*, New York 1942

D. von Hadeln, *Venezianische Zeichnungen des Quattrocento*, Berlin 1925

D. von Hadeln, *Venezianische Zeichnungen der Hochrenaissance*, Berlin 1925

D. von Hadeln, *Venezianische Zeichnungen der Spätrenaissance*, Berlin 1926

W. Hugelshofer, *Schweizer Handzeichnungen des XV. und XVI. Jahrhunderts*, Freiburg 1928

R. Huyghe–P. Jaccottet, *Le dessin français au XIXe siècle*, Lausanne 1956

I Disegni dei Maestri, series edited by W. Vitzthum, Fratelli Fabbri Editori, Milan 1970

Il Disegno Italiano, series directed by L. Grassi, Treviso n.d.

I Grandi Maestri del Disegno, series edited by C. Baroni, Martello, Milan 1952–64

I Maestri del Disegno, Bompiani, Milan 1964–66

R. Ironside–J. Gere, *The Pre-Raphaelites*, London 1948

N. Ivanoff, *I disegni italiani del Seicento. Scuola veneta, lombarda, ligure, napoletana*, Venice n.d.

U. E. Johnson, *20th Century Drawings*, Drawings of the Masters, London 1964

O. Kurz, *Falsi e falsari*, Venice 1961

J. Kuznetsov, *Capolavori fiamminghi e olandesi*. I Disegni dei Maestri, Milan 1970

P. Lavallée, *Le dessin français du XIIIe au XVIe siècle*, Paris 1930

P. Lavallée, *Le dessin français*, Paris 1948

Le dessin français, edited by J. Adhémar, Lausanne 1951–6

H. Leporini, *Die Stilentwicklung der Handzeichnung XIV. bis XVIII. Jahrhundert*, Vienna–Leipzig 1925

H. Leporini, *Die Künstlerzeichnung*, Brunswick 1955 (1st ed. 1928)

F. Lugt, *Les marques de Collections de dessins ... avec des notices historiques sur les collectioneurs, les collections, les marchands et éditeurs*, Amsterdam 1921

S. Macchioni, *Il disegno nell'arte italiana*, Florence 1975

P. J. Mariette, *Description sommaire des dessins des grand maîtres ... du cabinet de feu M. Crozat*, Paris 1740

P. J. Mariette, *Abécédaire ...*, edited by Ph. de Chennevières and A. de Montaiglon, Paris 1851–60

F. R. Martin, *The Miniature Painting and Painters of Persia, India and Turkey from the 8th to the 18th century*, London 1912

Master Drawings, New York 1963

J. Meder–W. Ames, *The Mastery of Drawing*, New York 1978

M. Meiss, *French Painting in the Time of Jean de Berry: the late XIVth Century*, 1967

D. M. Mendelowitz, *Drawing*, New York 1967

C. M. Metz, *Imitations of Ancient and Modern Drawings from the Restaurations of the Arts in Italy to the Present Time*, London 1978

T. Miotti, *Il collezionista di disegni*, Udine 1962

H. Möhle, *Deutsche Zeichnungen des 17. und 18. Jahrhunderts*, Berlin 1947

C. Monbeig Goguel, *Il manierismo fiorentino*. I Disegni dei Maestri, Milan 1971

A. Morassi, *Settecento inedito*, in Arte Veneta, 1952, pp. 85 ff.

Morel D'Arleux, *Le Cabinet du Roi*, Paris 1797–1827

I. Moskowitz, *Grandi disegni di ogni tempo*, Milan 1963

T. W. Muchall Viebrook, *Flemish Drawings of the Seventeenth Century*, London 1926

G. Nebehay, *Die Zeichnung*, Vienna 1927

C. Nordenfalk, *Celtic and Anglo-Saxon Painting Book Illumination in the British Isles 600–800*, New York 1977

Old Master Drawings, London 1926–40

M. Pallottino, *La Peinture Etrusque*, Geneva 1952

K. T. Parker, *Drawings of the Early German Schools*, London 1926

K. T. Parker, *North Italian Drawings of the Quattrocento*, London 1927

A. E. Pérez Sánchez, *Gli spagnoli da El Greco a Goya*. I Disegni dei Maestri, Milan 1970

T. Pignatti, *I disegni veneziani del Settecento*, Treviso n.d.

T. Pignatti, *La scuola veneta*. I Disegni dei Maestri, Milan 1970

A. E. Popham, *Drawings of the Early Flemish School*, London 1926

M. Robertson, *La Peinture Grèque*, Geneva 1959

R. Roli, *I disegni italiani del Seicento*, Treviso 1969

J. Rosenberg, *Great Draughtsmen from Pisanello to Picasso*, Cambridge (Mass.) 1959

G. Rowley, *Chinese Painting*, Princeton 1947

P. J. Sachs, *Modern Prints and Drawings: A Guide to a Better Understanding of Modern Draughtsmanship*, New York 1954

P. J. Sachs, *The Pocket Book of Great Drawings*, Washington 1961

F. J. Sanchez Canton, *Dibujos españoles*, Madrid 1930

R. W. Scheller, *A survey of Medieval Model Books*, Haarlem 1963

A. van Schendel, *Le dessin en Lombardie jusqu'à la fin du XVe siècle*, Brussels 1938

M. Sérullaz, *Drawings of the Masters: French Impressionists*, New York 1962

E. Schilling, *Altdeutsche Meisterzeichnungen*, Frankfurt 1937

A. Schmitt, *Italienische Zeichnungen der Frührenaissance*, Munich 1966

L. Sickman–A. Soper, *L'arte e l'architettura cinese*, Turin 1969

Societé de reproduction des dessins de maîtres, Paris 1909–12

F. H. Taylor, *The taste of Angels: a History of Collecting from Ramses to Napoleon*, Boston 1954

A. Terukazu, *La Peinture Japonaise*, Geneva 1961

The 'Vasari Society' for the Reproduction of Drawings by Old Masters, Oxford 1905–22

C. Thiem, *Florentiner Zeichner des Frühbarock*, Munich 1977

H. Tietze, *European Master Drawings in the United States*, New York 1947 and 1973

H. Tietze–E. Tietze Conrat, *The Drawings of the Venetian Painters in the XVth and XVIth Centuries*, New York 1944

P. Toesca, *La pittura e la miniatura nella Lombardia*, Milan 1912 (2nd ed. Milan 1966)

J. Vallery Radot–P. Jaccottet, *Le dessin français au XVIIe siècle*, Lausanne 1953

W. Vitzthum, *Il Barocco a Napoli e nell'Italia Meridionale*. I Disegni dei Maestri, Milan 1971

W. Vitzthum, *Il Barocco a Roma*. I Disegni dei Maestri, Milan 1971

H. Voss, *Zeichnungen der italienischen Spätrenaissance*, Munich 1928

E. Wiegand, *Drei südostdeutsche Federzeichnungen des 14. Jahrhunderts*, in Anzeiger des Germanischen Nationalmuseum, 1934–5, pp. 49 ff.

F. Windels, *Lascaux, 'Chapelle Sixtine' de la Préhistoire*, Montignac-sur-Vézère (Dordogne) 1948

R. Wittkower, *Great Master Drawings of Seven Centuries*, New York 1959

R. Zeitler, *Die Kunst des 19.Jahrhunderts*, Berlin 1966

C. Zoegel von Manteuffel, *Italienische Zeichnungen von 14.bis 18.Jahrhundert*, Hamburg 1966

Specific Works
The titles of both studies and specific articles from magazines are listed here.

A. Ananoff, *L'oeuvre dessiné de Jean Honoré Fragonard (1732–1806). Catalogue raisonné*, Paris 1961–70

A. Ananoff, *L'oeuvre dessiné de François Boucher*, Paris 1966

T. Andersen, *'Présentation' de K. S. Malevich*, in Essays on Art, vol. IV, Copenhagen 1978

L. Aragon, *L'exemple de Courbet*, Paris 1952

F. Arcangeli, *Graham Sutherland*, Milan 1973

L. Armstrong, *The Paintings and Drawings of Marco Zoppo*, New York and London 1976

W. Arslan, *I Bassano*, Milan 1960

G. J. Aubry–R. Schmit, *Eugène Boudin*, Neuchâtel 1968

A. Ballarin, *Introduzione a un Catalogo dei disegni di Jacopo Bassano, I*, in Arte Veneta, 1969, pp. 85 ff.

A. Ballarin, *Introduzione a un Catalogo dei disegni di Jacopo Bassano, II*, in Studi di Storia dell'Arte in onore di Antonio Morassi, Venice 1971, pp. 148 ff.

A. Ballarin, *Introduzione a un Catalogo dei disegni di Jacopo Bassano, III*, in Arte Veneta, 1973, pp. 91 ff.

G. Ballo, *Boccioni, la vita e l'opera*, Milan 1964

A. Barr jr., *Matisse: His Art and His Public*, New York 1951, 1966

E. Baumeister, *Eine Zeichnung des jungen Greco*, in Münchner Jahrbuch der bildenden Künste, 1929, pp. 201 ff.

J. I. H. Baur, *George Grosz*, New York 1954

L. Behling, *Die Handzeichnungen des Mathis Gothart Nithart genannt Grünewald*, Weimar 1955

O. Benesch, *The Drawings of Rembrandt*, London 1954–7

M. Bernardi, *Antonio Fontanesi*, Milan 1968

L. Berti, *Pontormo. Disegni*, Florence 1966

A. Bertini, *Botticelli*. I grandi maestri del disegno, Milan 1953

C. van Beuningen, *The Complete Drawings of Hieronymus Bosch*, London–New York 1973

A. Blunt, *The Art of William Blake*, New York 1959

A. Blunt, *The Drawings of Poussin*, New Haven and London 1979

O. Breicha, *Gustav Klimt*, Salzburg 1978

G. Briganti, *Pietro da Cortona o della pittura barocca*, Florence 1962

J. Brown, *Jusepe de Ribera*, in Record of the Art Museum Princeton, 1972, p. 7

J. Brown, *Jusepe de Ribera. Prints and Drawings*, Princeton 1973

L. Browse, *Degas Dancers*, New York 1949

L. Budigna, *Giovanni Segantini*, Milan 1962

L. Burchard–R. A. d'Hulst, *Rubens Drawings*, Brussels 1963

J. Byam Shaw, *Lorenzo di Credi*, in Old Master Drawings, June 1928, p. 6

J. Byam Shaw, *The Drawings of Francesco Guardi*, London 1951

J. Byam Shaw, *The Drawings of Domenico Tiepolo*, London 1962

J. Byam Shaw, *Titian's Drawings: a Summing up*, in Apollo, Dec. 1980, pp. 386 ff.

M. Carrà–F. Russoli, *Disegni di Carlo Carrà*, Bologna 1977

J. Cassou–J. Leymarie, *Fernand Léger. Dessins et Gouaches*, Paris 1972

A. Chappuis, *The Drawings of Paul Cézanne. A Catalogue Raisonné*, London 1972

J. Ciervo, *El Arte y el vivir de Fortuny*, Barcelona n.d.

M. Cinotti, *Zandomeneghi*, Busto Arsizio 1960

R. Cocke, *Pier Francesco Mola*, Oxford 1972

R. Cocke, *Veronese's Independent Chiaroscuro Drawings*, in Master Drawings, 1977, pp. 259 ff.

C. E. Cohen, *The Drawings of Giovanni Antonio da Pordenone*, Florence 1980

W. G. Constable–J. G. Links, *Canaletto*, Oxford 1976

D. Cooper, *Pastels d'Edgar Degas*, Basle 1952

J. Cox Rearick, *The Drawings of Pontormo*, Cambridge (Mass.) 1964

E. Dacier, *Gabriel de Saint-Aubin*, Paris 1929–31

F. Daulte, *Pierre Auguste Renoir, Aquarelles, pastels et dessins en couleurs*, Basle 1958

B. Degenhart, *Pisanello*, Turin 1945

B. Degenhart, *Giacomo Manzú. Mädchen und Frauen*, Munich 1958

B. Degenhart–A. Schmitt, *Gentile da Fabriano in Rom und die Anfänge des Antikenstudiums*, in Münchner Jahrbuch der bildenden Kunst, 1960, pp. 59 ff.

G. de' Grassi, *Taccuino di Disegni*, Monumenta Bergomensia, Bergamo 1961

M. Delaroche–Vernet Henraux, *Henri Toulouse-Lautrec dessinateur*, Paris 1949

B. Della Chiesa, *L'opera completa di Fattori*, Milan 1970

G. Delogu, *G. B. Castiglione detto il Grechetto*, Bologna 1928

R. Descharnes, *Dali de Gala*, Paris 1962

H. Dorra–J. Rewald, *Seurat*, Paris 1959

M. G. Dortou, *Toulouse Lautrec et son Oeuvre*, New York 1971

P. Dreyer, *Tiziansfälschungen des sechzehnten Jahrhunderts*, in Pantheon, 1979, pp. 365 ff.

J. Dupin, *Juan Miró; la vie et l'oeuvre*, Paris 1961

L. Düssler, *Die Zeichnungen des Michelangelo. Kritischer Katalog*, Berlin 1959

E. H. Dwight, *The Ballet*, in Cincinnati Art Museum Bulletin, Dec. 1952, pp. 8 ff.

H. Edwards, *Two Drawings by Maurice Quentin de la Tour*, in The Art Institute of Chicago Quarterly, March 1961, pp. 2 ff.

R. Enggass, *The Paintings of Baciccio. Giovanni Battista Gaulli, 1639–1709*, Clinton 1964

R. Escholier, *Delacroix*, Paris 1926

L. D. Ettlinger, *Antonio e Piero Pollaiuolo*, Oxford–New York 1978

J. B. de la Faille, *The Works of Vincent van Gogh: His Paintings and Drawings*, London 1971

A. Fermigier, *Courbet*, Geneva 1971

O. Ferrari–G. Scavizzi, *Luca Giordano*, Naples 1966

A. Flament, *Georges Barbier: dessinateur du théatre*, in La Renaissance de l'Art Français et des Industries de luxe, April 1924, pp. 180 ff.

A. J. Finberg, *In Venice with Turner*, London 1930

G. Fiocco, *I disegni di Giambellino*, in Arte Veneta, 1949, pp. 40 ff.

O. Fischel, *Raphaels Zeichnungen*, Berlin 1913–42

O. Fischel, *Raphael*, Berlin 1962

E. Fleury–B. Brière, *Catalogue des Pastels de M. Quentin de la Tour*, Paris 1920

A. Foratti, *Canova disegnatore*, in Bollettino d'Arte, 1922

B. Ford, *The Drawings of Richard Wilson*, London 1951

F. Fosca, *Les dessins de Fragonard*, Lausanne 1954

M. Fossi Todorow, *I disegni del Pisanello e della sua cerchia*, Florence 1966

S. J. Freedberg, *Andrea del Sarto*, Cambridge (Mass.) 1963

V. Fresch–T. Shipley, *Auguste Rodin*, New York 1939

M. J. Friedländer, *A Drawing by Roger van der Weyden*, in Old Master Drawings, 1926–7, pp. 29 ff.

M. J. Friedländer, *Zeichnungen. M. Grünewald*, Berlin 1927

M. J. Friedländer, *Lucas van Leyden*, Berlin 1963

M. J. Friedländer, *Rogier van der Weyden and the Master of Flémalle*, Leyden–Brussels 1967

M. J. Friedländer, *The van Eycks–Petrus Christus*, Leyden–Brussels 1967

M. J. Friedländer, *Albrecht Altdorfer. Ausgewählte Handzeichnungen*, Berlin n.d.

W. Friedländer–A. Blunt, *The Drawings of Nicolas Poussin. Catalogue Raisonné*, London 1939–74

H. von der Gabelentz, *Fra Bartolommeo und die florentiner Renaissance*, Leipzig 1922

J. Gantner, *Konrad Witz*, Vienna 1943

P. Ganz, *Die Handzeichnungen Hans Holbein d.J.*, Berlin 1937

K. Garas, *Franz Anton Maulbertsch*, Budapest 1960

A. T. E. Gardner, *Winslow Homer*, New York 1961

P. Gassier, *Les dessins de Goya*, Fribourg 1973

B. Geiger, *I disegni del Magnasco*, Padua 1945

C. Glaser, *Hans Holbein d. J. Zeichnungen*, Basle 1924

C. Gnudi–G. C. Cavalli, *Guido Reni*, Florence 1955

L. Godefroy, *L'Oeuvre gravé de Adriaen van Ostade*, Paris 1930

V. Goloubew, *Die Skizzenbücher Jacopo Bellinis*, Brussels 1908–12

E. de Goncourt, *Catalogue raisonné de l'oeuvre de P. P. Prud'hon*, Paris 1876

W. Grohmann, *Paul Klee Handzeichnungen*, Cologne 1959

G. Grosz, *George Grosz Drawings*, New York 1944

D. von Hadeln, *Zeichnungen des Giacomo Tintoretto*, Berlin 1922

D. von Hadeln, *Zeichnungen des Titians*, Berlin 1924

D. von Hadeln, *Handzeichnungen von G. B. Tiepolo*, Florence–Munich 1927

D. von Hadeln, *The Drawings of Antonio Canal called Canaletto*, London 1929

W. Haftmann, *Marc Chagall. Gouachen, Zeichnung, Aquarelle*, Cologne 1975

H. R. Hahnloser, *Villard de Honnecourt*, Vienna 1935

F. Hartt, *The Drawings of Michelangelo*, London 1971

J. Hayes, *The Drawings of Thomas Gainsborough*, London 1970

D. Heikamp, *Vicende di Federigo Zuccari*, in Rivista d'Arte, 1957, pp. 175 ff.

J. S. Held, *Rubens: Selected Drawings*, London 1959

R. Holland, *The Carracci Drawings and Paintings*, Newcastle upon Tyne 1961

C. Holme, *Corot and Millet. Studio*, London 1902–3

J. Hulsker, *The Complete van Gogh. Paintings. Drawings. Sketches*, New York 1980

R. A. d'Hulst, *Jordaens' Drawings*, London 1974

M. Jardot, *Picasso–Dessins*, Paris 1959

E. A. Jewell, *Georges Rouault*, New York 1945

H. Jouin, *Charles le Brun et les Arts sous Louis XIV*, Paris 1889

C. Koch, *Die Zeichnungen Hans Baldung Griens*, Berlin 1941

J. Lassaigne, *Kandinsky*, Geneva 1964

J. Lauts, *Domenico Ghirlandaio*, Vienna 1943

J. Lauts, *Carpaccio*, London 1962

C. Leger, *Courbet*, Paris 1948

A. de Leiris, *The Drawings of Edouard Manet*, Berkeley–Los Angeles 1969

P. A. Lemoisne, *Degas et son oeuvre*, Paris 1946

J. Leymarie, *Paul Gauguin*, Basle 1960

J. Leymarie, *Acquarelli di Morandi*, Bologna 1968

R. Lightbrown, *Sandro Botticelli*, London 1978

J. Lord, *Alberto Giacometti Drawings*, London 1971

G. K. Loukomski–P. de Nolhac, *La Rome d'Hubert Robert*, Paris 1930

H. Macfall, *Aubrey Beardsley*, New York 1927

G. Mack, *Toulouse Lautrec*, New York 1938

D. Mahon, *Il Guercino. Catalogo critico dei disegni*, Bologna 1969

K. E. Maison, *Honoré Daumier. Catalogue Raisonné of Paintings, Watercolours and Drawings*, London 1968

E. Major–E. Gradman, *Urs Graf*, Basle n.d.

L. Malvano, *Gustave Courbet*, Milan 1966

G. Marchiori, *Disegni di Scipione*, Bergamo 1954

H. C. Marillier, *The Early Work of Aubrey Beardsley*, London 1899, New York 1967

H. C. Marillier, *The Later Work of Aubrey Beardsley*, London 1899, New York 1967

A. Mariuz, *Giandomenico Tiepolo*, Venice 1971

A. R. Masetti, *Cecco Bravo pittore toscano del Seicento*, Venice 1962

J. Mathey, *Ingres dessins*, Paris n.d.

G. Mazzariol, *Zoran Music*, Milan 1980

G. Mckim-Smith, *The Problem of Velazquez's Drawings*, in Master Drawings, 1980, no. 1, pp. 3 ff.

J. Meier-Graefe, *Renoir*, Leipzig 1929

A. Mellerio, *Odilon Redon*, Paris 1923

L. Menegazzi, *Gino Rossi*, Milan 1974

H. L. Mermod, *Dessins de Pablo Picasso, époques bleue et rose*, Lausanne 1960

F. Meyer, *La vita e l'opera di Marc Chagall*, Milan 1962

A. Michel, *François Boucher*, Paris 1906

U. Middledorf, *Raphael's Drawings*, New York 1945

A. Morassi, *Un libro di disegni e due quaderni di Sebastiano Ricci*, in Cronache d'Arte, 1926, pp. 256 ff.

A. Morassi, *Guardi. Tutti i disegni di Antonio, Francesco e Giacomo Guardi*, Venice 1975

V. Moschini, *Disegni di Jacopo Bellini*, Bergamo 1943

L. Münz, *Bruegel. The Drawings*, London 1961

M. Muraro, *Notes on Old and Modern Drawings. The Drawings of Giovanni Antonio Pellegrini*, in The Art Quarterly, 1960, pp. 359 ff.

M. Muraro, *I disegni di Vittore Carpaccio*, Florence 1977

R. M. Muthmann, *Angelika Kauffmann und ihre Zeit Graphik und Zeichnungen von 1760–1810*, Düsseldorf 1979

G. Nicodemi, *Tranquillo Cremona*, Milan 1933

K. Oberhuber, *Raphaels Zeichnungen. Abteilung IX. Entwürfe zu Werken Raphaels und seiner Schule im Vatikan 1511–12 bis 1520*, Berlin 1972

H. Olsen, *Federico Barocci*, Copenhagen 1962

O. Paecht, *A Forgotten Manuscript from the Library of the Duc de Berry*, in The Burlington Magazine, 1956, p. 150

R. Pallucchini, *Sebastian Viniziano (Fra Sebastian del Piombo)*, Milan 1944

R. Pallucchini, *Piazzetta*, Venice 1956, 1961

K. T. Parker, *Carletto Caliari*, in Old Master Drawings, 1936, pp. 27 ff.

K. T. Parker–J. Mathey, *Antoine Watteau. Catalogue complet de son oeuvre dessiné*, Paris 1957

G. Passavant, *Verrocchio. Sculture, Pitture e Disegni. Tutta l'opera*, Venice–London 1969

R. Paulson, *Rowlandson*, London 1972

H. Pearson, *The Man Whistler*, New York 1952

J. Pečirka, *Degas dessins*, Paris 1963

R. Penrose, *Mirò*, London 1970

A. Percy, *Giovanni Benedetto Castiglione. Master Draughtsman of the Italian Baroque*, Philadelphia 1971

K. Perls, *Jean Fouquet*, London 1940

T. Pignatti, *Acqueforti dei Tiepolo*, Florence 1965

T. Pignatti, *Disegni dei Guardi*, Florence 1967

T. Pignatti, *Les dessins de Pietro Longhi*, in L'Oeil, 1968, pp. 14 ff.

T. Pignatti, *Pietro Longhi*, Venice 1968

T. Pignatti, *Canaletto. Disegni*, Florence 1969

T. Pignatti, *Vittore Carpaccio. Collana Disegnatori Italiani*, Milan 1972

T. Pignatti, *Tiepolo: Disegni*, Florence 1974

T. Pignatti, *Veronese*, Venice 1976

T. Pignatti, *Giorgione*, 2nd ed. Milan 1978

T. Pignatti–M. A. Chiari, *Tiziano, Disegni*, Florence 1979

G. M. Pilo, *Otto nuove acqueforti e altre aggiunte grafiche a Marco Ricci*, in Arte Veneta, 1961, pp. 165 ff.

F. Ponge–P. Descargues–A. Malraux, *G. Braque*, Paris 1971

J. Pope Hennessy, *The Complete Work of Paolo Uccello*, London 1950

A. E. Popham, *The Drawings of Leonardo da Vinci*, New York 1946, 1963

A. E. Popham, *Drawings by Lotto*, in British Museum Quarterly, 1951, p. 72

A. E. Popham, *Correggio's Drawings*, London 1957

A. E. Popham, *Catalogue of the Drawings of Parmigianino*, New Haven and London 1971

P. Pouncey, *A Study by Sebastiano del Piombo for the 'Martyrdom of St. Agatha'*, in The Burlington Magazine, 1952, pp. 116 ff.

P. Pouncey, *Lotto disegnatore*, Vicenza 1965

V. Price, *The Drawings of Delacroix*, Los Angeles 1961

H. E. Read, *Henry Moore, Sculpture and Drawings*, London 1955

W. R. Rearick, *Jacopo Bassano 1568–69*, in The Burlington Magazine, 1962, pp. 524 ff.

J. Rewald, *Renoir Drawings*, New York 1946

J. Rewald, *Gauguin Drawings*, Paris 1958

J. Rewald, *Giacomo Manzú*, Salzburg 1966

E. K. J. Reznicek, *Hendrik Goltzius Zeichnungen*, Utrecht 1961

C. Ricci, *Jacopo Bellini e i suoi libri di disegni. I. Il libro del Louvre; II. Il Libro del British Museum*, Florence 1908

D. C. Rich, *Seurat and the Evolution of 'La Grande Jatte'*, Chicago 1935

A. Robaut, *L'Oeuvre de Corot*, Paris 1895–1905

A. Robaut–E. Chesnau, *L'oeuvre complet de E. Delacroix …*, Paris 1885

G. Robertson, *Giovanni Bellini*, Oxford 1968

M. Roethlisberger, *Claude Lorrain. The Drawings*, Berkeley and Los Angeles 1968

J. Rosenberg, *Martin Schongauer, Handzeichnungen*, Munich 1923

J. Rosenberg, *Die Zeichnungen Lucas Cranachs d.A.*, Berlin 1960

P. Rossi, *I disegni di Jacopo Tintoretto*, Florence 1975

P. Rossi, *Per la grafica di Domenico Tintoretto*, in Arte Veneta, 1975, pp. 205 ff.

E. Ruhmer, *Ergänzendes zu Zeichenkunst des Ercole de Roberti*, in Pantheon, 1962, pp. 241 ff.

E. Ruhmer, *Grünewald Drawings*, London 1970

E. Sack, *Giambattista und Domenico Tiepolo*, Hamburg 1910

C. Sala, *Max Ernst et la démarche onirique*, Paris 1970

F. Salamon, *G. B. Piranesi. Acqueforti e disegni*, Turin 1961–2

D. Sanminiatelli, *L'opera completa di Domenico Beccafumi*, Milan 1967

A. Scharf, *Filippino Lippi*, Vienna 1935

G. Schiff, *Johann Heinrich Füssli 1741–1825*, Zürich–Munich 1973

J. Scholz, *Drawings by Alessandro Magnasco*, in Essays in the History of Art Presented to R. Wittkower, London 1967, pp. 239 ff.

G. Schönberger, *The Drawings of Mathis Gothart Nitharth called Grünewald*, New York 1948

M. Seuphor, *Piet Mondrian. Sa vie, son oeuvre*, Paris 1956, 1970

J. Shearman, *Andrea del Sarto*, Oxford 1965

M. Sonkes, *Les Primitifs Flamands. Dessins du XVe siècle. Groupe Van der Weyden*, Brussels 1969

M. S. Soria, *Zurbarán*, London 1953

L. Souillié, *J. F. Millet*, Paris 1900

W. L. Strauss, *The Complete Drawings of Albrecht Dürer*, New York 1974

W. Suida, *Bramante pittore e il Bramantino*, Milan 1953

B. Suida Manning–W. Suida, *Luca Cambiaso. La vita e le opere*, Milan 1958

V. Surtees, *The Paintings and Drawings of Dante Gabriel Rossetti*, Oxford n.d.

A. Sutherland Harris, *Selected Drawings of Gian Lorenzo Bernini*, New York 1977

D. Ternois, *Jacques Callot. Catalogue Complet de son Oeuvre Dessiné*, Paris 1961

E. Tietze Conrat, *Andrea Mantegna. Le Pitture. I Disegni. Le Incisioni*, Florence–London 1955

H. Tietze–E. Tietze Conrat, *Domenico Campagnola's Graphic Art*, in The Print Collector's Quarterly, 1939, pp. 451 ff.

C. de Tolnay, *Hieronymus Bosch*, London 1966

P. Torriti, *Luca Cambiaso. Disegni*, Genoa 1966

R. Tozzi, *Disegni di Domenico Tintoretto*, in Bollettino d'Arte, 1937, pp. 19 ff.

R. Tozzi Pedrazzi, *Le Storie di Domenico Tintoretto per la Scuola di San Marco*, in Arte Veneta, 1964, pp. 73 ff.

E. Trautscholdt, *Uber Adriaen van Ostade als Zeichner*, Berlin 1960

M. Valsecchi, *Filippo de Pisis. Collana Disegnatori Italiani*, Milan 1971

A. Venturi, *Per Antonello da Messina*, in L'Arte, 1921, pp. 71 ff.

L. Venturi, *Cézanne, son art, son oeuvre*, Paris 1936

H. Vey, *Die Zeichnungen Anton van Dycks*, Brussels 1962

W. Vitzthum, *Pietro da Cortona Drawings for the Pitti Palace at the Uffizi*, in The Burlington Magazine, 1965, pp. 522 ff.

A. Vollard, *Tableaux, Pastels et Dessins de Pierre Auguste Renoir*, Paris 1918

E. T. de Wald, *The Illustrations of the Utrecht Psalter*, Princeton 1932

D. Waldman, *Roy Lichtenstein. Drawings and Prints*, New York and London 1970

C. Welcher, *Hendrick Avercamp, 1585–1634 …*, Zwolle 1933

H. E. Wethey, *El Greco and his School*, Princeton 1962

H. Wichman, *Leonard Bramer*, Leipzig 1923

J. Wilton Ely, *Piranesi*, London 1978

F. Winkler, *Die Zeichnungen Albrecht Dürers*, Berlin 1936–9

F. Winzinger, *Albrecht Altdorfer Zeichnungen*, Munich 1952

F. Winzinger, *Die Zeichnungen Martin Schongauers*, Berlin 1962

R. Wittkower, *Works by Bernini at the Royal Academy*, in The Burlington Magazine, 1951, pp. 51 ff.

M. Woodall, *Gainsborough's Landscape Drawings*, London 1939

C. Zervos, *Pablo Picasso*, Paris 1932–78

A. P. Zugni Tauro, *Gaspare Diziani*, Venice 1971

Exhibition and Museum Catalogues
Of the catalogues belonging to series (e.g. Windsor, Royal Library; Paris, Louvre; Florence, Uffizi) only those containing specific references to drawings reproduced in this volume are listed individually by author (e.g. K. T. Parker, The Drawings of Antonio Canaletto … at Windsor Castle, London 1948).

G. Arnolds, *Zeichnungen des Kupferstichkabinetts in Berlin. Italienische Zeichnungen*, Berlin 1949

R. Bacou, *Dessins des Carrache*, Paris 1961

R. Bacou, *Dessins de l'Ecole de Parme*, Paris 1964

R. Bacou, *Le Cabinet d'un grand Amateur, P. J. Mariette 1694–1774*, Paris 1967

R. Bacou, *Cartons d'artistes du XVe au XIXe siècle*, Paris 1974

R. Bacou, *Millet dessins*, Fribourg 1975

R. Bacou–J. Bean, *Dessins Florentins de la collection de Filippo Baldinucci*, Paris 1958

R. Bacou–A. Calvet, *Dessins du Louvre, Ecoles allemande, flamande, hollandaise*, Paris 1968

R. Bacou–F. Viatte, *Dessins du Louvre. Ecole italienne*, Paris 1968

R. Bacou–F. Viatte, *Dessins italiens de la Renaissance*, Paris 1975

F. Baldinucci, *Listra de' nomi de' Pittori, di mano de' quali si hanno disegni . . .* , Florence 1673

A. M. Barcia, *Catálogo de la colección de dibujos originales de la Biblioteca Nacional de Madrid*, Madrid 1906

A. Barigozzi Brini–R. Bossaglia, *Disegni del Settecento Lombardo*, Vicenza 1973

P. Barocchi, *Michelangelo e la sua scuola. I disegni di casa Buonarroti e degli Uffizi*, Florence 1962

Basel-Kunstmuseum, *Die Malerfamilie Holbein in Basel*, Basle 1960

E. Bassi, *Il Museo Civico di Bassano. I disegni di Antonio Canova*, Venice 1959

J. Bean, *Italian Drawings in the Art Museum Princeton University* n.d.

J. Bean, *17th Century Italian Drawings in the Metropolitan Museum of Art*, New York 1979

J. Bean, *100 European Drawings in the Metropolitan Museum of Art*, New York n.d.

J. Bean–F. Stampfle, *Drawings from New York Collections, I, The Italian Renaissance*, New York 1965

J. Bean–F. Stampfle, *Drawings from New York Collections, II, The Seventeenth Century in Italy*, New York 1967

J. Bean–F. Stampfle, *Drawings from New York Collections, III, The Eighteenth Century in Italy*, New York 1971

M. Beau, *La collection des dessins d'Hubert Robert au Musée de Valence*, Lyon 1968

S. M. Béguin, *Mostra di Niccolò dell'Abate*, Bologna 1969

O. Benesch, *Die Zeichnungen der Niederländischen Schulen des XV. und XVI. Jahrhunderts*, Vienna 1928

O. Benesch–E. Benesch, *Master Drawings in the Albertina*, London (1967)

Berlin, *Meisterwerke aus den Berliner Museen. Deutsche Zeichnungen der Dürerzeit. Ausstellung Berlin-Dahlem*, Berlin 1951–2

Berlin-Kupferstichkabinett, *Zeichnungen Alter Meister im Kupferstichkabinett der K. Museen zu Berlin. Erster Band. Italien–Frankreich–Spanien*, Berlin 1910

A. Bertini, *Disegni di maestri stranieri della Biblioteca Reale di Torino*, Turin 1951

A. Bertini, *I disegni italiani della Biblioteca Reale di Torino*, Rome 1958

A. Bettagno, *Disegni e dipinti di Giovanni Antonio Pellegrini*, Venice 1959

A. Bettagno, *Disegni veneti del Settecento della Fondazione Cini e delle collezioni venete*, Venice 1963

A. Bettagno, *Disegni di Giambattista Piranesi*, Vicenza 1978

Z. Birolli, *Letteratura-Arte: miti del '900*, Milan 1979

P. Bjurström, *Drawings from Stockholm*, New York 1969

P. Bjurström, *Drawings in Swedish Public Collections. Italian Drawings*, Stockholm 1979

E. Bock, *Die Zeichnungen deutscher Meister im Berliner Kupferstichkabinett*, Berlin 1920

E. Bock–J. Rosenberg, *Staatliche Museen zu Berlin. Die Zeichnungen Alter Meister im Kupferstichkabinett. Die niederländischen Meister*, Frankfurt 1931

K. G. Boon, *Dutch Genre Drawings of the Seventeenth Century*, Washington 1972

G. Bora, *Disegni di manieristi lombardi*, Vicenza 1971

G. Bora, *I disegni del codice Resta*, Bologna 1976

H. van Borsum Buisman, *Teyler Museum. Handzeichnungen*, Leipzig 1924

Boston-Museum of Fine Arts, *Catalogue of Paintings and Drawings in Watercolor*, Boston 1949

J. Bouchot Saupique, *Musée National du Louvre. Catalogue des Pastels*, Paris 1930

J. Bouchot Saupique, *French Drawings. Masterpieces of Five Centuries*, New York 1952–3

I. Budde, *Beschreibender Katalog der Handzeichnungen in der Staatlichen Kunstakademie Düsseldorf*, Düsseldorf 1930

Budapest Museum, *Meisterzeichnungen aus dem Museum der Schönenkünste in Budapest*, Vienna 1967

L. Burchard–R. A. d'Hulst, *Tekeningen van P. P. Rubens*, Rotterdam 1956

J. Byam Shaw, *Drawings by Old Masters at Christ Church Oxford*, Oxford 1976

J. Byam Shaw–T. S. Wragg, *Old Master Drawings from Chatsworth*, Washington 1969–70

M. Catelli Isola et al., *I grandi disegni italiani del Gabinetto Nazionale delle Stampe di Roma*, Milan 1980

A. Châtelet, *Italiaanse Tekeningen int te Museum te Rijssel (Les dessins italiens au Musée de Lille)*, Amsterdam 1967–8

M. Campbell, *Mostra di disegni di Pietro Berrettini da Cortona per gli affreschi di Palazzo Pitti*, Florence 1965

Canaletto. Paintings and Drawings. The Queen's Gallery, London 1980

G. C. Cavalli–C. Gnudi, *Mostra di Guido Reni*, Bologna 1954

H. de Chennevières, *Les dessins du Louvre: I, Ecole flamande, hollandaise et allemande; II, Ecole italienne; III, 1–2, Ecole française*, Paris n.d. (1882)

Cincinnati Art Museum, *The Lehman Collection*, Cincinnati (Ohio) 1960

L. Cogliati Arano, *Leonardo. Disegni di Leonardo e della sua cerchia alle Gallerie dell'Accademia*, Milan 1980

J. Cordey, *Les dessins français des XVIe e XVIIe siècles au British Museum*, in Bulletin de la Société de l'Histoire de l'Art Français, 1932

S. Colvin, *The British Museum. Catalogue of Drawings by Dutch and Flemish Artists*, London 1915, 1924

E. Croft Murray–P. Hulton, *The British Museum. Catalogue of British Drawings. Volume one, XVI and XVII Centuries*, London 1960

B. Degenhart–A. Schmitt, *Italienische Zeichnungen 15.–18. Jahrhundert*, Munich 1967

C. del Bravo, *Mostra di disegni italiani del XIX secolo*, Florence 1971

M. Dobroklonsky, *Die Zeichnungen. Sammlung der Ermitage*, in Pantheon, 1928, pp. 475 ff.

M. Dobroklonsky, *Drawings of the Italian School, 15th and 16th cent.*, Leningrad–Moscow 1940

M. Dobroklonsky, *Hermitage Collections. Catalogue of Drawings of the Italian school, 17th and 18th cent.*, Leningrad 1961

P. Dreyer, *Römische Barockzeichnungen aus dem Berliner Kupferstichkabinett*, Berlin 1969

A. Emiliani–G. Gaeta Bertelà, *Mostra di Federico Barocci (Urbino 1535–1612)*, Bologna 1975

Fairfax Murray = J. Pierpont Morgan Collection of Drawings by the Old Masters, formed by C. Fairfax Murray, London 1912

T. Falk, *Katalog der Zeichnungen des 15.und 16.Jahrhunderts im Kupferstichkabinett Basel*, Basle–Stuttgart 1979

E. Feinblatt, *Recent Purchases of North Italian Drawings. The Los Angeles County Museum Art Division*, Bulletin, 1958, pp. 10 ff.

I. Fenyö, *Disegni veneti del Museo di Budapest*, Vicenza 1965

I. Fenyö, *North Italian Drawings from the Collection of the Budapest Museum of Fine Arts*, Budapest 1965

P. N. Ferri, *Catalogo riassuntivo della raccolta di disegni Antichi e Moderni posseduta dalla R. Galleria degli Uffizi di Firenze . . .* , Rome 1890

Florence–Uffizi, *Gabinetto Disegni e Stampe degli Uffizi. Cataloghi*, Florence 1951

G. Fogolari, *I disegni delle R.e Gallerie dell'Accademia*, Milan 1913

A. Forlani Tempesti, *Il Gabinetto dei Disegni e delle Stampe*, in Gli Uffizi. Catalogo Generale, Florence 1979

A. Forlani Tempesti–M. Fossi Todorow–G. Gaeta–A. M. Petioli, *Mostra dei disegni italiani della Collezione Santarelli*, Florence 1967

A. Forlani Tempesti–A. M. Petrioli Tofani, *I grandi disegni italiani degli Uffizi di Firenze*, Milan 1972

Frankfurt–Städelsches Kunstinstitut, *Handzeichnungen alter Meister im Städelschen Kunstinstitut*, Frankfurt 1908–15

M. J. Friedländer, *Jheronimus Bosch*, Amsterdam 1967

M. J. Friedländer–E. Bock, *Staatliche Museen zu Berlin. Die Zeichnungen alter Meister im Kupferstichkabinett, Die deutschen Meister*, Berlin 1921

P. L. Ganz, *Fuseli Drawings*, Washington 1954

K. J. Garlick, *Eighteenth Century Master Drawings from the Ashmolean*, Washington 1979–80

J. A. Gere, *Mostra di disegni degli Zuccari*, Florence 1966

J. A. Gere, *Portrait Drawings XV–XX Centuries*, Scarborough 1974

F. Gibbons, *Catalogue of Italian Drawings in the Art Museum Princeton University*, Princeton 1977

C. Gilbert, *Drawings of the Italian Renaissance from the Scholz Collection*, Bloomington 1958

Giorgione a Venezia. Exhibition Catalogue, Milan 1978

A. Griseri, *I grandi disegni Italiani alla Biblioteca Reale di Torino*, Milan 1978

R. Hadley, *Drawings. Isabella Stewart Gardner Museum*, Boston 1968

P. Halm, *German Drawings. Masterpieces from Five Centuries*, Washington 1955–6

P. Halm, *Berichte der Staatlichen Kunstammlungen. Staatliche Graphische Sammlung*, in Münchner Jahrbuch der bildenden Kunst, 1964, pp. 254 ff.

P. Halm–B. Degenhart–W. Wegner, *Hundert Meisterzeichnungen aus der Staatlichen Graphischen Sammlung München*, Munich 1958

R. Harprath, *Italienische Zeichnungen des 16. Jahrhunderts aus eigenem Besitz*, Staatliche Graphische Sammlung München, Munich 1977

Hartford–Wadsworth Atheneum, *Handbook*, Hartford (Conn.) 1958

C. van Hasselt, *Flemish Drawings of the Seventeenth Century*, London–Paris–Berne–Brussels 1972

E. Haverkamp Begemann, *Vijf Eeuwen Tekenkunst. Tekeningen van Europese Meesters in het Museum Boymans te Rotterdam*, Rotterdam 1957

E. Haverkamp Begemann–S. D. Lawder–C. W. Talbot jr., *Drawings from the Clark Art Institute*, New Haven and London 1964

A. M. Hind, *Catalogue of Drawings by Dutch and Flemish Artists. Department of Prints and Drawings, British Museum*, London 1915–31

W. Hugelshofer, *Swiss Drawings. Masterpieces of Five Centuries*, Washington 1967

R. A. d'Hulst, *De Tekeningen van Jacob Jordaens*, Brussels 1956

H. Joachim, *Master Drawings from the Art Institute of Chicago*, New York 1963

H. Joachim, *The Helen Regenstein Collection of European Drawings*, Chicago 1974

H. Joachim–S. Folds McCullach, *Italian Drawings in the Art Institute of Chicago*, Chicago and London 1979

J. J. van der Kellen, *Hondred Teekeningen im Rijksprentenkabinet*, Amsterdam 1908

H. Kögler, *Beschreibendes Verzeichnis der Basler Handzeichnungen des Urs Graf*, Basle 1926

H. Kögler, *Beschreibendes Verzeichnis der Basler Handzeichnungen des Niklaus Manuel Deutsch*, Basle 1930

E. Kondo, *Stampe e disegni giapponesi dei secoli XVIII–XIX nelle collezioni pubbliche fiorentine*, Florence 1980

G. Knox, *Victoria and Albert Museum Catalogues. Department of Prints and Drawings. Tiepolo Drawings*, London 1975

W. Koschatzky, *200 Jahre Albertina, Herzog Albert von Sachsen-Teschen und seine Kunstsammlung*, Vienna 1969

W. Koschatzky–E. Knab–K. Oberhuber, *Dessins italiens de l'Albertina de Vienne*, Paris 1975

W. Koschatzky–A. Strobl, *Die Albertina in Wien*, Salzburg 1969

R. Kultzen–P. Eikemeier, *Venezianische Gemälde des 15.und 16.Jahrhunderts. Vollstandiger Katalog*, Munich 1971

H. Landolt, *100 disegni di maestri del XV e XVI secolo del Gabinetto delle Stampe di Basilea*, Basle 1972

P. Lavallée, *La collection des dessins de l'Ecole des Beaux-Arts*, in Gazette des Beaux-Arts 1917, pp. 265 ff.

Leningrad–Ermitage, *Catalogue*, Leningrad 1867

Leningrad–Ermitage, *Catalogue*, Leningrad 1871

J. Leymarie, *Braque*, Rome 1975

W. S. Lieberman, *Max Ernst. The Museum of Modern Art*, New York 1961

W. S. Lieberman, *Drawings from the Kröller– Müller Museum, Otterlo*, New York 1973

F. Lippmann, *Zeichnungen von Sandro Botticelli zu Dantes Göttliche Cömodie*, Berlin 1887, 1896

G. Lorenzetti, *Il Quaderno del Tiepolo al Museo Correr di Venezia*, Venice 1946

F. Lugt, *Inventaire Général des Dessins des Ecoles du Nord (Ecole Nationale Supérieure des Beaux-Arts), I, Ecole Hollandaise*, Paris 1950

F. Lugt–J. Vallery Radot, *Inventaire Général des Dessins des Ecoles du Nord (Bibliothèque Nationale)*, Paris 1936

H. Macandrew, *Ashmolean Museum Oxford – Catalogue of the Collection of Drawings. III. Italian Schools: Supplement*, Oxford 1980

L. Magagnato, *Disegni del Museo di Bassano*, Venice 1956

L. Magagnato, *Pio Semeghini (1878–1964)*, Venice 1978

D. Mahon, *Mostra dei Carracci. Disegni*, Bologna 1956

L. S. Malke, *Städel. Italienische Zeichnungen des 15.und 16.Jahrhunderts*, Frankfurt am Main 1980

J. H. Martin, *Malévitch. Oeuvres de Casimir Severinovitch Malévitch (1878–1935)*, Paris 1978

S. Massari, *Carlo Carrà. Opera grafica*, Rome 1978

M. Mattarozzi, *I disegni di Felice Giani nel Gabinetto Stampe degli Uffizi a Firenze*, in Gutenberg Jahrbuch, 1965, pp. 293 ff.

J. Meder, *Albertina-Facsimile. Handzeichnungen französische Meister in der Albertina*, Vienna 1922

J. Meder, *Albertina-Facsimile. Handzeichnungen vlämischer und holländischer Meister des XV.–XVII. Jahrhunderts*, Vienna 1923

L. Menegazzi, *Guglielmo Ciardi*, Treviso 1977

H. Mielke–M. Winner, *Pieter Paul Rubens. Kritischer Katalog der Zeichnungen. Originale–Umkreis–Kopien, Die Zeichnungen alter Meister im Berliner Kupferstichkabinett*, Berlin 1977

E. W. Moes, *Oude Teekeningen van de Hollandsche en Vlaamse School, Rijksprentenkabinet Amsterdam*, The Hague 1905–6

H. Möhle, *Das Berliner Kupferstichkabinett*, Berlin 1963

A. Moir, *Drawings by Seventeenth Century Italian Masters from the Collection of Janos Scholz*, Los Angeles 1974

A. Mongan, *One Hundred Master Drawings*, Cambridge (Mass.) 1949

A. Mongan–P. J. Sachs, *Drawings in the Fogg Museum of Art*, Cambridge (Mass.) 1946

I. Monod Fontaine, *Matisse. Oeuvres de Henri Matisse (1869–1954). Collections du Musée National d'Art Moderne*, Paris 1979

Morandi exhibition, London = *Exhibition Giorgio Morandi*, Arts Council of Great Britain, London 1970–1

Morandi exhibition, Paris = *Giorgio Morandi*, Réunion des Musées Nationaux, Paris 1971

M. Muraro, *Mostra dei disegni veneziani del Sei e Settecento*, Florence 1953

M. Muraro, *Disegni veneti della collezione Janos Scholz*, Venice 1957

New York-Metropolitan, *European Drawings from the Collection of the Metropolitan Museum of Art; I, Italian Drawings; II, Flemish, Dutch, German, Spanish, French and British Drawings*, New York 1942–3

New York–Museum of Modern Art, Junior Council, *Recent Drawings*, New York 1956

J. W. Niemeijer, *Franse Tekenkunst van de 18de eeuw uit Nederlandse Verzamelingen*, Amsterdam 1974

K. Oberhuber, *National Gallery of Art. Recent Acquisitions*, Washington 1974

K. Oberhuber, *Disegni di Tiziano e della sua cerchia*, Vienna 1976

K. Oberhuber–D. Walker, *Sixteenth Century Italian Drawings from the Collection of Janos Scholz*, New York 1973–4

U. Ojetti, *Cremona e gli artisti lombardi del suo tempo. Catalogo delle opere esposte nel Castello Visconteo di Pavia*, Milan–Rome 1938

Oskar Kokoschka Aquarelle und Zeichnungen. Ausstellung zum 80. Geburtstag, Stuttgart 1966

Ottawa–National Gallery of Canada, various authors, *De Raphaël à Picasso. Dessins de la Galerie Nationale du Canada*, Florence 1969

G. Paccagnini–A. Mezzetti–M. Figlioli, *Andrea Mantegna. Catalogo della Mostra (Mantova)*, Venice 1961

R. Pallucchini, *I disegni del Guardi al Museo Correr di Venezia*, Venice 1943

G. Panazza, *Girolamo Romanino*, Brescia 1965

Paris–Louvre, *Inventaire général des dessins du Musée du Louvre et du Musée de Versailles Ecole française*, Paris 1907–38; I, 1907 (2nd ed. 1933); II, 1908; III, 1909; IV, 1909; V, 1910; VI, 1911; VII, 1912; VIII, 1913; IX, 1921, edited by J. Guiffrey and P. Marcel; X, 1928, edited by J. Guiffrey, P. Marcel and G. Rouches; XI, 1938, edited by G. Rouches and R. Huyghe

Paris–Louvre, *Musée du Louvre. Expositions du Cabinet de Dessins. Catalogues*

Paris–Louvre, *Musée du Louvre. Inventaire Général des Dessins des Ecoles du Nord. Ecole Hollandaise*, edited by F. Lugt, Paris; I, 1929; II, 1931; III, 1933

Paris–Louvre, *Musée du Louvre. Inventaire Général des Ecoles du Nord. Ecoles Allemande et Suisse*, edited by L. Demonts, Paris; I, 1937; II, 1938

Paris–Louvre, *Musée du Louvre. Inventaire Général des Dessins des Ecoles du Nord. Ecole Flamande*, edited by F. Lugt, Paris I, 1949 (A–M); II, 1949 (N–Z)

K. T. Parker, *Catalogue of the Collection of Drawings in the Ashmolean Museum. I, Netherlandish, German, French and Spanish Schools*, Oxford 1938; *II, Italian Schools*, Oxford 1956

K. T. Parker, *The Drawings of Antonio Canaletto in The Collection of His Majesty the King at Windsor Castle*, London 1948

G. Pauli, *Zeichnungen alter Meister in der Kunsthalle zu Hamburg. Italiener*, Frankfurt 1927

H. Pauli, *Handzeichnungen alter Meister in der Hamburger Kunsthalle*, Hamburg 1920

C. Pedretti, *Disegni di Leonardo da Vinci e della sua Scuola alla Biblioteca Reale di Torino*, Florence 1975

A. E. Peréz Sánchez, *Real Academia de Bellas Artes de San Fernando. Catálogo de los dibujos*, Madrid 1967

A. E. Pérez Sánchez, *The Collection of Drawings in the Prado Museum*, in Apollo, July 1970, pp. 384 ff.

A. E. Pérez Sánchez, *I grandi disegni italiani nelle collezioni di Madrid*, Milan 1977

T. Pignatti, *Disegni e incisioni. Mostra del Tiepolo*, Venice 1951, pp. 182 ff.

T. Pignatti, *Il quaderno di disegni del Canaletto alle Gallerie di Venezia*, Milan 1958

T. Pignatti, *Eighteenth Century Venetian Drawings from the Correr Museum*, Washington 1963–4

T. Pignatti, *Disegni veneti del Settecento nel Museo Correr di Venezia*, Vicenza 1964

T. Pignatti, *I grandi disegni italiani nelle collezioni di Venezia*, Milan 1973

T. Pignatti, *Venetian Drawings from American Collections*, Washington 1974

T. Pignatti, *I grandi disegni italiani nelle collezioni di Oxford*, Milan 1976

T. Pignatti–F. Pedrocco, *Disegni antichi del Museo Correr di Venezia*, vol 1 (Aliense–Crosato), Venice 1980

G. M. Pilo, *Marco Ricci*, Venice 1963

A. E. Popham, *Italian Drawings Exhibited at the Royal Academy Burlington House (1930)*, London 1931

A. E. Popham, *Catalogue of Drawings by Dutch and Flemish Artists. Department of Prints and Drawings, British Museum*, London 1932

A. E. Popham, *A Handbook to the Drawings and Water colours in the Department of Prints and Drawings. British Museum*, London 1939

A. E. Popham, *Italian Drawings in the Department of Prints and Drawings in the British Museum. Artists Working in Parma in the Sixteenth Century*, London 1967

A. E. Popham–K. M. Fenwick, *The National Gallery of Canada. Catalogue of European Drawings*, Toronto 1965

A. E. Popham–P. Pouncey, *Italian Drawings in the Department of Prints and Drawings in the British Museum. The Fourteenth and Fifteenth Centuries*, London 1950

A. E. Popham–P. Pouncey, *Supplement to the Catalogue of Italian Drawings XIV–XV Centuries*, in British Museum Quarterly, 1952, pp. 61 ff.

A. E. Popham–J. Wilde, *The Italian Drawings of the XV and XVI Centuries ... at Windsor Castle*, London 1949

P. Pouncey–J. A. Gere, *Italian Drawings in the Department of Prints and Drawings in the British Museum. Raphael and his Circle ...*, London 1962

M. Precerutti Garberi, *Marino Marini alla Galleria d'Arte Moderna*, Milan 1973

Prestel Gesellschaft, *Handzeichnungen alter Meister in Frankfurt am Main*, 1929–30

L. Ragghianti Collobi, *Disegni della Fondazione Horne in Firenze*, Florence 1963

L. Ragghianti Collobi, *Disegni inglesi della Fondazione Horne in Firenze*, Cremona 1966

L. Ragghianti Collobi–C. L. Ragghianti, *Disegni dell' Accademia Carrara di Bergamo*, Venice 1962

W. R. Rearick, *Tiziano e il disegno veneziano del suo tempo*, Florence 1976

J. Q. van Regteren Altena, *Dutch Drawings. Masterpieces of Five Centuries*, Washington 1958

J. Q. van Regteren Altena, *Keuze van Tekeningen bewaard in het Rijksprentenkabinet*, Amsterdam 1963

J. Q. van Regteren Altena, *Les dessins italiens de la reine Christine de Suède*, Stockholm 1966

H. Reitlinger, *Victoria and Albert Museum. A Selection of Drawings by Old Masters in the Museum Collection with a Catalogue and Notes*, London 1921

A. Rizzi, *Sebastiano Ricci disegnatore*, Milan 1975

A. Robison, *Master Drawings from the Collection of the National Gallery of Art and Promised Gifts*, Washington 1978

Roma–Gabinetto Nazionale delle Stampe, Cataloghi di Mostre

P. Rosenberg, *French Master Drawings of the 17th and 18th Centuries in North American Collections*, London 1972

P. Rosenberg, *Chardin. 1699–1779*, Paris 1979

Rotterdam–Museum Boymans–van Beuningen, *Catalogues van Teekeningen in het Museum te Totterdam*, Rotterdam 1952

U. Ruggeri, *Disegni lombardi settecenteschi all'Accademia Carrara di Bergamo*, Bergamo 1975

U. Ruggeri, *Disegni Veneti del Settecento nella Biblioteca Ambrosiana*, Vicenza 1976

U. Ruggeri, *Disegni Veneti della Biblioteca Ambrosiana anteriori al secolo XVIII*, Florence 1979

L. Salmina, *Disegni veneti del Museo di Leningrado*, Venice 1964

E. Santarelli–E. Burci–F. Rondoni, *Catalogo della raccolta dei disegni autografi antichi e moderni donata dal Prof. Emilio Santarelli alla Reale Galleria di Firenze*, Florence 1870

W. Schade, *Dresdner Zeichnungen 1550–1650*, Dresden 1969

W. Schmidt, *Handzeichnungen alter Meister im Kgl. Kupferstichkabinett zu München*, Munich 1884

H. J. Scholten, *Musée Teyler à Haarlem, Catalogue raisonné des Dessins des Ecoles Françaises et Hollandaises*, Haarlem 1901

H. J. Scholten, *Catalogue Teyler Museum*, Haarlem 1904

J. Scholz, *Italienische Meisterzeichnungen vom 14.bis zum 18.Jahrhundert aus americanischen Besitz. Die Sammlung J. Scholz*, New York–Hamburg–Cologne 1963–4

J. Scholz, *Italian Master Drawings 1350–1800 from the Janos Scholz Collection ...*, New York 1976

J. Schönbrunner–J. Meder, *Handzeichnungen alter Meister aus der Albertina und anderen Sammlungen*, Vienna 1896–1908

J. Schulz, *Master Drawings from Californian Collections*, Berkeley–New York 1968

M. Sérullaz–L. Duclaux–G. Monnier, *Dessins du Louvre. Ecole française*, Paris 1968

R. Shooman Slatkin, *François Boucher in North American Collections. 100 Drawings*, Washington 1974

R. Schoolman–C. E. Slatkin, *Six Centuries of French Master Drawings in America*, New York 1950

G. Sinibaldi, *Italian Drawings. Masterpieces of Five Centuries*, Washington 1960

O. Sirén, *Dessins et Tableaux de la Renaissance italienne dans les Collections de Suède*, Stockholm 1902

O. Sirén, *Italienska Handtekningar fran 1400-och 1500 talen i Nationalmuseum. Catalogue raisonné ...*, Stockholm 1917

O. Sirén, *Italienska tavlor och teckningar i Nationalmuseum*, Stockholm 1933

C. E. Slatkin–R. Shoolman, *Treasury of American Drawings*, New York 1947

K. L Spangenberg, *French Drawings, Watercolors and Pastels, 1800–1950*, Cincinnati 1978

E. Spina Barelli, *Disegni di Maestri Lombardi del Primo Seicento*, Milan 1959

F. Stampfle, *Drawings. Major Acquisitions of the Pierpont Morgan Library 1924–1974*, New York 1974

F. Stampfle–C. D. Denison, *Drawings from the Collection of Lore and Rudolf Heinemann*, New York 1973

A. Stix–L. Fröhlich Bum, *Albertina Katalog. Die Zeichnungen der Toskanischen, Umbrischen und Römischen Schulen*, Vienna 1932

A. Stix–A. Spitzmüller, *Albertina Katalog. Die Schulen von Ferrara, Bologna, Parma und Modena, der Lombardei, Genuas, Neaples und Siziliens ...*, Vienna 1941

S. A. Strong, *Reproduction of Drawings by Old Masters in the Collection of the Duke of Devonshire at Chatsworth*, London 1902

D. Sutton, *French Drawings of the Eighteenth Century*, London 1949

C. Thiem, *Italienische Zeichnungen 1500 1800 Bestandkatalog der Graphische Sammlung der Staatsgalerie Stuttgart*, Stuttgart 1977

H. Tietze–E. Tietze Conrat–O. Benesch–K. Garzarolli Thurnlackh, *Albertina Katalog. Die Zeichnungen der Deutschen Schulen bis zum Beginn des Klassizismus*, Vienna 1933

M. Valsecchi, *I grandi disegni del '600 lombardo all'Ambrosiana*, Milan 1975

L. Vayer, *Master Drawings from the Collection of the Budapest Museum of Fine Arts, 14th–18th Centuries*, New York 1956

Venezia–Fondazione Giorgio Cini, Cataloghi di Mostre, Venezia 1955

W. Vitzthum, *Italian Drawings*, Regina and Montreal 1970

P. Ward Jackson, *Victoria and Albert Museum Catalogues. Italian Drawings. Volume One, 14th–16th Century*, London 1979

P. Ward Jackson, *Victoria and Albert Museum Catalogues. Italian Drawings. Volume Two, 17th–18th Century*, London 1980

M. Wheeler, *Modern Drawings. Museum of Modern Art*, New York 1944

J. White, *Drawings from the National Gallery of Ireland*, London 1967

F. Wickoff, *Die italienischen Handzeichnungen der Albertina; I, Die Venezianischen Schule*, in Jahrbuch Kh. Samm. Wien, 1891, pp. CCV ff.; II, *Die Römische Schule*, in Jahrbuch Kh. Samm. Wien, 1892, pp. CLXXV ff.

Wien Albertina, *Beschreibender Katalog der Handzeichnungen in der graphischen Sammlung Albertina*, Vienna 1926–41

J. Wilde, *Italian Drawings in the Department of Prints and Drawings, British Museum, Michelangelo and His Studio*, London 1953

Windsor–Royal Library, *The Drawings of ... at Windsor Castle* (catalogues of the collection)

M. Winner, *Pieter Bruegel d.Ä als Zeichner*, Berlin 1975

K. Woermann, *Handzeichnungen Alter Meister im Königlichen Kupferstichkabinett zu Dresden*, Munich 1897

T. S. Wragg, *Old Master Drawings from Chatsworth*, Washington 1962–3

A. Zander Rudenstine, *The Guggenheim Collection, 1880–1945*, New York 1976

Zoran Music. Catalogue of the council for artistical and historical treasures in Venice, Venice 1980

Techniques, Restoration and Conservation
Although not quoted individually, many relevant articles are to be found in the magazines listed below.

Bollettino dell'Istituto Centrale del Restauro, Rome

C. F. Bridgman, *Radiographie du papier*, in Studies in Conservation, Feb. 1965, pp. 8 ff.

Bulletin of the International Institute for Conservation, London

T. Dalley, *The Complete Guide to Illustration and Design Techniques and Materials*, London 1980

C. de Tolnay, *History and Technique of Old Master Drawings*, 2nd ed. New York 1972

F. W. Doloff–R. L. Perkinson, *How to Care for Works of Art in Paper*, Boston 1976

O. H. Giglioli, *La technique de la conservation des*

dessins au Musée des Offices, in Mouseion, 1930

C. Hayes, *The Complete Guide to Painting and Drawing Techniques and Materials*, London 1978

K. Herberts, *The Complete Book of Artist's Techniques*, New York 1958

H. Hutter, *Die Handzeichnung ...*, Vienna– Munich 1966; English ed. *Drawing. History and Technique*, London 1968

W. Koschatzky, *Die Kunst der Zeichnung, Technik, Geschichte, Meisterwerke*, Salzburg 1977

P. Lavallée, *Les techniques du dessin, leur évolution dans les différentes écoles de l'Europe*, Paris 1943

P. Lavallée, *Les techniques du dessin*, Paris 1949

L. Lepeltier, *Restauration des dessins et estampes*, Fribourg 1977

C. Maltese, *Le tecniche artistiche*, Milan 1973

R. Mayer, *The Artist's Book of Materials and Techniques*, New York 1957

J. Meder, *Die Handzeichnung. Ihre Technik und Entwicklung*, Vienna 1919 and 1923

F. Negri Arnoldi, *Il disegno e le tecniche grafiche*, in Storia dell'Arte italiana Einaudi, vol. IV, pp. 178 ff.

R. Oertel, *Wandmalerei und Zeichnung in Italien*, in Mitteilungen des Kunsthistorisches Institut in Florenz, Dec. 1937–July 1940

G. Piva, *L'arte del restauro*, Milan 1961

H. J. Plenderleith–A. E. A. Werner, *The Conservation of Antiquities and Works of Art*, London 1971

J. Rudel, *Technique du dessin*, Paris 1979

H. Simon, *Techniques of Drawings*, New York 1972

O. Wachter, *Restaurierung und Erhaltung von Büchern, Archivalien und Graphiken*, Vienna–Cologne–Graz 1975

C. Walter, *Die Manuellen graphischen Techniken*, Halle 1923

J. Watrous, *The Craft of Old Master Drawings*, 2nd ed. Madison, 1967

Index

Picture sources

a = above; b = below; l = left

Jörg P. Anders, Berlin: pp. 66, 92, 102, 146–7, 159, 167, 168, 174–5, 224, 230–1, 291. J. Blauel, Munich: pp. 81, 90, 91, 117, 118, 122–3, 149, 166, 177, 200, 222, 225. Bulloz, Paris: p. 140. Cacciago, Milan: pp. 17, 70. Chomon-Perino, Turin: p. 110. Clichés Musées Nationaux, Paris: pp. 2–3, 65, 83, 88, 93, 113, 114, 116, 121, 134, 138, 160, 188, 229, 263, 293, 334*l*. Colorphoto H. Hinz, Allschwil: pp. 165, 168, 170, 171, 173, 342. R. Descharnes, Paris: p. 373. G. Fini, Treviso: p. 38. Fitzwilliam Museum, Cambridge, reproduced by permission of the Syndics: p. 136. G. Furla, Milan: p. 333. Fotostudio Max (photo Mirko Lion), Venice: pp. 108, 131, 186, 205, 236–7, 238, 240, 241, 245, 246, 249, 252, 255, 258, 259, 317, 362*b*, 363, 365, 370. Giraudon, Paris: p. 255. The Governing Body of Christ Church, Oxford: p. 151. László Gyarmathy, Budapest: p. 69. R. Kleinhempel, Hamburg: p. 178. Lichtbildwerkstätte Alpenland, Vienna: pp. 22, 23, 27, 33, 99, 103, 119, 141, 152, 161, 162, 163, 172, 179, 196, 204, 206–7, 214–15, 216, 218, 275, 345. M. Malaisy, Lille: p. 307. D. Manso, Madrid: p. 120. W. Mori, Milan: p. 366*b*. H. Petersen, Copenhagen: p. 107. M. Quattrone, Florence: pp. 16, 59, 79, 94–5, 96, 125, 135, 145, 148, 183, 190, 195, 250, 290, 295, 312, 313. G. Reinhold, Leipzig-Mölkan: p. 98. Roma's Press Photo (photo Cioni), Rome: p. 376. Royal Library, Windsor, reproduced by gracious permission of Her Majesty Queen Elizabeth II: pp. 19, 80, 87, 254. Saporetti, Milan: pp. 314, 315, 360, 362*a*, 367. O. Savio, Rome: pp. 20, 109. Scala, Florence: p. 41, 45. Studio Clam 2003, Bergamo: p. 71. J. Vertut, Issy-les-Moulineaux: p. 42. F. Zanetti, Verona: p. 364.

Photographs not listed above have been kindly supplied by the Museums and Collections where they are housed.